YALE UNIVERSITY PRESS
PELICAN HISTORY OF ART

FOUNDING EDITOR: NIKOLAUS PEVSNER

SEYMOUR SLIVE

DUTCH PAINTING
1600–1800

Seymour Slive

Dutch Painting 1600–1800

Yale University Press
New Haven and London

TO THE MEMORY OF
WILHELM VON BODE (1845–1929)
ABRAHAM BREDIUS (1855–1946)
CORNELIUS HOFSTEDE DE GROOT (1863–1930)

Some sections of this book were previously published as parts one and two of *Dutch Art and Architecture: 1600–1800* by Penguin Books Ltd, 1966

Set in Linotron Ehrhardt by Best-set Typesetter Ltd., Hong Kong
Printed in Singapore by CS Graphics Pte

Designed by Sally Salvesen

Library of Congress Cataloging-in-Publication Data

Rosenberg. Jakob, 1893–1980
 Dutch painting 1600–1800 / Jakob Rosenberg and Seymour Slive. – Rev. and expanded / by Seymour Slive.
 p. cm. – (Yale University Press Pelican history of art)
 "Some sections of this book were previously published as parts one and two of Dutch art and architecture: 1600–1800 by Penguin Books Ltd., 1966" – T.p. verso.
 Includes bibliographical references and index.
 ISBN 0-300-06418-7 (hardcover)
 978-0-300-07451-2 (paper)
 1. Painting, Dutch. 2. Painting, Modern – 17th–18th centuries – Netherlands. I. Slive, Seymour, 1920– . II. Rosenberg, Jakob, 1893– Dutch art and architecture, 1600–1800. III. Title. IV. Series.
ND646.D594 1995
759.9492'09'032 – dc20 95-14215
 CIP

Title page: detail of fig. 246, Hendrick Avercamp: *Winter Scene on a Canal.* Toledo, Ohio, Toledo Museum of Art, Gift of E.D. Libbey

Contents

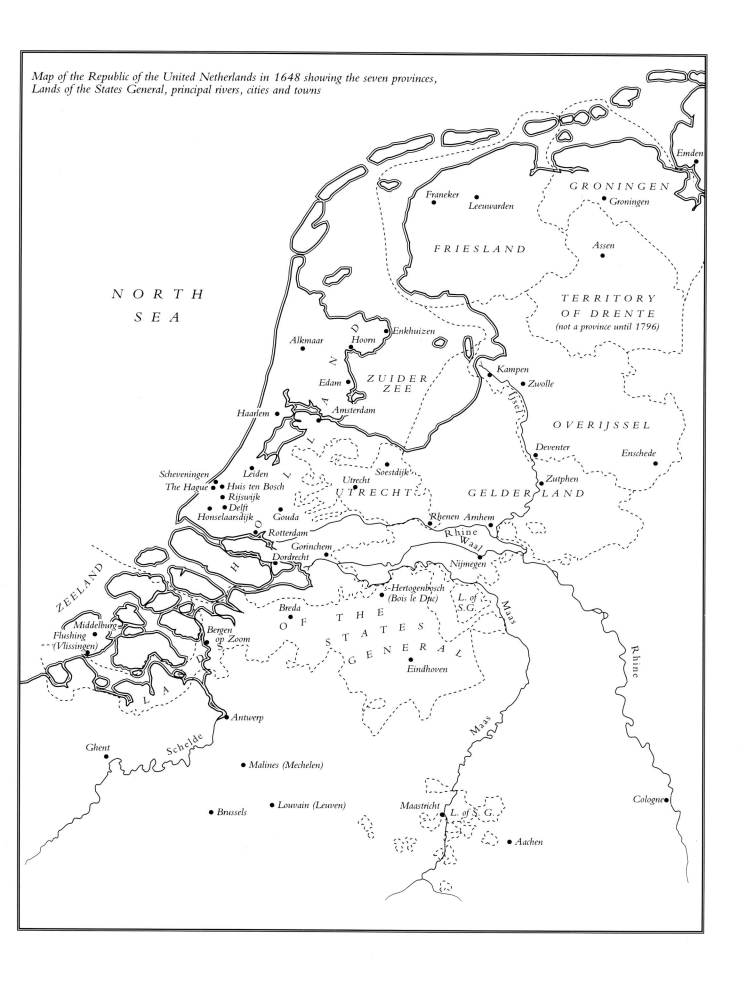

Map of the Republic of the United Netherlands in 1648 showing the seven provinces, Lands of the States General, principal rivers, cities and towns

NORTH
SEA

GRONINGEN

Emden

Franeker
Leeuwarden
Groningen

FRIESLAND

Assen

TERRITORY
OF DRENTE
(not a province until 1796)

Alkmaar
Hoorn
Enkhuizen

ZUIDER
ZEE

Kampen
Zwolle

Edam

OVERIJSSEL

Haarlem
Amsterdam

Deventer
Enschede

Scheveningen
Leiden
Soestdijk
Zutphen
The Hague
Huis ten Bosch
Utrecht
Rijswijk
UTRECHT
GELDERLAND
Delft
Honselaarsdijk
Gouda
Rhenen
Arnhem
Rotterdam
Rhine
Gorinchem
Waal
Dordrecht
Nijmegen

s-Hertogenbosch
(Bois le Duc)
L. of
S.G.

ZEELAND
OF THE
Breda
Maas

Middelburg
Bergen
STATES
Flushing
op Zoom
(Vlissingen)
GENERAL
Eindhoven

Rhine

Antwerp

Ghent
Schelde

Malines (Mechelen)
Maas

Louvain (Leuven)
Maastricht
Cologne
Brussels
L. of S.G.

Aachen

Preface

This book is based on the sections devoted to painting in *Dutch Art and Architecture: 1600–1800* by Jakob Rosenberg (died 1980) and me, first published in the Pelican History of Art series in 1966. Apart from a few minor changes to the text and notes, and some additions to the bibliography made in the 1972 and 1977 editions, our work has been published in more than a half-dozen reprints as it originally appeared.

Soon after Yale University Press acquired the Pelican series in 1992, one of its representatives asked if I would consider revising the painting sections for a new edition the press planned to issue. My response was negative. At the time I was working on a rather large, long-term project which I had firmly resolved to complete before putting another morsel on my dish. At my age I find it prudent to limit my liability.

The press countered my rejection with another proposal: would I consider writing a brief, new introduction for a projected reprint? The alternative suggestion was reasonable and not without appeal. After all, a steady stream of significant work on Dutch painting has been published in monographs, articles, and exhibition catalogues since Jakob Rosenberg's and my effort appeared a generation ago. Diligent archivists also have made important finds, and conservators and scientists working in the laboratories of museums and institutes have broadened our knowledge of the art of the period. Perhaps a short essay on the differences between the subject's status when we began our joint effort in the early 1960s and its current state would interest general readers and students. Attractive too was the hunch that such an essay probably could be written relatively quickly. However, before giving a final answer to the new proposition, it seemed sensible to freshen my memory of the entire text by rereading it from beginning to end – something I confess I had not done since the 1966 edition appeared.

Re-reading the text produced mixed reactions and a change of heart. It compelled me to abandon the notion of doing nothing more than writing a new introduction, and although it leaves me open to the charge of fickleness, it also made me disavow my categorical assertion that I would not consider revising the text until the undertaking I had been working on was finished. That project was put on a back-burner.

To be sure, some aspects of Dutch painting that are surveyed in our pages are, in my view, still satisfactory and need little or no adjustment. However, other parts patently demand expansion, revision, or correction in light of recent research, discoveries, new interpretations, and changes in my own opinions. (I have no doubt that my co-author and close friend Jakob Rosenberg would have agreed that if you do not change your mind about some matters during the course of a generation you probably do not have a mind to change.) Rather than generalize about the needed adjustments in an introductory essay, it seemed best to go through the volume and place them where they belong.

The most prominent change is an increase in the number of illustrations by more than fifty per cent with the text and notes adjusted accordingly. Other modifications include recasting of some parts on Frans Hals, on Rembrandt and the master's pupils and followers, and on Vermeer. Chapters devoted to the diverse branches of painting that became Dutch specialities have been expanded, and sections on late seventeenth- and eighteenth-century artists have been reshaped. There is also more material on traditional biblical and historical subjects painted during the period as well as on patronage and trends in art theory, criticism and collecting. Recent iconological studies have been considered too, but, as noted in various passages in the book, not all the conclusions offered by contemporary specialists have been endorsed. Iconologists who attempt to find hidden symbolic meaning in every shoe, fallen tree, storm-tossed boat, or piece of cheese painted by Dutch artists bring to mind Freud's reputed word to a colleague who was making too much of the symbolism of cigars: 'Sometimes a cigar is simply a cigar.' The bibliography has also been brought up to date, and, as in earlier editions, some items are briefly annotated.

The present volume does not include the sections on sculpture and architecture by E.H. ter Kuile (died 1988) that are in earlier editions of the book. In light of recent research, they too want revision and expansion. In due course Yale University Press plans to fill the need by commissioning a separate volume for the Pelican series devoted to these important subjects in the history of Dutch art.

At Yale's press I am beholden to John Nicoll for his infectious faith in the merit of revised and expanded historical texts and to Sally Salvesen for her superior editorial work and handsome design of the volume. I am also indebted to Bridget Swithinbank, Alice Carman and Antien Knaap for typing an almost illegible manuscript and I owe special thanks to Alice I. Davies for proofreading the typescript, galleys, and page proofs.

Finally an editorial note: following Dutch usage, patronymics have been abbreviated in the text. Those ending in sz or sdr should be read as '-zoon' or '-dochter', that is, the son or daughter of. Put another way, Fransz means Franszoon (the son of Frans), and Harmensdr means Harmensdochter (the daughter of Harmen).

S.S.
Cambridge, Massachusetts
January 1995

PART ONE
1600–1675

Introduction

Dutch painting of the seventeenth century has such a distinctive character that one easily overlooks its ties with the Baroque style as an international phenomenon. Yet the moment one thinks of such artists as Rubens and Bernini, Frans Hals and Velázquez, in juxtaposition, one feels a common denominator. Baroque art, however, seems to defy an all-embracing definition. It finds more eloquent expression in the absolutist Catholic countries than in the Protestant Republic of the United Netherlands. Moreover, the phenomenon of classicism seems to interfere with the international scope of the Baroque movement. Seventeenth-century France is more classicist than Baroque, and in Italy there is a frequent shift from one to the other, even in the careers of individual artists. Rudolf Wittkower, in his *Art and Architecture in Italy 1600–1750* (*Pelican History of Art*), used, we believe, the best way out of this dilemma by dividing the Baroque, as it has often been done, into three successive phases: Early (1600–25), High (1625–75), and Late (1675–1750), and by distinguishing between the classicist manifestations in each of the three phases. In other words, he subordinates the recurrent classicism in Italian art to the progressive waves of the Baroque and allows to each form of classicism its special period aspect.

Holland finds its place in this concept of seventeenth-century art, however, with modifications. Dutch painting can be considered a part of Baroque art, since the latter embraces realism as well as classicism. In the case of Holland, realism is more important than classicism. In the field of painting this widened aspect of the Baroque can best be maintained when we realise that the European leadership lies with Italy only during the early decades (with Caravaggio), shifting in the second generation to Flanders (with Rubens), and about the middle of the century to France (with Poussin and then the style of Louis XIV). This is the course of development which Holland also follows, although at a certain distance and, as we said, with considerable modification. Holland's High Baroque phase, manifested particularly in Rembrandt's work of the 1630s and early 1640s, is closer to Rubens's mature years than to Bernini's, and around the middle of the century the classical influence which found its most conspicuous expression in architecture in Jacob van Campen's great town hall at Amsterdam, which was built as a public monument to the powerful metropolis and is now the royal palace on the city's principal square, was paralleled by certain classical tendencies in the painting of that time.

However, such classification in terms of successive phases of the Baroque does not adequately solve our problem of grouping the Dutch material. Holland's deviation from the international movement – owing to her national and cultural peculiarities – is at least as significant as her participation in it. In Holland alone was to be found the phenomenon of almost an all-embracing realism which was unparalleled in both comprehensiveness and intimacy. The Dutch described their life and their environment, their country and their city

sights so thoroughly that their paintings seem to provide a nearly complete pictorial record of their culture. However, it was much more than mere reportage. Dutch painters may seduce us into believing that they merely transcribed what was before their eyes. But they were not apes of nature. They always reorganised and selected from nature and the better ones had formidable creative imaginations. Vermeer was not functioning as a human Kodak when he painted his incomparable *View of Delft*. The clouds and light did not stay frozen while he painted them. They are his brilliant pictorial inventions. Moreover, some paintings that can easily appear to modern viewers as straightforward quotidian scenes may include symbolic allusions as well as have a moralising, allegorical or titilating intent that can escape us until we are alerted to them. With or without these added meanings, a sensitive feeling for the painterly beauty of everyday life and nature not infrequently raised the production of Dutch artists to the level of great art.

This new phenomenon of a comprehensive realism, along with a high standard of artistic craftsmanship, may help explain the unusual degree of specialization in subject matter on the part of the individual artist, which in itself constitutes a striking feature of Dutch painting. The new specialization also may be related to the Dutch Calvinist Church's hostility to religious imagery. In earlier times the church had been the Dutch artist's best client. When this was no longer the case artists turned to different subjects. To be sure, some painters continued to depict biblical themes – after all, Rembrandt's most moving pictures are his religious paintings. Traditional historical and mythological subjects continued to be painted as well; however, during the course of the century their rate of production dwindled.

While in a limited field genius could flourish – as the examples of Frans Hals and Vermeer show – the so-called 'Little Masters' often rose to a high rank of originality and quality unequalled in any other country. Thus the total aspect of Dutch painting is not determined by a few great artists, as in Flanders. Genius and talent both have their share, and this makes a simple grouping of the material by great personalities only, or by subject matter, inadvisable. A compromise in this respect does better justice to the situation in Holland. Rembrandt was no less a giant than Rubens, but he did not dominate the whole field in Holland. And Hals and Vermeer had a limited range of influence, in local areas only. Thus the grouping of the material in the pages that follow will be partly by great personalities (Rembrandt, Hals), partly by periods (Mannerism), partly by what can be termed loosely as by local schools (Utrecht, Leiden, Delft), and most frequently by subject matter (genre, landscape, portraiture, and so forth). This will lead to minor overlapping, but the authors thought it best to concede to the pheonomena instead of holding rigidly to one system of grouping. The diversity of Dutch painting, which can be seen as an expression of Holland's democratic character, requires such flexibility. History, after all, should not be forced into classifications, but should itself determine the character of its presentation.

Detail of fig. 58, *Regentesses of the Old Men's Almshouse*

Historical Background

During the seventeenth century the republic of the United Netherlands developed a very individual culture which did not have much in common with the ideals that governed the art of neighbouring Flanders and the greater part of Europe.[1] After a long and heroic struggle under the military leadership of the princes of the House of Orange the Dutch freed themselves from the Spanish yoke. Fierce resistance by religious reformers, as well as by the nobility and burghers who maintained that their traditional rights and privileges were threatened by Philip II, began under Willem the Silent (1533–84). His valiant efforts to unify the seventeen northern and southern provinces of the Netherlands failed. Only seven of the northern provinces eventually won independence and formed a confederation: Holland, Zeeland, Utrecht, Gelderland, Overijssel, Friesland, and Groningen. Its foundation was the political compact known as the Union of Utrecht, signed by several of the northern provinces in 1579, which bound them, as if they were one province, to maintain their rights against foreign tyranny. This compact remained the basis for the organization of the country until Napoleon's armies conquered the republic in 1795. *De jure* recognition was only gained in 1648, when the Treaty of Münster was signed, but *de facto* recognition was achieved as early as 1609, when the United Provinces concluded a twelve-year truce with the Spanish.

The road to the final peace was not an easy one. The bitter struggle resumed after the truce and the situation was exasperated by deep divisions among the ruling classes on both sides regarding issues involved. Nevertheless, under Prince Maurits of Orange (1567–1625), son of Willem the Silent, stadholder of the provinces of Holland, Zeeland, Utrecht, Gelderland, and Overijssel, and captain-general of the Union, the United Provinces began its quick rise as the greatest sea power in the world, with extensive colonial possessions in the East and West Indies which brought wealth and prosperity to the Dutch nation. During the century the House of Orange provided the Netherlands with some of her most capable leaders. The immediate descendants of Willem the Silent were endowed with extraordinary military and political ability, but they did not play the same role as the absolute monarchs of other European countries. Their authority was mostly limited to military leadership, and only in case of war, or when the nation was seriously endangered from outside, were they able to gain control over civilian authorities. Their significance in the cultural life of the Netherlands was negligible. Courtly life at The Hague, where the stadholders had their residence, was on a modest scale. Prince Frederik Hendrik (1584–1647), the younger brother of Maurits, who succeeded him as stadholder of five of the provinces and as captain and admiral-general of the Union, gave a few important commissions to Rembrandt, but as far as we know neither he nor other members of the House of Orange patronized or collected works by Frans Hals, Vermeer, Ruisdael, or Jan Steen, not

to mention other outstanding Dutch painters. Frederik Hendrik had been brought up in the courts of Paris and London and his taste was modelled on that of the rulers of France and England. He patronized Dutch artists who worked in an Italianate or classicizing style, and his special preference was for Flemish artists, particularly Rubens and Van Dyck. The plain fact is that there was little contact between life at The Hague and the bourgeois culture developing in other Dutch cities. On the occasion when Amalia van Solms, widow of Prince Frederik Hendrik, wanted to decorate Huis ten Bosch, her *villa suburbana* near The Hague, with paintings glorifying the life of her husband, she followed her consort's taste. She employed Dutch artists who worked in the classical tradition and Flemish painters who did so too. Jacob Jordaens, not a Dutchman, received the commission to paint the centrepiece of the project.

Real opposition to an extension of the power of the House of Orange into the field of civilian administration came time and again from the more liberal and republican bourgeois elements. It was in the first place an antagonism between the principles of a limited democracy and absolutism, but antagonism also extended to the field of religion. The burgher class favoured a milder form of Calvinism. They are often called Arminians, after the religious leader Arminius, or Remonstrants, because of their opposition to the very austere tenets of Calvinism, such as the dogma of predestination. These burghers stood for tolerance and a form of Christianity which was modified by humanism. They stood for more democratic principles of government, and as far as foreign policy was concerned, they favoured a peaceful course which did not interfere with their all-important trade. The House of Orange, on the other hand, tended towards a more militant policy, and towards the centralization of power in their own hands. They had their supporters in the country rather than the cities, and among the strict Calvinists who wanted strong authority in worldly as well as religious affairs.

Permanent tension between the burgher faction, which favoured a decentralized government and relative independence of the single provinces, and the orthodox, absolutist groups who followed the princes of Orange led to repeated clashes. The first serious one came in 1618–19, when Prince Maurits of Orange used the Synod of Dordrecht to wipe out his opposition and their leaders. The wise statesman Johan van Oldenbarnevelt, who had given invaluable counsel to Maurits during the decisive formative years of the Republic, was condemned to death and beheaded; the distinguished scholar Hugo Grotius was sentenced to perpetual imprisonment (through the ingenuity of his wife, however, Grotius managed to escape from prison hidden in a chest). Remonstrants went into hiding or had to flee. Their church was officially recognized only in 1630. A second less serious clash came in 1650, when Prince Willem II (1626–50) threatened Amsterdam with a siege because of the city's refusal to contribute sufficiently to the republic's

military power. Willem's sudden and early death in the same year and the infancy of his son, Willem III (1650–1702), better known as William III, King of England (his name is englished *passim* in the present text), gave the patrician oligarchy a chance to come to the front and actually to enjoy a long period of prosperity under the leadership of a burgher, Johan de Witt.

The single provinces of the United Netherlands were very anxious to preserve something of the old decentralized form of government, and with it, their relative independence. Each province was liberal within its own borders and only loosely attached to any central power. They sent their delegates to the States-General, the body representing the United Provinces in foreign affairs, but since each of the provinces claimed sovereignity for itself, the States-General was more an assembly of sovereign provinces than of a sovereign country. This made it very difficult for governors of the republic to attain sufficient authority for speedy and united action. Holland was by far the mightiest of the seven provinces. It was the largest in population and the richest. Probably this is why foreigners to this day refer to the entire nation as Holland, a name hardly calculated to please Dutchmen with strong loyalties to other provinces of their small country. The province of Holland was the centre of the Dutch colonial empire, and its merchants and bankers frequently contributed more to the budget of the republic than the other six provinces combined. In 1651 representatives of the seven provinces met and agreed that all sovereign powers belonged to them severally and that there was no need for a captain-general of the Union. The five provinces which in earlier years elected the Prince of Orange their stadholder agreed to leave this position open. These decisions in effect made Johan de Witt, representative (Grand Pensionary) of the dominant province of Holland to the stadholderless republic, the leader of the Union. De Witt's regime (1653–72) was a period of great economic growth and prosperity for the republic's elite. It also was the time of its greatest cultural flowering.

De Witt favoured a peaceful policy in order to promote and protect a flourishing overseas trade. England, however, resented the leading position of the Netherlands. Two naval wars were fought with England (1652–4; 1665–7), and in spite of great heroism on the part of the Dutch under Admiral Tromp and Admiral de Ruyter some overseas possessions were lost. One of the colonies surrendered was New Netherland, with New Amsterdam as its capital. In 1664 the name of both the colony and capital was changed to New York, a symbol of the growing power of England. During De Witt's regime the Dutch army was neglected. This suited the patrician oligarchy, for it was relieved of making heavy financial sacrifices for military precautions. De Witt paid dearly for this policy. Danger to the Netherlands became acute when England and France joined in a secret pact against the republic. In 1672, 'The Year of Calamities', the two powers as well as Cologne and Münster declared war on the Union. The English attacked on the seas, thereby beginning the third Anglo-Dutch War. Louis XIV, eager to extend his hegemony, invaded the republic with his powerful armies. The ill-prepared Dutch could offer little resistance. Town after town fell to the French. After they took Utrecht,

only inundation of polders protected Amsterdam. During this hour of distress once again there was a serious clash between the two antagonistic Dutch powers, the patrician oligarchy and the partisans of the House of Orange. This time the Orangists were the victors. The Dutch turned to Prince William III for help and military leadership. In June 1672 he was elected stadholder of Zeeland and Holland and captain-general of the Dutch armies. Two months later an infuriated mob at The Hague lynched Johann de Witt and his brother, Cornelis, who played a role in de Witt's administration, and tore them to pieces. A painting attributed to The Hague portraitist Jan de Baen [1] and cheap broadsides illustrating the event that were published immediately after the lynching show their grisly end. They are reminders of the false impression we get of life in the republic after the signing of the Peace of Münster if we derive it from celebrated Dutch paintings of tranquil domestic scenes in homes of the gentry and pictures of droll tradesmen and peasants.

William III swiftly organized the Dutch against their foreign enemies, and by 1674 the naval war was over and peace was declared with England, Cologne, and Münster. War with France only ended in 1678 at the signing of the Peace of Nijmegen; according to its terms the French agreed to give up virtually all their conquests. Eleven years later William III and Mary became king and queen of England. Now the Prince of Orange's political and military genius was

1. Jan de Baen (attributed to): *The Mutilated Corpses of the de Witt brothers, Johan and Cornelis, hanging on the Groene Zoodje on the Vijverberg, The Hague*, 1672. Amsterdam, Rijksmuseum

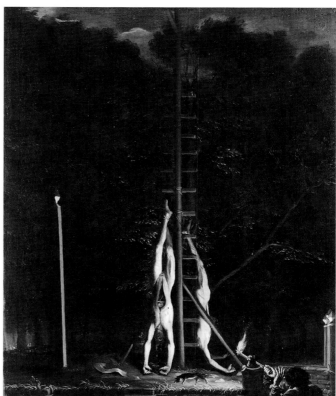

mainly devoted to his new kingdom, and from this time onwards the republic of the United Netherlands began to play a secondary role on the European stage.

The amazing rise to power of the United Provinces during a comparatively short period of their national history was due above all to the heroic Dutch navy and the bold spirit and bravery of their merchant and fishing fleets. The Dutch helped to break the supremacy of Spain with their sea power, created a world-wide empire, and even pushed England for some time to second place. The country's geographical situation helped to make it a centre of world trade. As it is situated on the sea and crossed by the Rhine and Maas, two of northern Europe's most important waterways, from which a network of canals spread all over the country, traffic and communication were easier than in any other nation of Europe. The Dutch succeeded in closing the mouth of the Scheldt river to make it impossible for Antwerp to communicate with the sea. This ruined Antwerp as an important world trading centre, and Amsterdam rapidly became a greater commercial and political power than Antwerp had ever been. Extensive navigation on the highways of the sea as well as at home also helped the country to develop its democratic structure. A town culture with easy communication between communities evolved. Fisherman and peasant, sailor and merchant were the main occupations, and the principal products of the country in those days were textiles, salt, soap, tar, and rope. In addition, there were large shipyards, breweries, refineries for sugar and tobacco, and extensive trade in fish, cheese, timber, stone, iron, and minerals. A wave of skilled refugees from the southern Netherlands, who fled to the northern provinces to escape religious persecution and their country's depressed economic condition, helped to stimulate economic as well as artistic development. Tremendous gains were attained by the vigorous colonial trade, particularly by the import of spices. Trade abroad was helped by Dutch navigational charts, which were acknowledged by the community of sea-faring nations as among the best, as were the maps, atlases, and globes produced by the Dutchmen Willem Jansz Blaeu, Joan Blaeu, and Jodocus Hondius I – a terrestial globe by Hondius appears in Vermeer's *Geographer* and *Allegory of the Faith* [175, 198], and his celestial globe is in the Delft master's *Astronomer* [180]. Holland took the lead as the European centre for publishing and printing books and pamphlets as well as newspapers. Branches of the natural sciences also began to flourish. There were botanists, biologists, and astronomers who scrupulously scrutinized and recorded what they saw as intently as some artists did. The lenses ground by Dutchmen for rudimentary microscopes and telescopes were in advance of those found in other countries. Scientific knowledge began to be systemized, but emphasis was placed on the solution of practical problems and the needs of the day. Among the heroes were engineers who designed windmills, dikes, and hydraulic systems that enabled land to be drained and reclaimed from the sea. Their unmatched expertise gave them an international clientele.

Throughout the century the country's economic system remained premercantile. Essentially it was the old medieval system of unrestricted economic liberty for every individual commuity. These rights were jealously guarded. The upheaval against Spain was not only due to religious oppression. The Dutch also waged what became their war of independence because the economic privileges of the individual communities and provinces were seriously threatened by the enforced centralization imposed by the absolutist Spanish regime.

Another important reason for the United Provinces' elevated position during the first half of the seventeenth century was the general political situation of Europe. The small country could flourish because the great nations of Europe were either involved in war or had internal religious strife which was still an after-effect of the period of the Reformation. This was the case with France, where the Huguenots fought for their rights; in England, where the Puritans stood against the Royalists; and in Germany, where the Thirty Years War paralysed foreign expansion. The young republic not only profited politically by remaining relatively undisturbed, it also gained commercially by becoming the banker of Europe at a time when princes were willing to pay high interest rates for money needed so badly for their endless and costly wars.

The sociological structure of the Netherlands was to a certain extent democratic during the first decades of the century. It showed little signs of militaristic or aristocratic character. But from the beginning well-to-do families monopolized the higher offices in the administration of the provinces and municipalities. This did not change and, with the development of great family fortunes, patricians began to adopt aristocratic tendencies and habits. They bought estates in the country to which they retired during the summer months; some acquired a kind of title or sign of nobility. The gap between rich and poor, which was never bridged, grew wider. However, from the beginning municipal officials and wealthy private citizens also showed a concern for the needy that was unique in Europe. They established numerous charitable institutions to care for the poor, the sick, orphans, and old people. The need for such institutions increased the moment Catholic monasteries and hospitals were abolished. The Dutch effectively accepted their new responsibility and there was hardly a foreign visitor who did not express admiration and wonderment at how well Dutch charitable institutions were managed. Support for them was furthered by general acceptance of traditional concepts of Christian charity and the importance of doing good works for the salvation of one's soul. Enlightened arguments also were voiced regarding the necessity of eradicating the root causes of poverty as well as alleviating its misery.

The founders and regents (governors) of these charitable institutions provided painters and architects with important commissions that remain key monuments in the history of seventeenth-century Dutch art. Haarlem offers a good case in point. During the first decade of the century the city's authorities commissioned Lieven de Key, its highly gifted municipal architect, to build an Old Men's Almshouse. It is now the Frans Hals Museum which houses, among other masterworks, Hals's supreme group portraits of the men and women who served as regents and regentesses of the Almshouse from 1662 to 1665 [57, 58]. As all regent group portraits seen today in Dutch museums, they originally hung

in the board rooms of their institution (unlike other Dutch paintings, collective group portraits of this type seldom were coveted by later foreign collectors). Regents also continued the venerable tradition of commissioning or acquiring biblical or allegorical paintings that alluded to the charitable purposes of their institutions. It is not astonishing to learn that an inventory compiled in 1786 of the contents of the chambers of the regentesses of Haarlem's Old Men's Almshouse lists a painting of *The Good Samaritan*.

The Dutch army consisted mostly of mercenaries from all countries, whereas the navy was mainly made up of native Dutchmen and the republic's great naval heroes – Tromp, de Ruyter, and Piet Hein – came from the middle classes. This was also the case with numerous artists, who made their living – some just barely – because the art of painting was in great demand among all strata of the Dutch population. Peter Mundy, who travelled to Amsterdam in 1640, reported:

> As For the art off Painting and the affection off the people to Pictures, I thincke none other goe beeyond them, there having bin in this Country Many excellent Men in that Facullty, some att presentt, as Rimbrantt, etts, All in generall striving to adorne their houses, especially the outer or street roome, with costly peeces, Butchers and bakers not much inferiour in their shoppes, which are Fairely sett Forth, yea many tymes blacksmithes, Coblers, etts., will have some picture or other by their Forge and in their stalle. Such is the generall Notion, enclination and delight that these Countrie Native[s] have to Paintings.[2]

In the following year John Evelyn visited Rotterdam at the time of the annual fair and was amazed by the great numbers of pictures he saw, 'especially Landscips, and Drolleries, as they call those clownish representations'. According to Evelyn,

> The reason of this store of pictures and their cheapenesse proceede from their want of Land, to employ their Stock; so as tis an ordinary thing to find, a common Farmor lay out two, or 3000 pounds in this Commodity, their houses are full of them, and they vend them at their Kermas'es to very great gaines.[3]

Contemporary inventories which include appraisals of the effects owned by farmers and tradesmen indicate that Evelyn was reckless with the truth when he estimated the value of the paintings they owned, but there is no question that pictures were acquired by all classes of society.

The predominance of painting over sculpture and architecture is largely explained by the lack of great patrons. To be sure, there were some important civic commissions, particularly for the decoration of municipal buildings, but there were no great princes, no cardinals, no grand seigneurs who wanted monumental sculpture and architecture. Dutch paintings were within the means of the large middle class. Rembrandt and Frans Hals painted not only members of the Dutch elite who served as burgomasters, aldermen, and officers of civic guard companies, but also preachers, calligraphers, ship-builders, doctors, engravers, and framemakers. The numerous portraits of ministers are a good indication of how important religious life was in the Netherlands during the seventeenth century. As with the artists, most of them

came from the middle class. This may be one of the reasons why the church contributed to the democratic spirit of the communities. The bulk of the people were probably Calvinists by the middle of the century – this is a guess, there are no statistics available. Calvinism never became a state religion in the strictest sense. Other religious groups – Lutherans, Mennonites, Jews – were tolerated and allowed to lead their own religious life. Catholicism was officially banned, but the authorities soon became lenient and priests were permitted to conduct religious services for Catholics in concealed chapels; their location was an open secret. Since the days of Erasmus of Rotterdam and not least through the ideas of this great humanist, liberalism and tolerance flourished on Dutch soil. Although bitter religious strife occurred during the century – recall the terrible treatment the Arminians received from righteous Calvinists – it is fair to say that most of the time the majority of the population remained in a state of benevolent passivity towards other religious groups.

The question how much Dutch culture and Dutch art owe to Calvinism is not easy to answer. Calvinism arguably strengthened the moral qualities of the people, as well as increased action and responsibility in public affairs. It may also be true that Calvinism gave a certain confidence and resoluteness to the fighting forces, in particular to the bold and adventurous naval heroes. But we notice comparatively little influence of Calvinism on contemporary Dutch science, philosophy, law. No one has convincingly connected the great achievements of the Dutch in these fields with religion. As for art, we have already heard that Calvinist antipathy toward religious imagery deprived Dutch artists of the patronage of that church. Altarpieces were not commissioned for Calvinist churches; occasionally paintings with religious subjects for the folding doors of new organs were ordered – a favourite subject was David playing the harp to soothe Saul – but not without the protests of strict Calvinists. One may admit that a general simplicity of taste has something to do with the moral attitude and puritan spirit of Calvinism. However, before any casual connections are made between Calvinism and seventeenth-century Dutch painting, it should be noted that during the first half of the century the United Provinces were not as Calvinist as was maintained by nineteenth-century historians, who assumed that the division of the Lowlands into the Dutch and Belgian Netherlands was the end of an inevitable historical process, and that differences in the national character of the Dutch and Flemish predestined them by their very nature to become separate nations adhering to Calvinism or Catholicism. On the contrary, it has been shown that the split in the Lowlands was principally the result of military and geographic considerations and not of religious differences. The great rivers brought a stalemate in the war with Spain which was confirmed by the truce of 1609. For the year 1609 it is not possible to speak of a Protestant north and a Catholic south. The final result of Catholicism in the south and Protestantism in the north was an outcome of the course of the Eighty Years' War. It was the result, not the cause of the split. What became the frontier between the north and south Netherlands was the line the United Provinces were able to maintain against the Spanish. It did not mark a religious or linguistic

boundary. Although the Catholic religion was suppressed and Catholic churches were purged of their altars and other religious images and seized for the Reformed as soon as a town fell, the United Netherlands did not become a Protestant nation overnight. The change in this emerging multi-confessional country was a slow one, particularly in the rural districts. More artists remained Catholic than is generally known.[4] Jan Steen and Jan van Goyen were Catholics; Vermeer became one too.

Conclusions about the importance of Protestant creeds in the formation and achievement of seventeenth-century Dutch painting which do not take into account these facts are of limited value. Moreover, so much of what we recognize as especially Dutch in painting, its peculiar bourgeois taste and character, an interest in the effect of space and light, a concern for landscapes and interiors, and the special reticence, which in the works of the greatest Dutch artists is transformed into a searching introspection, appears in fifteenth-century Netherlandish painting long before the birth of Calvinism. In the final analysis, the amazing pictorial gift of the Dutch remains as inexplicable as the genius of their great masters.

Late Mannerism and International Trends 1600–1625

Dutch painting in its prime is one of the great achievements in the history of art, and it has all the aspects of a truly creative period when sureness of instinct and quality of performance hold a safe balance. Yet the long and traditional acceptance of seventeenth-century Dutch painting as a culmination of realism in Western art, and its persistent influence on later periods, in particular the nineteenth century, can hinder a fresh view and blunt our consciousness of its true originality and significance.

Naturally, we are eager to know how this phenomenon came into being and how Dutch painting was involved in its total course with the broader stream of European art. We shall see that even in its prime, during the so-called classical phase of the mid-seventeenth century, a subdued influence of foreign art – in this case the Italian Renaissance as well as Baroque Classicism – is noticeable. But by then the Dutch character had expressed itself so independently and vigorously that Holland's artists could easily absorb outward influence with profit for themselves and without deeper disturbances. Not so during the first decades of the seventeenth century, when Italian art enjoyed a strong leadership on the Continent. At this time consciousness of the value of the Northern Renaissance (Dürer, Bruegel) strengthened. Hence the growth of native trends within the still internationally minded artistic community of Holland did not come about without shocks and turbulences. Contrasting elements are found in the works and careers of single artists. To avoid injustice to such figures as Hendrick Goltzius, Cornelis van Haarlem, Abraham Bloemaert, Jacques de Gheyn II, and others who tried to absorb the successive trends of Late Mannerism and Early Baroque Classicism, we have to visualize their international situation. No doubt those moments in their life and work when they seemed least inhibited as straightforward realists are often the most appealing ones. They occur more frequently in their drawings than in their paintings, and happen mostly in portraiture, genre, and landscape. They are also most significant for the future of Dutch art. This is equally true of artists like Miereveld or Moreelse when they concentrated on portraiture after their escapades into Mannerist subject pictures or of the early genre painters and landscapists like Vinckboons, Buytewech, and Esaias van de Velde (these artists are treated later in the chapters on genre painting and landscape). The Utrecht School is in a class by itself, with its concentration on large-scale religious, historical, and genre pieces, and on chiaroscuro effects; their subjects and style are primarily derived from Caravaggio's vigorous art. In their works there is hardly a trace of Dutch intimacy.

Thus the following account of this initial phase, while perhaps confusing by the diversity of trends and influences, may gain coherence if we keep in mind that both things happened: the strong influence of foreign, in particular Italian, art on Dutch painters, and a gradual moving on towards a more unified native culture of high originality and distinction.

THE MANNERISTS

Eugène Fromentin, the influential nineteenth-century enthusiast of Dutch art, wrote that the Dutch right to a native school of painting seems to have been laid down as one of the stipulations of the Twelve Year Truce which the Dutch concluded with the Spanish in 1609. Fromentin's formulation is an ingenious one. The unique interest in the everyday world and in nature that Netherlandish painters had shown since the fifteenth century, and which is the hallmark of seventeenth-century Dutch painting, became more evident during the years of the truce. Landscape, genre, and still life, categories which hundreds of seventeenth-century Dutch artists made their speciality – a phenomenon without precedent in the history of Western painting – were firmly established and received their characteristic direction during the second decade of the century. Frans Hals, the first genius of the greatest period of Dutch painting, did not appear on the scene until the truce was signed. None of Frans Hals's existing works can be dated before about 1610, and these were made when he was almost thirty years old. Historical hindsight makes all this clear. However, it is anachronistic to imagine that in 1609 any painter or patron thought that a national Dutch school would soon arise. To be sure, there was an indigenous style in the northern Netherlands, which is best seen in portraits by Cornelis Ketel (1548–1616) and Cornelis van Haarlem (1562–1638). But there is reason to believe that these artists were a bit bored with, or even ashamed of, their paintings of faces. Cornelis van Haarlem confessed to one of his contemporaries that he did not enjoy making portraits, and around 1600 Ketel began amusing himself and his clients by using his toes instead of brushes to paint pictures.[1]

Around 1600 Dutch artists implicity if not explicitly accepted the notion promulgated by Italian Mannerist theorists (Vasari, Lomazzo, Armenini, Federigo Zuccaro) that nature must be studied, but never slavishly copied. It was the artist's duty to improve upon it according to the 'idea' (concetto) he had formed in his imagination of perfected nature.[2] They also agreed with earlier theorists that the most noble subject a painter could depict was a religious or historical theme, and that the sine qua non of painting was the representation of the idealized nude figure. These tenets are endorsed in Het Schilderboek, a handbook for artists and the wider public published in 1604 by Karel (or Carel) van Mander (1548–1606), the oldest member of the group of Dutch painters called the Haarlem Mannerists. The label is not a very good one because none of them were exclusively Mannerists, but it would be hopeless pedantry to try to change the tag at this date.

Van Mander was born in Meulenbeke, a small town near Courtrai in western Flanders. As a young man he was more concerned with drama and poetry than painting, and he never lost interest in literature. Van Mander is frequently called 'the Dutch Vasari'. The title is an appropriate one.

Like Vasari, he was a painter of some distinction, but his main claim to fame rests upon his written works. He was in Italy from about 1573 until 1577, where he was as impressed by Vasari's *Lives of the Italian Artists* as by High Renaissance Italian painting; the bulk of van Mander's *Schilderboek* is modelled upon Vasari's *Lives*. The most important and original section contains biographies of Netherlandish and German artists from the time of the van Eycks up to van Mander's young contemporaries. It is the first extensive account of the lives of the major northern European artists and is still our principal source for the history of northern fifteenth- and sixteenth-century painting. Another part of his book is a condensed Dutch translation of Vasari's *Lives of the Italian Artists*, and contains valuable original material about Italian artists who worked after 1568, the date of publication of Vasari's second edition. It is impressive to discover that some time before 1604 word reached van Mander at his country estate, located between Haarlem and Alkmaar, where he retired to write *Het Schilderboek*, that 'a certain Michelangelo da Caravaggio was doing wonderful things in Rome...'. A third part is a long didactic poem called *Den Grondt der edel vry schilderkonst (The Foundation of the Noble Free Art of Painting)*, which lays down precepts for young artists on what is best to paint and how to paint it. It contains some original sections (e.g. the chapter on landscape painting is the first extensive treatment of the subject in occidental literature), but most of it codifies well-known Italian art theory and practice. In 1604 it would have been difficult to predict that as far as the leading Dutch artists of the following three generations were concerned – and this number includes Frans Hals, who was van Mander's pupil – the *Grondt der schilderkonst* fell still-born from the press. In fact, the next significant Dutch treatise on the subject was published three generations later. It is Samuel van Hoogstraten's *Inleyding tot de hooge schoole der schilderkonst anders de zichbare werelt (Introduction to the Advanced School of Painting, otherwise the Visible World)* which appeared in 1678 after the heroic age of Dutch painting was over – Hals died in 1666, Rembrandt in 1669, and Vermeer in 1675. Hoogstraten's book is largely an extended version of van Mander's *Grondt* in which he still finds it necessary to break a lance with Dutchmen who believe painting is merely a craft, not a noble art.[3]

Van Mander's *Schilderboek* also provides a long 'Commentary on Ovid's *Metamorphoses*' which is an exegesis on Ovid's descriptions of the ancient gods and their adventures. Since in van Mander's time mythological subjects were as much part of the principal stock-in-trade of artists as biblical and ancient historical themes, this section served an immediate purpose. Later Dutch artists who kept the gods in their repertoire relied on it as well. Another section of the *Schilderboek* called the 'Depiction of Figures' is a recipe book on the various emblematic meanings of allegorical personifications. Additionally, the volume includes a section on the lives of ancient painters. Like us, van Mander knew virtually none of their works in the flesh; what he wrote about them and their art was culled from what he found in classical and later Italian texts.

Like many of his countrymen, van Mander emigrated from Flanders to the northern Netherlands because of troubled conditions brought about by the war with Spain. According to a scanty contemporary report, shortly after he settled in Haarlem in 1583 he met Cornelis van Haarlem and Hendrick Goltzius (1558–1617), the gifted printmaker and most influential artist of the period. The three men are said to have founded an academy where they could study from life ('om nae 't leven te studeeren'). The nature of the 'academy' has been much discussed, but its character remains a matter of conjecture. However, one thing is clear: It was not an art school where the theory and practice of art was taught according to a set curriculum. Aspiring Dutch artists were trained and regulated by the guild system until well into the seventeenth century. The Haarlem 'academy' should not be confused with organizations such as the Accademia di San Luca of Rome, which was opened in 1593, or the Académie Royale de Peinture et de Sculpture established at Paris in 1648. When the so-called Haarlem 'academy' was established, or how long it existed, is not known. Probably it did not function much longer than most informal arrangements between artists do. It is noteworthy that van Mander himself, who takes every opportunity to extol artistic activity in Haarlem – and who even invents some occasions to do so – never mentions the 'academy' in his *Schilderboek*.[4]

More significant for the development of Dutch art than the nebulous Haarlem 'academy' were some drawings by the Flemish Mannerist Bartholomaus Spranger (1546–1611), brought to Holland by van Mander. He wrote that shortly after his arrival he showed Spranger's drawings to Hendrick Goltzius. Goltzius was quickly seduced by Spranger's intensely Mannerist style. By 1585 he had made his first engraving after Spranger, and around the same time Goltzius began to incorporate the elegantly attenuated figures, the over-agitation, and eroticism of Spranger's works into his own prints. Spranger's personal transformation of Italian Mannerism had a wide and immediate appeal in the northern Netherlands. Soon Cornelis van Haarlem, Abraham Bloemaert (1566–1651), Joachim Wtewael (1566–1638), Jacques de Gheyn II (1565–1629), and Jan Muller (1571–1628) adopted aspects of his manner. In his lengthy biography of Spranger in *Het Schilderboek*, van Mander tells us that the celebrated artist received princely receptions in Haarlem and Amsterdam when he briefly visited the northern provinces in 1602.

The violent contortions and foreshortenings of the herculean nudes, the exaggerated tension, and the forced perspective in Cornelis van Haarlem's life-size *Massacre of the Innocents* of 1591 (Haarlem, Frans Hals Museum) [2] are all characteristic of late-sixteenth-century Dutch Mannerism. But not all Dutch artists were fascinated by Mannerism for very long. Goltzius, for example, only worked in Spranger's style for about five years. His decisive rejection occurs in 1590, when he left Haarlem for a brief trip to Rome, where he made an intensive study of classical sculpture; more than forty of his drawings of ancient statues are now at the Teyler Foundation in Haarlem. He also digested what he could of High Renaissance art. Van Mander, who included a detailed, laudatory biography of Goltzius in *Het Schilderboek*, wrote that his friend was impressed while in Italy by Raphael's grace, by Correggio, Titian, and Veronese, and when he returned to his homeland 'he was no longer

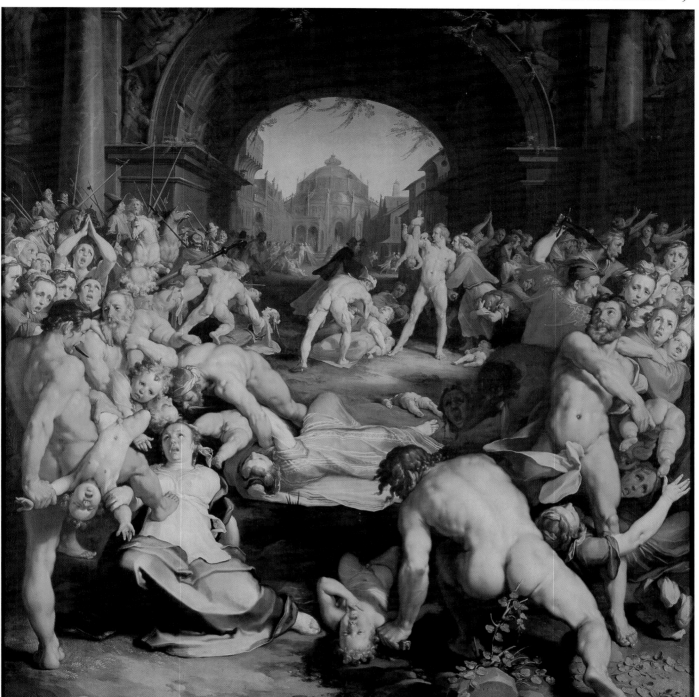

2. Cornelis van Haarlem: *Massacre of the Innocents*, 1591. Haarlem, Frans Hals Museum

satisfied with Netherlandish painting'. Goltzius was back in Haarlem in 1591. He returned a changed artist. From this time onwards he no longer made prints after Spranger's extravanganzas. The monstrous muscle-men and over-elongated female nudes with tiny heads who contort in his prints and drawings of the late eighties were replaced by figures with more normal proportions and movements. A kind of classicism now entered his work, one of the earliest signs of a revival which became an international movement during the first decade of the seventeenth century. After

1600 all traces of Mannerism disappear and classicism becomes the dominant strain in his work. After his death, this trend was continued in Haarlem by a group of artists appropriately called the Haarlem classicists, which includes Goltzius's pupil Peter de Grebber, Salomon de Bray and his son Jan, and Caesar van Everdingen from nearby Alkmaar.

Although the quality of his paintings should not be underestimated, Goltzius's fame rests on his work as a graphic artist. Notwithstanding his crippled right hand – fire maimed it, and he was unable to extend his fingers – he was

3. Hendrick Goltzius: *Proserpine*, c.1588–90. Chiaroscuro woodcut

4. Hendrick Goltzius: *Dirck Volkertsz Coornhert*, c.1590. Engraving

an extraordinary technician and unsurpassed virtuoso of the engraver's burin and the pen. Uncanny sureness and infinite patience never failed him, and he dazzled his contemporaries with his performances. He won acclaim for a series of six engravings of the *Life of the Virgin* (called by print collectors the *Meisterstiche* or master prints). Each print was deliberately done in the style of a different northern or Italian master. The set includes a *Circumcision* (Bartsch 18) which was mistaken for an original Dürer and an *Adoration of the Magi* (Bartsch 19) which passed as a Lucas van Leyden until the artist issued impressions signed with his own monogram. Both prints indicate that he had fully absorbed traditions of northern Renaissance art. His virtuosity also enabled him to include compositions in his *Meisterstiche* done in the style of Raphael and Parmigianino. Not without reason, van Mander

5. Hendrick Goltzius: *View of the Dunes near Haarlem*, 1603. Drawing: pen and touches of wash. Rotterdam, Boymans-van Beuningen Museum

called Goltzius the Proteus or the Vertumnus of art, who had as many styles as Ovidian heroes have disguises.

Among Goltzius's most attractive and original works are his decorative chiaroscuro prints. His bold design, freedom in cutting (whether he himself was able to cut into wooden planks with his crippled hand is moot), and sure use of tone blocks to describe forms without relying upon the black line block is seen in his oval coloured print of *Proserpine* [3], which belongs to a series of deities datable not long before he went to Rome. The figure still has Mannerist proportions and it is difficult to determine how the seated goddess manages to keep her balance or to give a rational explanation for the position of her fluttering draperies; but these are the liberties that delighted the artist and his public during this phase. Goltzius was also the first printmaker to design and perhaps cut chiaroscuro landscapes. Equally impressive are his numerous engraved likenesses. The forceful characterization and immediacy of the one he made of his teacher Dirck Volkertsz Coornhert [4] must have been an inspiration to young Frans Hals as well as later Dutch engravers. The portrait, unprecedently large in scale, is posthumous and is based on a lost drawing made *ad vivum*. Impressions also exist that include an elaborately engraved rectangular frame printed from a separate plate most probably done by another printmaker. It includes an arsenal of emblems symbolic of Coornhert's activity as an artist as well as a humanist, musician, fencer, notary, and city official. Goltzius also drew exquisite miniature portraits, mostly in metal-point, and made studies of animals and plant life marked by his acute power of observation and unfailing accuracy. Around 1600 he executed open-air drawings of clumps of trees and some extensive views of the Dutch countryside (*View of the Dunes near Haarlem*, 1603, Rotterdam, Boymans-van Beuningen

Museum) [5]. These are among the earliest drawings of the scenery of Holland, and establish Goltzius as a leading forerunner of artists who specialized in depicting Dutch panoramic landscapes. It is no accident that van Mander does not mention these epoch-making nature studies in his lengthy biography of Goltzius. Van Mander praised most what an artist produced from his imagination, not what he copied from nature. For the same reason he is silent about Goltzius's portrait studies and animal drawings, works which foretell more about the development of Dutch art than his celebrated *Meisterstiche*.

The Goltzius drawings that van Mander and his contemporaries admired above all were his highly finished pen and ink drawings that simulate the swelling and tapering lines of engravings – they were called *penwerken* ('pen works'). Dazzling examples of these virtuoso performances depicting *Without Ceres and Bacchus, Venus would Freeze (Sine Cerere et Libero friget Venus)* are at the British Museum (1593) and the Hermitage, St Petersburg (160[4 or 6]). They illustrate the popular adage derived from Terence that without food (Ceres, the Roman god of agriculture) and wine (Bacchus), love (Venus) is left cold. The colossal scale of the Hermitage 'pen work' (219 × 163 cm) enabled Goltzius to show the principal figures as almost life-size idealized nudes; it is an awesome *tour de force*. Venus's need for the assistance of food and drink for invigoration was one of Goltzius's favourite themes; he represented the subject in various ways and media at least ten times. His most stunning illustration of the proverb is now at Philadelphia [6]. Drawn with elaborate pen lines in ink that give the effect of an engraving, half-nude Venus is seen close-up accompanied by an adoring young satyr bearing fruit and a smiling old one with his hands full of luscious grapes, obvious representatives of Ceres and Bacchus. Handsome Cupid, who turns sympathetically to us, holds a large flaming torch that warms as well as illuminates the figures. Unlike most of Goltzius's 'pen works' which are done on paper or parchment, this one is on canvas with a grey-blue oil ground that is an integral part of the scene's nocturnal effect. Unique is the conspicuous addition of flesh tones in brush and oils that are literally and figuratively warmed by the vivid red, orange, and yellow flames of Cupid's torch, also done in oil paint. The mixed media makes the work hard to classify. Is it a 'pen work' or a painting? The question most probably vexed the Holy Roman Emperor Rudolf II (1552–1612) who almost certainly had the Philadelphia picture as well as other 'pen works' by the artist in his famous *Kunstkammer* at Prague. In his biography of Goltzius, van Mander offers a detailed description of a picture, then in Rudolf's possession, that perfectly fits it, and adds that the emperor 'was highly astonished at its technique; to discover how this had been done he called in some experts on art, who also were astonished, because it really is something most unusual to behold'.[5]

Goltzius continued to make 'pen works' until late in his career. However, in about 1600 he completely stopped producing engravings and chiaroscuro prints and began devoting his genius and energy to painting.[6] His existing paintings, which number about fifty, mainly represent biblical scenes, mythological subjects, and allegories. His ravishing, virtually life-size *Danaë*, dated 1603, one of his early efforts

6. Hendrick Goltzius: *Without Ceres and Bacchus, Venus would Freeze*, *c.*1599–1602. Philadelphia Museum of Art

in the medium, shows his complete mastery of it as well as his wit and inventiveness [7]. The maiden Danaë is seen as a sleeping Titianesque nude in the chamber of the tower to which she has been condemned by her father, Acrisius, King of Argus, because an oracle prophesied that if she bore a son he would murder him. Jupiter, smitten by her beauty, was not deterred. He visited her as a shower of gold. From the union Perseus was born, who did, in fact, accidentally kill his grandfather with a discus, thereby fulfilling the prophecy.

Renaissance artists established a visual tradition for depicting Danaë's story, which is told by Ovid in his *Metamorphoses*. The subject remained popular. About a generation after Goltzius completed his version Rembrandt made the tale the subject of one of his most original pictures, and before it was extensively and irreparably damaged in 1985 it was one of his most beautiful paintings (see fig. 77 and p. 67). Traditional in Goltzius's picture is the appearance of Jupiter, symbolized by his eagle against a golden sky and gold coins, the presence of the princess's old servant, and the ample display of Danaë's lovliness. Less traditional are the two *putti* drawing aside the bed curtains that evidently covered the chaste maiden until Jupiter's sudden arrival. New is the crone's gesture of gently awaking her mistress; with the gold coins that she has caught in her bowl she appears to be playing the role of a paid procuress about to fulfill her part of an agreed arrangement. New

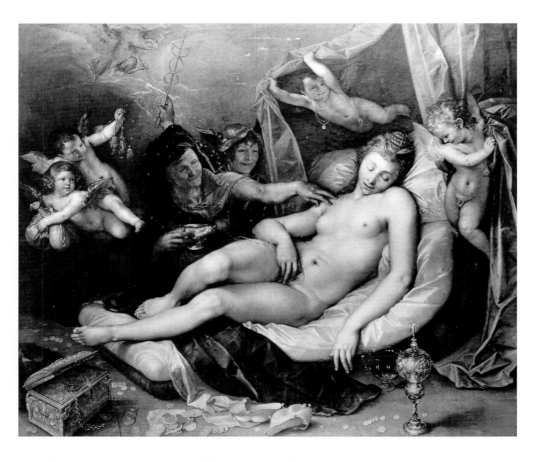

7. Hendrick Goltzius: *Sleeping Danaë being prepared to meet Jupiter as a Shower of Gold*, 1603. Los Angeles County Museum

8 (*below*). Jacques de Gheyn II: *Woman and Child looking at a Picture Book*, c.1600. Drawing: pen and wash. Berlin, Staatliche Museen, Kupferstichkabinett

9 (*right*). Karel van Mander: *Kermis*, 1600. St Petersburg, Hermitage

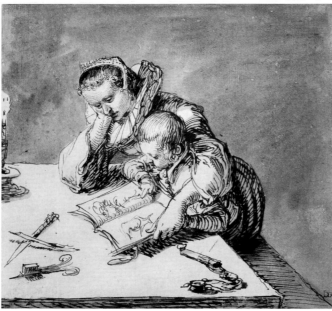

too is the presence of Mercury, Jupiter's mischievous companion, as a smiling voyeur. The pair of *putti* bearing gifts which can only be interpreted as presents from Jupiter also are novel. Van Mander mentions the picture in his lengthy biography of Goltzius published in his *Schilderboek*, a year after it was painted, as a sleeping Danaë large as life reclining in a very beautiful way that is 'wonderfully voluptuous and expressive'. He says nothing of his friend's

unusual representation of the episode and makes no reference to his own moralizing gloss on the story, which focuses on gold's evil power to conquer virtue and honour, that appears in his commentaries on Ovid's *Metamorphoses*, also published in *Het Schilderboek*.[7]

Goltzius's pupil, Jacques de Gheyn II, who was also active as an engraver and painter, matches his teacher as a draughtsman and at times even surpasses him. Like his teacher, de Gheyn was equally gifted with pen, metal-point and chalk, but he did not have Goltzius's compulsion to make an ostentatious display of his virtuosity. De Gheyn's pen line frequently resembles the technique of engraving in its swelling and diminution and extensive use of hatching and dots to model form, but his touch is more nervous and hence seems less impersonal. His choice of subject ranges from ghostly drawings of witches' sabbaths to tender domestic scenes such as his *Woman and Child looking at a Picture Book* at Berlin [8]. If any of the early Dutch draughtsmen gives a foretaste of Rembrandt in spiritedness of line and vivacity of characterization, it is de Gheyn.

Cornelis van Haarlem was apparently affected by Goltzius's early rejection of Mannerism. By 1594 he had begun to paint less athletic-looking nudes and his compositions became more planimetric (*The Judgement of Apollo*, Madrid, Prado), and before 1600 Cornelis worked out the kind of bland classicism to which he adhered until the end of his life. He remained impervious to the radical innovations made by younger Dutch painters. His *Christ blessing the Children* of 1633 (Haarlem, Frans Hals Museum) is painted in the style he formulated about four decades earlier.

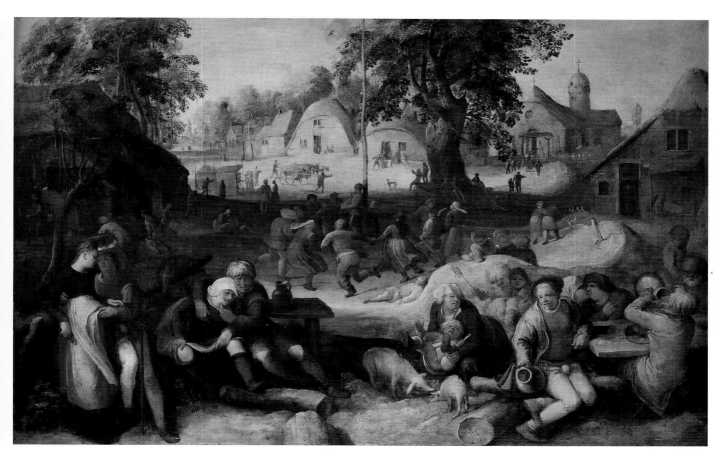

Van Mander's role as a painter was different from that of his Haarlem friends. The panoramic view of a village populated by carousing peasants in his *Kermis* (1600, St Petersburg, Hermitage) [9] reveals a debt to Pieter Bruegel the Elder and his followers. The coarse subject of the genre piece indicates that he himself did not always depict the edifying subjects and follow the rules of decorum he wrote about in his *Grondt der schilderkonst*. The picture also shows his importance for the development of seventeenth-century Dutch painting. Van Mander is a link between late-sixteenth-century Flemish genre painters and the artists active in Holland during the first decades of the new century (e.g., Frans Hals, Vinckboons, Esaias van de Velde), who laid the foundation for the great achievement of Dutch genre and landscape painting. Paintings by van Mander are rare, but enough remain to reconstruct his development. Like the other Haarlem Mannerists, he worked in more than one style. Paintings made before he settled in Haarlem show no trace of Spranger's influence (*Martyrdom of St Catherine*, 1582, Courtrai, St Maartenskerk); then he had Mannerist and Classicist phases. His sweet nocturnal *Adoration of the Shepherds* of 1598 (Haarlem, Frans Hals Museum, on loan from the Netherlands Office for the Fine Arts, The Hague) recalls the treatment of similar themes by the Bassani, but van Mander makes the picturesque ruins and the mysterious light and shadow in his small painting play a more important part than late-sixteenth-century Venetian artists did. His *Adoration*, like Goltzius's *Ceres, Bacchus, and Venus* at Philadelphia [6], shows that night scenes were painted in the Netherlands before the Dutch followers of Caravaggio

returned to Holland around 1620. More than once van Mander writes in his *Schilderboek* of the striking effects that can be achieved with artificial light, and it is possible to point to northern Netherlandish artists who used the device long before van Mander appeared on the scene. The predilection of the Dutch for nocturnal pictures can be traced back at least to Geertgen tot Sint Jans's *Nativity* painted about 1485, now in the National Gallery, London.

Two Utrecht painters, Abraham Bloemaert (1566–1651) and Joachim Wtewael (1566–1631), belong to the same generation as the Haarlem Mannerists. Wtewael studied with Joos de Beer who also was one of Bloemaert's teachers for a time. Wtewael was in Italy from about 1588 to 1590; he lived in Padua, close enough to Venice to become familiar with the Venetian masters. He also studied works by Correggio and the Tuscan Mannerist Jacopo Zucchi. Wtewael returned to the Netherlands via France, and by about 1592 he had settled in Utrecht. He painted portraits and kitchen scenes as well as subject pictures. His religious and allegorical pieces are frequently cabinet-size on copper supports and are characterized by masterfully drawn, highly polished figures often set in capricious poses. He painted in metallic colours and had a predilection for vivid yellow, intense reds, deep greens, and browns. When well preserved his little pictures glow like gems. One of them is his *Marriage of Peleus and Thetis* of 1602 at Braunschweig [10] which includes almost one hundred perfectly proportioned gods and their attendants in the vast heaven, with a glimpse of a beautifully painted earthly landscape below. It may be identical with the 'excellent small piece on copper, a Feast of

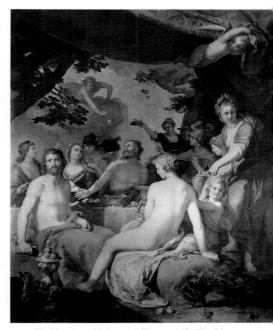

10. Joachim Wtewael: *The Marriage of Peleus and Thetis*, 1602. Braunschweig, Herzog Anton Ulrich-Museum

11. Abraham Bloemaert: *The Marriage of Peleus and Thetis*, 1638. The Hague, Mauritshuis

the Gods, full of detail and entirely nicely and neatly done' that van Mander tells us in his *Schilderboek*, published two years after the little picture was painted, was in an Amsterdam collection. Wtewael was one of the few Dutch artists who did not abandon Mannerism after 1600; there is little difference between his early and his late works.

The same cannot be said of Abraham Bloemaert. During his long and productive life Bloemaert tried his hand at more than one of the styles used in Holland during the first half of the seventeenth century. After studying with his father Cornelis and then briefly with Joos de Beer and five other artists, Bloemaert went to France around 1580. A few years later he returned to Utrecht, and from about 1691–3 he was active in Amsterdam where he became acquainted with the style of Spranger and the leading Haarlem Mannerists. The works made during the 1590s mark his High Mannerist phase (*Judith displays the Head of Holofernes to the People*, 1593, Vienna, Kunsthistorisches Museum). He settled in Utrecht in 1593, and within a decade began to adopt the mild classicism that Goltzius had brought back from Italy. In Utrecht Bloemaert was remarkably successful as a teacher. His pupils include his four sons, leading Dutch Caravaggesque painters (Honthorst, Bijlert, and probably ter Brugghen), and the Italianate painters Poelenburgh, Jan Both, and Jan Baptist Weenix who were his students before they travelled to Rome – in fact, it is difficult to name an important Utrecht painter of his day who did not receive some training from him. The number of Utrecht artists who went to Rome is also striking, and an index of the city's close connection with the Catholic church. Utrecht was the leading Catholic centre in the northern Netherlands during the Middle Ages and the Renaissance, and even during the seventeenth century, when Catholicism was suppressed, it continued to keep something of its Catholic character. Bloemaert, a devout Catholic, received commissions for large

altarpieces from patrons in both the northern and southern Netherlands, and many of his more than 600 designs for prints were intended for a Catholic clientele.

Bloemaert learned as easily as he taught. His candlelight picture of the *Supper at Emmaus* (1622, Brussels, Musées Royaux des Beaux-Arts) is proof of his rapid assimilation of Honthorst's personal transformation of Caravaggio's style. The *Marriage of Peleus and Thetis* of 1638 (The Hague, Mauritshuis) [11] indicates that he was also a successful interpreter of classicism. Bloemaert may have admired Wtewael's small painting of the same subject [10], but in 1638 he would have thought it as well as his own earlier pronounced mannerist efforts extremely old-fashioned. His picture was the kind of decorative painting that made the court at The Hague prefer artists who adopted a classical style. There was a close affinity between classicism and the aristocratic tendencies of the Baroque period. Decorative paintings made in this mode were better suited to the purposes of a court than those made by most other seventeenth-century Dutch masters. Bloemaert also made an outstanding contribution as a landscapist (see pp. 179–80). Testimony of the fame he won during his lifetime is offered by the visit Rubens paid to his studio in 1627; a year earlier the Queen of Bohemia called upon him. His posthumous fame was spread by his vast production as a print designer and by the publication of *Artis Apellae liber* (*c.*1650/6) by his son Frederick which is a book of 120 engravings based on his drawings of parts of the body and human figures in various poses and settings; it was intended as a model book for aspiring artists. The volume, better known as the *Tekenboek* (*Drawing Book*), received hard use until the nineteenth century; an expanded de luxe edition of it was published by Bernard Picart in Paris, 1740.

Michiel van Miereveld (1567–1641) and Paulus Moreelse (1571–1638) are two Utrecht artists best known for their

traditional portraits (see pp. 248–9, figs. 337, 338), but both started as history painters working in the international Late Mannerist style. Miereveld never left Holland; he apparently derived his Mannerism from his teacher, Anthonie Blocklandt. After his training he settled in Delft. Van Mander cites a few subject pictures by Miereveld, but the only one known today is *The Judgement of Paris* of 1588, now at the Nationalmuseum, Stockholm. It seems that he gave up history painting to become a portraitist, and if Joachim von Sandrart is to be trusted, once he started to paint portraits he never stopped; Sandrart reports that Miereveld made more than ten thousand portraits.[8] Moreelse, who was Miereveld's pupil, was not such a pronounced specialist. He was active as an architect as well as a painter, and he made subject pictures throughout his career. After a trip to Italy he settled in Utrecht where he became the city's leading portraitist. He was even more active there as a teacher than Abraham Bloemaert; however, apart from Baburen, his pupils left less of a mark than Bloemaert's. We shall see that during the 1620s and 1630s he helped set a vogue for arcadian pictures of shepherds and shepherdesses dressed in bright silk and bedecked with flowers. His late works (*Cimon and Pera*, 1633, Edinburgh, National Gallery of Scotland) show the distinct impact of Rubens. In general, his portraits have a little more splendour and softness than those of Miereveld.

PIETER LASTMAN AND THE PRE-REMBRANDTISTS

Van Mander belongs to the group of art historians who are not afraid to write judgements on modern art and artists. He wrote in his *Schilderboek* that 'now in Italy there is a certain Pieter Lastman who shows great promise'. Lastman (*c.*1583–1633) returned from Italy to his native town of Amsterdam by 1607, not long after *Het Schilderboek* was published, and quickly fulfilled his promise by becoming one of the principal painters of religious and mythological subjects in the new republic. According to van Mander, Lastman's teacher was Gerrit Pietersz Sweelinck (1566–in or after 1608), brother of the celebrated Dutch composer and organist Jan Pietersz Sweelinck. Gerrit Pietersz was a pupil of Cornelis van Haarlem, and like his teacher was a Mannerist. Young Lastman began working in the same mode. He probably arrived in Italy about 1603 and soon afterwards abandoned his early brush with Mannerism. The style of his topographical sketch of the Palatine Hill, signed and dated 1606 and inscribed 'Roma' (private collection) suggests that by this date he had made contact in Rome with Flemings such as Paulus Bril and Willem Nieulandt II who, at the turn of the century, were in the Eternal City specializing in landscapes with small figures, based on their study of the Roman countryside and its ruins; the type of ruins seen in the early drawings often appear in Lastman's later paintings. His signed drawing of Veronese's *Adoration of the Shepherds* (Cambridge, Fitzwilliam Museum), a painting now in Venice and which never left the city, offers good reason to believe he also visited Venice. But Lastman learned most in Rome. In addition to works by Flemish landscapists, his art was affected there by Caravaggio and Annibale Carracci, the foremost Italian artists of the time, and even

more decisively by Adam Elsheimer (1579–1610), a painter of German origin who settled in Rome about 1600 after a brief stay in Venice.[9] Like so many painters active in Rome during the first decades of the seventeenth century, Elsheimer also was stimulated by Caravaggio. Although they worked on completely different scales – Caravaggio concentrated exclusively on life-size pictures while Elsheimer only painted cabinet-sized pictures on small copper panels – the new feeling for sculptural values which is so impressive in Caravaggio's figure compositions and the intense expression of mood through the pictorial means of light and shadow that distinguish his pictures are also found in Elsheimer's meticulously painted little masterworks. However, Elsheimer also made an important contribution of his own. He discovered the classical serenity of the ancients in the Roman campagna and created a new type of landscape that appealed to northern seventeenth-century artists, who were susceptible to his fine feeling for light and atmosphere. The new mood and pictorial devices of Elsheimer's landscapes had a wide and immediate appeal and, as we shall see, along with those by Paulus Bril who spent most of his long career in Rome, they had a marked effect upon the development of seventeenth-century landscape in the Netherlands and Italy.

Elsheimer's magnetic personality attracted a group of artists around him. The talented Venetian Carlo Saraceni (*c.*1580–1620) probably joined Elsheimer's circle even before Lastman arrived; Saraceni assimilated Elsheimer's miniature style with such perfection that it is sometimes difficult to distinguish their hands. While he was in Italy Rubens became one of Elsheimer's most devoted admirers. Elsheimer's untimely death moved Rubens to write that the melancholy German painter 'had no equal in small figures, in landscapes, and in many other subjects...I have never felt my heart more profoundly pierced by grief than at this news...'[10] Soon after Elsheimer's death masterful engravings of his paintings by Hendrik Goudt (active *c.*1608–30), a Dutch printmaker, helped disseminate his subjects and style in the north [see 245, 249]. Whether Lastman was an active member of Elsheimer's Roman circle is unknown but there is ample evidence that he was inspired by him. Testimony of Lastman's pleasure and pride in his rich Italian experiences, which remained with him throughout his career, is offered by his practice of often signing his works Pietro Lastman instead of Pieter Lastman (some later Dutch artists who travelled south of the Alps did the same; e.g. Jan Baptist Weenix used the signature Giovanni Battista Weenix after his trip to Italy in the 1640s).

The paintings Lastman made shortly after his return to Amsterdam in 1607 effectively use landscape to help set a mood (*Flight into Egypt*, 1608, Rotterdam, Boymans-van Beuningen Museum; *Paris and Oenome in a Landscape*, 1610, Atlanta, High Museum of Art). They show the profound influence of Elsheimer. Around 1610 he also began to make history pictures with the landscape subordinate to many figures, a type of painting that became his speciality. At first his crowds were scattered, and it is sometimes difficult to distinguish protagonists from secondary figures; but by the end of the decade he was able to use a crowd to enhance the dramatic action of a story. *Nausicaa and Odysseus* (1619, Augsburg, Staatliche Gemäldegalerie) [12] is an example of

12. Pieter Lastman: *Nausicaa and Odysseus*, 1619. Augsburg, Staatliche Gemäldegalerie

Lastman's narrative power at its height. He depicts the moment when Odysseus emerges from the bushes and surprises Nausicaa and her servants. This is the kind of story Lastman continued to favour: a crowd reacting to a dramatic situation. He also liked scenes which allowed him to introduce many genre and still-life details. Nausicaa and her handmaidens have come down to the river mouth to do the family washing. Odysseus, the group of handmaidens, and the barking dog are grouped together. Only modest Nausicaa, who was given courage by Athena to stand alone before naked Odysseus, is silhouetted against the low horizon and light sky. The rather harsh outlines, the chiaroscuro, and strong realism of Odysseus's figure indicate that here Lastman was indebted to Caravaggio rather than Elsheimer. Lastman probably saw the dirty soles of bare feet in pictures by Caravaggio, about which the Italian master's critics made such a fuss. Two years before he painted *Nausicaa and Odysseus* he could have seen them once again in Holland; the conspicuous ones in Caravaggio's *Madonna of the Rosary*, now in Vienna, could be viewed when the altarpiece was in Amsterdam in 1617 (see p. 25). In the year he executed *Nausicaa* he had an opportunity to renew his study of the Italian master when he signed a joint statement with a group of artists in Amsterdam regarding the authenticity of a *Crucifixion of St Andrew* by Caravaggio. The qualities found in *Nausicaa* are not evident in Lastman's late works; in them the lively movements of his figures become stereotyped, glossy paint surfaces turn dry, and his vivid colours acquire a certain harshness.

Lastman is best known in the modern literature as the leading member of a group of artists called the pre-Rembrandtists. The label is unsatisfactory. Discounting the thought that every Dutch artist who worked before Rembrandt appeared on the scene qualifies as a pre-Rembrandtist, the label implies that the significance of the group is limited to their relationship to Rembrandt. Pioneer students of these artists, who began studying them in the second half of the nineteenth century, would not have denied the charge. Their interest was generated by a desire to learn

more about Rembrandt's teachers and immediate predecessors. They were engaged in what can be called Old Testament art history: who begat whom? Universal usage of the label today and a solid body of literature on the group by specialists who still choose to call them pre-Rembrandtists makes it quixotic to attempt to unstick the label here.[11]

The group was mainly active in Amsterdam. What they have in common is their dedication to history painting, often employing biblical and mythological subjects that hitherto were rarely depicted by Dutch painters. Their style is derived from sources that Lastman used and all of them borrowed from Lastman, the most influential member of the group. So did the artist for whom they are named. It was to Lastman in Amsterdam that young Rembrandt was sent, about 1624, after a three-year apprenticeship with a minor Leiden painter. The six months Rembrandt spent with Lastman made a deep impression, and he may well have inspired Holland's greatest artist to become a history painter. He certainly influenced his early narrative style and choice of subjects. The pupil surpassed his master with lightning speed. But this anticipates our story.

The group categorized as pre-Rembrandtists is small. Besides Lastman, it includes Jan Pynas (*c.*1581/2–1631) and his younger brother Jacob (1592/5–still active in 1656), their brother-in-law Jan Tengnagel (1584–1635), Claes Cornelisz Moeyaert (*c.*1590/1–1655), and Lastman's brother-in-law François Venant (1590/1–1636). The little that remains of the last named artist's paintings indicates that he was his brother-in-law's close follower. Although the others show the same tendency they have more distinct artistic personalities. According to Arnold Houbraken, author

13. Jan Pynas: *The Raising of Lazarus*. Philadelphia Museum of Art, John G. Johnson Collection

of *De groote schouburgh* (1718–21), a three-volume work which is still our main source on the lives of numerous seventeenth-century Dutch and Flemish artists, Jan Pynas spent some years in Italy with Lastman. No documentary evidence corroborates his statement. However, Pynas was in Italy in 1605 when Lastman was there, and apparently made the trip again in 1617. Houbraken also wrote that after Rembrandt had spent six months with Lastman in Amsterdam he studied for a few months with Jan's brother Jacob. He adds that some people maintain Jacob Pynas was Rembrandt's first teacher. These statements helped stimulate later interest in Jacob, but subsequent study revealed nothing to support these statements either. Both brothers are known to have signed their works 'J. Pynas' or with a monogram, and this has not simplified the problem of separating their hands. However, about the attribution of the *Raising of Lazarus* [13], clearly inscribed 'Jan Pynas', there can be no question. Jan Pynas usually avoids the emphatic gestures his younger brother favours. His figures tend to be elongated and static; in the Lazarus painting Christ appears to have performed the miracle with a flick of his finger. The tangled vines and the ruins are evidence of Elsheimer's imprint but the dramatically lit main group silhouetted against the dark, thinly painted background is quite original. History paintings by Jacob Pynas are of two types: dynamic compositions with large Lastman-like figures and works that appear at first blush to be landscapes until one discovers small biblical or mythological scenes in them. The latter works carry on the traditions of Elsheimer and Bril. Apart from Lastman none of the other members of the group painted similar historiated landscapes. To judge from an inventory made of Rembrandt's effects in 1656, after he declared himself insolvent, he preferred Jan's paintings to Jacob's. It lists two pictures by the older brother and one by 'Pynas' without a Christian name; Jacob's name is not mentioned.

Jan Tengnagel is the only other member of the group who is recorded as a traveller to Italy; he was there in 1608. His early works are so close to Lastman's that they have erroneously passed as the better known artist's autograph pictures, but he soon developed an original style marked by large figures seen close to the foreground that almost fill the picture plane with merely a small vista of a landscape in the background done in the predictable Elsheimer-Bril tradition (*Raising of Lazarus*, 1615, Copenhagen, Staatens Museum). Tengnagel was at home working on a life-size scale. In 1613 and again 1623 he was commissioned to paint large group portraits of members of Amsterdam's *Handboogdoelen*, one of the city's civic guard companies; both include self portraits. He was a prominent public servant who held the position of deputy sheriff of Amsterdam from 1625 until his death a decade later. He apparently gave up painting about the time he assumed his important post; none of his existing pictures postdate 1624. He died rich enough to bequeath his family a house and 7,000 guilders.

Claes Moeyaert's early works are a *potpourri* of Lastman, Jacob Pynas, and Bril. He found his speciality in the mid-1620s: small pictures of bacchanals characterized by a silver-grey tonality (*Triumph of Bacchus*, 1624, The Hague, Mauritshuis). The animals in his lusty processions usually have as much character as the revellers who accompany

them. The outstanding Italianate landscapists Nicolaes Berchem and Jan Baptist Weenix, who were also animal painters, were his pupils. Early works by Paulus Potter, the most famous of all seventeenth-century Dutch animal painters, are similar to Moeyaert's. This has led some students to claim that he was Potter's teacher; there is no documentary evidence for this assertion. Moeyeart's late histories lose their charm; compositions become disjointed, figures are stiff, and colours are dry (*Christ blessing the Children*, c.1653, Karlsruhe, Kunsthalle). Moses van Uyttenbroeck (1595/1600–1646/7), who spent his entire career at The Hague, painted biblical and lively mytholigical scenes set in heavily wooded landscapes that recall Bril and Elsheimer (*Feast of Bacchus*, 1627, Braunschweig, Herzog Anton-Ulrich Museum). Unless we are willing to make the term pre-Rembrandtist more amorphous than it is now, these reminiscences do not qualify him as a member of the group. Uyttenbroeck's paintings, often based on themes from Ovid's *Metamorphoses*, found favour in the court at The Hague; the stadholder Frederik Hendrik had some in his collection by the mid-1630s and he was called upon to help decorate his hunting lodge at Honselaarsdijk.

The Delft artist Leonaert Bramer (1596–1674) is an interesting independent who cannot be pigeonholed. He began a lengthy trip in 1614/15 which took him to Arras, Amiens, Paris, Aix-en-Provence, Marseille, Genoa, Livorno, and finally to Rome, an itinerary that was a main route for Dutch artists who made the pilgrimage to the Eternal City. He is first documented in Rome in 1620. There he saw Caravaggio's paintings and had contact with the Italian master's followers, but the impression they made was not profound; his earliest known Caravaggesque painting was painted long after he left Italy (*Denial of St Peter*, 1642, Amsterdam, Rijksmuseum). According to his early biographer (Cornelis de Bie, 1661) during his stay in Italy Bramer visited Venice, Florence, Mantua, Siena, Bologna, Parma, and Naples. Elsheimer, Agostino Tassi, Correggio, the Bassani, and his countryman Cornelis van Poelenburgh who was in Rome (see pp. 227–9) are among the artists who attracted him. His stay in Italy seems to have come to an abrupt end in 1627 when he got involved in a drunken tavern brawl and had serious trouble with the Roman police. He found it judicious to leave Italy quickly. By 1628 he was back in his native town of Delft.

Bramer is best remembered today for his small nocturnal scenes illuminated by phosphorescent colours and streaks of light [14]. In a work such as *Resting Soldiers* (1626, The Hague, Bredius Museum) he anticipates the romantic mood of Salvator Rosa; the Bredius picture is painted on slate, a particularly suitable support for a night scene. Bramer's contemporaries considered him an outstanding wall painter and, like Uyttenbroeck, he was one of the artists commissioned by Frederik Hendrik to help decorate his hunting lodge at Honselaarsdijk; he also received commission for the decoration of the stadholder's new palace at Rijswijk. Both assignments were given to him soon after his return from Italy. At Delft he painted a series of eight pictures for the hall of the Guild of St Luke that represented the Seven Liberal Arts; Bramer added 'Painting' as the Eighth Art. He also painted the main hall of the Prinsenhof at Delft (1667–9) with

14. Leonaert Bramer: *The Adoration of the Magi*, *c*.1628–30. Detroit Institute of Arts

historical scenes and its ceiling, *The Ascension of Christ*. Part of the ceiling of the Prinsenhof project is all that remains of these large-scale decorations. Bramer was one of the few seventeenth-century Dutch artists who painted frescoes in Holland; none have survived the Dutch climate. As far as we know he had no pupils of any significance, but his name has been invoked in connection with Rembrandt's early phase. The question of whether Bramer's early night scenes influenced Rembrandt, or if Rembrandt inspired Bramer's late works, is best answered negatively. The resemblance between their works is superficial. It is safe to say both artists arrived at their results independently. Bramer's name is also linked with the greatest Delft artist: Johannes Vermeer. In 1653, when his future mother-in-law was blowing hot and cold about the marriage of her daughter to young Vermeer, Bramer gave testimony before a Delft notary that enabled the couple to publish their marriage banns. It is tantalizing to think that there was even closer contact between the Delft artists. Vermeer's teacher is not known. Perhaps Vermeer studied with the man who was at the time the most celebrated artist of his native town. If he did, Bramer's dark manner left no impression upon the artist who is best known as a painter of light.

THE UTRECHT SCHOOL AND THE 'CARAVAGGISTI'

The Utrecht school of painting reached the height of its importance during the 1620s when Hendrick ter Brugghen (*c*.1588–1629), Gerrit van Honthorst (1592–1656), Dirck

van Baburen (*c*.1595–1624), and other Dutch followers of Caravaggio were active there. Unlike Bramer, who seemed to have a delayed and not very significant reaction to Caravaggio, these painters brought Dutch art into close contact with Caravaggio's achievement soon after they returned from Italy, and thereby introduced one of the main currents of Italian Baroque art into the Netherlands. Even the greatest masters of seventeenth-century Dutch painting, who were never in Italy – Hals, Rembrandt, and Vermeer – received decisive impulses from the Caravaggesque style. Thus, for an understanding of the historical position of the development of Dutch painting some knowledge of the art of the great Italian innovator of Baroque painting is needed. It has already been noted that Caravaggio's fame and aspects of his style reached the Lowlands even before he died in 1610. Lastman and other Dutch artists who were in Rome during the first decade of the century learned how to look at Caravaggio in miniature. Of far greater importance was Caravaggio's effect upon Rubens, the principal representative of the High Baroque style in northern Europe. When Rubens returned to Flanders, probably before the end of 1608, from his eight-year stay in Italy, Caravaggio's influence was a paramount one in his work.

Caravaggio belongs with those artists who had a recurrent influence upon succeeding generations. His power was also strongly felt in his own time, when he had an important mission to fulfil. He seems to have appeared at a turning point of history when the inner conflicts and the spiritual upheaval of the late sixteenth-century were gradually giving way to a new reassurance of concrete values in life and

nature. This vigorous trend in Baroque painting makes us feel that we have ground under our feet and blood in our veins, that life is powerful when seen close up in its physical and emotional reality, and that artists can dramatize it by the realistic intensity of their representation. Caravaggio achieved this, and his vast influence came from the fact that he showed a way to a new and much needed confidence in reality and the power of life itself. Caravaggio was also able to project his intense feelings about the virtues of humility and simplicity into his religious works. This disturbed most of his contemporary critics, and many of his later ones, who accused him of ruining art. They charged Caravaggio with depicting biblical subjects without decorum or imagination, and failed to see that he used his bold and uncompromising naturalism, emphasized by strong contrasts of light and shade, to make deeply religious works that carry the stamp of the popular religious movements of his time.

Caravaggio's most radical stylistic innovation was his new use of chiaroscuro. Chiaroscuro, an Italian word which has been accepted in the English vocabulary, literally means bright and dark; in the literature on art it refers to the contrasting of light and shadow as a principal means of painterly expression. In our time of almost universal electrification, when everything is illuminated with nearly the same intensity during day and night, we no longer feel the mystery of darkness or the spell of those manifold, flowing transitions from light to shadow which candlelight produces in a darkened room. We can hardly imagine how sensitive Baroque artists were to the picturesque effects of chiaroscuro. They not only subtly observed the contrasts and transitions of light and shadow, but adopted the chiaroscuro effect as a means of composition to bind together the separate forms into one pattern and to achieve a unity that was attained during the Renaissance period largely by other means. The great Venetian masters, with their special gift for the pictorial, had already begun to use chiaroscuro effects in the sixteenth century, but Caravaggio was the first to create a style in which chiaroscuro became the dominating device. In his religious pictures it was one of the principal means of making Christian miracles palpable to a worshipping community.

To turn to Caravaggio's Dutch followers after seeing the master's work is a disappointment. Even Hendrick ter Brugghen, the most inspired of them, never matched the expressive power of Caravaggio's chiaroscuro and the unusual subdued glow of his colours, which give the Italian master's pictures a kind of magical attraction. Earlier students were not unaware of the qualities and the importance of Dutch Caravaggesque painters; indeed, some exaggerated them. Burckhardt claimed in his *Cicerone* that the *Entombment* (1617?, Rome, S. Pietro in Montorio) by the Utrecht *Caravaggist* Dirck van Baburen is a more noble work than Caravaggio's well-known painting of the same subject now at the Vatican. This assertion would find few supporters today. The reappraisal made of Caravaggio's achievement by later historians, and the re-examination of his widespread influence on seventeenth-century painters in Spain, France, Italy, as well as the Lowlands, thoroughly changed earlier ideas about the accomplishment and relationship of the master and his followers. One fact has become evident:

hardly any of the *Caravaggisti* actually studied under the master. We know, for example, that Baburen did not have even a glimpse of Caravaggio. As is the case with most Dutch artists who went to Italy, it is not known precisely when he arrived in Rome, but we do know that Baburen was still an apprentice in Utrecht in 1611. Caravaggio died in 1610.

Caravaggio had settled in Rome around 1592, when he was scarcely twenty. His spectacular Roman career was short. He fled from the city in 1606 after killing a man during a dispute about the score of a game. From the time of his departure until his untimely death four years later he was constantly travelling because of difficulties with the authorities. From what is known about his explosive temperament, particularly during the final decade of his life, he hardly could be called a born teacher. He was not a Rubens or a Rembrandt, who always had pupils – although, like them, he had numerous devoted followers. And finally, Caravaggio was not the man to set up a curriculum for budding artists, or even adhere to a set of guild rules designed for apprentices. It is not difficult to imagine him prescribing to a youthful artist the deceptively simple and enigmatic formula: 'Merely follow nature! Follow nature!' Dutch artists interested in assimilating Caravaggio's style had to study the master's works in the churches and private collections of Rome, or make contact with Italian *Caravaggisti* such as Orazio Gentileschi, who came under Caravaggio's influence early in the century, Bartolomeo Manfredi, who made Caravaggio's life-size genre scenes common currency during the second decade of the century, or Carlo Saraceni, who had a Caravaggesque phase after 1610. These painters quickly assimilated Caravaggio's motifs, compositions, strong chiaroscuro, and vivid colour harmonies – everything, it seems, except the intensity of the master's vision.

Hendrick ter Brugghen, who arrived in Utrecht in 1614 or 1615 after a reported, but undocumented, ten-year sojourn in Italy, was the first Dutch Caravaggesque painter to return to Holland. Very little is known about his early life. There is not much in the older literature about him. Ter Brugghen's resuscitation is a phenomenon related to the rediscovery by nineteenth-century critics of the beauty of Vermeer's hushed world, and to the re-evaluation of Caravaggio's genius by twentieth-century writers. His art is now seen as a link between Baroque Rome and developments in Utrecht, Haarlem, and Delft. Ter Brugghen, born at The Hague or Utrecht around 1588, is said to have been a pupil of Abraham Bloemaert in Utrecht. If he really met Rubens in Rome, as an old source tells us, he must have been in the city before the Flemish master returned to Antwerp in 1608, and if the report that he was in Rome as early as 1604, or 1605, is true, he is the only follower of Caravaggio who could have met the master himself. Apparently his experiences in Italy did not send him into a frenzy of creativity. Nothing painted during his stay in Rome has been discovered.[12] What he did during his first years back in the Netherlands is not very clear either. He entered Utrecht's guild in 1616 or 1617, and the rare pictures made from around this time until 1620, when he painted *The Crowning with Thorns* (Copenhagen, Staatens Museum), are unusual works. To be sure, there are Caravaggesque

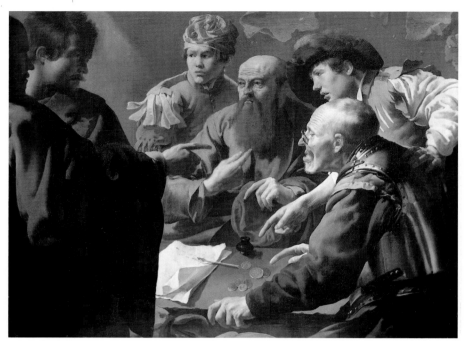

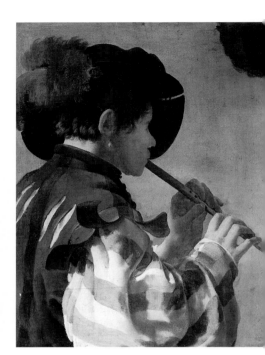

15. Hendrick ter Brugghen: *The Calling of St Matthew*, 1621. Utrecht, Centraal Museum

16. Hendrick ter Brugghen: *Flute Player*, 1621. Kassel, Staatliche Kunstsammlungen

elements in them; the composition of the *Calling of St Matthew* (Le Havre, Musée), variously dated from *c.*1616 to 1620, is unthinkable without Caravaggio's picture of the same subject at S. Luigi in Rome, and his lighting effects show knowledge of Caravaggio's chiaroscuro. But the northern sixteenth-century archaisms in the pictures of this early period are equally important. Ter Brugghen used motifs from Dürer and Lucas van Leyden; some of his grotesque types are derived from Quentin Massys and his follower Marinus van Reymerswaele. His colour scheme of yellow-browns, greens, and pale violets recalls the Mannerist palette of his putative teacher Bloemaert, not Caravaggio. The multiplicity of details and hues of his early Dutch works and his obsession with nervous, brittle outlines is abandoned only after 1620. Perhaps the return of other Dutch *Caravaggisti* to Utrecht from Rome gave ter Brugghen courage to become more Italianate. Honthorst came back to the north in 1620 imbued with an uncomplicated kind of classicism which indiscriminately regularized and generalized forms; Baburen returned about the same time a converted Caravaggist. It is also possible that ter Brugghen made a second trip to Italy between 1619 and 1621, when he made a more mature study of Caravaggio's works, and saw what the Italian *Caravaggisti* (Orazio Gentileschi, Manfredi, Saraceni, young Serodine) had accomplished after he had left Rome by 1614. In any event, ter Brugghen's most Caravaggesque pictures, for example the *Liberation of St Peter* (1629, Schwerin, Staatliches Museum), were made during the last, not the early, years of his career. During his final phase he also painted works which prefigure the shimmering light and cool, silvery tonalities of Vermeer (*Duet*, 1629, Rome, Galleria Nazionale, Palazzo Barberini).

Another unorthodox thing about ter Brugghen is his archaisms. We have noted they are marked in his 1620

Calling of St Matthew and are patent in his monumental *Adoration of the Shepherds*, indistinctly dated 1619 (Amsterdam, Rijksmuseum), which shows a conspicuous debt to Dürer, and little relation to Caravaggio and even less to Bloemaert who often depicted the subject. His archaisms never completely disappear. The *Crucifixion with the Virgin and St John* painted *c.*1625 (New York, Metropolitan Museum) recalls late Gothic sculpture and early woodcuts as well as Grünewald. All this makes it difficult to work out a precise chronology for ter Brugghen's pictures. However, his achievement and contribution to Dutch painting are quite clear. They are seen in the *Calling of St Matthew* of 1621 [15]. The work is a revision of his own earlier picture of the same subject. This is also characteristic of ter Brugghen; he frequently revised his own compositions and he copied them as well. The relation to Caravaggio is still unmistakable, but the Utrecht *Calling of St Matthew* is not a slavish imitation. The life-size figures are half-length instead of full-length, and the large empty space in Caravaggio's version at S. Luigi, where the drama of Christ calling the tax-collector to his vocation echoes in the shadows above the figures, has been eliminated. The composition has also been reversed; Christ and his follower appear to the left as dark figures in the foreground. The main accent is on the brightly illuminated group on the right. Ter Brugghen's original talent and old Netherlandish realism successfully merge here with Caravaggesque motifs and elements. The mercenary soldier pointing to the money on the table shows a profile which marks him as a descendant of types popularized by early sixteenth-century Flemish artists, and the six gesticulating hands in the centre are also a survival of an older tradition. Ter Brugghen's debt to Caravaggio is seen most clearly in the manner of illumination. The light enters in a broad beam, and as usual in ter Brugghen's work, from the left.

17. Hendrick ter Brugghen: *St Sebastian tended by Irene and her Maid*, 1625.
Oberlin College, Ohio, Allen Memorial Art Museum

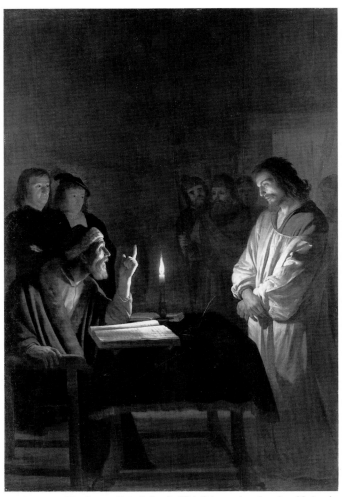

18. Gerrit van Honthorst: *Christ before the High Priest, c.*1617. London, National Gallery

However, the quality of the light is original; it is lighter, richer, and more atmospheric than Caravaggio's, which seldom has the brightness or softness of real daylight. In this work of 1621 with its colour harmonies of cool blues, pale yellows, creamy whites, violets, and red-browns, as well as its soft silvery tonality, the effects of the Delft School are already anticipated.

Ter Brugghen's two half-length pictures of flute players at Kassel, also of 1621 [16], are outstanding examples of the breadth, force, and beauty of his new pictorial manner. They also are among the earliest life-size, half-length Dutch paintings of musicians, a motif that quickly became a staple of Utrecht painters and soon entered the repertoire of other Dutch artists. Ter Brugghen made more intricate pictures than the Kassel companion pieces, but he never surpassed their poetic arcadian mood and delicacy. The effect of the dark-shadowed flute player before a bright wall in the background is another anticipation of an essential pictorial theme of the Delft School. Fabritius and Vermeer continued the scheme of painting dark figures against light backgrounds, which enabled them to make pictorial variations in a kind of open-air atmosphere. This device, first exploited by the ingenious ter Brugghen, relieves the dramatic tension and allows more room for purely pictorial still-life beauty.

Ter Brugghen's ability to combine exquisite painterly

effects with restrained emotion accounts for the power of his masterpiece, *St Sebastian tended by Irene and her Maid* (1625; Oberlin College, Ohio, Allen Memorial Art Museum) [17]. The women tenderly and efficiently go about their business of trying to save the life of the saint, who has been pierced with arrows and left for dead. The large, full forms of the group have been knit together into a magnificent design, and what could have been hard and sculptural is remarkably softened by the cool silvery light which plays over Sebastian's half-dead, olive-grey body as well as the reds, creamy whites, and plum colours worn by the women who tend the saint. If Rubens really said on his visit to Holland in 1627 that 'travelling throughout the Netherlands and looking for a painter, he had found but one, namely Henricus ter Brugghen', he must have had pictures like the *St Sebastian* in mind. Ter Brugghen also made pictures of night scenes illuminated by artificial light; the finest is *The Concert, c.* 1626, at the National Gallery, London. He brought the same sensitivity to the study of nocturnal effects that he gave to daylight, but nocturnal pictures were never his speciality. They were popularized by Gerrit van Honthorst, who established his reputation in Italy with this type of painting. It was there that Honthorst was nicknamed 'Gherardo delle Notti'.

Honthorst was born in 1592 at Utrecht; there he was Abraham Bloemaert's pupil. He is said to have been in Rome as early as 1610–12, but he is not documented there until 1616. Nothing is known about his artistic activity until the last years of the decade, and not a work painted before he went south has been discovered. But unlike ter Brugghen's, a number of Honthorst's Italian works have been identified. He enjoyed the patronage in Italy of the grand duke of Tuscany, Cardinal Scipione Borghese, and especially the Marchese Vicenzo Giustiniani, one of the greatest collectors of his day, who had a flair for recognizing young talent and finding important pictures. An inventory of his collection made in 1638 lists names which range from Raphael, Giorgione, and Titian to Bramer. Giustiniani owned paintings by Caravaggio and the Carracci, and in his house Honthorst could also study works by the major *cinquecento* masters – including night scenes by Bassano and Luca Cambiaso. Honthorst, who became the best-known Dutch follower of Caravaggio, continued to find favour in court circles throughout his life. Ter Brugghen, on the other hand, was always an outsider; he was not even awarded the minor distinction of election to an office in the Utrecht Guild, which he entered as early as 1616 or 1617.

Honthorst's *Christ before the High Priest (c.*1617) [18] shows the two special artistic problems he mastered in Rome. He found the solution for both in works by Caravaggio and his followers: one is the exact study of the expression on different physiognomies reacting in a personal way to a dramatic effect; the other is the chiaroscuro, which Honthorst developed in his own manner. Unlike Caravaggio, he preferred scenes illuminated by artificial light (frequently the source of light is hidden), and he is responsible for popularizing this trend in Dutch painting. Whether Georges de la Tour, the most original French Caravaggesque painter, learned about the dramatic possibilities of a nocturnal scene from a glimpse of works by Honthorst or discovered them

after studying paintings by Caravaggio and other Italian *Caravaggisti* during an unrecorded trip to Italy remains a matter of conjecture.

Though Honthorst continued to depict scenes from Scripture after his return to Utrecht in 1620, the religious pictures he made in Rome are from many points of view the climax of his work as a painter of biblical themes. During the 1620s he painted works in the arcadian mode such as *Granida and Dafilia*, 1625 (Utrecht, Centraal Museum), which shows that he had looked at the Carracci as well as Caravaggio while in Italy. Its light tonality anticipates the classical style Honthorst adopts in the following decade. The painting depicts an episode from P.C. Hooft's pastoral play *Granida* (1605), a popular source for Dutch arcadian pictures which began to enjoy a vogue with the elite in Holland during the 1620s. Its first known owner was Stadholder Frederik Hendrik, who had it mounted at Honselaarsdijk, the prince's hunting lodge, where other arcadian paintings were hung. In Holland Honthorst also painted religious, mythological scenes and at least one illusionistic ceiling, *Musical Group on a Balcony*, 1622 (Los Angeles, J. Paul Getty Museum) [19], which was done for his own house in Utrecht. The painting, only partially preserved, is the earliest existing Dutch illusionistic painted ceiling. Equally innovative for Holland is his illusionistic *Concert on a Balcony*, 1624 (Paris, Louvre). Like the Los Angeles ceiling, it shows, in steep perspective, life-size musicians and their companions in an architectural setting, but this one was intended as illusionistic wall not a ceiling. Drawings by Bramer indicate that he also was familiar with this kind of decoration, but no paintings related to them survive. The prototype for Dutch illusionistic fields of walls and ceilings is found in decorative schemes executed for high-placed patrons in Italy. The unmistakable source for Honthorst's illusionistic paintings is Orazio Gentileschi and Agostino Tassi's life-size *trompe l'œil* frescoes, painted in 1611–12 for Cardinal Scipione Borghese's garden 'Casino of the Muses', now part of the Palazzo Pallavicini-Rospigliosi in Rome. Honthorst had ample opportunity to study them when he worked for the Cardinal, who, a contemporary reported, led 'a life largely devoted to the cultivation of pleasure and pastimes'. In Holland, illusionistic paintings also found favour in elite circles; they were employed to decorate the main hall at Honselaarsdijk and perhaps a ceiling at the stadholder's palace Huis ter Nieuwburch near Rijswijk. However, they apparently did not generate widespread interest during the first half of the century. A few by the Utrecht painter Jan Gerritsz van Bronchorst (1603–61), datable to the 1640s, of life-size musical companies at balustrades seen in frog's-eye perspective which now hang in museums (e.g. Braunschweig and Utrecht) as independent pictures probably originally hung high as part of large-scale decoration. Their derivation from Honthorst is blatant.

Honthorst's genre pictures of light-hearted gatherings had a greater impact. He made such pictures while he was still in Italy. His *Supper Party* (*c.*1619), at the Uffizi [20], painted during his last months in Italy, set a precedent for similar scenes done in the 1620s at Utrecht where artists favoured the erotic as well as the ascetic side of Baroque art. This is already evident in Honthorst's *Supper Party* where the old

woman typifies the traditional procuress (the same type appears in Baburen's *Procuress* painted a few years later [21]). The merry genre scenes of the demi-monde that the Utrecht painters helped to popularize – they often double as pictures of the Prodigal Son wasting his substance with loose woman – never disappear from seventeenth-century Dutch painting, although they often take on a more refined character in the following generations. In the Uffizi's nocturnal *Supper Party*, Honthorst uses two light sources that cast a warm golden glow on the characteristic strong reds, blues, and yellows of his picture. There is one open light on the right, where a young woman is putting a piece of chicken into the mouth of her gluttonous companion. The procuress is enjoying the scene, and Honthorst took delight in painting the reflections of light on her withered face. The young man regards this action only as an interruption of another more important occupation, since he holds his glass and bottle ready for the next draught. The people on the left are interestedly watching the proceedings. On this side Honthorst uses a covered source of light, emphasizing by this kind of illumination the expression of joy and interest in the faces of his figures.

Today all this seems a rather primitive form of art, yet it was a sensation in Honthorst's time to have a titillating night scene so realistically rendered. The advantage of hiding the light source in the foreground is a double one. The foremost

19. Gerrit van Honthorst: *Musical Group on a Balcony*, 1622. Ceiling painting. Los Angeles, J. Paul Getty Museum

20. Gerrit van Honthorst: *Supper Party*, *c*.1619. Florence, Uffizi

person who covers the light has the effect of a *repoussoir*: the large dark figure in the foreground causes, by contrast, the merrymakers behind him to recede in space, and thus enhances the illusion of depth. The second advantage is the vivid reflection of light thrown on the figures and, in particular, on their faces, which are painted in reddish-yellow colours. This helps Honthorst to overcome the harshness found in the work of other Caravaggio followers. But a residue of harshness remains. Some Caravaggesque painters incorporated this very quality in their work. Matthias Stom (also Stomer), a Netherlander who is documented in Italy from 1630 until he disappears from the scene about 1650, can be distinguished from Honthorst and other Dutch *Caravaggisti* by the pronounced leathery quality of his flesh tones and the metallic colours of his draperies.

The most important artist of the following generation to learn from Honthorst was Rembrandt. His early *Rich Man from the Parable* [62] is obviously inspired by the art of Honthorst, and so is his *St Paul at his Writing-Desk* [63], painted a few years later; in the latter work a huge book rather than a figure hides the source of light. And as late as 1660 Rembrandt used the Honthorstian device of a hand masking a candle in his haunting *Denial of St Peter* at Amsterdam [118]. During his Leiden years, Rembrandt's friend Jan Lievens also used pictorial devices popularized by Honthorst.

Not all the Utrecht Caravaggists were fascinated by night scenes. Few seem to have been painted by Dirck van Baburen or Jan van Bijlert, the two painters who, after ter Brugghen and Honthorst, did the most to make Caravaggio's style known in Holland. Baburen was born in about 1595 at Wijk bij Duurstede, about twenty kilometres from Utrecht. He distinguished himself by studying with Moreelse in Utrecht instead of Bloemaert. By 1615 he was in Italy, and two years later he was in Rome working on his most important Italian commission, paintings for a chapel in S. Pietro in Montorio done with another Dutch painter (David de Haen; d. 1622). His best-known contribution to the chapel is the *Entombment*, already mentioned as the work Burckhardt praised with such enthusiasm. Around 1621 Baburen returned to Utrecht; he died there in February 1624. Not much time to build a career, but time enough to leave a considerable mark. When Constantijn Huygens, the secretary to Stadholder Frederik Hendrik listed the distinguished Utrecht history painters in his journal around 1630 he names Baburen as well as Bloemaert, Honthorst, and ter Brugghen. Baburen's *Christ Crowned with Thorns* exists in two autograph versions (Utrecht, Rijksmuseum Het Catharijneconvent; Kansas City, Nelson-Atkins Museum); they are datable soon after his return to Utrecht. Their compositions are based on a lost painting by Caravaggio but their silvery light recalls ter Brugghen's effects, while the

21. Dirck van Baburen: *The Procuress*, 1622. Boston, Museum of Fine Arts

narrow stratum in which the figures exist and the irregular rhythms are peculiar to Baburen. While he was in Utrecht Baburen also was at home with bawdy genre subjects such as *The Procuress* (1622) at Boston [21]. Vermeer knew the composition well. The painting (or a copy of it) was owned by Vermeer's mother-in-law and after his marriage in 1653 he and his wife probably lived with her. The painting appears in the background of two of his own works: *The Concert* (formerly Boston, Isabella Stewart Gardner Museum; stolen 1990) [193] and the *Woman seated at a Virginal* (London, National Gallery). The diaphanous light, the clear tones, the yellow and sky-blue and white colour scheme, if not the exaggerated types in this ancient drama of a procuress demanding her share of the money a man is offering a prostitute, must have appealed to Vermeer. Early in his career, he made a life-size painting of a procuress scene that shows a distinct debt to Baburen and other Dutch *Caravaggisti* [see 180].

Jan van Bijlert (1597/8–1671) returned to Utrecht, his native city, from Italy by 1624. He arrived as a confirmed Caravaggist relying heavily on the Italian master's strong chiaroscuro effects, but by the early thirties, like most Utrecht painters, he adopted a classical manner and a lighter palette. An example of his classicism is his *Madonna and Child* (c.1630/5, Braunschweig, Herzog Anton Ulrich-Museum) which is distinguished by its clarity and great swatches of drapery handled *al'antica* but it is almost airless.

Utrecht painters also popularized life-size, single half-length genre figures vividly appealing to the spectator. They are usually shown with a cheerful, open expression, and the illusionistic effect is heightened by the use of realistic flesh tones and careful attention to the texture of stuffs. A favourite trick was to represent a figure at a window or behind a balustrade with an outstrechted arm reaching towards the spectator. Honthorst's *Merry Violinist* of 1623 at Amsterdam

[22] is an exemplar of the type. It is hard to say who invented the motif but it is not difficult to see a relation between the musicians and drinkers painted by the Utrecht *Caravaggisti* and Caravaggio's early genre pictures of androgynous youths and of *bravi* in striped doublets and hats decorated with plumes. Caravaggio's Italian follower Bartolommeo Manfredi painted similar half-lengths and so did Louis Finson (also Finsonius), a Flemish Caravaggesque painter who moved to Amsterdam after working in Italy and France. Finson's posthumous 1617 inventory made in Amsterdam lists three Caravaggios in his possession; one can be securely identified as the Italian master's *Madonna of the Rosary*, the large altarpiece that Pieter Lastman probably studied carefully.[13]

The vogue for pictures of musicians and drinkers started in the early 1620s, when both Honthorst and ter Brugghen began to turn out many – perhaps too many – of them. Bloemaert's serious *Flute Player* of 1621 (Utrecht, Centraal Museum) is the earliest known dated work of this type. However, it is hardly likely that Bloemaert, who was never in Italy, invented the motif. Since Bloemaert's *Flute Player* shows the influence of Honthorst's nocturnal lighting, the assumption that the picture was inspired by a lost Honthorst is a reasonable one. In 1622 Baburen painted a half-length life-size *Singing Lute Player* (Utrecht, Centraal Museum), and in the following years other Utrecht painters followed suit. During the twenties pictures of this type had a direct influence on the genre paintings Hals did in Haarlem, but it is to ter Brugghen, not Honthorst, that Hals probably owes the biggest debt. It was from ter Brugghen that Hals could have learned what rich effects could be achieved by allowing

22. Gerrit van Honthorst: *Merry Violinist*, 1623. Amsterdam, Rijksmuseum

23. Jacob van Campen: *Diogenes with a Lantern in Athens Market*, 1628. Utrecht, Centraal Museum

brilliant daylight to play over his subject; as far as we know, Hals never painted a nocturnal scene.

None of Hals's half-length genre pictures datable to the twenties bears a firm date. However, one by the Haarlem artist Pieter de Grebber (*c.*1600–52/3) of a *Musical Trio* (private collection) is securely monogrammed and dated 1623. Its debt to Utrecht Caravaggism is unmistakable in the types, the gestures, and hidden artificial light source de Grebber used in his painting. It firmly establishes that the innovations made by the Utrecht *Caravaggisti* found their way to Haarlem as early as 1623. How did they get there so quickly? Perhaps Jacob van Campen (1595–1667) was the conduit.[14] Although van Campen's secure position in the history of Dutch art rests on his work as an architect – he introduced classical architecture to Holland and designed Amsterdam's new town hall [see 372], the most magnificent building done in the Netherlands in that style during the century – he was also a painter and his early activity as one is part of the story of painting in Utrecht.

Van Campen came from a wealthy Haarlem family and during the course of his career had close contact with leading Dutch lights: Stadholder Frederik Hendrik and his consort Amalia van Solms, Constantijn Huygens, Joost van den Vondel. He began as a painter apprenticed in Haarlem to Frans de Grebber (1572/3–1649), the father of Pieter mentioned above. In 1614 he joined Haarlem's Guild of St Luke. From about 1616 to 1620 he was in Italy where he had an opportunity to make contact with the Dutch *Caravaggisti* who were still in Rome. After his return to Haarlem he presumably was able to keep in touch with them, thanks to the large landed estate his family owned

near Amersfoort, about twenty kilometers from Utrecht. His close connection to Amersfoort would have enabled him to stay abreast of their innovative paintings, and as he commuted between Amersfoort and Haarlem, he could have kept his colleagues in Haarlem informed of the latest news from Utrecht. This hypothesis is supported by van Campen's own rare paintings of the twenties. They indicate that at the time he was an accomplished Caravaggist. His life-size *Diogenes with a Lantern in Athens Market* of 1628 [23] shows him in full control of the new style and technique of the Utrecht painters, particularly ter Brugghen and Baburen. Although Diogenes holds a lit lantern, in accord with the story, the scene is in daylight; Diogenes, who drove home his philosophic tenets with unorthodox actions and caustic wit, is depicted searching for people worthy of the name with a lantern in broad daylight. The conspicuous view of the cornice, entablature and corinthian capitals of a classical building in the background sets the episode in Athens and displays van Campen's knowledge of classical architecture at this early date as well as his desire to give the scene an archeologically correct setting, a rare note in Dutch painting at this time.

In 1626 van Campen inherited his family's large family estate near Amersfoort; his subsequent settlement there a few years later gave him closer contact with Utrecht. During the following years, among other projects, he helped the stadholder build his hunting lodge at Honselaarsdijk and palace at Rijswijk, designed the Mauritshuis at The Hague for Count Johan Maurits of Nassau-Siegen (1633), and a town house nearby for Huygens. In the late forties he began designs for his masterpiece, Amsterdam's new town hall.

During these years he also worked on another important commission: decoration of Huis ten Bosch near The Hague. Originally built as a summer retreat by Frederik Hendrik, it was transformed into a memorial to him by his consort Amalia van Solms after his death in 1647 [311]. In collaboration with Huygens, van Campen devised the elaborate iconographical programme for its large central hall, the Oranjezaal, and helped select and supervise the Dutch and Flemish artists with classicistic tendencies commissioned to paint its large fields of decorations. Van Campen himself contributed eight paintings to the Oranjezaal (see pp. 231–3).

By the 1630s the Utrecht Caravaggesque movement had spent its force. Some of its leaders had already disappeared from the scene – it will be recalled that Baburen died in 1624 and ter Brugghen in 1629. Honthorst, the doyen of the group, and other painters abandonned their earlier style for a classicizing one. The shift was not accompanied by the creative energy and inventiveness of their earlier efforts. The change, however, did not affect Honthorst's international reputation. He continued to be in demand as a court painter, and was popular as a teacher; amongst his pupils were the exiled Queen of Bohemia and her daughter. In 1628 he was invited by Charles I to England, where he painted the large canvas now at Hampton Court of *Mercury presenting the Liberal Arts to Apollo and Diana*, in which the King personates Apollo, his Queen is seen as Diana, and the Duke of Buckingham plays Mercury. Honthorst may have been on trial in London as court painter. Charles rewarded him handsomely, but did not keep him. The king did well to postpone the appointment. In 1632 he knighted Van Dyck and made him 'principalle Paynter in ordinary to their Majesties'.

After 1630 Honthorst was mainly active at The Hague and there are contemporary references to him as painter to Stadholder Frederik Hendrik, Prince of Orange. Although the title was never an official one, Honthorst made numerous smooth, conventional portraits of the prince and his consort Amalia van Solms [24] as well as other court personages, and his history paintings were well represented at the prince's residencies. About the time Honthorst made The Hague his base, Van Dyck visited Holland. Even though the northern and southern Netherlands were still at war, the Flemish master made the trip in 1631–2 (and he may have made an earlier one in 1628–9). He was warmly welcomed at the Dutch court where he painted companion pieces of Frederik Hendrik, showing him in armour with a baton as commander of the States-General armed forces, and of his consort; replicas were made of the pendants for distribution to other courts and friends. Additionally, the prince commissioned two paintings of literary themes from Van Dyck: *Amaryllis and Mirtillo* (Pommersfelden, Graf von Schonborn), an episode from Guarini's *Il Pastor Fido*, and *Rinaldo and Armida* (Paris, Louvre), a scene from Tasso's *Gerusalemme Liberata*; both works rank with the finest he painted in this genre. During his stay in Holland Van Dyck also painted splendid full-lengths of the King and Queen of Bohemia's two sons (Vienna, Kunsthistoriches Museum), a portrait of Huygens (now untraceable), and made portrait drawings of a number of Dutch artists which were subsequently used for

24. Gerrit van Honthorst: *Prince Frederik Hendrik and Amalia van Solms*, c.1637–8. The Hague, Mauritshuis

his series of prints knows as *The Iconography*. There probably is some truth to the report that Frederik Hendrik tried to convince Van Dyck to become his court painter, and there can be no question of the prince's passion for his works; the 1632 inventory of his collection lists eight of his paintings. Did the formidable competition the Flemish artist offered make Honthorst breathe a sigh of relief when he learned in spring 1632 that Van Dyck had decided to leave the Netherlands for work at England's court?[15]

The most important international commission Honthorst received during his final decades came from King Christian IV of Denmark; in 1635 he sent him the first of a large series of historical pictures. At home he received a choice assignment in the late forties when Huygens and Jacob van Campen, acting on behalf of widowed Amalia van Solms, selected him as one of the artists commissioned to paint large-scale decorations for the Oranjezaal at Huis ten Bosch. According to gossip relayed by Huygens in a letter to Amalia most of the artists working on the project believe him to be a less great artist than themselves, no matter what a *grand seigneur* he may have been.[16]

Long before the importance of the Utrecht School began to wane outside of court circles Dutch art flourished with a more independent character at Haarlem. Its first great manifestation is in the works of Frans Hals, whose vital personality seems to reflect the vigour, the joy of life, and the prosperity of the Dutch after they won the prospect of peace by the conclusion of the Twelve Year Truce with Spain. It is to his art that we turn in the following chapter.

Frans Hals

EARLY WORKS 1610–1620

Frans Hals, second only to Rembrandt in making seventeenth-century Dutch painting famous, was probably born in Antwerp between 1582 and 1583, the son of Franchois Hals, a cloth-dresser from Mechelen, and Adriana van Geertenryck of Antwerp. His parents, like thousands of other Flemings, immigrated from Flanders to the northern Netherlands within a year after Antwerp fell to the Spanish in August 1585.[1] The earliest reference to Hals's parents in Haarlem, where the family settled, is of 1591, when the baptism of Frans's brother Dirck is recorded. Dirck made a name for himself as a painter of small genre pictures of figures in landscapes and interiors. Joost, a third brother, who was presumably born in Antwerp, was also a painter (d. before 16 October 1626); none of his works have been identified. Frans studied under Karel van Mander. A probable date for the contact between teacher and pupil is before 1603, when van Mander retired from Haarlem to a house near by, where he wrote most of his *Schilderboek*; he died three years later. As far as we can tell, he did not have much influence on his most famous pupil. Frans certainly did not follow the advice given to young artists by his teacher in *Het Schilderboek* to distinguish themselves by becoming history painters.

In 1610 Hals was enrolled as a master painter in Haarlem's Guild of St Luke, and about the same time he married Anneke Harmensdr, his first wife. Among his earliest works is a lost portrait most probably done in 1611 of *Jacobus Zaffius*, archdeacon of St Bavo, the principal church of Haarlem, a Catholic who struggled in vain to preserve Catholicism in the diocese of Haarlem. The lost original, which showed Zaffius three-quarter length, seated at a table with his hand resting on a skull, the most commonplace symbol of the transitory nature of man's life, is known from an engraving (in reverse) by Jan van de Velde II [25]. The print bears a Latin inscription that spells out the principal function of the portrait, and indeed of most formal portraits from the time they began to be painted in the early Renaissance until our own day. It was made as a memorial to posterity:

> Why is the likeness of Zaffius entrusted to fragile paper?
> So that the Man may outlive his ashes . . .

The bust of Zaffius, dated 1611, at Haarlem [26], long accepted as a fragment of the three-quarter length, may be a copy closely based on the lost original.[2]

What did Hals paint before we recognize his hand? Students of Dutch art, who have assiduously searched for Hals's juvenilia and works of his early maturity, have found nothing. What the artist, who seems to have been a master of the brush while he was still in his mother's womb, did before he was about twenty-eight or twenty-nine years old remains an unsolved riddle. Perhaps Hals spent his early years travelling, or perhaps we must accept the notion that he was a slow starter. When Hals's hand is finally identifiable in his portraits, a debt to late-sixteenth-century Dutch portraitists (Pieter Pietersz, Cornelis Ketel) is evident in the roundness, the rigid poses, and the sharp delineation of his figures. The pasty pink and rose colours of the flesh in Haarlem's version of the Zaffius portrait recall hues used by the Haarlem Mannerists, but the archdeacon's keen glance, the daylight which is cast on his face, and the parallel brush strokes, which were soon to operate in combination with zigzag touches, are some indications of Hals's immediate future.

It is arguable that another lost painting, the so-called *Banquet in a Park*, which is probably a scene from the life of the Prodigal Son, datable about 1610 (formerly Berlin, Kaiser-Friedrich Museum, no. 1611, destroyed in the Second World War) [157], was one of Hals's earliest known works. If it was really painted by Hals – and it is difficult to name another Dutch artist who used such juicy paint and fluent brushwork around this time – it suggests that at this stage of his career Hals painted pictures related to van Mander's genre scenes (*The Kermis*, St Petersburg, Hermitage) [9] and late religious paintings (*Dance round the Golden Calf*, 1602, Haarlem, Frans Hals Museum), as well as pictures of the Prodigal Son by David Vinckboons.[3] In our discussion of genre painting we shall see that Willem Buytewech, Esaias van de Velde, and Dirck Hals soon developed outdoor banqueting scenes into a special category, but as far as we know Hals never painted another picture of small figures in a landscape. His *métier* was portrait painting, and during the rest of his long career all his genre pictures, and even his rare biblical pictures, keep a portrait character. The crowded, life-size *Shrovetide Revellers* (New York, Metropolitan Museum) [27], painted about 1615, shows the direction his genre painting was to take.

In Hals's hands genre painting became a kind of portraiture, but of a freer, bolder, and more revealing character than that of the commissioned portraits of his day. In these works he was independent of the conventions of formal portraiture. No painter before Hals had ever approached simple folk with the same sympathetic feeling and love for an unadulterated expression of the joy of life. Hals's genius was to introduce the vitality and spontaneity perfected in his genre pictures into his commissioned portraits. Pieter Bruegel the Elder is often called the originator of merry and low life genre in Flemish and Dutch painting. As we have noted, Hals's teacher van Mander formed a link between the Late Renaissance and the Baroque masters; but van Mander's rare genre paintings are closer to Bruegel's than to Hals's. Bruegel is still far from the kind of immediate expression of instantaneous life found in Hals's work. His approach to human beings continues an intellectual detachment which was typical of the Late Renaissance and resulted in more abstract forms and stylization. There are, of course, additional intermediary stages between the genre painting of Bruegel and that of Hals. However, the fact remains that it

26. Frans Hals (attributed to): *Jacobus Zaffius*, 1611. Haarlem, Frans Hals Museum

27. Frans Hals: *Shrovetide Revellers*, c.1615. New York, Metropolitan Museum of Art, Altman Bequest

25. Jan van de Velde II: engraving after Frans Hals's *Jacobus Zaffius*, 1630

was Hals who first gave an explosive vitality to genre subjects and that he expressed them in the most sympathetic spirit.

The merrymakers in the New York painting [27] are not ordinary revellers. We know from an inscription on a contemporary copy of it that the group is celebrating Shrovetide, and among them are some stock characters from theatrical companies of the period. The stout man on the left is Peeckelhaering, a comic type; the man on the right can be identified as Hans Worst, a well-known figure in the farces of the period, whose character resembles Brighella of the *Commedia dell'arte*. The composition is cramped, there is an over-exuberance of details, the colours are loud, and the fat painting in the ruddy faces is still far from the master's later lightness of touch. Yet the essence of his vigour and vitality is already in the work.

As the *Portrait of Catherina Hooft and her Nurse*[4] (c.1619–20, Berlin, Staatliche Museen) [28] shows, in his early commissioned portraits Hals adhered more closely to the old technique and to accepted conventions than in his genre works. During the first decades of his career he continued to follow the ancient idea of adjusting his style to his subject.

Only after 1640, when he virtually stopped painting genre pictures, did he begin to use the technique once reserved for genre pieces for commissioned portraits of respectable burghers and their families. Of course it is appropriate that the gestures and expressions of the nurse and elegantly dressed Catherina are more refined than those used by a boisterous group celebrating carnival. The double portrait is an excellent early example of Hals's subtle invention. The nurse, it seems, was about to present an apple to the young child when both were diverted by the approach of a spectator, to whom they appear to turn spontaneously, one of the many ingenious devices used by Hals to give the impression of a moment of life in his pictures. The colour scheme still shows the dark tonality characteristic of his early commissioned portraits, and the minute execution of the child's richly embroidered costume is set off by a delightful vivacity in the brushwork on the faces and hands. In 1635 Catherina became the teenage bride of extremely wealthy Cornelis de Graeff who later served repeatedly as burgomaster of Amsterdam and became the city's guiding political force as well as adviser and confidant of Johan de Witt, Holland's leading statesman after the middle of the century.

In 1616 Hals painted the first monumental landmark of the great age of Dutch painting: the *Banquet of the Officers in the St George Civic Guard of Haarlem* [29]. The entire work exults in the healthy optimism and strength of the men who helped to build the new republic. There is no precedent for Hals's vivid characterisation of his twelve models, or for the impression of immediacy he achieved in his group portrait. Hals had the advantage of knowing the character of these officers who served from 1612 to 1615; he was a member of the company from 1612 until 1624. He seems to have arranged the officers casually around the festive board. But this is not the case. The places they occupy are in strict

28. Frans Hals: *Catherina Hooft and her Nurse*, c.1619–20. Berlin, Staatliche Museen
29. Frans Hals: *Banquet of the Officers of the St George Civic Guard Company of Haarlem*, 1616. Haarlem, Frans Hals Museum

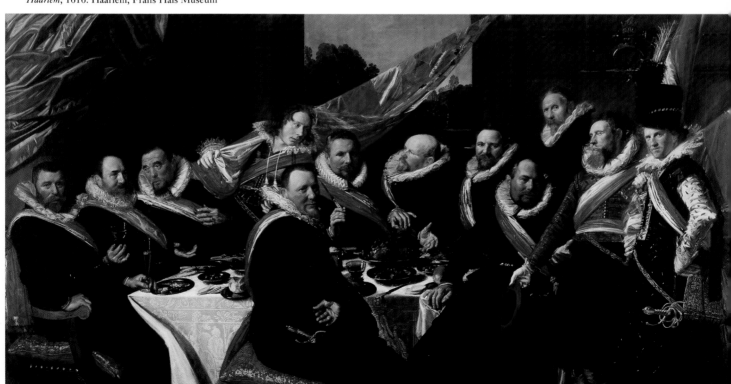

accord with military protocol. The colonel, the company's highest ranking officer, is seated at the head of the table; at his right is the provost, the second ranking officer. They are flanked by the company's three captains and the three lieutenants are at the lower end of the table. The three ensigns, who were not members of the officer corps, and the servant stand. Hals's other group portraits of officers at banquet tables, which look equally informal, follow a similar hierarchical arrangement [see 42].

Militia and civic guard groups, originally organized as guilds under the patronage of a saint, had a long history in the Netherlands. Even during the Middle Ages Dutch burghers maintained a certain degree of independence, and in order to help protect their towns against attack or civic commotion they formed guard companies. The Dutch word *doel* (plural: *doelen*), which is the generic name for companies of guards, as well as for the buildings that serve as their headquarters, is also the Dutch word for target. Early in the sixteenth century the companies began to decorate their buildings with group portraits of their members.[5] Portraying these groups was not an easy task for the artists. Fundamentally there are two ways of approaching the problem. One way is to give equal prominence to every individual, and thus achieve little more than a monotonous row of separate portraits. The other is to subordinate the individuals to a common action, and thus achieve unity for the composition. Between these two extreme possibilities one might expect others in which the artist tries to combine the emphasis on individual likenesses with a structural unity of the whole; but Dutch artists rarely achieved a really satisfactory combination of the two points of view. Their emphasis is always on the side of individual likenesses, perhaps the special appreciation of the Dutch for the worth of every single person made it difficult for artists to subordinate the representation of an individual for the sake of artistic unity. In any event, only one Dutch artist decided to avoid all compromise and offered the radical solution of subordinating a group of guards to a unifying dramatic action. This artist, as we shall see, was Rembrandt and the picture is the *Night Watch*.

The significance of Hals's achievement in his group portrait of 1616 is better understood if we have some idea of what was done in this category by his predecessors. The so-called *Banquet of the Copper Coin (Braspenningmaaltijd)* [30] of 1533 by Cornelis Anthonisz is the earliest example of a group portrait of guardsmen seated round a banquet table. It shows a rather primitive juxtaposition of single portraits. The stiff somewhat geometrical composition is characteristic of the early group pictures, and so is the bird's-eye view of the table. The arrangement is simple. Fifteen of the seventeen guardsmen have been lined up in two rows, with only a weak attempt to bind them together. Some of the men are looking towards the spectator, some of them elsewhere. This variety of movement slightly relieves the monotony of the setting, but it endangers the unity. The relief-like arrangement in planes parallel to the surface is characteristic of the Renaissance style. So is the accentuation of the straight horizontal and vertical directions, both giving a certain architectural firmness to the composition. After the middle of the sixteenth century painters of group portraits

adopt a freer arrangement within a more natural space construction. This is seen in Dirck Barendsz's group portrait of the banquet of an Amsterdam civic guard done in 1566 called the *Perch Eaters (Poseters)* [31]. Here the primitive view of the table from above is abandoned, and some natural loosening within the group has taken place. Smaller nuclei are formed, and foreground is better distinguished from the background. The turning of men, seated in front of the table, towards the spectator increases the illusion of space. In Barendsz's work the progress towards a more convincing realism is remarkable, but a satisfactory unity among the figures is still lacking.

A new solution to the problem was offered in 1583 by Cornelis van Haarlem in his group portrait of the men at a banquet who belonged to the squad of Corporal Jonge Jan Andriaensz van Veen of the Haarlem Militia [32]. The predilection for movement and the broken rhythm of irregularly formed groups interwoven in a curious way are all characteristic of Dutch Late Mannerism. Following the dynamic tendencies of this style Cornelis creates a rather extravagant variety of movement throughout the picture, but achieves little cohesion. The arrangement around the table can hardly be recognized. Only by the prominent figure of the standard bearer, who is joining the group from the foreground, does the composition gain something of a centre, and the diagonal line of his banner lends the composition a certain asymmetrical order. Cornelis has not abandoned the aims of distinct clearness of every single portrait. What he actually achieves is the remarkable impression of a crowd without any clear, satisfactory interconnection. Van Mander tells us that in this group portrait some of Cornelis's patrons had themselves portrayed as merchants; in their nascent rising economy some guards obviously combined business with pleasure. A proclamation inscribed above the chimney-breast in the great assembly hall of Haarlem's St Hadrian Militia Company indicates that the sensible men knew that in the sober light of day a merchant could have second thoughts about a deal made at a banquet where wine and beer were consumed by the barrel. It states: 'No commerce conducted in this hall can be held so binding that he who rues it may not revoke the agreement on the following day by paying for the wine'.[6]

We have already noted that Cornelis abandoned his Mannerist style during the 1590s for a mild kind of classicism. His group portrait of the *Banquet of the Officers of the St George Civic Guard* (1599, Haarlem, Frans Hals Museum) [33] is an attempt to introduce this classicism into the portraiture of a group. It is composed in a completely different way, and as a result there is a gain in clarity and order. Cornelis abandoned the old tradition of lining up the guardsmen in rows, in favour of a distinctly pyramid-like composition. There is less overlapping and movement. The handshaking, drinking, and peering into mugs of his group of 1583 have been eliminated. Calmness has taken the place of riotous confusion. But the similarity of the poses and lack of differentiation of the officers' physiognomies produces a wearisome effect. During this phase Cornelis attempted to ennoble a model as well as make a likeness. He did this by generalizing the features of his patrons. This led to a kind of standardization of faces. Cornelis gives us the impression

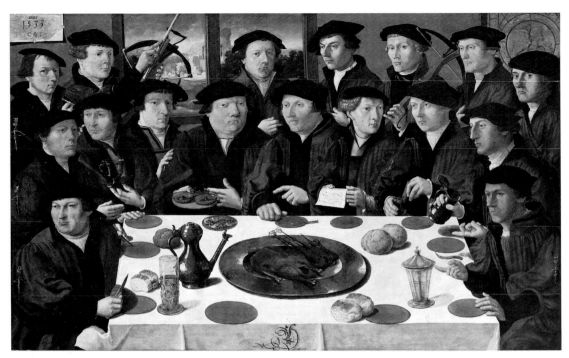

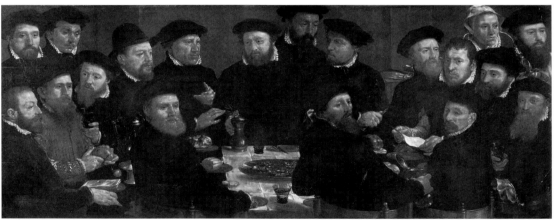

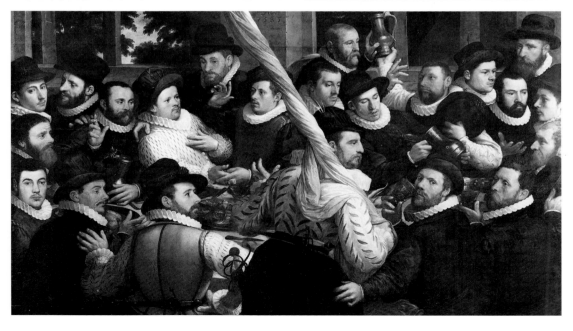

30. Cornelis Anthonisz: *Banquet of Members of Amsterdam's Crossbow Civic Guard, known as the 'Banquet of the Copper Coin'*, 1533. Amsterdam Historical Museum, on loan from the City of Amsterdam

31. Dirck Barendsz: *Banquet of Members of Amsterdam's Calivermen's Civic Guard (Kloveniers), known as 'The Perch Eaters'*, 1566. Amsterdam, Rijksmuseum, on loan from the City of Amsterdam

32. Cornelis van Haarlem: *Banquet of the Squad of Corporal Jonge Jan Andriaensz van Veen of the Haarlem Militia*, 1583. Haarlem, Frans Hals Museum

33. Cornelis van Haarlem: *Banquet of the Officers of the St George Civic Guard*, 1599. Haarlem, Frans Hals Museum

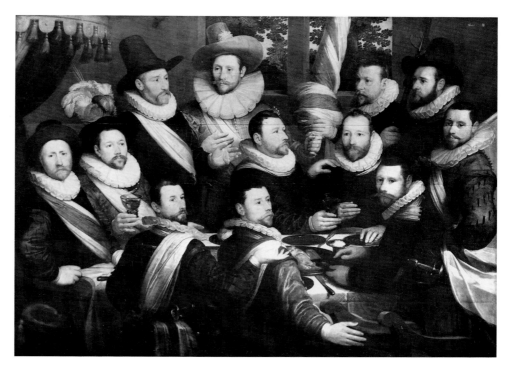

that the members of a large family took over the entire officer corps of the St George Company in 1599.

Rudiments of Hals's great composition of 1616 are found in Cornelis's group of 1599. It is striking how similar the two compositions are if, in our mind's eye, we delete the officer in the left foreground of Cornelis's picture. In both works four officers have been posed on the left, three standing men have been placed on the right, and a group has been constructed of the men seated in front of the table and behind it. The man painted out of Cornelis's picture in our imagination appears to have found a place in the group seated in the middle of Hals's painting. The similarities between the two compositions are proof of the close ties that even the boldest innovator has with the art of the past. The relationship does not diminish Hals's achievement; on the contrary, it shows what a spectacular transformation Hals made of an established tradition. Hals kept the symmetrical arrangement of Cornelis's composition, but in his masterwork, for the first time in the long history of Dutch group portraiture, Renaissance co-ordination of individual parts gives way to Baroque integration. Cornelis's composition contains prominent pairs of officers who retain their independence. They are not united into the group. Hals, on the other hand, by the use of great sweeping diagonals and by subtly arranging the heads of most of his patrons on the same level achieves a new kind of unity. Even his most animated groups have been subordinated to the whole. Hals has significantly enlivened the rigid compositions of his predecessors by various devices, particularly by the great diagonal formed by the flag which the young ensign holds upon his shoulder, the group of standing men on the right which repeats the dominant slanting accent, and also by the men sitting in front of the table. By these means he has also enhanced the illusion of space. His patrons have been given more elbow room than earlier sitters for Dutch painters enjoyed. The strong sculptural accents which model the heads still retain a good deal of the

sixteenth-century style, and the technique of painting has not yet reached the freedom Hals was to achieve in the following decade; however, in various parts – particularly the faces, the hands, the ruffs, and the still life on the banquet table – Hals's detached brushwork begins to manifest itself. Among the colours a dark, warm harmony, somewhat reminiscent of Venetian painting, of black, red, yellow, and white prevails.

Little is known about the character and personality of the artist who painted the first monumental masterpiece of seventeenth-century Dutch painting. He did not leave a single note or sketch[7] to give us an idea of his private thoughts or impressions of his milieu. This portraitist *par excellence* left only two self-portraits. An undisputed one appears in his large group portrait of nineteen *Officers and Sergeants of the St George Civic Guard* of c.1639 (Haarlem, Frans Hals Museum); the artist appears inconspicuously in the rear. There is also reason to believe that he made a small self-portrait in the late forties. This work is known today in a number of versions and variants by different hands; the best is now in the collection of the Clowes Fund, Indianapolis, Indiana.[8] Neither of these self-portraits shows the man romantic biographers like to consider a kind of swashbuckling Cyrano de Bergerac of the brush. Attempts have been made to determine his way of life by identifying him with the jolly topers he painted. The method is not foolproof. To be sure, the earliest known reference to Hals's conduct, a note written by the German painter Matthias Scheitz (c.1630–c.1700) in his copy of *Het Schilderboek*, states that Hals in his youth was 'wat lüstich van leven' (somewhat lusty).[9] Scheitz almost certainly received his information from his teacher, Philips Wouwerman, who was probably Hals's pupil. In 1718 Houbraken wrote that it was Hals's 'custom to fill himself to the gills every evening'. There is no documentary evidence that supports his assertion; Scheitz's brief comment does not corroborate it. Nevertheless, subsequent

biographers embroidered the theme and by the end of the nineteenth century Hals was accused of being a wife-beater as well as a chronic alcoholic. It is true that a Frans Hals was summoned before the burgomasters of Haarlem in 1616 for drunkenness and beating his wife, but the authorities admonished a Frans Cornelisz Hals, a weaver, not Frans Fransz Hals the painter.[10] Moreover, Hals was a widower in 1616 and did not have a wife to beat. His first wife, Anneke Harmensdr, died in June 1615, and he was left with two children. He did not marry again until 1617. He has been maligned because of a mistaken identification.

Hals seems to have held a respectable place in his community. His membership in the St George Civic Guard was a sign of some prestige. From 1616 to 1624 he was connected with the Haarlem rhetoricians' chamber *De Wijngaardranken* (The Vine Tendrils) as a 'friend' (not an 'active member'). In 1629 the city of Haarlem paid him for restoring paintings from the Commandery of the Knights of St John which had passed to the city after the order's secularization (did he work on pictures painted by Geertgen tot Sint Jans?) He was made warden of Haarlem's Guild of St Luke only once (1644) and during more than fifty years in the guild he never served in the higher position of dean. Other artists of the city held these posts repeatedly; perhaps Hals made a life-long effort to avoid boring administrative work and ceremonial obligations. Of one thing there can be no doubt: from the beginning to the end of his long career he had a distinguished clientele. Between 1616 and about 1664 he painted nine official large life-size group portraits. No other leading artist of the period did as many. He made numerous portraits of Haarlem's burgomasters and aldermen – he was, in effect, portraitist-in-residence to the families of the city's oligarchy. He also had many identifiable patrons whose status was a cut or two below Haarlem's elite: traders (some of whom ventured as far as Russia, Africa and India), clergymen, artists, professors, historians, and calligraphers.

Yet it should be noted that Hals's existing *œuvre* is not large. In our view only about 225 of his paintings are known.[11] We have heard that not a single uncontested drawing can be attributed to him, and to our knowledge he never made engravings or etchings. By any standard his *œuvre* is not a tremendous one, and if one considers that it is the production of a man who was active as an artist for more than half a century and must have painted as easily as he breathed, its size is mysteriously small. How can we account for this? The best hypothesis is that a high percentage of his portraits have been lost. Not long after they were painted many of them were conceivably exiled to storage rooms, or suffered a worse fate, because their sitters' jet-black costumes clashed with the pinks, baby blues and white of rococo interiors, or because they became only vaguely recognizable as merely another portrait of a great-uncle on the mother's side. They began to be highly treasured only around the middle of the nineteenth century. Perhaps by that time many had disappeared. As for the absent drawings: probably he never made many. No doubt he belonged to the group of artists who have the skill and courage to attack a canvas without a preparatory drawing in hand. Moreover, preliminary and preparatory portrait drawings are relatively rare in seventeenth-century Dutch art. It seems to have been studio practice to work without them. Nevertheless, it seems inconceivable that during the course of more than fifty years of activity as an artist he never made a portrait drawing, that no client ever asked for a drawing that would give an idea of a finished work, or that he did not make preliminary sketches to help resolve the pictorial complexities of his large civic guard banquet pieces which are as intricate in composition and spatial arrangement as those made by Baroque masters who have left us a corpus of preparatory drawings. The dream that one day a chest will be found in a Dutch attic that contains Hals's missing drawings is as difficult to abandon as the notion that he never made a single sketch. On the other hand, that he apparently never made prints is not a mystery. Not every artist is inclined to work with an engraver's burin or an etcher's needle.

In spite of the important portrait commissions Hals received, he was repeatedly in financial difficulties. Even during the 1630s, when he seems to have had as much work as he could handle, he was sued by his butcher, baker, and shoemaker. There can be no question that he was not sufficiently rewarded or esteemed during his lifetime, but apparently the situation was not helped by the fact that, like many of us, he was not very good at managing his personal financial affairs. The lengthy list of petty claims against him begins in 1616, the year he completed his first guard piece. In that year he was sued for not paying for the board of his two motherless children. He was not present to answer the complaint; it was said that he was in Antwerp. He was there from August until November – long enough to see what was happening in Rubens's studio. This is the only record that Hals ever left Holland. One of the children boarded in 1616 was Hals's son Harmen (1611–69), who became a painter. In 1617 Hals married Lysbeth Reyniersdr who presented him with a daughter nine days after their marriage. His second wife, who was illiterate, was a vigorous woman. She was still alive in 1675, aged eighty-two, thereby outliving many of her children and Frans by at least nine years. The names of eleven children of the second marriage are known. Four became painters: Frans Hals II (1618–before November 1677), Jan (Johannes) Hals, alias 'the Golden Ass' (*den Gulden Ezel*) (c.1620–before 11 November 1654), Reynier Hals (1627–72), and Nicolaes (Claes) Hals (1628–86). A couple of Jan's portraits appear close to his father's until they are juxtaposed to them.[12] Adriaentje, a daughter of the second marriage, married Pieter van Roestraten, a genre and still-life painter. Roestraten and Vincent van der Vinne, a Haarlem painter best known for his still lifes, are his only documented students; not a trace of their contact with him is evident in their works. His brother Dirck and his five sons who became painters probably learned their craft from him too. From the little that is known of his sons' output he could not have derived much pleasure from their efforts. In 1661 Cornelis de Bie wrote in his *Gulden Cabinet*, a compilation of artists' lives, that Philips Wouwerman was Hals's pupil. Without his word no one would think that this specialist of equestrian themes set in landscapes started as

Detail of fig. 29, *Banquet of the Officers of the St George Civic Guard Company of Haarlem*

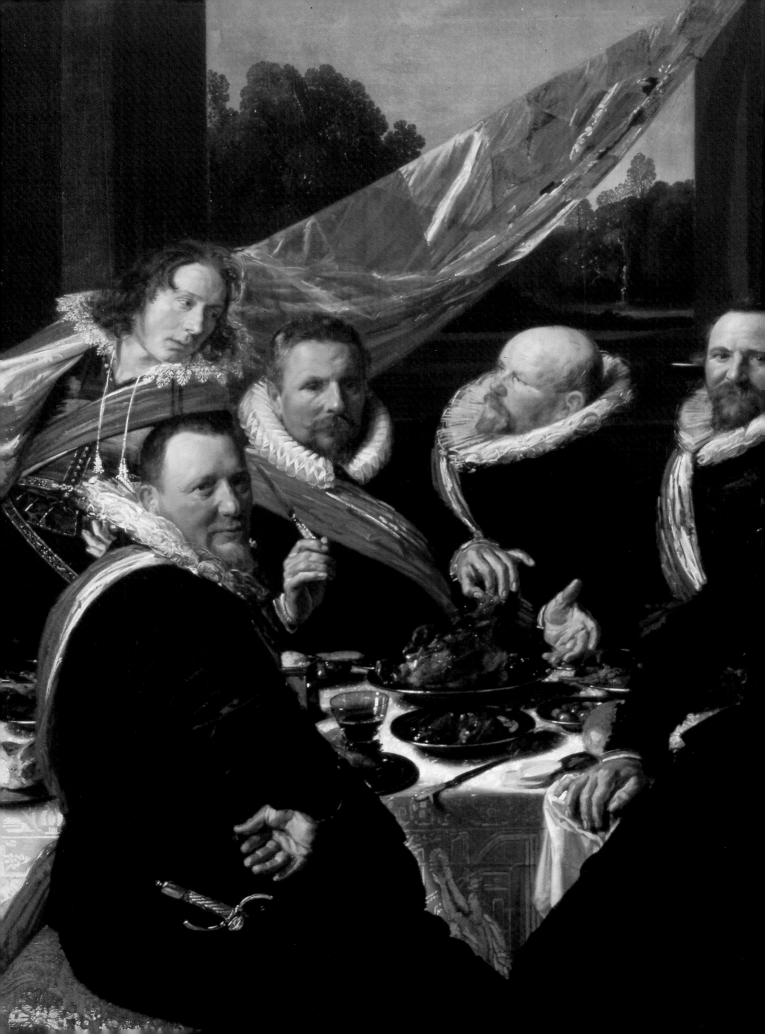

35. Title page of W.D. Hooft, *Heden-daeghsche verlooren soon* (*Contemporary Prodigal Son*). Amsterdam, 1630

34. Frans Hals: *So-called Yonker Ramp and his Sweetheart (The Prodigal Son?)*, 1623. New York, Metropolitan Museum of Art, Altman Bequest

Hals's apprentice. De Bie was well informed. He not only states that at the time he wrote old Hals is still alive in Haarlem but gives a vivid description of his brushwork: 'Hals . . . is a marvel at painting portraits or counterfeits which appear very rough and bold, nimbly touched and well composed, pleasing and ingenious, and when seen at a distance seem to lack nothing but life itself'.[13] His characterization, which indicates firsthand knowledge of the artist's work, is one of the rare statements by a contemporary about the master's paintings.

In 1718, more than a half-century after Hals's death, Houbraken adds Dirck van Delen, Adriaen van Ostade, and Adriaen Brouwer to his list of pupils. It has been shown there is little reason to believe that Brouwer was his student (see p. 133), and if van Delen and van Ostade were apprenticed to him, they reveal as little trace of their master's style as Roestraten, van de Vinne, and Wouwerman do. Unlike Rembrandt, it seems that Hals was the kind of teacher who encouraged his students to go their own way quickly. His impact was greatest upon artists who are not

documented as his pupils: Judith Leyster and, for a brief period, her husband Jan Miense Molenaer.

WORKS BETWEEN 1620 AND 1640

During the 1620s, Hals perfected the rendering of vitality and spontaneity which characterize both his genre pictures and portraits. The so-called *Yonker Ramp and his Sweetheart* (1623, New York, Metropolitan Museum) [34] is an outstanding early example of this new phase. The title was given to the picture late in the eighteenth century on the erroneous assumption that the lively model is one of the ensigns in the *Banquet of the St Hadrian Civic Guard Company* of *c*.1627 (Haarlem, Frans Hals Museum) [42]. The painting is not a commissioned double portrait and probably not a genre scene *pur* but a representation of the Prodigal Son, in a contemporary setting, wasting his substance in a tavern with a loose woman. There was a hardy tradition in Netherlandish art for depicting the Prodigal Son in a public house or brothel with many companions. Hals probably modified it

36. Frans Hals: *The Laughing Cavalier*, 1624.
London, Wallace Collection

here by extracting the protagonist and one of his girlfriends from earlier crowded scenes for his interpretation of the subject. A raised glass was frequently used to identify the fashionably dressed Prodigal; the innkeeper in the background indicates the couple is not at home, but in a tavern. The dog is no stranger in this context either; dogs were multivalent symbols used to allude to unchastity, gluttony, as well as smell and fidelity. An engraving from the title page of a play published in Amsterdam in 1630 by Willem Dircksz Hooft called the *Contemporary Prodigal Son* (*Heden-daeghsche verlooren soon*) [35] shows the modern prodigal with his glass held high in a similar setting – a dog appears here too – indicates that some of Hals's contemporaries would have had no difficulty recognizing that the Metropolitan Museum's painting as a scene from the Parable. Hooft's play was moralistic in intent, and if Hals's painting was meant to illustrate the episode from Scripture it was too. But it is doubtful whether a painting which so convincingly shows the pleasure of wine and women would ever effectively reform a confirmed or potential prodigal.[14] About a decade later

Rembrandt painted a self-portrait with Saskia on his lap [72] which, as I. Bergström has indicated, can also be related to the engraving in Hooft's *Contemporary Prodigal Son* and helps support the view that in it Rembrandt represented himself as the Prodigal Son.

The colour scheme in the so-called *Yonker Ramp* is much cooler than in the *Shrovetide Revellers* [27], where red and yellow predominate. Here the leather jerkin and large hat show fine grey tints, accompanied by a bright silvery blue in the sleeves and in the feather on the hat. Rembrandt's corresponding picture also strives for a momentary expression and for a vivid, most immediate appeal to the spectator. But in this respect Rembrandt's painting does not have the same striking effect as Hals's composition, with its bold diagonal arrangement. Rembrandt's gaiety is somewhat forced, instantaneousness does not really dominate, and Saskia appears curiously uncomfortable and out of proportion. Also in this Rembrandt of the mid-thirties the technique still lacks breadth and fluidity, the composition is too involved, and the figures are a bit overburdened with rich

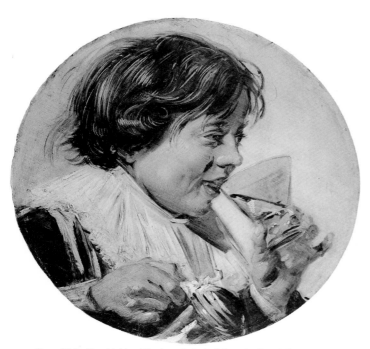

37. Frans Hals: *Boy drinking (Taste)*, c.1626–8. Schwerin, Staatliches Museum

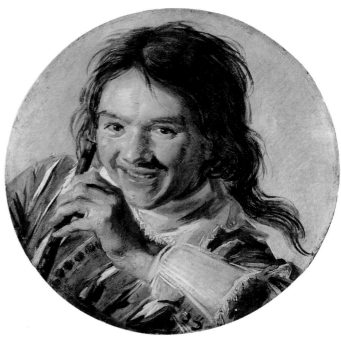

38. Frans Hals: *Boy with a Flute (Hearing)*, c.1626–8. Schwerin, Staatliches Museum

attire. It is only when Hals is compared with the mature Rembrandt that the Haarlem master loses somewhat in weight and significance.

The *Laughing Cavalier* (1624, London, Wallace Collection) [36], one of the most brilliant of all Baroque portraits, shows how successfully Hals conveyed a sense of immediacy in his commissioned portraits of the twenties. The handsome model's smile is a momentary one, the vivid characterization is indelible. The colours are brilliant: the embroidery on the gallant's black jerkin is orange, red, and yellow, white lace sparkles at his wrist and huge collar, and the splendid Baroque silhouette culminates with bravura in the outline of the black hat. The portrait is not handled as freely as *Yonker Ramp*. It was probably the patron's wish to have the embroidery, which has an emblematic character, meticulously rendered. Lovers knots, bees that sting like Cupid's arrows, and Mercury's symbols are readily recognizable, but in some passages – particularly on the cuff – Hals allowed his brush great freedom.[15] The spatial arrangement is a daring one; the figure moves in and out with courageous foreshortening. The light-grey background behind the sitter and the silver tonality indicate that Hals probably had been impressed by the innovations of ter Brugghen.

Hals's debt to the Utrecht Caravaggists is equally evident in his life-size genre pictures of musicians, drinkers, actors, and children of the 1620s and early 1630s. But there are some significant differences. Hals was never fascinated by the experiments the Caravaggesque painters conducted with dramatic chiaroscuro effects produced by artificial light. The instantaneous expressions of his subjects never freeze into grimaces, and even when his models are dressed in costumes (*Lute Player*, Paris, Louvre), he never creates the impression that they are posing in a studio: he always convinces us that we are watching a fleeting moment of life. Superior

examples of his studies of children are the *Boy holding a Flute* and the *Boy drinking* (c.1626/8, Schwerin, Staatliches Museum) [37, 38]. They were intended as personifications of Hearing and Taste, respectively, subjects taken from the allegorical theme of the Five Senses which was still a favourite in Hals's time when a few artists continued the earlier tradition of presenting each of the senses as an idealized figure accompanied by traditional attributes but most depicted the theme as scenes of daily life that allude to the senses.

Although there is no proof, one likes to imagine that the models for the Schwerin tondos were Hals's own children. These fresh, informal sketches, which are highly animated by silvery daylight and are most fluid in painterly treatment, should be consulted before making attributions of pictures of laughing children to Frans Hals; too many old copies and some modern forgeries in this category have been attributed to the master. Pictures by Hals's followers and imitators lack the sparkling accents which he added after the broader tonal relationships have been established for the expression of form. According to Houbraken's report Hals himself said he applied his brushstrokes after he laid in a painting 'to give it the master's touch'. Every square inch of the Schwerin tondos is alive, and although the movement is complex and the composition condensed on a small surface, the planes are clearly distinguished, forms retain their full three-dimensionality, surfaces are of a convincing texture, and expressions have an unmatched vivacity. The fluid treatment is consistent, and the swift brushstrokes add to the pictorial life of forms and textures.

The *Merry Drinker* (Amsterdam, Rijksmuseum) [39] of c.1628–30 is painted in a bright, blond tonality which anticipates nineteenth-century Impressionism in its most brilliant manifestations. Manet must have been particularly impressed by this painting. The picture also shows Hals's

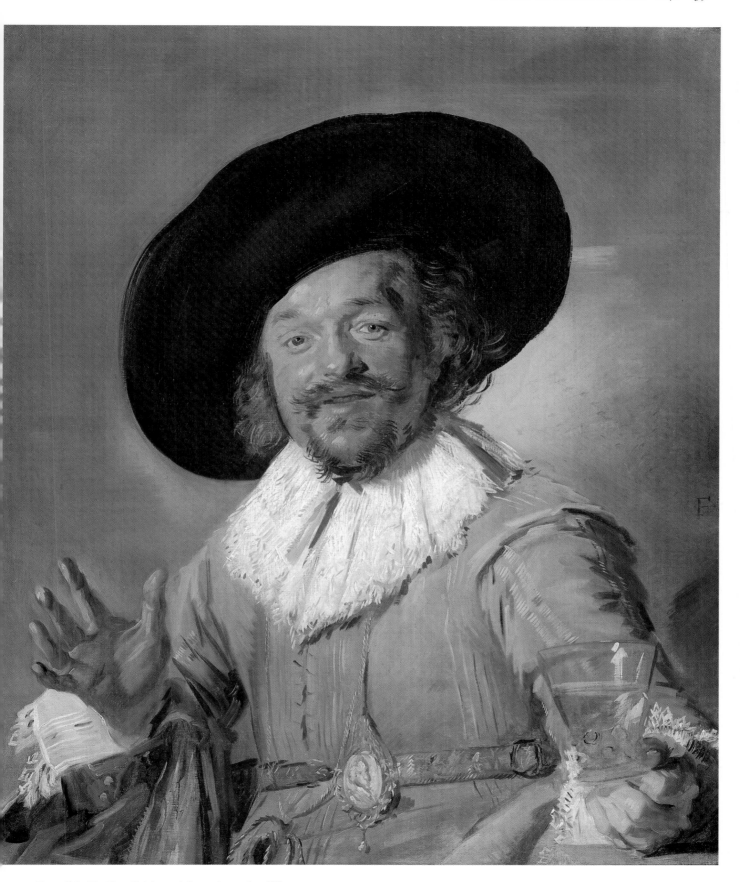

39. Frans Hals: *The Merry Drinker*, c.1628–30. Amsterdam, Rijksmuseum

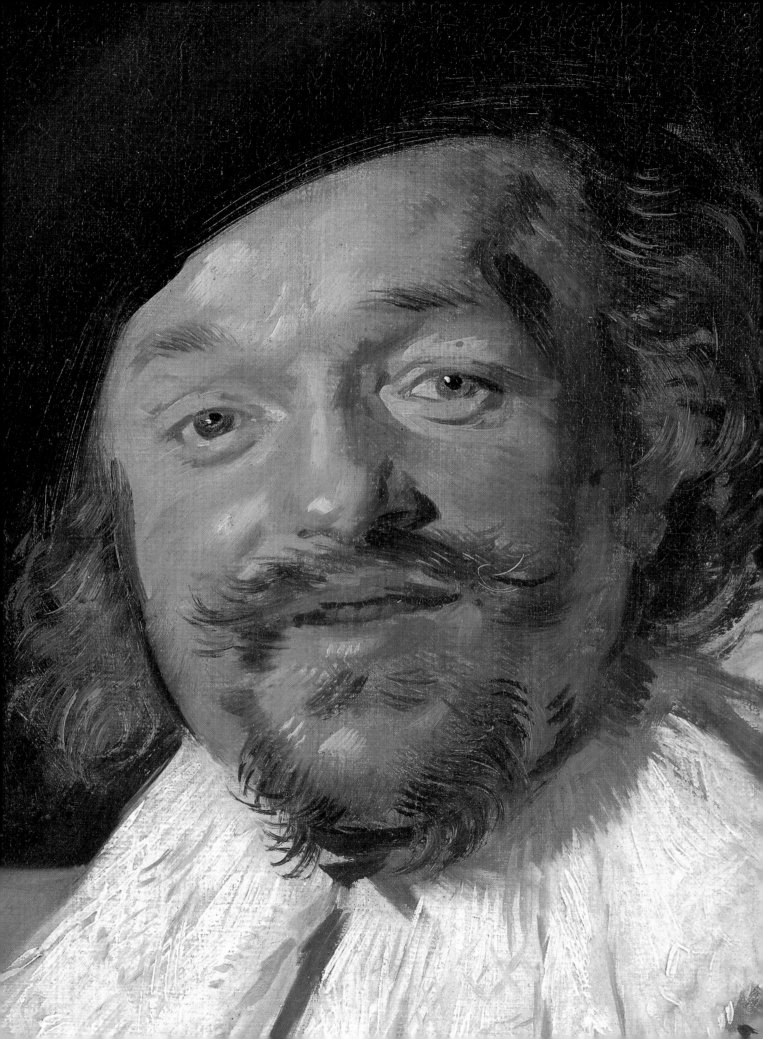

supreme mastery of one of the principal preoccupations of Baroque artists: the rendering of instantaneous emotion and movement. No seventeenth-century artist surpassed Hals in this field. The realism and illusionism of Caravaggio and his followers look forced compared to Hals, and Rubens and Van Dyck do not convey a comparable intensity in the suggestion of a fleeting instant packed with vitality. Hals's vigorous concentration on this was more than an ordinary rendering of reality. He selected moments when human nature reveals all its vital energy. Most frequently he shows the instant when the joy of life is at its highest: the spontaneous laughter of a child, the smile of a courtesan, the wild shriek of an old crone [41]. To be sure Renaissance portraits are not devoid of vitality either, but in them human nature manifests itself by restraint rather than outburst. Baroque portraitists, with their more dynamic tendencies, opened the way to a more immediate and instantaneous manifestations. He conveyed these ideas by a technique which was as original as it was adequate.

Hals frequently used the device of relating the figure represented to the spectator, or some person outside the picture by a glance or gesture, in order to heighten the illusion of a moment. As we have seen, this trick was not unknown to the Late Mannerists, or to his contemporaries in the Utrecht School. Another device – also employed by the Mannerists – was the violent use of diagonals to increase the impression of movement and of animation. Hals, however, used them with a consideration of the reality of space, whereas the Mannerists employed their diagonals in a more abstract and decorative fashion. But far more important than these two traditional schemes for producing the effect of a pulsating moment of life was Hals's revolutionary use of light. The sparkling and animating character of his light was hitherto unknown in painting. It is no longer the artificial, static light of the Caravaggio tradition, nor the rather idealizing light of Rubens: it is clear daylight of a silvery quality, floating all over, shimmering and animating surfaces, and comes very close to what the French Impressionists achieved. In Hals's works of the 1620s and early 1630s daylight become the life-giving element in nature, and its dynamic character is increased by his vigorous personality. The new character of his light ranks with the most radical stylistic innovations of Baroque painting. In his hands the emphasis shifts from the outlines and the sculptural quality of the subject represented to a most vivid surface play of values. Yet form and texture are never lost: they even gain in life under his new and brilliant surface treatment. It is Hals's revolutionary way of painting that gives his pictures a pictorial animation which make almost all previous painting appear frozen and lifeless.

An examination of Hals's technique helps to explain how he achieves the suggestion of palpitating life. A close-up of the head of the Amsterdam *Merry Drinker* [40] makes it appear a wild and rather loose combination of irregular strokes, patches, and daubs which tend to be sharp, broken, and angular; but, seen at the right distance, this impulsive brushwork resolves itself into a coherent impression, sug-

gests form and texture, besides a most amazing play of light for its own sake. This principle of relying on the optical effect at a certain distance and upon the suggestiveness of spontaneous, disconnected brushstrokes is one of the greatest discoveries in the history of painting. Both devices occur in sixteenth-century Venetian painting, but were never applied with Hals's consistency. It should be emphasized that there is no revolutionary change in the way Hals built up his portraits. He always begins by mapping the whole form in the middle tint. Then, upon this foundation, details are drawn with deft touches of light and shadow modelling the form and animating the surface at the emphatic points. The single stroke of his brush, although highly individual and spontaneous, is always adjusted to the character of the surface, and takes precisely the course needed to express the variety of surfaces and substances. Though each brushstroke retains its individual identity, there is never an abrupt break in the sequence of values, but a constant, subtle fusion of tones and a sensitive control over the value relationships. Form is consistently built up from the darks and the lights, and the painting increases in vivacity towards the highlights, where touches of impasto heighten the vibrating character of the whole.

The detail of the head of the Amsterdam *Drinker* shows two basic touches which are characteristic of the master. One is an angular or zigzag stroke which has a tendency to break up planes and to blur their edges; this counteracts roundness and isolation of forms and creates a steady surface movement. The other touch is hatching; these short parallel strokes create both a continuity of pictorial movement and vibration. The integration of these two devices and the seeming irregularity of his touch, together with its spontaneous character, are largely responsible for the brilliant surface life of his pictures. The irregularity of the touch is only an illusion: Hals's brushstrokes are kept under absolute control. His works have the hidden order and balance characteristic of the best Baroque painting. All his spirited surface treatment never degenerates into mere pattern because he subtly fuses the tones with an eye on the larger expression of form. As we have said, there is always a basic consideration of the whole form and a broad underlying tonal organization which secures the expression of mass in space.

The way Hals fuses his impasto highlights with the middle values and these again with the deeper darks, and nowhere gives the impression of an obvious transition or loses the spontaneous *alla prima* character of his brushwork, is perhaps the most miraculous feature of his technique. He is, no doubt, one of the greatest virtuosi in the history of painting, and, one must add, a virtuoso who had an exceptional feeling for his medium. Only Velázquez and the late Rembrandt exploited the viscosity of oil paint with equal ingenuity. Hals did not create a technique which could be followed by an average painter. None of his sons, pupils, or followers grasped its revolutionary aspects and later seventeenth- and eighteenth-century painters missed the significance of his technical innovations. In 1774 Reynolds acknowledged that Hals's ability to capture the character of an individual in a portrait was without equal, but he thought he lacked 'a patience in finishing what he so correctly

40. Detail of fig. 39, *The Merry Drinker*

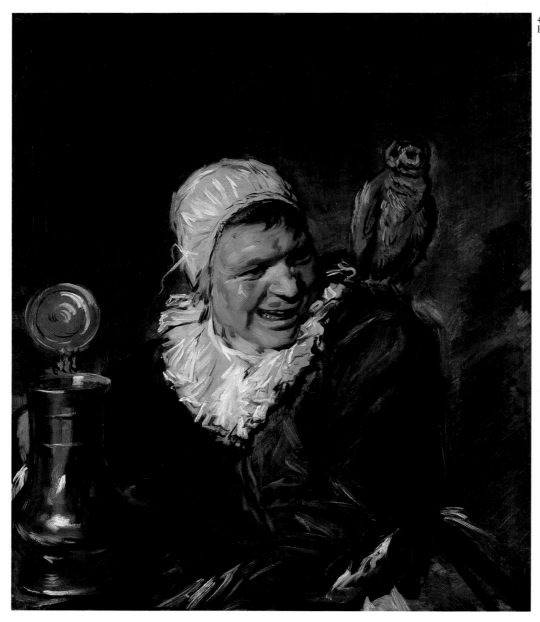

41. Frans Hals: *Malle Babbe*, c.1630–3. Berlin, Staatliche Museen

planned'. If he had finished his works, Reynolds wrote, Hals 'might justly have claimed the place which Vandyck, all things considered, so justly holds as the first of portrait painters.'[16] Only during the nineteenth century did masters such as Manet appear who understood his technique and were able to express themselves in his manner with necessary skill and spontaneity. But even a painter of Manet's stature remains behind in some respects, and does not achieve all the qualities found in the Dutch artist's work. Such a quality is solidity of form, which is often overlooked as a substantial part of Hals's painting. Art lovers of our day who appreciate the merits of Impressionist, Expressionist, and abstract painting are easily fascinated by the vivid and lightning brushwork which enlivens the surface of Hals's pictures. However, it is the solidity of form, animated by his technique, which distinguishes a work by Hals, and sets it apart from one made by a pupil or imitator. The forms of his followers disintegrate when they try to use his virtuoso

technique, and they are left with only a weak imitation of his surface treatment.

It is hard to say precisely when Hals discovered and perfected his new manner. As we have already heard, germs of it are already found in his earliest known works. A close and continuous contact with nature must have inspired him to his revolutionary achievement. This close contact with nature accounts for both his strength and his limitations. We have seen his strength. His limitations extended to dependence upon the model. This is not to say that he never took a brush in hand unless he had a model in front of him: it is absurd to think that he made a burgomaster of Haarlem – or even *Malle Babbe* [41] hold an instantaneous expression or momentary gesture until he transcribed what he saw into paint. Hals achieved his effects by careful calculation and selection, but the fact remains that during a career which extends over a half-century his range is virtually limited to portraiture and portrait-like genre and allegorical pictures.

Purely imaginary subjects hardly interested him. Apart from 1646 and 1647 inventory references to Prodigal Son paintings, which may be identical with so-called *Yonker Ramp* in New York [34] or the *Outdoor Banquet Scene* formerly in Berlin [157], his only known religious works belong to a set of the Four Evangelists done in the 1620s; they have the same character as his portraits and genre pieces of the decade.[17] Thrown upon the resources of his own imagination he must have been lost and unable to proceed. On the other hand, not everything he saw fascinated him. An idea of what breathtaking things he could have accomplished as a still-life painter can be formed if one compares the banquet on the table of the group of 1616 [29] with the dry and rather naive still-life pictures painted by the contemporary Haarlem specialists Floris van Schooten or Floris van Dijck. A glimpse of a dune and a patch of sky in the background of some of Hals's genre pictures of fisher folk made around 1630 shows what a landscape painter was lost in him. But apparently Hals only felt inspired to paint when he was confronted by a fellow human being.

Outstanding examples of how carefully Hals calculated his candid effects are the group portraits of banquets of the *Officers of the St Hadrian Civic Guard* (*c*.1627, Haarlem, Frans Hals Museum) [42] and of the *Officers of the St George Civic Guard* (*c*.1627, Haarlem, Frans Hals Museum). Hals heightened the momentary quality of both pictures by interlacing the figures on the surface of the canvas and in depth. The impression is of a casual irregularity, but, as in his technique, a hidden order underlies his large compositions. In both banquet pieces he links up two principal groups by long diagonals, and each single group shows a central seated figure, around which the other men are arranged, some seated and some standing. The crossing of the main diagonals coincides with the head of a seated figure in the second plane, which gains through this scheme an added interest and becomes a kind of occult centre. Ingenious variety of position and movement relates the figures to each other or to the spectator. The final result is an unprecedented illusion of an animated gathering. The impression that these guardsmen could consume gargantuan quantities of food and liquor is confirmed by an ordinance laid down by the municipal authorities of Haaarlem in 1621. Town officials took cognizance of the fact that some of the banquets of the militia lasted a whole week. Considering that the municipality had to pay the costs, and that the times were troubled (the ordinance was written after hostilities with Spain had been resumed), it was decreed that the celebrations 'were not to last longer than three, or at the most four days ...'

42. Frans Hals: *Banquet of the Officers of the St Hadrian Civic Guard*, *c*.1627. Haarlem, Frans Hals Museum

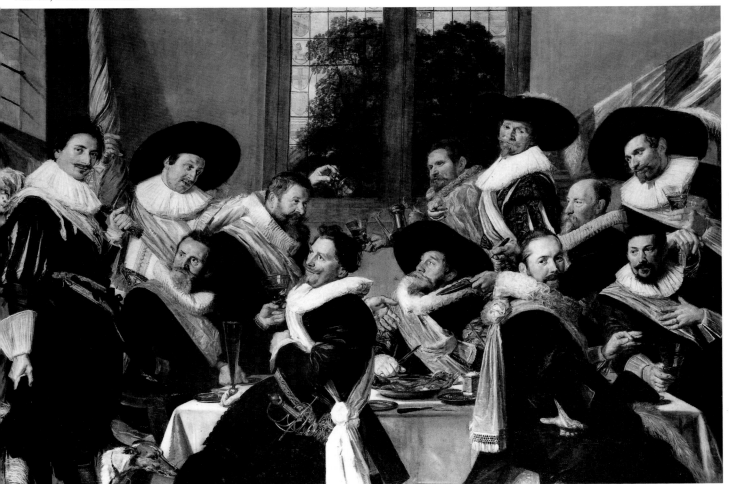

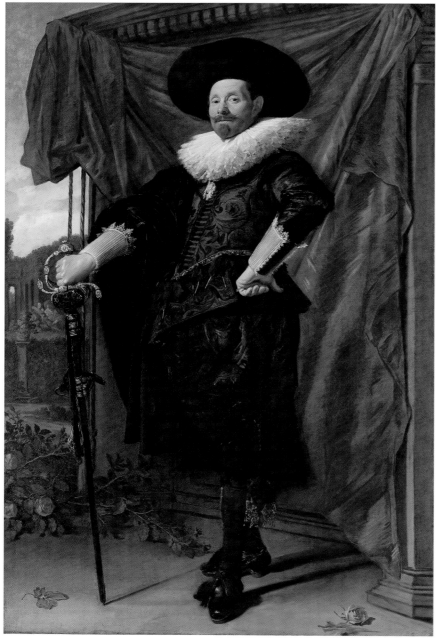

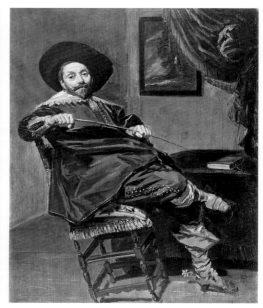

44. Frans Hals: *Willem van Heythuysen*, c.1637–9. Brussels, Musées Royaux des Beaux-Arts

43. Frans Hals: *Willem van Heythuysen*, c.1625. Munich, Alte Pinakothek

By creating a great diversity of attraction – perhaps too great a diversity in the portrait group of the *Officers of the St Hadrian Civic Guard* – Hals carefully avoided focusing attention upon one part of the picture at the expense of other parts. Value accents make the complexity of the spatial relationships as great as the richness and vividness of surface animation. The gaiety and freshness of the colour – there are bright pinks and blues, oranges and light greens, glittering greyish white and shiny blacks – contribute to the brilliant vibrancy of the whole. This tremendous variety of devices gains pictorial unity largely through the silvery daylight which floods the interiors, flows over the faces and costumes, brightens the air, and throws a delightful sparkle over the surfaces. Though in both pictures the scene takes place indoors, one is tempted to speak of a *plein-air* conception. Only at this point of his career does Hals anticipate

nineteenth-century Impressionism in a fuller sense, because he combines a *plein-air* approach with intense bright colours and enlivens almost every single inch of his paintings with his spontaneous brushwork. We shall see that there were other moments of promising *plein-air* effects in seventeenth-century Dutch painting. They are found in the landscape paintings of the 1630s and 1640s, and in the Delft School shortly after the middle of the century. But none were of long duration; they were soon subdued. Hals also succumbed to this general tendency. In the following decade he begins to show a gradual adjustment to a more monochromatic and darkened palette.

The portrait of *Willem van Heythuysen* (Munich, Alte Pinakothek) [43], which was formerly dated around 1635 but upon the basis of style and costume should be dated about a decade earlier, is Hals's only known life-size full-length.

This type of portrait was not popular during the first half of the seventeenth century in Holland. It was one that was still primarily used for state portraits and the nobility; only the most powerful, the wealthiest or the most pretentious commissioned them. Moreover, few Dutch homes were large enough for them. But van Heythuysen's residence was. A posthumous inventory made in 1650 of the effects of this very rich Haarlem merchant who made his great fortune in the city's textile industry, the principal source of Haarlem's prosperity after beer brewing, lists in the great hall of his large house his 'effigy or large portrait', and in the room above the 'likeness of the deceased in small'. No artists' names are mentioned; however, the former is almost certainly Munich's life-size portrait, and the latter, the small informal portrait now in Brussels [44]. The inventory also lists his extensive holdings: a vast number of paintings, expensive furniture and silver, a large library, jewelry, maps, a coin collection, weapons, and an expensive wardrobe, including red satin underwear.[18]

Even if nothing were known about van Huythuysen's life there is no disputing it: Hals's portrait of him standing big as life captures the confidence and vitality of the burghers who made Holland the most powerful and richest nation in Europe during the first half of the seventeenth century. It is one of those rare pictures that seems to sum up an entire epoch. A sense of energy is conveyed by the tautness the artist gave to his model's bolt-upright figure. His extended leg does not dangle, but carries its full share of his weight. One arm juts straight out, stiff as the sword he holds; the other makes a sharp angle from shoulder to elbow to hip, and even his knuckles take part in the taut, angular movement. As in most of Hals's portraits of the 1620s, the light falls with equal intensity on van Heythuysen's alert head, and on his hands. Shiny highlights and sharp shadows heighten the subject's palpable presence and the blended brushstrokes that model flesh are set off by adjacent areas where there are distinct, detached touches of the brush. No portraitist before Hals dared use such a variety of brushstrokes in a formal portrait. The Van Dyckian props, a rarity in Hals's œuvre, are beautifully worked into the design. The vertical accent of the pilaster on the right reinforces the figure's erect carriage, and the burgundy drapery is incorporated into the pattern formed by van Heythuysen's elephantine pair of bouffant knee-breeches and cloak cut like a cape. The prominent roses in this portrait of a man who remained a bachelor could allude, as they do so often in paintings of the period, to the pleasures and pain of love, but references in van Mander's *Schilderboek* and in Jacob Cats's popular emblems suggest that they and the lovers in the garden in its background were probably intended as reminders of life's transience.

About fifteen years later Hals painted another portrait of the same gentleman, now at Brussels [44].[19] In this informal, small oil sketch van Heythuysen does not show a face or posture prepared for public encounters. Here Hals's instantaneous quality is successfully combined with his model's nonchalant attitude. Movement is expressed by the swift brushwork, the highly developed flickering light, and above all by van Heythuysen's unusual pose with whip in hand, leaning back precariously in his tipped chair. The

glimpse of an interior in the intimate Brussels picture is an exception in his work. Hals usually preferred neutral backgrounds. But the size is not so extraordinary. Hals made small pictures, some of which can be held in the palm of one hand, from the beginning to the end of his activity. A few miniature portraits served as modellos for engravers (e.g. *Petrus Scriverius*, 1626, New York, Metropolitan Museum). Others were intended as finished 'portraits in small'. The suggestion that some are preliminary studies for larger paintings is an attractive one, because, as we have heard, not a single drawing can be attributed to him. It seems reasonable to assume that Hals, who saw the world in colour and tone, not line, made oil sketches more readily than drawings, and that some of his small oils were preparatory studies for larger works, but no preliminary oil sketch for a painting has been discovered. Some life-size copies were made by other artists after Hals's original small portraits; a prominent example is the famous *Portrait of René Descartes* in the Louvre, which we consider an enlarged copy after the small original in Copenhagen [50]. Followers also made reduced copies which have passed as authentic preparatory studies; for example, the oil sketch on paper formerly in the H. E. ten Cate Collection, which in our opinion is a copy after the life-size portrait of *Stephanus Geraerdts*, now at Antwerp [53], and not a preliminary study by the master himself.

A shift began to take place in Hals's style during the 1630s when his works acquired a greater unity and simplicity, and the bright colours of the 1620s gave way to more monochromatic effects. This shift was a general one in seventeenth-century Dutch painting, and can also be noted in van Goyen's landscapes and Heda's still-life pictures. The change is also reflected in the fashions of the day. This was the time when stately black clothes began to replace the multicoloured and richly embroidered garments worn during the first decades of the century. The imposing three-quarter-length portraits of the wealthy Haarlem brewer, alderman, and burgomaster *Nicolaes Woutersz van der Meer* and his wife *Cornelia Claesdr Vooght* both dated 1631 [45, 46], with their simplified silhouettes and the contrast between the figures and their backgrounds reduced, are indicative of the change. Blacks predominate and there are only a few subdued colour accents (the colourful coats of arms on the paintings are later additions). Hals had portrayed Nicolaes van der Meer once before. He appears as the seated captain with his arm akimbo in the foreground of the 1616 civic guard piece (see fig. 29 and fig. facing p. 34). At that date it seemed safe to predict the brewer would gain weight as he grew older. Hals made no effort to minimize his girth when he portrayed him fifteen years later during van der Meer's fourth term as burgomaster.

These pendant portraits of husband and wife are the type of commission that Hals received most frequently during the course of his career. At least thirty pairs are known today, and it is possible to cite a few of his single portraits that almost certainly originally had mates that have disappeared without a trace. Since husband and wife always complement each other in some way in his companion pieces the loss of one, or their separation into different museums or collections, is always a misfortune. When merely one member of a pair is viewed only half the artist's intention is seen.

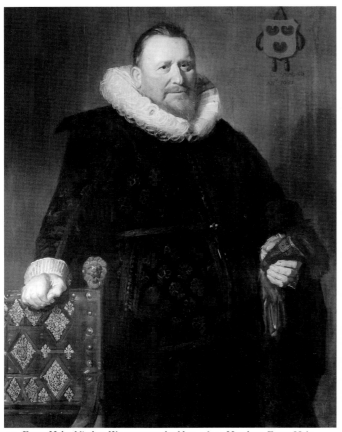

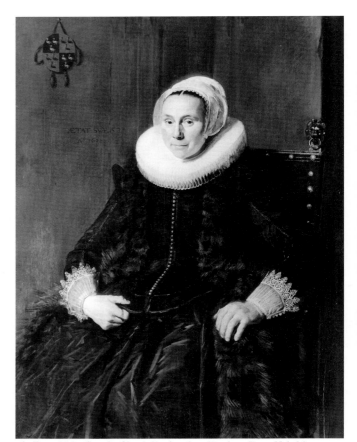

45. Frans Hals: *Nicolaes Woutersz van der Meer*, 1631. Haarlem, Frans Hals Museum

46. Frans Hals: *Cornelia Claesdr Vooght*, 1631. Haarlem, Frans Hals Museum

47. Frans Hals: *Officers and Sergeants of the St Hadrian Civic Guard of Haarlem*, *c.*1633. Haarlem, Frans Hals Museum

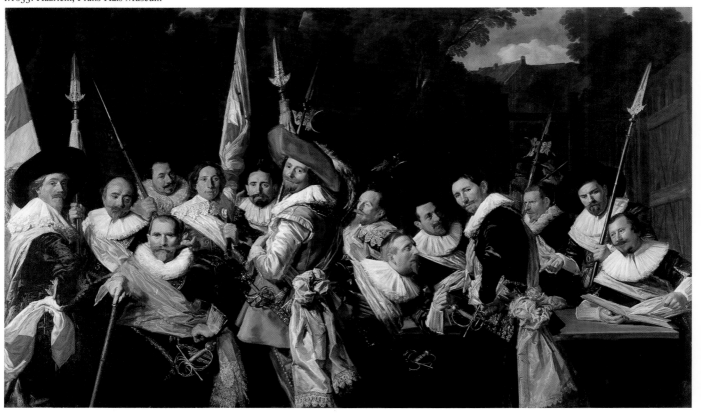

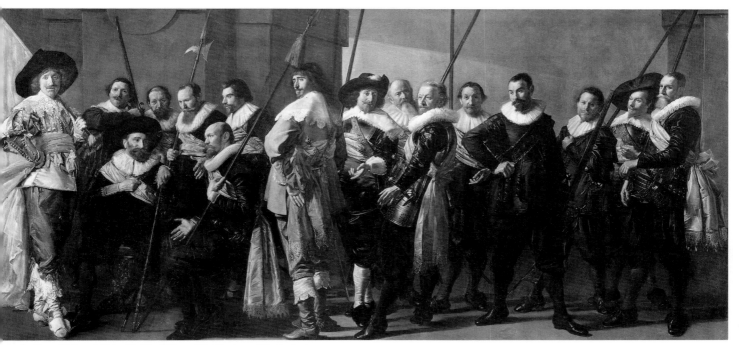

48. Frans Hals and Pieter Codde: *Officers of the Company of the Amsterdam Crossbow Civic Guards under Captain Reynier Reael, known as 'The Meagre Company'*, begun by Hals, *c*.1633, completed by Codde, 1637. Amsterdam, Rijksmuseum, on loan from the City of Amsterdam

Ample evidence indicates that the place women held in seventeenth-century Dutch society was more important than it had been in earlier times. But in portraiture the male still took precedence over the female. This was acknowledged by Hals and other artists when they painted pendants, double, or family portraits according to the laws of heraldry. As in the van der Meer-Vooght pair, the pictures were composed so the husband took his traditional place of precedence on the dexter side and the wife was on the sinister side (the sides dexter and sinister refer respectively to the right and left of the person wearing the escutcheon). The tradition was an old one. It was used by late medieval artists when they painted donors in altarpieces, and later Renaissance portraitists continued to give husbands this kind of priority over their wives. The dexter-sinister rule was not iron-clad. However, it was hardly ever broken by Hals. His pendants of an unidentified couple datable about 1633/5 now at Stuttgart are his only known breach of the arrangement. In this exceptional case the man's portrait may have been painted while he was still a bachelor and the pendant a bit later.[20]

Hals's new tendency towards restraint is seen in the three large group portraits of civic guards made during the 1630s. The vivacity of the setting is already slightly subdued in the group portrait painted in the early thirties of the *Officers and Sergeants of the St Hadrian Civic Guard* (*c*.1633, Haarlem, Frans Hals Museum) [47] by the subordination of the figures to a horizontal band, and this horizontal accent completely dominates the arrangement of the figures in the group portrait of the *Officers and Sergeants of the St George Civic Guard* (*c*.1639, Haarlem, Frans Hals Museum). In both group portraits the figures are set in the open air, but they lose rather than gain in *plein-air* quality. This is particularly

true of the picture of 1639, which is dominated by a warm golden olive tone, while the one of 1633 still retains a good deal of the colouristic vivacity and charm of the 1620s, with bright blues, dazzling whites, and oranges, and also some of the compositional boldness and agitation of the earlier period. The picture of 1639, in which Hals's rare self-portrait is to be seen, is the master's last representation of a civic guard group. The whole category virtually disappears in the Netherlands around the middle of the century. After the Treaty of Münster of 1648, which gave Holland *de jure* recognition in the councils of Europe, Dutch patricians preferred to be seen as dignified regents rather than military men.

The third civic guard picture Hals was commissioned to paint during the 1630s is the so-called *Meagre Company* [48]. He received the commission from a group of Amsterdam guards in 1633. The honour was a singular one and good proof of the high esteen he enjoyed at the time. Hals was chosen to paint the group of officers under Captain Reynier Reael instead of one of Amsterdam's leading portrait painters: Nicolaes Eliasz Pickenoy, Thomas de Keyser, or Rembrandt, who had established his reputation in the city a year earlier with his *Anatomy Lesson of Dr Tulp*. Moreover, Amsterdam's painters' guild tried to run a closed shop; artists who did not belong to it were seldom allowed to work in the metropolis. Guilds in other Dutch cities had a similar regulation. In the portrait Hals followed an Amsterdam tradition by showing Captain Reael and his men as full-length figures (all the Haarlem guard pieces are three-quarter lengths). The commission that had an auspicious start in 1633 ended with bad blood between the artist and his sixteen patrons. We learn this from detailed notarized

documents – the only surviving ones that tell us anything about a transaction between Hals and his clients and the fee he received for a portrait. If Hals had finished the piece he would have been paid sixty-six guilders for each militiaman he portrayed. The honorarium was a reasonably good one; less than a decade later, when Rembrandt was at the peak of his popularity, he received about one hundred guilders for every civic guard he portrayed in the *Night Watch*. Put another way, Hals would have been paid 1,056 guilders for the group portrait when the annual wage for a master carpenter or bricklayer in Amsterdam was about 300 guilders. But Hals never finished the work. It was still in progress in 1636 when the exasperated guards summoned the artist by legal writ to come to Amsterdam to finish it; according to them he had agreed to work on it there. After an acrimonious exchange (which includes the allegation that the artist was a liar and Hals's own assurance that, if the men whose portraits were still unfinished would come to Haarlem to pose, he would finish the job quickly) his patrons found it impossible to make him comply with their demands. Whereupon they employed Pieter Codde to bring the work to completion.[21] Codde finished his part in 1637. The design of the whole is Hals's and so is the ravishing painting in the left part of the picture. Codde's hand is clearly recognizable in the right half.

THE LAST DECADES 1640–1666

As Hals grew older, genre and allegorical subjects disappeared from his *œuvre*. The mature artist limited himself exclusively to portraiture. At the same time he acquired an increased depth of expression, and a serious strain enters his joyful art. The dignified character of his group of the *Regents of the St Elizabeth Hospital* (Haarlem, Frans Hals Museum) of 1641 [49] sets the key for the last decades. The bravura and gaiety of an earlier generation is now replaced by sobriety. The five regents of the charitable institution gathered at the conference table appear to be engaged with an important matter. A kind of intimacy is given to the group by the character of the light which is thrown into the interior by a side window and concentrated on the faces of the sitters. This kind of illumination allows a moderate chiaroscuro effect. But the darks do not dominate yet, and there is still enough brightness and brilliancy to remind us of Hals's *plein-air* period. However, the character of the colour has changed considerably. Nearly all pure colour has disappeared and the colour composition has become almost monochromatic, showing a subdued harmony of greyish blacks and subtle gradations of ochres. Johannes Cornelisz Verspronck painted a group portrait of the regentesses of the same institution in the same year

49. Frans Hals: *Regents of the St Elizabeth Hospital*, 1641. Haarlem, Frans Hals Museum, on loan from the Elizabeth Hospital

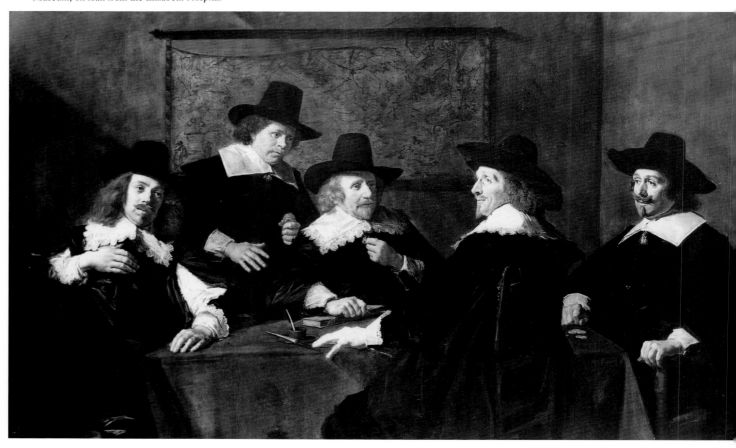

50. Frans Hals: *René Descartes, c.*1649. Copenhagen, Statens Museum for Kunst, on permanent loan from the Ny Carlsberg Glyptotek, Copenhagen

51. Frans Hals: *Portrait of a Woman, c.*1655–60. Hull, Yorks., Ferens Art Gallery

[344]. The two works are the earliest existing regent portraits produced in Haarlem. It was a branch of portraiture that was much more popular in Amsterdam.

Despite the choice assignment, Hals began to receive fewer commissions during the 1640s. This was the time when a wave of elegance and aristocratic taste began in the Netherlands and a considerable part of the Dutch public began to give preference to portraitists such as Bartholomeus van der Helst, who could give sitters Van Dyckian airs. The sixty-year-old Hals did not slavishly follow the new mode. However, his loss of patronage during his last decades should not be exaggerated. More pictures are known by Hals the septuagenarian and octogenarian than by young Hals. There were still Dutch men and women who preferred his subtle understatement to the pretentious display which was the speciality of the more popular portraitists. Two of his life-size family portraits (Madrid, Thyssen-Bornemisza Foundation; London, National Gallery) can be dated in the late forties. In the same decade he painted members of the Coymans family, one of the leading families of Haarlem; of 1643 is his *Paulus Verschuur* (New York, Metropolitan Museum), director of the largest textile mill in Rotterdam and one of that city's outstanding civic leaders; around 1649 he painted a small oil sketch of *René Descartes* [50], by far his most famous sitter. Until the end Hals's clientele included patricians, clergymen, professors, and artists.

Hals's most penetrating characterizations date from the last decades. With uncanny subtlety, he grasped the personalities of all types: the strong and the vulnerable,

the pompous and the meek, the brutal and the tender. Private dramas can be read on their faces, and unlike many portraitists of his time, his portraits of women [51] are as remarkable as those of men. Though he found some sitters more congenial than others, the aged master never seems to have been bored with his job. During these years he was especially sympathetic to sitters of his own generation. The pictorial reserve of his last phase was particularly suitable for the portrayal of his peers, whose age and tastes made them shun the new vogue for the ostentatious. But we sense he could also be critical of them. He was, however, more devastating when appraising members of the younger generation who found themselves dissatisfied with their fathers' tastes, and began to imitate the manners and clothes of the French nobility. Yet the artist was able to satisfy the desire of young patrons for rich effects without losing his extraordinary sensitivity to tonal gradations as is seen in his half-length of *Jasper Schade* (*c.*1645, Prague, Národní Galerie) [52], a patrician of Utrecht who later was representative of his province to the States-General. Hals's characterization of him, and his firm control of pictorial organization, convince us that as a young man his sitter was a vain, proud peacock, an impression confirmed by a contemporary report that he spent extravagant sums on his wardrobe. In a letter written in 1645 (almost certainly the date of Hals's portrait) his uncle admonished his son, then in Paris, not to run up tremendous bills with his tailors the way his cousin Jasper Schade had done.[22] A subtle emphasis on verticality in the portrait contributes to Jasper's haughty

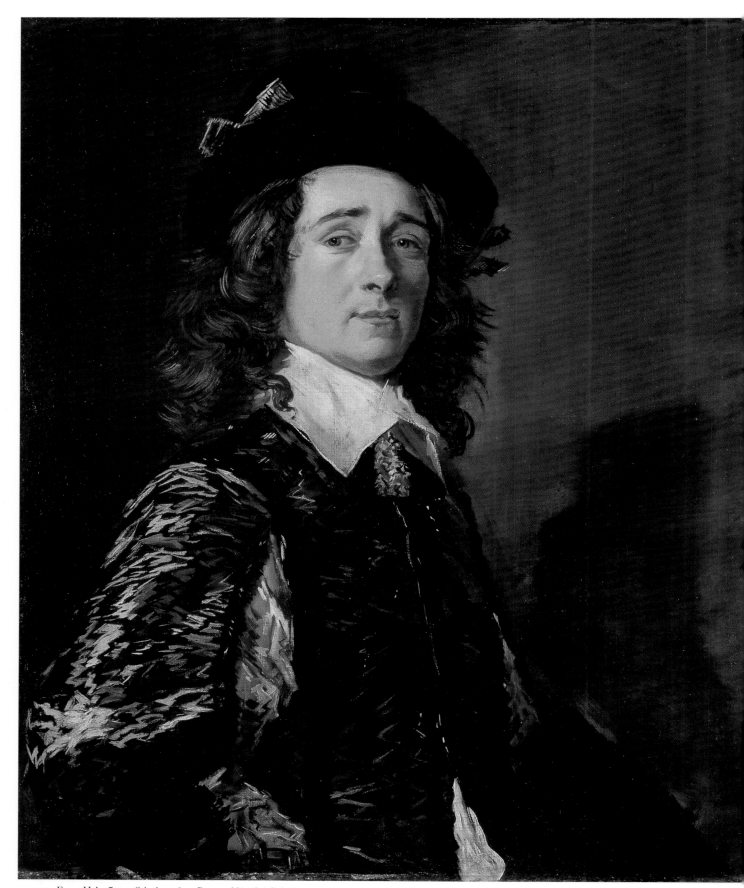

52. Frans Hals: *Jasper Schade*, *c*.1645. Prague, Národní Galerie

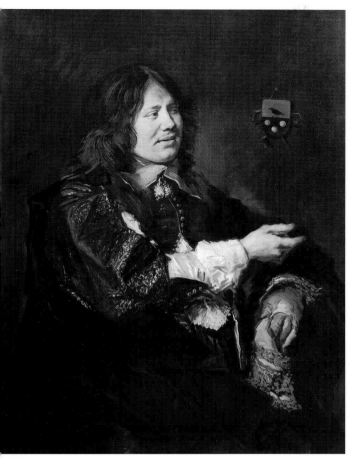

53. Frans Hals: *Stephanus Geraerdts*, c.1650–2. Antwerp, Koninklijk Museum voor Schone Kunsten

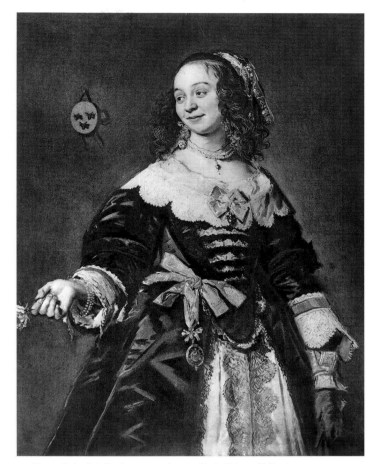

54. Frans Hals: *Isabella Coymans*, c.1650–2. Paris, Private Collection

air – not that an emphasis on vertical forms must needs express arrogance, but here it certainly does. His hat's upward turned brim and the straight arrangement of his long hair accent the length of the face of a man looking down at people below his station. And while thin, frail bodies may contain most noble spirits, this one hardly inspires confidence in its inner strength. As dazzling as Hals's appraisal of his sitter are the zigzag and angular brushstrokes that suggest the nervous dance of bright light on his grey taffeta jacket while creating an electrifying movement on the picture surface.

A series of pendant portraits of husbands and wives take a prominent place in the work of the forties and fifties. The most original pair is the portraits of *Stephanus Geraerdts* at Antwerp [53] and *Isabella Coymans* in a private collection [54]. There is nothing comparable in his *œuvre*, or in the history of earlier marriage portraits, for the action he arranged between the couple. Isabella was designed, as was customary, to hang as the sinister pendant. She stands turned toward her husband offering him a rose. Portly Stephanus is portrayed seated with his arm outstretched to receive it. When juxtaposed, the glances they exchange, their smiles, and their gestures create a tension that psychologically and rhythmically binds them together. Disunited, these links are broken. Sadly, the portraits are no longer joined. Of all cases of separation of Hals's companion pieces this is the

cruelest. Since 1888, when they were separated by a dealer who had them in stock, Stephanus has been seated in Antwerp companionless with his arm outstretched, while irresistable Isabella has been alone, offering her rose in private collections. It has been proposed that her rose should be read as a vanitas symbol, and as warning of earthly love's fickleness and the dangers of voluptuousness. Granted, in some contexts roses could have these meanings for Hals's contemporaries. But these allusions and others than can be compiled (then as now 'no rose without a thorn' was a popular adage) are so distant from the sympathetic relationship Hals established between the couple it seems perverse to search for them. One must lead a very dull life indeed not to recognize that Isabella's rose is a token of love, the flower's most popular meaning since the late Middle Ages, and in no more need of an exegesis than a Valentine.

In the final years austere and even tragic moods are not uncommon [55]. The pictures become darker, the blacks richer and more predominant. Dark greys and deep golden olive-greens are now substituted more consistently for the light silver-greys and yellow ochres of the earlier works. The artist relies more and more for pictorial effects upon contrasting warm and cool tones which are close in value. His paint becomes thinner, his touch even broader and more summary. The frontal pose used for the impressive *Portrait of a Standing Man* (1650–2) [56] is now favoured more often

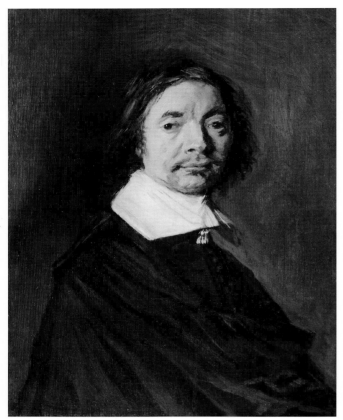

55. Frans Hals: *Portrait of a Man*, c.1660. The Hague, Mauritshuis

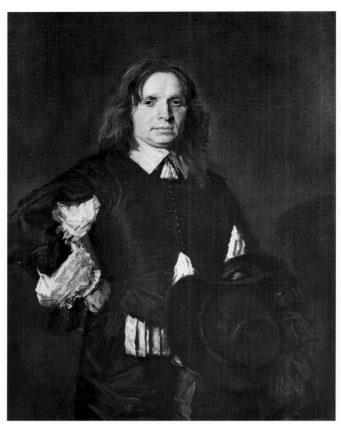

56. Frans Hals: *Portrait of a standing Man*, 1650–2. New York, Metropolitan Museum of Art, Marquand Bequest

and helps to account for the new dignity and imposing grandeur of the last works. Incredibly subtle distinctions between the blacks of the man's suit, hat, and mantle in the Metropolitan Museum portrait make clear what Vincent van Gogh had in mind when he wrote, half in awe and half in envy, 'Frans Hals had no less than twenty-seven blacks'.[23]

Portraits of the last years have some of the psychological penetration and restraint which characterize the majestic works of Rembrandt's mature phase. To be sure, Hals never touched Rembrandt's universal range; but it is frequently overlooked that Hals had Rembrandtesque moments – just as Rembrandt had his Halsian ones [72]. In his final years Hals also used chiaroscuro, a pictorial device most often associated with Rembrandt when Dutch painting is considered. There are however, basic differences between the chiaroscuro effects achieved by Hals and Rembrandt during their late periods. Rembrandt's figures always seem to be more enveloped by space and atmosphere than Hals's, because he made his light and dark areas interpenetrate each other by using still more subtle tonal gradations and reflections in his half-tones. Rembrandt also turned naturalistic Caravaggesque spotlighting effects into a pictorial device of symbolic significance. He was able to add an inner glow to the outer animation, to express man's inner life. In Rembrandt's hands chiaroscuro became an occult device to express the intangible and invisible through the visible. For Hals, chiaroscuro was primarily a pictorial affair rather than a means to reveal a more comprehensive grasp of human

nature. It does not follow, however, that old Hals was unable to continue to speak to us of the human condition. His last portraits prove that he could. Nowhere is this more evident than in the peerless group portraits of the *Regents of the Old Men's Almshouse* (Haarlem, Frans Hals Museum) [57] and the *Regentesses of the Old Men's Almshouse* (Haarlem, Frans Hals Museum) [58], painted about 1664, when the artist was over eighty years of age.

The painting of the women governors is perhaps the more impressive of the two, by the great simplicity of its composition as well as by the power of characterization. The characters of the women appear to range from iron strength and firmness – a quality which the old artist seems to have respected – to sheepishness, but there is no distinction in social degree except for the servant on the right, who seems to bring in some message. Like most of Hals's late works, the picture is done essentially in black and white. The whites are brilliant, the blacks deep and glowing. The impressionist-like technique is fully developed, but can only manifest itself here in the lightest passages. Single strokes have gained still more in breadth and power. Some

57. Frans Hals: *Regents of the Old Men's Almshouse*, c.1664. Haarlem, Frans Hals Museum

58. Frans Hals: *Regentesses of the Old Men's Almshouse*, c.1664. Haarlem, Frans Hals Museum

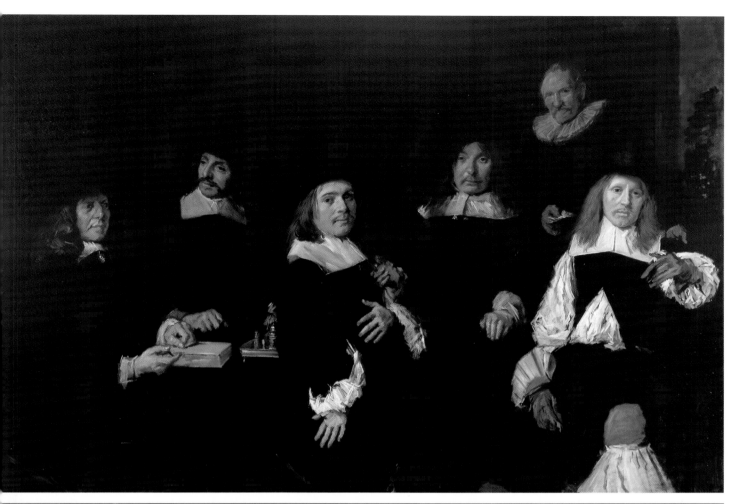

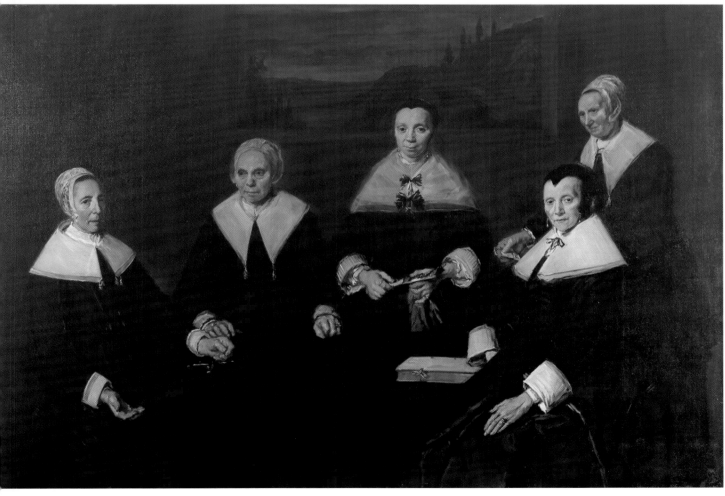

bold colour accents emphasize salient points, yet a general softness is achieved by the transitional tones, and the individual touches have become more fused with the surrounding areas. The group portrait of the male regents is less successful than its companion piece, but not because of a faltering hand, which some critics maintain they recognize in Hals's last works. Hals never lost his unsurpassed sureness of touch, which could simultaneously draw, model form, define texture, and create lively spatial and surface accents. In the group portrait of the men, an old characteristic of the master reappears: each person stands out with equal importance. This was a definite quality in his earlier work, when all devices co-operated to increase the impression of a casual variety, informality, and instantaneousness. But this principle is less fortunate when combined with chiaroscuro, a device which was used by Caravaggio as well as Rembrandt to focus the spectator's interest on a few essential passages, thereby creating concentration instead of animating diversity. Thus, one principle involved here stands for diversity of attraction, the other for concentration; the result is not fully satisfactory. However, lack of compositional coherence is quickly forgotten as soon as one examines the masterly painting and characterization of the six men, and when one discovers a passage like the broad touch of red on the knee of the man on the right, which brings a breathtaking colour accent to the monochromatic character of Hals's late palette.

The aged Hals may have been reasonably well rewarded for his late masterpieces. About a year after they were painted, he was able to act as guarantor for his son-in-law for the large sum of 458 guilders, 11 stuivers. Perhaps this sudden affluence was due to the payment he received for his last two group portraits. But it would be a mistake to think that Hals's financial situation improved during the last decades of his life: on the contrary, in 1654 his meagre possessions were seized by a baker in payment for an unpaid debt for bread and a loan, and during the final years of his long life he was apparently destitute. The Haarlem Guild of St Luke exempted the master from the payment of dues in 1661 because of his old age. In 1662 the burgomasters of Haarlem awarded him a direct gift of 50 guilders and a subsidy of 150 guilders for one year. The following year the subsidy was changed to a life pension of 200 guilders annually. Hals was not a burden on the city for long. On 1 September 1666 a grave was opened for him in the choir of St Bavo in Haarlem. If any of Hals's contemporaries appreciated the exuberance and joyful vitality of his early pictures or the depth and concentrated power of his late work, they failed to communicate their enthusiasm to posterity. Only after the middle of the nineteenth century, when artists and critics rediscovered his pictorial genius, was Frans Hals generally recognized as one of the greatest Western painters.[24]

Rembrandt

Rembrandt Harmensz van Rijn was born on 15 July 1606 in Leiden, the son of the miller Harmen Gerritsz van Rijn.[1] His mother Neeltgen Willemsdr van Zuytbrouck was the daughter of a baker. The parents owned a malt mill just outside the city's gates on a bank of the Old Rhine called 'de Rijn'; the family name 'van [de] Rijn' was derived from it. On his mother's death in 1640 – his father died in 1630 – an inventory was taken of her estate which reflects comfortable circumstances. In addition to half of the mill, she owned some houses and land. The total value of her estate, not far from 10,000 guilders, was to be divided among the heirs. While Rembrandt was the ninth of at least ten children, only four were alive at this time: Adriaen, a shoemaker, Willem, a baker, Rembrandt, and his sister Elysabeth. The facts of Rembrandt's origin are not unimportant. The harsh force in the master's nature, most obvious in his early works, and his inexhaustible vitality may have something to do with his background. They should also be considered in connection with the remarkable scope of his development. Rembrandt progressed, with powerful impulses, with extraordinary *élan*, and with an intensity hitherto unknown, from the rough to the sensitive, and from a somewhat brutal character in his art to the sublime. One wonders if a man who had been brought up from the beginning in greater wealth and in more cultivated surroundings would ever have been driven by such dynamic forces to the height of his activity.

According to Jan Jansz Orlers, Rembrandt's first biographer, the boy's parents destined their gifted son for a learned profession, apparently with the ambition of opening his way to a higher social sphere.[2] He first attended the Leiden Latin school, and on 20 May 1620 was enrolled as a student at Leiden University. It is not known how long Rembrandt studied there. It is certain only that his parents soon recognized their son's natural inclination towards art as

59. Rembrandt: *Stoning of St Stephen*, 1625. Lyon, Musée des Beaux-Arts

too strong to be denied, and that the boy was allowed to leave the university. He was then sent to Jacob Isaacsz van Swanenburgh (*c.*1571–1638), a Leiden painter who had travelled to Italy. He was a history painter who specialized in scenes of hell and also made architectural views. Rembrandt spent three years with van Swanenburgh, but not a trace of his style can be seen in the youthful artist's work. It is also noteworthy that, as far as we know, Rembrandt, who depicted almost every subject during the course of his career, never painted a view of hell or an architectural piece. Orlers tells us that Rembrandt's work with van Swanenburgh showed such great promise that his father, in order to ensure his son's best advantage, sent him to Amsterdam to study for six months with the famous Pieter Lastman. The eighteen- or nineteen-year-old youth returned to Leiden about 1624–5 and set himself up as an independent master. The earliest works attributed to him are datable to these years.

THE LEIDEN PERIOD 1625–1631

Rembrandt's development can be divided into four basic periods: the beginnings in Leiden, and three phases in Amsterdam. At the time Leiden was not a sleepy provincial town. It was second in population only to Amsterdam, it had a flourishing textile industry, and its famous university made it a centre of scholarship, theological studies, and humanism. However, it was no match for Amsterdam as a cosmopolitan centre – no city in the Netherlands was. It was in Amsterdam that Rembrandt was more strongly exposed to the great international trends of Baroque art, and it was there, in the thirties, that he first reached a High Baroque phase, clearly under the impression of Rubens's art. Later – in the fifties and sixties – a more classical style, though far from outright classicism, showed some influence of the tectonic and monumental character of Renaissance art. An intermediary period during the forties was a time of transition.

This division of Rembrandt's career into four periods must, however, be applied with caution and judgement. Rembrandt's artistic development was not a rigid one. He could shift moods and modes with great rapidity, and the style he used in one medium did not fully parallel one he used when he worked in another. Rembrandt's genius was flexible and sometimes explosive. There are fluctuations, cross-currents, premonitions, and recurrences in his *œuvre*.

His first period was a time of rapid growth, rich enough to fill out the whole life of a minor master, but in Rembrandt's career only a beginning which was followed by more important stages. From the moment he embarked on independent activity he began to paint history pictures. It is evident the budding artist wanted to make his mark in the branch of painting that had been implicity or explicitly accepted as paramount since the Early Renaissance. His lofty aim never changed.

Rembrandt's earliest existing dated work, the *Stoning of St*

60. Rembrandt: *Self-Portrait*, c.1629. Amsterdam, Rijksmuseum

Stephen of 1625 at Lyon [59], shows how impressed he was by Lastman's forcefulness based upon lively gestures and a vivid chiaroscuro. For his painting of the death of the first Christian martyr the young Leiden artist used the same kind of fanciful Italianate setting that his teacher employed, and depended on similar strong contrasts of light and shade to give his work a dramatic character. In his colouring Rembrandt also follows the example of Lastman in giving a hard brilliance to the illuminated figures. Rembrandt's immaturity is evident here in the overcrowding and confused spatial relationships; however, the young artist already surpasses his famous teacher by achieving a greater concentration in his composition. The horsemen and figures on the left have been massed into a group by a dark shadow which suppresses detail in almost half the painting. This device focuses attention on the main action and intensifies the mood. There is nothing comparable to it in the *œuvre* of Lastman.

One of the heads in the Lyon picture – the one looking at the scene in pained horror just below the arm of the man holding a rock with both hands high above his head – shows that Rembrandt was already making studies of his own physiognomy at this early date. It is a self-portrait, the earliest existing one by the artist, who represented himself more frequently by far than any other Renaissance or Baroque master. More than seventy-five painted, etched, and drawn self-portraits by Rembrandt are known. This unique record includes Rembrandt's conception of himself from the beginning to the end of his career: as a dashing gallant, a proper bourgeois, a majestic Titan, and finally, as the aged sage. His unprecedented series of self-portraits is frequently called

an autobiography, but perhaps it is better to characterize it as a journal, since an autobiography is usually written at a single stage of a person's life – preferably after the subject has ceased to blush at youthful indiscretions and before old age has made its author gaga. Rembrandt's series covers a span of forty-four years.

During his Leiden years the young artist also frequently used himself as a convenient model to study chiaroscuro effects and facial expressions. The results of these studies were incorporated into his more ambitious historical compositions. This experimental approach was not an uncommon one among Baroque artists; both Caravaggio and Bernini used themselves as models for their early physiognomical studies. The intensity and bold originality of the young genius is seen in the early *Self-Portrait* now at Amsterdam [60].[3] Rembrandt painted his powerful head and bust in deep shadow and silhouetted them against the light wall – a scheme reminiscent of the Utrecht *Caravaggisti*. But the distribution of light and shade in the self-portrait is unique. The upper part is deeply shadowed, and it requires a strong effort on the part of the onlooker to recognize the artist's questioning glance. The effect is as dramatic as it is bold in the neglect of the portrait conventions of the time, and it shows how early Rembrandt began to exploit the variety of texture that can be achieved by altering the fluidity of oil paint. Here he used a heavy impasto for the accents of light on his shoulder, neck, and cheek; the grey wall was brushed

61. Rembrandt: *Tobit and Anna with the Kid*, 1626. Amsterdam, Rijksmuseum

in with thin paint; and vigorous scratches into the wet colour with the butt end of his brush were used to depict his wild mane. Such passages anticipate the master's later freedom in handling paint. The result is one of intense realism and romanticism – a combination found frequently in Rembrandt's art.

Lastman's influence persists in the subject pictures painted during the Leiden years, and in Amsterdam upon occasion during the thirties and forties.[4] But he quickly displayed more power than Lastman. Works by the youthful artist already reveal on an intimate scale unmistakable signs of the complete master. This is seen in his small, exceptionally well-preserved picture of *Tobit and Anna with the Kid* of 1626 at Amsterdam [61]. The subject, taken from the Book of Tobit, one of the apocryphal books of the Bible, depicts the moment after blind Tobit unjustly accused his wife Anna of stealing the kid she has brought home, while she stares at him incredulously. Blind Tobit has recognized that his inner blindness made him make his false accusation; he asks for God's forgiveness and begs Him for his death. No painter in Holland could have equalled the humanity and power of perception Rembrandt brought to the story. Meticulous depiction of the poor couple's clothing and room, illuminated by a window and open fire, do not detract from the drama. Neither does Tobit's little dog (it is surely accidental the dog's watchful look seems to foreshadow the mood of some of the artist's early self-portraits).

During the Leiden years Rembrandt was also as much at home with the etcher's needle as he was with the painter's brush. His earliest dated prints, inscribed 1628, already have a radiance and intimacy of effect that exert a miraculous power. Here, too, Rembrandt discovered his way with lightning swiftness. After making a few experiments with the technique in about 1625–6 he was soon able to exploit the potential of the medium with absolute surety and we increasingly feel the graphic charm. By the time he left Leiden for Amsterdam he was the outstanding etcher of Holland.

There is, however, one important category of Rembrandt's later activity which is almost absent in his first period. Rembrandt did not execute portrait commissions until about 1631, his last year in Leiden. Neglect of this genre was in accord with his high ambition to be a history painter, not a mere face-painter. The heads and busts he made in Leiden of old people and interesting characters in fanciful guises were not bespoke portraits. They were made as studies or as finished works to satisfy a demand for portraits of picturesque figures. The Dutch called a portrait of this type a *tronie* (the term also occurs as a synonym for a commissioned portrait; e.g. in the documents related to the controversy over Frans Hals's unfinished *Meagre Company* the term is used to refer to portraits of the guards [48]). *Tronies* could have an allegorical intent as well; those that depict old people praying possibly were made to typify Piety. Printmakers made good use of them too; in the inscriptions on their copies of them they are often baptized with the names of famous and infamous men and women.

Young Rembrandt had an uncommon interest in old people and a keen appreciation for their potentialities for expression, particularly when they were in a meditative mood. Best known are his portraits of the same old bearded man and old woman seen in a number of works of this period. They are

often called Rembrandt's father and mother, but there is no documentary evidence to support the claim.[5] Yet another old bearded man was a favourite model of Rembrandt and his Leiden friend Jan Lievens during these years. He appears as the apostle *St Paul at his Writing Desk* datable about 1629–30 [63], a painting that impresses by its chiaroscuro effect.

From the very beginning Rembrandt used chiaroscuro in his own individual manner. In the works by Caravaggio and his early followers the light and shade are intensely contrasted, and there is little penumbra transition. In their pictures, sharp borders between the illuminated and the shadowed parts create the effect of clear-cut contours, and in consequence of this, figures as well as separate objects stand out with a pronounced sculptural character against a dark and rather spaceless background. In *The Rich Man from the Parable* of 1627 at Berlin [62], which depicts the rich old man examining a coin by the light of a candle, young Rembrandt takes up the problem of the light and shadow produced by the flame of a taper hidden by a hand. Here he was no doubt inspired by Honthorst, who popularized this device. Rembrandt, following Honthorst's example, carefully studied the coloured reflections on the face of the bespectacled man and the other objects near the lit candle. There is, however, a difference in effect between this nocturnal scene by young Rembrandt and any by Honthorst. Rembrandt has already surpassed his model in unifying light and atmosphere throughout an interior. The Berlin picture was traditionally called a genre scene of a moneychanger, and then an allegory of Avarice, which is closer to the mark. It has been more specifically identified with Jesus's story of the foolish rich man, a parable warning against avarice (Luke 12:13–21).[6] The rich man decided to build bigger barns after a particularly good harvest so he could live in ease on what he stored away. But God said to him: 'Thou fool, this night thy soul shall be required of thee: then whose will those things be, which thou has provided?' The moral is clear: 'So is he that layeth up treasures for himself, and is not rich toward God'. The parable explains why the scene is a nocturnal one and the presence of the clock, almost

62. Rembrandt: *The Rich Man from the Parable*, 1627. Berlin, Staatliche Museen

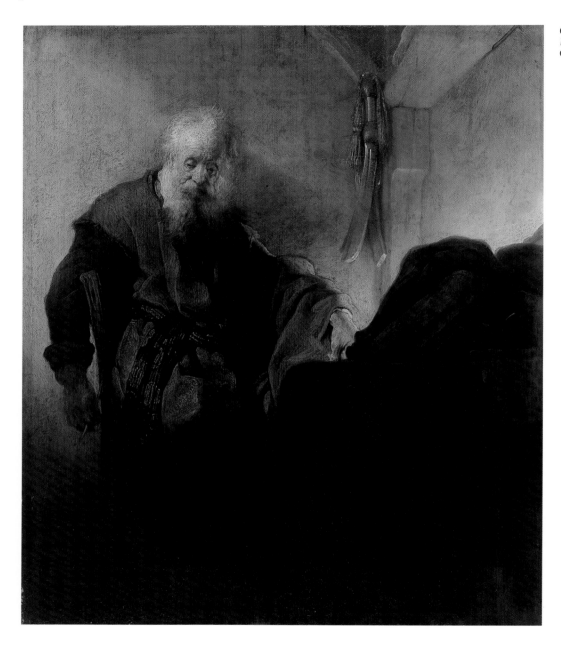

63. Rembrandt: *St Paul at his Writing-Desk*, *c*.1629–30. Nürnberg, Germanisches Nationalmuseum

hidden in the shadows on the left: this night the avaricious rich man's hour has come.

In his *St Paul at his Writing-Desk* [63], painted a few years later, the light and shadow are even more closely interwoven. A fluctuation from the one to the other takes place, producing a tenebrous atmosphere, full of mysterious effect. But more than this is achieved: by the fluctuating light the figure is expressly connected with the surrounding space, and the space itself is drawn into the representation. It becomes a vibrant, living medium. Space and figure in Rembrandt's art now share one inseparable existence and are equally expressive. At this point of his development Rembrandt was already able to use chiaroscuro to give the atmosphere both a visual and a spiritual meaning. Throughout his career, chiaroscuro remained his most powerful means of expression. Of course, there are other important features of his art: his colouristic treatment, his compositional devices; but in a way they are all subordinated to, or in any case co-ordinated with, his chiaroscuro.

During his last years in Leiden Rembrandt's style became finer and more intimate. A subtly diffused, yet dramatic chiaroscuro develops, and cool, delicate colours predominate. In some cases this precious style continues into the early years in Amsterdam. The dimly lit interior of colossal dimensions, the fantastic columns, and deep shadows intensify the mysterious atmosphere of the *Presentation in the Temple* of 1631 at the Mauritshuis [64], but the small figures of the main group gain distinctness by means of the sparkling sunlight which strikes them. The golden halo of the Christ Child who will be 'a light to lighten the Gentiles' makes a source of light within the beam.

Around this time Rembrandt also painted mythological scenes in expansive landscapes with a minuteness of attention recalling Elsheimer's pictures. There is almost the exquisite

64. Rembrandt: *Presentation in the Temple*, 1631. The Hague, Mauritshuis

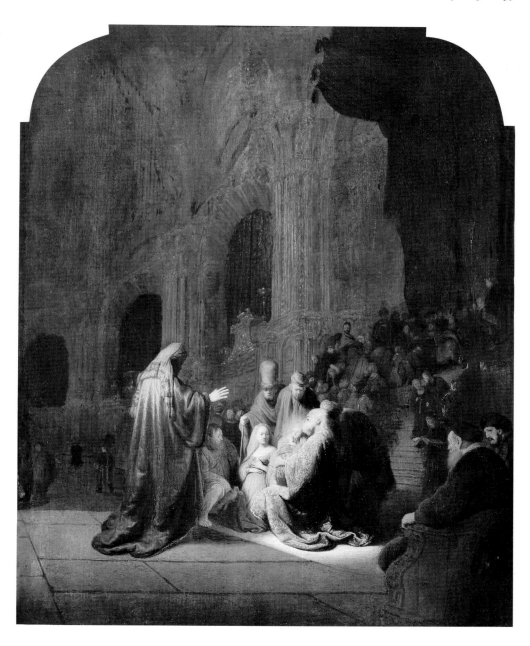

refinement of fifteenth-century Netherlandish painting in these jewel-like works (e.g. *The Rape of Proserpine*, c.1631, Berlin, Staatliche Museen), in which the dramatic possibilities of the Baroque style are still somewhat checked by the very small scale of the figures and the extremely subtle execution. The delicate connoisseur taste of a group of Dutch humanists apparently valued these qualities, and must have been treasured by them as one of the perfections of contemporary art.

A leading figure among this group of art lovers was Constantijn Huygens, secretary to Stadholder Frederik Hendrik, Prince of Orange. Around 1630, Huygens noted in his journal *cum* autobiography that the miller's son Rembrandt and his friend Jan Lievens were on a par with the greatest painters, and would soon surpass them.[7] This was not routine praise. Huygens, a well-travelled, cultivated man who combined a full life of service to his country with a

mastery of the polite accomplishments, was extremely familiar with the art world of his day. It was he who suggested to Rembrandt and Lievens that they should travel to Italy to perfect their art. But neither artist had a desire to go south. Huygens reports that the painters said that now, in the flower of their youth, they had no time for travel, and they did not want to interrupt their work. Moreover, they added, pictures by the finest Italian artists could be seen in Holland. If Huygens's report of their response is accurate, they exaggerated. The quality of the Italian paintings which could be seen in the Netherlands around 1630 was not very impressive. But what is more important, they cared little for classical and Renaissance models during this period of their careers. Young Rembrandt was more attracted by the romantic and the picturesque than he was by a classical ideal of beauty. His predilection is clear in his choice of subjects, his models, the fanciful oriental attire of his subjects, and even his studio

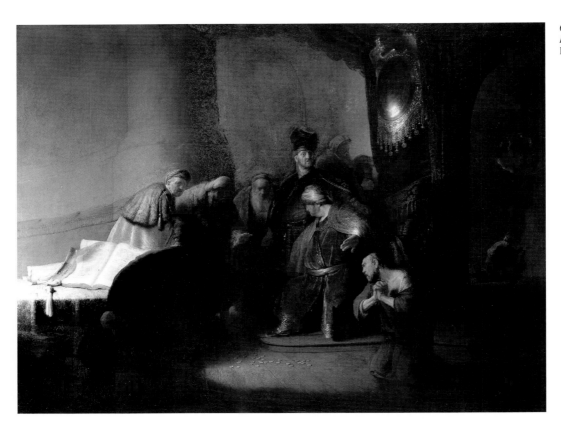

65. Rembrandt: *Judas returning the Pieces of Silver*, 1629. Great Britain, Private Collection

props. He was also interested in the mean and the ugly. Unlike so many of his forerunners, he did not view poor people as quaint or amusing creatures. His early etchings and drawings of beggars represent them as pathetic and suffering. Nothing could be farther away from the classical ideal.

Huygens was keen-eyed enough to appraise the difference between Rembrandt and his gifted friend Jan Lievens. Rembrandt, he wrote, is superior to Lievens in judgement and in the representation of lively emotional expression. Lievens, on the other hand, has a grandeur of invention and boldness which Rembrandt does not achieve. Huygens selected *Judas returning the Pieces of Silver* (1629, private collection) [65] to show Rembrandt's superior ability to convey the expression of emotion in a small, carefully worked-out picture. He wrote at length how impressed he was with Rembrandt's skill in representing expression, appropriate gestures, and movement, particularly in the central figure of Judas, who appears ravaged and convulsed by despair. Huygens applauded Rembrandt's ability to paint biblical pictures, and adds that Lievens would not easily achieve Rembrandt's vivacious invention. Thus Rembrandt won recognition as a history painter even before he left Leiden, from one of the leading figures of his day. Huygens did more than write praise. About this time he almost certainly helped the young artist get commissions from Stadholder Frederik Hendrik for two mythological pictures listed in his inventory of 1632, Berlin's *Rape of Proserpine* (c.1631) and *Minerva in Her Study* (c.1631) also in Berlin,[8] and for a portrait of his wife *Amalia van Solms* (1632; Paris, Musée Jacquemart-André). It must have been with great confidence that he decided to move from his native town to

the principal city of Holland about the end of 1631 or early in 1632.

THE FIRST AMSTERDAM PERIOD 1632–1639

With Rembrandt's arrival in Amsterdam he embarked on the most successful epoch of his life – successful, that is, in the eyes of his contemporaries. He became wealthy, and quickly acquired an international reputation. As his influence on Castiglione shows, his prints had even percolated down to Genoa by 1635. He experienced a kind of social ascent, thanks to his popularity as a portraitist, as a master in the field of biblical and mythological painting, and as a popular teacher. His self-esteem was high. Soon after his move he began his life-long practice of consistently signing his works with only his given name 'Rembrandt' [66], probably in emulation of the Italian Renaissance masters Leonardo, Raphael, and Michelangelo.[9] More than two centuries later Vincent van Gogh adopted the same practice when he signed his works 'Vincent'.

During his first years in the metropolis Rembrandt had close contact with the art dealer Hendrick Uylenburgh who provided him with lodgings, studio space, and probably helped him procure commissions. In 1634 he married Saskia Uylenburgh, the art dealer's cousin, and initially the couple stayed with him. In the same year he bought Amsterdam citizenship and joined the city's St Luke Guild. Saskia came from a respected Frisian family; her father had been pensionary of Friesland's court and mayor of Leeuwarden. The artist's activity as an art collector and dealer probably started about this time, and in 1639 he purchased a large, elegant house for 13,000 guilders which was heavily mortgaged –

66. Detail of Rembrandt's signature on his *Portrait of Maria Bockenolle*, 1634. Boston, Museum of Fine Arts

today it is the museum called the Rembrandt House in the Jodenbreestraat (Jew's Broad Street).

The move to Amsterdam was an important one for his development. It was during his first years there that Rembrandt came into close contact with contemporary High Baroque art, an art in which he finally excelled. Here he discovered the monumental style of Rubens, who had become universally known by the engravings after his work. Now the young Rembrandt dared work consistently on a large scale, and in vigour of realism, as well as dramatic intensity, he soon outdid his Flemish model. It is a case of a man with a tremendous temperament throwing himself upon the ideals

of his time and rapidly assimilating them. Only after he had mastered them did his art begin to take a new direction.

In Amsterdam Rembrandt's portrait production rapidly became prodigious, and there may be some truth to the report that people had to beg him as well as pay him for a portrait. As we have noted, Rembrandt only began to work as a professional portraitist about 1631. His earliest existing dated commissioned portraits (*Portrait of a Scholar*, St Petersburg, Hermitage; *Portrait of the Amsterdam Merchant Nicholaas Ruts*, New York, Frick Collection) are both of that year. The *Anatomy Lesson of Dr Nicolaes Tulp* (The Hague, Mauritshuis) [67] of 1632 shows how quickly he surpassed the smooth technique of the fashionable Amsterdam portraitists Nicolaes Eliasz Pickenoy and Thomas de Keyser. The group portrait of Tulp, appointed *praelector anatomiae* of Amsterdam's surgeon's guild in 1628, and seven of the guild's members probably established his reputation immediately. All potential clients must have been impressed by the new vitality and pictorial richness he gave to the portraits. The picture still impresses us today by the dramatic concentration of the figures on Tulp's demonstration of the dissection of a forearm. The corpse is the focus of the composition, by its intense brightness. From here, the eye of

67. Rembrandt: *The Anatomy Lesson of Dr Nicolaes Tulp*, 1632. The Hague, Mauritshuis

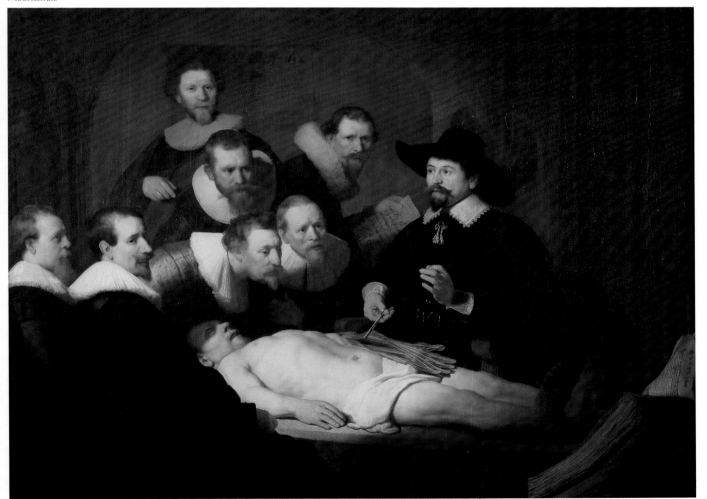

68. Rembrandt: *Marten Soolmans*, 1634. Paris, Private Collection

69. Rembrandt: *Oopjen Coppit*, *c.*1634. Paris, Private Collection

the spectator is led to the illuminated heads of the listeners, whose expressions and attitudes reflect different degrees of attention, and to the face and hands of Tulp, who is a most convincing representation of a scholar absorbed in his subject. With forceps in his right hand Tulp holds the muscles and tendons of the arm that control the movement of the hand, while the bent fingers of his left hand demonstrate an aspect of their wonderous action.[10] The illusionism is enhanced by the vivid characterization of the individuals as well as by the artist's great power in dramatizing the moment within a coherent group. Without the strong chiaroscuro and the fine atmospheric quality that is combined with it, the picture would lose its intensity, the sculptural quality of the forms, and all the excitement of the moment. Here, psychological and pictorial tension combine to create the feeling of an extraordinary event.

In 1632 he also painted his portrait of Amalia van Solms, wife of the stadholder, Prince Frederik Hendrik (Paris, Musée Jacquemart-André); we have already noted that the prince's secretary Constantijn Huygens almost certainly helped him get this important commission. The portrait depicts Amalia in profile seen behind a painted cartouche; it must have been done as a pendant to Honthorst's profile portrait of Frederik Hendrik which fits its dimensions and

uses the same painted framing device (1631, The Hague, Huis ten Bosch). Many of his portraits of the period are companion pieces of husbands and wives. Some are busts, others are half- or three-quarter-lengths; there are also a few full-lengths and double portraits of couples. The high standard of characterization and pictorial execution he maintained while satisfying the taste for a detailed description of elegant clothes with a precise rendering of lace, embroidery, and the black on black designs on the fabrics from which costumes were cut is seen in the life-size, full-lengths of *Marten Soolmans* and his wife *Oopjen Coppit* of 1634, (Paris, private collection) [68, 69]. The pendants were probably painted to commemorate the couple's marriage in 1633, a hypothesis supported by the glove Marten seems to offer his wife which can be related to the tradition of a groom giving his bride a glove to seal a marriage contract.[11] Despite Marten's momentary gesture toward his wife and the forceful perspective used to enhance the illusionism, the connection between the companion pieces is not fully successful. The different perspectives used for the large floor tiles suggest husband and wife are portrayed in different rooms. Their sumptuous clothing also makes it difficult to concentrate on the sensitive portrayal of their character, particularly in Marten's portrait where the dazzling gigantic lace rosettes

that decorate his shoes attract more attention than his head. There are also from this period *tronies* of old men and women, and fanciful portraits of Orientals which are often freer in execution than the commissioned portraits. An excellent example is the *Portrait of an Oriental* (1633, Munich, Alte Pinakothek) [70]. By means of a strong contrast of light and shade, Rembrandt made the powerful head stand out from the pictorial plane with a more pronounced sculptural character than in most commissioned works.

Rembrandt also continued to portray himself year by year. The self-portraits of the 1630s exhibit an air of bold confidence, and some are even aggressive. A few of the etched portraits have a more serious expression, and so does the intense painting of 1634 at Berlin [71] which shows him dressed preciously with his black velvet beret, a silky green scarf, and a fur-trimmed coat. The Baroque element is most obvious now in the forcefully curved silhouette of the figure and the pronounced chiaroscuro effect. By the vertical division of his face into one shadowed and one lit part, he cleverly conceals the inelegant breadth of his face.

In his famous *Self-Portrait with Saskia on his Lap* at Dresden [72], painted a year or two later, husband and wife are turned towards the spectator with an animated expression of gaiety, and the pattern made by the couple has the freshness and irregular lines of a wild flower. The over-rich attire of the figures speaks of an extravagance of taste and a parvenu revelling in luxuriant dress. The colours, however, are delicate and restrained. The red, which is a kind of copper colour, is still somewhat pale; a refined blue and yellows occur too.

The painting was formerly interpreted as an intimate scene of Rembrandt and Saskia celebrating their unrestrained way of living in the intimacy of their home soon after they were married. But it has been convincingly shown that the picture belongs to the well-established tradition of representing the Prodigal Son in contemporary or old-fashioned dress wasting his substance with riotous living. Traditionally this episode of the Parable depicts the Prodigal in a tavern with loose women. We have seen that Frans Hals's so-called *Jonker Ramp and His Sweetheart* [34], painted about a decade earlier, probably represents the same subject and is related to the print used on the title page of W.D. Hooft's *Contemporary Prodigal Son* published in 1630 [35]. In Rembrandt's painting there is no question that the scene takes place in a tavern, not in a home. Proof is offered by the conspicuous tally board hanging in the left corner. It is a score board on which the drinks a customer consumed were marked, a familiar piece of equipment in Netherlandish depictions of pot houses – one is shown in use in the engraving made for Hooft's *Contemporary Prodigal Son*. The tally board can be read as an allusion to the Prodigal's wasted patrimony. The peacock pie in the print can also be seen in the double portrait; since peacocks are tradition symbols of *Superbia*, the peacock pies in these works probably allude to pride, one of the seven deadly sins. Additional support for interpreting the picture as the Prodigal in a tavern is offered by x-rays of it which show that Rembrandt originally painted a young woman playing a lute behind the couple, and later he painted her out. An idea of his original intention for the painted out figure is seen in his vigorous pen and wash drawing at

70. Rembrandt: *Portrait of an Oriental*, 1633. Munich, Alte Pinakothek

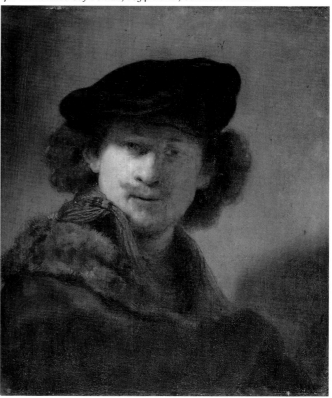

71. Rembrandt: *Self-Portrait*, 1634. Berlin, Staatliche Museen

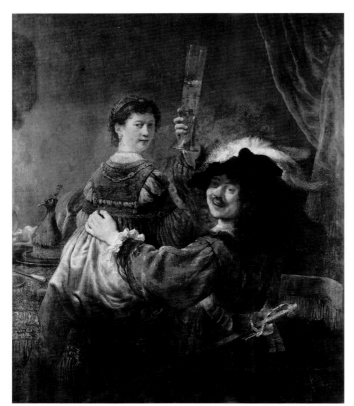

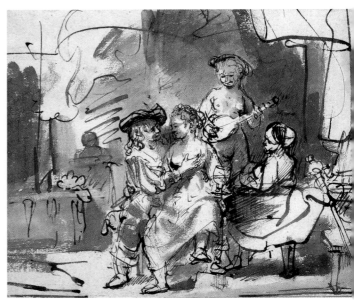

73. Rembrandt: *The Prodigal Son*, c.1635. Drawing: pen and wash. Frankfurt, Städelsches Kunstinstitut

72. Rembrandt: *Self-Portrait with Saskia on his Lap (The Prodigal Son in an Inn)*, c.1635. Dresden, Gemäldegalerie

74. Rembrandt: *The Holy Family*, c.1634. Munich, Alte Pinakothek

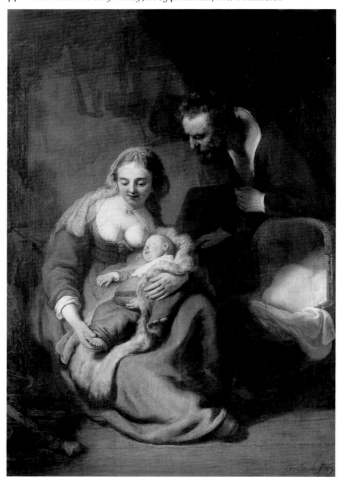

Frankfurt of the same subject, also datable about 1635, that includes a naked woman playing a lute [73]. Although the Dresden painting is more decorous than the Frankfurt drawing and other sketches he made of the theme about the same time, one still wonders why Rembrandt chose to depict himself as the Prodigal and Saskia as a courtesan on his lap. Was it confession that he and Saskia are prodigals, and as he laughingly turns towards us with his glass raised high, inviting us to join the party, was he implying that we too are prodigals in need of grace and forgiveness?[12]

Saskia remained Rembrandt's favourite model from the time of their betrothal on 5 June 1633 until her death in 1642 at the age of thirty. Numerous drawings and etchings give intimate glimpses of the nine years they shared, and they also show her change from a radiant maiden to a sick, frail woman resigned to her exhaustion. Saskia bore four children. None of the first three lived beyond the age of two months. Only the fourth child, the boy Titus (baptized 22 September 1641), lived to young manhood.

The Baroque spirit of this period is most obvious in Rembrandt's biblical and mythological pictures, now often done on a monumental scale. In some cases direct traces of the influence of Rubens can be seen. The celebrated Flemish painter was the idol not only of Flemish, but also of Dutch society at this time. About 1630 Constantijn Huygens called Rubens the greatest painter of the Netherlands – for him, the sharp distinction we make between Netherlandish artists who worked in the north and those who worked in the south did not exist. The picture by the Flemish master, among the many he has seen, Huygens chose to discuss was a horrific Medusa head, which created such terror that it was usually covered with a curtain. Huygens and his contemporaries were fascinated by the representation of the terrible and the

sanguinary, the drastic and the erotic. They delighted in the display of physical strength and vigorous action in art, and praised the glorification of heroic personalities and grand gestures. No artist surpassed Rubens's mastery of all these effects. The large size and the unusual naturalism of Rembrandt's *Holy Family* (Munich, Alte Pinakothek) [74], which can be dated to about 1634, is one of the early indications of Rubens's influence. Rembrandt has chosen a moment when the child has fallen asleep after nursing. As in one of Rubens's paintings, the mother's breast is still uncovered, and Joseph leans over the cradle and watches the scene. The touch is broad and the colours are relatively subdued. The shape of the canvas was altered by another hand after it was painted, particularly on the left side where a relatively wide strip has been removed. There may have been a wood fire on the floor painted on the strip indicating that Mary is not just holding the feet of the Child but warming them.[13]

It was most probably due to Huygens's efforts that Rembrandt received the enviable commission to paint a series of Passion pictures for Stadholder Frederik Hendrik during the 1630s. The five cabinet-sized pictures which make up the series are of the same format and once hung in the Noordeinde Palace at The Hague; all are now in the Alte Pinakothek, Munich. The series began about 1632–3 with *The Descent from the Cross* [75], followed by *The Elevation of the Cross. The Descent* is inspired by Rubens's famous life-size altarpiece of the same subject in the cathedral at Antwerp, known to Rembrandt by the reproductive engraving of Vorsterman. But Rembrandt's masterly arrangement of the figures in space, his treatment of mysterious light and dark shadow, and his incisive realism, which does not shrink from brutal veracity, have completely transformed the Flemish master's conception. Rembrandt's picture is closer in spirit to Caravaggio than it is to Rubens. The artist daringly pushed the main action back to the middle distance, where supernatural light breaks the darkness and illuminates the central group. The body of Christ is a pitiful dead mass, sinking down on the shoulder of a supporter, instead of a heroic body with beautiful outlines, and the individual faces are different from the ideal types Rubens used. Rembrandt deepened and intensified the realistic content of the scene by sharp individual characterizations of the emotional reaction of the men devoutly concerned with the painful and complicated task of lowering the corpse. In his *Elevation of the Cross* Rembrandt introduced an extraordinary note; he portrayed himself as an active participant in the event. The face of the man in the centre helping raise the cross is unmistakably his own.

We know from a letter that Rembrandt sent to Huygens in 1636 that the prince asked the artist to paint three additional scenes from the Passion (an *Entombment*, a *Resurrection*, and an *Ascension of Christ*) after he had received the *Descent from the Cross* and the *Elevation of the Cross*. Only six other letters written by Rembrandt are known,[14] and, like the first, they are addressed to Huygens and are mainly concerned with matter-of-fact business affairs pertaining to the Passion series. None of Huygens's letters to the artist have survived but it is clear from one of Rembrandt's letters that Huygens must have complained late in 1638 or early in 1639 that it was

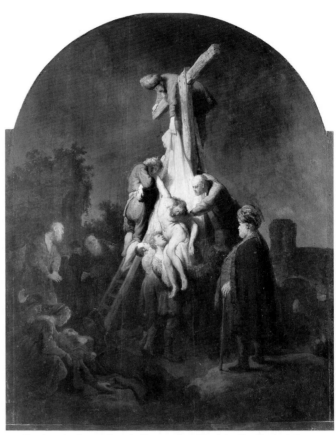

75. Rembrandt: *Descent from the Cross*, *c.*1633. Munich, Alte Pinakothek

high time that he finish the *Entombment* and the *Resurrection* [409]. Rembrandt's letter written on 12 January 1639 gives his reason for the delay and includes a passage on what he tried to achieve: 'In these two pictures the greatest and most natural emotion and animation have been observed, which is also the principal reason why they have been so long in the making.' The brief phrase 'the greatest and most natural emotion and animation' (*die meeste ende die natureelste beweechgelickheijt*) is a precious one. It is the only known remark by the artist himself about the intent of his work.

The prince must have been satisfied with the five Passion pictures since in 1646 he paid for two paintings that were added to the group: a nocturnal *Adoration of the Shepherds*, dated 1646, now at Munich, and an untraceable *Circumcision*, known today from a copy in the Herzog Anton Ulrich-Museum, Braunschweig.[15] Rembrandt's price for each picture was 1,200 guilders, but he received that sum for only the last two. For the other five he was paid half his asking price.

The story of Samson, which had a great attraction for the Baroque public, is prominent in Rembrandt's production during the thirties. He painted *Samson threatening his Father-in-Law* (1635, Berlin, Staatliche Museen) and the *Marriage of Samson* (1638, Dresden, Gemäldegalerie). His *Blinding of Samson* of 1636 at Frankfurt [76] more than any other work shows Rembrandt's unrivalled use of the High Baroque style to appeal to his contemporaries' interest in the sensational. Perhaps it is the life-size painting Rembrandt mentioned in a letter to Huygens that he was presenting to him both in

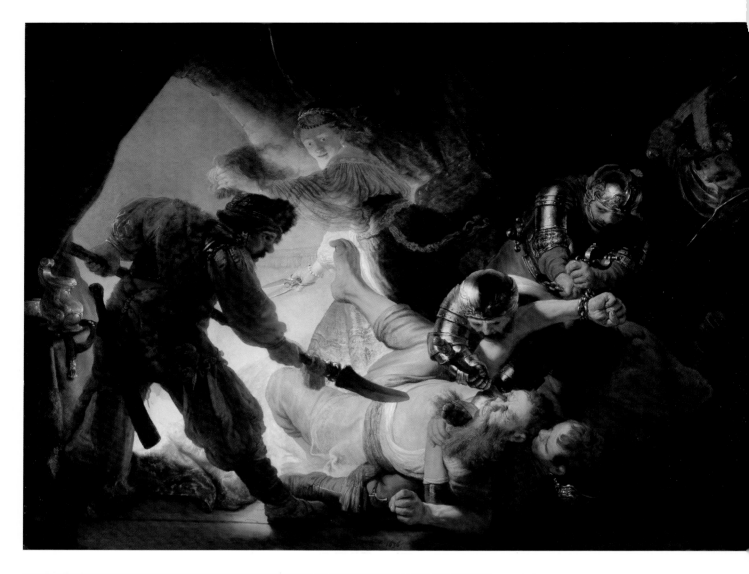

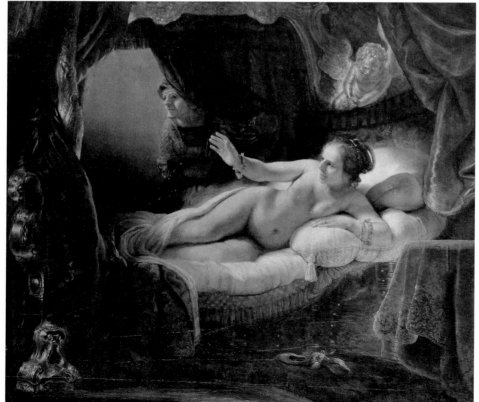

76. Rembrandt: *Blinding of Samson*, 1636. Frankfurt, Städelsches Kunstinstitut

77. Rembrandt: *Danaë*, 1636 (state of the painting before June 1985). St Petersburg, Hermitage

friendship and as payment for services rendered in connection with the Passion series – did he know about Huygens's interest in pictures so horrific they had to be covered with curtains? In a postscript to his letter Rembrandt added: 'My lord, hang this piece in a strong light so that one can stand at a distance from it; then it will show at its best.' The short sentence is noteworthy: Rembrandt gave instructions on how to hang a picture, not how to look at one.

If Rembrandt sent Huygens his *Blinding of Samson*, he gave him his most gruesome and violent work. It represents the bloody climax of the story. Samson has been overwhelmed by one of the Philistines, who has the biblical hero locked in his grip. Samson's right hand is being fettered by another soldier, and a third is plunging a sword into his eye, from which blood rushes forth. His whole frame writhes convulsively with sudden pain. The warrior standing in front, silhouetted against the light in the Honthorst manner, has his halberd ready to plunge into Samson if he manages to free himself before the hideous deed is done. Delilah, with a look of terror mixed with triumph, is a masterful characterization seen in a half haze, as she rushes to the opening of the tent. Here again the chiaroscuro adds an element of mystery and pictorial, as well as spiritual, excitement. The whole scale of light, from the deepest shadows to the intense bright light pouring into the tent, has gained in power and gradations over the works of the Leiden period. The scene could not have been represented with more dreadful accents, and Rembrandt may have finished it with the triumphant feeling of having surpassed Rubens's dramatic effects, for this picture was also inspired by a work of the Flemish master: *The Capture of Samson* now at Munich (a painting designed by Rubens and executed by a studio assistant). Rubens chose to represent the moment when the Philistines invade the tent with torches and have caught hold of Samson as he rises from his couch. The herculean giant struggles against his tormentors and Delilah watches the success of her treachery with undisguised joy. But even in the most tense situations Rubens remained faithful to the classical ideals of the beautiful and the heroic.[16] For Rembrandt, the moment of the Samson story chosen by Rubens was not violent enough. At this point of his career Rembrandt knew no restraint and did not shrink from the horrible or the bizarre. However, Rembrandt did not continue to exploit this aspect of the Baroque for very long. He never represented this episode of the Samson saga again. The *Marriage of Samson* (Dresden, Gemäldegalerie) painted two years later shows a happier moment in the life of the Old Testament hero, and there are already indications in it of a softer pictorial atmosphere.

Among the mythological subjects, the *Rape of Ganymede* (1635, Dresden, Gemäldegalerie) and the *Danaë* (1636, St Petersburg, Hermitage) [77] are outstanding examples of Rembrandt's sense of high-pitched drama and expressive chiaroscuro. Both these pictures, done on a monumental scale, are of extreme originality and uncompromising realism. There have been various suggestions about the subject of Rembrandt's life-size nude reclining on a bed, but there is no reason to think that the traditional title of Danaë is incorrect.[17] Unlike Goltzius's beautiful depiction of the subject done in 1603 [7], Rembrandt follows tradition and

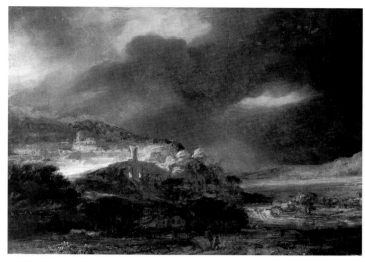

78. Rembrandt: *Stormy Landscape*, c.1637–8. Braunschweig, Herzog Anton Ulrich-Museum

shows Danaë awake, not asleep. The servant draws the curtain back as if in expectation of a visitor. The fettered crying Cupid decorating the bedstead is an obvious allusion to the heroine's story. The bound Cupid, a symbol of chastity, alludes to the life-time confinement in a tower to which the maiden Danaë was condemned by her father because an oracle prophesied that if she bore a son he would murder him. Rembrandt made a radical innovation in his painting on the theme. For the traditional shower of gold coins indicating Jupiter's arrival he substituted golden light to allude to the god's entry. The golden light becomes a key part of the story as it glorifies the body of the young woman and lends warmth and brilliance to the painting which is relieved of an oppressive sensuousness by its pictorial beauty. Until it was horribly damaged in 1985, it was the most attractive painting of this period.[18] Its Baroque character is evident in the undulating rhythm of the soft forms of the nude, which are exposed only for a moment. It is also evident in the curvilinear design of all the other objects, the rich surroundings, the decoration of the bed, and the dramatic manner of illumination. The key of the whole composition is the woman's outstretched hand, which is beautifully illuminated by reflections. It is of the greatest significance for the spatial and pictorial organization of the picture, for it defines the intermediary plane between the nude and the background, and it relates the various light accents to a coherent design. The gesture also has psychological significance: more instinctive than conscious, it can be interpreted as a gesture of invitation for her approaching lover as well as one of protection against the blinding light.

Rembrandt began painting landscapes after the middle of the 1630s. His work in this important branch of Dutch painting is a very small part of his *œuvre*. Today less than ten are attributable to him.[19] But we know he must have painted at least a few more. His 1656 inventory lists eleven, some of which are not identical with those that have survived. Among them four are listed as done 'from life' (*naer 't leven*); only one or two of the known ones seem to qualify as paintings of this type [see 81], and they cannot be pinpointed in the inventory. His other existing painted landscapes belong

to a different category. They are imaginary panoramic views of broad valleys and mountain ranges, gigantic trees, fantastic buildings and ruins in which the influence of Hercules Segers is obvious. Characteristic of them is his *Stormy Landscape* of about 1637–8 at Braunschweig [78]. In this dramatic view with deep emotional overtones, threatening storm clouds, pierced by bursts of warm sunlight, fill the land with darkness. Here Rembrandt imposes his brilliant Baroque imagination upon nature. The drama of the chiaroscuro does not describe meteorological conditions, but embodies Rembrandt's reaction to the mysterious forces of the sky and the earth. Something of Rubens's exuberant response to nature can be felt, but Rembrandt's landscapes are always more mysterious and less colourful than those of the Flemish master. The colour remains fairly subdued, with a few brilliant contrasts of golden yellow and browns against greens, pinks, and greys.

The bulk of Rembrandt's landscape production, which is found in his etchings and numerous drawings, sets in only about 1640. These works offer a naturalistic treatment of nature, and some of the sites he depicted in them have even been identified, thanks to Frits Lugt's ingenuity.[20] By the 1640s we sense that Rembrandt must have felt that there was something theatrical and pompous in the High Baroque mode. In any event, during the course of the forties he abandoned it.

THE MIDDLE PERIOD 1640–1647

Even the greatest artist remains somewhat bound within the framework of his or her time, and within the general lines of the stylistic development of the period. Rembrandt is no exception. His work and development can be classified with the international development of Baroque art which is marked by its path from the flamboyant High Baroque of the second quarter of the century to more classicistic achievements. Rubens is the most outstanding figure of the former, Poussin is representative of the latter. Rembrandt develops from one style to the other. This statement, however, only indicates in a very general way his position in the history of seventeenth-century art. For a fuller understanding we must try to discern his individual achievement in both these phases. This has been attempted in the discussion of Rembrandt's work of the 1630s. It is more difficult with his production of the forties, because at this time Rembrandt is much more unusual than he was at the beginning of his career, and it will be still more difficult in his last phase.

For the artist the years from 1640 to 1647 are a time of transition. At first the Baroque and classical tendencies run side by side and interpenetrate, but finally, about 1648, the latter gain precedence. It goes without saying that Rembrandt never became a classicist, but we shall see that during the forties he accepted certain classical devices which give a more adequate expression to his new mood than the exuberance of his earlier style. But the Baroque character is not eliminated: it lives on in a deepened chiaroscuro and an increasingly fluid painterly treatment. This formal development is paralleled by an emotional change from ostentatious loudness and dramatic violence to stillness and calm. Tragic experiences in Rembrandt's life during this period – the

death of his wife Saskia in 1642 and his decreasing popularity – are generally considered responsible for the artist's turn to the introspective, to a greater intimacy of feeling, and to a deepening of religious content. These events may have had some influence on his development – although it should be emphasized that the importance of these events for his attitude toward his art during this decade are difficult to measure and his loss of patronage can be exaggerated.

For example, there is not a scrap of evidence to support the seemingly indestructible myth that the men who commissioned the *Night Watch*, completed in 1642, condemned it. Of course there is no question that in this painting Rembrandt's tremendous imagination broke the traditional way of representing a civic guard company; but we lack any proof that his patrons were dissatisfied and refused to accept it. On the contrary, contemporary records prove that Rembrandt was handsomely rewarded for it. Sixteen of the men who figure in the group portrait paid him on the average of 100 guilders. Thus he received about 1,600 guilders for the painting, and since we know that the work includes eighteen commissioned portraits he probably was paid more. It also is known that the *Night Watch* was never hidden in some obscure place. It hung in the great hall of the new wing of the Kloveniersdoelen where six of Amsterdam's civic guard companies met for festive events and for target practice at an adjacent shooting range. It was exhibited there with five other civic guard pieces and a group portrait of the governors of the Kloveniersdoelen expressly commissioned to decorate the hall. It hung there until 1715, when it was moved to the town hall of Amsterdam. The picture was trimmed to fit its new location; a terrible, but not an unusual fate for works of its dimension. Moreover, Rembrandt continued to receive important commissions after he had painted the *Night Watch*. We have heard that in 1646 Stadholder Frederik Hendrik paid him 2,400 guilders for small pictures of the *Adoration of the Shepherds* (1646, Munich, Alte Pinakothek) and the *Circumcision*, now lost. The fee the stadholder gave the artist was a good one if one considers what he was paid for the *Night Watch*. We shall also see that Rembrandt continued to have important patrons at home and abroad during the last decades of his life.

What then was the case? Did Rembrandt have an appreciative public and ample reward for his genius during his middle and mature years? The answer is no. The legend about the refusal of the *Night Watch* veils a truth. During the forties and his final decades Rembrandt did not enjoy the success he had as a young painter. A shift in the appreciation of his work by his contemporaries did take place. But the *Night Watch* did not cause it, and the alteration was neither as dramatic nor as complete as some of his romantic biographers have maintained.

A change of taste began in Amsterdam during the 1640s, when the bright colours and elegance of Van Dyck came into fashion, and many of Rembrandt's former pupils and imitators followed this path with success. The new vogue must have made the dark manner of Rembrandt's pictures look old-fashioned. The fact that the painter was now approaching the ripeness of middle age, which generally brings a more objective, calmer, and more comprehensive outlook upon life, should not be overlooked: it helps to explain his increased

79. Rembrandt: *Six's Bridge,* 1645. Etching

80. Rembrandt: *View on the Bullewijk looking towards Ouderkerk, c.*1647–50. Drawing: pen, wash, some white body-colour. Chatsworth, Duke of Devonshire and the trustees of the Chatsworth Settlement

81. Rembrandt: *Winter Scene,* 1646. Kassel, Staatliche Kunstsammlungen

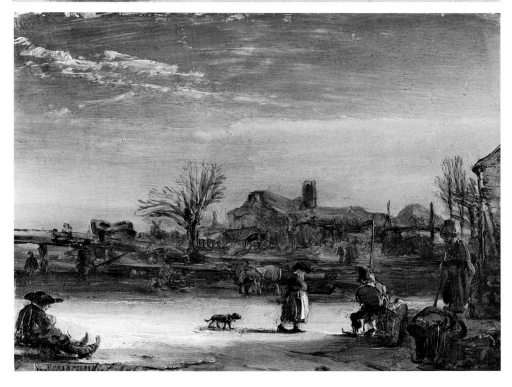

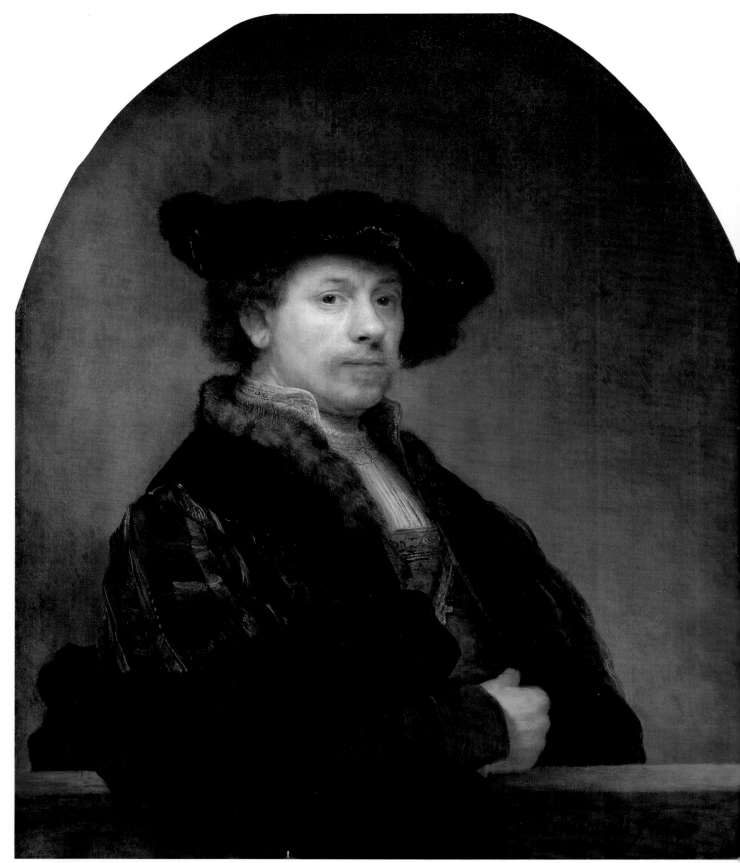

82. Rembrandt: *Self-Portrait leaning on a Stone Sill*, 1640. London, National
Gallery

subtlety of feeling during this period. Rembrandt sought and began to find ways to establish the mood of a picture by more sensitive pictorial treatment of chiaroscuro, atmospheric effects, and colour. He became more concerned with man's inner life than his outer actions. Not many of his contemporaries were prepared to follow him on this road, but Dutchmen still considered him one of their greatest masters, and Rembrandt's name continued to come easily to the lips of those of his countrymen who wanted to make a show of their knowledge of the arts.

Rembrandt began a more intimate study of landscape in his graphic work during these years. This new preoccupation seems to have given him a broader outlook. He roamed around the environs of Amsterdam, where he made drawings and etchings which capture the breadth of the Dutch plain and the brightness and airiness of the Dutch sky with an unprecedented economy of touch. An example of Rembrandt's masterly landscape etchings of the period is the so-called *Six's Bridge* of 1645 [79]. There is a tradition that Rembrandt made it in the neighbourhood of Burgomaster Jan Six's country house as the result of a wager that he would be able to finish it during the time a servant was sent to fetch mustard for a picnic. The story is almost certainly an invention, but the fact that Rembrandt succeeded in showing all the essential features of a landscape with the utmost brevity cannot be denied. Even the wind in the air is expressed by his suggestive touch. The numerous landscape drawings made during the forties are equally impressive. They are mostly pen-and-brush studies expressing the spaciousness, the diaphanous atmosphere, and the shimmering light of the homely Dutch countryside with matchless sensitivity [80]. The late landscape drawings grow bolder, the technique becomes more summary, and structural features are stressed without loss of luminosity or atmospheric effect. An unique naturalistic painted landscape dates from the middle period. It is the outstanding tiny *Winter Scene* of 1646, now at Kassel [81], which has the spontaneity and freshness of the etchings and drawings after nature and seems to be a direct study of the effects of cold air and winter light. Although it is not cited in the artist's 1656 inventory, it qualifies as the type of landscape the compiler characterized as done 'from life'. It could hardly differ more from Rembrandt's imaginary landscapes of a visionary character.

Substantial things came out of Rembrandt's experience with nature. The softer chiaroscuro of the forties was probably formed upon his open-air studies, and their atmospheric qualities soon appear throughout his work. Even the portraits begin to gain in spaciousness and transparency of tonality, and in so doing they show a deeper understanding of the sitter within his environment. The *Self-Portrait leaning on a Stone Sill* of 1640 (London, National Gallery) [82] shows the new mood of the period as well as the new stylistic tendency. The artist still represents himself in precious attire, as he did formerly. He wears a richly embroidered shirt and an old-fashioned, heavy fur-trimmed velvet coat. More important, however, is the seriousness and reserve of the man who has abandoned all signs of sensational appeal to the spectator. The illumination serves to achieve a more objective rendering of his face. The arrangement of the

figure is also changed. It is no longer close to the front plane, but recedes behind a stone sill. The figure has a firmer outline and can almost be inscribed into a pyramid-like shape having the sill as a base. Instead of stressing the sweeping curvilinear silhouettes of the 1630s, here Rembrandt repeatedly emphasized the horizontal: in the sill, the position of the arm leaning on it, the main accent of the face, and even the position of the cap. These repeated horizontals lend the picture stability, firmness, and calm. This, as we have mentioned, is the period when classical influence makes a pronounced appearance in Dutch painting, and in this particular portrait we know of definite links with Italian Renaissance art. There are reminiscences of Raphael's portrait of *Baldassare Castiglione*, now in the Louvre, which Rembrandt had seen at an auction in Amsterdam in 1639. He made a quick pen sketch of it (Vienna, Albertina) and noted the price the picture fetched, as well as the total amount of the sale. In the same year Rembrandt based an etched self-portrait on that sketch (Bartsch 21), but the London *Self-Portrait* of 1640 comes closer to the essence of Raphael's style than either the immediate sketch made after the Castiglione portrait or the etching. The buyer of Raphael's painting at the Amsterdam auction in 1639 was Alphonso López, who worked as an agent in Holland for the French crown. In 1641 López also owned Titian's so-called *Ariosto* (London, National Gallery) and *Flora* (Florence, Uffizi). There can be little doubt that Rembrandt had a chance to study both these pictures, as well as the Raphael. Titian's so-called *Ariosto* was as important as Raphael's *Castiglione* for his etched self-portrait of 1639 and the London picture of 1640: the leaning posture on the sill and the prominence of the sleeve in both works are derived from it. As for López's *Flora* by Titian, distinct traces are in Rembrandt's lovely *Portrait of Saskia with a Flower* of 1641 (Dresden, Gemäldegalerie).[21]

Self-portraits are not very frequent during the middle years. After depicting himself as a *gentilhomme* in his etching of 1639, he does not etch another self-portrait until 1648, and in it he is portrayed as an artisan-burgher at work on a plate (Bartsch 22). The few painted ones that follow the 1640 London picture are reserved and restrained, apart from the *Self-Portrait* of about 1645 (Karlsruhe, Kunsthalle) where some Baroque features seem to be revived in the picturesque clothing of the artist, who even decorates himself with pearl earrings. The romantic vein in Rembrandt's art never completely disappears. Again and again he wishes to see himself or his subjects in a world of fantasy and of higher pictorial beauty.

Saskia died in 1642. Rembrandt's etching of her datable to the same year (Bartsch 359) renders her illness with almost clinical detachment. In her testament Saskia made Rembrandt guardian of Titus, their only surviving child, and gave him control over her whole inheritance, stipulating that if he remarried he must transfer it to Titus. Her testament's terms were neither vindictive nor unusual. Why should a second wife, not her son, receive the benefits of her assets? In the event, we know that after Saskia's death Rembrandt had liaisons with two women. He did not marry either. The first was Geertje Dircx, a ship trumpeter's widow who entered the artist's household in about 1642, the year Saskia died, as

Titus's wet nurse. Geertje became Rembrandt's common-law wife. In about 1647 Hendrickje Stoffels appeared on the scene and by 1649 probably was his mistress. The new arrangement infuriated Geertje. In 1649 she and Rembrandt had a bitter separation. The end of the affair, which shows the artist was not a paradigm of virtue, and the artist's subsequent relationship with Hendrickje are discussed in the following section on the artist's final decades.

During the year of Saskia's death Rembrandt finished his most famous and largest existing picture, the *Night Watch* [83]. The correct title of this masterwork, now the centre-piece of the Rijksmuseum, is *Officers and Men of the Company of Captain Frans Banning Cocq and Lieutenant Willem van Ruijtenburgh*. Its popular title is based on a false interpretation by early-nineteenth-century critics. The picture represents a day, not a night scene. This became very clear when the colossal painting was cleaned and stripped of its dark varnish and dirt shortly after the Second World War. At that time it was promptly baptized 'The Day Watch'. But there is no foundation for that title either. The civic guards represented did not go out on day or night watches. However, the misinterpretation is understandable because of Rembrandt's brilliant transformation of the traditional Amsterdam group portrait into a highly animated, unified composition, and before the picture was cleaned the forceful chiaroscuro gave it a nocturnal effect.[22]

Rembrandt's dynamic interpretation raises an insignificant event to a historical spectacle of extraordinary pictorial splendour. There is a maximum of action, with complex motion deeply set into space yet vigorously united by a dramatic chiaroscuro with intense colour accents. Light and shadow are powerfully contrasted, and in different degrees. Most effective is the centre group of Captain Cocq and Lieutenant Ruijtenburgh who appear to be striding out of the picture. From an inscription on a contemporary water-colour copy of the painting made for Cocq's personal album (private collection, on loan to the Rijksmuseum) we know that the captain is giving his lieutenant orders to make his men march. Not long after the painting was completed the names of eighteen members of the company depicted were inscribed on a large cartouche added by an anonymous hand to the archway as if it were hanging from the cornice. Most of these men can be spotted without difficulty. But Rembrandt gave his patrons much more. In addition to portraying them, he enriched the group's portrait by adding more than a dozen extras, including the prominent girl (and a glimpse of another one) running in the middle ground, a drummer, a scampering powder boy wearing a man's helmet that comes down to the tip of his nose, and in the distance, to the right of the prominent ensign bearing the company's flag, a fragmentary self-portrait. The captain and his lieutenant are the focus of the colouristic arrangement. A brilliant lemon-yellow in the uniform of the lieutenant, a warm orange-red in the sash, and a deep black in the suit of the captain form the main colour accord. The red is repeated in the full-length figure of the guard on the left, muzzle-loading his caliver, an early type of musket, and in the guard on the right, cleaning the pan of his weapon by blowing upon it. The brilliant yellow recurs in the spotlighted girl in the middleground; her contemporaries would have recognized

that the claws of the fowl she bears at her waist allude to the Calivermen – their emblem was the claw of a bird of prey. There are also some tints of blue, green, and golden olive, and the whole background shows a golden olive-brown tone.

The impression of increased activity by an unprecedented variety of movement and direction in the *Night Watch* represents a revolutionary conception of a traditional subject in Dutch painting. It is easy to understand why Rembrandt's pupil Samuel van Hoogstraten singled it out for special mention when he discussed the subject of composing pictures in his *Introduction to the Advanced School of Painting* (*Inleyding tot de hooge schoole der schilderkonst*), a handbook published for artists and dilettanti in 1678. Hoogstraten had an opportunity to study the painting in the new assembly hall of the Kloveniersdoelen where it hung with other group portraits of guards who used the *doelen* (for Bartholomeus van der Helst's civic guard piece that was also mounted there see fig. 347). By 1678 Hoogstraten had abandoned aspects of Rembrandt's manner that appear in his early work and was no longer a great admirer of his style. Nevertheless, when he wanted to tell his readers that true masters must unify their pictures and not place figures next to each other in a row, as one sees in so many Dutch guard portraits, he wrote Rembrandt achieved unification excellently in his piece at the *doelen*, and it 'will outlive all its competitors, being so painterly in conception, so daring in invention, and so powerful that, as some people feel, all the other pieces there stand beside it like decks of playing cards'. Hoogstraten also informs us that some of his contemporaries were well aware of the extra figures Rembrandt added to the *Night Watch* when he notes that many believe the artist overdid it by making more work out of the large picture by depicting more than the individual portraits he was commissioned to portray. And Hoogstraten himself expressed a reservation about Rembrandt's achievement. We can almost hear him sigh when he concluded his passage with 'I still wish he had lit more lights in it'.[23]

The Baroque effect of the *Night Watch* must have been even greater before the composition was cut on all four sides. The contemporary copy of it in Captain Cocq's album and another by Gerrit Lundens (1622–after September 1683), on loan to the Rijksmuseum from the National Gallery, London, show that the greatest loss was on the left, where two additional men and a child behind a parapet were once visible. In its original state the impression must have been of a much greater spaciousness around the figures, with a wider range of chiaroscuro, better organizing the composition and lending it greater recession as well as dramatic pictorial life. A comparison with the *Anatomy Lesson of Dr Tulp* of a decade earlier shows the advance Rembrandt had made, and the change of style. The different character is not only conditioned by the greater multitude of figures: a new and more complex spatial and pictorial design is involved. Its spatial design is also more clearly thought out. The ground plan reveals a zigzag formation, a familiar Baroque device to lead the eye forward and back into space. As for the arrangement in depth, a succession of four planes constitutes the framework. This is most clearly distinguishable in the area where the composition opens up towards the brightly illuminated figure of the running little girl on the left. The first plane is marked by the glove that dangles from

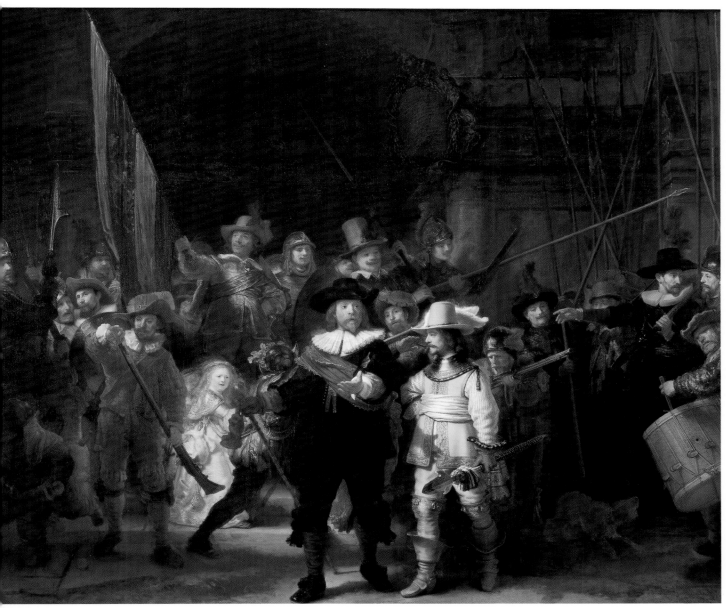

83. Rembrandt: *The Night Watch*, 1642. Amsterdam, Rijksmuseum

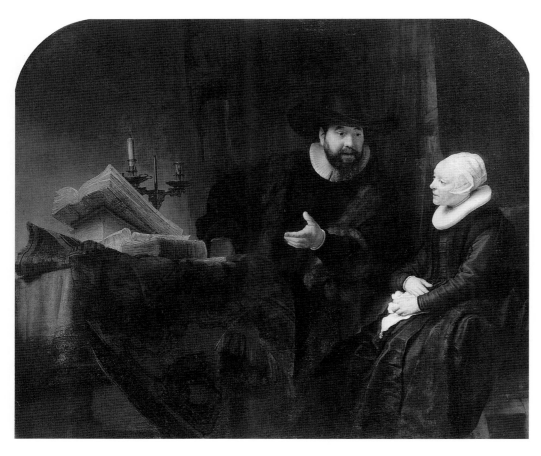

84. Rembrandt: *The Mennonite Preacher Cornelis Anslo and his Wife Aeltje Gerritsdr Schouten*, 1641. Berlin, Staatliche Museen

85. Rembrandt: *Nicolaas van Bambeeck*, 1641. Brussels, Musées Royaux des Beaux-Arts

86. Rembrandt: *Agatha Bas*, 1641. Collection of H.M. Queen Elizabeth II

Captain Cocq's outstretched hand; the second by the guard loading his caliver and the darting powder monkey at his side; the third by the little girl; and the fourth by the ensign above and behind her. Rembrandt has left no doubt about the extension of these four planes to either side, or their relation to one another, while in the *Anatomy Lesson* such spatial clarity is not attained. With it goes a higher compositional order, in which we should not overlook, in spite of the predominantly Baroque character, the slight classicistic elements that come into the composition through the threefold division of the architecture in the background. It sets the group off on either side from the advancing stream of men in the centre.

Another picture of the beginning forties on a monumental scale is the life-size portrait of the *Mennonite Preacher Cornelis Anslo and his Wife Aeltje Gerritsdr Schouten* (1641, Berlin, Staatliche Museen) [84]. Rembrandt represented the preacher talking to Aeltje who holds a handkerchief in her hand. Apart from the exquisitely rendered heads and hands the handling is broad. The vantage point is low, indicating that the portrait was intended to hang high in wealthy Anslo's large home (Rembrandt's celebrated group portrait of *The Syndics* of 1662 has a similar low viewpoint [109]). A great Bible lies open on the table together with other books and a candle; this still life, comprising a third of the picture, is distinguished by a fine play of light and shadow in golden brownish tones above the warm red of the tablecloth. On the other side, the most intense light is given to the head and hands of Aeltje. Rembrandt shows her under the spell of her husband's words. It is a brilliant characterization of a person

absorbed in thought. In his portrayal of Anslo Rembrandt seems to have painted the kind of 'speaking portrait' which impressed his contemporaries so very much; he has suggested the power of Anslo's speech as well as giving a likeness. Rembrandt apparently has accomplished precisely what Vondel, Holland's greatest seventeenth-century poet, admonished him to do in a quartrain he published in 1644 about a portrait by the artist of Anslo:

> O, Rembrandt, paint Cornelis's voice
> The visible part is the least of him:
> The invisible is perceived through the ears alone.
> He who would see Anslo must hear him.

Vondel's epigram, equally applicable to both the Berlin double portrait and to the artist's etching of Anslo done in the same year (Bartsch 271), has been reasonably interpreted as an expression of the literary tradition of the superiority of the spiritual, imperishable word over images which decay.[24]

We have noted already that commissioned portraits were less frequent during the forties. Those from the beginning of the decade excel by their elegance and the golden warmth of their tonality. The companion pieces, each dated 1641, of *Nicolaes van Bambeeck* (Brussels, Musées Royaux des Beaux-Arts) [85] and his wife *Agatha Bas* (Collection of H.M. Queen Elizabeth II) [86], show how he began to soften the chiaroscuro effect. The compositional scheme used for Nicolaes's portrait, especially the strong horizontal accent made by his right arm, recalls the pose Rembrandt used for his *Self-Portrait* of 1640 in London [82]. But Nicolaes's arm is not set on a painted sill or parapet. It is resting on the

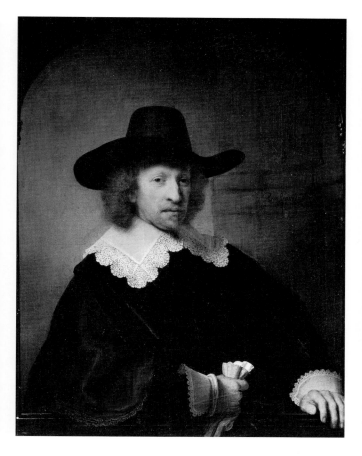

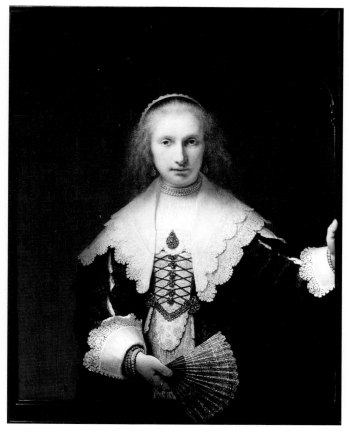

lower edge of the painted frame Rembrandt provided for the portrait to heighten the illusionistic effect, and to heighten it even further he depicted his patron's cloak and glove projecting beyond the painted frame and his left hand on it. A cautionary note: until the thick coat of discoloured varnish that has painfully obscured the qualities of the portrait for more than half a century has been removed, it will be easy to miss these devices when confronting the original in Brussels. On the other hand, Rembrandt's intent is clear in the almost miraculously well-preserved portrait of Agatha in the Royal Collection which is not veiled by a discoloured surface coating. Here it is patent how subtly Rembrandt used *trompe l'œil* effects. Nothing is overdone. The illusionistic black ebony frame has only a few accents of light on its simple moulding; one of Agatha's hands grasps a side of it and the fan held in her other hand appears to extend beyond it into the viewer's world. Painters working in Rembrandt's time as well as long before he was active used similar tricks. Pliny tells the tale of the competition between the two ancient Greek painters Zeuxis and Parrhasios to determine which artist was the greatest. Zeuxis painted grapes that were so realistic that sparrows came to peck at them. His competitor then took Zeuxis to his studio and asked him to pull back the curtain covering a painting. Zeuxis tried but failed. Lo and behold, the curtain was painted! Zeuxis then acknowledged Parrhasios's superiority. A painter who could deceive a man was greater than one who merely takes in birds.

Rembrandt's marvellous portrait of Agatha and her rich costume introduces something new (and most probably the Brussels portrait will show it too after its discoloured varnish

has been removed). Agatha has been placed precisely where the transition between light and shade occurs. The space she occupies and the transparent atmosphere and circumambient air that surround her are lighter than the painted world in front of her. Chiaroscuro has not only lost its hardness; it creates a broader and more intimate union between figure and space. The soft atmosphere is characteristic of the period and, as often happens, in the following decades.

Whether he deals with the Holy Family or episodes from Christ's childhood or from the Old Testament, Rembrandt's biblical representations during this phase show in general a preference for quiet, intimate, and tender scenes. Drama is not excluded (*Susanna and the Elders*, 1647, Berlin, Staatliche Museen), but the emphasis is shifted from outward action to inward reaction. Landscape settings often widen the scene and contribute to the expressive mood. This trend is announced in the *Visitation* of 1640 at Detroit [87]. Mary has crossed the mountains, and the happy moment of her arrival at the house of Zacharias and Elizabeth is represented. A black servant takes off the mantle of the visitor. Aided by a boy, old Zacharias lumbers down the stairs of his great house to greet his wife's cousin, and a friendly dog sniffs at the newly arrived guest. The intense light which falls upon Mary and Elizabeth focuses attention upon the glances exchanged by the pregnant women, and the dark shadows soften the realistic detail. It is a beautiful example of Rembrandt's easy, unburdened way of telling a story.

The Holy Family and other representations of the childhood of Christ occur frequently during the forties. Domestic happiness and intimacy are their dominate mood. The *Holy*

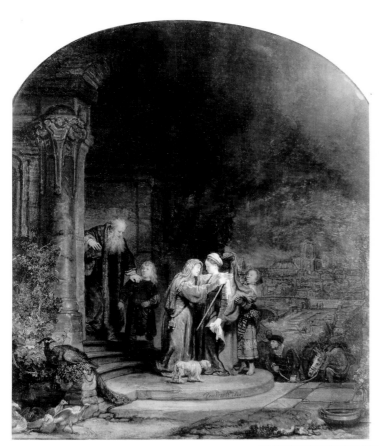

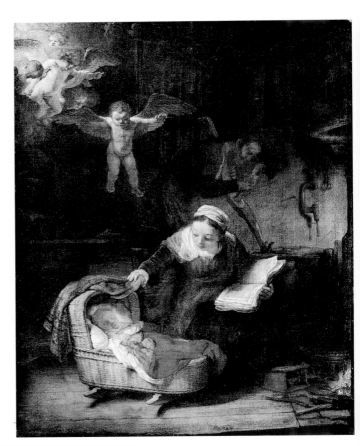

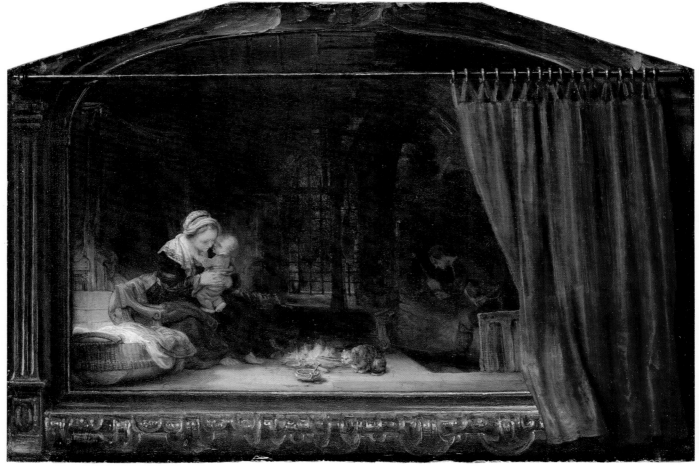

87. Rembrandt: *The Visitation*,
1640. Detroit Institute of Arts

88. Rembrandt: *The Holy Family
with Angels*, 1645. St Petersburg,
Hermitage

89. Rembrandt: *The Holy Family
with a Curtain*, 1646. Kassel,
Staatliche Kunstsammlungen

90. Rembrandt: *Rest on the Flight
into Egypt*, 1647. Dublin, National
Gallery of Ireland

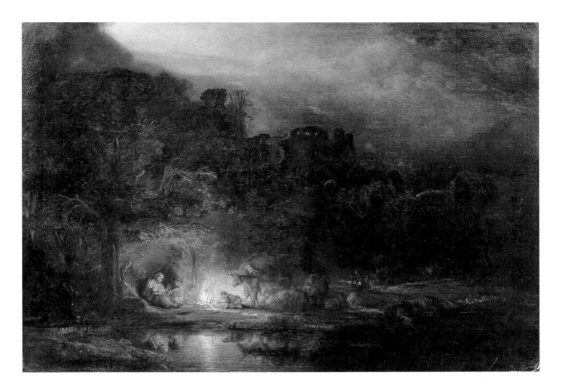

Family (1640, Paris, Louvre) which shows the Virgin nursing the Child is already considerably less overpowering in size than the pictures Rembrandt made during the thirties under Rubens's influence [74]. The *Holy Family with Angels* of 1645 at the Hermitage [88] glows with human warmth; small details contribute to this effect. A burst of divine light accompanies the angels who invade the chamber to witness the scene from the everyday life of the Holy Family. The tenderness of the young mother's movement accords with the deep, warm colours, among which the cherry-red of her skirt is the strongest accent. Another representation of the same subject made a year later at Kassel [89], is equally pervaded with the happiness of peaceful family life. This small picture has the illusionism of the portraits of *Nicolaes van Bambeeck* and *Agatha Bas* [85, 86], for it too has a painted frame, and here a painted curtain has been added as well. The Virgin is seated before the cradle near a little fire to warm her feet. A cat crouches ready to snatch the remnants in the bowl. Joseph is working with an axe. Rembrandt convinces us that all this takes place in a humble interior sanctified by faith.

Particularly poignant is the even smaller *Rest on the Flight to Egypt* of 1647 at Dublin [90] which depicts the Holy Family as tiny figures seated by a fire in a mysterious nocturnal landscape. The painting shows the lasting influence of Elsheimer, for it is based on his nocturnal *Flight into Egypt* now in Munich (Alte Pinakothek) which was brought to Holland by Goudt from Rome. Whether Rembrandt saw the original or a painted copy of it is moot, but he certainly knew the fine engraving Goudt made after it in 1613. The inscription on Goudt's print could serve as a caption for the precious Dublin panel: 'He flees into the darkness, The Light of the World, and the Creator of the Earth, as one banished . . .'.

The representations of the Holy Family of the 1640s show

that one thing remained permanent, even in this period of transition: Rembrandt's ever-increasing interest in and deepening observation of life and the world around him. This quality comes out most strikingly in the master's drawings. In the quick red chalk sketch of *Two Women teaching a Child to walk* (London, British Museum) [91] Rembrandt made a distinction between the old woman, who can only follow the child in a slow and bent attitude, and the other woman, whose posture expresses youthfulness and elasticity. The structural quality which Rembrandt develops in his middle period is evident here in the powerful straight lines and the block-like figures. It is combined with accents on all vital points, such as the anxious expression of the baby wearing a well-padded hat that will protect its little head if there is a fall, and the attention of the two women. Nobody but Rembrandt could express so much with so little. The drawing of a *Lioness* (British Museum) [92] is another example of a study from life from this period. The lioness holds food between her paws, but she still looks as if she wants another victim. There is tension in her body and keenness in her glance. Her head is bent over, watching. An enormous vitality and force are conveyed with a few powerful strokes of charcoal. Without a similar vitality in the master's own nature he would not have been able to seize the character of his subject with such striking forcefulness. Power and sensitivity are found side by side in Rembrandt's work of the middle period. Both qualities were to continue to increase and lead to the final height of his art finding their fullest expression in his mature phase.

THE MATURE PERIOD 1648–1669

There is an aspect of Rembrandt's art which cannot easily be explained by an analysis of his composition, colouring, and pictorial methods. This is particularly true of the works

91. Rembrandt: *Two Women teaching a Child to walk*, c.1635–40. Drawing: red chalk. London, British Museum

92. Rembrandt: *Study of a Lioness*, c.1638–42. Drawing: charcoal(?), grey wash, heightened with white. London, British Museum

made during the mature period. We feel there is something of a deeper meaning that lies behind their formal qualities, something we must grasp if we are to fathom the art and personality of this great master. What is it?

Rembrandt opened a new field in the history of painting. It is the world which lies behind visible appearances, but is, at the same time, implied. It is the sphere of the spirit, of the soul. One may ask, with good reason, what is this spiritual element? The terms 'spirit' and 'soul' are perhaps too vague; they can be interpreted in many ways. And we must admit that it is as difficult to give a simple, direct answer as it is to define the meaning of these words in connection with Rembrandt's art. Perhaps, if we approach the question in an indirect way and consider the limitations of this spiritual sphere, and note what is not of interest to Rembrandt, in contradistinction to other artists, we may touch the centre of the problem.

It is worth noticing that Rembrandt usually does not express in the physiognomies of his subjects in the mature stage of his art either the power of the will or superficial emotions. In portraits like the man at Buscot Park [93] traditionally called *Clement de Jonghe* and *Bearded Man in a Cap* at the National Gallery, London [94], none of the forces

that make up the so-called active life, by which we build our social position and careers, are accentuated. During his mature phase, the *vita activa* was of secondary importance to Rembrandt. He stresses what lies behind man's exterior activity and emphasizes the more contemplative side of life which is the domain of the spirit. This side, which is less conditioned by any social standard, is not always apparent, but men and women of every rank and station may possess it. Extremely revealing in this connection is the magnificent picture of *Two Black Men* done in his maturity (The Hague, Mauritshuis) [95], which brings no suggestion of a stereotyped conception of a black man, something that the artist did not always avoid in earlier works; in both heads Rembrandt has captured what we feel is the spiritual and moral substance of these men.[25]

Our inner spirit is a very elusive element. As the Latin word *spiritus* suggests, it is a breath, deep-seated and concealed, easily disturbed and troubled by the forces of external activity. Nevertheless, the inner part of our life is the more basic one of our existence. And to this quality, which can be called the soul, the great religious leaders, above all Christ, have appealed. Rembrandt was born with a new, deep, and unique sense of it, and was able to probe with rare concentration through the external appearance of human beings, forcing us to participate with him in this, their most precious substance.

We have already noted that Rembrandt's development follows the international trend of the Baroque style, which

93. Rembrandt: *Portrait of a Man* (traditionally called *Clement de Jonghe*), c.1652. Buscot Park, Berks., Farringdon Collection

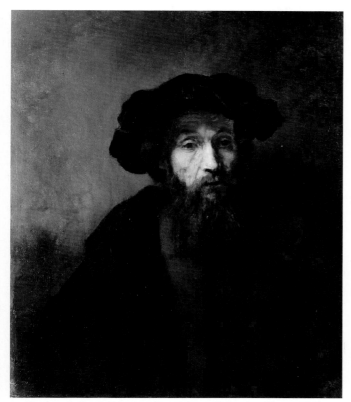

94. Rembrandt: *Bearded Man in a Cap*, 165[3 or 7?]. London, National Gallery

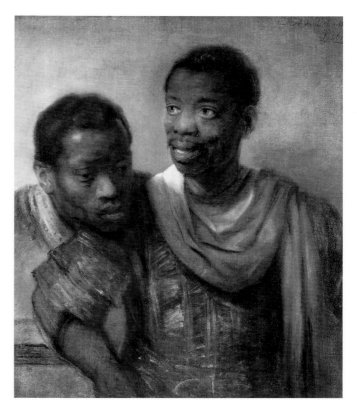

95. Rembrandt: *Two Black Men*, c.1650–5. The Hague, Mauritshuis

proceeded from a flamboyant High Baroque phase to a more classicist one. The late Rembrandt, however, went far beyond contemporary and national ideals. He adopted, in a very personal and selective way, only those classical qualities which were of a deeply human value. Besides his peculiar classical tendency, the deepening of his conception of Christianity in his art is an outstanding feature of his mature period. Both these tendencies have been fundamental in the development of Western civilization through the Middle Ages into modern times. Although not unshaken in our epoch, they are still pillars of Western culture. The mature Rembrandt takes a definite and very personal attitude towards each of these basic conceptions. His synthesis of the two into a higher unity can be considered the principal content of his late works – and in this synthesis the Christian element predominates, while the classical one only contributes some essential features.

The classical element can be studied in Rembrandt's beautiful pen-and-brush drawing of *Christ healing a Sick Person* (Berlin, Staatliche Museen, Kupferstichkabinett) [96], which he made about 1655. A feature immediately apparent in the drawing is the dignity and nobility of the figures and the attitude of Christ, which recalls the great Renaissance masters, particularly Titian. However, one feature, which usually accompanies classical art, is missing: there is not a trace of a purely formal attitude. None of the figures seems to have struck a pose. Rembrandt's Christ does not gesticulate. He is silent, and the impression he creates on those around him reflects his inner qualities. Another element of classical origin characteristic of the late works is the monumental quality of the composition in this drawing. The

simplicity of the rectangular formation of the left group and of the triangular one in that of the right affords a great clarity and firmness. These qualities are, however, softened by a wonderful atmospheric treatment and are integrated with the spatial design. Rembrandt avoids the schematic abstraction and the rigidity of a geometric formation often found in classical compositions. He also avoids the strict linear manner to which conventional classicists adhere. His line is interrupted, and the rhythm of the whole group is

96. Rembrandt: *Christ healing a Sick Person*, c.1655. Drawing: pen, wash, in some places rubbed with the finger, some white body-colour. Berlin, Staatliche Museen, Kupferstichkabinett

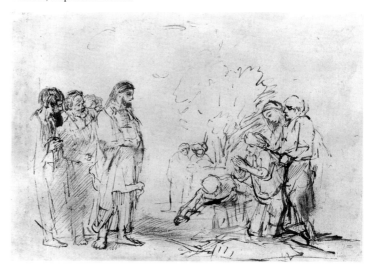

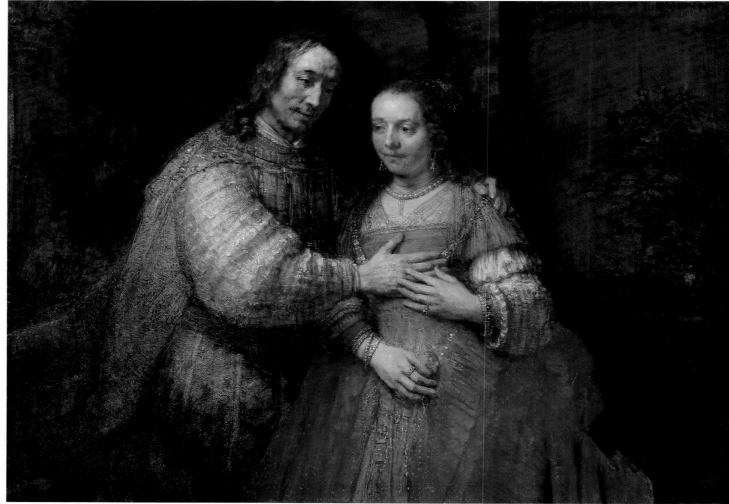

97. Rembrandt: *The Jewish Bride, c.*1666. Amsterdam, Rijksmuseum, on loan from the City of Amsterdam

slightly broken. The dissolved forms add tonal accents and are imbued with atmospheric implication. They link the figures to the space around them. In brief, the mature Rembrandt avoids the posed attitudes, the rigid abstraction, and the isolation of the classical ideal. He takes only those formal elements which are suited to increase the monumentality, simplicity, clarity, and the ethical features of dignity, nobility, and calm, while those of a conventional or academic nature are avoided.

Rembrandt's devotion to the chiaroscuro principle, which dominates his art from the very beginning, and to which he subordinated even the colourism of his late years, is another reason why he could never accept the classical style except for certain selected features. The concept that such intangible elements as light and shade are the most essential means of pictorial expression was thoroughly unclassical. For Rembrandt, the chiaroscuro device became a guiding stylistic principle by which he expressed not only pictorial, but also spiritual values. His development shows a steady increase in this direction in his portraiture as well as in his religious art. In his early paintings, for example the *Anatomy Lesson of Dr Tulp*, the chiaroscuro served primarily to dramatize the representation from the outside; it is a kind of sharp spotlight effect which Rembrandt derived from Caravaggio's Dutch followers. In his mature works the chiaroscuro is as powerful as it was during the thirties, if not more so. Intense lights are

combined with the deepest shadows and have been deliberately interwoven into a rich harmony of tones, subtle and strong, and at the same time colourful and transparent. Rembrandt takes advantage of his earlier achievements, but lifts them to a higher plane. One great example is *Jacob blessing the Sons of Joseph* of 1656 at Kassel [116]. Here, light and shade seem to be independent of an outside source, and take on a more ideal meaning. Faces, figures, costumes appear to glow from within wherever their significance requires special attraction. A general atmosphere is created in which we become aware of the most subtle inner emotions.

Rembrandt's colour, as well as his chiaroscuro, remains thoroughly unclassical. His colouristic power increases tremendously during his last period, although not all of his mature works display it; some of the single portraits remain largely monochromatic. Both the so-called *Jewish Bride* (*c.*1666) at Amsterdam [97, 101], which may be a commissioned portrait of a couple in the guise of a biblical pair such as Isaac and Rebecca,[26] and the *Family Portrait* of about 1668 at Braunschweig [98] belong to his most brilliant colouristic creations. Even in reproductions it is possible to see something of the fluctuating quality of his late paint, the vibration of the tones, and the harmonious fusion of the whole; but they can hardly suggest the warmth of the fiery scarlets, the golden yellows, the delicate blues and olives, the powerful whites, and deep blacks of his late palette. In both

pictures, the broad, calm, relief-like arrangement of the life-size half-figures recalls a certain type of Venetian Renaissance painting. This reveals a touch of classical taste, but the use of colour in these portrais is quite unclassical. The classical functions of colour are largely defining and often decorative. In the works of Raphael, Poussin, or Ingres, colour is added in fairly flat areas of localized hues. With the mature Rembrandt, a radical change takes place. Rembrandt's colour not only acquires increasing warmth and intensity; it becomes a living, moving, substance which ebbs and flows through space. The fluctuating character of his colours, which is in a way very similar to the interrupted line of his drawings, goes far beyond the more limited function of colour in classicist art. It produces the impression of a dynamic inner connection between all substances, and links the subjects with their mysterious dark background and even with infinite space. Rembrandt's ingenious brushwork also contributes much to the colouristic effect. He combines bold impasto passages with a subtle glazing technique, and this creates an up-and-down, or push-and-pull movement in the relief of the paint which heightens the floating character of the late works. Thus, it is chiefly in his colour and chiaroscuro that

the Baroque dynamism lives on in his paintings, but it is restrained by a classical simplicity and dignity of setting.

What is read about Rembrandt in some contemporary documents that date from his final decades can tell quite a different story than is told by his art. During his mature period his personal life was a difficult one and he doubtlessly had problems that he himself created. Consider the end of his affair with Geertje Dircx. It will be recalled that she joined Rembrandt's household as Titus's nanny and after Saskia's death in 1642 she became the artist's common-law wife. Geertje became a problem for Rembrandt after Hendrickje Stoffels also joined his household around 1647. At the time Hendrickje was around twenty, about half Geertje's age. It is not known when Hendrickje and Rembrandt became intimate but it must have been before June 1649, when she witnessed unsuccessful negotiations for a permanent separation between Geertje and Rembrandt. Geertje rejected the artist's offer to pay her 160 guilders straightaway and a piddling 60 guilders annual life annuity. She countered with a breach-of-promise suit which she must have known he would reject, for according to the terms of Saskia's last testament, if he remarried he was required to

98. Rembrandt: *Family Portrait*, c.1668. Braunschweig, Herzog Anton Ulrich-Museum

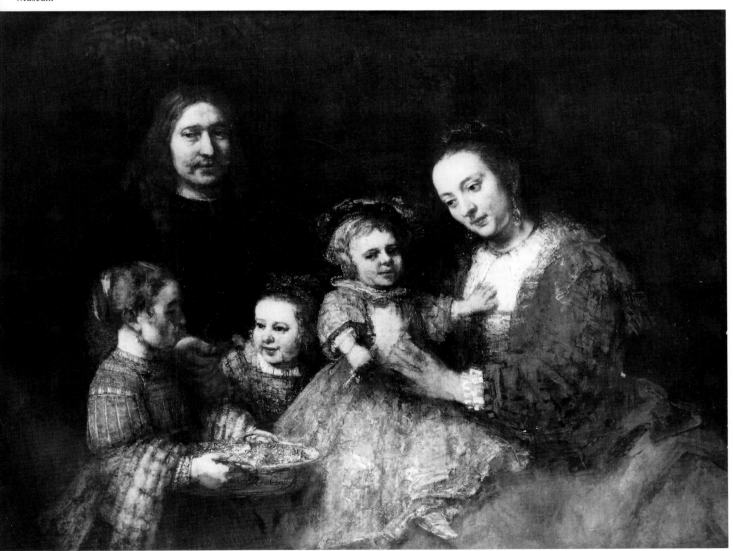

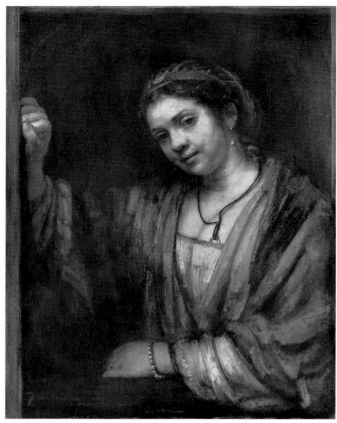

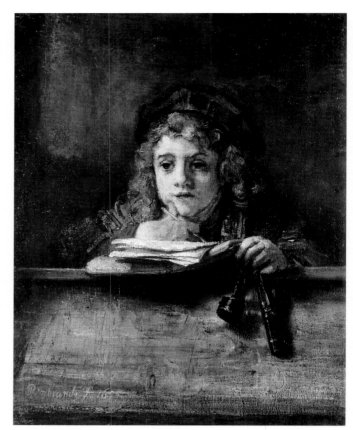

99. Rembrandt: *Woman at a Half-open Door* (probably *Hendrickje Stoffels*), c.1655–7. Berlin, Staatliche Museen

100. Rembrandt: *Titus*, c.1655. Rotterdam, Boymans-van Beuningen Museum

settle Titus's inheritance immediately. Marriage would have put an unwanted, perhaps an impossible strain on his financial situation. Geertje's ploy worked. Rembrandt raised his offer to 200 guilders immediately and an annual alimony of 160 guilders for life, but to no avail. The affair was finally settled by the court in October 1649. It did not decree he had to marry Geertje, but found in favour of the plaintiff by ordering him to pay her an annual alimony of 200 guilders for life. Like most breach-of-promise suits Dircx vs. Rembrandt was shabby and acrimonious. However, it has a sequel which makes the story worse. The role Rembrandt plays in it is despicable. On the basis of what were at best flimsy charges and with the collusion of scrupleless members of Geertje's family, in 1650 he succeeded in having his former mistress sentenced to a workhouse in Gouda for twelve years. While she was locked up she was without legal rights. Geertje's friends managed to procure her release in 1655. She died in the following year.[27]

After Geertje's departure from Rembrandt's household, Hendrickje Stoffels lived with Rembrandt as his close companion until she died in 1663; she was with him longer than either Saskia or Geertje. Once again there probably was never a question of a legal marriage because of the terms of Saskia's will. When she became pregnant she was summoned before the Calvinist church council in June 1654, to answer the charge 'that she had committed the acts of a whore with Rembrandt, the painter'. She acknowledged the charge and was barred from communion. Rembrandt was not summoned by the council because he was not a member of the church. Their daughter Cornelia was baptized in October 1654. No documented portrait of Hendrickje has been identified but

the attractive model for the *Woman at a Half-open Door* of about 1655–7 at Berlin [99], who appears in a number of guises in works of the 1650s, is generally accepted to be her. The Berlin portrait excels by its compositional strength and rich pictorial beauty. Accents given to the door upon which she is leaning impart a great firmness. Both her arms – one resting on the door, the other pressed against the end of the opening – emphasize the tectonic character of the composition. In contrast, the movement of her head and the soft, deep glance of her eyes are most expressive. The mature Rembrandt knew how to combine an easy naturalness with greatness of style. The firmness of the composition is also softened by the warm depth and the broad fusion of the colours, among which a deep red contrasted with golden yellows, black, and white are predominant. After Hendrickje and himself, the person he portrayed most frequently during this period was his son Titus. The portrait of about 1655 at Rotterdam [100] is an early one. Few portraitists have been able to suggest in pictures of venerable philosophers surrounded by a scholar's paraphernalia anything like the sympathetic contemplative mood Rembrandt conveys in this portrait of his son when he was about fourteen-years-old.

About the time the beautiful Rotterdam portrait of Titus was painted serious financial troubles developed for Rembrandt. He had incurred heavy debts and payment for the large house he had purchased in 1639 on an installment arrangement was long overdue. He finally acquired the house in 1654, but it was still encumbered by a mortgage. In the

101. Detail of fig. 97, *The Jewish Bride*

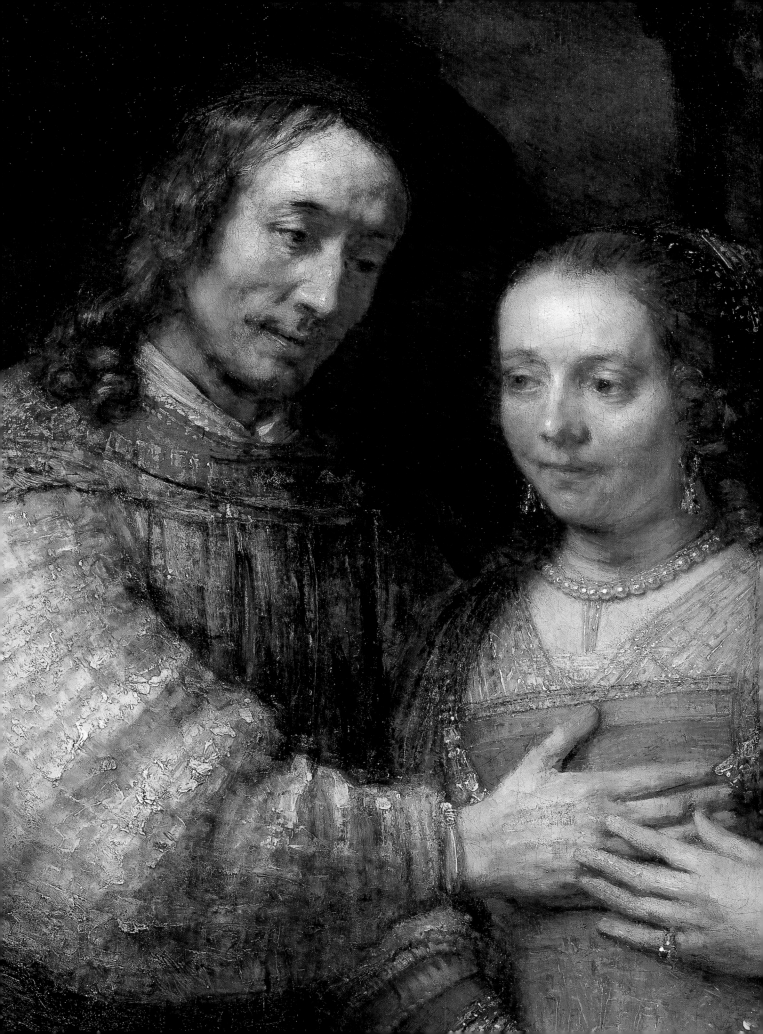

following year he transferred its ownership to his young son and arranged for the boy to draw up a will which would pass ownership to him in case Titus died young. To meet his urgent need for cash he arranged a public sale of some of his possessions but the attempt failed to help his plight. Pressed to the wall and to avoid outright bankruptcy in 1656 he petitioned and was granted by the authorities a *cessio bonorum* (*bodel afstand*), a less degrading procedure than bankruptcy, often granted on the basis of losses at sea. Rembrandt's property was now in the hands of Amsterdam's Chamber of Insolvent Estates which ordered its liquidation. The inventory of his collections, furniture, and some of his household goods (his painting and etching equipment were not included) was drawn up on 25–26 July 1565.[28] It gives a detailed insight into his extensive collections. Results of the public auctions of his effects, which took place in 1657 and 1658, were very disappointing. The proceeds were not enough to enable Rembrandt to pay off his debts. However, Hendrickje and Titus managed to protect him from his creditors by forming a business partnership in 1660 as art dealers and by making Rembrandt their employee. By this transparent stratagem, the artist was able to save the earnings from his work.

Even a cursory examination of Rembrandt's collections as described in the 1656 inventory is instructive. The size of it suggests that his passion for collecting may have been partially responsible for his financial difficulties. There were arms, costumes, bowls, and baskets from the Far and the Near East. One section consisted of natural curiosities, marine and terrestrial flora and fauna, minerals, antlers, a lion's skin, a stuffed bird of paradise, and other objects commonly found in Renaissance and Baroque *Kunst- und Wunderkammern*. Sculpture was not wanting. Ancient busts of the Roman emperors are listed, and it is noteworthy that Rembrandt had them arranged in a room in chronological order; this is not the only evidence which suggests that he was interested in the study of ancient history. 'A child by Michelangelo' is also listed; it may well have been a copy or cast of the Christ Child from Michelangelo's group of the Madonna and Child at Notre Dame in Bruges (for a painting by a follower of Dou that includes the Child from the Bruges group see fig. 128). As for paintings and the graphic collection, the range was wide. The paintings include works attributed to masters of the Italian Renaissance and the Early Netherlandish school as well as contemporary Dutch masters. The names of Raphael, Giorgione, Palma Vecchio, Jacopo Bassano, Van Dyck, and Lucas van Leyden are met. By Adriaen Brouwer there were paintings and also a sketchbook. Among the Dutch seventeenth-century painters there were works by his teacher Lastman, and by Jan Pynas, Hercules Segers, Lievens, Porcellis, de Vlieger, and others. Naturally, the various categories of Rembrandt's own work were represented. Three pictures by his son Titus are also listed; none of them has been identified (for further word of Titus's little-known activity as an artist see p. 118). The graphic section contained prints by Mantegna and Lucas van Leyden, by Schongauer, van Meckenem, Cranach, and Holbein. There were engravings after Michelangelo and Titian. The Bolognese school was represented by the Carracci and Guido Reni; the Netherlandish school included

artists who ranged from Heemskerck, Frans Floris, and Pieter Bruegel to Rubens, Van Dyck, and Jordaens; Hendrick Goltzius and Abraham Bloemaert represented the Dutch Mannerists. There were only a few books – among them an old Bible, the *Jewish History* of Flavius Josephus with woodcuts by Tobias Stimmer, and Dürer's treatise on *Human Proportions*, but not van Mander's *Schilderboek*. It was altogether an enormous accumulation, which shows that Rembrandt was truly a man of his time in his susceptibility to the curious, the exotic, and the picturesque, and that he availed himself, as an artist and collector, of the endless opportunities which the international art market of Amsterdam offered. The inventory also offers one of the instances that indicates he dabbled in the art market. It states that the Amsterdam dealer Pieter de la Tombe owned a fifty per cent interest in the paintings attributed to Giorgione and Palma Vecchio; when the pictures were sold, half the proceeds were due to him.

What was the impact of his collections on his art? We have already seen that he learned from Renaissance masters and from Hercules Segers's imaginary landscapes. His numerous specific borrowings from other artists, particularly from prints by and after earlier Italian and northern masters that were in his collection, have been noted.[29] But in the search for influences, the transformations he made to works that inspired him should be borne in mind. A good example is Rembrandt's drypoint *Ecce Homo* (Bartsch 76), completed a year before the inventory was made. It has frequently been noticed that this print was influenced by Lucas van Leyden's *Ecce Homo* of 1510. The differences, however, between Rembrandt's print in its late states are more significant than its similarities to Lucas's engraving, and the connection that can be established between the two is proof of the artist's independence rather than his dependence. It also is noteworthy that apart from his 1656 etching of *Abraham Entertaining the Angels* (Bartsch 29) scant trace can be found in his work of the impact of more than twenty free but carefully worked up drawings he made after Mughal miniatures (possibly they were in an album 'full of curious miniatures' cited in his inventory).

The last decade of Rembrandt's life brought no relief in his economic situation, and these were the years when the artist had to suffer most serious blows in his family life. Of the two large commissions which he received at the beginning of this decade, the group portrait of the *Sampling Officials of the Amsterdam Drapers' Guild*, popularly called *The Syndics* (1662, Amsterdam, Rijksmuseum) [109] may have had some success, but the monumental painting of the *Conspiracy of Claudius Civilis*, done for the town hall of Amsterdam, apparently did not meet with favour. It was hung in place for a short time, then was taken down, and was finally replaced by an uninspired work by Jürgen Ovens. Only a fragment of this masterwork has survived (Stockholm, Nationalmuseum) [110]. However, Rembrandt still produced portraits in fair numbers, and it seems that many of these were commissions.

There was also some demand for his work abroad. Don Antonio Ruffo, a Sicilian nobleman who lived in Messina, ordered a painting of a philosopher in 1652. Rembrandt sent him the incomparable *Aristotle with the Bust of Homer* (1653, New York, Metropolitan Museum) [102]. In 1661 Ruffo

102. Rembrandt: *Aristotle with the Bust of Homer*, 1653. New York, Metropolitan Museum of Art

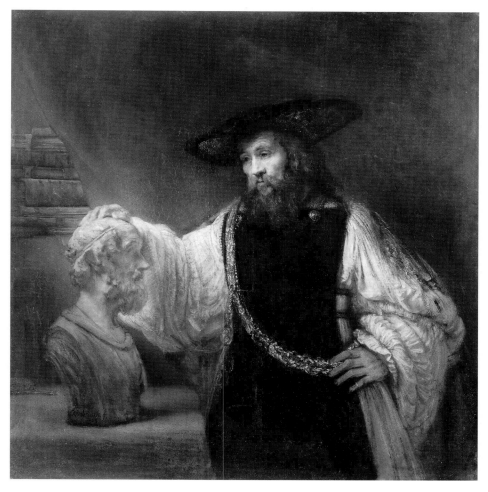

acquired an *Alexander the Great* from the artist (perhaps identical with the painting in Glasgow; Bredius-Gerson 480), and in 1663 the *Homer* now in the Mauritshuis, The Hague, entered his collection. The Sicilian collector ordered and received 189 of the master's etchings in 1669, the year of Rembrandt's death. But on the whole Rembrandt's late years must have remained very difficult ones. After his large house was sold, he moved with Hendrickje and Titus to a much smaller rented one in the Rozengracht, in a modest district of Amsterdam where a number of painters lived. After Hendrickje died in 1663, Titus continued to help his father, but he was sickly around this time. The haunting expression in the pale portrait made of him during these years (Paris, Louvre) presages his early death. Soon after Titus's marriage with Magdalena van Loo on 16 February 1668, he died. He was buried on 7 September 1668, and his property went to his young widow. A posthumous daughter, Titia, was born to Magdalena, and at the baptism in March 1669, Rembrandt was present as godfather. The artist's death came six months later, on 4 October 1669. He was buried on 8 October in an unknown rented grave in the Westerkerk of Amsterdam. He left nothing but his clothes and painting equipment.

The troubles and tragic events of the last years did not have an adverse effect upon his work. On the contrary, as outward circumstances became more difficult, his art gained in spiritual depth and power of expression. An artist who did

not possess Rembrandt's extraordinary inner strength would probably have been crushed by the experiences he had during his late phase. The self-portraits of the period are particularly revealing as to the maturity of his personality and art. The moods vary from a most assailable sensitiveness [103] to majestic calm, and from laughter [104][30] to a mellow resignation. The late self-portraits are on the level of the greatest achievements of self-characterization in literature. They rank with the *Confessions* of Augustine or Jean-Jacques Rousseau's *Confessions*.

In the *Self-Portrait* painted in 1659 (Washington, National Gallery of Art, Mellon Collection) [105], a man mightier than he who appeared in any of the earlier ones speaks to us through a greater breadth of composition, a richer pictorial treatment, and, not least, the increased power and softness of the chiaroscuro. The light seems to glow from within. A rich inner life and many tragic experiences seem to have left their mark on his features. An imposing objectivity speaks from this self-analysis. The muscles of his face have already slackened, but, at the same time, an extraordinary sensitivity is evident. The old Rembrandt's eyes have grown large and dominating. They betray a most vulnerable human being, but we also feel that sorrow has deepened his understanding. We sense that he is free from resentment, self-pity, and any trivial sentimental reaction.

A number of commissioned portraits were made during the fifties and sixties, and some of these rank among the

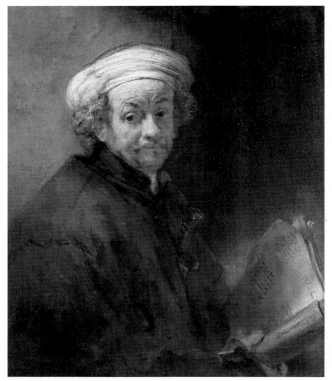

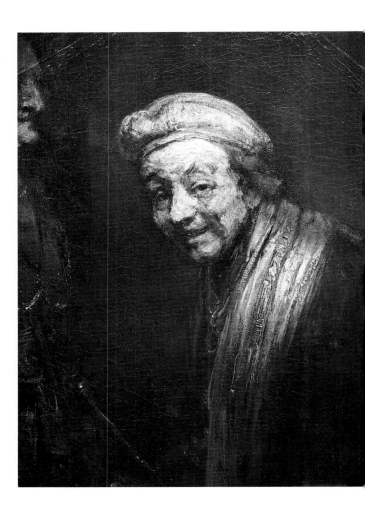

103. Rembrandt: *Self-Portrait as the Apostle Paul*, 1661. Amsterdam, Rijksmuseum

104. Rembrandt: *Self-Portrait*, c.1665–9. Cologne, Wallraf-Richartz-Museum

105. Rembrandt: *Self-Portrait*, 1659. Washington, National Gallery of Art, Mellon Collection

106. Rembrandt: *Jan Six*, 1654. Amsterdam, Six Collection

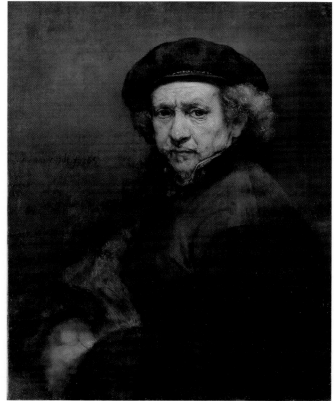

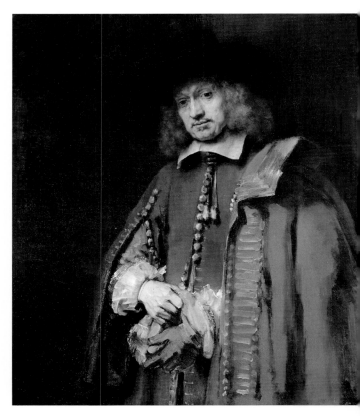

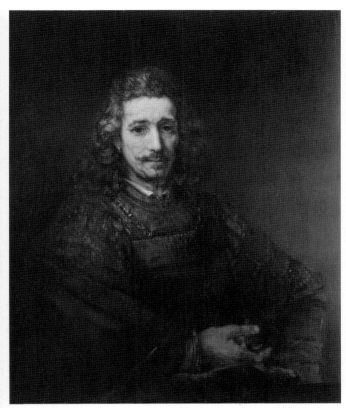

107. Rembrandt: *Man with a Magnifying Glass*, c.1665. New York, Metropolitan Museum of Art, Altman Bequest

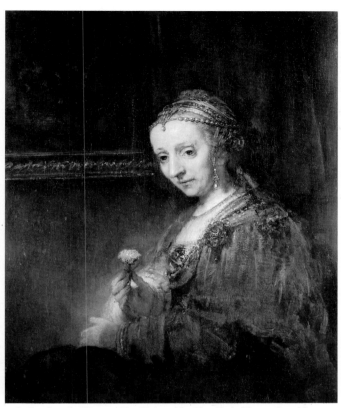

108. Rembrandt: *Woman with a Pink*, c.1665. New York, Metropolitan Museum of Art, Altman Bequest

highest achievements of European portraiture. Particularly impressive are *Nicolaes Bruyningh* (1652, Kassel, Staatliche Kunstsammlungen), the *Portrait of a Man* at Buscot Park [93], and the famous *Jan Six* (1654, Amsterdam, Six Collection) [106]. In the *Jan Six*, one of Rembrandt's most informal portraits, the colouristic splendour dominates the chiaroscuro effect. The distinguished Amsterdam burgomaster, humanist, and connoisseur wears a grey coat with gold buttons. His scarlet, gold-braided mantle is casually draped over his shoulder. He is pulling on – or taking off – his chamois glove. The greys form a beautiful contrast with the bright reds, gold, and creamy whites. But more moving than the matchless colouristic harmonies in this portrait and the freedom of the broad brushwork is Rembrandt's psychological grasp of the instant when a man's gaze has turned from the outer world to his inner self. Although the companion portraits of the last decade of the *Man with Gloves* and the *Woman with an Ostrich Fan* in the National Gallery at Washington have been partially disfigured by repaint, the heads still show the further increase in power of characterization, and even more impressive are the companion pieces in the Metropolitan Museum of the *Man with a Magnifying Glass*[31] and the *Woman with a Pink* [107, 108]. The veiling and revealing function of chiaroscuro is employed in these portraits, as it is used in the late religious works; it helps to create a deep and comprehensive mood. This mood is sometimes characterized as meditative. But that term seems inadequate, because it refers chiefly to the work of man's brain, whereas in Rembrandt's late works, one senses that feeling plays the dominant role. One is reminded of

Rembrandt's great contemporary, the French philosopher Pascal, who made the distinction between *raison* and *coeur* and put the work of the latter higher than that of the former.

The *Sampling Officials of the Amsterdam Drapers' Guild*, popularly called *The Syndics*, dated 1662, at the Rijksmuseum [109], Rembrandt's largest portrait commission during his late years, is an ideal solution of the principal problem of painting a portrait group. Equal importance has been given to each of the five officials – their servant, wearing a skull cap, is in the centre yet the whole is united by ingenious psychological and formal means. The subtle composition, the glowing colouristic harmonies, and above all the sympathetic interpretation and profound psychological grasp of the personalities of the six men make this Rembrandt's greatest group portrait. The total impression is of delicately adjusted harmony and tranquility. X-ray examinations of the picture show how Rembrandt struggled to attain the impression of equilibrium.[32] While he worked on the painting he shifted all the figures, but the person with whom he experimented most was the servant. He tried placing him in two different positions on the extreme right, he also posed him between the two officials on the right, and finally gave him his place, after taking some liberties with the laws of perspective, above the two seated officials in the centre of the picture. Rembrandt brilliantly exploits horizontals – a classical rather than a Baroque device – for the unification of the group. Three horizontals run through the picture at almost equal intervals: the edge of the table and the arm of the chair at the left mark the lowest one; the middle one is established by the prevailing level of the heads; and the

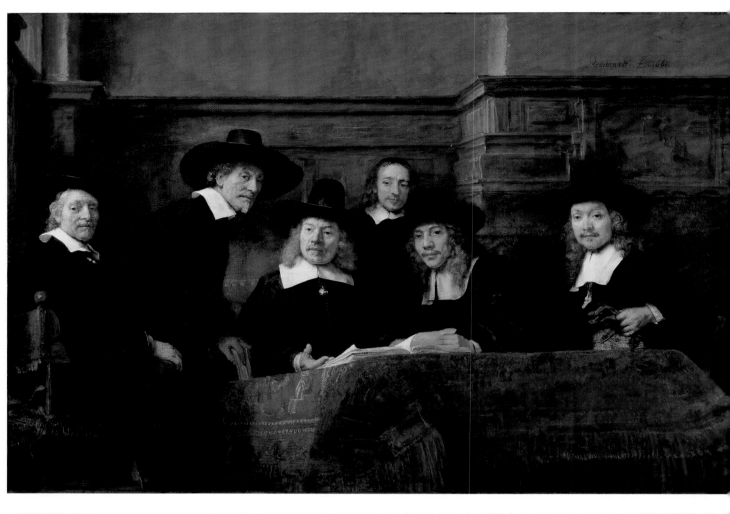

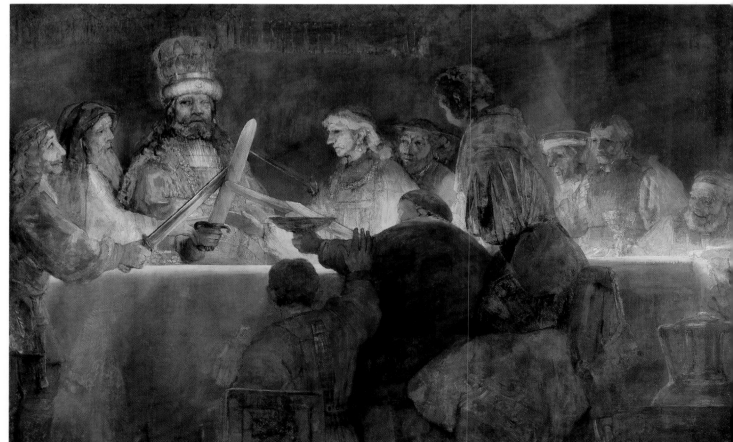

upper one runs along the edge of the wainscoting. But here again Rembrandt avoids all formal rigidity. These repeated horizontals are broken by sharp deviations on all three levels. The sharpest is in the group itself, in the strong curve of the head on the left. With a kind of contrapuntal effect, this movement is echoed by the slight rise in the upper horizontal on that side. While this style of composition is similar to the relief-like manner of grouping favoured by artists who worked in the classical tradition, there is an increased effect of space and atmosphere by Rembrandt's use of chiaroscuro and colour. The harmonies are definitely on the warm side. A flaming red in the rug on the table, which is the most outstanding accent, is interwoven with golden tints. Golden browns reappear in the background, in the panels of the wall, and within these warmly coloured surroundings the strong blacks and whites in the men's costumes have a noble and harmonious effect.

The traditional interpretation of the painting is that the men were shown seated on a platform, before the assembly of the Drapers' Guild and that they are giving to the assembly – unseen by the viewer – an account of the year's business. The official seated near the centre of the picture makes a gesture with his right hand which most seventeenth-century observers understood immediately; the gesture was a standard one employed by orators demonstrating evidence. H. van de Waal has shown that the sampling officials did not have meetings at which they reported to their guild.[33] They were appointed by and reported to Amsterdam's burgo-masters, and met in private to implement their mandate: maintenance of the quality of dyed cloth manufactured and sold by members of the guild. Therefore the often repeated interpretation that the official on the left is rising to deal with someone making a disturbance in the audience must be wrong.

But even if this assumption is discarded, the fact remains that the rising man's posture is a very momentary one. In addition, all the men look at one point. It cannot be denied that the rising man adds substantially to the illusion that the group is reacting spontaneously to somebody in front of them. And since this object of attention cannot be somebody in an imaginary assembly, it must be the entering spectator. So Rembrandt was not only concerned with giving an ordinary illusion of a gathering, but dramatizes it slightly by aiming at the very moment of the spectator's appearance. The low viewpoint from which the group is portrayed, which indicates the painting was intended to hang high, contributes to the illusionistic effect. Such pointed illusionism would have endangered a lesser master. Not so with Rembrandt. He always endowed his group portraits with dramatic tension, and here the mature Rembrandt successfully combined it with the general impression of tranquillity. While the momentary diversion from their work brings an animating element into the syndics' gathering and configuration, it is still the profound characterization of the group and of each individual which prevails.

Side by side with portraiture, history painting remained

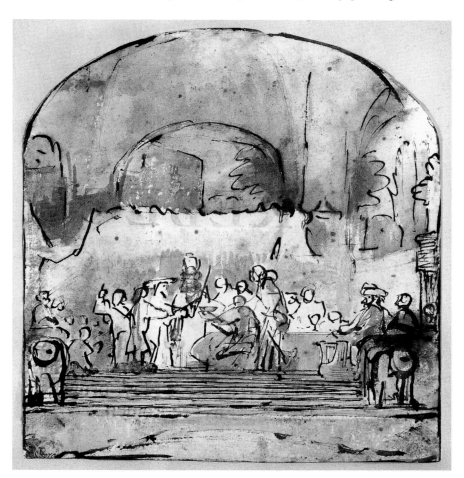

109. Rembrandt: *Sampling Officials of the Amsterdam Drapers' Guild (The Syndics)*, 1662. Amsterdam, Rijksmuseum, on loan from the City of Amsterdam

110. Rembrandt: *The Conspiracy of Claudius Civilis*, 1661–2. Stockholm, Nationalmuseum

111. Rembrandt: Preparatory drawing for the *Conspiracy of Claudius Civilis*, 1661. Pen, wash, some white body-colour. Munich, Staatliche Graphische Sammlung

Rembrandt's most productive field during the mature period. In genre painting there are only a few works, but these, like the powerful picture of a *Slaughtered Ox in an Interior, with a Woman* (1655, Paris, Louvre), are remarkable for their originality. Among the historical paintings relatively few represent scenes from classical mythology and history; the vast majority have biblical subjects. Of classical subjects, the *Aristotle with the Bust of Homer*, the *Alexander*, and the *Homer*, made for export to Sicily, have already been mentioned. Other impressive figures are the late representations of *Juno* (c.1662–5, Los Angeles, Los Angeles County Museum) and of *Lucretia* (1664, Washington, National Gallery; 1666, Minneapolis, Institute of Art). The greatest of all his works representing a scene from ancient history is the aforementioned *Conspiracy of Claudius Civilis* (1661–2) at Stockholm [110].

When the great classicistic town hall was built in Amsterdam in the 1650s, the burgomasters agreed to decorate the twelve lunettes of the great corridors that surround the Burgerzaal, its vast public space, with episodes from the story of the revolt of Claudius Civilis, the Batavian, who led an insurrection against the Romans in AD 69.[34] The choice of subject was not an unusual one. Seventeenth-century men frequently made parallels between episodes from the Bible or ancient history and events of national history. For Dutchmen, their successful revolt against Spain, initiated under the leadership of Willem the Silent, was prefigured by Claudius's rebellion; according to Rembrandt's contemporaries, Claudius was the prototype of Willem.

Rembrandt's pupil Govert Flinck, not the master himself, was originally asked to execute this vast project, the largest and most prestigious commission given to a seventeenth-century Dutch artist. Flinck had already painted a huge moralizing history painting for the town hall (see p. 106, fig. 133); the city fathers were obviously satisfied with his performance. He prepared sketches, and on 28 November 1659 was commissioned to execute twelve pictures for the building's gallery. Eight lunette paintings were to represent scenes from the revolt of the Batavi, and four others were to show heroes who performed noteworthy deeds for their country, as David and Samson did among the Jews, and Marcus Curius Denatus and Horatius Cocles for the Romans. Thus biblical and classical patriots, as well as early national heroes, were chosen as prefigurations of the recent victory of the Dutch over the Spanish monarchy and they were seen as exemplars of the virtues of Amsterdam's ruling class. Flinck died on 2 February 1660 before he could make much progress on the scheme. The commission was then distributed among several artists. Jan Lievens and Jacob Jordaens were asked to paint scenes early in 1661, and probably in the same year Rembrandt received his order to paint the first episode of the story of the revolt.

According to Tacitus (*Historiae*, IV, 13), the conspiracy began when Claudius Civilis, the mighty chieftain who was disfigured by the loss of one eye, 'summoned the chief nobles and the most determined of the tribesmen to a sacred grove. Then, when he saw them excited by their revelry and the late hour of the night, he began to speak of the glorious past of the Batavi and to enumerate the wrongs they had suffered, the injustice and extortion and all the evils of their slavery.' Claudius Civilis's impassioned speech inciting his countrymen to revolt 'was received with great approval, and he at once bound them all to union, using the barbarous ceremonies and strange oaths of his country.'

The night scene made by the acknowledged master of nocturnal painting shows the Batavi taking an oath on Claudius Civilis's sword. This idea was original; Tacitus's reference was merely to 'barbarous ceremonies and strange oaths'. Although the sword oath was not unknown in the seventeenth century – both Vondel and Shakespeare make reference to it – other artists who represented this subject showed the Batavi sealing their oath with a handshake. Rembrandt's colossal picture (larger than the *Night Watch*, it originally measured about 5.5 meters high and broad) was in the town hall by 21 July 1662. Shortly after it was mounted, it was removed, and it was never returned to the lunette for which it was designed. By 1663 its place had been taken by a painting by Jürgen Ovens, a weak artist who possibly was Rembrandt's pupil in about 1640 – if so, his impact on him was negligible. Ovens did not produce an original picture; he spent less than a week completing the composition Flinck left unfinished at his death. His effort is still *in situ*.

Rembrandt's painting was cut down, probably by the master himself, to make it more saleable. He made some changes in the fragment, which is only the central group of the original picture, to make it a unified whole. A single precious preliminary drawing (1661, Munich, Staatliche Graphische Sammlung) [111] gives us an idea of his majestic conception for one of the most monumental historical pictures ever painted. The drawing is on the back of part of a funeral ticket – it is not the only indication that he was ready to draw on any piece of paper at hand; the missing part of the ticket bore the date 25 October 1661.[35] Rembrandt's preparatory drawing shows that he set the night scene in a huge vaulted hall with open archways, and not in the sacred grove which Tacitus described. The change in setting was an important one, enabling Rembrandt to give his composition the architectonic grandeur and spaciousness which helped to emphasize the drama of the scene. Earlier masters of European monumental wall decoration often used architectural settings to attain similar effects.

Rembrandt's unique achievement, as we can see from the small sketch and the fragment of the picture, was to subordinate the architecture to his dramatic chiaroscuro and phosphorescent colouring. Thus for the first time an artist achieved monumentality in a large wall painting primarily by pictorial means. In the preparatory drawing the distribution of light and shade is of great importance for the total effect, and in the fragment of the painting, which has lost its architectural setting, the eerie light and shadow and the irridescent greyish blues and pale yellows are even more important in bringing out the mysterious barbaric character of the conspiracy.

One cannot help wondering what the gallery of the town hall of Amsterdam would look like if Rembrandt had been commissioned in 1661, when he was at the peak of his power, to paint all twelve pictures of the series. If he had received the commission, he surely would have created a great climax of monumental Baroque painting. His series would be as famous as the grand-scale compositions Rubens

painted for Marie de' Medici, and perhaps even more impressive. Apparently the city authorities had no idea of the opportunity they missed. Even the single work they commissioned from Rembrandt did not remain in place. Why was it removed? The answers which have been given to this question are not above dispute, and regrettably the relevant documentary evidence is meagre and vague. A lengthy contract signed by Rembrandt on 28 August 1662 states that one of his creditors shall receive one-quarter of everything which Rembrandt should earn on the 'painting delivered to the town hall, and of any amounts on which he has claim, or stands to profit by repainting [*verschildering*] or might in any other way be benefited, however this might befall.' If this document refers to the Claudius Civilis painting,[36] it seems that the city officials wanted some changes made in the picture. We can only conjecture what adjustments might have been asked for. However, it is not difficult to imagine that the picture did not suit men who followed the classicistic vogue which became popular in Holland around the middle of the century. Identification with the heroes of one's national history was an acceptable idea, but Rembrandt's conception of the ancient heroes was probably too brutal to suit all the city fathers of Amsterdam. Learned critics could also argue that Rembrandt failed to meet one of the principal tenets of classistic art theory in a history painting designed for the most important building of the Netherlands: he showed men as they are, instead of as they ought to be. Moreover, his critics could maintain that he lacked decorum.[37] They probably noted that Rembrandt should have depicted the one-eyed Claudius Civilis in the way that Apelles, the renowned painter of Antiquity, painted King Antigonos, who was also blind in one eye. Apelles devised a means of hiding the king's infirmity by presenting his profile, so that the absence of the eye would be attributed merely to the position of the sitter and not to a natural defect.

But there is also reason to believe that some of Rembrandt's contemporaries were not disturbed by his departure from the generally accepted notions about history painting. After all, he was given the commission, and in 1661 no one in Amsterdam could have been very surprised that Rembrandt did not concoct a conventional classical confection for the town hall. However, there was apparently enough powerful opposition to manage to have the work replaced by Ovens's dull effort. Ovens's work also was much cheaper. The burgomasters paid him 48 guilders for it. In view of the price they had agreed to pay other artists who made pictures for the lunettes, Rembrandt would have received approximately 1,000–1,200 guilders for his painting. In the end, the ambitious project for decorating the lunettes was never completed. It dragged on until 1697 when a Flemish painter only known as Le Grand was commissioned to make frescoes for four of them that still lacked pictures. Four of the lunettes were never commissioned. They remain empty today.

It is to the biblical pictures that we must turn to see Rembrandt's greatest contribution during his mature period. The deepening of the religious content of these works is connected with some shift in his choice of biblical subjects. During the thirties Rembrandt had used the Bible as a source for dramatic motifs; for example, the *Blinding of*

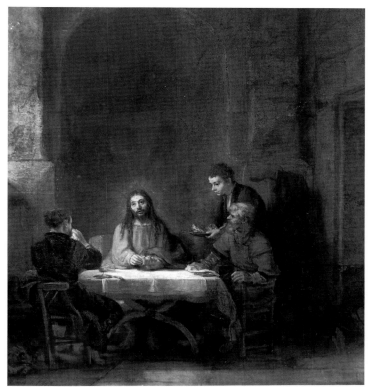

112. Rembrandt: *Christ at Emmaus*, 1648. Paris, Louvre

Samson. In his middle phase he turned to more calm and intimate subjects, particularly episodes from the life of the Holy Family. At the beginning of the mature period the figure of Christ becomes pre-eminent. Scenes taken from the life of Jesus, quiet episodes of his youth, his preaching and the deeds of his early manhood, and his resurrection form the main subject of the biblical representations. The emergence of the mature style is marked by works like *Christ at Emmaus* (1648, Paris, Louvre) [112], in which Rembrandt expresses the character of Jesus without any concrete action or noisy stage-like effect. A moment before, he appeared to be merely a man about to break bread with two pilgrims. Now he is the resurrected Christ whose tender presence fills the room. Without any commotion, Rembrandt convinces us that we are witnessing the moment when the eyes of the pilgrims are no longer 'held, that they should not recognize him'. A great calm and a magic atmosphere prevail, and we are drawn into the sacred mood of the scene by the most sensitive suggestion of the emotion of the figures, as well as by the mystery of light which envelops them. The monumental architectonic setting lends grandeur and structure to the composition, and the powerful emptiness of the architectural background is enlivened by the fluctuating, transparent chiaroscuro and the tender spiritual character of the light around Christ himself. A simple pathos and a mild, warm feeling emanate from his figure. Nothing could be farther from the conspicuous theatricality of the works of the thirties.

Although there is no documentary evidence, there is reason to connect Rembrandt's tender conception of Christ during the first years of his mature period with the teachings of the

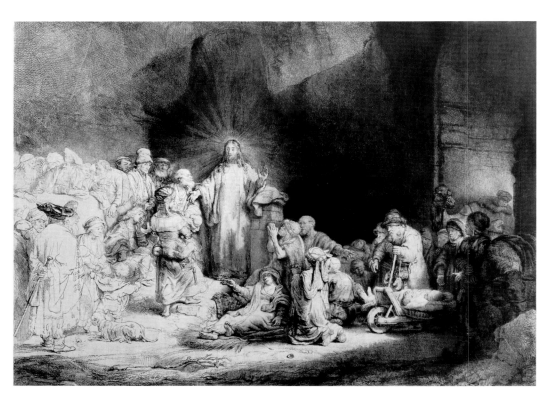

113. Rembrandt: *Hundred Guilder Print*, c.1647–9. Etching

Mennonite sect. According to Baldinucci, one of the artist's seventeenth-century biographers, Rembrandt was a Mennonite, and we have seen that he was in contact with Cornelis Anslo, a famous Mennonite preacher of Amsterdam. In 1641 Rembrandt made an etching of Anslo (Bartsch 271), and in the same year he made the impressive double portrait of the preacher and his wife [84]. In Rembrandt's day the Mennonite sect was a liberal one which discarded the sacerdotal idea, accepted no authority outside the Bible, limited baptism to believers, and held to freedom of conscience. They emphasized precepts which support the sanctity of human life and man's word and, following the Sermon on the Mount, they opposed war, military service, slavery, and such common practices as insurance and interest on loans. Compared with the severe Calvinists, the Mennonites represented a milder form of Christianity in which, according to the literal sense of the Sermon on the Mount, the leading principle was 'Love thy neighbour'.

This spirit permeates Rembrandt's most famous etching, the so-called *Hundred Guilder Print* [113], which is datable about 1647–9. Rembrandt began to make studies for this celebrated print earlier, but in its main types and in its final decisive achievement the etching belongs to the beginning of the mature period. The popular title, found in the literature as early as 1711, is derived from the high price the print is said to have fetched at a sale. According to an anecdote recorded by the eighteenth-century art dealer and collector J.P. Mariette in his *Abecedario*, it was Rembrandt himself who paid this sensational price for an impression of his own print. The etching illustrates passages from Chapter 19 of the Gospel of St Matthew. Rembrandt treated the text with liberty; he merged the successive events into a simultaneous one, with Christ in the centre preaching and performing his miracles. According to the text, Christ had come from

Galilee, a large multitude following, and he began to preach, healing the sick. The crowd look to the Lord, waiting for their turn to be healed. Near the centre, to the left, a young mother with a child advances to Jesus. St Peter interferes, restraining her, but Christ makes a counter-movement. It is the moment when he says the famous words: 'Suffer the little children, and forbid them not, for of such is the kingdom of heaven'. In addition, this chapter of St Matthew contains the story of the rich youth who could not decide whether or not to give his possessions to the poor and follow Christ's teachings. The young man is seen sitting to the left, in rich attire. Here too, on the upper left, are the Pharisees, arguing among themselves, but not with Jesus, as in the text. A warmth of feeling seems to emanate from him, spreading balm on the suffering souls of the sick, the poor, and the humble. The spell of devoutness and the intimate spiritual union of the composition are mostly due to a general atmosphere of wondrous light and shade that hovers and spreads over the whole scene. It is a light that by its infinitely subtle gradations and floating character transforms the transcendent sphere into reality. A miracle which binds visible energies with the invisible and the sublime is performed before our eyes.

The types of the Pharisees in the *Hundred Guilder Print* are of a more genuine Jewish countenance than those Rembrandt represented in his early works. Late in the forties he began to watch Jews more carefully, and to characterize them more deeply than before. Rembrandt had the opportunity to study the Jewish population of Amsterdam. From the time he purchased his large house in the Sint-Anthonisbreestraat (later the Jodenbreestraat) in 1639 until he was forced to sell it in 1658 he lived on the edge of the largest Jewish community in Holland. Among his Jewish acquaintances were the distinguished rabbi, author, and

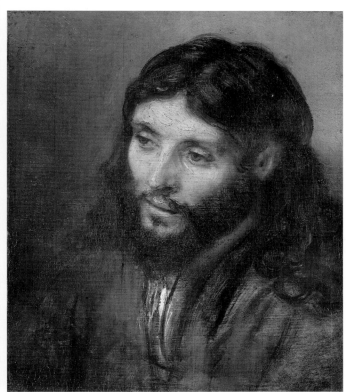

printer Menasseh ben Israel and the physician Ephraim Bonus; he made portraits of Bonus (Bredius-Gerson 252 and Bartsch 278) and perhaps one of Menasseh too (Bartsch 269). Menasseh, who lived near Rembrandt, commissioned the artist to illustrate one of his own books and he most probably provided him with the form of the cryptic Aramaic Menetekel inscription from the Book of Daniel that appears on the wall in his spectacularly dramatic *Belshazzar's Feast* of about 1635 (London, National Gallery). Rembrandt's intense familiary with the physiognomies of the Spanish Jews (the Sephardim) and the Eastern Jews (the Ashkenazim), who were allowed to live in Amsterdam in relative freedom during the seventeenth century, helped him to enrich his biblical representations. His interest in them was not merely a romantic and pictorial one. To Rembrandt the Jews were the people of the Bible, and with his deepening realism he wanted to become more authentic in his biblical representations. He found among them inspiration for mildly passive and emotional characters, and he also studied the harder and more intellectual types, who show the perseverance of the Jews and furnished models for his figures of the Pharisees. Even more remarkable is the series of portraits of Jesus made around the same time which are based on a Jewish model [114]. Rembrandt, it seems, was the first artist to derive his Christ-type from a personal study of Jews.

114. Rembrandt: *Head of Christ*, c.1647–50. Berlin, Staatliche Museen

115. Rembrandt: *Bathsheba*, 1654. Paris, Louvre

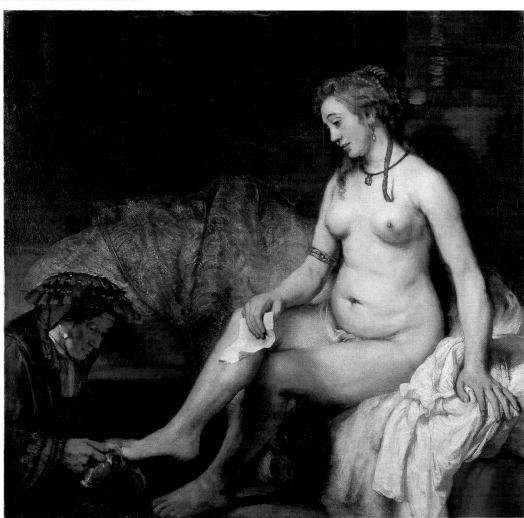

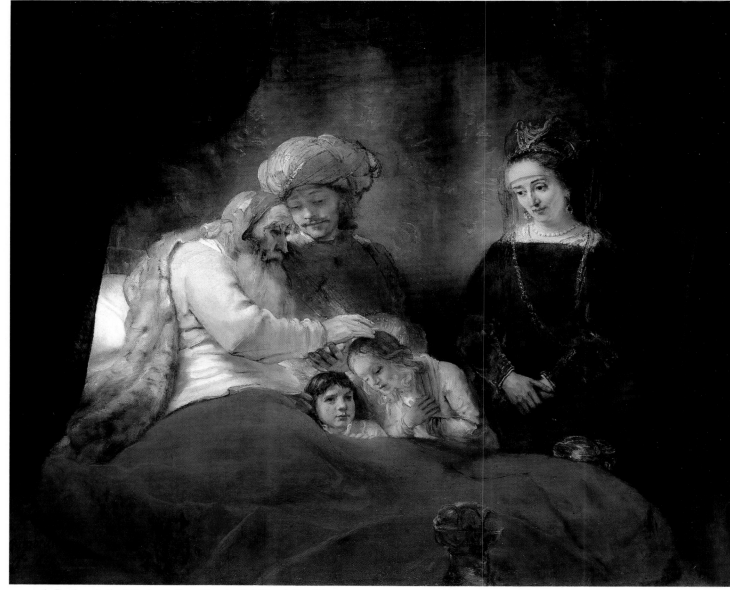

116. Rembrandt: *Jacob blessing the Sons of Joseph*, 1656. Kassel, Staatliche Gemäldegalerie

Although a basic change in his Christian attitude does not occur, the spirit of Rembrandt's religious works shifts about the middle of the 1650s. As early as 1653 his religious art begins to show a more gloomy cast. In contrast to the mild, harmonious tenor of the works made at the beginning of his mature period, a sombre atmosphere now prevails. It is hard to relate this shift to the teachings of a specific religious sect. The new mood can no longer be connected with the doctrines of the Mennonites. Rembrandt probably incorporated his own experiences and deepened sense of reality in his profound and highly personal interpretations of Scripture in his late biblical pictures. Realism has long been the domain of Dutch art: but it was only the late Rembrandt who could extend it to the reality of the innermost life, to the invisible world of religion. One can notice the beginning of the new tragic mood in the monumental etching of the *Three Crosses* of 1653 (Bartsch 78), where the emphasis is on the suffering of Christ, on the drama of Golgotha, and the mystery of his sacrifice. It is true that scenes from the

youth of Christ, his miracles, and the events following the Resurrection continue to appear in the etchings and drawings; but in the paintings themes from the Old Testament become more frequent, and they seem to be imbued with a sombre undertone. This is the mood of the life-size painting of *Bathsheba* (1654, Paris, Louvre) [115]. Hendrickje probably served as the model for the picture. Bathsheba, the beautiful wife of Uriah, is shown holding the letter which King David sent commanding her to come unto him (II Samuel 11). She will comply with David's wishes, but tragedy is inevitable. David will arrange for Uriah to be killed, and the child conceived by Bathsheba in adultery will be struck by the Lord and will die. Rembrandt captures every overtone of the tragic Bible story – from the pain of consciousness of sin to the desire of the flesh – in the tension he builds up between Bathsheba's reverie and the warmth and weight of her nude body. Most marvellous is the soft and mellow painting of the flesh. The expression of its solid form, which anticipates the heaviness of Courbet's nudes, is combined with the

unmatched brilliance and breadth of treatment of the late works. As always, the formal qualities are linked with naturalness. The effect of David's letter upon Bathsheba is shown in the inclination of her head and her meditative mood, which is expressed in a wonderful relaxation throughout the whole figure. Her attitude reveals the forms of her body with great clarity and simplicity. A classical touch is also noticeable in the tectonic quality of the figure, which has a static fullness and calm and the parallel arrangement of the entire composition. The classical qualities have been connected to an Antique relief showing two women in similar poses which Rembrandt could have known from an engraving published in 1645.[38] But the intent of the picture has nothing to do with the classical idea of the nude. It also is distant from paintings of nudes by Raphael, Titian, or Rubens. They painted the female nude to show their conception of ideal feminine beauty. Their's was a delight in the body made exquisitely perfect. Rembrandt's *Bathsheba* was primarily painted to show the mood and innermost thoughts of a woman. There is no precedent for his conception.

One of Rembrandt's most moving religious works is *Jacob blessing the Sons of Joseph* (1656, Kassel, Staatliche Kunstsammlungen) [116], which was painted in the year he declared himself insolvent and knew he would be forced to sell his house and treasures. This important picture, which is one of his largest biblical paintings, reflects nothing of that personal tragedy. It is relatively serene – the blond tonality contributes much to this effect – yet profoundly spiritual. The scene represents the last hours of the old and almost blind patriarch Jacob. Joseph has brought his two young sons, Manasseh and Ephraim, to be blessed by his father. The children kneel in childish awe and curiosity. Jacob laid his right hand upon the head of fair Ephraim, the younger son, first. When Joseph saw this 'it displeased him and he held up his father's hand, to remove it from Ephraim's head unto Manasseh's', who was entitled to the blessing (Genesis 48:17). But the ancient Jacob refused to change his benediction, and prophesied that the younger son would be greater than the older. According to tradition, Ephraim symbolized the coming of the Christian faith, while Manasseh stood for the Jews. Rembrandt showed the moment when Joseph tried to guide his father's hand to the older boy's head. But it is too late. The blessing of Ephraim takes place. God's will is done. Jacob gently pushes back Manasseh with the back of the fingers of his left hand. Assnath, Joseph's wife, stands apart with a wonderful expression of motherly feeling about the deep significance of the event. There is very little action in the picture – so little that any other Baroque painter would have been embarrassed by the subject as it appears here, and would have turned it into something more dramatic by exterior agitation.[39] But to the mature Rembrandt it was natural to neglect such Baroque conventions and to concentrate on the inner life of the figures, on their spiritual bond, during this sacred scene.

From the late fifties onwards, Rembrandt preferred to represent moments of heavy gloom, tragic upheaval, and of solemn pathos in human life, especially in the lives of great sinners or great worshippers. The aged Rembrandt is conscious, more deeply than before, of the fearful destiny to which many may be doomed and of the imminent terror that

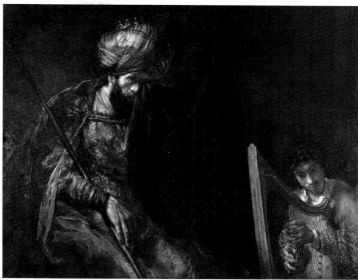

117. Rembrandt: *Saul and David*. The Hague, Mauritshuis

may at any moment engulf him. But as the *Prodigal Son* (*c.*1669, St Petersburg, Hermitage) [119], one of his latest works, and perhaps his greatest, shows, he also penetrates more profoundly the idea of God's grace by which repentant man may be forgiven and saved.

The picture of *Saul and David* at the Mauritshuis [117] shows the king haunted and depressed by heavy melancholy. He hopes to find some relief and consolation in the music made by young David playing the harp. We see the healing influence of music in the fact that King Saul is wiping a tear from his eye with the dark curtain. But at the same time a sinister feeling seems to stir within him. The king is possessed by hatred and jealousy against his young rival, whose growing fame is beginning to outshine his own. Saul's uncovered eye, wide open and darkly gleaming, betrays the approaching eruption. His right hand will in a moment hurl the lance at David. It is the inner conflict in the king's mind which the artist reveals. We feel the heavy burden of destiny that is imposed on the man by an unseen higher power. This deeper significance is expressed in the picture by pictorial undertones. Shades of black deepen the shadows and add force to the gloom of the colours, among which a glowing red and golden yellow in the king's attire are prominent. Even the brocade and jewellery share in the mood of the picture. We may say now that Rembrandt has become more conscious of the formidable side of God as expressed in this Old Testament story. The dominating expression, however, is the profound human aspect of the story, not a theological one. It is a sympathetic and powerful exposition of the doomed hero's inner conflict in his hour of trial.[40]

When we turn to a subject from the New Testament of about the same period, the *Denial of St Peter* of 1660 at the Rijksmuseum [118], we gain a similar impression. Here not an inveterate sinner like Saul is represented, but a repentant one who will be saved. Yet St Peter is also doomed to show human fallibility at his hour of trial. As Christ has foretold, he fails his crucial test and denies his Lord out of fear for his own life. Again Rembrandt's interpretation excels by

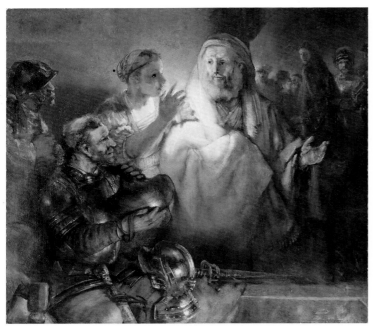

118. Rembrandt: *Denial of St Peter*, 1660. Amsterdam, Rijksmuseum

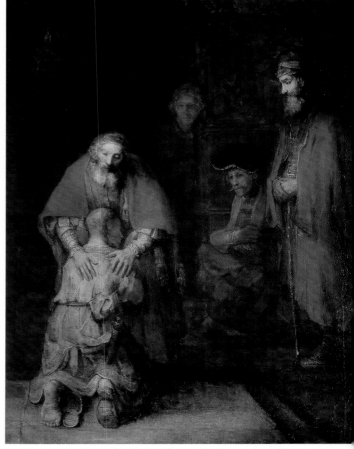

119. Rembrandt: *Return of the Prodigal Son*, c.1669. St Petersburg, Hermitage

sympathetic human insight into the saint's inner conflict at the moment when his faith has weakened. In this nocturnal scene everything hinges upon the expression of St Peter, from whom an answer is expected. The questioning maid, who hides her candle in the Honthorstian manner, focuses the light upon his face and looks into his eyes with searching attention. Her features show decision, in contrast to the apostle's embarrassment. The faces of the two grim warriors on the left are equally searching. These three figures form a wedge directed at St Peter and symbolize a powerful challenge to the steadfastness of his faith. In the rear we see Christ turning back at this moment, as if aware of Peter's trial and failure.

During the last years no basic change occurs in Rembrandt's style. His expressive power, however, grows until the very end. The boldness and freedom of his brush-work are at a peak in the great works of the later sixties. Very few artists – one thinks of Michelangelo, Titian, Goya – offer the same spectacle of an ever-increasing power of expression which culminated at the end of their lives.

Rembrandt's final word is given in his monumental painting of the *Return of the Prodigal Son* [119]. Here he interprets the Christian idea of mercy with an extraordinary solemnity, as though this were his spiritual testament to the world. It goes beyond the works of all other Baroque artists in the evocation of religious mood and human sympathy. The aged artist's power of realism is not diminished, but increased by psychological insight and spiritual awareness. Expressive lighting and colouring and the magic suggestiveness of his technique, together with a selective simplicity of setting, help us to feel the full impact of this event. The main group of the father and the Prodigal Son stands out in light against an enormous dark surface. Particularly vivid are the ragged garment of the son, and the old man's sleeves, which are ochre tinged with golden olive; the ochre colour combined

with an intense scarlet red in the father's cloak forms an unforgettable colouristic harmony. The observer is roused to a feeling of some extraordinary event. The son, ruined and repellent, with his bald head and the appearance of an outcast, returns to his father's house after long wanderings and many vicissitudes. He has wasted his heritage in foreign lands and has sunk to the condition of a swineherd. His old father, dressed in rich garments, as are the assistant figures, has hurried to meet him before the door and receives the long-lost son with the utmost fatherly love. The occurrence is devoid of any momentary violent emotion, but is raised to a solemn calm that lends to the figures some of the qualities of statues and gives the emotions a lasting character, no longer subject to the changes of time. Unforgettable is the image of the repentant sinner leaning against his father's breast and the old father bending over his son. The father's features tell of a goodness sublime and august; so do his outstretched hands, not free from the stiffness of old age. The whole represents a symbol of all homecoming, of the darkness of human existence illuminated by tenderness, of weary and sinful mankind taking refuge in the shelter of God's mercy.

120. Detail of fig. 119, *Return of the Prodigal Son*

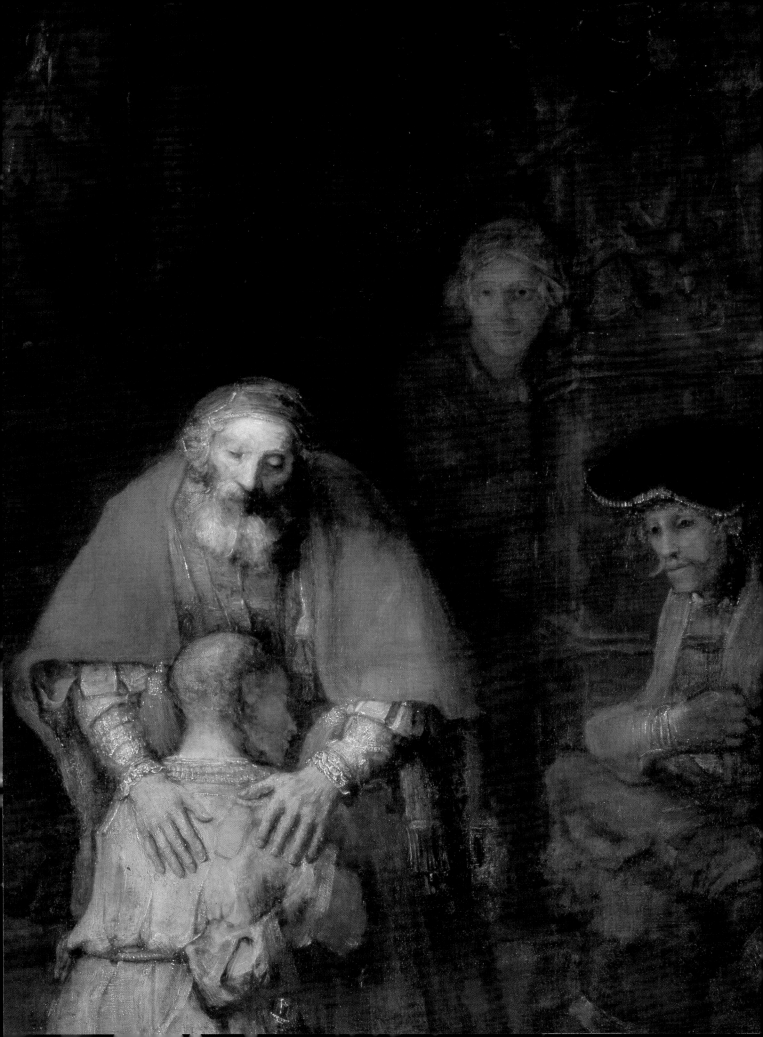

Rembrandt's Pupils and Followers

Rembrandt's impact upon the artists of his time was unique. Pupils, apprentices, and journeymen worked with him during every phase of his career, and there are strong reflections of his style in the work of artists who never entered his studio. He had more close followers than any of his contemporaries. Names of more than fifty have been listed and a host remain unidentified. However, it should be stressed that among those that have been named less than half can be documented or are cited in seventeenth-century sources. For identification of the others we are given clues by Arnold Houbraken whose three-volume compendium of the lives of seventeenth-century Dutch artists appeared in 1718–21 or we rely on stylistic evidence.[1] Contemporary drawings depict Rembrandt surrounded by pupils in his studio, and it is said that at one time he had to convert a warehouse into a school in order to handle the great number attracted to him [121]. According to Sandrart, who was in Amsterdam from around 1637 until 1645 when Rembrandt was at the height of his popularity, his pupils brought him in a large income. Sandrart wrote that almost innumerable scholars from good families paid Rembrandt 100 guilders annually, and he earned about 2,000 to 2,500 guilders every year from the sale of paintings and prints made by each of them. The practice of selling student work was not an unusual one. According to the rules of the guild, an apprentice was not allowed to sign his work and whatever he made belonged to his master. But Sandrart, who was the kind of man who liked to count other people's money, probably exaggerated Rembrandt's earnings from this source. The meagre documentary evidence about his income does not support Sandrart's estimate. One of the rare bits is a memo that Rembrandt scribbled on the back of a drawing he made just around the time Sandrart arrived in Amsterdam which states he received a total of 24 guilders, 6 stuivers for the sale of six works including three by his assistant Ferdinand Bol and one by his well-documented but nebulous pupil Leendert Cornelisz van Beyeren.[2] If these were average prices for pieces turned out in Rembrandt's studio, it is hard to see how he could have earned much from the sale of his students' work.

There was a good precedent among Renaissance and Baroque painters for large workshops. The most celebrated one of the seventeenth century belonged to Rubens. However, there are important differences between the studios managed by Rubens and Rembrandt. Most of Rubens's commissions were for colossal wall and ceiling decorations designed for churches and palaces. He also decorated huge temporary structures made for pageants, festivals, and the triumphal entries of royalty. Rubens did not paint these numerous monumental works single-handedly; he employed a team of collaborators to help him, and he equitably adjusted his prices according to how much he or his assistants did on a work. It was, of course, necessary for his helpers to subordinate their style to his, and it was his moral responsibility to see that the finished product was worthy of his shop. As court painter, Rubens did not answer to the Antwerp guild. He also employed a staff of graphic artists to make engravings after his original compositions. He himself hardly etched or engraved. His printmakers had to follow his style, not their own. In contrast, it is possible that traces of the hand of some of Rembrandt's pupils or assistants can be found in a few etchings the master signed (see p. 104), and that the uneven printmaker Johannes van Vliet may have actually been employed by Rembrandt in the early 1630s to reproduce some of his paintings. But the peerless etcher did not make a practice of having assistants reproduce his paintings or work on his plates. Rembrandt fundamentally conceived of etchings as independent works of art, not as reproductions of his own compositions made in other media by closely supervised helpers. Moreover, Rembrandt did not receive many commissions which would normally have required assistants. In the *Anatomy of Dr Tulp*, the *Night Watch*, *The Syndics*, and the huge remnant of the *Conspiracy of Claudius Civilis* – pictures made from the beginning to the end of his career for which he could have used help – there is no evidence that a hand other than the master's touched the original. In these works, his largest paintings, Rembrandt did not need, or want, the kind of collaborators some of his contemporaries and many of his predecessors used.[3]

Yet, the fact remains that apprentices and journeymen who entered his studio could not help adopting his style. This is not astonishing when we consider the method of training artists in seventeenth-century Holland. It was still in accord with traditions established by late medieval guilds for teaching young people crafts – the tradition is still alive in craft unions today. Aspiring artists were apprenticed to a master, sometimes as very young boys, to get the fundamentals. After learning them they became journeymen who could take part in the master's production. Only rarely were girls apprenticed to artists in the Netherlands during the century (see pp. 128–30); to our knowledge no girl or young woman was trained in Rembrandt's studio. After an apprentice learned the basics from one artist, he often went to another for additional training. This is the path Rembrandt himself followed. After his apprenticeship with Swanenburgh in Leiden, from the age of about fourteen to seventeen, his father sent him to work with the famous Lastman in Amsterdam for about six months to secure his best advantage. Then he returned to Leiden and set himself up as an independent master. In Leiden he had pupils and soon after he settled in Amsterdam in about 1631–2 young artists with high ambitions went to him (Lastman died in 1633). If Houbraken is to be trusted, after he was already a trained young artist, Govert Flinck joined his studio around 1633 expressly to learn his manner. It seems that Ferdinand Bol made the same move in about 1636–7 and so did Arent de Gelder as late at the 1660s. What an apprentice or journeyman produced while bound to his master was done in the latter's style. A 1651 ordinance of Utrecht's guild

121. Unidentified Rembrandt pupil: *Rembrandt's Studio with Pupils drawing from a Nude*. Drawing: black chalk, wash, heightened with white. Darmstadt, Hessisches Landesmuseum

expressly states this had to be the case.[4] Regrettably the existing regulations and records of the Amsterdam guild are pitifully scant; it is not known, for example, what requirements, if any, an apprentice (*leerjongen*) had to fulfill before he qualified as a journeyman or assistant (*knecht*).

Members of an artist's studio not only worked in his style; they also copied his works. Copying them was a standard part of their training and employment, and we have mentioned, copies as well as other work done by them belonged to the master. If their output met his (or the guild's) standard of quality control, he could sign and sell them as products worthy of his shop.

A question naturally arises regarding the assistance Rembrandt may have received from his apprentices and journeymen: are some works traditionally accepted as his originals copies done by them? Other questions arise too. Leaving aside Tulp's *Anatomy*, the *Night Watch*, *The Syndics*, and *Claudius Civilis*, did any members of his studio participate in works Rembrandt executed on commission or for the open market? And conversely, did he retouch works they made when attempting to match his style?

Specialists dedicated to establishing the canon of Rembrandt's autograph painted and graphic *œuvre*, like those doing the same for other artists, attempt to answer these questions on the basis of a scrupulous study of all aspects of the style and content of works unquestionably attributable to him. An equally close study must be made of the paintings, drawings, and etchings by his pupils and followers. Use also is made of technical analyses and every scrap of available documentary evidence. Then conclusions regarding the relationship of other works to this hard core are offered. The task is a formidable one which demands intimate familiarity with more than 2,000 paintings and works on paper that have been rightly or wrongly ascribed to him, not to mention the output of scores of artists whose production is closely related to his. No wonder that a consensus is not always reached regarding conclusions that have been offered. There also are some borderline cases that continue to defy unqualified attribution. In our discussion of artists associated with Rembrandt's circle an attempt has been made to include

122. *Anna and the Blind Tobit*. London, National Gallery

generally accepted works; instances where there are significant disagreements have been signalled.

Rembrandt's numerous drawings show that he constantly made variations on the themes of his finished paintings and etchings, particularly of religious subjects, and that he produced many more ideas for pictures than he could execute. These must have been a source of stimulation for his students while they were close to him. He was not the kind of artist to hoard ideas. He had too many. As a teacher he probably asked students to work up some into a more complete state, and his tremendous energy enabled him to correct and retouch their efforts as well as continue his own prodigious production. Drawings by his students reveal that he altered and corrected their essays. It is difficult to determine how many Rembrandt school pictures are based upon the master's own inventions. Definite connections are not always cut and dry. A case in point is the painting of *Anna and the Blind Tobit* in the National Gallery, London [122]. On the basis of its style and a contemporary engraving by Willem van der Leeuw inscribed *Remb. van Rijn inv.* some experts argue that it was painted by Rembrandt around 1630. Others note the engraving's inscription only tells us that the master designed the composition, not that he painted it. On the basis of the inscription and their analysis of its style they conclude it was painted by the young Gerrit Dou about 1630

123. Jan Lievens: *Feast of Esther*, c.1625. Raleigh, North Carolina Museum of Art

after a composition by Rembrandt while he was an apprentice in his studio. Yet another group of specialists propose that it was painted by Dou and retouched by his teacher. General agreement on who painted what in the picture has not yet been reached.

In Rembrandt's day, as in ours, knowledge that the master touched up a pupil's work made it more valuable. This is one reason why the students' paintings he corrected were carefully described as 'van Rembrandt geretukeert' ('retouched by Rembrandt') in the 1656 inventory made of his effects. The pupils who painted the pictures he embellished that were still in his possession in 1656 have not been identified, and neither has the artist (or artists?) of the six copies of his paintings listed in an inventory compiled as early as 1637 (see p. 105).

Rembrandt seems to have been the kind of creator who needs a retinue – just as he seems to have been the kind of man who needs a woman as wife or mistress in his household. From the very beginning he had pupils, and he was never without some. Dou, who entered his studio as early as 1628, based the style he successfully used for a lifetime on the minute and finely executed pictures which Rembrandt produced in the few years of his Leiden period. Rembrandt's magnetic artistic personality exerted equal force from this early date until his last years. Different pupils may be assigned to each epoch of his career. None kept abreast of him. Generally they learned his current mode and adopted the motifs he favoured when they entered his studio. From what we can tell, he made no effort, or was unable, to bring out their individuality. It is arguable, of course, that in view of the character of the master-apprentice relationship in Dutch studios, developing a pupil's individuality was not part of a teacher's mandate. Nevertheless, some masters were different. We have heard that Frans Hals was one of them. Without documentary evidence it would not be possible to tell that Pieter van Roestraeten and Vincent van der Vinne were his pupils and that probably Philips Wouwerman was as well. With Rembrandt it was otherwise. Close contact with

him always left an unmistakable mark. Rembrandt overwhelmed the pupils who came into his orbit. This may be one of the reasons why many abandoned their Rembrandtesque manner soon after they left his atelier. The unmistakable mark was not indelible, and in some cases quick rejection followed seduction. There were followers of Caravaggio, the other great innovator of Baroque painting, who reacted in the same way. There were, however, some notable exceptions in Rembrandt's circle. Gerbrandt van den Eeckhout, who probably entered Rembrandt's studio in the mid- or late 1630s and who was described by Houbraken as Rembrandt's 'great friend', soon went his own way; but he made one of his most Rembrandt-like works as late as 1667 (*Peter healing the Lame*) [141], and Arent de Gelder, who came to Rembrandt around 1660, continued to show the master's late manner and close familiarity with what he had accomplished well into the eighteenth century.

THE LEIDEN PERIOD

An important artist to consider in connection with Rembrandt during the Leiden years is Jan Lievens (1607–74), who was a gifted etcher and designer of woodcuts as well as a painter. He was not Rembrandt's pupil, but his close friend. For a time the young artists certainly shared the same models and perhaps the same studio. There was a symbiotic relationship and friendly rivalry between the two, and as early as 1632 it could happen that their hands were confused. In an inventory made in that year of Frederik Hendrik's effects at Noordeinde there is listed 'Simeon in the Temple, holding Christ in his arms done by Rembrandt or Jan Lievensz', and the *Rape of Proserpine* and *Minerva in her Study*, listed in the same inventory as works by Lievens are almost certainly paintings done about 1631 by Rembrandt, both now in Berlin.[5] Their early works have been confounded until this day.

Lievens, who was a year younger than Rembrandt, was much more precocious than his friend. He also had a considerable head start on Rembrandt as a student of art. At the tender age of eight, Lievens began a two-year apprenticeship in his native town with the Leiden figure painter and landscapist Joris van Schooten (c.1587–1652/3), and from about 1617 to 1619 he was with Lastman in Amsterdam. After this training the twelve- or thirteen-year-old boy began to work as an independent artist in Leiden. A contemporary reports that around this time he made copies after a *Democritus* and a *Heraclitus* by Cornelis Ketel which connoisseurs could not distinguish from the originals, and that in 1621 the fourteen-year-old youth made an impressive portrait of his mother.[6] Thus Lievens was already an accomplished artist before Rembrandt left Leiden University about 1620 to begin his apprenticeship. About four or five years had to pass – a considerable span of time among boys – before Rembrandt was able to match his friend's performance. From the beginning Lievens had a talent for working on a life-size scale, as seen in the unsigned, large *Feast of Esther* (Raleigh, North Carolina Museum of Art) [123], datable about 1625, now generally attributed to him. It depicts the moment after Esther has told Ahasuerus of Haman's treacherous persecution of the Jews; Haman shrinks back in fear, knowing that he will suffer Ahasuerus's wrath.[7]

124. Jan Lievens: *Constantijn Huygens*, *c.*1628–9. Douai, Musée de Douai, on loan to the Rijksmuseum, Amsterdam

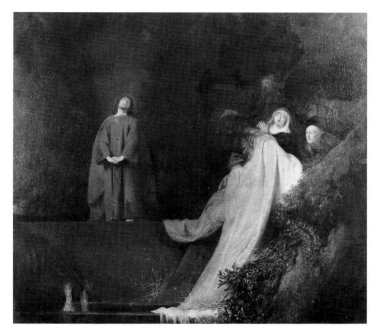

125. Jan Lievens: *Raising of Lazarus*, 1631. Brighton, Art Gallery and Museum

About this time, Lievens painted life-size genre pieces which are early examples of Utrecht Caravaggism in Leiden (*Boy blowing on burning Coals* and *Boy lighting a Candle*, both in the Muzeum Narodowe, Warsaw). Occasionally he painted large-scale portraits too; particularly beautiful is his introspective one of Constantijn Huygens (*c.*1628–9; Douai, Musée de Douai, on loan to the Rijksmuseum, Amsterdam) [124]. Thanks to a passage in Huygens's journal we know more about the way the portrait was painted and the patron's reaction to it than most done during the period. Huygens reports that Lievens was so eager to do his portrait that he invited him to his home in The Hague to satisfy his desire, but because he was very busy at the time, he did not have much patience for posing and since it was in the dead of winter when days were short Lievens was only able to finish the hands and clothing; completion of the face was put off until spring. Huygens was delighted with the finished portrait and other people were impressed as well. However, he notes, there are some who think Lievens portrayed him too thoughtful and failed to capture his 'natural cheerfulness'. In Lievens's defence he explains, he, not the artist, is responsible for its pensive mood since at the time he was deeply troubled by family matters and although he tried to hide his inner concerns, they were evident in his mien and eyes, and Lievens captured them in his portrait. In the Douai likeness of Huygens Lievens not only shows himself as an outstanding portraitist before Rembrandt tried his hand as a professional face painter but also anticipates the

characteristic contemplative portraits of his friend's maturity. Lievens himself did not paint other portraits that express similar moods.

Huygens's acute observation that the young Rembrandt surpassed Lievens in his ability to express emotion in a small, carefully worked out picture, but that Lievens was superior in grandeur of invention and boldness, is supported by the paintings the young friends made during their Leiden period. In Lievens's *Raising of Lazarus* of 1631 at Brighton [125], the dramatic tenor, the dark grey tonality, the minute technique, and the individual types recall Rembrandt's painting of the same subject now at the Los Angeles County Museum of Art datable about 1630–1 (Bredius-Gerson 538; *Rembrandt Corpus* A30) – perhaps the young artists made their versions of the miracle in a friendly competition. Although at this stage of their careers Rembrandt had already surpassed Lievens in power of concentration, incisive characterization, and in his ability to relate tightly and convincingly the single parts by the organization of the chiaroscuro effect, he recognized that he could continue to learn from Lievens's search for monumentality. After he moved to Amsterdam Rembrandt made a red chalk drawing (*c.*1635, British Museum; Benesch 17) based on Lievens's etching after his Brighton painting and a reproductive print of it by another artist. Rembrandt transformed it into an Entombment that served as a preparatory study for his painting of the subject made for Frederik Hendrik's Passion series; his *Entombment* was in progress by 1636 and finally delivered in 1639.[8] Lievens's large compositions done in Leiden about 1630 (*Job on the Dung Heap*, 1631, Ottawa, National Gallery of Canada) and portraits of picturesque types (*Head of an Old Man*, Braunschweig, Herzog Anton Ulrich-Museum) show some of the smoothness which increases during the following years. Even when he is closest to Rembrandt during this phase his paint is less dense than his friend's and he seldom attains his modelling power.

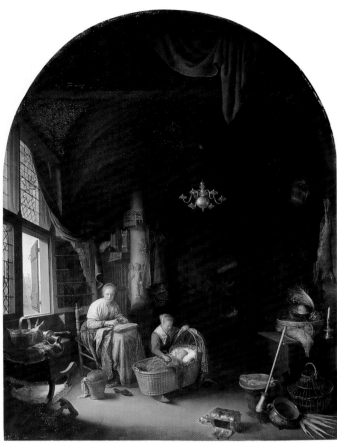

126. Gerrit Dou: *Young Mother*, 1658. The Hague, Mauritshuis

The close personal connection between the two Leiden painters was broken after Rembrandt moved to Amsterdam late in 1631, or early in 1632. Lievens left Holland in 1632 for a visit to England where he was active at the court of Charles I; he remained for three years. From London he went to Antwerp living there from 1635 until 1644. During his long stay away from Holland he fell under the spell of Flemish painters, particularly Van Dyck. A small group of landscapes, which reveals the impact of both Rubens and Brouwer, is his most striking contribution during his Flemish period. After he had settled again in the Netherlands in 1644 he made portraits that show the pronounced influence of Van Dyck and became one of Amsterdam's fashionable portraitists. He also received numerous important commissions for historical and allegorical pictures. Among them is a large *Five Muses* for Huis ten Bosch in The Hague. Others were for public buildings: a moralizing *Quintus Fabius Maximus* for Amsterdam's new town hall in 1656 (for Flinck and Bol's didactic paintings of classical subjects, also done for the town hall, see pp. 106–7 below) and four years later a picture for one of the building's large lunettes illustrating an episode of the history of the Batavi. Later he executed an allegorical painting of *War* for the chamber of the Provincial Assembly at The Hague and two allegorical pictures for the Rijnlandhuis at Leiden. All the late compositions continue to show the elegance, smoothness, and light colours of his Flemish experience. Whether Lievens made contact with his

boyhood friend during the last phase of his career is not known, but it is certain that the art of the two masters, had developed by then in completely different directions.

On 14 February 1628, Gerrit Dou, the pupil who heads the list of those who studied with Rembrandt, began a three-year apprenticeship. When Dou entered Rembrandt's studio he was just approaching his fifteenth birthday; his master was not yet twenty-two years old. Dou was born in 1613 in Leiden, the son of a glass-engraver. He was trained by him, and then by an engraver who made prints and also by a glass-painter. Under the influence of Rembrandt's early style, Dou initiated the Leiden tradition of small, minutely finished pictures, which continued well into the nineteenth century. In a way the work of the school of the Leiden 'fine painters' (*fijnschilders*) he founded can be considered a continuation of the microscopic tradition started by the van Eycks. Part of the secret of Dou's success, and that of his followers, is the simple pleasure people receive from seeing the world meticulously reproduced in small, with perfect craftsmanship. During his lifetime he was one of the best-paid artists in Holland, and he quickly acquired an international reputation. Pieter Spiering, the minister to The Hague from Sweden, paid him 1,000 guilders annually to obtain first choice of works destined for Queen Christina's collection. Spiering, it should be added, was more impressed than the queen was with Dou's paintings. She characteristically refused to take advice, and returned ten of Dou's pictures to her agent in 1652. In 1660 the States of Holland selected his *Young Mother*, dated 1658 [126], as one of the precious gifts to Charles II on the occasion of the Restoration. Of this picture John Evelyn wrote that it was painted 'so finely as hardly to be distinguish'd from enamail'. The following year one of his paintings was in Leopold Wilhelm's collection in Vienna. In 1665, a Leiden collector, Johan de Bye, rented a room in his native town where he exhibited twenty-seven of Dou's pictures. De Bye's cabinet, which consisted exclusively of works by Dou, was one of the first museums dedicated to exhibiting the production of a single artist. During the eighteenth century and the early part of the nineteenth century, collectors continued to compete for his paintings. Dou's international popularity began to wane only after 1860, when *avant-garde* artists were beginning to teach critics, collectors, and the wider public how exciting Dutch pictures which lacked a high finish could be. Interest in him and other Leiden *fijnschilders* revived after their modern champions rightly stressed than an important aspect of Dutch painting is embodied in pictures done in a fine, delicate manner.[9]

Young Dou admired and imitated his teacher closely. He frequently used Rembrandt's schemes and paraphernalia. A comparison of his *Old Woman reading a Bible*, at the Rijksmuseum [127], with Rembrandt's *Old Woman reading* (1631) at the same museum shows the master's superiority and the pupil's limitations. The face Dou painted is like a mask; it has a frozen surface which appears to have been over-exposed to the light. From the very beginning, Dou was compulsively fond of minute still-life accessories and genre details. He frequently over-emphasized these, and thereby lost the tension and coherence of Rembrandt's early compositions. This is seen if *Painter in a Studio* (formerly New

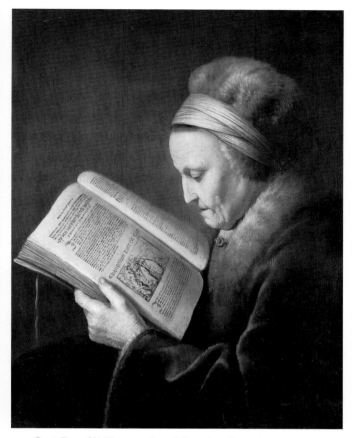

127. Gerrit Dou: *Old Woman reading a Bible*, c.1630. Amsterdam, Rijksmuseum

128. Follower of Gerrit Dou: *Artist in a Studio*. Formerly New York,
New York Historical Society

129. Rembrandt: *Self-Portrait in a Studio*, c.1629. Boston, Museum of Fine Arts

York, New York Historical Society; sold by the society, 1995) [128], which has been attributed to Dou but is more likely by one of his followers, is compared with Rembrandt's *Self-Portrait in a Studio* (c.1629; Boston, Museum of Fine Arts) [129]. The latter inspired a series of paintings of studios by Dou and members of his circle, but only in the Rembrandt are we struck by the boldness with which the mighty dark form of the easel is placed in the immediate foreground as a dramatic repoussoir for the small figure of the painter. This daring accent almost throws the picture out of balance, yet the psychological and pictorial interest in the figure is sufficient to restore it.[10] The version formerly in New York loses the drama and the mystery of Rembrandt's little masterpiece. Young Rembrandt's brilliant use of chiaroscuro for clear spatial distinctions and for expressive purposes is lacking. So is concentration; the final effect of the attempt to enrich the work by the addition of details is a series of digressions. However, some of the accessories have historical interest. For example, the sculpture on the table in

the painting is a copy or a cast of the Christ Child from Michelangelo's *Madonna and Child* group in Bruges, a familiar prop in seventeenth-century Dutch studios. It will be recalled that the reference to a 'child by Michelangelo' in Rembrandt's 1656 inventory probably refers to a copy or cast of the same piece.

After Rembrandt left for Amsterdam, Dou set himself up as an independent master in Leiden, where he lived until his death in 1675. He declined an invitation from Charles II to visit England. During the thirties he abandoned the warm browns and dark tonality of his early work for cooler and paler colours. At this time he also refined his technique and perfected the smooth, enamel-like surfaces which are the hallmark of his work. Dou won notoriety for his diligence and patience. When he was praised for the care with which he painted a broom about the size of a fingernail, he replied that he still had three days' work to do on it, and he is reported to have spent five days on the under-painting of one hand of a woman who sat for a portrait. Though he

must be credited for setting the long-lived Dutch vogue for small, carefully finished portraits, it is not difficult to understand why he was never in great demand as a portraitist – particularly since he charged by the hour (six guilders). He was meticulous about his tools and the conditions under which he worked. He ground his colours on glass, made his own brushes, and never started to work on his panels until he felt that the dust in his studio had settled. Apparently he was unable to find a Dutch woman who would meet his exacting standards for cleanliness and tidiness; he never married. Dou had cases made for his pictures to help protect them, and he sometimes painted their covers. His *vanitas* still life at Dresden was the lid of a case made to contain his picture of a *Boy and a Girl in a Wine Cellar* in the same museum. Dou's perseverance and careful industry frequently resulted in over-refinement, and his attention to detail, particularly in his larger compositions, which became more frequent after 1650, tends to isolate the forms and fails to convey a broader sense of unity within his works.

Dou's range of subjects was a wide one. In addition to genre scenes he painted pictures of saints, animals (*Goat in a Landscape*, formerly Amsterdam, Wetzlar Collection), and still lifes. Once he adopted a motif, it attained popular approval and a long life. Dou also popularized the compositional device of a figure engaged at some occupation at a window. The earliest dated one is *The Grocer's Shop* (Paris, Louvre) of 1647. Soon after, the window motif occurs frequently in the Leiden School. The window frames quickly become more elaborate, bas-reliefs are introduced under the sills, and the windows are draped with curtains. Dou can also be credited with starting a hardy vogue around the middle of the century for small pictures of nocturnal scenes lit by candlelight or lanterns, which usually throw a harsh red light. In this group the incident depicted – children at school, card players, a group around a table, a dentist at work, a girl leaning out of a window – is usually more important than the dramatic potential of the chiaroscuro.

Dou's success attracted many pupils and followers. Among the former, the most significant was Frans Mieris the Elder (1635–81); by about 1660 he rivalled Dou as head of Leiden's 'fine painters' (see pp. 166–8). Dou's other students include his nephew Dominicus van Tol (*c*.1635–76), Abraham de Pape (*c*.1621–66), Matthijs Naiveu (1647–1728) and Godfried Schalcken (1634–1706); the last-named specialized in the type of night scene which Dou had popularized (see pp. 306–8). Gabriel Metsu (1624–67) and Pieter van Slingelandt (1640–91) are among the painters influenced by his work.

Rembrandt's other Leiden pupils and followers are of less artistic importance than Dou. About a score of them can be counted. Most of them are mediocre; some are simply atrocious. They are of interest because they show how rapidly and emphatically the young Rembrandt left an impression upon the artists who saw his work. The numerous contemporary copies of Rembrandt's Leiden pictures (as many as six versions of *Judas returning the Pieces of Silver* [65] are known) testify to his early popularity.

An artist whose activity is associated with Rembrandt's final years in Leiden and first years in Amsterdam is Isack Jouderville (*c*.1612–before 1648). This less than gifted painter gains distinction as one of Rembrandt's pupils whose apprenticeship is solidly documented. Records state that his guardian paid Rembrandt an annual fee of 100 guilders in 1630 and again in 1631 for his apprenticeship, documentary evidence that substantiates Sandrart's report that Rembrandt received 100 guilders per year for tuition of his students. Jouderville's only signed work, *A Bust of a Young Man* (perhaps a self-portrait) at the National Gallery of Ireland, Dublin, shows close familiarity with his master's portraits of about 1630, but falls far below them in quality. On the basis of it and a few other works attributed to him, and knowledge that he completed his apprenticeship with his master in November 1631, it has been proposed, but not widely accepted, that he followed Rembrandt to Amsterdam and actively assisted him there painting portraits during his master's first years in the metropolis.

A Rembrandtesque *Portrait of an Old Man* (1630, The Hague, Mauritshuis) similar to Jouderville's scarce ones is monogrammed 'IVR'. On the basis of the inscription it has been assigned to Jacques de Rousseaux who was active in Leiden during the 1630s. He too has been called Rembrandt's pupil. However, since Lievens also made 'Rembrandtesque' studies of the same type, until more evidence is available it is as reasonable to call him Lievens's pupil or follower as to assign him to Rembrandt's studio.

Johannes Gillisz van Vliet (1600/10–*c*.1668), who probably made contact with Rembrandt around 1630 or 1631, is important as an etcher; specialists continue to debate whether any paintings can be attributed to him. He made about a dozen etchings after Rembrandt's pictures between 1631 and 1634. His copies, in turn, were quickly copied by foreign engravers, and they helped Rembrandt to acquire an international reputation with extraordinary rapidity. Van Vliet also made a few etchings after Lievens's and Joris van Schooten's works. Little is known about his activities after 1637, the date of his latest print. The high standard of van Vliet's early etchings (*Baptism of the Eunuch* and *Lot and his Daughters*, both dated 1631 and both after lost works by Rembrandt) suggests that they were executed under Rembrandt's close supervision. Perhaps, as indicated above, the young Rembrandt had the idea of using van Vliet as an assistant, and even considered employing him to make reproductions of his works. Rembrandt's large etchings of the *Descent from the Cross* (1633; Bartsch 81/2) and the *Ecce Homo* (1635; Bartsch 77) show that they were made with the help of an assistant; today there is general agreement they were worked on by van Vliet. Coarse etchings of beggars and cripples by van Vliet indicate that he was stimulated by Rembrandt in some of his independent works. The etchings which show nothing of Rembrandt's influence – for example, his series of crafts- and tradesmen – are crude, but they are of interest as social documents. The relationship to Rembrandt of other engravers who translated his early works into prints about the time van Vliet was active is still an open question. One worth considering is Willem van der Leeuw (1630–*c*.1665?) who made the engraving he inscribed *Rembr. van Rijn inv*, of *Anna and the Blind Tobit*, known today from the painting at London [122]. In addition to it, van der Leeuw engraved four other prints after Rembrandt datable to these years and one after Lievens.

Small biblical and allegorical pictures by Jacob de Wet (1610–71), Jacob van Spreeuwen (1611–?), and Willem de Poorter (1608–after 1648) can also be connected with Rembrandt's last years in Leiden and first years in Amsterdam, but it is not known if these artists actually worked in Rembrandt's studio. De Poorter's still-life paintings of flags and military equipment piled in dramatically lit grottoes (1636, Rotterdam, Boymans-van Beuningen Museum) hover between the works of Rembrandt and Bramer, without ever capturing the intensity of the former or the fantasy of the latter. The bursts of light and deep chiaroscuro effects in some of the rather wild biblical pictures by the Dordrecht artist Benjamin Gerritsz Cuyp (1612–52) can also be connected with Rembrandt's Leiden years and with his early activity in Amsterdam.

THE FIRST AMSTERDAM PERIOD

More students as well as patrons flocked to young Rembrandt soon after he settled in Holland's greatest metropolis. A period of study with him seemed to assure success. Govert Flinck (1615–60) and Ferdinand Bol (1616–80), who worked with him in the thirties, made brilliant careers for themselves, and by the middle of the century most citizens of Amsterdam would have agreed that Flinck had surpassed his master.

Flinck was the first to manifest the impact of Rembrandt's new Amsterdam style. He studied with the painter, dealer, and Mennonite preacher Lambert Jacobsz (1598/9–1636) in Leeuwarden before he left for Amsterdam to begin work with Rembrandt. Leeuwarden, one of the principal cities of Friesland, never became an artistic centre, but it was not a backwater where nothing was known about the contemporary international art scene. Lambert Jacobsz, father of the successful portraitist Abraham Lambertsz van den Tempel who became Bartolomeus van der Helst's best follower, is said to have been in Italy and to have studied with Rubens. He was familiar with the work of the Utrecht Caravaggesque painters as well as Lastman and Moeyaert. Included in a posthumous inventory of his effects made in 1637 were six copies of works by Rembrandt as well as one original.[11] No doubt they were part of his stock as a dealer and probably came from Hendrik Uylenburgh with whom he did business – we have heard that after Rembrandt moved to Amsterdam he lived in Uylenburgh's house until about 1635, and probably had a studio there. Friesland's leading portraitist, Wybrand de Geest (1592–1667), had been to France and Rome, where he made copies of Caravaggio's pictures. After his return to Leeuwarden he became in effect the court painter of the Frisian nobility. In 1622 he married Hendrickje Uylenburgh, a distant cousin (not the sister) of Saskia Uylenburgh who became Rembrandt's wife in 1636.

Flinck, born at Kleve in the Lower Rhine district, was originally apprenticed to became a silk merchant. According to tradition he was allowed to switch careers when Lambert Jacobsz visited Kleve and managed to convince his father that painting was an honourable profession. He took the boy north to Leeuwarden with him. Flinck was apprenticed to his new master for three years. Houbraken tells us he left for Amsterdam with Jacob Backer, who was also a pupil of

130. Govert Flinck: *Portrait of a Man*, 1637. The Hague, Mauritshuis, on deposit from The Netherlands Office for the Fine Arts

Lambert Jacobsz. Flinck entered Rembrandt's studio in about 1633 and worked with him for one year as a journeyman, not an apprentice. Like Rembrandt, he lodged with the dealer Hendrik Uylenburgh. Again, according to Houbraken, he went to Rembrandt to learn his manner, for he alone pleased the public at this time, and other artists had to adjust their style to his if they wanted to succeed. Houbraken adds that Flinck learned Rembrandt's manner so well that some of his pictures were mistaken for authentic Rembrandts and sold as such.

His earliest dated works, which are inscribed 1636, show that he was really very clever at imitating Rembrandt's early Amsterdam style and handling. His *Portrait of a Man*, dated 1637 [130], which once carried the master's fake signature, is one of his best approximations of Rembrandt.[12] Additional proof that Houbraken was on solid ground when he wrote that some of Flinck's works could pass for Rembrandt's originals is offered by the *Landscape with Obelisk* (1638, formerly Boston, Isabella Stewart Gardner Museum; stolen 1990) [131], which was almost universally accepted as an autograph Rembrandt until it was discovered in the 1980s that it too bore the remnants of Flinck's signature that had been faked into his master's.[13] The painting's design, with the colossal trees in the foreground, threatening sky, and fantastic background vista, is closely related to Rembrandt's imaginary landscape, which includes an episode from the parable of the Good Samaritan, at Cracow (1638; Bredius-Gerson 442; *Rembrandt Corpus* A125). The rediscovery, also in the 1980s, of Flinck's *Landscape with a Bridge and Ruins*, securely signed and dated 1637, now at the Louvre, is

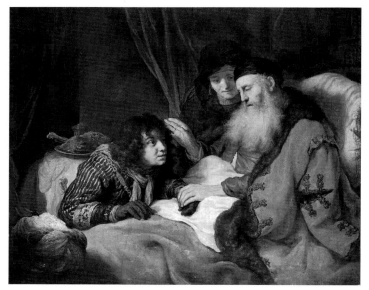

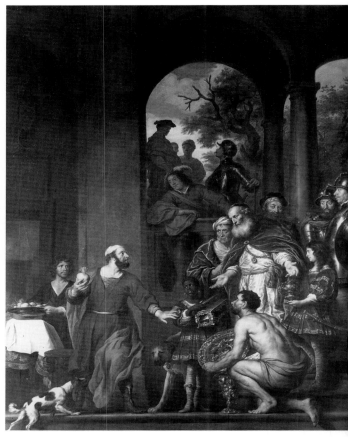

133. Govert Flinck: *Marcus Curius Dentatus refusing the Gifts of the Samnite Ambassadors*, 1656. Amsterdam, Royal Palace

131. Govert Flinck: *Landscape with an Obelisk*, 1638. Formerly Boston, Isabella Stewart Gardner Museum (stolen 1990)

132. Govert Flinck: *Isaac blessing Jacob*, c.1638. Amsterdam, Rijksmuseum

comparable in style and technique to the Gardner painting and helps clinch the attribution of the latter to Flinck. Long recognized as his masterpiece in the Rembrandtesque style is Flinck's *Isaac blessing Jacob* at the Rijksmuseum [132] datable to the late 1630s (the signature and date of 1638 disappeared during the course of a cleaning). The deep reds, violets, and golden yellows establish a colour harmony which is quite original; Flinck as a colourist tends to be more variegated and brilliant than his teacher. His conspicuous realism is also a personal touch. The things he represents have an over-distinctness compared to Rembrandt. He was less able to subordinate parts· of his composition to the overall design, and he did not grasp the function of Rembrandt's half-tones, which create a transition between forms, relating them to the whole work.

Flinck followed the pattern which became a standard one for so many of Rembrandt's pupils. In the forties he abandoned his teacher's manner – Houbraken reports that he did it with much difficulty – for a lighter style of painting. The change brought him great popularity and wealth, and he

assembled an outstanding group of drawings, including many by Rembrandt, and is reputed to have formed a remarkable collection of Italian art. He won more patronage from the ruling circles of Amsterdam than any of his contemporaries. Flinck painted three large group portraits for civic guard companies (1642; 1643; 1648), and he was commissioned to portray the heroes Admiral Tromp and Admiral de Ruyter, as well as the poet Joost van den Vondel; Rembrandt rarely portrayed such distinguished personages. As far as we know, Flinck never painted genre scenes or still lifes, and his landscapes remain an exception in his *œuvre*. He had a higher goal. Like Rembrandt, he wanted to be known as a history painter. No Dutch seventeenth-century artist with a similar ambition had better support.

Flinck worked for Amalia van Solms (*Allegory in Memory of Prince Frederik Hendrik*, 1654, Amsterdam, Rijksmuseum), and he received the lion's share of commissions to decorate Amsterdam's new town hall. In 1656 he completed *Marcus Curius Dentatus refusing the Gifts of the Samnite Ambassadors* [133] for the burgomasters' council chamber in the build-

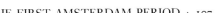

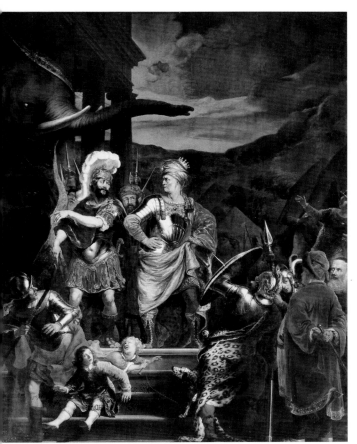

134. Ferdinand Bol: *Gaius Lucinus Fabritius in the Camp of King Pyrrhus*, 1656. Amsterdam, Royal Palace

Ferdinand Bol entered Rembrandt's studio about 1636–7 after serving an apprenticeship with Jacob Cuyp in Dordrecht, his birthplace, or in Utrecht with Abraham Bloemaert. Since he signed a document in 1634 at Dordrecht 'Ferdinandus Bol, painter' he apparently finished his training by the time he joined Rembrandt. He left Rembrandt around 1642 when he began working independently in Amsterdam where he settled for the rest of his life. As an etcher and draughtsman we know him best from his early period, when the strong Rembrandtesque character can easily lead to confusion with the master's work. His early painted portraits are very similar to the commissioned ones Rembrandt made in the late thirties and early forties and in them he successfully incorporates aspects of the transparent chiaroscuro the older master develops during these years. Bol frequently posed his sitters, who usually show the placid side of their personalities in his pictures, at an open window. A characteristic example is the *Portrait of a Young Man at a Window* (Frankfurt, Städelsches Kunstinstitut) [135]. As in the case of so many other Rembrandt pupils, some of his works have passed for originals by his master. A famous example is the unsigned portrait of *Elizabeth Bas* (Amsterdam, Rijksmuseum) which was accepted as a characteristic Rembrandt of about 1640, until 1911 when it was attributed to Bol. The proposal started a lively debate which has not yet been settled. (Jacob Backer as author has had his advocates too, but today that issue is closed; there is universal agreement among connoisseurs he is a non-starter.) In our opinion the absence of vigour and breadth supports the attribution of *Elizabeth Bas* to Bol. In his later career, when Bol turned to a more courtly

ing, and in the same year Rembrandt's sometime follower Ferdinand Bol painted *Gaius Lucinus Fabritius in the Camp of King Pyrrhus* [134] for the same room. The huge pictures show the incorruptibility of Denatus and the intrepidity of Fabritius. The former is seen indicating that he would rather live on turnips than accept a bribe of precious gifts, and the latter is shown fearless even when an elephant, intended to frighten him out of his wits, was produced. The pair of paintings were done to remind the burgomasters of two virtues city officials should possess (for Pieter de Hooch's painting of the interior of the council chamber with Bol's painting *in situ* see fig. 207). In 1658 Flinck executed *Salomon praying for Wisdom* for the town hall; the significance of its subject for Amsterdam's city officials needs no exegesis. A year later he received the most prestigious commission given to a seventeenth-century Dutch painter: an order to make twelve huge paintings to decorate the lunettes in the corridors of the town hall illustrating the history of the struggle between the Batavians and the Romans. Flinck died two months after he received this colossal commission. It was then distributed among a group of artists. As noted in the discussion of Rembrandt's mature phase, the city officials asked Rembrandt to make only one painting for the series: the *Conspiracy of Claudius Civilis* [110]; his painting was removed from the town hall shortly after it had been installed. The picture that Flinck had begun for this scene was then worked up by Jürgen Ovens, another sometime Rembrandt follower, and it is still in place.

135. Ferdinand Bol: *Portrait of a Young Man at a Window*, *c.*1645. Frankfurt, Städelsches Kunstinstitut

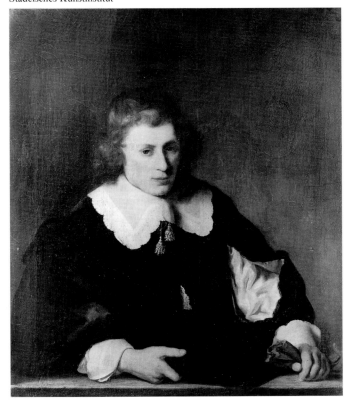

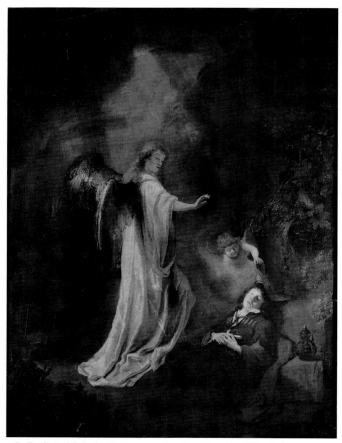

136. Ferdinand Bol: *Jacob's Dream*, c.1642. Dresden, Gemäldegalerie

style and a lighter tonality, the faces of his models look rather pasty, and the highlights on the red velvet he loved to paint appear to have been dusted lightly with talcum powder. In a subject picture like the *Jacob's Dream* of about 1642 (Dresden, Gemäldegalerie) [136] Bol captures something of the mood and tender character of Rembrandt's art of this period; but the elegant and noble attitude of the angel, with its long limbs and aristocratic gesture, is foreign to Rembrandt.

By the 1650s it is very hard to mistake a Bol for a Rembrandt. His pictures become smoother and bland. During these years Bol made portraits of the most famous citizens of the day (e.g. *Admiral de Ruyter*, 1667, The Hague, Mauritshuis). In the fifties he also began to receive a steady stream of commissions from Amsterdam's highest officials. For these works he adopted a style that has a distinct Flemish Baroque character. As we have seen, *Gaius Lucinus Fabritius in the Camp of King Pyrrhus* [134] was done for the burgomaster council chamber in the new town hall in 1656. Rembrandt was not completely forgotten in this work; the stout man seen from the rear in the left foreground is a direct quotation from the *Hundred Guilder Print* [113]. *Moses Descending from Mount Sinai with the Tablets of the Law* (c.1663) also was done for the town hall, and a series of history pictures and regent pieces were executed for other institutions of the city. His marriage in 1653 to a woman, whose mother was the daughter of an Amsterdam burgomaster who held office when the paintings for the town hall

were ordered, and whose father and brother held powerful positions in the city, must have helped him procure these prize commissions. Bol also worked for the municipal authorities of Leiden and painted a civic guard piece for Gouda. Godfrey Kneller, who became the leading portrait painter in England after the death of Peter Lely, studied with him during the sixties. After his first wife died and he married a wealthy merchant's widow in 1669, Bol virtually abandoned his career as an artist. He drew up the contract for his second marriage on 8 October 1669, the day of Rembrandt's funeral. Included in the inventory of the paintings he was bringing into the marriage were seven by Rembrandt, including one of Bol's father.[14]

Jacob Backer (1608–51) was a pupil of Lambert Jacobsz in Leeuwarden and, as we have heard, he travelled to Amsterdam in 1633 with Flinck who had studied with the same master. It had been assumed that, like Flinck, he entered Rembrandt's studio upon his arrival, but no documentary or visual evidence supports this hypothesis. Backer, only two years younger than Rembrandt, was an accomplished artist by the time he arrived in Amsterdam. He began to work there as an independent master and achieved success very quickly. His *Regentesses of the Burgher Orphanage of Amsterdam* of about 1633–4 (Amsterdam Historical Museum, on loan from the Burgher Orphanage), which does not show a trace of Rembrandt's style, depicts the regentesses life-size, full-length, in a spacious interior with an orphan child being introduced to the patrician governesses by the institution's housemother. He apparently invented the idea of using a child as an allusion to the good works of the officials; it was used by later portraitists. His beautiful *Portrait of a Boy*, dated 1634 (The Hague, Mauritshuis), painted in shades of grey has the quiet restraint, the smooth thin paint, and the ornamental brushwork that are characteristic of his hand. To be sure, in a few of his imaginary portraits of the thirties and his portrait of the Remonstrant minister *Johannes Uyttenbogaert* (1638, Amsterdam, Remonstrant-Reformed Congregation, on loan to the Rijksmuseum) are reminiscent of the more famous master. But even in these works he went his own way. In the portrait of Uyttenbogaert, the diffusion of interest created by the steady light, which shines with equal intensity on the head and hands and upon the carefully worked out still life, is something that Rembrandt would have avoided, as can be seen in the grand three-quarter-length of the same minister painted by him in 1633 (Amsterdam, Rijksmuseum; Bredius-Gerson 173; *Rembrandt Corpus* A80). Backer continued to receive commissions for group portraits of regents and civic guards during the course of his brief career. He also painted religious, historical, and mythological compositions with large figures; these were done in the classically oriented style that was becoming fashionable in the forties amongst the wealthy ruling class. If he had lived into the next decade, when assignments for the decoration of Amsterdam's town hall were distributed, he probably would have been selected to do some of them.

Although Rembrandt's impact during his first Amsterdam period on Backer was negligible, it is evident in the work of a number of other artists, who to our knowledge never studied with him. The one who was most strongly influenced

was Salomon Koninck (1609–56), who had been Claes Moeyaert's pupil and was a member of the guild in Amsterdam as early as 1630. By 1633 Koninck began to adopt Rembrandt's strong chiaroscuro, Baroque compositions, types, and trappings in his paintings of picturesque philosophers and rabbis and in his biblical compositions. Moeyaert, who was older than Rembrandt and started as a member of the Lastman group, also was tempted to emulate his production of the 1630s, and so was the fashionable Amsterdam portraitist Dirck Santvoort (1610/1–80). Large pictures by Jan Victors (1619–after 1676) of Old Testament subjects are distinctly related to Rembrandt's biblical pictures done after the mid-thirties; his paintings of tradesmen and rural genre scenes are more personal. In Haarlem, the classicist Pieter de Grebber had a brief Rembrandtesque phase, and in the same city Adriaen van Ostade made creative use of Rembrandt's chiaroscuro effects in the little genre pictures and rare biblical paintings he did in the thirties. The few landscapes known by Ostade's hand (Amsterdam, Rijksmuseum; Rotterdam, Boymans-van Beuningen Museum, van der Vorm Foundation) show that the landscapes Rembrandt painted in the late thirties had an impact on him almost before the paint on them was dry.

Lambert Doomer (1624–1700), primarily a landscapist, also belongs to the group of followers. His paintings, mostly topographical, are rare, but he was a productive draughtsman. Most major collections have examples of the drawings he made on a trip to France (1645–6) or on his extensive travels along the Rhine, in Bavaria, in Switzerland, or in the Netherlands. Although Rembrandt's influence on him is not evident during this period he may have had some contact with him around 1640, the year Rembrandt painted beautiful pendant portraits of his parents, now divided between the Metropolitan Museum and the Hermitage. Doomer's father was an ebony worker, a craft that included frame making. Did his son meet the master and get advice from him thanks to his business with Rembrandt? In 1654 Lambert's mother made a will bequeathing Rembrandt's companion portraits of herself and her husband to Lambert on the condition that he make copies of them for each of his brothers and sisters. At the time of her death in 1678 three of her children as well as Lambert were still alive. Thus, Doomer is documented as the maker of at least six copies of two Rembrandt portraits. To judge from the quality of those that have been identified none would be mistaken for a Rembrandt original.

THE MIDDLE PERIOD

Carel Fabritius, who was Rembrandt's most brilliant and original pupil by far, and whose very rare paintings form an important link between the art of Rembrandt and Vermeer, had a tragically short career. He was born in 1622 at Midden-Beemster, a small town about twenty-five kilometres north of Amsterdam. In their youth, both he and his younger brother Barent were carpenters, a trade that fits their surname. Fabritius (also Fabricius), worked with Rembrandt during the early forties. By 1650 he had settled in Delft, where he helped establish the famous school of painting in which Vermeer became the outstanding figure. The works he made in Delft anticipate a great deal of Vermeer's pictorial taste

and charm, and before he perished at the age of thirty-two in the disastrous explosion of a gunpowder magazine at Delft in 1654 he produced works which stimulated Pieter de Hooch and Emanuel de Witte, as well as a host of minor artists. In his early signed *Raising of Lazarus* at Warsaw [137] Christ's emphatic gesture and the composition of the work demonstrate the pupil's dependence upon Rembrandt's early representations of the same theme. The excited crowd and the warm tones show close familiary with the *Night Watch* completed in 1642, but in spite of all the agitation, Fabritius never approached Rembrandt's unerring sense for dramatic action or his teacher's narrative power. Rembrandt would never have made Christ perform his miracle by directing his command to Lazarus's feet. In about 1648 Fabritius painted a small *Portrait of a Man in a Helmet*, now at Groningen [177], which is similar to Rembrandt's oil sketches of the period. His sensuous and defiant *Self-Portrait* of about 1648–50 at Rotterdam [138], shows him as an accomplished and independent master. It also indicates how rapidly Fabritius developed a personal style. The broad, fluctuating manner of painting and the heavy, pasty paint are derived from Rembrandt's technique. However, Fabritius preferred to put a dark figure against a light background, whereas Rembrandt had a predilection for the opposite arrangement. Along with bright backgrounds Fabritius favoured cool silvery

137. Carel Fabritius: *Raising of Lazarus*, c.1643–6. Warsaw, Muzeum Narodowe

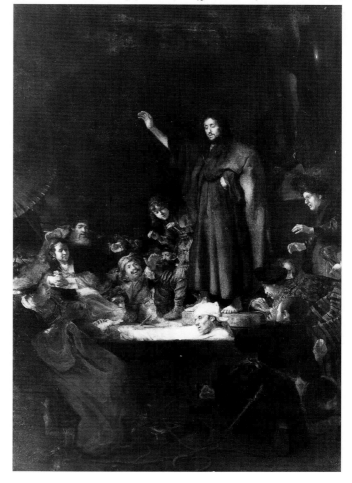

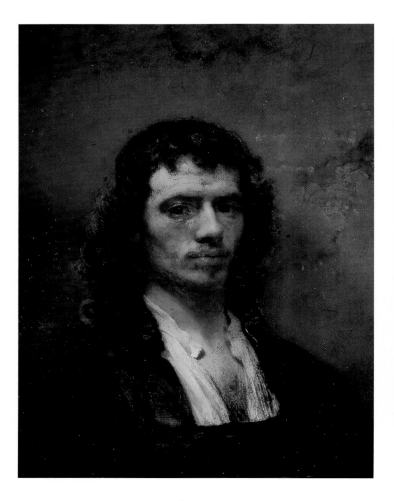

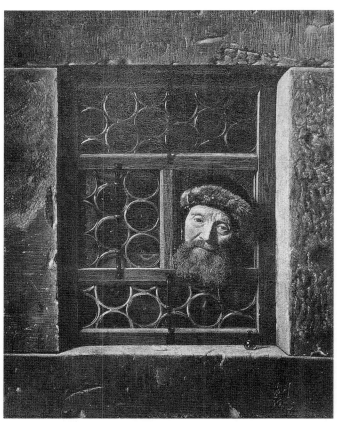

140. Samuel van Hoogstraten: *Old Man at a Window*, 1653. Vienna, Kunsthistorisches Museum

138. Carel Fabritius: *Self-Portrait*, c.1648–50. Rotterdam, Boymans-van Beuningen Museum

139. Samuel van Hoogstraten: *Self-Portrait with a Vanitas Still Life*, 1644. Rotterdam, Boymans-van Beuningen Museum

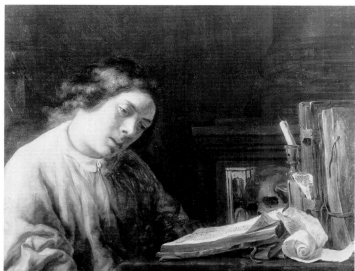

colours applied in flat, mosaic-like touches instead of Rembrandt's warm brown tonality; the shimmering daylight in the Rotterdam *Self-Portrait* is a clear sign of the direction Fabritius's art was to take. The significance of his few surviving later works for the Delft School is discussed in the following chapter.

Samuel van Hoogstraten (1627–78) was born in Dordrecht where he learned the rudiments of art from his father, a silversmith and painter. After the latter's death in 1640 he went to Amsterdam and entered Rembrandt's studio as a boy of fourteen or fifteen. By 1648 he had returned to his native city where he quickly established a reputation as one of Dordrecht's leading artists, and his appointment as provost of the city's mint distinguished him as one of its leading citizens. He travelled extensively but Dordrecht remained his base. Early in the 1650s he had a stay in Vienna where he received commissions from Ferdinand III, Emperor of the Holy Roman Empire, and then he went on to Rome. He also worked in Regensburg, and from 1662–7 he was in London. His place in even a cursory history of Dutch art is secured by his *Inleyding tot de hooge schoole der schilderkonst* (*Introduction to the Advanced School of Painting*), the first treatise on painting published in the Netherlands since van Mander's *Schilderboek* of 1604. His *Inleyding* appeared in 1678, the year of his death in Dordrecht. We have already heard that in it he singled out his teacher's *Night Watch* for special praise. The handbook is of particular value for documenting Rembrandt's pupils because in it Hoogstraten informs us that he himself was the master's student and that Carel Fabritius and Abraham Furnerius

were his fellow pupils while he was in his studio. He also records one of the rare existing statements his teacher made to a pupil. He writes that when he was in Rembrandt's atelier he troubled his master with too many questions concerning the origin of things. Rembrandt silenced his pupil when he replied: 'Take it as a rule to use properly what you already know; then you will come to learn soon enough the hidden things about which you ask'.

Hoogstraten's early paintings, like the *Self-Portrait with a Vanitas Still Life* of 1644 at Rotterdam [139], show a close affinity to his master. As a draughtsman he imitated Rembrandt more consistently than in painting, and his drawings have sometimes been confused with his teacher's. He tried to emulate the breadth of Rembrandt's late draughtmanship, but a close examination reveals that his outlines are dry and somewhat geometrical, the faces are without expression, and the chiaroscuro lacks Rembrandt's vibrancy. Hoogstraten's paintings of an *Adoration of the Shepherds* (Dordrecht, Museum) of 1647 and *Doubting Thomas* (Mainz, Museum) of 1649 exhibit the strong influence of his teacher, but by the 1650s Hoogstraten had abandoned Rembrandt's way of painting and adopted a pronounced illusionistic style which gained him the success he enjoyed as a portraitist, architectural, and genre painter in his later years. When he was in Vienna in the early 1650s Emperor Ferdinand III was so delighted with his pedantically completed *trompe l'œil* still lifes and pictures like *Old Man at a Window* [140] he decorated him with a gold chain and medal. It is the familiar story of how yet another pupil gained more success than his teacher as soon as he turned away from the teacher's art. Hoogstraten, however, continued to hold Rembrandt's work in high esteem. No only did he praise him in his *Inleyding* that was written in the 1670s, but he continued to make drawings that emulate his style after he abandoned his manner of painting. In addition to his *trompe l'œil* easel paintings, Hoogstraten had a keen interest in problems of perspective and illusionism. He made peep-boxes (examples are in the National Gallery in London, the Bredius Museum at The Hague, and the Detroit Institute of Arts) and large *trompe l'œil* decorations for homes. Carel Fabritius, as well as other artists of his generation, shared these interests. Godfried Schalcken was Hoogstraten's apprentice in about 1660, before he went to Gerrit Dou in Leiden, and Arent de Gelder studied with him before he joined Rembrandt. Not long before Hoogstraten died, Arnold Houbraken (1660–1719), best known for his *Groote Schouburgh*, was his pupil.

No doubt when mature Houbraken wrote his three-volume *Schouburgh* published in 1718–21 (the third volume was published posthumously) he tried to recall every scrap of information, hearsay, and gossip he heard from Hoogstraten when he was his student. Perhaps one of the bits was the basis for his report that the Amsterdamer Gerbrandt van der Eeckhout (1621–74) was one of Rembrandt's best pupils and that Eeckhout and Roelant Roghman were Rembrandt's friends. More is said about Roghman below. Regarding Eeckhout, we only have Houbraken's word that he studied with Rembrandt. However, the style of a number of his works, particularly his history paintings, portraits, and drawings, indicate he was his follower – perhaps he was in

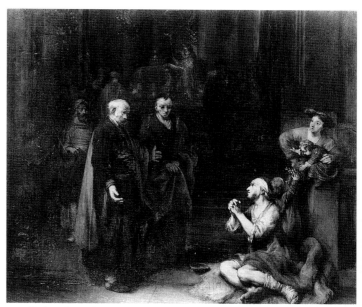

141. Gerbrandt van den Eeckhout: *Peter healing the Lame*, 1667. The Fine Arts Museums of San Francisco, gift of Mr and Mrs George I. Cameron

his studio by the late thirties. Eeckhout's development is not easy to trace because he responded to various influences and is rather rich in subject matter which shows at times quite a different character from Rembrandt's. During his early Rembrandtesque phase he also emulated Pieter Lastman's narrative pictures, and as late as 1656, in *Jeroboam's Sacrifice* (St Petersburg, Hermitage) the impact of Lastman is seen again. Around 1650 he began to depict guard room and elegant merry company scenes that anticipate Pieter de Hooch and have nothing in common with Rembrandt's paintings (his high society piece at the Worcester Art Museum, dated 1652, was once wrongly attributed to de Hooch). An Italianate character is also found in his work and he painted some portraits in Bartholomeus van der Helst's modish manner. However, Eeckhout has the distinction of coming close to Rembrandt's mature art in his late paintings. He did so in *Peter healing the Lame* (1667, The Fine Arts Museums of San Francisco) [141], one of his finest works, and achieves a truly Rembrandtesque effect with his chiaroscuro and colour. Although he received few official public commissions his varied output apparently earned him a good income; there is no evidence that he had to struggle to make ends meet. Perhaps he was helped by his father who enjoyed considerable prosperity after marrying, as a widower, the wealthy daughter of a director of the Dutch East India Company. During the last years of his life, still a bachelor, Eeckhout lived in a grand house on Amsterdam's Herengracht with his widowed sister-in-law.

Philips Koninck (1619–88), who was another member of Rembrandt's entourage, also seems to have been well-to-do, at least during the last decade of his life when he virtually stopped working as a painter. But it is not known if his income was generated from his work as an artist or his ownership of a shipping line. Houbraken tells us he learned from Rembrandt, a report supported by his drawings and early painted landscapes. However, by the middle of the

century he began to paint large panoramic views that are independent of the master's style. They rank with the most grandiose of the age (for this aspect of his work see p. 193 f.). Koninck's figure drawings sometimes recall those done by Rembrandt, and occasionally show something of Van Dyck's swift line, but they are schematic, miss structural quality, and do not have much human interest.

During the 1640s, when Rembrandt had a burst of activity sketching and making etchings of the countryside near Amsterdam, in addition to Philips Koninck other talented landscapists show a debt to his fresh views of nature. Among them is Abraham Furnerius (1628–54), whose early death cut off a promising career. We have mentioned that he was Rembrandt's pupil in the early forties along with Carel Fabritius and Hoogstraten. The latter reports in his 1678 treatise that Furnerius's landscapes are very pleasing. None of his landscape paintings have been identified, but his drawings support Hoogstraten's remark. Occasionally his drawings have been confused with those of Philips Koninck, who was his brother-in-law. At this time Jan Ruischer (after 1625–after 1675) was inspired by Rembrandt and Hercules Segers in his landscape drawings and etchings; the impact of Segers accounts for his contemporary cognomen 'de jonge Hercules'. Rocky mountainous landscapes by Roelant Roghman (1627–92) show affinities with Rembrandt as well as traces of the work of his mother's uncle, the Mannerist landscapist Roelandt Savery. In 1646–7, when Roghman was nineteen- or twenty-years-old he drew a set of more than 240 large views of Dutch castles, presumably to fulfill a commission. This remarkable set of careful topographical drawings, now widely scattered, has nothing in common with Rembrandt's style. Rembrandt helped satisfy the Dutch art market's hunger for many kinds of subjects but not its demand for exact topographical views. At first blush two of his well-known prints may appear to be exceptions, but they are not. They offer mirror images. His etched *View of Amsterdam* (c.1640; Bartsch 210) shows the city's skyline in reverse, and his peerless etched panoramic view commonly called the 'Goldweigher's Field' (1651, Bartsch 214), which is, in fact, an extensive panorama of the estate of Christoffel Thijsz (co-owner of the grand house Rembrandt purchased on the Jodenbreestraat in 1639) with a vista of Haarlem in the distance, also depicts the scene in reverse. Reversed topographical views apparently did not bother Rembrandt and those he made do not trouble us. Is there a soul who has been introduced to the wonders of Western art who would not exchange reams of correct topographic prints for good impressions of his two etchings? We have no way of knowing if there were sticklers for accuracy in his day who found his flopped images of Amsterdam and a specific site in the countryside near Haarlem unacceptable (for Rembrandt's etchings of other subjects that reverse images and apparently did not disconcert him see p. 289 [391], and p. 337, Note 14). The list of landscapists whose works show close familiary with Rembrandt's etchings and drawings of the 1640s includes Anthonie van Borssum (1630/1–77) and Pieter de With (active c.1650–died after 1689), but it is not known to whom they were apprenticed. De With's graphic works also reveal an affinity with landscapes by Jacob Koninck, the brother of Philips Koninck, and he made gouache drawings that have been mistakenly attributed to Elsheimer.

Judging from his style Rembrandt's second cousin, the minor Leiden artist Carel van der Pluym (1625–72), worked with the master during the forties. Van der Pluym painted small pictures of biblical subjects, old philosophers, scholars, and *Vanitas* themes – the stock-in-trade of Leiden artists – which earlier critics would have called clumsy and which modern specialists have admired for their primitive charm. His existing *œuvre* is small. Perhaps painting was not his main profession. In any event he had another full-time occupation; he was Leiden's municipal plumber. Contact between the cousins remained close. In 1665 van der Pluym was appointed Titus's guardian in a legal suit regarding his inheritance, and in his will he made Titus one of his heirs. The master's son did not enjoy the handsome bequest of 3,000 guilders he intended for him. Titus predeceased him by four years.

A group of foreign artists also had contact with Rembrandt during this period. The most original was the German Christoph Paudiss (c.1625–66) who was probably with the master around 1642. Sandrart (1675) called him Rembrandt's excellent disciple. His transformation of Rembrandt's dark chiaroscuro and warm palette is best seen in his still lifes, which are characterized by lost contours, a soft, diffused light, and a distinctive colour harmony of cool grey, greens, rose, and a silvery yellow. Only a few paintings support Houbraken's contention that the German artist Jürgen Ovens (1623–78) was Rembrandt's pupil. If correct, he must have been with him for a brief period about 1640 since his early works are already predominantly affected by the style of Flemish artists and he does not abandon their manner.

Ovens is most frequently remembered as the artist who finished Flinck's version of *The Conspiracy of Claudius Civilis* which, as we have heard, was substituted for Rembrandt's masterpiece in the town hall of Amsterdam. Other German artists who are said to have contact with Rembrandt during the decade are the Bremen painter Franz Wulfhagen (1624–70) and Michael Willmann (1630–1706), but there is no reason to hypothesize a pupil-teacher relationship for either of them. Secure is the connection of the Danish artist Eberhart Keilhau (1624–87) to Rembrandt (the surname Keil, frequently found in the modern literature is not supported by documents). After an apprenticeship in Copenhagen he went to Amsterdam where he studied with Rembrandt from about 1642 until 1644. Subsequently he worked for Hendrick Uylenburgh and then opened his own studio. In 1651 he left Amsterdam for Italy, where he spent the rest of his life. His pictures were first grouped together by Roberto Longhi[15] as the works of 'Monsù Bernardo', the name given to Keilhau in Italy. Life-size genre pictures of a few figures were his speciality. His themes are often related to simple allegorical subjects such as the Five Senses, the Seasons, and the Four Elements, and as protagonists he favoured dignified old people or children dressed in old clothes and rags. The early paintings attributed to him show virtually nothing of Rembrandt's influence; those done in Italy even less. Occasionally the latter recall works by Domenico Fetti and Bernardo Strozzi. Keilhau also gains

distinction as the man who gave Filippo Baldinucci data for the informative pages he published in 1686 about Rembrandt's life, character, and art in *Cominciamento e progresso dell'intagliare in rame*, the first extensive historical treatise on the history of engraving and etching.

THE MATURE PERIOD

The mature Rembrandt continued to attract to his studio young students who became his close followers. The best known is Nicolaes Maes (1634–93). As in the case of the majority of Rembrandt pupils, it is not known when Maes was sent to work with the master, or how long he stayed with him. Houbraken writes he learned drawing in his native Dordrecht from 'an ordinary master' (*een gemeen Meester*) and then continued his training with Rembrandt. He probably worked with him during the early 1650s. His earliest existing dated work, *The Dismissal of Hagar* (New York, Metropolitan Museum) of 1653, is distinctly Rembrandtesque in subject and style. By late 1653 Maes is recorded back in Dordrecht. He spent two decades there before moving to Amsterdam where he lived until his death. After his return to Dordrecht he painted a few additional biblical subjects which still show the unmistakable impact of Rembrandt as well as a large, unexpected painted copy, with some variations, of Dürer's engraved *Adoration of the Shepherds* of 1504 (Bartsch 2); it is at the Getty Museum, Los Angeles. However, Maes's secure reputation as an outstanding Rembrandt pupil and one of Holland's most innovative genre painters rests upon the appealing scenes he depicted of the domestic life of women done from about 1654 to 1659. The works of this very brief period make good use of Rembrandt's strong colour

142. Nicolaes Maes: *Young Woman at a Cradle*, c.1655. Amsterdam, Rijksmuseum

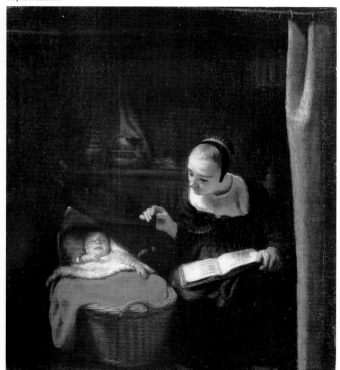

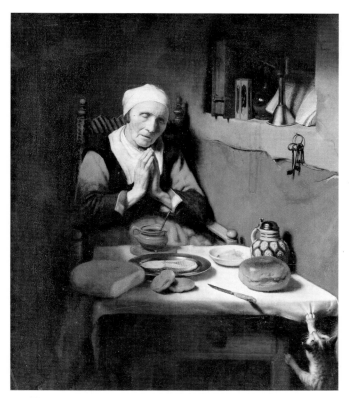

143. Nicolaes Maes: *Old Woman saying Grace*, c.1655. Amsterdam, Rijksmuseum

harmonies of black, red, and white, and his warm chiaroscuro of the forties. Rembrandt himself never painted similar genre scenes but he made numerous beautiful drawings of various aspects of the domestic life of women [see 91]. We know a posthumous inventory compiled in 1679 of the effects of the leading marine painter Jan van de Cappelle lists a portfolio containing 135 *vrouwenleven* (life of women) drawings by the master. Sketches of the type in that precious portfolio left a deep impression on young Maes.

The range of Maes's domestic subjects is large. Some depict young mothers with their infants which show a debt to Rembrandt's Holy Family paintings of the forties, and capture aspects of his master's tenderness and intimacy. The sweet one at the Rijksmuseum [142] can be seen as a secularization of Rembrandt's *Holy Family* of 1645 at St Petersburg [88], and it employs the *trompe l'œil* curtain the master used for his painting of the same subject, dated 1646, at Kassel [89]. Others show women praying, spinning, sewing, making lace, preparing food, or teaching children – all virtuous activities related to the centrality and sanctity of the home in Dutch society. During this phase Maes has a predilection for illustrative detail, such as a cat attempting to steal the fish dinner of a pious old woman saying grace [143], or a crying boy who has been chastized because he dared play his drum in a room where an infant is asleep. The solidity and sincerity of his painting prevents these motifs from slipping into *Kitsch*.

A few of his pictures have veiled erotic allusions and there are some that call attention to vices. A good natured one of the latter category is *The Idle Servant* at the National Gallery, London [144]. Its protagonist is a housewife appealing directly to us to witness the sloth of the sleeping servant who

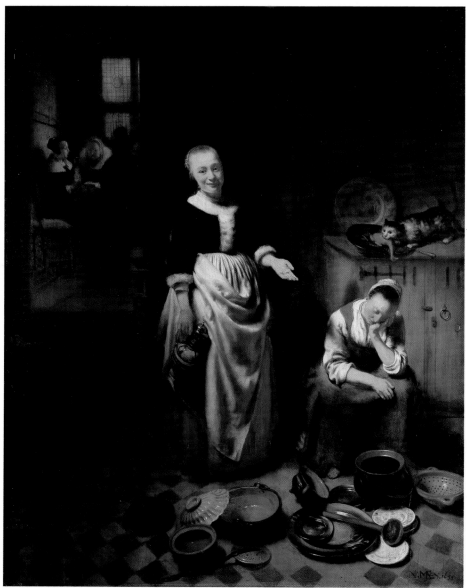

144. Nicolaes Maes: *The Idle Servant*, 1655. London, National Gallery

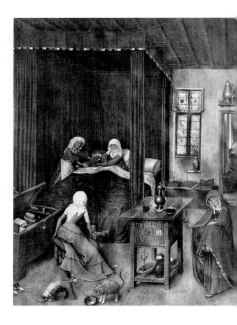

145. Hand G of the Turin-Milan Hours: *Birth of St Jo the Baptist*, c.1425–50. Turin, Museo Civico

146. Mirror attached to the outside frame of a window Dutch house. Photograph

not only left her mess of pots and dishes unwashed but allows the cat to snatch a fowl. The painting's strong chiaroscuro relates it to Rembrandt but Maes's personal contribution is the emphasis he places upon creating the illusion of interior space in which the scene is set. Here the stress on the expanse of the tile floor is not fully successful – the pots and dishes are dangerously close to sliding off it. More importantly, he allows us to look from one room to another where conversing women introduce a minor sub-plot. The Dutch call this a kind of glimpse, a *doorkijkje* (the diminutive of *doorkijk* = a look or a glance). Maes did not invent the motif. It was used expertly as early as the fifteenth century by an artist unimaginatively called Hand G (variously identified as Jan van Eyck, his assistant, or his follower), on a manuscript page that shows St Elizabeth in her lying-in

room after the birth of St John the Baptist [145]. Beyond Elizabeth's fully furnished room, which includes attendants, a child, and a couple of household pets, are two smaller rooms; in the first, well-windowed one St Zacharias is seated writing his son's name in a book (Luke 1:57–63), and in the second there is a woman seen from the rear – she may be washing up. Later artists used the motif too, but Maes gave it new life when he painted a number of domestic scenes in settings similar or more elaborate than the one seen in the London painting that offer views into distant upstairs and downstairs rooms that often include incidents related to those in the foreground scene.[16] All of them share a great sensitivity to the quality of light and atmospheric effects, and some anticipate the glorious interiors painted in Delft by Vermeer and Pieter de Hooch merely a few years later.

Although the *doorkijkje* motif is only found once in Vermeer's existing *œuvre* [183], there are parallels between the rooms he created for his genre scenes and those by Maes. De Hooch's more rigidly constructed interiors also can be related to them, and for him, as we shall see, views through doorways to both indoor or outdoor spaces are of frequent pictorial and psychological significance. Did the two great Delft masters know the interior genre pictures Maes painted in Dordrecht during the 1650s? The answer must remain speculative. No documentary evidence establishes that Maes had contact with them. We can, however, note that the trip from Delft to Dordrecht is a short, easy one.

In their use of an adjustable mirror secured to the outside frame of a window [146], the Dutch propensity to peek and peer continues in some quarters to this day. The main function of the device – its Dutch name is *spionertje* – is to allow occupants of a building to see who is at an entrance before responding to a knock or the ring of a doorbell. With a little adjustment it also can be used by the occupant of a room to spy upon activities in the street. However, its double usage has dwindled significantly since the ubiquitous spread of television. Not only can a television camera trained on a doorway do the principal job of a *spionertje* but the chance images that can be caught in one are no match for the endless variety and global range of those offered by TV sets. Moreover, the latter's images can be preserved and replayed as frequently as one's heart desires.

Maes included conventional portraits in his repertoire after his return to Dordrecht, and around 1660, with few exceptions, abandoned genre painting to become a portrait specialist. The change in subject was accomplished by a radical shift in style. After 1660 he discarded the dark, sober manner of his early Dordrecht portraits for a light and more elegant mode. This aspect of his production is discussed in the section on portraiture (pp. 258–60). The type of genre picture he initiated in the fifties did not disappear from Dordrecht, however. They are found in the *œuvre* of versatile Cornelis Bisschop (1620–74), a native of the city, and Reinier Covijn (1636–81), an artist of moderate talent also active there.

Barent Fabritius (1624–73), two years younger than his brother Carel Fabritius, was possibly Rembrandt's pupil during the early years of the master's mature period, but it is equally possible that he absorbed aspects of Rembrandt's style and motifs without entering his studio. His brother may have been the conduit for the Rembrandtesque aspects in his work. Like Carel, as a young man Barent was a carpenter and was active in his native Midden-Beemster, Amsterdam, and probably Delft. He also practised in Leiden where he received an important commission for a family portrait of the city's leading architect: *Willem van der Helm, his Wife and Son* (1656, Amsterdam, Rijksmuseum). A review of Barent's work shows no steady evolution. He is an example of a gifted artist who was easily stimulated by others. His earliest existing dated painting, bolder in conception than execution, is the striking *Portrait of a Young Man* of 1650 (perhaps a self-portrait) at Frankfurt (Städelsches Kunstinstitut). Its mood is Rembrandtesque while its light background and diffuse shadows are reminiscent of his brother's pictorial innovations. *The Expulsion of Hagar and Ishmael* at The Fine Arts

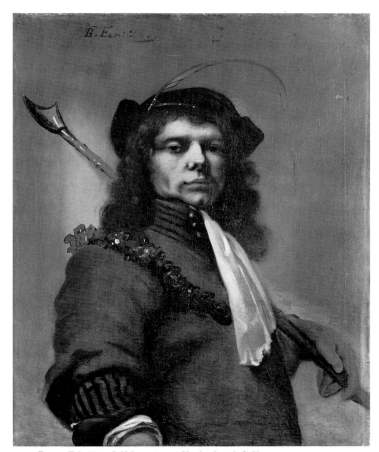

147. Barent Fabritius: *Self-Portrait as a Shepherd*, c.1658. Vienna, Gemäldegalerie der Akademie der bildenden Künste

Museums of San Francisco, which formerly bore not one but two false Rembrandt signatures, is now generally attributed to him and dates to the early fifties. It shows a considerable debt to Pieter Lastman's painting of the same subject (1612, Hamburg, Kunsthalle) as well as to Rembrandt. Although it has some similarities in details to the San Francisco painting, quite different in effect is his *Peter in the House of Cornelius* of 1653 (Braunschweig, Herzog Anton Ulrich-Museum), which is a portrait of the Fabritius family in the guise of a biblical subject (Acts 10:25); conceived in a style that is closer to Eeckhout than Rembrandt, this picture is a curious *mélange* of a historiated family portrait set in a Dutch tiled interior with a not very emphatic *doorkijkje*. The 1656 family portrait of the Leiden architect Willem van der Helm mentioned above has the distinctive light tonality and vivid hues that Delft painters were beginning to use in the mid-fifties. Barent's bold *Self-Portrait as a Shepherd* painted about 1658 [147], one of his most impressive works, shows the full impact of his brother's art. It is closely related to Carel's *Self-Portrait in a Cuirass* of 1654 at the National Gallery, London, but the viewpoint he chose – he seems to be looking down at us from above – and the soft contours of his figure that enhance the atmospheric effect are original. Barent did not continue in this vein or steadily in another. His three pictures illustrating parables (Amsterdam, Rijksmuseum) of about 1660 have the strong archaistic elements often found in his work; the *Naming of St John the Baptist* (166[9?], Frankfurt, Städelsches Kunstinstitut) makes

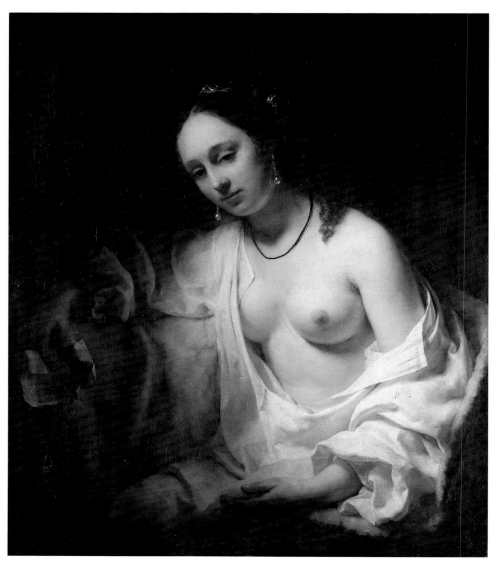

148. Willem Drost: *Bathsheba*, 1654. Paris, Louvre

wholesale use of figures lifted from a Goltzius print (Bartsch 18) and a Rembrandt grisaille (Bredius-Gerson 504); and four paintings of *The Seasons* (1669, Haarlem, Frans Hals Museum), used to decorate the cupola of a country house near his birthplace Midden-Beemster, are a feeble reflection of the illusionistic Baroque ceilings executed by painters who worked for the court at The Hague and various greater courts of Europe.

Like Barent Fabritius, Willem Drost's presence in Rembrandt's studio is undocumented, and even less is known about his life. The place and date of his birth and death have not been discovered. But once again Houbraken offers some assistance. He tells that Drost trained under Rembrandt, a statement corroborated by Drost's earliest known work, a signed etched *Self-Portrait* dated 1652, which suggests he had contact with the master in the late forties or early fifties. Further support for connecting him with Rembrandt is given by a small group of signed Rembrandtesque portraits of 1653 and above all by his sensuous, half-length *Bathsheba* dated 1654 [148] at the Louvre which was unmistakably inspired by Rembrandt's superb painting done in the same year of the same subject [115], also at the

Louvre. Drost's beautiful half-nude *Bathsheba* captures none of the overtones of Uriah's wife's story sensed in Rembrandt's moving portrayal of her contemplating her decision to go to David, but it impresses by the smooth painting of the palpable glowing flesh set off by heavy impasto of the drapery and its strong chiaroscuro effect. Not long after Drost painted his *Bathsheba* he travelled to Italy, where, according to Houbraken, he met the German painter Johan Carl Loth (1632–98), called Carlotto in Italy. Reference to a lost series of Evangelists painted collaboratively by Drost and Loth in Venice substantiates Houbraken's statement. Traces of Drost's Venetian experience are also evident in his *Self-Portrait* at the Uffizi, which was acquired in 1685 by Grand Duke Cosimo III de' Medici, and some history pictures that reflect firsthand knowledge of *seicento* painting in the Veneto.

Drost's stylish portrait of *Hillegonda van Beuningen* (The Netherlands, private collection), dated 1663, establishes that he had returned to Holland by that year. The portrait, his latest dated painting, does not show a trace of Rembrandt's manner; it has the clarity and polish that Bartholomeus van der Helst helped make fashionable in portraiture after the middle of the century and which Nicolaes Maes (who prob-

of Rembrandt's mature style. The motif, common in Dordrecht where the city's leading artist Aelbert Cuyp made pictures of domestic cattle one of his specialities, occurs only once in Rembrandt's work[18] and was hardly ever used by his other pupils. Perhaps Leveck had the idea of doing Cuyp *à la Rembrandt*. If he did, he apparently gave up the notion. His portrait of a cow is unique in his small existing *œuvre*. Following the example of Nicolaes Maes, another of his fellow townsmen, in the sixties Leveck completely abandoned his teacher's manner for the light, suave face painting that had become *le dernier cri* in the Netherlands.

Not many paintings by Constantijn Daniel van Renesse (1626–80) have been identified either – he probably was an amateur artist. Renesse is best known for his drawings that reflect Rembrandt's sketches of about 1650. He was a careful record keeper (after 1653 he became town clerk of Eindhoven), who inscribed on the verso of his Rembrandt-like *Daniel in the Lion's Den* (Rotterdam, Boymans-van Beuningen Museum) 'the first drawing shown to Rembrandt at his home in the year 1649' and on his *Judgement of Solomon*

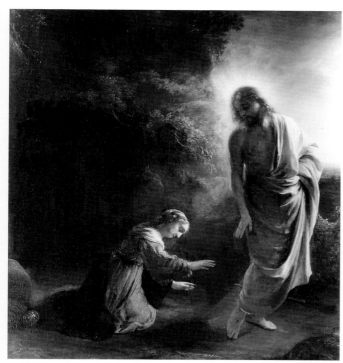

149. Willem Drost: *Christ and Mary Magdalene*, after 1663. Kassel, Staatliche Kunstsammlungen

ably was in Rembrandt's studio when Drost was there) adopted after 1660. There is general agreement that the delicate handling and classicizing character of Drost's signed *Christ and Mary Magdalene* at Kassel [149] place it after his return to Holland.[17] In *Ruth and Naomi* (Oxford, Ashmolean Museum) and a preparatory drawing for it (Bremen), that are attributed to him and datable before his trip to Italy, his figures are stocky and rather wooden. Attempts to enlarge the size of Drost's painted *œuvre* by assigning some traditionally accepted Rembrandts and nameless school pieces to him remain controversial. However, a group of drawings dependent upon the master's graphic works of the fifties has been plausibly ascribed to him; some of these sheets were formerly given to Rembrandt. Although they have the linear quality and hatchings of the master's drawings and etchings of this phase, their figures have more simplified outlines and are flatter than their models. Characteristic too are their numerous hatched lines, either long parallel ones or short, evenly spaced strokes going off in many directions; they are much more uniform than Rembrandt's and contribute little to the convincing spatial and atmospheric effects of the older artist's autograph drawings. In 1680 a Willem Drost witnessed an inventory compiled in Rotterdam of a painting collection. If he was identical with our Drost it is the last known reference to him.

The Dordrecht painter Jacobus Leveck (also Levecq; 1634–75) is documented as a Rembrandt pupil in 1653. In the following year he signed and dated two Rembrandtesque portraits (*Young Man*, Surrey, Polesden Lacey; *Old Woman*, Brussels, Musées Royaux des Beaux-Arts), and in 1656 he painted a *Cow in a Barn* [150] in which the handling of the heavy paint and the lights and darks are strikingly reminiscent

150. Jacobus Leveck: *Cow in a Barn*, 1656. Groningen, Groninger Museum

151. Constantijn Daniel van Renesse: *The Annunciation*, c.1650–52. Drawing with corrections by Rembrandt: pen, wash, red chalk, white body-colour. Berlin, Staatliche Museen, Kupferstichkabinett

152. Arent de Gelder: *Self-Portrait at an Easel painting an Old Woman*, 1685.
Frankfurt, Städelsches Kunstinstitut

(formerly London, L. Rudolf Collection) he wrote on the verso 'second composition shown to Rembrandt 1649'. His notations suggest he visited Rembrandt occasionally but was not an apprentice or journeyman in his studio. Rembrandt's corrections are apparent on some of Renesse's drawings. Most notable are those on his *Annunciation* at Berlin [151] where, with a few quick, bold strokes of a reed pen, his instructor dramatically transformed the pupil's earthbound angel into a supernatural being by enlarging and turning it, and he increased the size of the *prie-dieu* which makes the timid Virgin appear even smaller. He also strengthened the form of the Virgin with a couple of touches, and briefly indicated in no uncertain terms that closed shutters were more appropriate for the composition than an arched window.

Rembrandt's son Titus (1641–68) can be counted as one of the artist's pupils during these years. The master's inventory of 1656 lists three unidentified paintings by him which must have been done when he was fifteen years old or

younger. There is no consensus regarding attempts that have been made to attribute drawings and paintings to him.[19] Others who adopted Rembrandt as a model during his last phase include Abraham van Dijck (1635–72), a specialist of biblical pictures and paintings of old men and women, and Johannes Leupinius (1643–93), an Amsterdam surveyor and cartographer who made landscape drawings in the style of Jan Lievens as well as the master.

The last pupil to work with Rembrandt was the Dordrecht artist Arent (also called Aert) de Gelder (1645–1727), one of his most gifted and devoted followers. De Gelder retained distinct traces of Rembrandt's motifs and style until the end of his very long career, and he was the only Dutch painter who continued to work in Rembrandt's manner during the eighteenth century. The portrait of a man holding the *Hundred Guilder Print* is generally accepted as his *Self-Portrait* (St Petersburg, Hermitage) and as his homage to his teacher, but even if we ignore the fact that the Petersburg portrait does not show a cross-eyed man – we are told that de

Gelder bore his affliction with good humour – the evidence for this identification is flimsy. In his unusual self-portrait at Frankfurt he portrays himself laughing as he sits at his easel painting a portrait of an unlovely old lady [152]. Why is he laughing? Albert Blankert has persuasively argued that he has depicted himself as the ancient Greek painter Zeuxis who laughed so hard while painting the portrait of a funny old crone that he choked and died. The tale of Zeuxis's demise is found in a Roman source dated about 200 AD and was repeated by both van Mander (1604) and Hoogstraten (1678). De Gelder's Frankfurt painting was conceivably done in emulation of Rembrandt's *Self-Portrait* at Cologne [104] which shows the old master laughing. X-rays and a technical examination reveal that the latter was originally larger and showed him painting at his easel. Through the heavy coats of discoloured varnish that regrettably now veil Rembrandt's self-portrait, it is possible to see that he holds a maulstick and there is a grotesque head on the canvas he is painting. Thus Rembrandt may also have portrayed himself as Zeuxis laughing as he painted a portrait of an ugly old woman.[20]

Recognition that de Gelder emulated Rembrandt came early. Houbraken, who knew him and who wrote his *Groote Schouburgh* in Dordrecht while de Gelder was still living, flatly states none of Rembrandt's pupils come as close to his manner of painting as he did. At the time, Houbraken's claim would not have been recognized as high praise in all quarters. Some of his contemporaries would have considered de Gelder as an eccentric who never grasped the importance of the elegant mannerisms of classicizing painters and who obstinately clung to the old mode of using broken dabs of colour when others had adopted the smooth surfaces popularized by Adriaen van der Werff. His fame was only local, and he had no influence on the course of Dutch painting. Soon after his death he was virtually forgotten, and interest in him revived only during the last decades of the nineteenth century, when painters and critics began to prefer the mature Rembrandt to the young one. The change in taste led to a reappraisal of the master's late pupils.

According to Houbraken, de Gelder first studied the fundamentals of art in Dordrecht with Samuel van Hoogstraten and then went to Amsterdam, probably in about 1660–1, to work with Rembrandt. Houbraken tells us that he was sent to the master because his style was still very fashionable at that time – substantial proof from a good witness that the old Rembrandt was not a forgotten figure. He adds that de Gelder stayed with his master for 'two full years' and then returned to his native city. From the time Dou was apprenticed to Rembrandt in 1628, every talented youngster sent to work with him must have had mixed feelings of a desire to learn, emulate, and surpass, when he came into personal contact with Rembrandt's art and powerful personality. We can only guess what de Gelder's reactions were when, as a teenage apprentice, he saw his master at the height of his power paint *The Syndics*, *The Conspiracy of Claudius Civilis*, the series of Evangelists, Apostles, and self-portraits of the early sixties. However, we do know that the experience was an unforgettable one that left a permanent mark. De Gelder not only continued to follow Rembrandt's manner long after it was considered

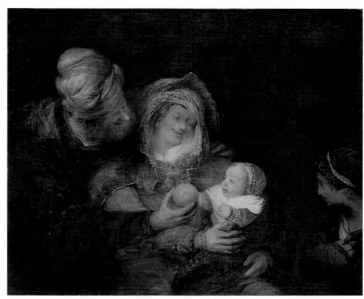

153. Arent de Gelder: *The Holy Family*, c.1680–5. Berlin, Staatliche Museen

passé, but he also adopted some of his master's habits. Houbraken reports that, like Rembrandt, he collected old costumes, footgear, weapons, armour, and all kinds of bric-à-brac as props for his pictures. The costumes and accessories seen in de Gelder's paintings amply support his biographer's report.

De Gelder could afford to work in an old-fashioned style for which there was little popular demand. He came from a wealthy family and seems to have been financially independent. His father was a director of Dordrecht's Dutch West Indies Company and his mother's parents were rich. Arent, who remained a bachelor with no family to support, moved in Dordrecht's patrician circles and enjoyed the patronage of the local nobility and professionals. In 1685 he joined one of the city's civic guard companies as an ensign, and in the following decade rose to the rank of lieutenant, and then captain. To judge from the number of his paintings listed in the inventory made of his estate after his death in 1727 he worked extensively for his own satisfaction as well as on commission and for the open market.

Although de Gelder made portraits and a handful of genre pieces, he mainly painted biblical and historical subjects of two types: relatively small, multi-figured compositions and large pictures with a few life-size half-lengths. An early one of the first category is his *Ecce Homo* dated 1671, at Dresden; it is clearly based on an early state of Rembrandt's monumental etching of the same subject dated 1655 (Bartsch 76). In it there are figures that show de Gelder's life-long predilection for picturesque types and fantastic oriental trappings which frequently evoke the world of Scheherazade more than that of Scripture. Among his life-size, half-lengths a masterful one is *The Holy Family* at Berlin [153], brimful of the good humour and warmth that informs so many of his biblical paintings. Here we see him as a fascinating colourist who takes his lead from his master. He began to paint with Rembrandt's late colours and fluctuating manner, but following the trend of late-

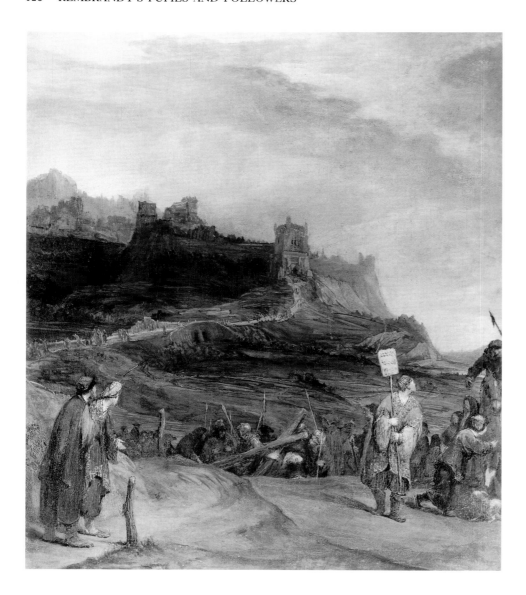

154. Arent de Gelder: *Bearing of the Cross*, *c*.1715. Aschaffenburg, Gemäldegalerie, on loan from the Bayerische Staatsgemäldegalerie

seventeenth-century art, his colouristic harmonies soon lighten. He achieved various textures by applying paint with his thumb, fingers, and palette knife as well as his brush, and relied more frequently than Rembrandt did upon obtaining effects by scraping away areas of paint that have other layers of paint beneath them and by scratching into wet paint with the butt end of his brush. He added pearly white, yellow, blue, orange, green, and violet to his palette, and with these colours produced sparkling effects which sometimes anticipate Goya. In his biblical pictures de Gelder's types are sometimes coarse and even ruttish. Contemporary Dutchmen who had cultivated a taste for decorum in painting must have complained that he used the same models for *Lot and his Daughters* and *The Holy Family*.

During his last decades de Gelder concentrated more on paintings with smaller figures. Most notable among them is his cycle of *Scenes from the Passion*, a series that originally was of twenty-two pictures; twelve are known today, ten at Aschaffenburg (on loan from the Bayerische Staatsgemäldegalerie) and two at the Rijksmuseum, Amsterdam. Houbraken writes that twenty were completed

by 1715 and all twenty-two are listed in the artist's 1727 posthumous inventory, a fact that suggests the cycle was not a commission but painted for his own use. The series is exceptionally large. None of comparable size were painted in the northern Netherlands during the period. It will be recalled that the famous Passion series Rembrandt was commissioned to make in the 1630s for Stadholder Frederik Hendrik comprised five paintings, and during the first decades of the eighteenth century Adriaen van Werff executed a set of *The Mysteries of the Rosary* for the Elector Palatine, Johan Wilhelm, consisting of fifteen pictures that includes seven Passion scenes (see pp. 310–11). A few of de Gelder's existing Passion paintings show a debt to Rembrandt's inventions, but others are highly original. Among the latter is his almost monochromatic *Bearing of the Cross* [154]. To modern eyes the episode, set in a vast imaginary landscape with an equally imaginary view of Jerusalem on a height in the distance, looks like the opening shot of a film of the episode conceived by a brilliant cinematographer. Attention has not yet focused on the main scene. Christ carrying the cross is virtually lost in the crowd

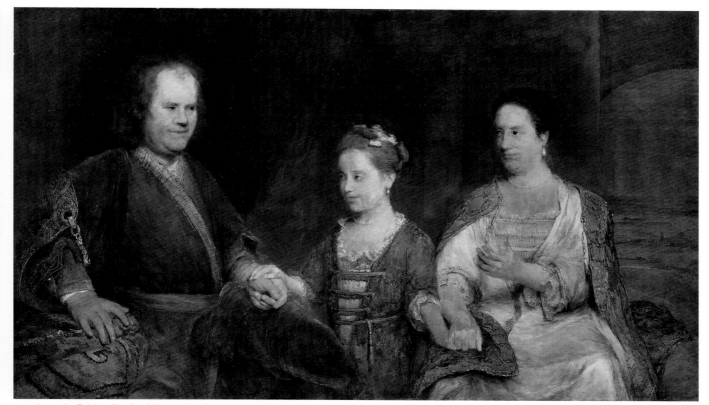

155. Arent de Gelder: *Family of Herman Boerhaave, c.*1722. Amsterdam, Rijksmuseum

just appearing on the road at the summit of the steep hill. He will come to the fore soon, but now the broad road is empty, apart from a dog, a boy scampering to the side, and a distracted striding man holding a pole bearing the inscribed board that will be nailed to Christ's cross. Elimination of histrionics increases the image's power. We seem to be witnessing just another day on the road to Golgotha.

De Gelder's lively portrait of *The Family of Herman Boerhaave* [155], the distinguished Leiden physician who introduced the system of clinical instruction at medical schools, shows his stature as a portraitist. In this late work by Rembrandt's last pupil done when he was almost an octogenarian there is not a trace of the contrived poses so popular among eighteenth-century portrait painters. The affectionate glances that father, mother, and daughter exchange, and the wonderful invention of their joined hands would have won approval from de Gelder's master, who was able to teach his best students naturalness, sympathy, and human warmth, as well as give them rudimentary and advanced lessons in the graphic arts and painting.

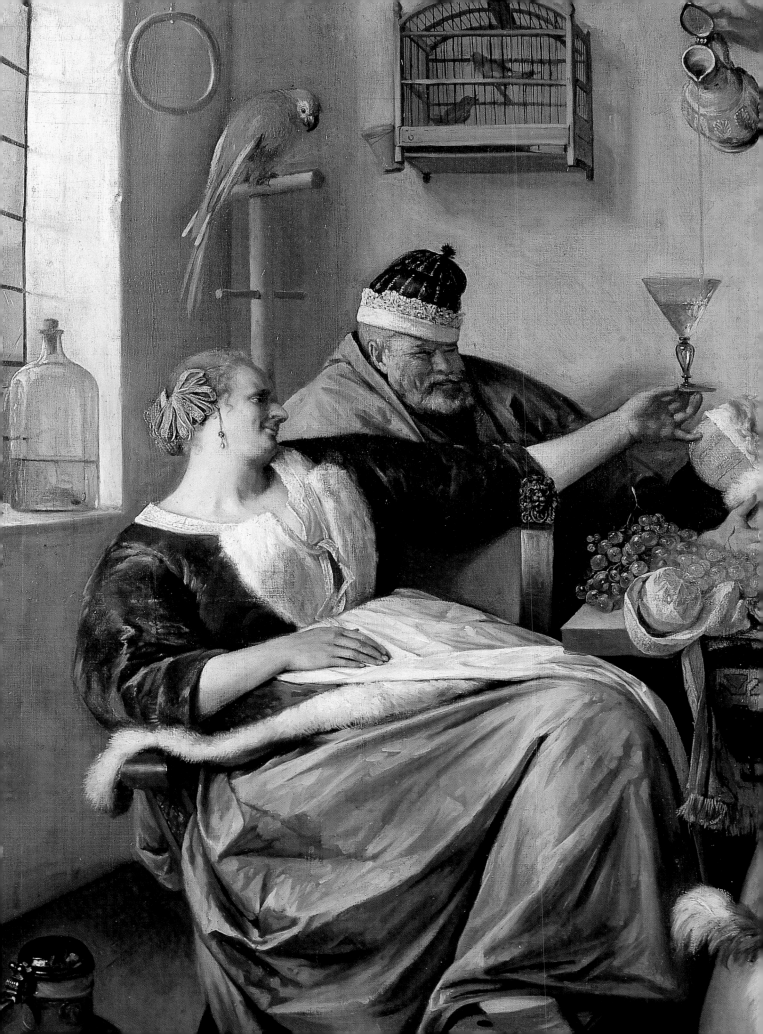

Genre Painting

It is curious that most European languages use the French word *genre*, which means 'kind', 'sort', or 'variety', to categorize the type of painting that depicts scenes of everyday life. Precisely when or how this special usage became current has not been determined. Diderot, the father of art criticism, still debated the proper definition of the category of genre painting in his *Essai sur la peinture* posthumously published in 1796, and as late as 1846 the editor of the English translation of Kugler's *Handbuch der Geschichte der Malerei*, which includes one of the first comprehensive surveys of Dutch painting, felt it necessary to offer an apology for using a term that 'is really more negative than positive, and is generally applied to works of a small scale which do not fall into any definite class'. However, he added, as many have since, 'It is convenient, and although not English, has been adopted without hesitation in the text.' It seems that seventeenth-century Englishmen sometimes called genre pictures 'drolleries', but Dutchmen of the period had no generic name for the branch of painting their countrymen developed into a speciality. When the Dutch wanted to refer to a painting of daily life, they merely described it. There are, for example, seventeenth-century references in Dutch sources to a *geselschapje* (usually translated as 'merry company'), a *buitenpartij* (an outdoor party or picnic), a *cortegaardje* (a guard or barrack-room scene), a *bordeeltjen* (a bordello scene), and a *beeldeken* or *moderne beelden* (a picture with little figures or modern figures), and so on, but the Dutch had no term for the class as a whole. In this case, as in most matters concerning Dutch painting, in the beginning was the picture, not the word.

Artists had painted scenes of everyday life since Renaissance times, but during the fifteenth and sixteenth centuries such pictures were seldom made for their own sake. They were painted as parts of cycles of the seasons or months, or were made to point a moral, illustrate a proverb, convey an allegorical idea, or illustrate a passage from the Bible. This tradition was a hardy one. Works discussed in earlier chapters have already demonstrated that it was alive and well in the northern Netherlands during our period, and the present chapter as well as those devoted to other branches of Dutch painting will also show its vigour. However, an important group of Baroque artists – and once again Caravaggio led the way – broke with this tradition when they depicted anonymous people doing ordinary things just for the sake of showing their actions in their milieu. Seventeenth-century Holland produced more and better artists dedicated to genre painting with and without messages than any other nation. We can only conjecture about the causes for this enormous production, but there is ample evidence that a large public in the United Netherlands appreciated genre painting. We also know that the prices they paid for it were relatively low.

EARLY HIGH-LIFE, DOMESTIC, AND BARRACK-ROOM SCENES

In his pioneer studies on Dutch painting, Wilhelm von Bode considered Frans Hals the originator and creator of the whole category of high- and low-life genre painting. Subsequent research has shown that Bode was wrong. Seventeenth-century Dutch genre painting has its roots in an older tradition, and by the time Frans Hals began to produce his characteristic pieces in the twenties, this category of painting was flourishing simultaneously in Haarlem, Amsterdam, and Utrecht. It is true that Hals gave a most decisive impulse to the whole category by his powerful temperament and brilliant pictorial treatment; but few Dutch genre painters can be called his followers. It is one of the delights of Dutch painting that the so-called 'Little Masters' often show a good deal of individuality and originality, and cannot be classified as mere imitators of the great ones.

Around the beginning of the century two trends of Dutch genre painting can be distinguished which are closely connected to earlier Netherlandish painting. The practitioners of both, like the sixteenth-century artists who were pioneers in the field, were not genre specialists. Specialization became wide-spread only after 1625. One type – which quickly came to a dead end – derives from the large pictures painted by Pieter Aertsen (1509–75) and his nephew and close follower, the Antwerp painter Joachim Bueckelaer (c.1530–73). These pictures frequently represent rather solemn, gesticulating life-size figures in a kitchen or a market crowded with fruit, vegetables, meat, poultry, fish, and game. A biblical event is sometimes depicted in the background. The idea of placing a scene from Scripture in the distance, where it is dwarfed by an over-stuffed foreground, is the characteristic Mannerist trick of inversion. The importance of the biblical scenes in these works is not negligible, however. They can refer to the significance of the spiritual life when contrasted with the mundane (also see p. 277 below). A small group of Dutch painters continued to work in the Aertsen-Bueckelaer tradition well into the seventeenth century, but, with the exception of Cornelis van Haarlem, they are of minor importance. It is not possible to trace a connection between Aertsen's monumental kitchens and Bueckelaer's markets and the achievements of either the great or little masters of Dutch genre painting. Large-scale genre pieces, like large-scale still lifes, which were also derived from the Aertsen-Bueckelaer tradition, are the exception in Dutch art. They were always more popular in Flanders than in Holland. It is worth noting that Aertsen had an international following about the time a few *retardataire* seventeenth-century Dutch artists were painting in

Detail of fig. 238, 'The young ones chirrup as the old ones sing'

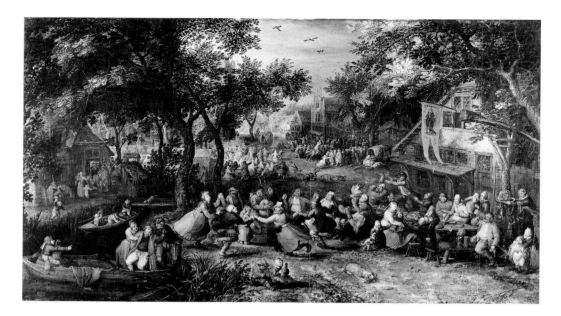

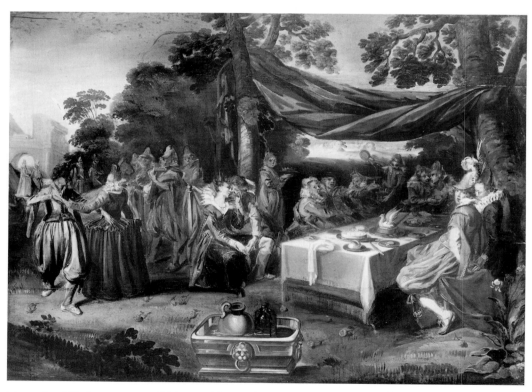

his style. Distinct traces of his motifs can be seen in the work of Italians in Bologna and Cremona, and some of the *bodegones* and religious paintings made by the young Velázquez suggest that he was familiar with pictures by Aertsen or his followers.

The other type of genre painting has its roots in the panoramic scenes depicted by Pieter Bruegel the Elder and his school. It was brought to the north by a wave of Flemish immigrants, who played an important part in establishing the Dutch school of landscape painting, as well as in setting the principal direction of the genre specialists. The versatile Mannerist Karel van Mander, who belongs to this group, has already been mentioned, and mythological scenes in

arcadian settings by other Dutch Mannerists also helped establish motifs which became part of the stock-in-trade of Dutch genre painters.

A leading figure in the transition from the Mannerist tradition to the new realism in genre painting was David Vinckboons (1576–1632), one of the most popular and prolific painters and print designers of his time. Good proof of Vinckboons's debt to Bruegel is the debate which scholars still hold about whether some pictures should be attributed to Pieter Brueghel the Younger, whose art was a shadow of his great father's, or to Vinckboons. Vinckboons's family had settled in Amsterdam by the time he was fifteen years old, and he apparently spent the rest of his life in Holland. His

works indicate that he had contact with Gillis van Coninxloo, the gifted Flemish landscape painter, who also immigrated to Amsterdam. Vinckboons was one of the artists who helped to forge the new landscape style, but toward the end of his career his interest in the activities of men and women increased. His genre pictures range from early multi-coloured ones of large crowds strolling through gardens and Bruegel-like kermis scenes [156], to those made in the last years of his life which show a close view of a single couple in a landscape. There are contemporary references to a lost picture by Vinckboons dated 1603 of a large crowd watching a lottery held at night illuminated by lights and lanterns – yet another example of the interest in nocturnal effects before the return of Caravaggio's followers to Holland. The works Vinckboons made during the first decade of the century frequently have a moralizing character, and he employed tradition allegorical subjects such as 'Death surprising Lovers in a Landscape'. For a few years before and after the Truce signed in 1609 he made pictures showing the plight of those who were plundered during the war and satires of the Spanish invaders, but these subjects are as exceptional in his œuvre as they are in the art of so many of his contemporaries.

Battles, apart from those fought at sea, play a relatively small role in the history of seventeenth-century Dutch art. The artists who are reputed to have used the world around them as their subject were not concerned with every aspect of it. It is noteworthy how many genre painters use the same themes. Banquets, tric-trac players, musicians, drinkers were favourite subjects from the beginning, and were used throughout the century. On the other hand, some motifs were seldom represented. Vinckboons made a few pictures of wretched beggars and blind hurdy-gurdy men early in his career, and during the following decades Adriaen van de Venne (1589–1662), whose style was also related to Bruegel's, made grisailles of the destitute and maimed which have a moralizing character. However, paintings of the high life of elegant young men and their fashionable women companions – the so-called 'merry company' pictures – were much more popular than those showing the predicament of the poor. Vinckboons's earliest dated painting of an outdoor banquet is inscribed 1610 (Vienna, Akademie).

Pictures of elegant young people dancing, drinking, and making love to the accompaniment of music also often had a didactic purpose. Late-sixteenth-century illustrations of Mankind before the Flood and Mankind awaiting the Last Judgement (Matthew 24:37–9) show that such scenes could be seen in this light. One of the earliest paintings of this type is the Banquet in a Park painted about 1610 (formerly Berlin, Kaiser-Friedrich Museum, no. 1611, destroyed in the Second World War) [157] and attributed to Frans Hals. The painting is based upon a print Vinckboons designed for an episode in the Life of the Prodigal Son which was engraved in 1608; most likely it also represents a scene from the parable. The riotous bordello scene from the story of the Prodigal Son is one of the ancestors of Dutch 'merry company' and 'modern figures' pictures. The complicated origins of this theme can also be found in sixteenth-century representations of the Feast of the Gods, and ultimately it can be traced to fifteenth-century prints and plaisance tapestries of love scenes in gardens.

The lost Berlin picture still shows a Mannerist heritage. The scattered vistas into the distance, the spotty illumination, the use of diagonals and zigzags to entangle figures and space in a complicated way, the ornamental treatment of the foliage, and, not least, the affected attitudes of the young ladies and their companions, all relate the picture to the last phase of Mannerism. The fresh, painterly treatment and a certain closeness to works by Hals's teacher van Mander argue for Hals's authorship. But, as we noted in our discussion of Hals, if he painted the picture, it is unique in his long career. As far as we know he did not make another small-scale painting of elegant figures in a landscape or an interior. This subject was developed into a special category at Haarlem by Frans Hals's brother Dirck, and by his contemporaries Esaias van de Velde and Willem Buytewech.

Esaias van de Velde (1587–1630), who is best-known for his realistic landscapes, which served as a point of departure for his pupil Jan van Goyen, also painted pictures of gallant companies feasting in a garden. Born in Amsterdam, Esaias arrived in Haarlem in 1610, an exciting time for a budding artist to settle there. During the same year Frans Hals joined the Guild of St Luke; two years later, Esaias van de Velde and Hercules Segers were inscribed as guild members. Esaias probably studied with Vinckboons in Amsterdam; he made a pen drawing after one of Vinckboons's 'merry company' scenes in a park, and two of his own pictures of outdoor banquets (1614, The Hague, Mauritshuis; 1615, Amsterdam, Rijksmuseum) are done in the spirit and technique of the popular Amsterdam master. In 1618 Esaias left Haarlem for The Hague, where he spent the rest of his career. The stay of Willem Buytewech (c.1591/2-1624) at Haarlem was equally short; there is no evidence that he was there before 1612, and it is certain that he settled once again in his native town of Rotterdam in 1617.

Buytewech, who was nicknamed 'Geestige Willem' (witty, inventive or ingenious Willem), was not very active as a painter. Only about ten pictures can be attributed to him, and these were all made during the last seven or eight years of his short life. Buytewech had close contact with Frans Hals: according to an old inventory reference, both artists worked on the same picture; they used the same models; and Buytewech even copied some of Hals's works. But he never acquired Hals's fluency or boldness in the use of fat oil paint and he never worked life-size. Compared with Hals, the efforts of Buytewech are tight and his touch is minute. Nevertheless, 'Geestige Willem' painted enough to justify the claim that he established the important category of the 'merry company' in an interior. An excellent example of the type is the picture painted about 1617–20 in the Boymans-van Beuningen Museum [158]. The fat Falstaff type who wears a garland of sausages is the same model who appears as Peeckelhaering in Hals's Shrovetide Revellers [27] painted a few years earlier; here he is shown in the guise of the theatrical character Hans Wurst. Buytewech's work already shows the Early Baroque phase of Dutch painting. The figures are much more forcefully painted than those by Vinckboons or Esaias van de Velde, and are depicted close to the spectator, with a detailed realism. The colours have become bright and show a bit of a plein-air effect, although there is too much local colour – particularly pinks, yellows,

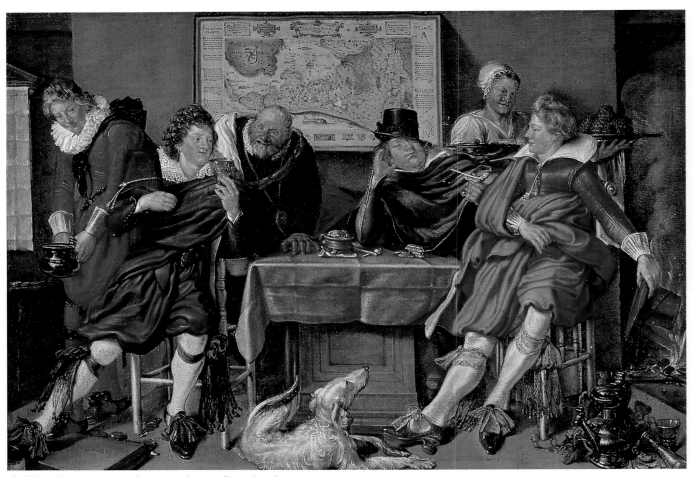

158. Willem Buytewech: *Merry Company*, *c*.1617–20. Rotterdam, Boymans-van
Beuningen Museum

and blues – to produce complete unity and harmony.
Buytewech was not yet the type of narrow specialist who
developed in the following generation. His subject matter
included religious themes, allegorical motifs disguised as
scenes from everyday life, book illustrations, and charming
landscapes, as well as genre scenes of the new *jeunesse dorée*
enjoying sensual pleasures, all this largely in graphic art. He
proved himself remarkable as a draughtsman and a graphic
artist. Among his most engaging etchings is a series of men
of different nations, designed as fashion plates. After the
Spanish fashion had dominated the whole of Europe in the
second half of the sixteenth century, the French elegance of
the court of Louis XIII, best represented in Callot's precious
etchings, began to fascinate the well-to-do people of Holland,
who had not yet developed their own burgher taste.
Buytewech's costume designs charmingly reflect the foppish
affectation of the young men who already enjoyed the fruits
of the heroic fight of their grandfathers and fathers for
liberation from Spain. His use of the etching needle is
ingenious. Simple lines and sketchy shading suggest move-
ment and daylight not so far from Frans Hals's innovations.
In his pen-and-brush drawings one feels even more of this
engaging master's gift and charm. His enchanting drawing of
an *Interior with two Women sewing before a Fireplace* (Hamburg,
Kunsthalle) shows a freshness and refinement which holds

its own at the side of any great draughtsman, and a mood
which anticipates the intimate domestic scenes by Gerard ter
Borch and Pieter de Hooch.

Buytewech's inventions left a strong impression upon a
number of contemporary painters in Haarlem. After he left
for Rotterdam in 1617, Hendrik Gerritsz Pot (*c*.1580–1657)
and Isack Elyas (active *c*.1620–30) continued to make small
genre scenes in carefully worked-out interiors which show
their debt to 'Geestige Willem'. Hendrik Pot, mainly a
portraitist, also tried his hand at large-scale genre scenes
(*Merry Trio*, *c*.1630, Rotterdam, Boymans-van Beuningen
Museum) which reveal that he emulated Frans Hals. The
spirited German artist Johann Liss (*c*.1597–*c*.1629/30), who
stayed in Holland in about 1615 before going on to Paris
and then to Venice, was as impressed by Buytewech's high
society pieces as he was by the older Haarlem Mannerists.

Buytewech also had a decisive influence on the art of
Dirck Hals (1591–1656). Dirck's nicely coloured paintings
of full-length 'modern figures', all on a small scale, show
some dependence on the art of his brother, but no mistake
can be made about his identity. The symmetrical arrange-
ment of the large groups of gallant companies Dirck depicted
in interiors and parks, and his elegant types, indicate that he
owes much more to Buytewech than to Frans Hals. The
similarity between the two also explains why the early works

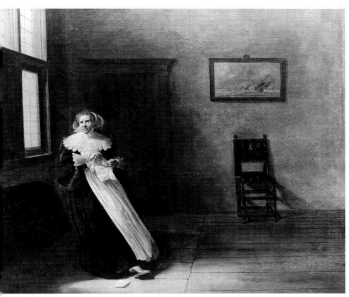

159. Dirck Hals: *Woman tearing up a Letter*, 1631. Mainz, Mittelrheinisches Landesmuseum

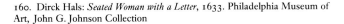

160. Dirck Hals: *Seated Woman with a Letter*, 1633. Philadelphia Museum of Art, John G. Johnson Collection

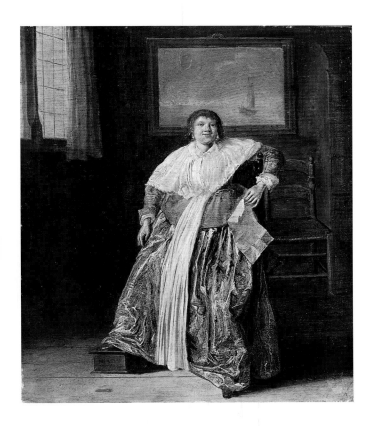

of Dirck and Buytewech have sometimes been confused. However, even when Dirck pilfers an entire figure from a Buytewech composition, which he did upon more than one occasion, it is not difficult to recognize Dirck's hand. His figures are seldom as slim or graceful as Buytewech's, and they wear expressions which do not often have much in common with Buytewech's subtle characterizations. Dirck's occasional paintings of a woman combing a child's hair or engaged in other domestic activities also are related to Buytewech's brilliant pioneer drawings of similar themes. In his oil sketches on paper (an outstanding one is at Fondation Custodia, Paris) Dirck seems to surpass himself. But the types he depicts are certainly his. They were used as preparatory studies for his 'modern figure' compositions, and in some cases the same figure is found in more than one painting. He obviously kept them in stock as handy, time-saving patterns. These sketches, with their fluid and sharp accents, are not very far from Frans, and perhaps they offer a clue to Frans's manner of drawing.

Although the name of Dirck's teacher is unrecorded it is hard to imagine he did not learn his craft from his older, more gifted brother. Like Frans, when he was a young man, Dirck was a member of Haarlem's St George Civic Guard Company and the city's rhetoricians' society 'The Vine Tendrils'. Anthonie Hals (1620–91), his eldest son, was a painter whose rare works indicate that artistic talent is not always inherited. When Dirck joined Haarlem's Guild of St Luke in 1627 he was thirty-six years old. At the time he was an accomplished painter who had been signing his works for almost a decade. The colours of his early paintings are gay and pleasant: yellow, bright blue, pink, green, and golden brown predominate. Around 1630 his palette, following

the trend of the time, becomes more monochromatic and subdued. Greys, olive greens, and dark browns set the key, and chiaroscuro effects play an important compositional and expressive role in these more modest works. At this time he paints some candlelight scenes and a few pictures that abandon the crowded composition of the 1620s for small ones showing the activities of one or two figures in an interior. *Woman tearing up a Letter* of 1631, at Mainz [159], gives a good idea of the new pictorial mood, and, in an unexpected way, a premonition of what Vermeer and his contemporaries were to achieve about a generation later. The single painting on the back wall of a small ship making way in an agitated sea in the Mainz picture may very well offer a clue to the meaning of the distraught woman's destruction of the letter, particularly when the work is juxtaposed to Dirck's painting of a smiling *Seated Woman with a Letter* of 1633, at Philadelphia, where a calm seascape is mounted on the back wall [160]. The expressions and actions of the young women and the marines within the two paintings probably refer to the pains and pleasures of love. Comparisons between the lot of lovers and life at sea came easily to seventeenth-century Dutch writers. In the words of one:

> Love may rightly be compared with the sea
> From the viewpoint of her changes
> Which one hour cause hope
> The next fear.
> So it goes with a lover
> Who like the skipper
> Who journeys to sea
> One day encounters good weather
> The next storms and roaring wind . . .[1]

The subject of a woman with a letter in an interior decorated

with a seascape was taken up by later masters, for example Metsu [222], but it is not always easy to decide whether the letters contain good or bad news, or whether the painting within the painting is related to the message being received or read. Viewers with lively imaginations may concoct a connection between the mood of the lovely letter reader in Metsu's painting and the choppy seascape mounted on the wall behind her, but there is no way of establishing that the artist intended the marine to provide a gloss on the content of her letter or thoughts.

For a brief period during the late twenties and thirties the Haarlemers Judith Leyster (1609–60) and her husband Jan Miense Molenaer (c.1610–68), Dirck's younger contemporaries, also made pictures of 'modern figures' that give a foretaste of the style and themes of Vermeer, Metsu, and other genre painters active after the middle of the century. However the connection should not be exaggerated. The story is more complicated; later masters of this branch of painting found inspiration elsewhere. Moreover, Leyster's career, as we shall see, was a very short one – she seems to have virtually stopped painting after her marriage to Molenaer in 1636. As for Dirck Hals and Molenaer, by the 1640s their creative energy slackens. Their late *moderne beelden* become repetitive and seldom attain the pictorial qualities of their earlier paintings. About the last thing they bring to mind is thoughts of Vermeer and his peers.

The individuality and worth of Judith Leyster, who was completely forgotten after her death in 1660, only began to be recognized in 1893 when Hofstede de Groot published the first study dedicated to her work. His important rediscovery of her identity was part and parcel of late-nineteenth-century interest in Frans Hals. The strong Halsian character of some of her paintings led early specialists to misattribute them to the better-known master. Hofstede de Groot showed their differences, and that some wrongly ascribed to Frans Hals are, in fact, clearly signed with her own hitherto overlooked distinctive monogram that includes a star, a play on her family name (*leysterre* = lode or leading star).

Leyster's decision to become a professional painter was unusual. In Holland, as in the rest of Europe, the profession was dominated by men. The few Dutch women artists mostly came from households where the craft was either a family tradition or from intellectual or well-to-do families who encouraged their daughters to acquire skill in the discipline; for these girls and young women facility in the arts began as a polite accomplishment that befitted a cultivated lady and ranked with learning classical and foreign languages, playing a musical instrument, versifying, and embroidery. Leyster's family belonged to neither category. When her father, one of the thousands of Flemings who emigrated to Holland after the fall of Antwerp in 1585 to the Spanish, settled in Haarlem he was a modest small-ware weaver. His attempt to improve his lot by buying a brewery ended in failure. In 1624 he declared himself bankrupt, and found it prudent to move to a village near Utrecht. He was still living there in 1628. In the following year, he settled in the vicinity of Amsterdam where he spent the rest of his life. There is reason to assume that young Judith did not move to the environs of Utrecht with her family, or if she did, she did not remain there long. The assumption rests on Samuel Ampzing's citation of her

as an artist active in Haarlem who 'paints with a good keen sense' in his history of the city published in 1628. Since Ampzing prepared his book for the press in 1626–7, it is evident that precocious Judith made a mark as a Haarlem artist, even before her nineteenth birthday, while her family lived in the neighbourhood of Utrecht.

Leyster's teacher is undocumented. Although she was one of Hals's most gifted followers, there is no documentary evidence that she was apprenticed to him, but visual evidence suggests she may have worked with him for a time in some capacity. It was formerly hypothesized that she also was a pupil of a Utrecht master, a supposition supported by her family's residence near the city and her early mastery of nocturnal effects which were part of the stock-in-trade of the Utrecht *Caravaggisti*. However, Leyster's stay in Utrecht's vicinity, if it occurred at all, must have been brief. Moreover, we now know that Caravaggesque lighting effects found their way to Haarlem even before the Leyster family left the city. Pieter Fransz de Grebber, another Haarlemer, painted at least one night genre scene illuminated by a lamp as early as 1623 (see p. 26). Indeed, it is quite possible that, while still a teenager Judith had contact with Pieter de Grebber and two other members of his family who were artists. Ampzing mentions all three de Grebbers in the same breath with her name in his history of Haarlem: Pieter, his sister Maria, and his father Frans Pietersz de Grebber, a leading Haarlem portraitist and history painter. Perhaps Judith, like Pieter and Maria, was a pupil of Frans Pietersz de Grebber. If she was, there is no indication whatsoever that his work left an impression upon her. It is hard to say much about the imprint Frans Pietersz made on his daughter Maria (c.1602–80), since her traceable *œuvre* consists of just one painting, a routine portrait dated 1631 of a Catholic priest (*Augustinus de Wolff*, Utrecht, Rijksmuseum Het Catherijneconvent). What Ampzing writes of Maria is worth mentioning. After saying a word in praise of the de Grebber family, he adds: 'Who ever saw a painting made by the hand of a daughter?' For Ampzing a woman painter apparently was almost as astonishing as a talking dog.

Although a number of works have been ascribed to Leyster since her rediscovery, by any standard the number attributable to her is small. Expansionists ascribe about thirty-five paintings to her; contractionists give her less than twenty.[2] Apart from a few Halsian portraits, a single still life, and one or two watercolours of tulips, they are genre paintings. The earliest secure ones are both dated 1629 and signed with her characteristic monogram. Both clearly show that from the start Frans Hals was a principal source of her themes and style, and that his works helped set her course. But Leyster did not work consistently in Frans Hals's style. In the early thirties she began to make pictures of 'modern figures' that have a communality with young Miense Molenaer's early works. They obviously had contact before their marriage; at this time they shared studio props and models. But more important for her than the early efforts of Molenaer were Dirck Hals's small *moderne beelden* of daylight and night scenes in interiors. She learned as much from Dirck as from Frans Hals's motifs and style.

An intriguing painting of these years that is closely related to Dirck in composition and technique offers a view of an

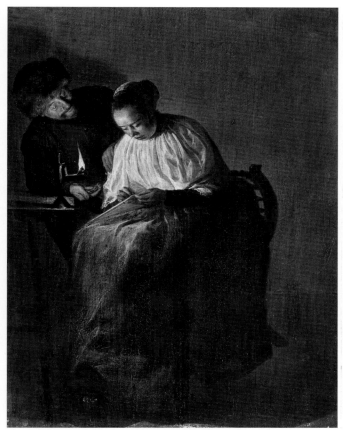

161. Judith Leyster: *The Proposition*, 1631. The Hague, Mauritshuis

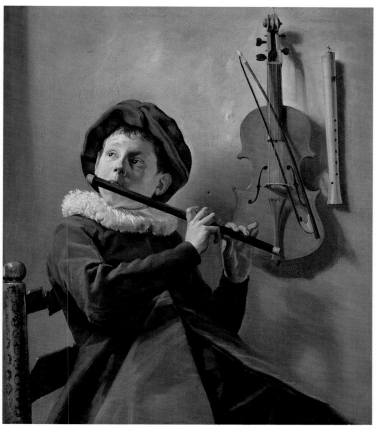

162. Judith Leyster: *Young Flute Player*, c.1635. Stockholm, Nationalmuseum

old man displaying coins to a dramatically lit young woman sewing by lamplight [161]. His hand resting on her shoulder suggests that he is not offering payment for her labour as a seamstress. Is he making a proposition for sex which she virtuously ignores? This interpretation has been offered, and with good reason. The theme had been used by northern artists since the Renaissance, and, as we have seen, was not rare with the *Caravaggisti*. To be sure, Leyster's young woman has nothing in common with the readily seductable recipients of offers of purchased love depicted by earlier artists. Leyster's young woman steadfastly remains occupied with her sewing, a model of domestic virtue. If this reading of the subject is accepted, the painting can be viewed as Leyster's critical response to the salacious treatment of the subject by male artists who demean women by representing them as sex objects exploited by men. It also would qualify the picture as Leyster's only painting that treats a feminist issue. However, it also has been argued that the painting is not a precursor of feminist ideology, but a depiction of the Dutch tradition of offering a woman coins as an invitation to court, a subject that is also unambiguously represented in works by Leyster's predecessors and contemporaries. Is Leyster's old man a dishonourable seducer or a respectable suitor? In the opinion of the present writer the mood of the painting leaves no doubt he is the former, but this interpretation is admittedly open to question.[3]

In 1633 Leyster, still unmarried, was enrolled in Haarlem's Guild of St Luke, thereby gaining the distinction of being the very first woman admitted to it. Her new status qualified her to take on apprentices which she promptly did. In the

same year she had three male pupils in her workshop. One of them spent only three or four days with her and then left to study with Frans Hals. Leyster did not take the departure of her pupil lightly. She lodged a formal complaint against Hals regarding the matter to the guild. The case included a quarrel about the payment of the apprentice's registration fees and tuition. The guild's solomonic resolution of the case included compromises and fines imposed on both artists – Leyster was fined because she had failed to register her pupil with the guild. The dispute is the only documented record of contact between Leyster and Frans Hals.

All known evidence indicates that Leyster virtually stopped working as a professional painter after her marriage to Molenaer in 1636. It seems that this gifted woman, who was strong enough to establish herself in a traditionally male trade and who did not hesitate to assert her rights when she thought Frans Hals infringed them, put aside her brushes for the life of a Dutch housewife, which eventually included the birth of five children and the care of at least two of them who lived beyond adolescence. The only generally accepted dated work done after her marriage is a botanically accurate watercolour on parchment of a single tulip, inscribed 1643 (Haarlem, Frans Hals Museum).[4] To be sure, she most probably helped her husband now and then in his active studio and we know she assisted him with his business affairs as a dealer and investor in real estate. The loss to Dutch art caused by her abandonment of painting when she was in her late twenties is keenly felt when we confront her *Young Flute Player*, of about 1635, at Stockholm [162], which shows her at her best. The brushwork here has become

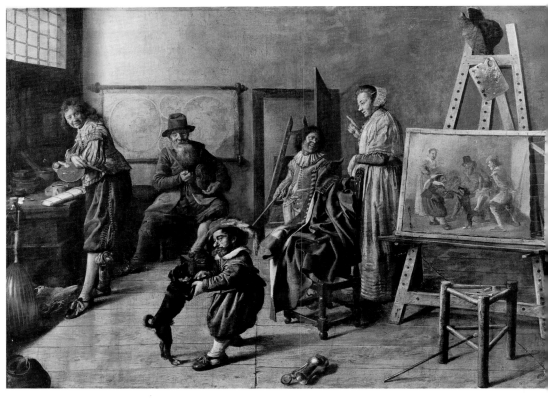

personal, and the subtle gradations in value on the light-grey wall and the colouristic harmony of the boy's red hat, olive-green jacket, violet trousers, and mottled green chair make an exquisite effect.

When looking at Stockholm's little masterwork it is difficult to understand how Leyster's name could have been forgotten for more than two centuries after it was painted. Even Arnold Houbraken does not say a word about her in his three-volume encyclopaedic compendium of the lives of seventeenth-century Dutch artists published in 1718–21 which he called *The Great Theatre of Netherlandish Painters and Painteresses* (*De groote schouburgh der Nederlantsche konstschilders en schilderessen*) [163]. But he does not offer a line about Vermeer's life or art either; he only cites his name in a roster he presents of Delft painters. Although Houbraken includes 'painteresses' (*schilderessen*) in his title they are given short shrift in his publication. He offers biographies of more than 550 male painters and only presents the lives of about a dozen women artists and mentions around the same number in passing.

There are marked parallels between Jan Miense Molenaer's early career and Leyster's. He too has frequently been called Frans Hals's pupil, but the name of his teacher has not been established. His earliest known works, like Judith's, are dated 1629. His *Merry Company at a Meal* of that date (Worms, Freiherr von Heil zu Hernnsheim) shows his debt to the joyous figures Frans Hals painted during the same decade as do the compositional schemes of his half-length genre pieces of transitory moments in the life of laughing children, musicians and drinkers seen in a shallow space against a neutral background. From the beginning, like Leyster, he was equally at home depicting scenes illuminated by daylight or artificial light. However, unlike Leyster, he made no attempt to imitate Frans's vigorous, detached brushwork. To judge from their surviving works he began to make small pictures of full-length figures in interiors (1629, *Children making Music*, London, National Gallery) before Leyster did. These works are closer to Dirck Hals than they are to Frans. Both he and Leyster continued to paint this type of picture. One of Molenaer's most attractive is his *Artist's Studio* [164] which gives a good glimpse of a Dutch artist's workshop.

Molenaer's paintings are replete with symbolic and allegorical allusions whose meanings are still debated by modern iconologists but there is no doubt that his pictures of five peasant scenes at the Mauritshuis, represent the *Five Senses* (1637). The series recalls types painted by Brouwer, but he misses the latter's bite. His coarse *Denial of St Peter* (1636, Budapest, Museum) is represented in a peasant tavern which includes a conspicuous dwarf among gamblers and drinkers. Molenaer had a penchant for painting dwarfs; one plays a conspicuous role in his artist's studio [164]. Molenaer also was a gifted portraitist. As early as 1633 he was commissioned to paint a smaller than life-size family group now in the Virginia Museum of Art, Richmond. Most specialists believe the meticulously finished painting, that concentrates on a fashionably dressed couple, musicians, and their servants on a tiled terrace in a garden, is crammed full of marriage symbolism; however, others maintain its symbolism refers to a betrothal. A few years later he did another small-scale, highly finished *Family making Music* (Haarlem, Frans Hals Museum, on loan from The Netherlands Office for the Fine Arts, The Hague) [165], that includes ten figures and has traditional symbolic allusions to love, marriage, and transience. In it he ingeniously managed to depict a host of absent or deceased members of the family by incorporating their framed portraits mounted on the wall of the imaginary interior that serves as a setting for the group, and he squeezed in yet another portrait by showing it in the hand of one of his patrons.

163. Title page of Arnold Houbraken, *De groote schouburgh der Nederlantsche konstschilders en schilderessen*, vol. 1, The Hague, 1718

164. Jan Miense Molenaer: *The Artist's Studio*, 1631. Berlin, Staatliche Museen

165. Jan Miense Molenaer: *Family making Music*, c.1635–6. Haarlem, Frans Hals Museum, on loan from The Netherlands Office for the Fine Arts, The Hague

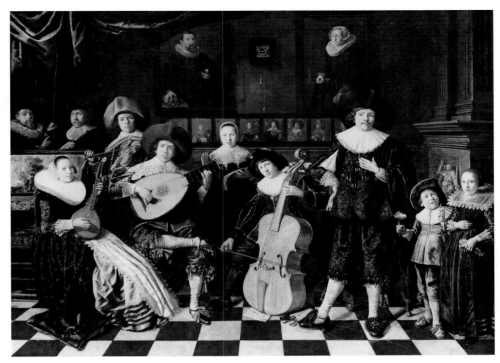

In 1636, the year Molenaer and Leyster were married, the couple moved to Amsterdam where they spent most of their married life. If the family portrait of the prominent *Van Loon-Ruychaver Family* (Amsterdam, Stichting van Loon) is by Molenaer, as has been reasonably proposed, he found important patrons in the metropolis straightaway. The family portrait, close in execution and scale to the *Family making Music*, is another group portrait with distinct symbolic allusions. The family is arranged to show the Five Ages of Man and the actions of some allude to the Five Senses. Molenaer prospered in Amsterdam. He had a busy workshop where, as we have heard, Leyster probably lent a hand. The participation of less gifted assistants may help account for the variable quality of his late works which are related to Adriaen van Ostade's crowds of peasants in large interiors but fail to capture Ostade's psychological insight or power of design. In these works his paint becomes more liquid and a rather uniform brown takes the place of the strong local colour and blond tonality he used earlier. His pictures of the period are sometimes confused with those by his follower Egbert van Heemskerck (1634–1704?). The Amsterdamer Gerrit Lundens (active 1643–83), best remembered for his much reduced copy of the *Night Watch* before it was cut (Amsterdam, Rijksmuseum, on loan from The National Gallery, London), also made genre pictures that resemble those done by Molenaer after the 1640s.

Molenaer also was active as an art dealer and invested in real estate. By 1655 he had acquired three houses for which he paid a total of almost 30,000 guilders. He paid for two of them partially in cash and partially in paintings, not an unusual arrangement; crafted objects probably were used as a medium of exchange from the time they were first made. Leyster acted as Molenaer's business agent upon more than one occasion, and in 1657 he gave her power of attorney to manage all his financial transactions. The posthumous

inventory of Molenaer's effects compiled after he died in 1668 lists numerous paintings. Among them were many of his own finished and unfinished works, eight pictures by Leyster, and two unframed portraits by Frans Hals of Molenaer and his wife. Hals's portraits, which remain unidentified, were in a second floor room, along with about 100 other framed and unframed paintings. The room was obviously used for storage of part of Molenaer's stock as artist and dealer. Why were the unframed portraits of the couple by the outstanding painter to whom they owed so much exiled to stock and not given a more respectable place with other paintings listed in one of the main floor rooms? Did Molenaer, and perhaps Judith Leyster too, nurse an old grudge against Frans Hals because one of Judith's pupils deserted her a few days after he entered her studio to become Hals's apprentice?

During the second quarter of the century a group of artists began to specialize in painting the life of soldiers. Scenes of plunder and battle were depicted but the ancient battle of the sexes, where the field of action was a room in an inn or a barrack, and in which the outcome of the struggle is not much in doubt, was more frequently represented. Other popular subjects were soldiers drinking, smoking, and gambling at cards or tric-trac, activities that contemporary predicants and moralists condemned as vices that endanger salvation. But it is doubtful if the painters of these scenes and their clients viewed them as pictorial reminders of the perils of sin and the inexorable need to lead a virtuous life. Pictures of the life of off-duty soldiers were called by the Dutch *cortegaardjes*, a corruption of the French term *corps de garde*. The better ones show little movement or overt action. Painters of them had a special feeling for tonal values and their pictures take on a certain still-life quality. In their half-dark interiors the light glitters over uniforms, and a fine subdued play of colours, mostly broken and harmonized

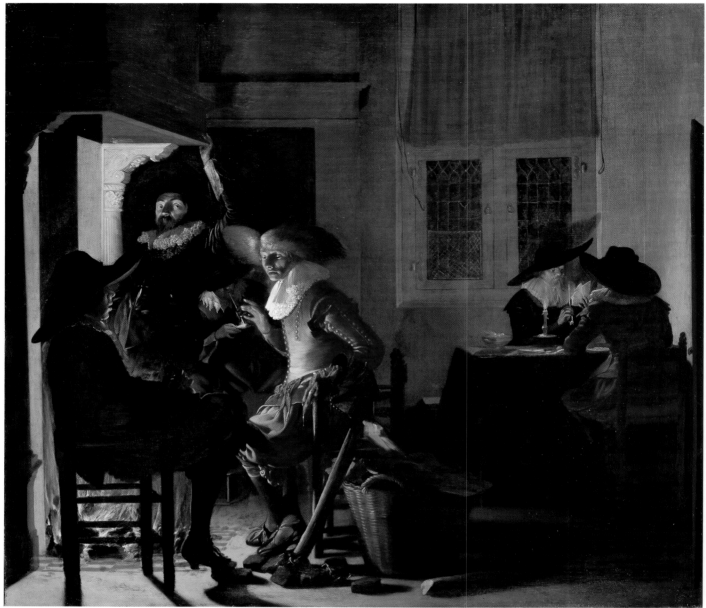

166. Willem Duyster: *Soldiers Beside a Fireplace*, *c*.1632. Philadelphia Museum of Art, John G. Johnson Collection

by delicate half-tones, betrays the Dutch gift for intimate pictorial qualities and a subtle rendering of textures. Some even anticipate the achievement of the high society painters of the following generation, when well-to-do burghers rather than soldiers and their friends became the favoured subject of genre painters. Specialists in this category worked in Amsterdam, Utrecht, Delft, but seldom in Haarlem. The leading ones in Amsterdam were Willem Duyster (*c*.1599–1635) and Pieter Codde, the painter who was called upon to complete Frans Hals's *Meagre Company* [48] when Hals refused to continue working on the life-size civic guard piece. What sets Duyster's rare pictures apart from those made by his contemporaries is his distinct chiaroscuro and the refinement of his colours. He was also better able than any of them to convey the fascinating visual drama which can take place when people do little more than confront each other. It is difficult to think of a painter of his time who surpasses his penetrating characterization of the personalities of the men gathered round a fireplace in the modest

nocturnal scene in the Johnson Collection, Philadelphia [166] (versions also in the Hermitage, and formerly in the W. Dahl Collection, Düsseldorf). Duyster's approach is always original. His *cortegaardjes* and small pictures of dignified full-length single figures seen against dark backgrounds served as one of the points of departure for ter Borch's great accomplishment in these branches of painting.

Pieter Codde was born in Amsterdam in 1599 (Duyster was born there too); he painted portraits, history paintings, and high-life scenes as well as military subjects. His small picture of a *Young Scholar in his Study* at Lille [167], painted in shades of silvery grey and ochres, is a kind of secularization of Dürer's *Melancholia*. It is more appealing than his more ambitious genre compositions, where he gives way to his preference for rather coarse and plump types, over-glossy textures, and exaggerated highlights. The rooms Codde represents are always of less interest to him than the people he placed in them, and although he lived long enough to see the accomplishments of the great Dutch painters of interiors

– he died in 1678, three years after Vermeer – he never attempted to emulate their achievements. But he made a least one attempt to make a radical shift in his style. In the half of Frans Hals's *Meagre Company* he completed he made a concerted effort to emulate Hals's touch.

Although Pieter Quast (1606–47), who was a prolific draughtsman, can be classed with the Amsterdam painters of military subjects, he does not fit comfortably in a pigeonhole. He also painted high- and low-life scenes, based works on contemporary theatrical performances and characters, and was one of the few who made pictures illustrating proverbs in the manner of Adriaen van de Venne. Jacob Duck (c.1600–60) represents the guardroom tradition in Utrecht. He prefers large crowds gathered in spacious halls and exploits all the tricks known to the artists of his time to create the illusion of space: curtains or large piles of weaponry in the foreground to set the front plane, an emphasis on the orthogonal lines made by the tiles or boards on the floor, vistas into rooms beyond the one in which the main action takes place, and aerial perspective. If mutual influence is a criterion, he was as unimpressed by the Utrecht followers of Caravaggio as they were by him. His subjects range from boorish episodes in taverns to a lovely picture of a woman ironing in a kitchen (Utrecht, Centraal Museum). The Delft portraitist Anthonie Palamedesz (1601–73) repeatedly made social scenes of groups of officers. The

167. Pieter Codde: *Young Scholar in his Study*, c.1630–5. Lille, Musée des Beaux-Arts

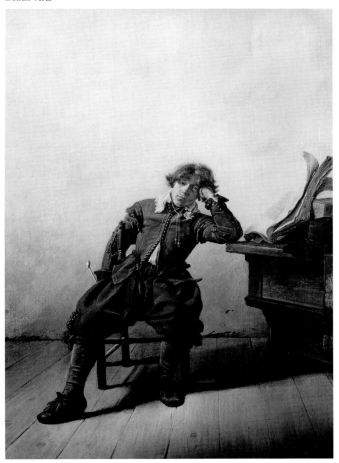

window which is the source of the light that gives his pictures their blond tonality is frequently visible. The dominant hues in his pleasantly coloured pictures are a blue and yellow of low intensity. Scarce works by Jacob van Velsen (d. 1656) are in the style of the earlier genre pieces by Palamedesz; Velsen's *Music Party* (1631, London, National Gallery) once bore a false Palamedesz signature.

PEASANT AND LOW-LIFE SCENES

A discussion of Dutch paintings of peasants should begin with Adriaen Brouwer, who, for good reason, is usually classified as a Flemish artist. He was born in 1605–6 in Oudenaerde, in Flanders near the Dutch border, lived in Flanders for the greater part of his life, and died in Antwerp in 1638. From the beginning to the end of his brief career he shows the daring touch and tendency to movement and action in his compositions which are qualities we like to consider Flemish rather than Dutch. Why, then, include him in a history of Dutch painting? The fact that he worked in Holland during his early period and that this experience was significant for both his own achievement and the development of seventeenth-century Dutch genre painting justifies brief mention of him here. Like all great artists, he is not easy to categorize. Certainly there are Flemish qualities in his style, but he shows the intimacy and subtlety of tonal treatment which in general distinguish Dutch from Flemish painting. Equally important is the fact that Holland did not yet have a special school of low-life genre painting by the early 1620s. The efforts of Vinckboons and Adriaen van de Venne in this branch during the first decades of the century failed to inspire any significant artists to follow their lead. It was due to Brouwer's activity that the category quickly gained such wide popularity among Dutch as well as Flemish artists and collectors. Adriaen van Ostade became Brouwer's most famous successor in Holland; David Teniers II carried on his tradition in Flanders.

Brouwer's first teacher was probably his father, who made tapestry cartoons at Oudenaerde. Nothing he painted before he moved to Holland is known, but he seems to have arrived in the north as an accomplished painter who was familiar with Pieter Bruegel the Elder's work. He probably had contact with followers of Bruegel before he left Flanders. The precise date of his arrival in Holland is not documented. There is, however, evidence that he was in Amsterdam in 1625 and 1626. In the latter year he also was in Haarlem where he was listed as a member of 'De Wijngaertranken' (The Vine Tendrils), the Haarlem chamber of rhetoricians to which Frans Hals and his brother Dirck belonged. There are contemporary references to him as 'Adriaen Brouwer haerlemiensis' and 'Schilder van Haerlem'. Houbraken wrongly though he was born in Haarlem. But even if we had no information about his connections with that city, the vivid brushwork which animates all his little paintings and the portrait-like character of some of his genre pieces would suggest that he had contact with Frans Hals. Although, to our knowledge, he never used Hals's life-size scale, he captures the vital impulses behind his work in his cabinet-size paintings. It is not hard to imagine that the swift, energetic line of Brouwer's rare sketches owes a debt to

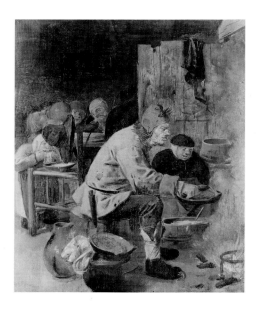

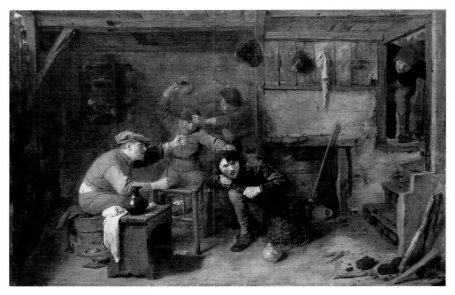

Hals's lost drawings. The date of his departure from Holland is also unknown. By the winter of 1631–2 he was back in Antwerp, where he became a master in the guild. He apparently spent the rest of his life in Antwerp. Whether he died so young as the result of the putative dissolute life his early biographers loved to describe, or was stricken by the plague which ravaged Antwerp in 1638, the year of his death, is a matter of conjecture.

In early works like the *Pancake Man* [168] Brouwer is still inspired by the art of Bruegel, the founder of the category of peasant subjects; the crudeness of the gnome-like types and the vivid local colours prove that. The drawing and the highlights are somewhat hard and sharp, and the types are created without much individualization. Yet we already feel Brouwer's keen observation and biting humour. Brouwer appears to have been a man who was completely at home with common people. This distinguishes him from his countryman Teniers, who remains a neutral spectator or even shows a condescending attitude when he represents himself as a gentleman visiting a village kermis. Brouwer, it seems, shared the pleasures of the people in his genre pictures. According to literary sources he was a Bohemian with an informal, genuine, and humorous personality. There are many stories and legends about his disorderly life. They follow the familiar, untrustworthy topos of identifying an artist's character and actions with the subjects he depicted. One tale (which is most probably apocryphal) states he was invited to grace a wedding because he had acquired a fine suit. After everyone had commended his rich apparel, he poured a dish of gravy upon his clothes, saying that it was proper to bestow the good cheer upon his suit, since it was for its sake and not his own that he had been invited. De Bie, a Flemish writer, tells us in his *Gulden Cabinet* (1661) that Brouwer made most of his quick drawings on the spot in pot houses and often paid his bills with his sketches. He was, in fact, often in need of money. In 1632 his debts necessitated the transfer of all of his effects to a creditor, and his imprisonment in Antwerp's fortress in the following year indicates he had troubles that were not minor ones.

Before Brouwer left Holland he began to give his figures more individuality, and developed strikingly original configurations for his compositions. Whether he represents a group engaged in violent action detonated by intoxication [169] or merely brings figures together who share a common mood, there is always a clear focus on the essential point. By the end of the 1620s the varied colours of his early manner give way to a single focal accent: a warm red or green, a golden yellow, or a fine blue. The rest of the picture is brushed in with warm translucent greys and browns, and the whole effect has become more atmospheric. Continuous space is suggested by subtle tonal adjustments and sensitive and economic accentuation. Everything is well blended into the atmosphere of the whole. The full appreciation of the spatial and psychological accents, the tonal refinement, the colouristic organization, and the delightful play of cool and warm tones in Brouwer's precious little masterpieces can hardly be reached without seeing the originals; the Alte Pinakothek in Munich has the richest collection of his works, and the Städelsches Kunstinstitut in Frankfurt am Main is not far behind.

After Brouwer returned to Antwerp his groups became more compact, his touch broader (although it never attains the breadth of Frans Hals), the atmospheric quality even greater, and the tonality more luminous. In Antwerp he became one of the finest *valeur* painters of all times. His power of expression also increased. The physiognomies and emotions in the *Bitter Draught* [170] and the *Operation on the Back*, both in the Städelsches Kunstinstitut, are not matched before Daumier. Brouwer's originality is also shown in his landscapes, which influenced the fresh ones Lievens painted in Antwerp. They belong to his last years, and rival the poetic mood and pictorial charm of landscape paintings by Rubens and the rare ones by Rembrandt. Both these great masters eagerly collected Brouwer's work. Rubens owned no less than seventeen of his paintings, and Rembrandt acquired six, a copy of one of his paintings, and a book (or album?) of his drawings. Another indication of the esteem in which he was held is Van Dyck's inclusion of him in his *Iconography*, a

168. Adriaen Brouwer: *The Pancake Man*, c.1625–6. Philadelphia Museum of Art, John G. Johnson Collection

169. Adriaen Brouwer: *Fighting Card Players*, c.1632–5. Munich, Alte Pinakothek

170. Adriaen Brouwer: *The Bitter Draught*, c.1635–8. Frankfurt, Städelsches Kunstinstitut

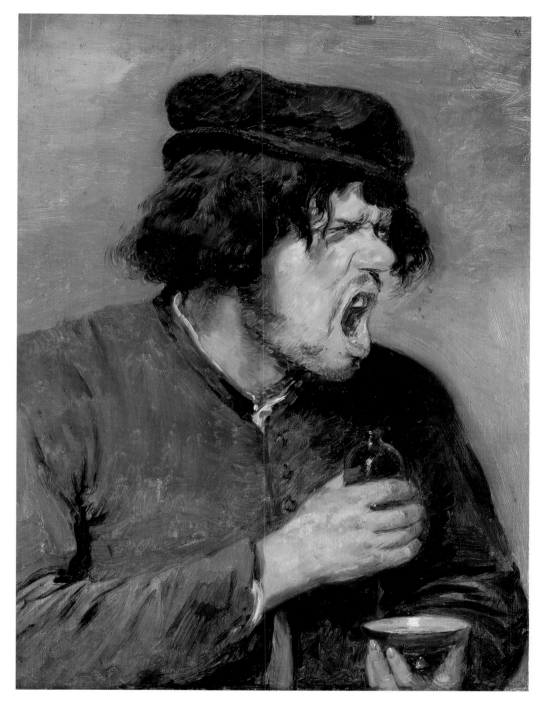

series of portrait prints of distinguished artists, soldiers, statesmen, and scholars of the time.

Adriaen van Ostade and his brother Isack are the most important Dutch painters who were inspired by Brouwer. Among the minor ones, the brothers Cornelis (c.1607–81) and Herman Saftleven (1609–85), Pieter de Bloot (1601–1658) and Hendrik Sorgh (1610/1–70), all of whom had close contact with Rotterdam, painted interiors and outdoor scenes that show the impact of his subjects and style. His Flemish followers include David Teniers II, Joos van Craesbeeck, David Ryckaert, and Gillis van Tilborch. Brouwer's fame did not diminish until the early nineteenth century, but with a new interest in realism, and due to

Bode's research, Brouwer came to the forefront again. His pictures are exceedingly rare, and one must be aware of the danger that many of them were already copied in his own time – so deceptively that even Rubens had to ask for a certificate of authenticity from Brouwer himself in order to guarantee one of his purchases.

Houbraken wrote that Brouwer and the Haarlem painter Adriaen van Ostade (1610–85) were pupils of Frans Hals at the same time. His statement is unsubstantiated. Although there is no difficulty imagining young Ostade, the son of a weaver, at home in Hals's circle, neither the subjects nor the style of his early paintings have much to do with Hals. If he had contact with him, his response to his art was slow. The

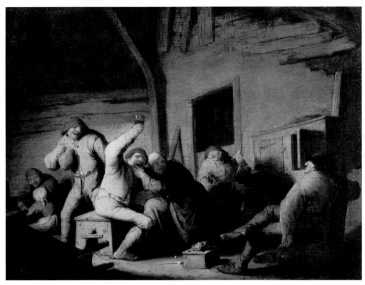

171. Adriaen van Ostade: *Carousing Peasants in an Interior*, *c.*1638. Munich, Alte Pinakothek

172. Adriaen van Ostade: *Men and Women in a Tavern*, 1660. Dresden, Gemäldegalerie

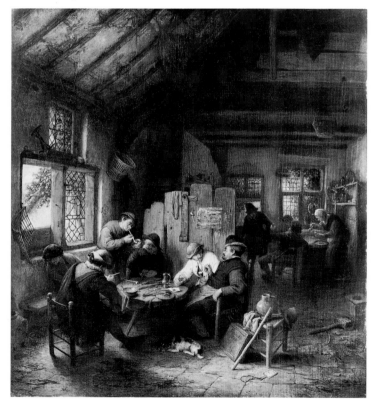

small, portrait-like genre pieces Ostade made in the late forties show a debt to the compositions which Hals used for the half-length, life-size genre pictures he painted in the twenties, when Ostade was supposedly his pupil, but it is noteworthy that Ostade only turned to this schema after Hals himself had ceased to make genre paintings. Ostade did multi-figure peasant scenes throughout his long and productive career. His first manner combines Brouwer's influence with pronounced chiaroscuro effects. Pictures of

grotesque peasants carousing, brawling, or engaged in swinish gluttony in disorderly hovels are characteristic of his boisterous work of the 1630s [171]. Ostade also used peasant scenes to illustrate the Five Senses (1635, St Petersburg, Hermitage). In works made early in the thirties the subtle play of colours, particularly light blue, light grey, rose, and violet, is more important in unifying his pictures than the rather bizarre chiaroscuro pattern. Later in the decade a tonal design begins to organize the surface and depth of his pictures. There is less local colour, and the light and shadow, which is concentrated in large areas, becomes almost Rembrandtesque. He also painted Rembrandt-like landscapes in the late thirties. In the forties his interiors gain in spaciousness and atmosphere. Some pictures of crowds gathered before inns and landscapes date from this decade as well. By the middle of the century Ostade had changed to a more idyllic style. His figures became calmer and more respectable [172]. There is a new emphasis on local colour and an orderly arrangement. The reason for the shift in Ostade's mood has not been established. Perhaps it is related to a change in his clientele, to his own conception of himself, and his ideas about his task as an artist. In this connection his *Self-Portrait with Members of the de Goyer Family* (The Hague, Bredius Museum), painted about 1650, is revealing. Hendrick de Goyer, who held responsible offices as a public official and who also received a gold medal and chain from the king of France, is seen seated with his wife and his famous sister-in-law, Catherina Questiers, who has been given the place of honour. Well-educated and talented, Catherina Questiers, whose accomplishments were praised in verse by Huygens and Vondel, was famous in Dutch intellectual and artistic circles. Ostade depicted himself standing respectfully and respectably. He appears to be at home in the quiet atmosphere of the house. It is not hard to accept the fact that this is a self-portrait of an artist who no longer painted the rowdy brawls of peasants.

In 1657, Ostade, as a widower, married a wealthy Catholic woman from Amsterdam; he may have converted to Catholicism about this time. Ostade was well-to-do before his marriage, and he continued to enjoy a comfortable income until the end of his life. His output was tremendous, and he must have been well paid for his work. Several hundred of his paintings and about fifty etchings are known. His numerous drawings, which are sometimes highly finished and delicately tinted with watercolour, are found in most comprehensive collections. Ostade's late pictures are of well-mannered farmers and tradesmen seen in comfortable surroundings. The riotous and seamy side of peasant life is not represented. With the departure from Brouwer's style, Ostade's peasants lose a good deal of their former vitality, but his painting always remains on a high level and he definitely retains a certain charm until the very end. Good-natured humour, human sympathy, and painterly refinement make his late works attractive. During the eighteenth century, when collectors took satisfaction in the representation of contented Dutch peasants who would not dream of disturbing the pleasures of the elegant figures who people Rococo paintings, Ostade was as highly esteemed as Rembrandt. This accounts for the great number of his works found in the princely collections built up during the eighteenth

century. He still appealed to early nineteenth-century collectors, who liked his intimacy and subtle painterly qualities, but later in the century his popularity waned. Though his etchings and drawings have been carefully studied and catalogued, it is significant that no substantial monograph has been devoted to his paintings, and he was not honoured with a one-man show until 1960, when an exhibition was organized in the Soviet Union to celebrate the 350th anniversary of his birth.

Adriaen van Ostade's principal pupil was his brother, Isack van Ostade. Judging from what Isack produced during his short career, he was even more talented than Adriaen. Isack was born at Haarlem in 1621 and died there in 1649. His earliest known dated work is inscribed 1639, and few of his pictures can be assigned an earlier date; thus he only painted for about a decade, but what he accomplished during those years is more impressive than what Adriaen did during his first ten years as an independent master. Isack's early works are very much like those painted in the thirties by his elder brother, but his peasants are less energetic and his colours are warmer than Adriaen's. It is sometimes difficult to distinguish their hands at this stage; perhaps they worked upon each other's pictures. But Isack soon went his own way. He specialized in rather large-scale summer and winter views of Holland which are generally crowded with people. They are a wonderful combination of genre and landscape painting, and his representations of the silvery light of a warm summer day or the atmospheric subtleties of a grey winter sky match those painted by the best landscapists of his day. A favoured motif is activity in front of a modest house. In his painting of this theme at the Frans Hals Museum [173] the man before the door is probably one of Holland's numerous underpaid itinerant workmen seeking employment. It is not known what Isack was paid for this painting but it is documented that during the early years of his short career his wages were about those received by an unskilled labourer. In 1642 he agreed to paint thirteen paintings for twenty-seven guilders, and in the following year he contracted to deliver nine paintings for fifty-six guilders – hardly wages that would place him with the well-fed, satisfied artisans and peasants his brother painted after the middle of the century. Another favoured theme of Isack's was a view of a roadside inn with travellers stopping for rest and refreshment. This was a subject which Philips Wouwerman also painted frequently; even the white horse which became Wouwerman's trademark is found in Isack's pictures. It is difficult to say if only one of these two Haarlem artists, who were almost exact contemporaries (Wouwerman was only two years older than Isack), should be given credit for popularizing this theme or if it was the result of their joint efforts.

Cornelis Bega (1631/2–64) also studied with Adriaen van Ostade, and worked in his tradition. Bega's pictures of life in peasant kitchens, taverns, and the shops of artisans sometimes capture psychological undercurrents which his teacher missed. His use of chiaroscuro to silhouette light figures against a dark background in his etchings is quite original, and the tonality of some of his prints anticipates in a surprising way the effects Goya achieved in his graphic work. Cornelis Dusart (1660–1704), whose style can be

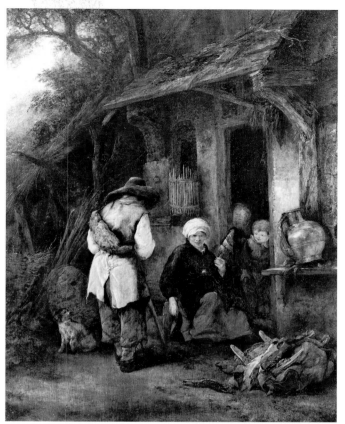

173. Isack van Ostade: *Figures at a Cottage Doorway*, 1648. Haarlem, Frans Hals Museum

deceptively close to Adriaen van Ostade's light and colourful late manner, must have entered Adriaen's studio during the last years of the master's life. He is more satirical and coarser than Adriaen, and shows a pronounced tendency towards caricature. Dusart worked as an assistant, helping Ostade to paint his pictures, and after Adriaen's death in 1685 he acquired some of his teacher's works in progress and finished them. He also completed paintings Isack van Ostade left unfinished at the time of his death in 1649. These pictures, begun at least eleven years before Dusart was born, must have belonged to Adriaen, and they probably fell into Dusart's hands when the old Ostade died. They are an indication of studio practice during a period when the premium on originality which later ages insist upon was not yet universally endorsed.

THE SCHOOL OF DELFT

Johannes Vermeer

Juxtaposition of Vermeer's *Geographer* [175], a supreme example of his art, with Rembrandt's etching called *Faust* (1650–2; Bartsch 270) [174] emphasizes basic differences between two of Holland's greatest artists. The subjects of both works are similar. Rembrandt's *Faust* – the title is questionable[5] – shows a scholar at the moment when a supernatural appearance (with definite Christian symbols in it) attracts his attention and causes him to interrupt his work

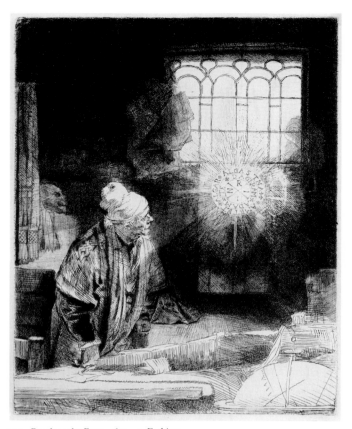

174. Rembrandt: *Faust*, 1650–2. Etching

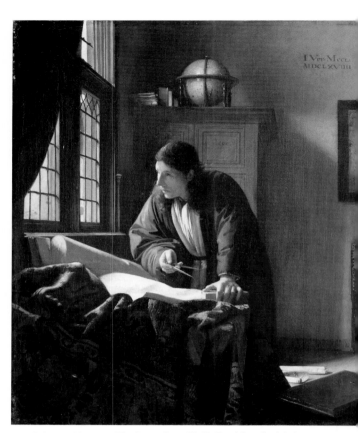

175. Johannes Vermeer: *The Geographer*, 1669(?). Frankfurt, Städelsches Kunstinstitut

176. Rembrandt: *Portrait of a Jew*, c.1648. Berlin, Staatliche Museen

and rise from his desk. The picture by Vermeer represents a geographer who also stops his work for a moment of meditation. One realizes at once that Rembrandt's conception of a scholar contains supernatural elements, and we are made aware of the mysteries inherent in the spiritual world, whereas Vermeer's subject seems to be a perfect representation of an exclusively rational mind. If we want to draw a parallel in the field of contemporary philosophy, it is a contrast similar to one between Pascal and Déscartes. With Rembrandt, the light is arbitrary, expressive of a spiritual content beyond the power of man; the space is subordinated to the chiaroscuro device, and its rational construction is less essential than the expression of some deeper emotional content. Something of the dynamic spirit of the Baroque is also inherent in Rembrandt's chiaroscuro, although here, in his mature style, it is fused with compositional elements of a classical character. Vermeer's representation shows, on the other hand, a consistent naturalistic lighting that lends solidity to the form and clarity to the space. The space is clearly constructed, and the position of every object is crystal-clear. The design lacks any dynamic element. Reason dominates the emotion and keeps the vision under sober control. The moment Vermeer chose in the life of the geographer is a brief one, but the transitory aspects have been subdued. Vermeer's composition has become more tectonic, his technique less arbitrary and spontaneous, and his brushwork less personal. By the time it was painted, the Baroque impulses of the preceding generations cooled, not only in Holland, but throughout the continent. Vermeer's picture dates from the period when Poussin was acknowledged as a leading figure of European painting.

Vermeer probably owes much in this phase of his art to Carel Fabritius, who can be considered a link between him and Rembrandt. Fabritius's great accomplishment was to transform Rembrandt's chiaroscuro into a more natural daylight atmosphere. His early work has been discussed above in the chapter on Rembrandt's students and followers, and, as we have already noted, Fabritius was one of the master's pupils who quickly asserted his independence. If we compare Rembrandt's *Portrait of a Jew* [176] of the late forties, with Fabritius's *Man in a Helmet* [177], datable about the same time, we see great differences. Fabritius is more interested in surface treatment than in the exploration of meditative and introvert moods – though in the final analysis, it is Rembrandt, not Fabritius, who attains the richest pictorial effects. Rembrant's mastery of what could be achieved by juxtaposing passages of heavy impasto with thin glazes of oil paint was never matched. Fabritius, even when he is close to Rembrandt, has a flatter and less complex treatment and shows a tendency to lighten his backgrounds. His interest in the atmospheric effects of clear daylight and his luminous tonality is evident, and it becomes more evident after he settles in Delft around 1650, but he always retains, in his life-size as well as his tiny pictures, the breadth and quality of Rembrandt's mature work. We have heard that few of Fabritius's works have survived – less than a dozen can be securely attributed to him today. Perhaps many were destroyed in 1654, the year he himself tragically perished in the explosion of Delft's gun-powder magazine which

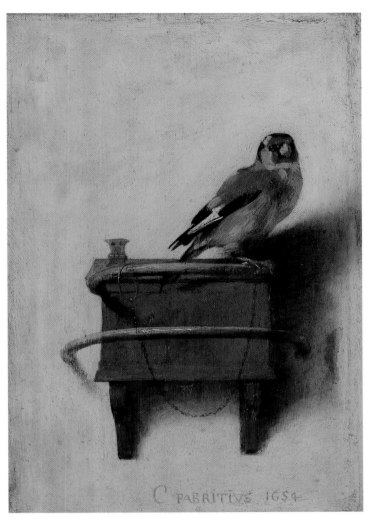

178. Carel Fabritius: *The Goldfinch*, 1654. The Hague, Mauritshuis

177. Carel Fabritius: *Man in a Helmet*, c.1648. Groningen, Groninger Museum

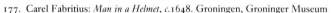

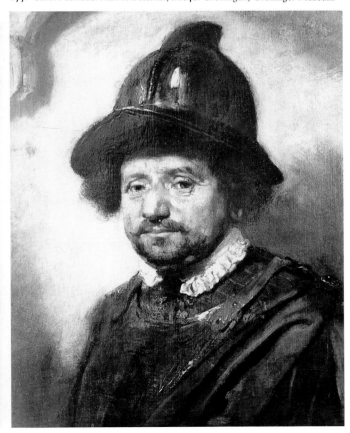

devastated much of the city. His little topographical *View in Delft, with a Musical Instrument Seller's Stall* (1652, London, National Gallery), painted as part of a perspective box or peepshow, manifests his interest in perspective effects, an interest which Vermeer shared during much of his career. *The Goldfinch* (The Hague, Mauritshuis) [178] and *The Sentry* (Schwerin, Staatliches Museum), both painted in the year of his death, are a premonition of Vermeer's best qualities in the fine, cool harmony of colours and the light tonality as well as the sense of classic composition and the firm handling of the brush. The distance from them to a work such as Vermeer's *Woman reading a Letter* (Amsterdam, Rijksmuseum) [179] is not very great.

The *Woman reading a Letter*, datable to the first half of the sixties, is a mature work and shows all Vermeer's essential qualities. His art has the charm and simplicity of a flower. We enjoy it, it seems, without effort. He is the darling of the art-loving public, gaining their hearts without much comment or advertisement. Yet this simplicity and easy attraction can be deceptive. These qualities are, in fact, the result of an intense intellectual effort and a superb control over all the

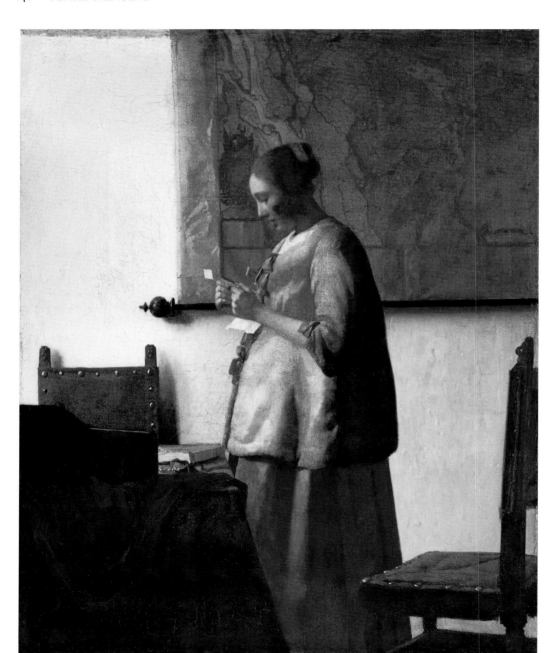

179. Johannes Vermeer: *Woman reading a Letter, c.*1662–5. Amsterdam, Rijksmuseum

artistic means. A very deliberate selection, concentration, and organization orders his modest pictures. In the Amsterdam painting we see a woman reading a letter. Her open mouth and lowered eyes subtly indicate her absorbtion. She fills the room with her solitary, quiet existence. The sympathetic arrangement of forms contributes to this effect; figure and objects are seen from nearby, but in a definite order and harmony. Light and atmosphere allow a clear existence of forms in space. The accurate rendering of tones in the shadows is not unimportant in producing this effect. A cool colour harmony with a predominant blue in the woman's gown, contrasted with a few fine yellow accents and softened by the silvery daylight, appeals to our sense of beauty and contributes essentially to the balanced mood of the whole. A design quality of unusual strength and clarity coincides with the clear spatial organization. Nothing remains accidental or unrelated. Rectangular and round forms, diagonals and verticals, the subtle light accents, and value contrasts all have their definite function within the whole. There is a most happy equilibrium of all essential formal elements. We are impressed by the artist's architectural sense, by his full expression of form, and by his pictorial sensitivity. It is an art which is classic in its perfect balance and clarity. In contrast to all the minor Dutch genre painters who are preoccupied with painting the texture of stuffs, there is an overall relationship of design which, through its breadth, has a distinct appeal and lends a certain monumentality to all Vermeer's rare works.

Vermeer did not immediately reach the subtle perfection of the sixties, and his style changed again in his later years. It

should be emphasized that establishing his development presents some problems, and not all students of his work have arrived at the same conclusions. Little is known about his life that would help to date his pictures accurately. Less than thirty-five paintings can be attributed to him and only two of his universally accepted works are securely dated, one at the beginning of his career, *The Procuress* of 1656 at Dresden [180], and another toward the end, *The Astronomer* of 1668 at the Louvre [181].[6] A third picture, Frankfurt's *Geographer* [175], dated 1669 by a later hand, is so close in style to the Louvre's *Astronomer* of 1668, all specialists agree that the inscribed date is a plausible one for it, and most probably is based on an original inscription. There are no graphic works to which one can turn to help determine his development. As far as we know he made no prints, and no drawings can be ascribed to him with certainty. Not a single letter or note written by Vermeer has survived, and contemporary documents and printed sources tell us little about his art. Dirck van Bleyswijck, who published his voluminous *Description of the City of Delft* (*Beschryvinge der stadt Delft*) in 1667, when Vermeer was at the height of his powers, mentions him only briefly. In the section on the artists of Delft this local chronicler noted the year of Vermeer's birth. Nothing more. Van Bleyswijck does, however, include a poem by Arnold Bon on Carel Fabritius. The poet calls Fabritius the Phoenix, who was snatched from life and fame in 1654 by the 'Delft Thunderclap', and adds that lucky Delft has Vermeer, 'who masterly his path doth tread'. We have heard that Houbraken, the major source for material on seventeenth-century Dutch artists, merely cites Vermeer's name in a list of a half-dozen Delft artists but says nothing more about him in his three-volume history published in 1718–21. The main evidence for a chronology of Vermeer's

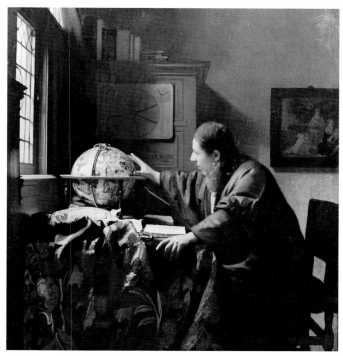

181. Johannes Vermeer: *The Astronomer*, 1668. Paris, Louvre

work lies in the pictures themselves, in the logical development of certain motifs and problems, and in the analogies which can be established between his small *œuvre* and the general trend of Dutch painting.

Vermeer was born at Delft in 1632,[7] the year which witnessed the birth of Spinoza, John Locke, and Christopher Wren. His father, Reynier Jansz Vos (occasionally called Vermeer), was a weaver who made caffa, a fine satin, and also an inn keeper; a year before Johannes's birth he was registered in Delft's guild as an art dealer. Vermeer also was active in a small way as a dealer and appraised pictures. In 1672 he and Johannes Jordaens, another Delft painter, were called to The Hague to evaluate twelve paintings, including works optimistically attributed to Raphael, Michelangelo, Giorgione, Titian, and Holbein. They testified before a notary that they were great pieces of rubbish and bad paintings worth less than one-tenth of the price at which they had been valued. Vermeer married Catherine Bolnes, a woman from a Catholic family, in 1653 and was probably converted to Catholicism at that time. When his future mother-in-law vacillated about his marriage, Leonaert Bramer helped him get his marriage banns published. This close personal connection has led some students to suggest that Bramer was Vermeer's master, but the plain fact is that we do not know with whom he studied. As already noted, Fabritius's art had an important influence on him; but this impact becomes evident only after Fabritius perished. There is no trace whatsoever of his style in Vermeer's earliest known works. At the time of Vermeer's death in 1675 he owned three pictures by Carel Fabritius. Of course these works may have been part of his stock as an art dealer, but it is also likely that he personally collected and treasured the works of his great predecessor. Possibly he also was stimulated by the

180. Johannes Vermeer: *The Procuress*, 1656. Dresden, Gemäldegalerie

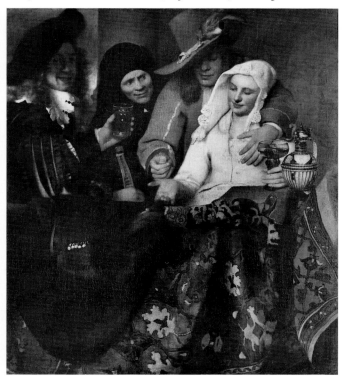

masterworks Pieter de Hooch began to paint in Delft during the second half of the 1650s.

Vermeer entered the Guild of St Luke at Delft in 1653, and he was elected an official of the guild two times. In the year he joined the guild he witnessed a document with Gerard ter Borch. How close Vermeer's contact was with this leading genre painter and portraitist has not been established. However, it is safe to say that ter Borch painted a number of Vermeer's favourite themes before they were used by Johannes (e.g. a woman writing or receiving a letter; a woman before a mirror). Both artists also share an uncanny gift for painting the texture and sheen of precious stuff and a genius for creating an ineffable sense of silence in their works.

Vermeer was heavily in debt at the end of his career. He probably never earned very much because his way of working was obviously very slow and deliberate – his rate of metabolism must have been significantly lower than Hals's and Rembrandt's. His meticulous manner of painting is the best explanation for the rarity of his works. Vermeer's burden was not eased by his need to support his wife and fifteen children, of whom eleven were still alive when he died in 1675 at the age of forty-three. To our knowledge this father of fifteen children never painted a child.

In 1676, a few months after her husband's death, Vermeer's widow petitioned the court for a writ of insolvency and declared that her husband had earned almost nothing during his last years because of ruinous economic conditions brought on by Holland's war with France and England in 1672, and that he had only losses as an art dealer. Her petition was granted and the court appointed the Delft scientist Anthony van Leeuwenhoeck, whose pioneer work with the microscope was to earn him the title of the 'father of microbiology', as executor of Vermeer's bankrupt estate. There is no evidence that Vermeer and Leeuwenhoeck were close friends. Indeed, we do not know if they were acquainted, but is noteworthy that these two distinguished citizens of Delft were born at the same place and virtually the same hour – their baptisms are registered on the same page of the record of the New Church of Delft – and that both rank, thanks to their extraordinary gifts, with the rare men about whom Leeuwenhoeck himself once said: 'Through labour and diligence [they] can discover matters which were thought inscrutable before.'

One record, if it can be trusted, shows that Vermeer's pictures were highly priced during his own lifetime. The French amateur Balthazar de Monconys, when passing through Delft in 1663, called at Vermeer's house. The artist was absent, and the collector complained that there was not a single painting available in his studio. The only picture by Vermeer that he was able to see belonged to a baker in the neighbourhood, who, he was told, had paid 600 livres (about 600 guilders) for it. De Monconys found this price highly exaggerated, considering that there was only one figure represented in the picture. In 1696 twenty-one of Vermeer's paintings were sold at an anonymous Amsterdam auction sale. This was the largest stock ever found in the possession of a single collector. The fortunate owner of it was the Delft printer Jacob Dissius (died 1695). But most probably Dissius cannot be credited with assembling it. There is excellent

reason to believe that it passed to him through his marriage to the daughter of Pieter Claesz van Ruyven, a Delft amateur who was Vermeer's patron since the late 1650s; he has the distinction of bringing the majority of Vermeer's best pictures known to us into his possession. At the 1696 sale none of the paintings fetched anything near the high price the Delft baker was reputed to have paid for his Vermeer. However, most were knocked down at reasonable prices for the period: *The View of Delft* [186], *Milkmaid* [187] and *Woman holding a Balance* [190], fetched the most: 200 guilders, 175 guilders and 166 guilders, respectively. But a *Lace Maker*, most likely the masterwork now in the Louvre [195], sold for merely 28 guilders. As late as 1888 it was still possible to buy a pinnacle of Vermeer's accomplishment at an even lower price. In that year, at an auction in The Hague, his *Girl with a Pearl Earring* [196] was sold for 2 guilders, 20 stuivers.

Vermeer's development spans a period of about twenty years. Since only two paintings or perhaps three are reliably dated,[8] it is impossible to date each of his pictures precisely, but it is possible to distinguish the broad phases of his work. When we first recognize his hand in about 1654–5 he does narrative pictures which show that Holland's greatest genre painter began as a history painter. By 1656 the impact of the Utrecht Caravaggists is obvious. Soon afterwards he develops his classic genre painting in cool harmonies of which we have discussed outstanding examples. This phase extends through the sixties. His brief late period is characterized by an exaggeration of decorative elements, and also by a certain hardening of pictorial effects.

Vermeer's life-size *Procuress*, securely signed and dated 1656 [180], is a firm point of departure for an appraisal of his achievement. There is very little indication of the interior and more action in it than there will be in the later paintings. The erotic subject, size, and decorative splendour are all closely related to pictures the Utrecht *Caravaggisti* painted a generation earlier. Additional evidence that Vermeer was familiar with their work is the fact that he placed Baburen's painting of the same theme [21] in the background of two of his pictures. It appears in his *Concert*, formerly at the Isabella Stewart Gardner Museum in Boston (stolen 1990) [193], and in the *Woman seated at a Virginal* in the National Gallery, London. Vermeer knew Baburen's painting of a procuress with her employee and a client well; his mother-in-law owned the original or a copy of it. The chiaroscuro effect and the warm colour harmony of reds and yellows of Vermeer's *Procuress* also indicate a connection with works painted in the early fifties by Rembrandt and his followers; perhaps Maes, who had settled in nearby Dordrecht by 1653, was the conduit. It has been suggested that the smiling man on the left holding a lute and a glass is a self-portrait. If so, it is the only time Vermeer allows us to approach him on such intimate terms. But the identification remains speculative; no visual or documentary evidence corroborates it. There are, however, personal qualities in the Dresden picture that we shall meet again and which we may call characteristic: a still-life beauty, the colour accord of blue and yellow (which is here only a partial effect), and the broad painterly treatment.

Works that can be dated a year or so earlier than *The Procuress* of 1656 are *Diana and her Companions* (The Hague,

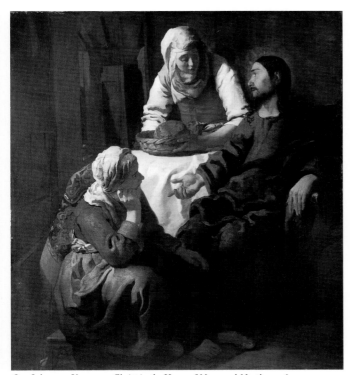

182. Johannes Vermeer: *Christ in the House of Mary and Martha*, *c*.1655. Edinburgh, National Gallery of Scotland

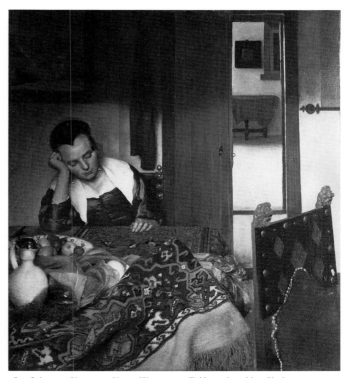

183. Johannes Vermeer: *Young Woman at a Table*, *c*.1657. New York, Metropolitan Museum of Art, Altman Bequest

Mauritshuis) and *Christ at the House of Mary and Martha* (Edinburgh, National Gallery of Scotland) [182]. Both support the claim that Vermeer began as a history not a genre painter, and both show a Baroque fullness and exuberance which was soon to give way to a greater simplicity and clarity, and to an architectural feeling with a predilection for straight lines.[9] With the *Young Woman Asleep at a Table* (New York, Metropolitan Museum) [183], which was probably painted shortly after the Dresden *Procuress*, Vermeer comes to his favourite subject: the quiet existence of a single figure within a mildly lit interior seen from close by. The quietness in the New York picture is of a special type. The lovely sleeping woman is drunk, as her untied collar, the disorder on the table, and the wine pitcher discreetly indicate. Vermeer, like Dutch artists before and after him, used a sleeping woman to moralize on the evils of drink: 'Wine is a mocker, strong drink is raging, and whosoever is deceived thereby is not wise' (Proverbs 20:1). But unlike so many of his contemporaries, he did not represent a slattern in order to make his point, and it is his sense of decorum which made later critics, who assumed that Dutch painters merely depicted what they saw, overlook the didactic aspect of the painting. However, its message would have been recognized by Vermeer's contemporaries, and when it appeared in the 1696 auction of the artist's paintings, it was described by the compiler of the sale catalogue as 'A drunken young woman asleep at a table' ('Een dronke slapenpende Meyd aen een Tafel'). As an admonition to use alcoholic beverages moderately the painting was probably a failure. The chance of looking as beautiful as Vermeer's sleeping young woman is enough to drive a woman to drink. A certain diffusion of interest in the picture is created by the vista into another

room. X-ray and autoradiograph examinations of it reveal that the picture originally included additional diversions: a large dog going through the doorway and a man beyond the threshhold. A sound second thought led Vermeer to paint both out. Except for a reference in the 1696 sale to a lost Vermeer of 'A Gentleman washing his Hands, in a room with a through view with sculptures, artful, and rare', it is the only one we know by the artist that employs a *doorkijkje*, a device discussed in the section on Maes, and which was used brilliantly by Pieter de Hooch.[10]

To obtain a sense of the general direction of Vermeer's development it is helpful to examine the relation of figures and space in his pictures. In the early *Soldier and a laughing Young Woman* (*c*.1658, New York, Frick Collection) [184] there is an emphasis on the figures, particularly the soldier who is seen close-up, and on the anecdote. Only a few years later he achieved, as we have seen in the Amsterdam *Woman reading a Letter* [179], an uncanny balance between all elements, in particular between figures and space. The harmonious organization justifies the name of classic for this and other masterworks he painted during the sixties. During the same decade he also occasionally employs striking perspective effects [192, 193, 194] but of course, the figures still exist and lend human content to the interior. It is often a characteristic of Late Baroque art to extend the field of vision into landscape and landscape architecture. Figures, buildings, and trees can shrink to tiny details within a mighty perspective. Jacob van Ruisdael's flat landscapes are an example of this tendency. Another expression of it is found in the grand perspectives at Versailles, where views to a distant horizon are often dominated by the sky with its infinite height.

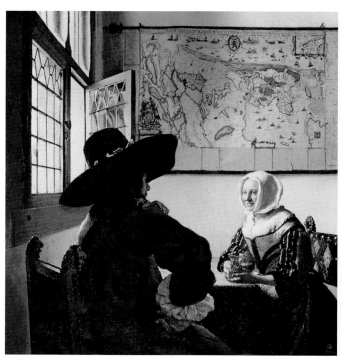

184. Johannes Vermeer: *A Soldier and a laughing Young Woman*, c.1658. New York, Frick Collection

As in the case of Rembrandt in the transition from his flamboyant style of the 1630s to the restraint and breadth of his mature years, we can observe that Vermeer had visual experiences in the open air which widened his sense of space, clarifed his pictorial conception, and added to his atmospheric quality. Only two of his landscapes – or more accurately, cityscapes – are known. The earlier (c.1660) and smaller of the two is *The Little Street* (Amsterdam, Rijksmuseum) [185], which shows that Vermeer, along with Pieter de Hooch, discovered the beauty of simple houses. In spite of the closeness of the view, the effect is made spacious by the appearance of the sky and an intense suggestion of atmosphere. In its strong, yet soft harmonies of the grey and vermillion of the brick buildings and window shutters, of the black and white around the doors, and the blue, red, and yellow accents in the passageway and on the figures, 'Het Straatje' – as the Dutch call it – is a colouristic jewel. (The foliage of the trees, originally green, now looks blue by the partial disappearance of a fugitive yellow, which was once combined with the blue to make green – this change, however, is not a discordant note.) The silvery tonality and the tectonic feeling for composition predominate here. Besides, the picture excels by its wonderful velvety texture. It is a masterpiece which embodies all of Vermeer's visual endowment, and in its simplicity and colouristic charm appears to reflect the gentle, homely spirit of Dutch urban, middle-class life.

In the famous *View of Delft* (The Hague, Mauritshuis) [186], which is much larger, Vermeer created one of the most colourful and impressive cityscapes in the history of European painting. It has been rightly related to the Netherlandish topographical tradition of depicting profile views of towns and cities,[11] but these connections are forgotten when

one views its design quality and decorative beauty which are as outstanding as the truth in the rendering of light and atmospheric life. Depth and height have been achieved without any conspicuous diagonals. Here, the clouds and the lighting, the aerial perspective, and the ingenious device of the reflections of the buildings in the water reaching out towards the foreground create the impression of a wide open space – and the strip of sunlight that hits the rear buildings as well as the brightening of the clouds towards the hidden horizon loosen the town from the sky. It may be springtime. In any case the weather is typical of the windy climate of Holland, where rain and sunshine alternate quickly and cloud formations are often of an extraordinary grandeur and lucidity, contrasting in their shining whiteness with a fresh patch of blue sky here and there. Vermeer the colourist speaks here as impressively as in his most beautiful interiors. With the exception of Aelbert Cuyp, no other landscape painter of the seventeenth century dared to use in open-air painting such strong decorative colours; copper-red and blue, grey and ochre, silver-white and black predominate. Yet there is not a single hard edge at any place. Every form is surrounded by atmosphere and every colour properly related to the whole both in value and intensity. Thoré-Bürger declared it was the *View of Delft*, which he saw on his first trip to Holland in about 1842, that led to his study of the master who he called 'mon sphinx'. He confessed that it intrigued him more than the Rembrandts and other marvellous paintings he saw and 'pour obtenir une photographie

185. Johannes Vermeer: *The Little Street*, c.1660. Amsterdam, Rijksmuseum

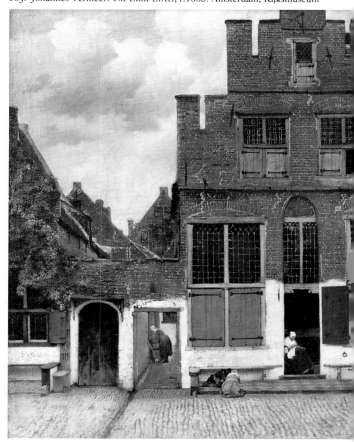

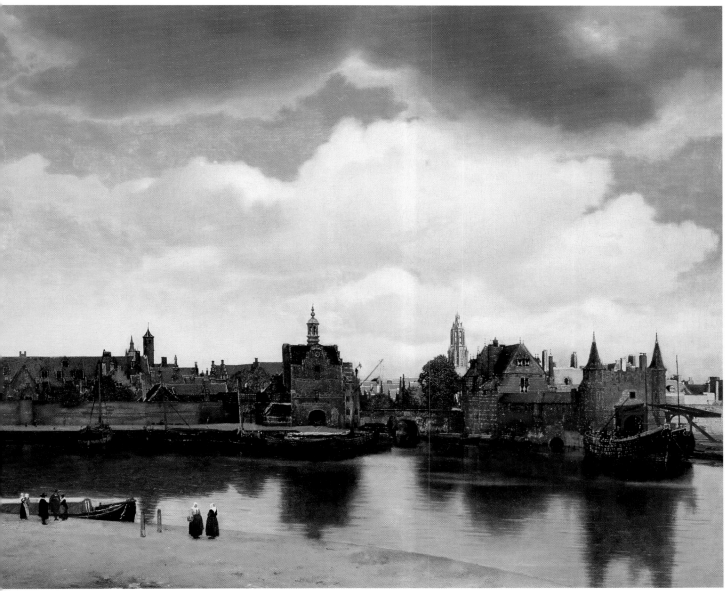

186. Johannes Vermeer: *View of Delft*, *c*.1661. The Hague, Mauritshuis

de tel van der Meer, j'ai fait des folies'. His passion culminated in the fundamental articles he published in 1866 that resuscitated Vermeer's international reputation.[12]

The absence of a precedent in the artist's work for the simplicity and freshness of vision of the *View of Delft* makes it hard to place in Vermeer's chronology. His handling of the paint, however, gives us a clue. In the *View of Delft* Vermeer is in full control of his technique, which can be broad and almost impasto in passages, and also smooth and transparent. The first characteristic, the broad impasto touch, prevails in his earlier work; the latter, the smooth and transparent one, in his mature period. Vermeer is seen between these two extremes in the *View of Delft*. In it he makes extensive use of a kind of *pointillé* technique, which spreads thick bright points as highlights over a dark area. This device, which Vermeer favoured in the late fifties and early sixties, gives the illusion of glittering light without changing the basic value of the form. In all Vermeer's more mature paintings we feel the structural significance of a coherent tonal value that underlies and carries the composition. The *pointillé*

technique allows Vermeer to lighten passages, to increase the illusion of glittering daylight and atmosphere, and to produce textural effects without destroying or changing too much of the underlying tonal design.[13]

The Milkmaid (Amsterdam, Rijksmuseum) [187] is datable shortly before 1660, when Vermeer began to concentrate upon single figures, which can be somewhat overpowering in their existence. Sir Joshua Reynolds considered this forceful genre piece one of the best Dutch pictures he saw on his trip to Holland in 1781, and nineteenth-century artists from Millet to van Gogh were impressed by its vigorous paint, powerful realism, and rich texture. The paint is rather thick and grainy, the impasto heavy, and Vermeer's *pointillé* technique already begins to play an important role [189]. Yellow (the cook's blouse) and blue (her apron, the lining of her sleeves, the cloth, and the Nassau stoneware pitcher on the table) predominate. During the sixties the blue and yellow accord continues to be the dominant one and the tonality becomes distinctly cooler. The *Young Woman with a Water Jug* (New York, Metropolitan Museum) [188] clearly shows

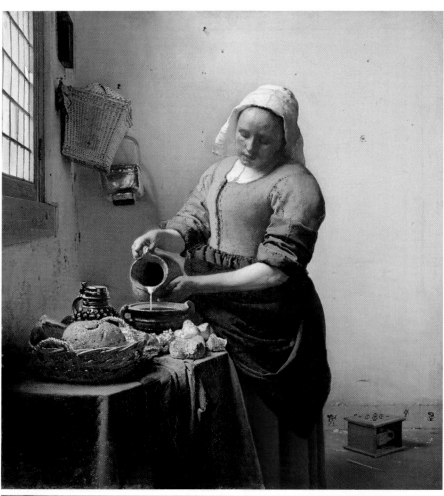

187. Johannes Vermeer: *The Milkmaid*, c.1658–60. Amsterdam, Rijksmuseum

188. Johannes Vermeer: *Young Woman with a Water Jug*, c.1662–5. New York, Metropolitan Museum of Art

189. Detail of fig. 187, *The Milkmaid*

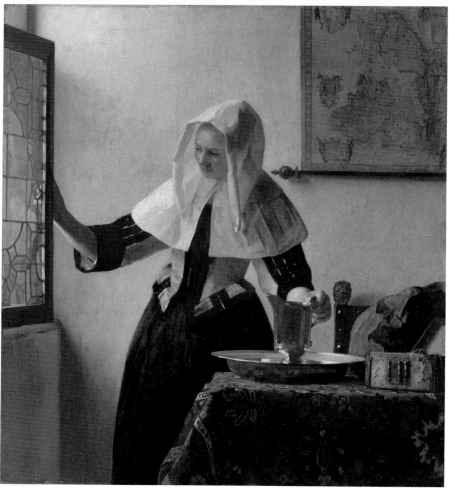

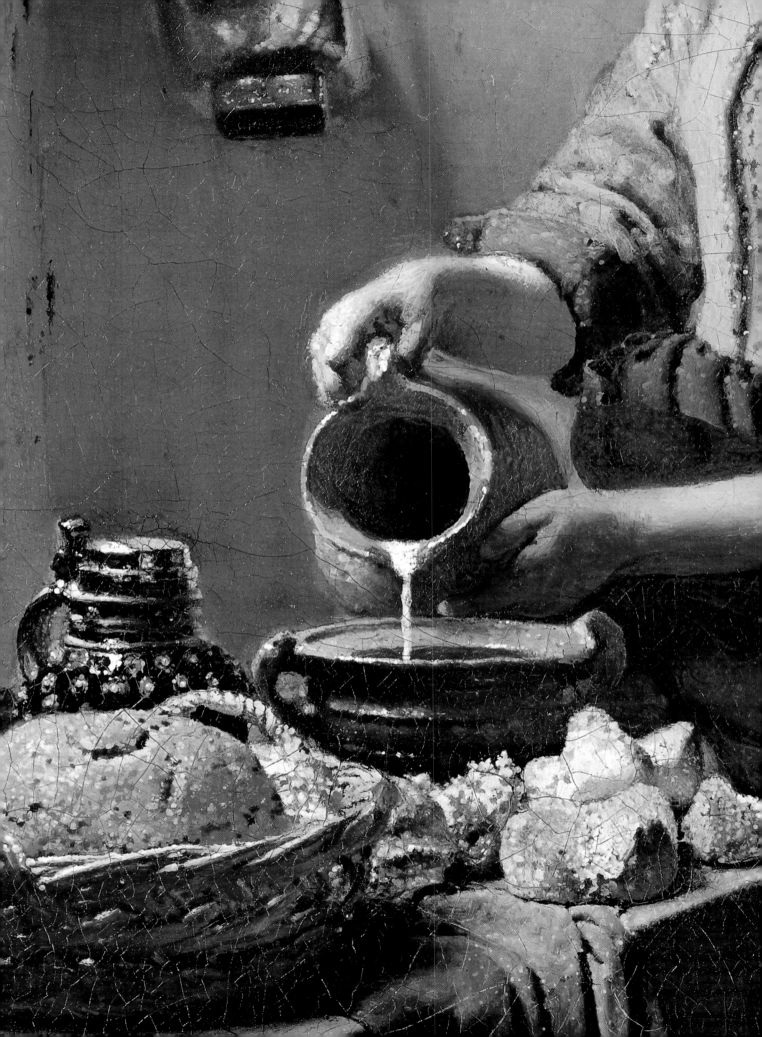

190. Johannes Vermeer: *Woman holding a Balance*, c.1662–5. Washington, National Gallery of Art, Widener Collection

the style of the sixties. The chiaroscuro of his first efforts has been abandoned in favour of full daylight brightness. There is an increase in simplicity, order, and harmony. The space is organized with greater clarity, there is a fine modulation of values, with more transparency in the shadows, and greater consideration is given to the effects of reflected light. The *Young Woman with a Water Jug*, like the *Woman reading a Letter* in Amsterdam [179], allows us to study Vermeer at the height of his art, where his accents on form and silhouette, on space and surface design, on light and colour were most selective and full of formal significance. An uncanny equilibrium is struck between the animate and inanimate in this perpetuation of a transitory moment. It is the kind of Vermeer which Proust loved, and, as in the master novelist's work, detail fascinates us and contributes to the expressive grandeur and exquisite beauty of the total design.

Woman holding a Balance at Washington [190] was erroneously called 'Woman weighing Gold' or 'Woman weighing Pearls' from the time it appeared in the 1696 Dissius sale until 1977, when a microscopic examination

revealed the pans of the balance are completely empty.[14] The work also has the noble simplicity of the classic phase. Here, too, every detail is significant and indispensable. The light is mild and harmonious. Again the figure, her mood, and her delicate action dominate the interior and fill it with a gentle atmosphere. The subdued centre of the composition is the hand holding the balance, and by very subtle compositional means Vermeer focuses our interest on this action without distracting too much from her whole appearance. Comparison of the painting with the *Woman reading a Letter at an Open Window* (Dresden, Gemäldegalerie) [191], which dates from the late fifties, is instructive. In the earlier work the relation between figure and space is still indeterminate, the light, which is almost sunlight, is more intense, and the colours are warm, with much red. The paint is grainy and heavy compared to the smooth, thin paint of the Washington picture. The artist revels in the reflections in the window, the still-life arrangement on the table, and the *trompe l'œil* effect of the glittering curtain, and he is still a bit obvious in his intentions.

Various interpretations have been given to the meaning of the *Woman holding a Balance*. Most critics have found the principal clue to its significance in the close juxtaposition of the woman's action and the prominent painting, by an unknown artist, of the *Last Judgement* hanging behind her. They argue, some with more certainty than others, that most likely the painting is, in effect, an allegory on the popular *Vanitas* theme: Vermeer intended the viewer to reflect upon the material treasures about to be weighed (before the discovery that the pans of the balance are empty it was said gold or pearls were being weighed) and the fateful weighing of souls on Judgement Day. Thoré-Bürger made the point as early as 1866 in his discussion of the painting in his pioneer article on Vermeer: 'Ah! tu pèses des bijoux? tu seras pesée et jugée à ton tour!'[15]

In paintings such as *Woman at a Virginal with a Man* of about 1665 (Collection of H.M. Queen Elizabeth II) [192], and the Gardner Museum's *Concert* [193], datable about the same time, the perspective is much emphasized; in the former the effect of space almost dominates over the figures. The colour shows rich gradations in fine cool harmonies, and the light is most subtle, and becomes intense in the distance, in contrast to a darker foreground. This contrast, in conjunction with the prominent tables covered with turkey carpets in their foremost planes, helps to increase the effect of depth. It has been proposed that the pictures were painted as pendants, but this proposition is difficult to accept because of the differences in the views of the interiors and perspectives. Unlike the Gardner painting, the Royal Collection

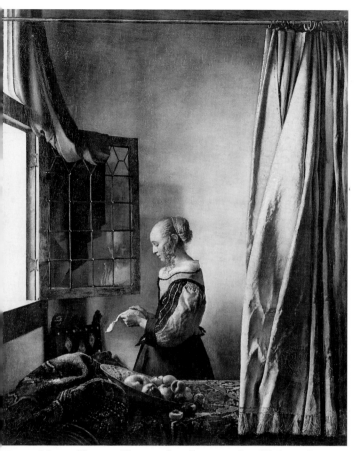

191. Johannes Vermeer: *Woman reading a Letter at an Open Window*, c.1659. Dresden, Gemäldegalerie

192. Johannes Vermeer: *Woman at a Virginal with a Man*, c.1665. Collection H.M. Queen Elizabeth II

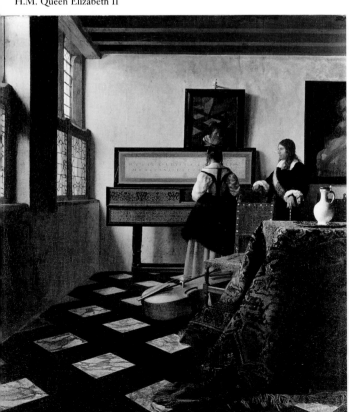

193. Johannes Vermeer: *The Concert*, c.1665. Formerly Boston, Isabella Stewart Gardner Museum (stolen 1990)

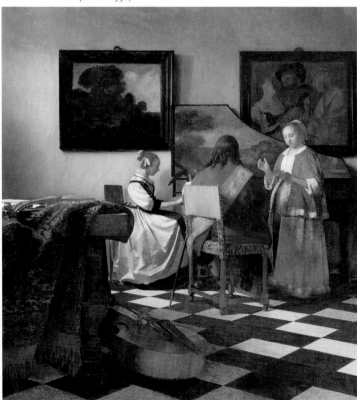

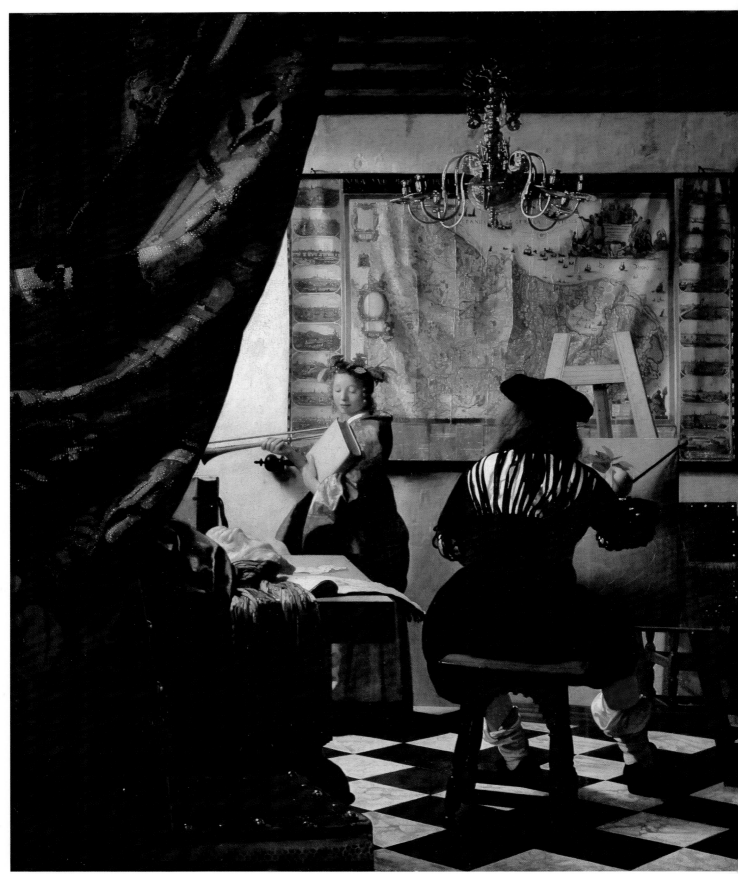

194. Johannes Vermeer: *The Art of Painting*, c.1665–7. Vienna,
Kunsthistorisches Museum

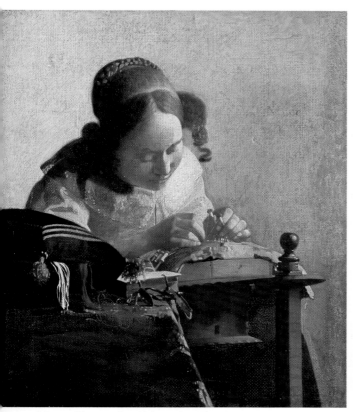

195. Johannes Vermeer: *Lace Maker*, *c*.1670. Paris, Louvre

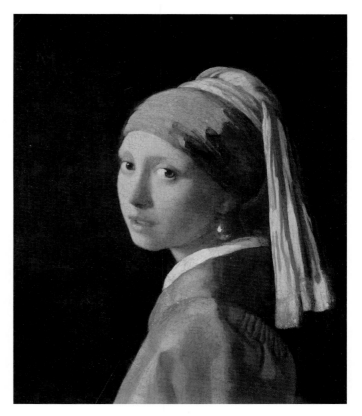

196. Johannes Vermeer: *Head of a Girl*, *c*.1665. The Hague, Mauritshuis

picture includes a wall with double windows, a good deal of the room's beamed ceiling, and a tiled floor with a dramatic slope. A vital part of the picture is the mirror on the back wall which reflects the young woman's hidden face, the tile floor, as well as a glimpse of the artist's easel and his paint box. The mirror, earthenware jug, and square back chair appear in other paintings. (The same map can also be spotted in his pictures [179, 184, and *The Love Letter* at Amsterdam, Rijksmuseum].) These props must have been part of his household effects. On the lid of the virginal there is a Latin inscription that reads, in translation: Music Companion in Joy, Balm for Sorrow. The partially framed painting seen in the right background represents *Roman Charity*, the name given to the depiction of Pero suckling her father, who was starving in prison (an inventory compiled in 1641 of the effects of Vermeer's mother-in-law establishes she owned a 'painting of a figure sucking a breast'). The theme can allude to the dependence of man upon woman. The attempts that have been made to establish a firm connection between the painting within the painting, the inscription on the virginal, and the pensive gentleman who accompanies the woman playing the musical instrument remain problematic. The efforts that have been made to determine the significance of Baburen's *Procuress* [see 21] mounted on the back wall of the Gardner *Concert* also remain hypothetical (as we have noted, Vermeer's mother-in-law owned the original Baburen or a copy of it).

We are on more solid ground when we turn to the subject of Vermeer's *Art of Painting* (*c*.1665, Vienna, Kunsthistorisches Museum) [194], sometimes called 'The Artist in his Studio'. It is intended as a glorification of the art of painting. The seated artist dressed in a fanciful, old-fashioned costume is

portraying an allegorical figure, Clio, the muse of history, as described by Cesare Ripa in his *Iconologia*; a Dutch translation of his handbook appeared in 1644.[16] Clio is seen with a laurel wreath and bearing a trumpet to broadcast her fame. She holds a book (according to Ripa it should be inscribed Thucydides) symbolizing history. The idea that Vermeer, in his discreet manner, portrayed himself from the rear, painting the muse of history, is attractive, but it must be discarded. Even if a mirror reflected a face, it could not be correlated with a portrait of Vermeer since, as we have noted, none has been identified. The painting was done as a celebration of the art of painting, not as a self-portrait. As early as February 1676, less than three months after Vermeer's death, the artist's widow referred to it as 'de Schilderkonst' (the Art of Painting), not as a portrait of her deceased husband. In the following year she gave it the same title. For us the miraculous illusion Vermeer creates of an artist at work in a luminous interior is more expressive of the power of the art of painting than any armoury of traditional Baroque allegorical trappings.

Whether he paints a dark figure against a light background, as in the serene *Lace Maker* (Paris, Louvre) [195], or a light figure against a dark one, as in the *Head of a Girl* (The Hague, Mauritshuis) [196], in the small paintings done during his maturity, the harmony is the same, and the light is of equal beauty and mildness. His shadows remain transparent by reflected light and allow the most wonderful modelling. Form and texture, colour and *valeur*, design and spaciousness are in perfect balance. Thoré-Bürger called the *Head of a Girl* at The Hague 'La Gioconda du Nord'. She does have a mysterious charm, an almost Leonardesque softness and tenderness, and so does the mild harmony of

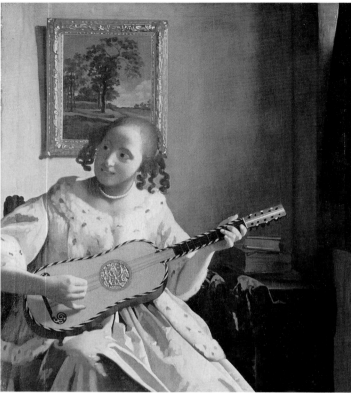

197. Johannes Vermeer: *Woman playing a Guitar*, *c*.1672. London, Kenwood House, Iveagh Bequest

198. Johannes Vermeer: *Allegory of Faith*, *c*.1671–4. New York, Metropolitan Museum of Art

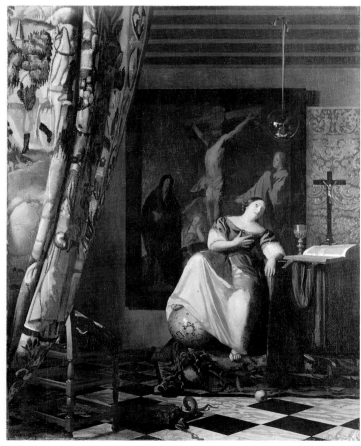

the colours. The Dutch painter and critic Jan Veth expressed well the peculiar quality of the light and the mother-of-pearl tonality, when he said that the substance of the paint seems as if it is made of crushed pearls melted together.

In the few pictures datable to the last years of his life there is evidence of a weakening of Vermeer's creative power. Although many of his old qualities remain, particularly his brilliance as a colourist and luminarist, a hard, procelain-like finish enters his work and the expressions on the faces of his figures becomes forced. In the *Woman playing a Guitar* at Kenwood House [197] he experimented with cropping a figure in a precariously balanced composition; the experiment was not a complete success. Another late picture is the *Allegory of Faith* (New York, Metropolitan Museum) [198]. The scheme he employed for it is strikingly similar to his earlier allegory of the *Art of Painting* [194], but here the final effect is discordant. His personification of Faith looks out of place in the fashionable seventeeth-century interior as do the accompanying symbols introduced to add specific meaning to the allegory: the serpent spitting blood, crushed under a stone, alludes to heresy; the nearby apple symbolizes the cause of sin; the meticulously painted globe of the world upon which Faith rests her foot needs no exegesis (it is identical to the one seen on a cabinet in *The Geographer* [175]) – the list of other objects and their significance can be extended. The painting's iconographical programme is mainly derived from recipes Cesare Ripa provides in his popular *Iconologia* for depictions of Faith and the Catholic Faith. Among Vermeer's own contributions to the programme is the large painting on the back wall of Jordaens's *Crucifixion*; it is probably identical with the 'large painting representing Christ on the Cross' that was in his widow's possession in 1676.

The exceptional character of the *Allegory of Faith* suggests it was commissioned by a pious Catholic patron who specified its iconography. Today, few would argue the painting adds much to Vermeer's stature. However, it is helpful to recall that not long after the artist's death in 1675 there were still Dutchmen who believed it ranked with his finest works. When it was sold in Amsterdam in 1699 it fetched 400 guilders, twice the amount paid for the most expensive picture at the famous auction of twenty-one of Vermeer's paintings in the same city in 1696.

Pieter de Hooch

Pieter de Hooch (or de Hoogh) was almost Vermeer's exact contemporary. He was born in Rotterdam only three years earlier, that is, in 1629. His art is more uneven than Vermeer's. He created masterworks from about the late 1650s, when it seems he anticipated certain elements of Vermeer's mature period, until the late 1660s. During the best years of his activity he shows a distinct character of his own and it was perhaps due to contact with the art of Carel Fabritius and Nicolaes Maes, who began to paint domestic scenes in illusionistic interiors in Dordrecht in about 1655 (see p. 114), that his genius flared up so suddenly. Later, about a decade after he moved from Delft to Amsterdam in 1660–1, he lost much of his inspiration and charm. A review of his late works is disappointing. Except for a visit to Delft in 1663, he

seems to have remained in Amsterdam for the rest of his life. He died in the city's insane asylum (*Dolhuis*) in 1684. The date and circumstances that led to his commitment to the institution are unknown.

The earliest dates on his pictures are 1658. By this time he was in his middle and best phase, painting masterpieces such as *A Maid with a Child in a Delft Courtyard* in London [202]. Unlike the case of Vermeer, a rather large group of pictures can be assigned to an early period. These youthful works [199] are mostly barrack-room scenes in a chiaroscuro style reminiscent of the low-life episodes represented by the Amsterdam painters of soldiers and women such as Codde and Duyster. They also are related to soldier paintings by the Rotterdammer Ludolf de Jongh (1616–79) whose pictures have occasionally been wrongly attributed to young de Hooch. None show signs of the influence of the Haarlem landscapist Nicolaes Berchem, who, Houbraken says, was his teacher. A strong chiaroscuro prevails during this first phase, the technique is liquid, and here and there it rises to an impasto touch. The marked preoccupation with space construction which stamps his more characteristic works is not yet evident. This early period extends from around 1650 until about 1657. In 1653 de Hooch is mentioned as a painter and as the servant of a merchant who lived in Delft and Leiden. In 1655 his employer owned eleven of his paintings, and in the same year de Hooch entered the guild at Delft. His classic middle period begins about 1657–8. He now paints well-to-do burghers and their servants in a brighter and more colourful manner.

A juxtaposition of de Hooch's *Card Players* (1658, Collection of H.M. Queen Elizabeth II) [200] and Vermeer's

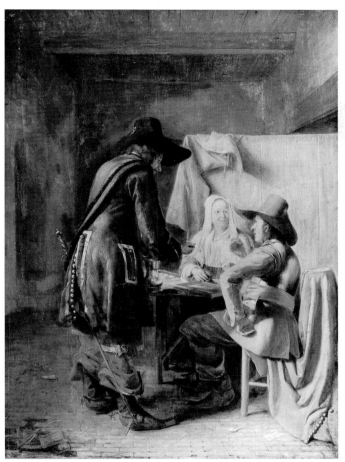

199. Pieter de Hooch: *Backgammon Players*, c.1652–5. Dublin, National Gallery of Ireland

200. Pieter de Hooch: *The Card Players*, 1658. Collection H.M. Queen Elizabeth II

201. Johannes Vermeer: *A Woman drinking with a Man*, c.1660 Berlin, Staatliche Museen

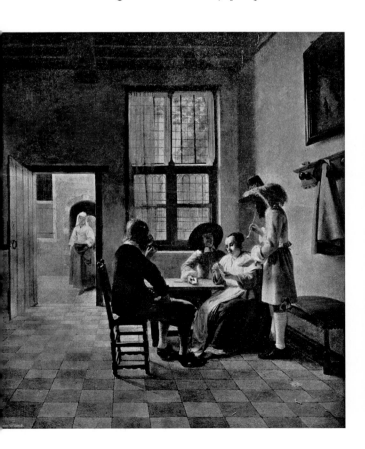

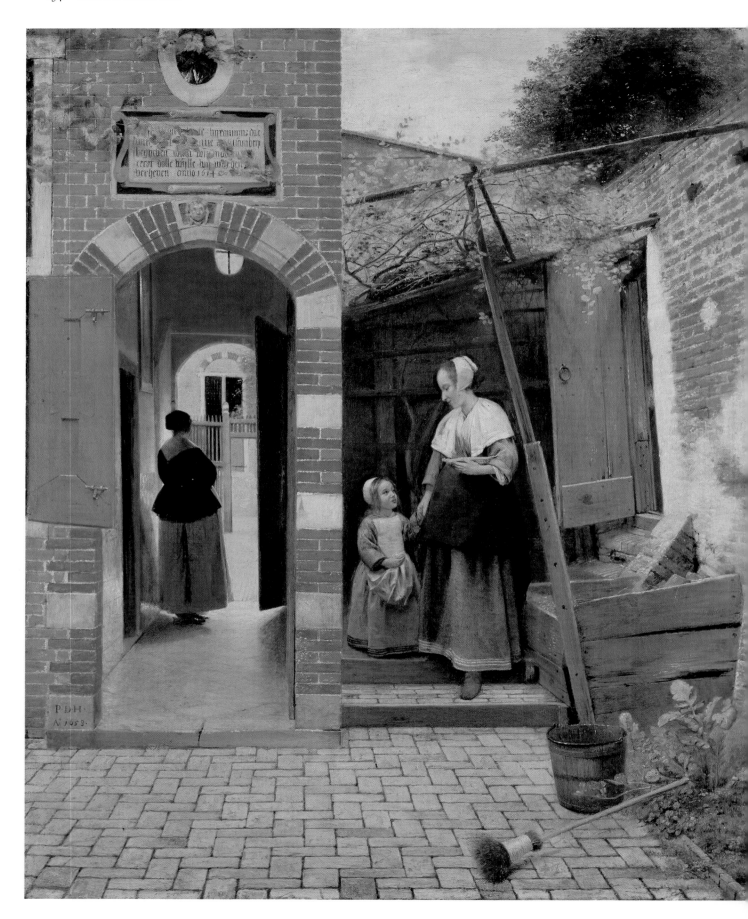

Woman drinking with a Man (Berlin, Staatliche Museen) [201], datable only a few years later, and which may have been inspired by de Hooch's interiors of the late fifties, helps to clarify the differences between the two masters when they were at high points of their careers. Three factors stand out in de Hooch's art during his Delft period. One is an elaborate space construction with emphasis on rectangular forms which often frame figural motifs, heightening the expression of their movement – or lack of movement. Frequently a door is left open to allow a look into the next room or a courtyard. The rather rigid space construction seems necessary for the support of the figures, which show little body and articulation compared with Vermeer. The second characteristic is de Hooch's light, which, like Vermeer's, is also daylight, but warmer, more sunny and intense, leading to deeper contrasts with the shadows. De Hooch makes ample use of these contrasts for the pictorial animation of his compositions. He does not shrink from deep black shadows in fully sunlit interiors, nor from strong chiaroscuro effects in the open air. As a rule, Vermeer has one constant light source – usually from the left; de Hooch employs several, and they are not always followed up with equal consistency. Reflections interfere and make the play of light more vivid and emotionally richer. Finally, in accordance with his warmer and more glowing sunlight atmosphere, de Hooch's colours too are warmer, deeper, and often of an extraordinary brilliance and intensity. Deep reds prevail, with contrasting blacks, blues, greys, and yellows. His colour scale is richer than Vermeer's, and he places an emphasis on all hues of the colour circle. Vermeer, however, is more consistent in the handling of colour intensities and *valeurs*, with full consideration of their modification by light, shadow, and aerial perspective. Vermeer's emotional and pictorial restraint is a sign of power and mastery. It indicates a supreme taste as well as intellectual superiority. Pieter de Hooch, on the other hand, can move us by the emotional effect and beauty of his light and colour, by a tender feeling which his figures radiate.

Perhaps de Hooch learned his perspective from Carel Fabritius, who was highly praised by his contemporaries for his 'perspectives', and for illusionism which depends upon knowledge of perspective for its effect. In any event, de Hooch appears to have mastered the representation of figures in elaborate space constructions, while Vermeer was still primarily concerned with vigorous figure painting. Vermeer probably welcomed what he could learn from de Hooch when he began to try to bring figures and space into a clearer and more proper arrangement. We have already seen how quickly Vermeer mastered this problem and developed it in his own way.

The glory of de Hooch's genre painting is largely found in his enchanting representations of homely scenes in which a mother or maid and a child appear in an interior or a courtyard in some domestic occupation [202]. These works, which express Dutch ideals of caring for children and the home, strike a tender note, free from sentimentality. They help us understand why his reputation is unshakable. Children play an important role in his pictures; it will be recalled, to our knowledge, Vermeer, the father of fifteen, never painted a child. In *The Pantry* (*c.*1658, Amsterdam, Rijksmuseum) [203], the prevailing colour accord in the

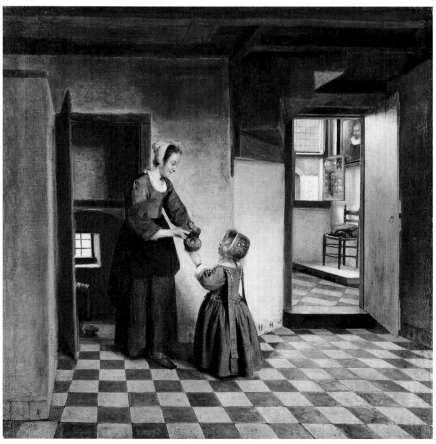

202. Pieter de Hooch: *A Maid with a Child in a Courtyard of Delft*, 1658. London, National Gallery

203. Pieter de Hooch: *The Pantry*, *c.*1658. Amsterdam, Rijksmuseum

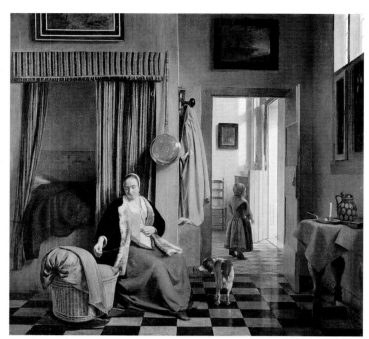

204. Pieter de Hooch: *A Mother lacing her Bodice beside a Cradle*, c.1661–3. Berlin, Staatliche Museen

figures is an orange-brown and bluish grey, whereas the same colours reappear in the rear room slightly faded, because they are in an intensified light. It is as if the painter traced the origin of the sunshine back to the source, or at least to the spot where it has its highest intensity. Every corner of the picture lives pictorially and is sensitively related to the whole. The *Mother lacing her Bodice beside a Cradle* [204], painted a few years later in Amsterdam, shows some influence of the Rembrandt school, in the warmth and depth of the colouring, in the golden tonality, in the broad treatment of the figures, and in the impasto passage on the white fur. The intense reddish-orange of the woman's bodice, of the skirt hanging on the wall, and of the cradle cover are contrasted with the blue and grey in her coat, the bed curtain, the floor tiles, and the jug on the right.

De Hooch's use of the *doorkijkje*, the device also employed by Nicolaes Maes of opening the vista from one room to another, or from a courtyard into a house, and then again from there into the street is not a mere play with perspective; in his paintings it adds a pictorial and psychological note of some significance. De Hooch sensed that in daily life one often experiences a pleasant relief when a relationship between indoor and outdoor space is established by the widened outlook and by the enrichment of light and atmosphere which it brings. In his refinement of the *doorkijkje* device, as well as in other respects, de Hooch shows his own character. We also see in his work that the domestic culture of the Dutch burghers was not confined to their small houses, but extended to their trim gardens and their neat courtyards. De Hooch represents with equal success out-of-door scenes in which the light has often the same warm quality and the colours shows the same deep glow as in his interiors.

Soon after his move to Amsterdam his works gain a little more in power and body, and his colour and chiaroscuro

increase in warmth. This is seen in the full character of the figures in the *Woman peeling Apples, with a Child* (c.1663, London, Wallace Collection) [205] with its concentration on the motif close to the spectator without side views. The painting recalls Vermeer's paintings of one or two figures in a lighted corner of a room (Thoré-Bürger wrongly attributed the picture to Vermeer in his 1866 study of de Hooch's contemporary), and its theme of a woman watched by a child as she works at a simple kitchen task is related to Maes's depictions of household activities. Yet de Hooch's painting is unmistakably his own; his ability to suggest the intensity and flow of light is undiminished, and the relationship between the woman and child absorbed in their simple activities retains human charm and naturalness. In his *Two Women beside a Linen Chest* (1663, Amsterdam, Rijksmuseum) [206] he succeeds in giving the routine work of a wealthy matron a poetical charm through his warm-hearted approach and his fine sense of composition and pictorial beauty. Here we are offered an aspect of the celebrated virtue of the Dutch housewife: fulfilment of her duty as efficient manager of her household with a passion for a neat and proper arrangement of material possessions. The interior is much richer than those depicted in pictures of his Delft period – an equally rich one served as the setting for his *Family Portrait Group making Music* (Cleveland, Cleveland Museum of Art) painted in the same year. An idea of what may have been stored in the expensive, highly polished oak and ebony linen chest in the Amsterdam painting is offered by an inventory compiled of the contents of a linen chest that belonged to a wealthy Dordrecht woman: sheets arranged according to their place

205. Pieter de Hooch: *Woman peeling Apples, with a Child*, c.1663. London, Wallace Collection

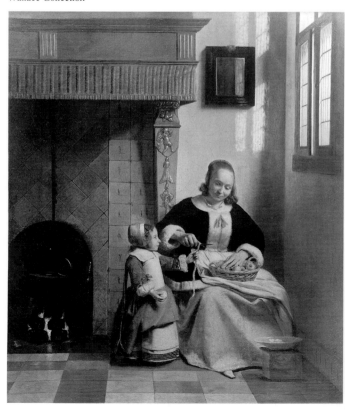

206. Pieter de Hooch: *Two Women beside a Linen Chest*, 1663. Amsterdam, Rijksmuseum

with it one sees that he introduces a brilliant conceit. His action implies there is a wall behind the onlooker, accommodating him or her to the pictorial space. Moreover, he is doing what the viewer is doing; he is looking at a picture. His concentration on Flinck's invisible Dentatus calls attention to the didactic content of that painting as well as Bol's partially visible picture of Fabritius above the mantel; as we have noted, both were intended to serve as models of conduct for the burgomasters who conducted their business in the chamber.[18]

De Hooch also used the marble galleries on the ground floor of the recently built town hall as a setting for the *Musical Party* at Leipzig (c.1665–70; Museum der bildenden Kunst). It will be recalled that the lunettes of the galleries are decorated with episodes of the revolt of the Batavians, and for a brief period Rembrandt's *Claudius Civilis* was mounted in one of them. But instead of showing one of the actual paintings that are in the galleries, de Hooch made an astonishing substitution in the Leipzig *Musical Party* by depicting Raphael's fresco of the *School of Athens* in the Stanza della Segnatura at the Vatican in the lunette he painted. His introduction of Raphael's famous painting is yet another indication of the growing interest in High Renaissance Italian art.

In the seventies, when the effects of dusk are favoured, de Hooch's style definitely changes and his art loses much of its previous attraction. Once in a while the former beauty of his interiors seems to revive, particularly in dark pictures that are illuminated by a shaft of sunlight, but if we look closely,

207. Pieter de Hooch: *Interior of the Burgomasters' Council Chamber in the Amsterdam Town Hall*, c.1665–70. Madrid, Thyssen-Bornemisza Foundation

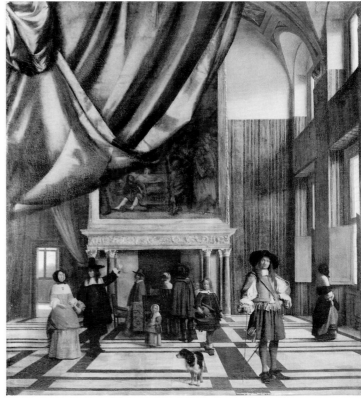

of origin (Haarlem, Amsterdam, Alkmaar, Friesland, Emden, Flanders, and the East Indies); bonnets; handkerchiefs; neckerchiefs dating back to her grandmother's childhood; and no less than twenty-four dozen shirts, forty dozen tablecloths and napkins set aside for her children's doweries.[17]

Exceptional in de Hooch's œuvre is *The Interior of the Burgomasters' Council Chamber in the Amsterdam Town Hall* (c.1665–70, Madrid, Thyssen-Bornemisza Foundation) [207] with visitors admiring the spectacle of a lofty interior of the monumental new building. The height and breadth of the space is unmatched in his work and probably reflects the influence of the majestic church interiors painted by the eminent architectural painter Emanuel de Witte who had settled in Amsterdam by the early fifties. It is known that de Hooch was familiar with at least one of de Witte's paintings (and probably three others) through his testimony given in 1670 that he saw the artist's *Adriana van Huesden at the New Fishmarket in Amsterdam* [368] in the home of the man who had indentured de Witte; from his testimony we can deduce he saw Adriana van Huesden's portrait before 1663. De Hooch's painting does not offer a completely faithful portrait of the grand council chamber: he changed the pattern of the tiled floor; the doorway on the left exists but it leads to a windowless room; he took the liberty of providing it with one of his favoured lighted *doorkijkjes*. On the other hand, the elaborate fireplace and the large painting above it, partially hidden by a huge curtain, are still *in situ*. The painting is Ferdinand Bol's *Gaius Lucinus Fabritius in the Camp of King Pyrrus* [134]. The attentive gentleman on the right can only be looking at the equally large painting on the oposite wall of the chamber, also still *in situ*: Govert Flinck's *Marcus Curius Dentatus refusing the Gifts of the Samnite Ambassadors* [133]. The effectiveness of his presence depends upon the spectator's knowledge of the burgomasters' council chamber, but armed

the even, drier touch lacks finer gradations. The pictorial animation has definitely weakened. There is a change in content too. Domestic scenes of the life of women and children are still depicted, but they are now often set in somewhat pompous interiors with many decorative elements; gilt leather coverings and heavy silk curtains replace white-washed walls. Not fully successful attempts to absorb aspects of French taste, which began to invade Holland before the French army actually arrived in 1672, also are evident. Musical parties in richly appointed rooms are frequent. Stiff ladies are now dressed in silk and velvet, and deficiencies in drawing and construction become more apparent because the colour has lost its warmth and glow. The palette has darkened, the light is often cold and without vibration. It has been suggested that de Hooch's decline was part of the general downward trend of Dutch art at the end of the century, but some personal problems – perhaps the malady that led to his commitment to Amsterdam's insane asylum – may have been responsible for it. In any case, if we think of Pieter de Hooch as one of the loveliest Dutch masters, we have in mind the glorious paintings from his Delft and first Amsterdam years, which live on in our memory, while his late works are forgotten soon after we turn away from them.

Although de Hooch had no recorded pupils he influenced and was often imitated by other painters in Delft and Amsterdam, and since his own original works decline in his later period, his followers come at times pretty close to him, and now and then it is difficult to distinguish hands. Those whose works have been confused with his include Hendrick van der Burch (1627–after 1666), Pieter Janssens Elinga (1623–before 1682), Jacobus Vrel (active 1654–62), Ludolf de Jongh (1616–79), Esaias Boursse (1631–72), and versatile Cornelis de Man (1621–1706), but now the artistic personalities and special charms of these minor artists are more or less clear. We shall see that other painters who made views of interiors and street scenes can be associated in one way or another with the school of Delft by borrowing motifs and making variations on the compositional devices and pictorial refinement of its masters.

GERARD TER BORCH, GABRIEL METSU,
AND OTHER PAINTERS OF DOMESTIC AND
HIGH-LIFE SCENES

There are, apart from Vermeer and Pieter de Hooch, outside the school of Delft, several distinguished genre painters of domestic life. Who were the great ones among them? The evaluation of the Dutch masters has changed considerably since the middle of the nineteenth century when the intense, general revival of interest in the painting of the period began. Thoré-Bürger, the rediscoverer of Vermeer, suggested that after Rembrandt the outstanding painter was Gerard ter Borch. Fromentin, in his famous *Les Maîtres d'autrefois* of 1876, claims that the greatest figure of the Dutch school after Rembrandt was not a genre painter but Jacob van Ruisdael. Around 1900 the sensitive Dutch critic and artist, Jan Veth, wanted to raise Aelbert Cuyp to rank with the highest. Others singled out Frans Hals, and there were also some who gave preference to Vermeer and Pieter de Hooch. Bode, in his *Rembrandt und seine Zeitgenossen* published in

1906, finds that all these critics are right, that each master of the Dutch school is, in his own way, so perfect that it is a matter of individual taste whether precedence is given to one or the other – Rembrandt alone is excepted. Since these critics presented their estimations we have, perhaps, learned to make sharper distinctions about greatness in art, not uninfluenced by the new points of view offered by succeeding generations of modern painters. We raise Vermeer above the other genre painters, yet in landscape the high level of Jacob van Ruisdael and Aelbert Cuyp remains uncontested.

Gerard ter Borch (1617–81) was born at Zwolle, in the eastern province of Overijssel, and lived for most of his life at Deventer, also in Overijssel. Deventer never became the centre of a school of painting. Ter Borch travelled extensively in Europe, and his knowledge of the world is sensed in the delicate psychology and noble restraint of his art – qualities that add an attractive note to his domestic genre scenes and portraits. His exquisite taste is seen in the picture which is best known by its popular title *The Parental Admonition* (Berlin, Staatliche Museen) [208]; another version is at the Rijksmuseum, Amsterdam. The first reference to this title is found on an eighteenth-century engraving of the work made by J.G. Wille, and it was used by no less a person than Goethe in a charming passage in *Die Wahlverwandtschaften* in which he notes the delicacy of attitude of the figures. He remarks how the father quietly and moderately admonishes his daughter, who is seen from behind. The woman in black, sipping from a glass, Goethe interprets as the young woman's mother, who lowers her eyes so as not to be too attentive to the 'father's admonition'. This moralizing title, however, is without foundation and not in accordance with ter Borch's usual themes. The authoratative biographer of the artist interprets the picture in the opposite sense, as a brothel scene, assuming that the seated gentleman holds a coin in his right hand, offering it to the girl.[19] In fact, the detail of the coin is not visible. The passage is rubbed; a former owner may have had it painted over because he or she found it an embarrassing allusion. The Amsterdam version does not show the coin either, but its original paint surface is generally abraded; thus, it is impossible to tell if it ever included the tell-tale coin. Ter Borch's psychology is so delicate that the common scenes he repeatedly painted are raised to the level of highly civilized life. That Goethe's interpretation was possible at all shows the refinement of ter Borch's treatment. Even if he made a mistake, Goethe had the right feeling for the way ter Borch treated his subjects. Psychologically and pictorially he retains a sensitive touch and delicacy. The young woman is seen from behind; thus her face is averted. The only flesh visible is her neck, which is modelled with tender, silvery grey shadows. We have, however, opportunity to admire the silver-grey satin and black velvet of her gown. When even the mature Vermeer is compared with ter Borch, he is found less sophisticated and more direct in his psychology. Vermeer is also broader in his touch and more powerful in the integration of the two- and three-dimensional aspects of his design. Ter Borch's minuteness and nicety of handling concentrate largely on painting stuffs. The dim light and the subdued chiaroscuro do not allow a forceful grasp of the whole field of vision. The light comes mostly from the front and stops at the

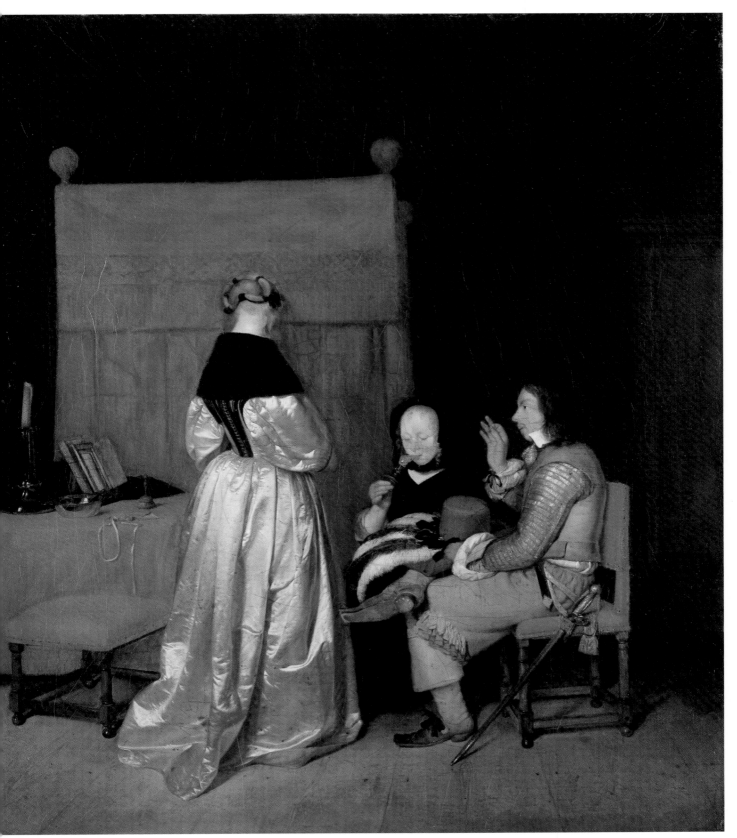

208. Gerard ter Borch: '*The Parental Admonition*', *c.*1654–5. Berlin, Staatliche Museen

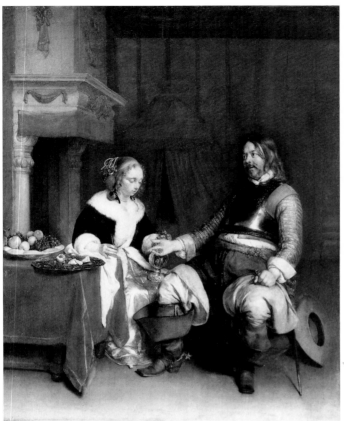

209. Gerard ter Borch: *Man offering a Woman Coins ('The Gallant Officer')*, c.1662–3. Paris, Louvre

of sites of Rome and its environs in the style of Paulus Bril and Willem Nieulandt II. He continued to practise professionally until the early 1620s when he took a civil service post as a tax receiver in his native Zwolle. He continued to sketch now and then and his love for art also found expression in collecting and teaching drawing to five of his children. More is known by far about the artistic activities of this talented family than any other of the century because the bulk of its studio estate comprising more than 1,000 works has survived; it is now in the Rijksmuseum.[20] The unique cache includes Gerard the Younger's juvenilia. The earliest sheet in this group, made when the boy was seven years old (it is inscribed and dated 1627 by the proud father of the prodigy), represents the rear view of a man on horseback; rear views of figures became one of his *leitmotifs*. Other drawings allow us to follow the boy's progress year by year until he is a teenager. Ter Borch the Elder also inscribed and saved drawings by his youngest son Moses ter Borch (1645–67), a child of his third marriage. Moses also was precocious and had he lived longer (he was killed at sea during the final battle of the Second Anglo-Dutch War) there is little doubt he would have rivalled the achievement of his famous half-brother. Virtually all of his existing *œuvre* is in the precious family estate at the Rijksmuseum. Most notable are his figure and portrait drawings. Their remarkable quality is seen in his black and white chalk drawing on blue paper of his father [210]; the latter's inscription and date on the sheet tells us it was drawn '*nae het leven*' in 1660,

210. Moses ter Borch: *Portrait of Gerard ter Borch the Elder*, 1660. Drawing: black chalk, heightened with white chalk, brush, on blue paper. Amsterdam, Rijksmuseum, Rijksprentenkabinet

glossy surfaces of the costumes and other textures. In ter Borch's dim backgrounds the tones become dull and the surfaces flat. There is something of the refinement of the fifteenth-century Netherlandish painters in the intimacy of his details and the subtle minuteness of handling, but this is achieved at the expense of the broader design relationships. Vermeer has his eye much more upon the whole picture, on the organization of tone and colour and their interaction, for the sake of a clear spatial effect and balanced composition.

Ter Borch continues to show his superiority in psychological subtlety even when his subject is an obvious one. In his mercenary love scene (euphemistically known as *The Gallant Officer*) at the Louvre [209], a soldier offers pieces of money to a young lady who is charming in type and dress. Her reaction is not surprise. Again the stuff painting is particularly excellent, as is the rendering of the facial expressions and the fine draughtsmanship and subtle lighting of the hands; also the still life on the table. The apparent casualness is the result of careful thought and execution. The appearance of the tip of the woman's shoe peeking out from under the edge of her satin dress at the tremendous toe of the soldier's wonderful hip boot is as calculated as the colour harmony of opulent browns, reds, buff, white, and silver.

Ter Borch began his training under his father Gerard ter Borch the Elder (1582/3–1662), who started his own career as an artist. The latter was in Italy from about 1604–5 to 1610–11. He is best remembered for drawings done during his Italian sojourn: minutely executed topographical sketches

211. Gerard ter Borch: *Soldiers in a Guard Room*, c.1638–40. London, Victoria and Albert Museum

when Moses was fifteen years old. A third member of the family worthy of mention is Moses's sister Gesina ter Borch (1631–90), a gifted artist and calligrapher. After her father's death she became the self-appointed curator of the family collection. Among the works she preserved are her own fascinating illustrated poetry and calligraphy albums. She also makes frequent appearances as a model in her famous brother's genre pieces.

By 1634 Gerard the Younger was in Haarlem apprenticed to the landscapist and occasional genre painter Pieter de Molyn, and in the following year he joined the city's St Luke Guild. His first paintings indicate that he began his career as a painter of barrack-room scenes, as did de Hooch. *Soldiers in a Guard Room* (c.1638–40, London, Victoria and Albert Museum) [211] equals his prototypes in this branch of painting in its fine gradations of greys, yellows, and blues, and in sensitive *valeur* painting, in which ter Borch excels from the beginning. Ter Borch's stay in Haarlem was brief. By 1635–6 he was in London, where he worked with his step-uncle Robert van Voerst, a printmaker who made engravings for Van Dyck's *Iconography*. Through him he acquired familarity with the *dernier cri* in English court por-traiture; however, he never adopted the swagger introduced to it by Van Dyck. During the forties he began to make extraordinary small and miniature portraits. One of the most touching is his tiny portrait of *Helena van der Schalcke as a Child* (Amsterdam, Rijksmuseum) [212], which holds its own when hung next to the pictures Hals and Rembrandt made of children. Sometimes ter Borch's small portraits recall the psychological penetration Velázquez achieved in his life-size works, a parallel that gains support from reports that he was in Spain around 1640, and that he even was commissioned to paint a portrait of Philip IV. A trip to Italy probably preceded his reputed journey to the Iberian peninsula; it is visually documented by an unusual painting of a *Nighttime Procession in Rome of Flagellants* (Rotterdam, Boymans-van Beuningen Museum). It also is likely that he visited France, and the southern Netherlands more than once.

During the forties he remained mobile. In 1645 he was in Münster where he joined the entourage of Adriaen Pauw, the powerful Amsterdam burgomaster who was a leading representative to the negotiations with Spain that led to the peace treaty that ended the Eighty Years' War and gave the Netherlands its independence. He painted the arrival of Pauw at Münster with his family in a fine carriage drawn by six horses, accompanied by his retinue, in a landscape by the hand of an unidentified artist (c.1646, Münster, Westfälisches Museum, on loan from the City of Münster). While and after the negotiations were in progress he painted many small portraits of Dutch and Spanish representatives, and for a time he was a member of the household of the principal Spanish envoy, the Condé de Peñeranda; his incisive minia-ture oval portrait of the Condé is now at the Boymans-van Beuningen Museum.

His most famous picture of this phase is his record of the consummation of the negotiations between the Netherlands and Spain, *The Swearing of the Oath of Ratification of the Treaty of Münster*, dated 1648, at the National Gallery, London [213]. The small painting (45.4 × 58.5 cm), which includes over seventy plenipotentiaries and their retainers as well as the artist's self-portrait, reproduces the historic event with extraordinary accuracy; he only took a few liberties with the arrangement of the figures at the ceremony. It is one of the rare pictures made of a contemporary historical event in seventeenth-century Dutch painting. As we noted in our discussion of Rembrandt's *Claudius Civilis*, Dutch artists

212. Gerard ter Borch: *Helena van der Schalcke as a Child*, c.1644. Amsterdam, Rijksmuseum

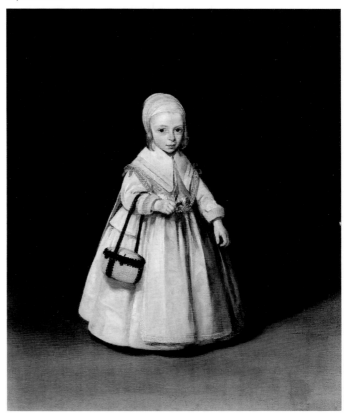

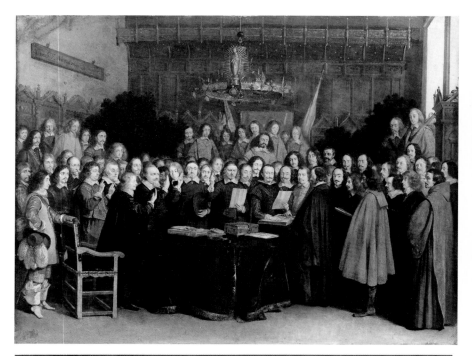

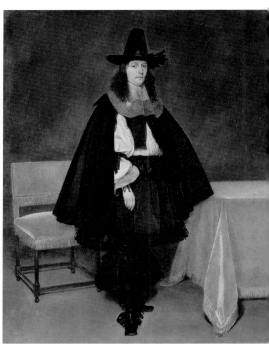

213. Gerard ter Borch: *The Swearing of the Oath of Ratification of the Treaty of Münster*, 1648. London, National Gallery

214. Gerard ter Borch: *Portrait of a Man*, c.1663–4. London, National Gallery

215. Gerard ter Borch: *Boy delousing a Dog*, c.1655. Munich, Alte Pinakothek

216. Gerard ter Borch: *The Music Lesson*, c.1675. Cincinnati Art Museum

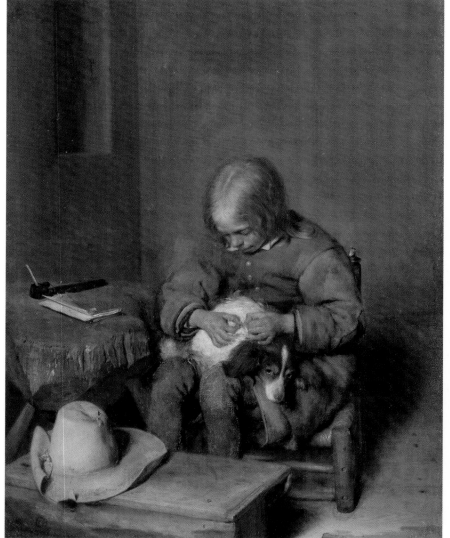

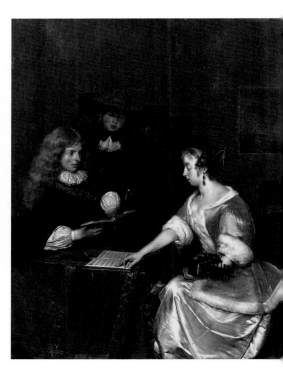

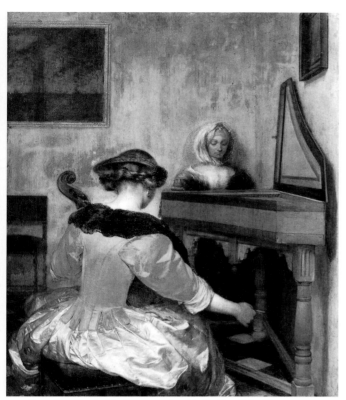

217. Gerard ter Borch: *The Concert*, *c.*1675. Berlin, Staatliche Museen

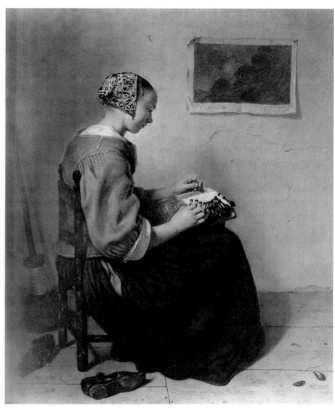

218. Casper Netscher: *The Lace Maker*, 1664. London, Wallace Collection

were usually asked to represent parallel scenes from Scripture, classical antiquity, or from their own early national history, not actual contemporary events. Ter Borch was apparently unable to sell his painting of one of the most important episodes in the history of the Dutch people. The picture was in the collection of a Deventer relative in 1672–4, and remained in the hands of the family for about a century. Perhaps ter Borch was unable to sell it because of the price he asked for the work. Houbraken reports that he demanded 6,000 guilders for it (about 4,500 guilders more than Rembrandt received for the *Night Watch*) and, because he was offered less, he kept it.

Ter Borch continued to be peripetetic until his marriage in 1654 when he finally settled in the Netherlands and made Deventer his home. He continued to paint miniature-like portraits of great reserve and decorum, specializing in small full-lengths in interiors which are always painted in a subdued tonality. Their restrained nobility, even when his clients appear overdressed in their finery [214], distinguishes them from those made by his contemporaries. None of his late portraits show any sign that he attempted to satisfy the taste for likenesses done in a light, classicizing manner that became ever more popular during his last decades.

His great fame, however, rests mainly upon the genre pictures he made after the middle of the century which help define the subjects and pictorial schemes used by many artists of his generation and those who worked later. What sets him apart is his mastery of subtle narration which can charge every episode with subdued tension. Few genre painters ever revealed more delicately the character of three individuals and their relation to each other as they ostensibly

go about their business of making music in a drawing-room (*The Music Lesson*, Cincinnati Art Museum) [216]. His rendering of simple themes, such as a boy who has put aside his school work to concentrate upon delousing a patient dog [215], shows the same knowledge of people as his more ambitious pieces. In contrast to Pieter de Hooch, ter Borch maintains his fine taste and craftsmanship in his genre pieces until the very end. His contact with Vermeer in Delft in 1653 may have had an impact on the younger master. Then there conceivably was a shift; some of ter Borch's late works seem to show a sign of Vermeer's influence. The fullness and clarity of the foreground figure playing the cello in *The Concert* at Berlin [217] and the bright illumination of the room recall the Delft master; but it is also possible that the two artists arrived at similar solutions independently. In any event, in the ter Borch, the exquisite and minute treatment of materials, textures, and stuffs with the most intricate light accents is completely personal. The spatial relationships are not grasped with Vermeer's sureness, and the composition lacks the Delft painter's masterly consideration of the surface plane and the adjustment of the spatial accents to the overall design. It will be noted that the figure playing the harpischord has no ter Borch character. Originally this figure represented a man. Ter Borch subsequently transformed the man into a woman, and a whimsical restorer, who worked on the picture at the end of the nineteenth century because of its bad state of presentation, changed the woman's gown and gave the model his wife's features.[21]

Ter Borch's influence is unmistakable upon a number of leading genre painters (Metsu, Frans van Mieris the Elder, Ochtervelt, Eglon van der Neer) but he never attracted

a flock of students. The most important one was Caspar Netscher (1635/6[?]–84). Netscher, who studied with him at Deventer and quickly learned his technique of rendering the texture of costly materials, made clever copies of his teacher's works; his signed copy, dated 1655, of ter Borch's so-called *Parental Admonition* is at Gotha. Netscher continued to make small genre scenes during the sixties. *The Lace Maker* (1664, London, Wallace Collection) [218] shows what heights he could reach. It also suggests that he was affected by the school of Delft. Did Whistler have it in mind when he painted *Arrangement in Grey and Black* (c.1872, Paris, Louvre) known today by almost every schoolchild as 'Whistler's Mother'? Netscher settled at The Hague in 1662, where he was soon in demand in court circles as a portraitist. By 1670 he had virtually abandoned genre painting and specialized in making small-scale half-length portraits of the aristocracy and patricians, with special care given to the elegant clothes worn by his patrons (see p. 261 and figs 356–7).

Gabriel Metsu (1629–67) was born at Leiden, and is said to have been a pupil of Gerrit Dou. He was active in Leiden during most of his brief career, but, like Pieter de Hooch and many others from provincial centres, he was finally attracted by the opportunities Amsterdam offered. He had settled in the city by 1657 and spent the rest of his life there. Metsu's artistic development is much more unpredictable than that of most of his contemporaries, and his chronology is difficult to establish. His early Leiden works, which include rather broadly brushed religious and allegorical pictures, as well as genre paintings, do not show signs of Dou's influence or the high finish and polished manner associated with the Leiden School. They have more in common with works by Jan Baptist Weenix (e.g. Metsu's *Allegory of Faith*, The Hague, Mauritshuis) or by Jan Steen and Nicolaus Knüpfer (e.g. his *Prodigal Son*, St Petersburg, Hermitage). It was only after Metsu had settled in Amsterdam that he adopted more of the Leiden *fijnschilder* technique and became a prolific painter of the well-to-do bourgeoisie. Though he often achieved a pictorial refinement which equals ter Borch's, he remains an uneven painter who was undecided in his colouristic taste. His technique is more liquid than ter Borch's and has a little more surface movement, but he seldom attains the delicacy and originality of ter Borch's psychological interpretations.

Metsu adopted the device of representing figures behind a window frame which Gerrit Dou popularized, but in Metsu's pictures, as is characteristic of this phase of Dutch art, the effect is broader and more classical. Dou shows his debt to Rembrandt's early chiaroscuro and colour even in his late pale paintings, and his touch remains minute. He also keeps a Baroque intricacy of design. Among Metsu's most delightful and unusual paintings is his spacious *Vegetable Market at Amsterdam* [220] which offers a full description of the vendor's wares and a view of houses flanking one of the city's canals. The man flirting with a pretty young woman is not an unexpected note, but the strident woman quarrelling with a vegetable seller is; boisterousness is unusual in his work.

Most of Metsu's paintings are domestic scenes. In some the influence of Vermeer and Pieter de Hooch can be

219. Gabriel Metsu: *The Sick Child*, c.1660. Amsterdam, Rijksmuseum

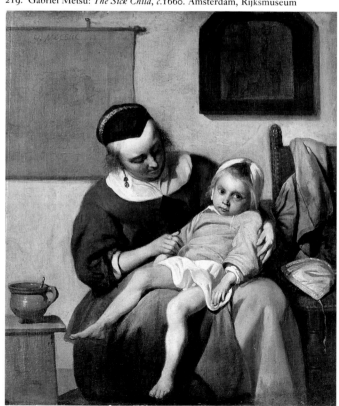

220. Gabriel Metsu: *Vegetable Market at Amsterdam*, c.1660–5. Paris, Louvre

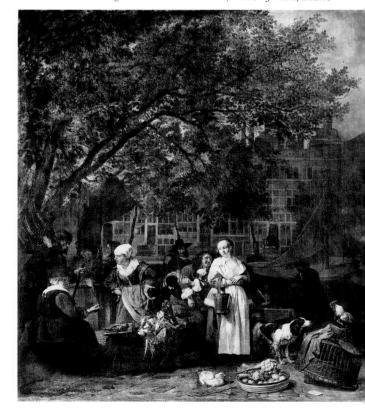

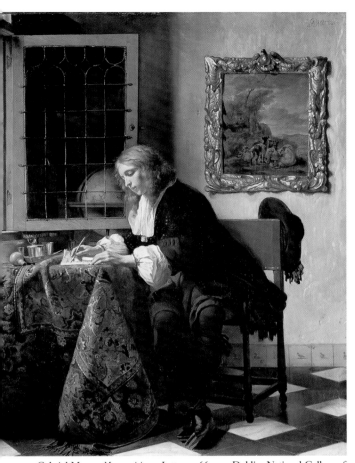

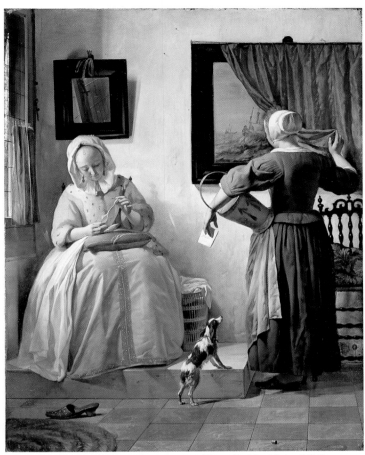

221. Gabriel Metsu: *Man writing a Letter*, c.1662–5. Dublin, National Gallery of Ireland

222. Gabriel Metsu: *Woman reading a Letter*, c.1662–5. Dublin, National Gallery of Ireland

detected. In his famous *Sick Child* (Amsterdam, Rijksmuseum) [219], which, because of its motif and general prettiness, is one of his most popular pictures, the fullness of the figures and the composition recall Vermeer, but the red and blue of the woman's clothes lack the sensitive adjustment of intensities to *valeurs* in the interest of clear spatial relationships. The suggestion that the child's pose in the sympathetic picture recalls schemes used for the Deposition and Pietà and that there is a link between it and the painting of the Crucifixion on the back wall seems far-fetched. In *The Lady at a Virginal* (Rotterdam, Boymans-van Beuningen Museum, on loan from the van der Vorm Foundation) the figure is close to Vermeer, and the interior with its vista through an open door and its rectangular accents recalls de Hooch. The lady is seated at the instrument, but not playing. She turns towards her lap-dog – a constant accessory in Metsu's interiors – and speaks to it. The motif, used to divert the onlooker, is not a very ingenious one. Vermeer had the courage to rely repeatedly upon the power of more simple motifs. But Metsu's picture shows virtues in costume painting, in the silvery-blue dress of the woman at the virginal, which rival those painted by his great models.

His indisputable masterpieces are *Man writing a Letter* and *Woman reading a Letter* [221, 222] which were painted as companion pieces. In both paintings, the way the silvery daylight flows over the figures set against light walls is not surpassed by Vermeer. The pendants offer a small drama:

the handsome man writes a letter, and its patient recipient attentively reads it by the light of a window. Here letter writing and reading are most likely associated with love. The discreet waiting maid pulls aside a curtain hanging from a rod to reveal a choppy seascape, possibly but not demonstrably a reference to the popular adage that love is as hazardous as a sea voyage. The maid's momentary movement contrasts with the concentration of the young woman who, one senses, will not move until she has finished reading the letter. The curtain over the painting is not an unusual detail. The Dutch often protected paintings with curtains, either to keep off the light and dust, or to look at them only occasionally, as is the traditional way of the Chinese and Japanese – a practice that comes from the fine feeling that a work of art cannot be looked at continually. *Trompe l'œil* curtains on rods painted to give the illusion that they have been drawn aside to reveal a framed picture are not uncommon either; best known is the one Rembrandt included in his intimate *Holy Family* at Kassel [89]. The *Man writing a Letter* offers a view of the love of comfort and beautiful materials in the home of a well-to-do burgher about 1660, and the heavily carved gilt Baroque frame around the landscape painting on the wall behind the handsome young man makes clear that not all seventeenth-century Dutch pictures were enclosed in rectilinear black ebony mouldings.

Metsu made a few small-scale group portraits of elegantly dressed families in carefully worked out interiors which are

decorative in their effect and full of nice details. In 1657, the
year he moved to Amsterdam, he portrayed *The Family of the
Amsterdam Burgomaster Dr Gilles Valckenier* (Berlin, Staatliche
Museen) in a richly appointed interior with genre-like
elements.[22] It is one of the Dutch small-scale, family group
portraits that anticipate 'conversation pieces', a branch
of portraiture that became popular during the eighteenth
century, particularly in Holland and England.

Quiringh van Brekelenkam (active *c.*1647–68) worked in
Leiden, where he was influenced by Dou's domestic subjects
and by Metsu's broad touch and intense colours. He is best
known for his paintings of men and women artisans working
at various crafts: cobblers, lace makers, spinners, fish
mongers, and so forth. Outstanding is his *Tailor's Shop* of
1653 at the Worcester Art Museum [223] where he finds
quiet poetry in a view of a humble interior with the master
and his two apprentices at work, seated tailor-fashion on
the table while an old woman prepares a meal. Thirteen
variations of the Worcester painting have been recorded
(fine ones are at Amsterdam, London, Philadelphia, and
Bonn), an indication that there must have been a good
market for the motif. Like so many genre painters of his
time, he turned to more elegant subjects in the sixties.

Far better known than Brekelenkam is Frans van Mieris
the Elder (1635–81), who after Dou is the principal rep-
resentative of the Leiden school of *fijnschilders*. Apparently
by the time he was born his parents stopped keeping track
of the number of children they produced; he is vaguely
mentioned as one of the last of twenty-three. Mieris studied
with Dou, and the latter acknowledged him as the 'crown
prince of his students'. The characterization is still valid.
Mieris fell heir to Dou's technique and compositions. Like
his teacher, he was extremely popular with the wealthy col-
lectors of his time. He received important commissions from

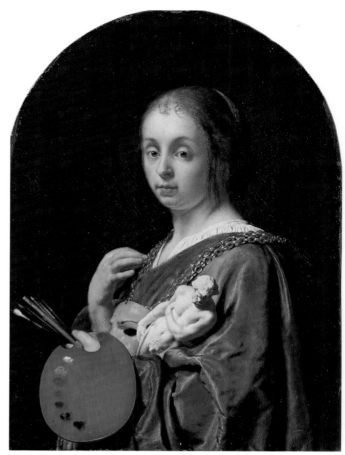

224. Frans van Mieris the Elder: *Pictura* (*An Allegory of Painting*), 1661, Los
Angeles, J. Paul Getty Museum

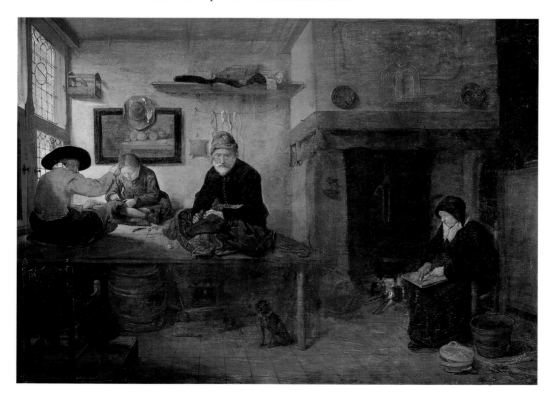

223. Quiringh van Brekelenkam:
Interior of a Tailor's Shop, 1653.
Worcester, Massachusetts,
Worcester Art Museum

Grand Duke Cosimo III de' Medici and Archduke Leopold Wilhelm. The latter invited him to work at his court in Vienna. He turned down the offer and, as far as we know, spent his life in his native town. A review of his *œuvre* brings to mind the work of many of his contemporaries, although he always manages to keep his own personality, particularly his impeccable, highly polished finish which had a lasting effect on later painters with a passion for 'fine painting'. Exemplary of his refined technique is *Pictura* of 1661, at the Getty Museum [224]. Done on copper, the tiny picture, reproduced here in its actual size, follows more or less the formula Cesare Ripa gives in his *Iconologia* for representing the art of painting: 'A beautiful woman . . . with a golden chain around her neck, on which hangs a face mask . . . [with] brushes in one hand, and in the other a palette, dressed in a lustrous garment . . .' Among the attributes Ripa prescribes for the allegorical representation of *Pictura* that Mieris thankfully omits are the inscription 'Imitatio' written on the woman's forehead and a bound cloth over her mouth. We have seen that a few years later Vermeer also turned to Ripa's *Iconologia* for his *Art of Painting* [194] and *Allegory of Faith* [198] and that he did not follow the iconographer's instructions to the letter either.

In addition to a few other allegories Mieris painted biblical, historical, literary subjects, and portraits. His principal contribution, however, is found in his genre scenes. His earliest dated picture is *The Doctor's Visit* at Vienna, of 1657 [225]; an autograph version bearing the same date is at Dublin. It already shows the polished technique characteristic of what Dou gave his pupils, but even at this relatively early stage Mieris preferred to work with less elaborate chiaroscuro effects than his master. As in so many of his subsequent pictures, the vivid colours have a jewel-like lustre and glow. Like *Pictura* it is painted on copper; however, here Mieris gave the copper support a gold ground which contributes to the glittering effect. The view through a doorway into another room suggests he was familiar with the interior genre scenes painted by Maes in Dordrecht a few years earlier. *The Doctor's Visit* employs a subject that began to gain popularity after the middle of the century: a sick woman, visited by a doctor, usually dressed in an archaic costume reminiscent of those worn by actors, suggesting he is a quack. The clue to the woman's distress is offered by the doctor's action. In these pictures the doctor is shown either taking the woman's pulse count or examining a phial of urine, contemporary procedures endorsed by some physicians and ridiculed by others, to determine if the woman is suffering from love sickness, a euphemism for pregnancy. Another test for love sickness depicted by Mieris and others was unadulterated hokum: a blue ribbon taken from the sick woman's apparel was burned; on the basis of its odour the quack pronounced on the woman's condition. Alternatively, the burned blue ribbon was given to the patient to smell; if this procedure worsened her condition it was proclaimed she is an expectant mother.

A high point among the series of outstanding works Mieris produced during the late fifties and early sixties is *The Duet* of 1658 at Schwerin [226]. Its *doorkijkje* into another room again shows familiarity with Maes; the light filled room recalls paintings done in Delft by de Hooch in the very same year and there are reminiscences of ter Borch and Steen too.

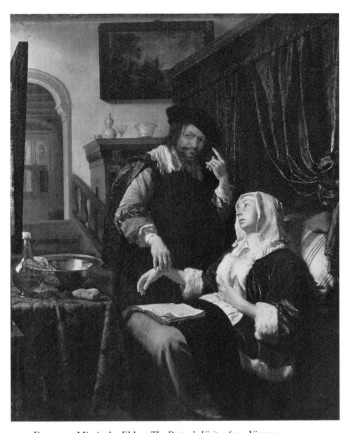

225. Frans van Mieris the Elder: *The Doctor's Visit*, 1657. Vienna, Kunsthistorisches Museum

226. Frans van Mieris the Elder: *The Duet*, 1658. Schwerin, Staatliches Museum

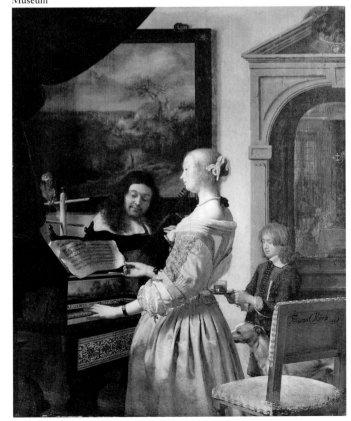

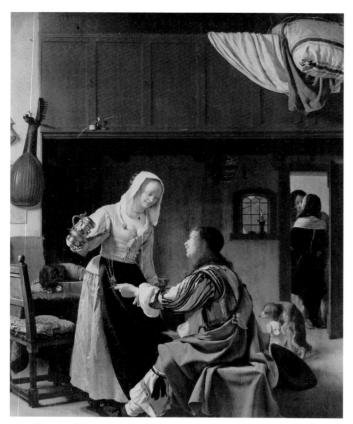

227. Frans van Mieris the Elder: *Inn Scene*, 1658. The Hague, Mauritshuis

van Mieris the Younger (1689–1763) painted in a watered-down version of his grandfather's style [see 403].

Jacob Ochtervelt (1634–82), almost Frans van Mieris the Elder's exact contemporary, was principally influenced by him and ter Borch. Houbraken writes that Ochtervelt was Nicolaes Berchem's pupil at the same time as Pieter de Hooch, which would put him in Haarlem during the early 1650s. Ochtervelt's *Hunting Party* of 1652 (Chemnitz, Städtische Museen) confirms he had contact with Berchem. However, to our knowledge his activity was mainly centred in his native Rotterdam, until 1674 when he is recorded in Amsterdam; he spent his last years there. During his early phase he painted history subjects and barrack-room pictures as well as hunting scenes. He also did a few group portraits during the course of his career. But he is best known for his genre pictures which received a strong impetus from Mieris's works done in the late fifties and early sixties. He adopts and often refines Mieris's motifs. Mieris's sexual allusions are not missing, but they are less explicit. He gains distinction as a remarkable stuff painter and develops a personal palette of lovely salmon pinks, light blues, silvery greys, violets, and orange browns. After 1660 he concentrates on the high life of the wealthier classes and the domestic life of affluent women, their children, and servants. His highly original contribution in his domestic scenes is the perfection of the entrance hall motif. In them he focuses on the open door of a well-to-do home at which food vendors or begging musicians appear [228]. In Ochtervelt's hands the threshold device creates three prominent distinctions: the differences between indoor and outdoor light and space; the separation

228. Jacob Ochtervelt: *Street Musicians at the Doorway of a House*, 1665. St Louis Art Museum, gift of Mrs Eugene A. Perry in memory of her mother, Mrs Claude Kilpatrick

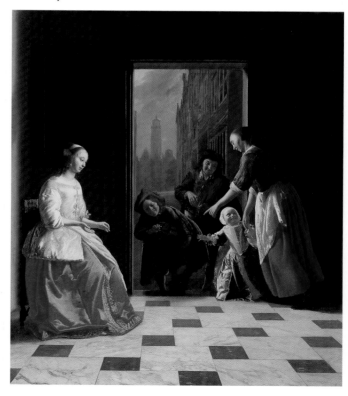

But original is the close-up he offers of the young woman playing the virginal and the cropped view of the chair in the foremost plane. Here he seems to anticipate Vermeer's paintings of the sixties. Mieris continued to give close views of his protagonists, particularly of flirting couples. In the *Oyster Meal* (1661, The Hague, Mauritshuis) the obvious amorous relationship between the happy couple is underlined by the delicacy they are sharing; references in poems, emblems, and medical texts indicate that the notion that oysters are aphrodisiacs was regarded as a truth in seventeenth-century Holland. Mieris had a predilection for the erotic. At times he expressed sexual relationships with psychological subtlety but he is usually more obvious in showing the relationship of his characters to each other as in the *Inn Scene* at the Mauritshuis [227] where the glance exchanged between the woman and the solder, who tugs at her apron, the woman's deep *décolletage*, the sheets and bolster draped over a balcony, and other details, not least the copulating dogs, make clear the inn is a brothel. Mieris could also be gross (e.g. *The Sleeping Courtesan*, 1669, Florence, Uffizi) but almost to the very end he keeps control of his great technical skill. Only during his last years do his colours become harder and his compositions schematic. Despite his great local and international success, during the last decades of his life he was constantly in debt. Houbraken's report that he was a habitual drunkard is amply confirmed by records in Leiden's archives. Two of his sons painted. Works by Jan (1660–90) are rare. Those made by Willem (1662–1747) are similar to his father's, but his over-scrupulous attention to detail makes them tiresome. Willem's son Frans

of private and public spheres of life; the differentiation of social classes. His vendors and beggars are well-kempt and jolly; they seem to live in a world where the misery of poverty has never been experienced. They hardly could differ more from the wretched ones Rembrandt depicted in his etchings earlier in the century. As seen in his *Street Musicians at the Doorway of a House* [228], in the sixties Ochtervelt's figures become slender and attenuated reflecting a new ideal of beauty. About the same time Jan Steen begins to use a similar canon of proportion for the fine women in his genre pieces. What soon became recognized as an elegant thinness, an earlier generation would have called skinny.

JAN STEEN

Jan Steen was extremely productive. Hundreds of his paintings with entertaining satirizing and moralizing motifs have survived, and they can be seen in most European museums. He is, however, less well-represented in the United States, where his works were never sought after by the men who built the great American picture collections. Perhaps a painter who delighted in poking fun at virtuous frugality was not serious enough for them. He is the humorist among Dutch painters. Schmidt-Degener – and before him Thoré-Bürger – compared him with Molière, and suggested that the lavishness of Steen's pictures would have met with the great French dramatist's approval: 'Flaubert reminds us that Molière could not rest satisfied with one single apothecary's assistant. He had of necessity to bring a whole battalion of them on the boards, each one armed with his purgative

230. Jan Steen: *Self-Portrait as a Lutenist*, c.1660–3. Madrid, Thyssen-Bornemisza Foundation

229. Jan Steen: *Self-Portrait*, c.1670. Amsterdam, Rijksmuseum

apparatus.' Nature may be content with little, as the moralizing inscription 'Natura paucis contenta' reminds us in Steen's picture of *Marius Curius Dentatus refusing the Gifts of Samnite Ambassadors* (formerly J.C.H. Heldring coll., Oosterbeek), but Steen filled every nook and cranny of his picture of this story with turnips, onions, and pumpkins. His art revels in profusion.[23]

The Dutch are rightly proud of Steen, and love his kind of humour. His name is still proverbial in the Netherlands, where a 'Jan Steen household' is to this day an epithet for a lively untidy home. Steen's exuberant lavishness is also his limitation. His wit often fascinates, but he can overdo his points and can become repetitious with his jests, tricks, and ironical hints. Not all of the hundreds of pictures attributed to him are of equal quality. A wisely chosen group of a few dozen could prove that Steen is a superb master. Another group could force one to the erroneous conclusion that he is a sloppy hack. A redeeming feature of his better works is his pictorial sparkle. Steen has something of Hals's vivid touch, but his technique, though fresh and lively, is more minute. Something of Steen's Leiden heritage always remains with him. He also seems to have derived some inspiration from the Ostade brothers for his indoor and outdoor pictures of the life of villagers.

In Steen's only traditional self-portrait, at Amsterdam [229], he shows himself half-length, as a respectable burgher

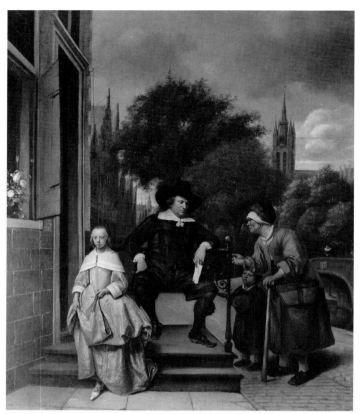

231. Jan Steen: *A Burgher of Delft, his Daughter, and Two Beggars*, 1655. Bangor, Penryhn Castle, Lady Janet Douglas-Pennant

who could have easily asked Bartholomeus van der Helst to provide him with one of his suave portraits. Not a single accessory has been included to indicate that he is an artist. On the basis of the Amsterdam self-portrait he has been identified in various guises as the principal subject or as one of the mirthful, debauched or licentious participants in dozens of his paintings of various themes. For example, he presents himself dressed in the archaic costume worn by actors who played the part of lovers in his *Self-Portrait as a Lutenist* [230], and he is the laughing man in a tall hat who foolishly gives a young boy a drag on his long clay pipe in *The Young Ones chirrup as the Old Ones sing* [238]. In these pictures, as in the others in which he portrayed himself as well as members of his family, we enjoy his wit and humour. These numerous self-portraits raise a question: are the various farcical roles he plays in his paintings, which range from protagonist to merely a spear carrier, autobiographical statements that offer clues about his character and behaviour? According to Houbraken they are. He writes: 'his paintings are like his way of life and his way of life like his paintings'. But not a shred of documentary evidence has been found that can be used to corroborate Houbraken's statement or later ones regarding his personal conduct and habits that are derived from his art. As is the case with Frans Hals, Adriaen Brouwer, and, indeed, any artist, without additional proof it is falacious to draw firm unqualified conclusions regarding the artist's life and personality from the subjects he depicts.[24]

Steen was born at Leiden, the son of a brewer and grain merchant. When he was inscribed at Leiden University in 1646 he was said to be twenty; thus he was born in 1625 or 1626. It is not known how long he was at the university, but it seems that he had enough schooling to acquire some Latin and familiarity with classical authors. From the time he was a student he was always on the move. Something made him restless, and it is as difficult to associate him with a single Dutch town as it is to keep track of his peregrinations. The one city he studiously avoided was Amsterdam. As far as his paintings are concerned, Rembrandt never lived. Steen's works support Weyerman's contention that his first teachers were Nicolaus Knüpfer, a Leipzig artist who settled in Utrecht, Adriaen van Ostade at Haarlem, and Jan van Goyen at The Hague. He joined Leiden's Guild of St Luke in 1648 and from this time until about 1660 he frequently made short trips from his birthplace to The Hague and to Delft. In 1649 he married Jan van Goyen's daughter at The Hague, and he had his residence there for the next few years. With the help of his father, he leased the brewery 'The Snake' at Delft from 1654 to 1657, the very years in which Vermeer and Pieter de Hooch were laying the foundations for their great achievement. Steen must have been aware of the early accomplishments of the Delft masters. However, his ties with the city should not be over-emphasized; there is no evidence that he settled in Delft. Moreover, his extraordinary portrait of *A Burgher of Delft, his Daughter, and two Beggars*, dated 1655 [231], does not follow but predates the daylight effects and fine, detailed observation achieved by de Hooch and Vermeer in their outdoor scenes. This extraordinary double portrait *cum* genre scene and topographical view (Delft's Oude Kerk is in the background) suggests that Steen may have played an innovative part in the development of what we now term the Delft school. It also shows another side of his art. Here there is not a trace of Steen the comic or entertaining moralist. To modern eyes there is something unnerving about the beautiful painting. There is no indication that his well-fed sitter will give alms to the pathetic begging woman and her humble little son, and the patron's exquisitely dressed daughter is cooly oblivious to the distributions of alms, one of the seven traditional acts of Christian mercy.

From 1656 to 1660 he lived at Warmond, near Lieden, and it was the Leiden painters whose influence upon Steen was decisive during these years. Around this time Steen was apparently more attracted to Frans van Mieris the Elder than he was to Dou, who was still the *doyen* of the Leiden school. A comparison of Mieris's *The Doctor's Visit* (1657) [225] with Steen's attractive *Girl with Oysters* (The Hague, Mauritshuis) makes the connection between the two artists clear. Steen, who painted his picture about 1660, goes even farther than Mieris in abandoning Dou's chiaroscuro. In 1661 Steen settled at Haarlem, and in the same year he became a member of the guild there. He had associations with Haarlem throughout the sixties, and his greatest pictures, which masterfully combine a detailed treatment with considerable breadth, were made during this phase of his career. One likes to imagine that at this time Steen established contact with the aged Frans Hals. Perhaps he did. There is no question that the pictures by Haarlem's greatest artist had an

232. Jan Steen: *Skittle Players outside an Inn*, *c*.1660–3. London, National Gallery

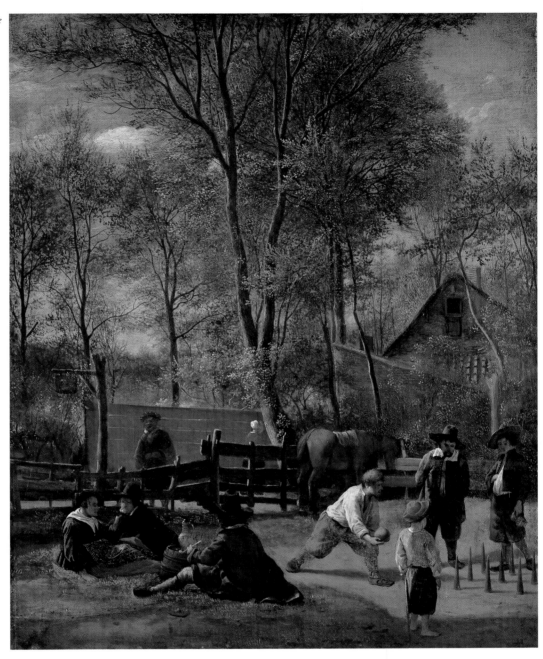

impact upon him, and it seems that Steen collected Hals's paintings. Hals's *Peeckelhaering*, now at Leipzig, hangs on the wall of two of the interiors he painted: *The Baptism* (Berlin, Staatliche Museen) and *The Doctor's Visit* (London, Apsley House). Additionally, a lost painting by Hals of *Malle Babbe* is mounted as a pendant to *Peeckelhaering* in Steen's *Baptism Party* at Berlin. In 1670 Steen returned to Leiden, where he remained until he died in 1679. He continued to work in a fine and in a broad manner until the end, and a few of his pictures have the smooth surfaces favoured by so many late-seventeenth-century Dutch painters. During his last years he held responsible positions in the artists' guild at Leiden, but he did not sever his connections with brewers. In 1672, the catastrophic year the French invaded Holland and marked

the beginning of the third Anglo-Dutch Naval War, he received a licence to operate an inn in the town.

There is in Steen's work a tremendous variety of lively scenes in interiors and out-of-doors, as well as religious, historical, and mythological themes. He used stock types from the repertoire of the Italian *commedia dell'arte* in many of his pictures, and he also showed Dutch amateur actors from the local chambers of rhetoricians in action. He frequently included himself as a mirthful participant in his rhetorician groups. His birds and animals are as finely painted as those made by the Dutch specialists in this branch. Steen also made a few commissioned portraits, which are marked by a genre-like character. His unorthodox double portrait of the Leiden baker *Arent Oostward and his Wife* [233] shows

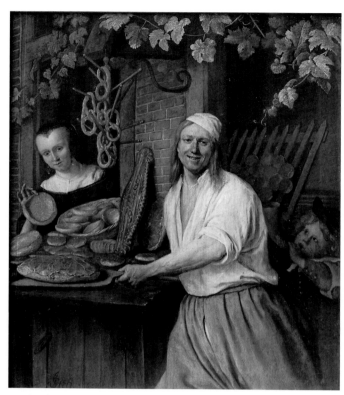

233. Jan Steen: *The Baker Arent Oostward and his Wife*, c.1658. Amsterdam, Rijksmuseum

234. Jan Steen: *Poultry Yard*, 1660. The Hague, Mauritshuis

his smiling patron and his wife displaying an assortment of baked goods while a little boy blows a horn to let neighbours know that hot, fresh bread is ready. The portrayal of Oostward with his shirt wide open, his sleeves rolled up, and wearing his baker's cap could hardly be more informal. If an early eighteenth-century inscription on the back of the panel did not identify the sitters (it also states the young horn blower is Steen's son), the painting would probably pass as a genre piece.

His early works, which can be dated in the late forties, are mostly open-air scenes with crowds of rather grotesque little figures set in expansive wooded landscapes. *The Winter* Landscape (*c.*1650, Skokloster Castle, Bålsta, sold to the Swedish state with the castle in 1967) suggests that around this time he studied the landscapes of Isack van Ostade more closely than those by his father-in-law Jan van Goyen. Steen always kept a fine feeling for the atmospheric effects of the out-doors, but he does not have the instinct of a landscape painter. For him, nature does not exist without prominence given to people of all ages and classes. The *Skittle Players outside an Inn* (*c.*1660–3, London, National Gallery) [232] charms by its distinct feeling for the air and light of a summer day. It is a colouristic marvel, with pinks, greys, blacks, and whites set into the green surroundings. *The Poultry Yard* (1660, The Hague, Mauritshuis) [234] is a portrait of a young girl who has been variously identified. She clearly was connected to the family whose coat of arms is above the archway and which lived in Lokhorst Castle (or Oud-Teilingen) seen in the distance; the great house was situated in the village of Warmond where Steen lived when the portrait was done. The little girl, the focus of attention, is shown offering milk to a lamb in a yard full of prize poultry and domestic birds. She is flanked by two servants, one a dwarf, wearing a cast-off jacket that serves as a coat, the other is in distinctly old-fashioned clothes. The tonality and slightly scattered arrangement already suggest the lightness and openness of eighteenth-century compositions. The portrait of the shy little maid, who is oblivious to the cackling around her and the admiring glances of the barnyard help, shows what a master Steen was a portraying children. No painter surpasses his representation of the wide range of their actions and emotions from the time they are in swaddling clothes until they must be categorized as young men or women.

The subtleties of the expression on the faces and in the demeanor of children experiencing pain, dumb wonderment, malicious joy at another's misfortune, sympathy, or obliviousness are seen in *The Schoolmaster* (Dublin, National Gallery), and it is not surprising that Steen painted at least six pictures of the Feast of St Nicholas, the festival traditionally dedicated to Dutch children. On the eve of 5 December, St Nicholas comes to the Netherlands from Spain to leave appropriate gifts in the shoes of children. The good ones receive cakes, sweets, and toys; the naughty ones get canes and coals. The finest version of this theme is in the Rijksmuseum [235]. A complicated play of diagonals helps bind the family of ten together – from the heap of special pastries to the man pointing to the chimney on the right, where St Nicholas made his entry, and from the carved table covered with sweets up to the girl holding the shoe with the

distressing birch-rod. Figures which lean in one direction are balanced by those leaning in the other; foreground and background, right and left are held together by gestures, glances, and expressions which give the painting familial as well as pictorial tautness. The smiling boy who points to the shoe makes the onlooker part of this family scene by smiling directly out at him or her. The colouristic effect is brilliant, and does not lack unification or become too diffuse, as is sometimes the case in Steen's work. It must have been works of this calibre which prompted Sir Joshua Reynolds, who was still firmly rooted in the classicist tradition of art theory, to write in 1774 of Jan Steen:

> ...if this extraordinary man had had the good fortune to have been born in Italy, instead of Holland, had he lived in Rome instead of Leyden, and been blessed with Michael Angelo and Raffaelle for his masters, instead of Brower and Van Gowen; the same sagacity and penetration which distinguished so accurately the different characters and expression in his vulgar figures, would, when exerted in the selection and imitation of what was great and elevated in nature, have been equally successful; and he now would have ranged with the great pillars and supporters of our Art.[25]

At heart, Steen was a storyteller with a passion for drawing moral conclusions in his numerous pictures based on Scripture, old proverbs, aphorisms, emblems, literature, and the theatre that are laden with accessories to help tell his tales. In his *Woman at her Toilet* (1663, Collection of H.M. Queen Elizabeth II) [236] the skull, music book, and lute with a broken string, traditional symbols of death, transience, and love, lying on the bedroom's threshold, invite viewers to moralize, if they are so inclined, about the erotic overtones in the scene of a lovely woman *en déshabille* seated on a dishevelled bed provocatively pulling on her stocking. Steen's many pictures of doctors' visits to young ladies, like those by Frans Mieris the Elder [see 225], are not commentaries on the social conditions of the times, but are meant to be illustrations of the kind of sickness which medicine can never cure. All these maidens suffer from 'love sickness' or pregnancy, and on the walls, in the background of these pictues, sometimes there is a conspicuous painting representing a romantic or erotic love scene to reinforce the significance of the motif. Steen was able to tell this story repeatedly, with wit and irony; it is the subject of about a score of his paintings. The doctors, who play an indispensable role in these pictures, are often represented as quacks dressed in the garb used for the stage. Again Molière comes to mind. Their fantastic or anachronistic black costumes make an effective contrast with the light colours worn by the women they are never able to cure.

Much of Steen's moralizing is based upon familiar platitudes. 'Easy come, easy go' was a favourite. He frequently includes an inscription in his paintings to make his meaning clear. Variations on the expression 'no doctor needed here, since it is the pain of love' are found on his doctor's visit pictures. A more explicit one was inscribed on a lost painting of the subject: 'Unless I am mistaken, this maid is with child'. Inscribed on the print tacked above the dead-drunk

235. Jan Steen: *Feast of St Nicholas*, c.1665–8. Amsterdam, Rijksmuseum

236. Jan Steen: *Woman at her Toilet*, 1663. Collection H.M. Queen Elizabeth II

237. Jan Steen: *Drunken Couple*, c.1670. Amsterdam, Rijksmuseum

238. Jan Steen: '*The young ones chirrup as the old ones sing*', c.1663. The Hague, Mauritshuis

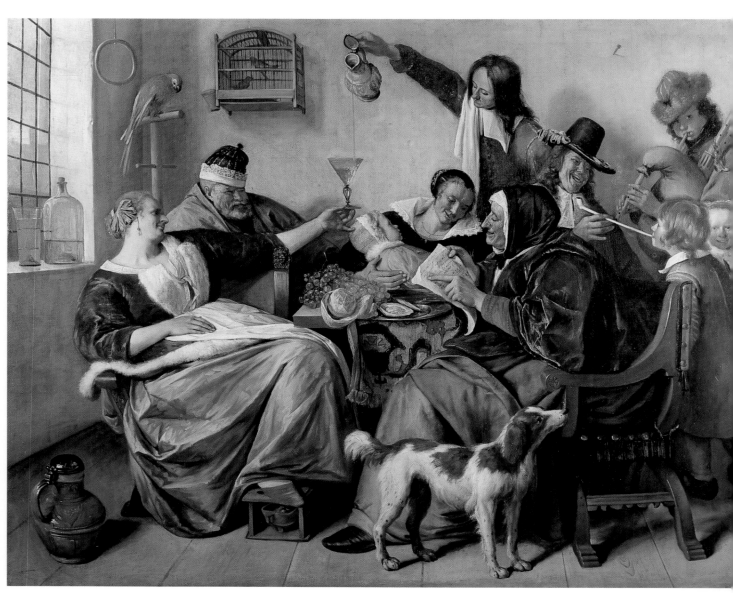

couple in his painting at the Rijksmuseum [237] is the admonition: 'what need of candle or glasses if the owl cannot and does not want to see'. The warning is a timely one; the coat of the elderly debauched roué is being stolen. Many of his exuberant pictures of families around a festive table, where grown-ups, children, and animals make an ingenious hotchpotch, are designed to illustrate well-known proverbs. The most common is 'the young ones chirrup as the old ones sing'. This is the subject of the group eating, making music, drinking, smoking, laughing, and shouting in the picture at the Mauritshuis [238]. As we have seen, here Steen introduced himself giving a boy a pipe, and there have been attempts to identify three generations of his family in the painting. The old woman sings the song written on the sheet of paper she holds:

> As we sing you'll have to chirrup,
> It's a law the whole world knows.
> I lead, all follow suit,
> From baby to centenarian.

In this major work, which is large in size and broader in execution than most, an abundance of animating details illustrate the obvious moral. It can be dated around 1663, when Steen was in Haarlem and had the opportunity to study at firsthand a number of Frans Hals's pictures. The tonality is light, and the dominant hues are Steen's favourite ones: violet, rose, salmon-red, pale yellow, and bluish-green. These, of course, have nothing in common with Hals's late sober palette. Steen avoids regularity and rectangular construction in the composition and indulges in pointed oblique accents – as Hals did in his early phase – to give the suggestion of movement and animation, and of continuous medley.

In his painting of pious families saying grace before a meal placards with appropriate verses from Proverbs or the Psalms are often included. Steen, who remained a Catholic all his life, also made religious pictures from the beginning to the end of his career. More than sixty are known today. Most are treated as genre subjects and some incorporate comical incidents in them. As one might predict, scenes from the Passion did not attract his attention. His favourite subject was the Marriage at Cana, which he painted at least half a dozen times. If his biblical paintings are judged by the criteria used by the Tribunal of the Inquisition which condemned Veronese for introducing in his *Feast in the House of Simon* an apostle cleaning his teeth with a toothpick and other secular elements, they will be condemned. There are, however, a few exceptions. His *Adoration of the Shepherds* (Amsterdam, Rijksmuseum) has a genuine human warmth and tenderness without a trace of the sensual or the burlesque found in some of his other scenes from Scripture. *Christ at Emmaus* (Amsterdam, Rijksmuseum) [239] is a most personal and original work. Instead of showing the moment when Christ reveals himself to wide-eyed and gesticulating disciples as Caravaggio, Rubens, and the young Rembrandt did, Steen represented a scene after the Revelation. Christ is only seen in the doorway of the terrace as a vanishing apparition. A disciple, not Christ, is the centre of the composition. The boy pouring wine, who has his back turned towards us, is as unaware of the onlooker as he is of

what has just occurred. The maid and the two disciples seem to be stunned by the event, and the half-peeled lemon on the table and the crumbs and broken eggshells on the floor, which are Steen's constant props for banquets and brawls, help lend credibility to the mystery that occurred after the miracle of the Resurrection.

During the 1670s, when Steen returned to Leiden and was apparently active as an innkeeper, he continued to be prolific. Large subject pictures and genre scenes, as well as tiny, carefully finished paintings, were made during his last years. There is an increasing elegance and an occasional use of overly glossy paint during this phase, but his sharp wit and good humour are not affected at all. In the *Two Men and a Young Woman making Music on a Terrace* (London, National Gallery) [240], which has considerable charm in the arrangement of the couple against the open sky – the man in the centre is dressed in the costume of Pantalone, a figure from the *commedia dell'arte* – there is already a premonition of Watteau's elegant idylls. This eighteenth-century note is not unique in his late works. The *Nocturnal Serenade* (Prague, Národní Galerie), which can be dated about 1675, shows a whole group dressed and masked as Italian comedians; the theme is one Rococo painters were to use frequently. The slightly elongated proportions of Steen's masquers are already closer to those used by eighteenth-century artists than to the ones employed by his own contemporaries. In Steen's latest existing dated work, *The Garden Party* of 1677 [241], the

239. Jan Steen: *Christ at Emmaus*, 1665–70. Amsterdam, Rijksmuseum

240. Jan Steen: *Two Men and a Young Woman making Music on a Terrace*, c.1670–5. London, National Gallery

241. Jan Steen: *Garden Party*, 1677. Belgium, Private Collection

dionysiac energy of the early pictures has diminished, but his propensity to moralize has not. His comment on the vanity of the festivities is provided by the bubble-blowing children on the high stone stairs of the large building on the left. The scene, which is set against a ruddy sunset, was formerly considered a refined presentation from the life of the Prodigal Son – the theme which, as we have seen, was the source for motifs used by so many seventeenth-century Dutch genre painters. The picture is, in fact, a view of the garden which belonged to a patrician family of Leiden. The stately home in the background has been identified as the residence of the Paedts family; the embroidered pillow on the stool on the left bears its coat of arms joined with an unidentified one.[26] Figures strolling in the garden are dressed in the costume of the day, and two young ladies are playing a kind of golf which was popular at the time. However, the amorous couples can hardly be recognized as portraits of members of a regent family of Leiden. The principal lover, who is receiving wine, as well as the prominent musicians, are dressed in theatrical costumes. Characters from the make-believe world of the theatre have assumed the importance of the Dutch burghers in their garden. With a little more magic – or, stated more prosaically, with a more unified conception – we are not very remote from Watteau's wondrous *fêtes champêtres*, where reality mingles with dreams and fantasies become real.

Landscape

In the vast production of seventeenth-century Dutch painting a predominant subject is landscape, and some of the greatest talents of the period expressed themselves in this branch of painting. Within the general category there was a great deal of variety and specialization. Panoramic views, woods, dunes and country roads, rivers, and canals were represented, and each of these subjects developed continuously as separate categories. Winter landscapes have to be added, also landscapes with animals. All aspects of the countryside and nature were considered worth rendering. We even find specialists in sunset pictures and moonlight scenes. There also were artists who specialized in painting mountainous Tyrolean and Scandinavian landscapes, and an important group called the Italianate landscapists (see p. 225 ff.) introduced southern motifs that evoke the pastoral mood of the Roman Campagna. The romance of classical ruins in a landscape was not lost on the Italianates, and during the course of the century, Dutch artists who never travelled south also employed actual or credible looking classical ruins as accessories or major accents in their pictures peopled with shepherds and herdsmen or biblical or mythological figures. Native ruins were depicted as well. The devastating Eighty Years' War and subsequent land wars on Dutch soil left an ample supply of ruined architectural monuments for landscapists to study.

It seems that to appeal to their countrymen Dutch landscapists had to appear to be close to nature. This tendency can be traced back to the work of the fifteenth-century Netherlandish masters, who gave equal attention to details in landscape, to flowers, rocks, trees, brooks, and even in some degree to the sky. Michelangelo, if we can believe Francesco da Hollanda, once mocked the interest of the Early Netherlandish painters in landscape. He is supposed to have said

> They paint in Flanders only things to deceive the external eye, things that gladden you and of which you cannot speak ill. Their painting is of stuffs, bricks and mortar, the grass of the fields, the shadows of trees, and bridges and rivers, which they call landscapes, and little figures here and there; and all this, although it may appear good to some eyes, is in truth done without reasonableness or art, without symmetry or proportion, without care in selecting or rejecting, and finally without any substance or verve.

Kenneth Clark correctly appraised Michelangelo's prejudice against Early Netherlandish painters when he noted that the Italian High Renaissance master was so steeped in Neo-Platonism, and struggled with an ideal of art so strenuous and exalted, that the mere pleasure of perception seemed to him beneath contempt, and he could therefore justifiably ignore the flowers and meadows of Flemish painters as suitable for women – especially very old or very young ones – for monks and nuns, and also for certain noble persons who have no ear for true harmony.[1]

Things changed after the time of Michelangelo. Anticipated by Pieter Bruegel and his followers, seventeenth-century Dutch landscapists and their French contemporaries Claude Lorrain and Nicolas Poussin raised landscape painting to a category of real power. Claude and Poussin still inherited a great deal from the classical tradition. The Dutch, on the other hand, were the first to teach that nature in all its varied aspects has a grandeur and intimacy of its own which can be appreciated outside the rigid boundaries of classicism. They showed that there is a pictorial charm in nature which only painters can bring out and convey. It is no accident that the great *plein-air* artists of the nineteenth century turned to the Dutch masters time and again for inspiration, and singled out their achievement as a justification for their own approach to nature.

The unique contribution of Dutch landscapists was not recognized during periods when artists, theorists, and critics offered a rather derogatory interpretation of Dutch art and its character based on the axiom that painters must present more than their visual impressions of life and nature. They argued, and the argument is still heard, that Dutch art is nothing else but a mirror of reality, and thus can hardly be called art in the highest sense. This argument is unjust, at least with regard to the great masters among the Dutch. The critics who hold this opinion overlook two essential points. One is that the Dutch painters approached reality with a purity of feeling, and even an awe and devotion, that were almost religious, and cannot be called completely devoid of any ideal or spiritual value. A landscape by Jan van Goyen or Jacob van Ruisdael, a genre painting by Vermeer or Pieter de Hooch, a still life by Willem Kalf convey to us more than a naked representation of reality. The same religious undertone that still flavours the great rational conceptions of seventeenth-century pantheism is felt in the deep devotion of the masters of Dutch painting to their subjects. The other point overlooked is that the quality of formal organization and the degree of expressive value in a work of art play a more important role in determining its level than either a representational or anti-representational programme. An artist who is concerned with what he sees in the world around him can be creative. One need only think of Vermeer and Jacob van Ruisdael. The artist must find proper pictorial means for his task in order to build up a work of an original and expressive organization. Selecting and rejecting from the infinite aspects of nature is involved, as well as a great deal of transformation. In short, the best masters among the Dutch show considerable painterly imagination in their realistic rendering of landscape.

If we turn to the more specific artistic features of Dutch landscape, we may say that the Dutch developed in the course of the seventeenth century a type of landscape in which both atmospheric life and an impressive spaciousness became the dominating features. They developed this programme gradually, and many remained limited to a conception which is unmistakably derived from the appearance of the Dutch countryside and the Dutch sky. In the discussion

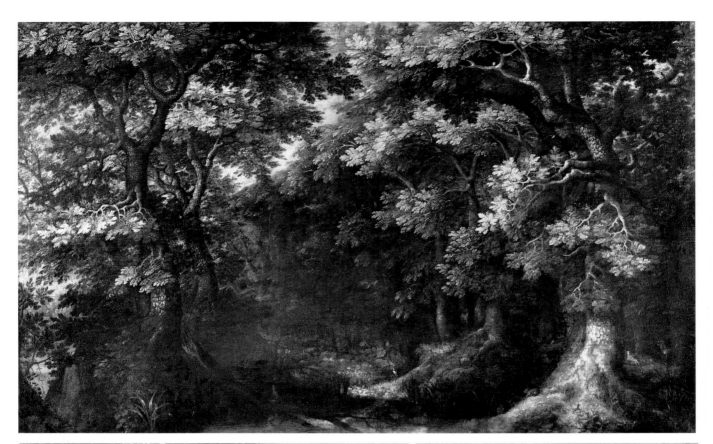

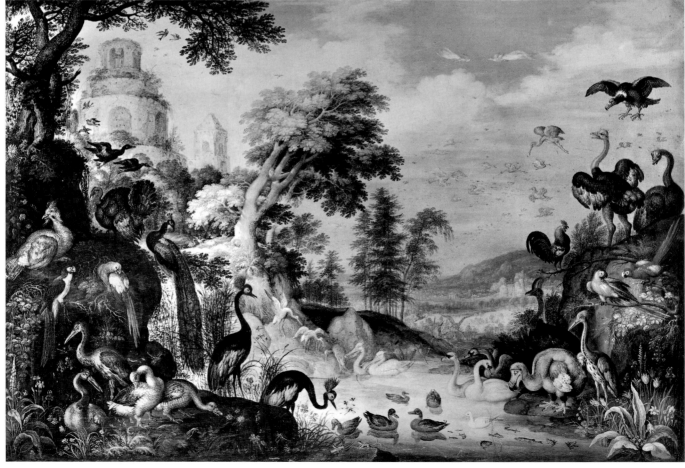

of this development it will be noticed that the classifications used can also be applied to the development of other categories of Dutch painting; for example, to genre or still life. It is a classification which reflects the general trend of Dutch painting during the seventeenth century. Individual artists express themselves differently within these common trends. To get the total picture of this great age, or indeed of any period, we must time and again consider both aspects: the common phenomena, or the style of the period, and the style of individual artists. They are interconnected, and the relative independence of the great artists should never deceive us about this fact. For the style of a phase we make a cross section of the period, lining up representative works of art of a given time. For the individual we must trace his development. On the whole an individual artist is connected primarily with one phase, in spite of his going through various periods. Generally the time an artist enters early maturity is most decisive for the total character of his or her art. Thus in our discussion of Dutch landscape, we have taken van Goyen and Salomon van Ruysdael as representative of the monochromatic style of the thirties and early forties, and Jacob van Ruisdael and Aelbert Cuyp as representatives of the next, the classic phase, although all of them, as we shall see, reflect the style of more than one phase in their total production.

MANNERISTS

Van Mander notes in his *Schilderboek* that he does not know a better landscape painter in his time than Gillis van Coninxloo, whose manner of painting is now beginning to be followed in Holland, and he adds, though some nurserymen do not like to acknowledge it, Dutch trees which were always a bit barren are now beginning to grow like his. Van Mander did not exaggerate. Coninxloo was the most important landscapist who worked in Holland during the first decade of the century. This Mannerist painter was a Fleming by birth (b. 1544), who left his native Antwerp in 1585 when it fell to the Spanish. With a group of other Flemish painters he settled at Frankenthal, a little place near Frankfurt, where a colony of landscape artists gathered under his leadership. In 1595 he moved to Amsterdam, where he lived until his death in 1606/7. Thus, his career in Holland was a brief one. His earliest known works – nothing is dated earlier than 1588 – are bird's-eye panoramic views of craggy mountain ranges and river valleys in the tradition of Patenir and Bruegel. An illustrative tendency still prevails. Nature is a stage for biblical or mythological scenes. It is a place where exciting or astounding events occur. Space is not yet rendered as a powerful unity animated by atmosphere. The early Coninxloo still used the traditional device employed by sixteenth-century Netherlandish painters: he sets off successive planes by dividing his landscape into three distinct colouristic sections: warm brown for the foreground; shades of green for the middle distance; and cool blue tones

for the background. His piling up of meticulously rendered details also recalls an earlier tradition. Like most Mannerists, he is prepared to manipulate light and shadow with great freedom. The dramatic character of his landscapes generally depends upon arbitrarily relieving broad masses of light by large contrasting areas in shadow. The dark parts are usually trees in the foreground used as stage wings to frame the composition with ornamental foliage. Coninxloo's originality is best seen in his late paintings of majestic forests done about 1600 [242], which look like places where dramatic things will happen. But now there is little action in his gigantic groves. The men and animals in them are completely dwarfed by primeval trees. It was, therefore, the late Coninxloo who broke with the anthropocentric tradition of Netherlandish landscape painting and made the romantic mood evoked by luxuriant nature his subject. These tendencies were not lost in the further development of Dutch art. Hercules Segers, who was Coninxloo's pupil, Rembrandt, and Jacob van Ruisdael – the more romantic and imaginative minds among the Dutch landscapists – borrowed elements from the fantastic panoramas and forests painted by Coninxloo and his followers but transformed them into the more solid character of their period.

Coninxloo's principal followers were David Vinckboons and Roelandt Savery, who were also born in the southern Netherlands and emigrated north. As we have heard, the popular Amsterdam master Vinckboons remained fundamentally a genre painter. Huge crowds generally play an important role in his panoramic vistas. It is his late pictures of woods and heroic oak trees which earn him a place in even a cursory discussion of Dutch landscape painting. They became less schematic than Coninxloo's, and have a suggestion of the light and air which was to fill the landscapes of the Dutch painters of the following generation. Roelandt Savery (1578–1639), who was born at Courtrai, was called to Prague about 1604 by Rudolf II. While in the emperor's service he travelled in the Tyrol and made drawings of mountain scenery which are among his most attractive works; he used these as a source for his compositions during the rest of his career. After working for the court in Vienna for a time, he finally settled at Utrecht by 1619. Many of his landscapes include a whole Noah's ark of wild and domesticated beasts and birds. In 1626 the Utrecht government paid him the high price of 700 guilders for a painting of 'diverse animals of the air and earth' to be given as a present to Amalia van Solms, consort of the stadholder Frederik Hendrik. Savery can be credited with popularizing the Dutch vogue for paintings of animals and birds in a landscape. Among the birds he depicted is the now extinct dodo. One appears in the lower right of his fantastic *Landscape with Birds* [243] now at Vienna. The Dutch became familiar with the dodo in 1598 when an expedition visited Mauritius, the island in the Indian Ocean the bird once inhabited.

The extremely prolific and long-lived Utrecht master Abraham Bloemaert (cf. pp. 13–4 above) made landscapes in the Mannerist tradition too. The figures in his numerous designs for engravings of biblical and mythological scenes executed during the first decades of the century are usually subordinated to dramatic and ornamental landscapes. In his bucolic pictures, which frequently include religious, historical

242. Gillis van Coninxloo: *View of a Forest*, *c*.1600. Vienna, Kunsthistorisches Museum

243. Roelandt Savery: *Landscape with Birds*, 1628. Vienna, Kunsthistorisches Museum

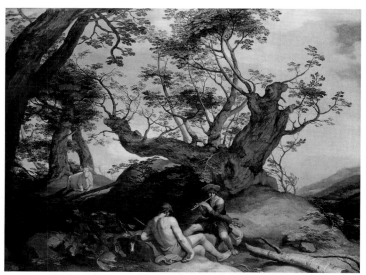

244. Abraham Bloemaert: *Mercury, Argus, and Io*, 1645. Vaduz, Prince of Liechtenstein Collection

245. Hendrick Goudt: *Tobias and the Angel* ('The Small Tobias'), 1608. Engraving, after Adam Elsheimer

(*Metamorphoses*, I, 589–751); the figure of Mercury, shown lulling hundred-eyed Argus to sleep so he can decapitate him and free poor Io who was transformed into a white heifer after Jupiter seduced her, is derived from a print Goltzius designed more than a half-century earlier. Bloemaert, who successfully mastered so many styles, never grasped – or refused to use – the great discovery of Dutch landscape painting; namely, that changes in the *valeurs* and intensity of colours – even a single one – can create a greater illusion of space and atmosphere than Mannerist devices. But his views of nature always have a decorative charm and sometimes anticipated the bucolic idylls painted by Rococo artists. Boucher recognized Bloemaert as a sympathetic spirit; he issued a series of etchings after his drawings (*Livre d'études d'après les desseins origineau de Blomart*, Paris, 1735) and in his early pastorals, like artists active before him, openly re-used his motifs.

We have already noted the importance of Adam Elsheimer, the foreigner who, next to Caravaggio, exerted arguably the greatest impact on seventeenth-century Dutch painting (see p. 15). This German master probably had close contact with the Frankenthal landscape painters in his youth. He was born at Frankfurt, near the place where Coninxloo and other Flemish landscapists had settled after immigrating from Antwerp. His early works show a connection with Coninxloo's ornamental treatment of foliage and the fantastic character of the older painter's forest scenes. The Mannerist elements in Elsheimer's pictures were replaced by a new simplicity shortly after he had settled in Rome around 1600 and felt the impact of Caravaggio's powerful art. Landscapes by the Flemish painter Paulus Bril (1554–1626), who also settled in Rome, stimulated him too, but he was most impressed by Caravaggio's chiaroscuro and tried to achieve similar effects in small nocturnal scenes. In his rare Roman landscapes, where the massive, rounded forms of dark trees are frequently set against a bright sky which spreads a tender light over the earth, southern monumentality is infused with northern intimacy. Elsheimer established a type of classical landscape different from Annibale Carracci's more constructed and architectural compositions. Annibale's landscapes inspired Poussin; Elsheimer's art stimulated Claude and the Dutch landscapists, who responded to his delicate light and calm lyrical moods.

Seven of Elsheimer's pictures were engraved by the gifted amateur Count Hendrick Goudt (1580/5–1648) of Utrecht, one of the Elsheimer's patrons in Rome. Goudt's plates after Elsheimer, which are the main basis for this mysterious artist's reputation, popularized his achievement in Holland. Goudt's print of *Tobias and the Angel* (1608; called '*The Small Tobias*') [245] is a beautiful example of his reproduction of Elsheimer's landscape art. The swelling rhythm of the rounded masses of the trees receding into the distance gives an effect of great spaciousness, and the very delicate illumination of the landscape and the reflections in the water contribute to the idyllic mood of the whole. A group of young Dutch artists responded to these qualities of Elsheimer's landscapes, as well as to his highly original night scenes which also were engraved by Goudt. Those who had contact with Elsheimer in Italy are discussed above (p. 15 ff.). Landscapes by Hercules Segers, Willem Buytewech, and Jan

or allegorical subjects, he often abandoned the high point of view used so frequently by the Mannerists, and focused his attention upon a clump of gnarled trees or a tumbledown farmhouse. Many of these motifs are based on drawings done from nature of the countryside near Utrecht which were praised by van Mander. A series of twenty of them were etched by Boëtius Adams Bolswert as early as 1613–14 – etching was a better technique than engraving for rapidly translating Bloemaert's dynamic Mannerist line into a print. The modest farmyard themes they employ were later favoured by van Goyen, Molyn, and Salomon van Ruysdael. Until the end of his life, when Bloemaert composed landscape paintings, he continued to use the schemes he employed earlier, as is seen in the setting he used for his *Mercury, Argus, and Io* [244] of 1645, done when he was almost eighty, in the bright colours, the ornamental foliage, and the powerful ancient twisted trees on the hill which dominates the entire front plane and makes a sharp contrast with the small distant view. The subject is taken from Ovid

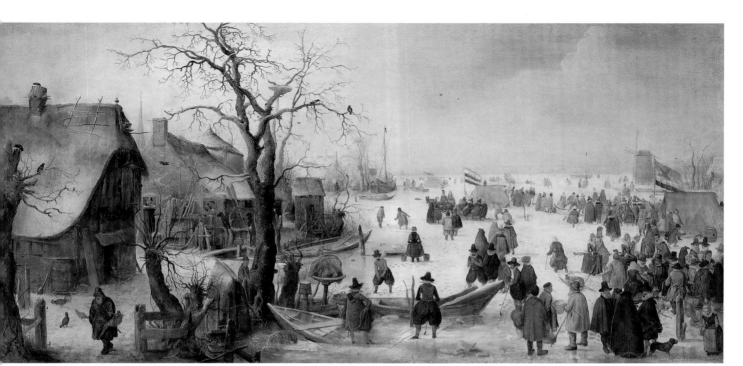

246. Hendrick Avercamp: *Winter Scene on a Canal*. Toledo, Ohio, Toledo Museum of Art, gift of E.D. Libbey

van de Velde, who never crossed the Alps, also show the impact of Elsheimer's art, and a generation later it served as a source of inspiration for some of Rembrandt's works. We have seen that Rembrandt's exquisite nocturnal *Rest on the Flight into Egypt* of 1647 at Dublin [90], a religious painting conceived as a landscape, is clearly derived from Elsheimer's moonlight *Flight into Egypt* (1609, Munich, Alte Pinakothek), which was engraved by Goudt a generation earlier.

EARLY REALISTS

When discussing realism in connection with seventeenth-century Dutch landscapists, it is important to bear in mind that these artists hardly ever painted their pictures out of doors. The practice of making paintings in the open air became common only during the nineteenth century. In earlier times landscape paintings were nearly always composed in studios. To be sure, since the Renaissance, drawings had been done from nature, and the versatile Goltzius made a handful of extraordinary small pen sketches of the dunes near Haarlem [5] which anticipate the panoramic views painted by Segers, Philips Koninck, and Jacob van Ruisdael. But these drawings are unique in Goltzius's *œuvre* and he did not use them as the basis for paintings. They apparently were made for his own private pleasure or instruction. Seventeenth-century Dutch landscape specialists drew from nature much more often than their precedessors, and they frequently used motifs sketched in the countryside as preliminary studies or *aides-mémoire* for their paintings. But, like their forerunners, they worked up their pictures in their studios, where they relied upon modifications of old schemes as well as their own inventive power and imagination to transform a sketch into a finished painting. Highly finished landscape drawings, sometimes touched with watercolour or gouache, done in the studio from sketches, are known too. They probably sold at lower prices than landscapes done in oil paint on canvas, wood, or copper panels.

In this phase religious, historical, and allegorical scenes continue to be used; however, secular activities become more frequent. Unification begins to develop in the works of Hendrick Avercamp (1585–1634) and Esaias van de Velde (1587–1630) through atmosphere and a coherent spaciousness, but their forms are still rather thin and their figures are sharply silhouetted with only cautious pictorial touches. Carefully executed details play an important role in this early realism, which has a certain freshness and crispness. The influence of the Flemish is still felt. As we have seen, Flemish *emigrés* were the leading landscapists in Holland when Avercamp and Esaias van de Velde began to paint, but even the earliest works of these Dutch artists show the beginning of that subtle atmospheric life which was to become so characteristic in the future. This effect is brought out with a watercolour brightness and lucidity. Their pictures are generally many-coloured and have a gaiety kindred to Frans Hals's works of the early twenties. However Hals has more vigour and advances more boldly towards unified compositions than these little masters.

Avercamp, also called 'de Stomme van Kampen' (the Mute of Kampen) because of his disability, spent most of his life in the small quiet town of Kampen on the eastern shore of the Zuider Zee. Residence relatively far from the principal artistic centres of the Netherlands helps to explain why this delightful artist, who discovered the pictorial qualities of flat landscapes and was the first to specialize in winter scenes of outdoor sport and leisure, had little influence on the development of Dutch landscape painting. Avercamp's pictures peopled with motley crowds of all ages and classes skating, sledging, golfing, and fishing on the frozen canals of Holland [246] fascinate social historians as well as art historians. The latter sometimes find him a troublesome painter, because it is difficult to trace his development. The plain fact seems to be that he did not have a very marked one. From the very beginning he could paint a landscape with a high horizon, a great accumulation of detail, and a number of light colours

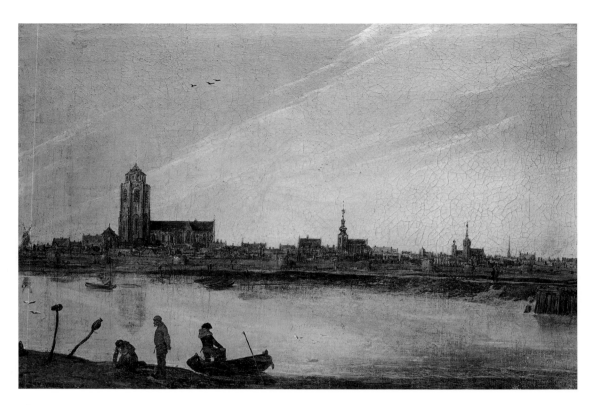

247. Esaias van de Velde:
View of Zierikzee, 1618.
Berlin, Staatliche Museen

248. Hercules Segers:
Mountain Landscape,
c.1630–5. Florence, Uffizi

(*Winter Landscape*, 1608, Bergen, Picture Gallery), or one with a low horizon, few details, and vivid colours in the foreground which lighten as they recede to the distance (*Winter Landscape*, 1609, formerly Paris, Baroness Gabriele Bentinck).[2] The two possibilities existed simultaneously and could be used at will until the end of his career, depending on either the artist's or his patron's predilections.

Hendrick Avercamp's nephew Barent Avercamp (1612/3–1679) closely imitated his uncle's works during the early years of his career, without attaining the finer qualities of his model. Arent Arentsz, called Cabel (*c*.1585/6?–1635), whose works are sometimes confused with Hendrick Avercamp's, also specialized in painting the flat landscape of Holland. His colours are darker and more vivid than Hendrick's delicate hues, and the figures in Cabel's pictures – they are frequently fishermen or waterfowl hunters – are somewhat larger and cruder.

In 1610 Esaias van de Velde settled at Haarlem, the most exciting centre of artistic activity in the Netherlands during the second decade of the century. In our review of his genre pictures we heard he was admitted to the city's Guild of St Luke in 1612, the same year as Hercules Segers and Willem Buytewech, and that he remained in Haarlem until 1618, when he moved to The Hague. In the beginning his works are a *mélange*. Traces of the style of Coninxloo and Vinckboons are evident, as well as signs of the influence of Pieter Bruegel's followers. About 1612–17 Esaias made a series of etchings of Dutch motifs which use the low point of view and triangular compositional schema favoured by Elsheimer. They are the earliest examples of the translation of the German master's style into Dutch art. He probably learned about Elsheimer's works from Goudt's prints. A few years later Buytewech followed van de Velde's lead, and made landscape drawings and etchings based upon the stylization Elsheimer invented. Jan van de Velde (1593–1641), a second cousin of Esaias, made prints in a similar vein. Cornelis Vroom (*c*.1591–1661) also painted modest little pictures (*Landscape with a River by a Wood*, 1626, London, National Gallery) which show the impression of the art of Elsheimer and anticipate in a remarkable way the works of Jacob van Ruisdael. Neither Buytewech nor Jan van de Velde seems to have been specially interested in landscape painting; their views of nature were done as prints and drawings. Esaias van de Velde, on the other hand, continued to paint scenes of nature until the end of his career.

Even before 1615 Esaias was making pictures with an unprecedented freedom and simplicity of spatial setting such as his *Flight into Egypt in a Winter Landscape* (formerly Lucca, Mansi Collection) which abandon the bird's-eye view, the stage wings on either side of the composition, and wealth of accessories favoured by his predecessors and contemporaries.[3] In this picture the principal motif of the bare trees is placed in the centre of the middle distance, and the composition has been left open on either side. The Holy Family trudging through the snow as it makes its way into Egypt are small and insignificant figures. The painting's companion piece depicts *The Pilgrims and Christ on the Road to Emmaus in a Summer Landscape* (Oberlin, Ohio, Allen Memorial Art Museum). The pair follows the old tradition of representing seasons as well as biblical themes. Esaias's profile *View of Zierikzee*[4] of 1618 [247], unifies the foreground and background of a townscape even more successfully by subtle shifts in *valeurs*, from the strip of land and water in the foreground to the town silhouetted against the

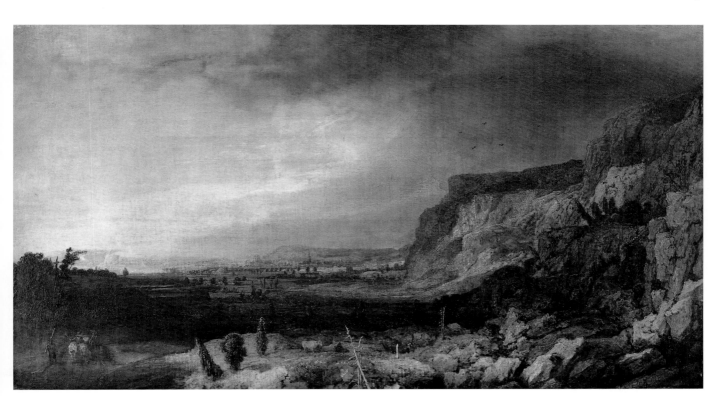

light horizon. The picture not only gives a premonition of the convincing space construction and tonal painting adopted by the next generation, but even of Vermeer's *View of Delft* [186]. During the following decade Esaias's touch became more fluid and his palette more monochromatic (*Dunes*, 1629, Amsterdam, Rijksmuseum). The tradition he established during his brief career was carried on by Jan van Goyen, but not until this outstanding pupil had spent a full decade retracing the steps of his master.

Esaias also made small innovative pictures of cavalry skirmishes, mounted battles, and attacks by horsemen upon wayfarers. Jan Martsen the Younger (1609?–after 1647), Esaias's nephew and pupil, developed these themes into a speciality, and he in turn was probably the teacher of the Italianate landscapist Jan Asselyn whose first known efforts depict similar subjects in Martsen's manner. Undoubtedly the best painter of fighting horsemen was versatile and productive Philips Wouwerman who appears on the scene in Haarlem in the late thirties. An outstanding example of his work in this category is his unusually large *Cavalry making a Sortie from a Fort on a Hill* (1646, London, National Gallery); like most Dutch paintings of this type during this period it is an imaginary land battle. As we shall see marine painters worked differently; they often portrayed identifiable naval engagements. The list of Dutch painters of mounted forays and seiges is not very long. Among Esaias's contemporaries it includes a few by the architect-painter Pieter Post, brother of Frans, known for his landscapes of Brazil, and Palamedes Palamedesz (1607–38) brother of the genre painter Anthonie. The tradition was continued by Jan van Huchtenburg (1647–1733) whose *œuvre* is distinguished by the depiction of historical as well as imaginary battles; reference to his work is made in the discussion of landscapists whose activity extends into the eighteenth century (p. 321).

HERCULES SEGERS

Hercules Segers was the most inspired, experimental, and original landscapist working in Holland during the first decades of the century. He was probably born at Haarlem about 1589–90, studied with Coninxloo in Amsterdam, and, as we have heard, entered the Guild of St Luke at Haarlem in 1612. Like his close contemporaries Avercamp and Esaias van de Velde, he shows a certain dependence upon the Flemish tradition of landscape painting. He seems to have been impressed by Joos de Momper and Roelandt Savery as well as by Coninxloo, but he was more inspired by the fantastic and visionary aspects of Mannerist and *Flamisant* landscape painting than he was by realism. To be sure, during the course of his rather brief career (we last hear of him in 1633 at The Hague where he was active as a dealer, and in 1638 a woman who apparently was his second wife is described as his widow) he made realistic as well as imaginary views; however, the latter comprise most of his *œuvre*. Few Dutch painters explored the haunting world he discovered, and only Rembrandt and Jacob van Ruisdael evoke moods similar to his.

Samuel van Hoogstraten, in his *Introduction to the Advanced School of Painting* (*Inleyding tot de hooge schoole der schilderkonst*) of 1678 cites Segers as an example of an artist whose true worth was only recognized after his death. According to him Segers's despair over his failure to achieve success drove him to drink and he died after falling downstairs while drunk. Hoogstraten's account has the ring of a story often told about artists who do not achieve wide popularity. Nevertheless, it is known that Segers had financial difficulties. On the other hand, there also is evidence he enjoyed some popularity among his contemporaries. In about 1621 one of his paintings was offered to King Christian of Denmark as

TOBIAS cœli sequitur cum iusa parentis, Nam Genium comitemque aussoremque malorum
Commeruit magni numinis auxilium: Nactus, lustato fæfruitur thalamo.
H Goudt Palat. Comes, et Auv. Mil. Eques.
ᴁ 1613.

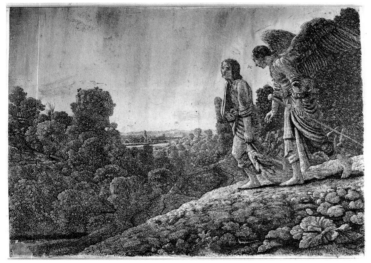

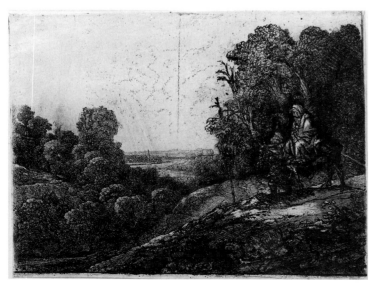

part of a gift. Two of his landscapes were acquired for the collection of Stadholder Frederik Hendrik at The Hague in 1632. An Amsterdam dealer had twenty-one of his paintings and twelve 'rolled pieces' (unmounted canvases or rolled etchings?) in 1640. Additionally there are references to other Segers paintings in seventeenth-century inventories.

Today his paintings are rare. Only about a dozen are known, none of which is dated. Their extreme rarity and knowledge that more existed have led some critics to ascribe paintings by his followers and imitators to the master himself.[5] The high quality of his authentic works can be seen in the *Mountain Landscape* (Florence, Uffizi) [248]. The vast panoramic view of a valley flanked by a great mountain range is a sign of his descendance from the Mannerists, but his touch is more vigorous, and his work suggests a greater closeness to nature. The drama of light and shadow in the sky and upon the plain is his own invention. Rembrandt, who was deeply impressed by Segers's works, owned no less than eight of his paintings and acquired one of his etched plates that depicted *Tobias and the Angel* [250]. The plate was originally Segers's free copy (in reverse) of Hendrick Goudt's engraving of *Tobias and the Angel* [249] faithfully done after an Elsheimer painting (commonly called '*The Large Tobias*' to distinguish it from Elsheimer's other depiction of the subject, also engraved by Goudt [see fig. 245]). Mature Rembrandt radically reworked Segers's plate by scraping and burnishing out Tobias and the Angel. In their place he etched a Holy Family on a much smaller scale seen against a luxuriant landscape; apart from a few very minor changes, he left Segers's extensive verdant landscape intact [251]. Segers's creative etched copy after Elsheimer and Rembrandt's partial but dramatic transformation of Segers's copper plate offer unquestionable proof of the symbiotic connection between these pre-eminent landscapists. Segers's print also can be read as part homage and part critique of Elsheimer's achievement. Similarly, Rembrandt's partial reworking of Segers's etched plate is an indication that his almost reverential regard for most of the landscape in his great predecessor's print did not preclude the thought that his changes would improve the image. His contribution transforms the etching into a precious unicum; albeit a joint effort done more than a decade after the death of one of the participants, it is a collaborative work by seventeenth-century Holland's best printmakers.

Rembrandt's painted imaginary landscapes of the late thirties have a Segersesque character in their fantastic mood and deep brown tonality, and for a long time many of Segers's landscapes were ascribed to Rembrandt. The powerful *Mountain Landscape* [248] in the Uffizi was attributed to him until 1871, when Bode recognized it as a Segers. The confusion is easy to understand. No work by

249. Hendrick Goudt: *Tobias and the Angel* ('*The Large Tobias*'), 1613. Engraving, after Adam Elsheimer

250. Hercules Segers: *Tobias and the Angel*. Etching

251. Rembrandt: *Flight into Egypt*, c.1653. Etching, reworked on Segers's plate, fig. 250

Segers shows more clearly Rembrandt's debt to him, and there is now general agreement it is another work by Segers that Rembrandt actually changed. The younger painter's hand can be seen in the figures and cart on the left of the picture, the mountains on the right, and in part of the sky. Segers also painted imaginary views of the flat Dutch countryside and at least one topographical view (*Town of Rhenen*, Berlin, Staatliche Museen). These achieve a powerful and unified spaciousness, and establish Segers as one of the founders of panoramic landscape in the Netherlands. Even a relative chronology of his rare, undated paintings is difficult to establish, but it seems that towards the end his compositions gain in firmness and monumentality. Their brown tonality enlivened by green and blue in the farther distance closely connects Segers to the tonal phase. He retained the predilection landscapists of his generation had for a horizontal format, and always emphasized the vastness of the earth more than the vault of the heavens. The high skies in his paintings of a *View of the Town of Rhenen* and *View of a Dutch Town on a River* (both at Berlin, Staatliche Museen) are not by his hand; they were added by another seventeenth-century painter who wanted to make the pictures conform to the taste of a later generation.[6]

Segers is equally well known for his graphic work, which is remarkable for its imaginative quality, innovative techniques, originality of motifs, and power of treatment and design. He etched both realistic and imaginary scenes, the latter prevailing, with mountain views, waterfalls, desolate valleys, rocky slopes, mostly bare of human figures and of an imposing, almost primeval solitude [252]. Characteristic details are lonely, lunar-like rocks and decayed pine trees. His vigorous and somewhat grainy line is well suited to suggest weather-worn surfaces of rocks and ruins. A crumbling edifice which reminds viewers of the transitory nature of their life and accomplishments was one of his favourite motifs. It has been maintained that some of his etchings of ruins were done in Italy, or etched from studies made there. But we know ruins could be studied in the Netherlands too. Moreover, Segers was as capable of imagining them as he was of imagining mountain ranges and precipitous cliffs. Sometimes he found inspiration in the work of other artists. It has been established that his etchings of Roman ruins are based on drawings or prints by earlier artists of classical sites. He also made a creative copy after a woodcut of *The Lamentation of Christ* by Hans Baldung Grien as well as the variation after Goudt's engraving of Elsheimer's 'Large Tobias' already cited [250]. More unusual are his still-life etchings of a close view of a pile of *Three Books* and a *Skull* [253].

Segers spent much time and effort in experimenting with ways of making colour prints from etched plates, but they are colour prints in the most limited sense. He used only one plate, but printed on a coloured surface (paper or cloth). Thus his etchings were limited to two colours, that of the ink and that of the paper or fine cloth support. Sometimes the surface was coloured only after the print had been pulled. With this technique he produced extraordinary variations on his themes; white or yellow ink on a dark ground transformed a daylight scene into an eerie nocturnal view. If he wanted more colour, and he frequently did, he touched the

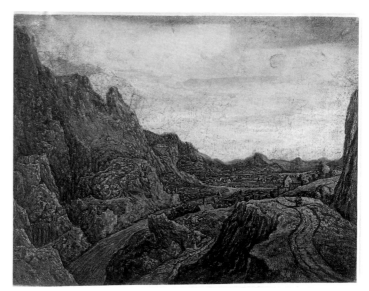

252. Hercules Segers: *Rocky Valley with a Road leading into It*. Etching with watercolour and body-colour added. Amsterdam, Rijksmuseum, Rijksprentenkabinet

253. Hercules Segers: *A Skull*. Etching, unique impression: black ink on cloth dyed grey. Amsterdam, Rijksmuseum, Rijksprentenkabinet

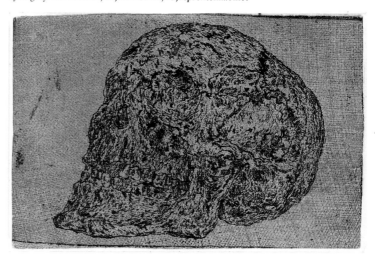

print with oil, gouache, or watercolour, and in this way he also achieved radically different effects from the same etched plate. Hoogstraten aptly wrote Segers 'printed ... paintings' (*drukte ... Schilderey*). The unique impression at Dresden of *The Big Ship* which modern observers find especially appealing because of the economy of line and the great expanse of white paper, was probably intended for extensive hand colouring. Elaborate full-colour printing which could dispense with hand work was possible only after the German graphic artist Jakob Christoph Le Blon (1667–1741) had invented a technique in the eighteenth century which used a different plate for each of the three primary colours. Christoph's invention was based on Newton's colour theories, which were published in 1669, about a generation after Segers's death. Segers constantly experimented with graphic techniques. He made counterproofs; that is, he placed a sheet over his original etching while the ink on it was still wet in order to produce a reverse impression. He

254. Pieter de Molyn: *Dunes*, 1626. Braunschweig, Herzog Anton Ulrich-Museum

255. Jan van Goyen: *Dunes*, 1629. Berlin, Staatliche Museen

also obtained unusual effects by working with a special kind of soluble ink, a technique known as 'lift ground' etching, and made complicated use of repeated bitings and extensive reworkings of his etched plates. Anticipating a practice used later by photographers, he frequently cropped impressions of his etchings to achieve different compositional effects. No Dutch etcher continued his novel technical experiments.

Segers's etchings, many of which only exist in unique impressions, are almost as rare as his paintings. The most recent catalogue of them lists fifty-four, with only 184 known impressions in all.[7] The print room of the Rijksmuseum at Amsterdam owns about one-third of these. Most of the impressions now at the Rijksmuseum belonged to the Amsterdam lawyer Michiel Hinloopen (1619–1708). Among them is the unique impression of a *Skull* illustrated here [253]. Soon after Hinloopen's death they became the property of the municipality of Amsterdam. If he had not brought so many of Segers's etchings into his possession, today we would know little about his awesome achievement as a graphic artist.

TONAL PHASE

Constantijn Huygens must have been one of the better judges of painting in seventeenth-century Holland. We have already noted that an entry in a journal he kept about 1629–30 shows that not long after the greatest Dutch painter had picked up his brushes, Huygens recognized Rembrandt's genius, and at the same time he was able to make a penetrating distinction between the qualities of Rembrandt as a history painter and those of the young master's gifted, close friend Jan Lievens. Huygens's understanding of what landscape painters were doing was equally shrewd. He wrote in his journal that the young Netherlandish

landscapists of his day lacked nothing to show the warmth of the sun and the movement caused by cool breezes. In the representation of such things, he maintained, the new generation would surpass its teachers. Later critics have endorsed Huygens's judgement. About the time Huygens wrote, Jan van Goyen, Salomon van Ruysdael, and Pieter de Molyn, the leading members of the group of artists who brought plausible realism in Dutch landscape to a climax, were just beginning to paint pictures in which the impression of nature dominates over the human figure. They discovered means to suggest atmosphere as the most animating element. The Dutch sky begins to play a dominant role in their works, and a humid atmosphere throws a veil about everything, creating an almost monochrome grey or greyish-green tonality with transparent browns in the shadows. Van Goyen and Ruysdael began to build up their pictures with detached touches of paint, which are often suggestive of the windy Dutch climate. Molyn never matched their vivid fluidity, but he was the first to make a consistent significant break with the style of the early realists.

Pieter de Molyn (1595–1661) was born of Flemish parents in London. Neither the date of his emigration to Holland nor the name of his teacher are known. There is no documentary evidence for the assertion found in the early literature that he studied with Frans Hals; however, he did provide landscapes for a few of Hals's portraits.[8] In 1616 he joined the guild at Haarlem, where he spent most of his life. His earliest works show the influence of Mannerists, such as Bloemaert and Savery, but much more important for him, as it became for van Goyen and Salomon van Ruysdael, was the impact of Esaias van de Velde's art. Van de Velde was active in Haarlem when Molyn joined the guild there. Not much later, Molyn probably met van Goyen, who was sent to Haarlem around 1617 to study with van de Velde. Molyn's

innovations are first seen in his modest *Dunes*, dated 1626 (Braunschweig, Herzog Anton Ulrich-Museum) [254], which abandons the device of breaking up a landscape into many layers. Scattered details seen from a low point of view have been subordinated to large areas of light and shadow, and the scene has been unified by prominent diagonals which lead the eye over the dunes past the small figures into the distance. In 1626 Molyn also made a series of four landscape etchings using the diagonal schema which became so popular during the following decade. For the next few years (*Landscape*, 1628, Prague, Národní Galerie; *Landscape*, 1629, New York, Metropolitan Museum) Molyn made pictures of the dunes and flat Dutch terrain which are equally original, but his inventive power spent itself rather rapidly. During his maturity he seems to have been more active as a draughtsman than as a painter, and he frequently repeated motifs used early in his career. Most of his lively chalk drawings of landscapes, which are usually signed and dated, were apparently designed as finished works, not as preliminary studies for paintings.

Jan van Goyen was made of different stuff. This great painter and prolific draughtsman, born at Leiden in 1596, began his apprenticeship at the age of ten and is said to have studied with six different masters. However, only Esaias van de Velde, with whom he spent a year at Haarlem, had decisive influence upon him. Van Goyen settled in The Hague in about 1631, and had connections there until his death in 1656. He was a restless soul, travelling frequently about the Netherlands, and like many Dutch painters he did not exclusively devote himself to his craft. He was a picture dealer, a valuer, arranged auction sales, and also speculated in tulip bulbs, land, and houses. His sketchbooks, which include many of his more than 1,000 known drawings, are full of vivid rapid chalk sketches of canals and dunes made

from nature; they also contain plans for dividing up plots of land. In spite of all his financial activities van Goyen was constantly in money difficulties and died with at least 18,000 guilders in outstanding debts.

As an artist he occupied a respected place in the painters' guild at The Hague, and in 1651 the municipality paid him the high fee of 650 guilders for a very large panoramic view of the town which was recorded in the burgomasters' room of the town hall in 1653. Dated pictures by van Goyen are known from 1620 until the year of his death in 1656. His earliest works are so close to Esaias van de Velde's that it is sometimes difficult to distinguish their hands. Like Esaias, he used both a round and an oblong format for small views of Dutch villages and country roads, crowded with illustrative details. The atmospheric treatment in these colourful early works is insignificant, the foliage is ornamental, and there are glittering highlights reminiscent of the Mannerists. In the late 1620s van Goyen shifted to simpler motifs – a few cottages along a village road or in the dunes [255] – and he achieved unification and depth by a leading diagonal and by a tonal treatment that subdues the local colour and is expressive of atmospheric life. His palette turned monochromatic, with browns, pale greens, and yellows.

During the course of the 1630s van Goyen became the leading master of the tonal phase. His technique grew bolder and more vivacious, the space opened up, and atmosphere predominated. Water begins to play a more important role, as in the *River Scene* of 1634 [256]. This picture shows the diagonal recession characteristic of the thirties, and an all-over airiness that grows in transparency towards the far distance, with its brightened horizon. Sailing boats are sketched in, wet in wet, with the lightest touch. A fine tonal harmony is achieved by the subdued contrast of greys and silvery whites against pale yellows and browns.

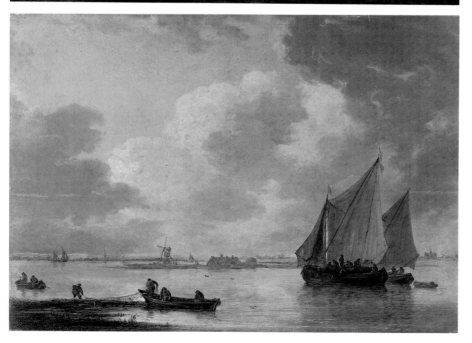

256. Jan van Goyen: *River Scene*, 1634. Cambridge, Massachusetts, Harvard University Art Museums, Fogg Art Museum

257. Jan van Goyen: *View of Leiden*, 1643. Munich, Alte Pinakothek

258. Jan van Goyen: *River Scene*, 1656. Frankfurt, Städelsches Kunstinstitut

259. Salomon van Ruysdael: *River Scene*, 1632.
Hamburg, Kunsthalle

The tonal trend continues into the 1640s, bringing still increasing spaciousness and fluidity. Van Goyen's technique often shows an open interplay of over- and underpaint, and the quick, whirling strokes make the vibration of the moist air almost physically felt. Side by side with river scenes, seascapes with choppy little waves appear. Often we meet wide views over the flat country that are lit by streaks of sunlight. A good number of city views occur, and they are set into the wide context of the Dutch countryside, like the beautiful fanciful *View of Leiden* of 1643 (Munich, Alte Pinakothek) [257]. In this *capriccio* (the artist placed Leiden's famous St Pancras Church alongside an imaginary wide, winding river) we see how the horizontal begins to dominate over the diagonals at this time. The subdued colouristic touches of yellows, greens, and browns become more luminous, and the sky brightens up. Winter landscapes are not the least remarkable at this phase. Their crowds of people skating or moving over the ice in horse-drawn sleighs show van Goyen's vivid draughtsmanship at its best.

In the 1650s he – like Salomon van Ruysdael – did not remain uninfluenced by the new classical trend, but he never moved away from the dominant monochromatic tonality of his middle period. Some tectonic accents, with verticals opposing horizontals, enter his compositions. The clouds become more voluminous and his touch a bit more forceful; now and then his skies include vivid blues. But it is largely the deepening of his tonality that enlivens his late work, by strong contrasts of dark accents in the foreground against the luminous openings in the sky and bright reflections on the surface of water. All of this can be seen in one of his latest works, the river scene at Frankfurt of 1656 [258], the year of his death. In his last years van Goyen rivalled Aelbert Cuyp in the glow and force of luminaristic phenomena without adopting the more colourful palette of the younger master. Cuyp himself had a pronounced Goyenesque phase during his early years and so did a number of other landscapists. A measure of van Goyen's enormous impact on his contemporaries is offered by H.-U. Beck's study (1991) which catalogues works by more than seventy-five artists

who either made a career working in his manner or who were affected for a time by his style.

Salomon van Ruysdael (1600/3?–70), who was a few years younger than van Goyen, shares with him – as we have heard – the fame of tonal landscape in Holland, though he moved more slowly and differed considerably from van Goyen's vivacious temperament. But Ruysdael's charm is undeniable, and the calm lyricism as well as the pictorial subtlety of his river scenes are not easily forgotten. In his landscape production he is less versatile and more uniform than van Goyen, although for a while, and rather late in his career (from about 1659 to 1662), he tried his hand at a different subject matter, painting some still lifes and hunting trophies (also see pp. 190, 289 below).

Ruysdael was born at Naarden in Gooiland. During his early years he was known as Salomon de Gooyer (i.e. Salomon from Gooiland); he was inscribed in the guild at Haarlem in 1623 with this name, and he lived in the city for the rest of his life. He frequently experimented with the spelling of the name Ruysdael, but he never spelled it Ruisdael, the orthography used by his more famous nephew, Jacob Isaacksz van Ruisdael. Salomon's son Jacob Salomonsz Ruysdael (c.1630–80) also was a landscapist; his works are closer to those by his cousin than to his father's.

The teacher of Salomon van Ruysdael is unknown, and he seems to have been slow in finding his way. Unlike van Goyen and Molyn who left us hundreds of drawings, not a single sketch has been securely attributed to his hand. The influence of Esaias van de Velde is unmistakable in his earliest dated paintings of 1626 (a *Horse Market* and a *Hunting Scene*), and in the winterscapes of the following year. He then fell under the influence of Pieter de Molyn, and it was only about 1630–1 that he finally worked out a personal style.

It was early in the thirties that Ruysdael, like van Goyen, discovered the picturesque beauty of river scenes [259], and he rivals van Goyen in his fine tonal treatment, subduing the local colours and making us feel the moist atmosphere of Holland in monochromatic harmonies. Salomon also uses

260. Salomon van Ruysdael: *Halt at an Inn near Beverwijk*, 1649. Budapest,
Museum of Fine Arts

the diagonal scheme in his compositions. The bodies of
water he paints are less agitated, but pictorially animated
by the reflections of the trees, and the sky seems slightly
thinner. Ruysdael's tonality often tends to the cool side in
his delicate greens, yellows, and greys. His touch is more
minute than van Goyen's and slightly schematic, yet he has
the capacity to create poetical moods by his pictorial refine-
ment as well as by his stillness and the sincerity of his vision.
These various differences between the two masters are not
very pronounced during the thirties, and during the early
years of the decade they can come so close to each other
that some confusion has occurred in the attribution of their
paintings. This similarity disappears about the middle of the
1640s, when a new force and beauty marks Salomon's turn
to the later phase of his art (*Halt at an Inn*, 1649, Budapest,
Museum of Fine Arts) [260]. He, too, never fully adopted
the more classical style of the younger generation, but he
shows stronger signs of its influence than van Goyen. The
heroic tree motif, which Salomon's nephew Jacob raised to
an outstanding feature in his art, now appears prominently
in his paintings, strengthening the compositions by vertical
accents. They form a glowing dark contrast against a colour-
ful sunset sky. His trees never gain much body, and remain
thin and feathery in his early minute manner, but they func-
tion beautifully in the total pictorial effect, which can gain
an extraordinary splendour by the colours of the sky with
mother-of-pearl streaks of pink and blue, violet and grey.
The air is shiny, and more activities go on than before both

on the land and on the water. Max J. Friedländer must have
had works of this period in mind when he said: 'While the
weather in van Goyen's pictures always makes you feel it will
soon rain, Ruysdael's pictures make you feel it has rained,
and a fresh wind has driven the rain away'.[9]

As we have noted, at the beginning of the sixties Salomon
painted some still lifes. In these works he always represented
objects set on a marble tabletop. Probably he painted
the artificial marble he had invented, which according to
Houbraken could not be distinguished from the real thing.
Salomon's last decade does not bring any new ideas to
landscape painting. He held on to the compositional devices
of the 1650s, but his pictorial effects harden and the tonality
turns a bit darker.

Aert (Aernout) van der Neer (1603/4–77), a contem-
porary of Salomon van Ruysdael, specialized in moonlight
and winter landscapes – subjects which are particularly suit-
able for the monochromatic mode. Van der Neer apparently
came to painting rather late. His first dated painting is a
genre piece done in 1632 and his earliest known landscape
is dated 1633. According to Houbraken he was a steward
(*majoor*) in the service of a family at Gorinchem before he
moved to Amsterdam sometime in the early thirties, where
he finally dedicated himself to painting. The choice did not
make his life an easy one. Neither winter nor moonlight
pictures fetched high prices during the seventeenth century.
Van der Neer opened a tavern in Amsterdam in 1659; it
failed, and he was bankrupt in 1662. But it seems that

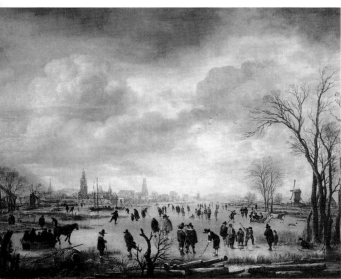

261. Aert van der Neer: *Winter Landscape*. Amsterdam, Rijksmuseum

when they throw pink, light blue, and silver reflections on the ice and the snow-covered ground [261]. But he is also remarkable in, and best known for, his moonlight scenes [262], which display the finest nuances of nocturnal lighting in the sky and on the ground, and where he knows how to enliven the darks by delicate tints of blue and reddish brown, maintaining both transparency and colour harmony in the general darkness. These nocturnal scenes must be examined in the original in order to appreciate the inventive way he exploits the brown ground of his panels. His technical ingenuity can also be seen where he scratches into the wet paint with the butt end of his brush or palette knife to achieve subtle monochromatic effects. Aert had no close followers. His son Eglon van der Neer, whom he trained, made his mark as a painter of high-life genre scenes (see p. 306 below).

A lesser known but interesting artist is the Frisian painter Jacobus Sibrandi Mancadan (c.1602–80). He was one of the rare Dutch painters who held a high municipal office; he served as burgomaster of Franeker from 1637 to 1639, an indication that he probably was prosperous. Mancadan was forgotten until the twentieth century, when a new appreciation of the formal values of art directed admirers of Dutch painting to the lovely light browns, ochres, pale yellows, rose-colours, and greens of his highly personal palette. Some of Mancadan's pictures represent shepherds and herdsmen with the flocks among fanciful craggy rocks, weathered trees, and classical ruins; they show his familiarity with the more famous Italianate Dutch painters. There is, however, no evidence that he visited Italy. Mancadan also painted landscapes of the flat Frisian countryside; his panoramic view of *Peat-Cutting at Groningen* (Groningen, Groninger Museum) is one of the rare seventeenth-century Dutch pictures of men at work on the land.

financial difficulties had little effect upon his art. The standard he maintained is consistently high. Paintings ascribed to him that fall below his high level are not the result of 'Monday morning' efforts but works by his many copyists and imitators. He apparently was unable to paint with the ease and facility of van Goyen or Ruysdael. One never gets the impression that he worked rapidly. His method was more deliberate; it is the approach of a shy and humble man who never lost his awe before nature. In some ways he remained old-fashioned. Virtually all his paintings are imaginary Dutch landscapes seen from a rather high point of view, and he seldom composes without the diagonal shores of a river or a frozen canal to help create the illusion of space. Van der Neer is a master in the subtle rendering of grey winter skies

262. Aert van der Neer: *River Scene by Moonlight*. Amsterdam, Rijksmuseum

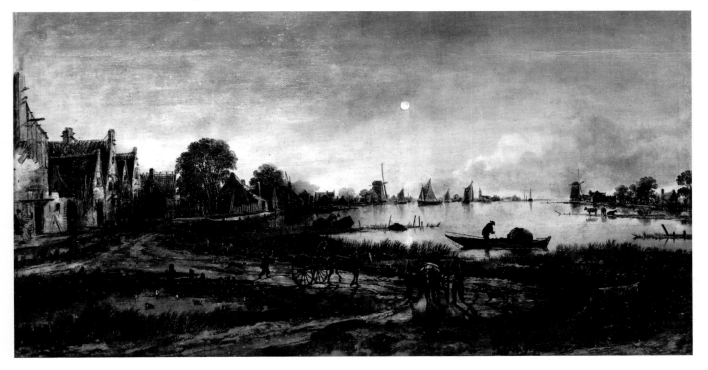

263. Frans Post: *São Francisco River and Fort Maurits*, 1638. Paris, Louvre

Frans Post (*c.*1612–80) is another landscapist resuscitated during our time. He was the brother of Pieter Post (1608–69), who was also a landscapist as well as a battle painter, and is credited with painting figures in several of Saenredam's architectural views, but he is better known as an architect who received commissions from the stadholders, the States General, the city of The Hague, and other municipalities in the northern Netherlands. Pieter also designed Huis ten Bosch, Amalia van Solms's *villa suburbana* near The Hague (see p. 231). Frans Post's works have a special historical interest. From 1637 to 1644 he made views of Brazil. They are the first firmly documented landscapes painted in the New World by a trained European artist, and are precious records of a Dutchman's reactions to a strange continent inhabited by exotic natives, plants, and beasts. Frans Post was one of the artists in the retinue of Prince Johan Maurits of Nassau-Siegen, the illustrious soldier and statesman who was sent to establish a secure footing for the Dutch West India Company in the northeastern part of Brazil after the Dutch seized the settlement the Portuguese had established there. Scientists, engineers, and architects, as well as artists, accompanied Johan Maurits. A sketchbook with views made on the voyage and in Brazil, and six paintings that depict views of the Dutch colony are the only surviving works Post made during the course of his trip to the New World. His simple and direct approach is best seen in the *São Francisco River and Fort Maurits* (1638, Paris, Louvre) [263]. The far bank of the broad river appears to offer an accurate topographical view of the fort and its setting, and on the near bank a giant cactus and a capybara, a large Brazilian rodent, are sharply silhouetted. The rather naïve quality of Post's pictures has earned him the title of the 'Douanier Rousseau' of the seventeenth century. Upon his return to Holland in 1644 he settled at Haarlem, where, for the rest of his career, he continued to represent the New World with the help of his early studies. In 1648 he painted a *Sacrifice of Manoah* (Rotterdam, Boymans-van Beuningen Museum) [264] set in a Brazilian landscape, complete with banana trees, cacti, an armadillo, and an iguana. It is Post's only known historical subject. However, the figures of Manoah, his wife, and the angel, who has announced that Manoah's barren wife will bear a son who will deliver Israel from the Philistines, are not by Post; Samson's future parents and the heavenly messenger are by a collaborator who has been variously identified as Bol, Flinck, Salomon de Bray and Claes Moeyaert. Post's late views of Brazil lack the fresh originality of the ones painted on the spot. He remained impervious to contemporary developments in Dutch landscape painting, and often resorted to the old-fashioned devices of organizing a bird's-eye view by a dark framing of the foreground, and use of a brown-green-blue colour scheme to achieve the suggestion of a vast space. Additionally, he copied himself; he frequently repeated his own motifs and compositions.

Albert Eckhout (active 1637–d. after 1664) also accompanied Johan Maurits to Brazil, where he made paintings, drawings, and watercolours of the natives and the flora and fauna. Johan Maurits gave a series of Eckhout's paintings to Frederick III of Denmark in 1654. These include some full-length, life-size portraits of Tupi and Tapuya Indians (Copenhagen, Ethnological Museum), which show the considerable adjustments a seventeenth-century artist made when he painted American Indians to fit seventeenth-century ideas of a noble savage. In 1678 Johan Maurits once again used New World material as a gift for royalty. In that year he presented Louis XIV with a series of forty-two pictures of Brazil, as well as some ethnological objects. The gift, which included paintings by both Frans Post and Eckhout, was offered to the French king to serve as a source for a set of tapestries. French designers put it to good use when they made a magnificent set of Gobelins known as the *Anciennes et Nouvelles Indes* (Paris, Mobilier National).

An artist whose views of foreign lands had a greater impact on the repertoire of Dutch landscapists than Frans Post or Eckhout was Allart van Everdingen (1621–75), who introduced and popularized the Dutch vogue for rocky mountainous Scandinavian landscapes and dramatic waterfalls. Born in Alkmaar he was a younger brother of the history painter Caesar van Everdingen (see p. 233). Allart's works support Houbraken's report that Roelandt Savery and Pieter de Molyn were his teachers, but he began in 1640 mainly as a seascape painter in the monochromatic tradition of Jan Porcellis. The trip he made in 1644 to the southeastern coast of Norway and the area around Göteborg in western Sweden inspired his new speciality. He returned to Holland and settled in Haarlem in 1645 with a stock of Scandinavian themes: rocky coastal scenes, mountainous landscapes studded with spruce and fir forests, torrential waterfalls, log cabins, and water mills. Subsequently, he incorporated these northern motifs into his numerous paintings [265], drawings, and etchings. His early treatment of mountainous themes recalls works his probable teacher Roelandt Savery made in the Tyrolean Alps for Emperor Rudolf II of Prague during the first decade of the century, but from the beginning Everdingen eliminated traces of Savery's Mannerist artifice. In 1652 he moved to Amsterdam and, apart from a few trips to Spa and the Ardennes in the southern Netherlands that can be deduced from several of his works, he spent the rest of his life in the metropolis. There is no reason to believe he returned to Sweden in the 1660s to paint the choice commission he received from the powerful Trip family, Europe's leading munition manufacturers, a large view of the family's *Cannon Foundry at Julitabroeck in Södermanland, Sweden*, now at the Rijksmuseum, and four overdoors, still *in situ* in the Trippenhuis in Amsterdam. He painted a few other topographical scenes but the bulk of his output after 1660 consists of nordic waterfalls in an upright format, with fluid paint applied broadly, in colour harmonies that range from dominant browns to pastel pinks, blues, and greens. Over 500 of his landscape drawings are known. His large production as an etcher includes a set of illustrations for the fable of Reynard the Fox. He also experimented with the relatively new medium of mezzotint. Allart's only known pupil is the marine painter Ludolf Bakhuizen. Among the artists he influenced are Jan van Kessel, Roeland Roghman, and later, in the nineteenth century, the Norwegian painter Johan Christian Dahl (1788–1837), but the most notable by far is Jacob van Ruisdael. Everdingen's Scandinavian waterfalls (the earliest painted one is dated 1646) served as a point of departure for those Ruisdael began to paint about a decade later in Amsterdam. Although Ruisdael convinces us, more frequently than Everdingen, that his paintings of powerful waterfalls cascading over heavy boulders and dead trees set in rugged northern mountains covered with giant spruces are based on his own firsthand studies of these motifs, he did not know them from direct observation. Ruisdael never travelled to Scandinavia. His vision of nordic landscape was derived from Everdingen's art, not nature.

The panoramic views that the remarkable landscapist and prolific draughtsman Philips Koninck (1619–88) began to

264. Frans Post: *The Sacrifice of Manoah*, 1648. Rotterdam, Boymans-van Beuningen Museum

265. Allart van Everdingen: *Scandinavian Landscape with a Waterfall*, 1650. Munich, Alte Pinakothek

266. Philips Koninck: *Panorama with Farmhouses along a Road*, 1655. Amsterdam, Rijksmuseum

267. Jacob van Ruisdael: *Windmill at Wijk bij Duurstede*, c.1668–70. Amsterdam, Rijksmuseum

make in the mid-forties also belong to the tonal phase. Although Houbraken tells us he was Rembrandt's pupil, we know that even before he settled in Amsterdam in 1641 he had already produced some independent works after studying in Rotterdam with his brother Jacob, who was also a landscapist. Koninck most probably arrived in Amsterdam after completing his training; moreover, a pupil-teacher relationship was not normally established in seventeenth-century Holland when an artist was in his twenties. However, a Rembrandt connection does exist. In 1640 Koninck married the sister of Abraham Furnerius, a Rembrandt pupil whose drawings are close to Koninck's, and a document tells us that Koninck and Rembrandt had a business transaction in 1652. In brief, Koninck almost certainly was not Rembrandt's pupil, but belonged to his circle of friends. Nevertheless, there can be no question that Koninck's early small extensive flat landscapes are organized with an emphatic chiaroscuro effect that recalls the art of Rembrandt. In his numerous landscape drawings he also is dependent upon the older master; he adopted Rembrandt's sketchy penmanship of about 1640 for them.

If Koninck's development had stopped in the middle of the century, he would be remembered as a talented Rembrandt follower. But from about 1649–50 until around 1665 he created a series of very large panoramic views in a distinctive personal style. They are more closely related to the classical phase of Dutch landscape painting than the tonal style and are amongst the great glories of Dutch art. *Panorama with Farmhouses along a Road* of 1655 [266], a six-footer, with its effect of a vast distance that seems to extend to infinity and its view of an imposing, heavily clouded yet lucid sky which casts shadows over the vast countryside, is characteristic of this group of masterworks. Rembrandt painted nothing similar – in fact, Rembrandt never painted a panorama *pur*. For comparable pictures of the grand sweep of an extensive view with subtle gradations that make space convincingly continuous to the distant horizon one must turn to the earlier rare paintings by Hercules Segers or the later majestic imaginary flat landscapes and views of the plains near Haarlem by Jacob van Ruisdael. The countryside seen in Koninck's powerful panoramas resembles the landscape of the eastern province of Gelderland but in none does he offer a topographical clue that helps pinpoint a site. A probable source for the three cottages at the side of the road in the Amsterdam painting can be identified, however; they resemble the farmhouses in Rembrandt's landscape etching *Three Gabled Cottages beside a Road* (Bartsch 217).[10] In the late 1660s Koninck shifts from the monumental grandeur of his panoramas to a more idyllic mood, his paint becomes thinner, and his touch less vigorous. During the last decade of his life he virtually stopped working as an artist. He seems to have been prosperous during these years, but it is not clear if his income was derived from his art or the inland shipping line he owned that travelled from Amsterdam to Rotterdam. Koninck was also active as painter of history picture, portraits, and low-life genre scenes. He portrayed the poet Vondel more than once. Vondel, in turn, praised his work as a portraitist and a history painter, but never mentioned the landscapes for which Koninck is best remembered today.

CLASSICAL PHASE

During these years, a new generation of Dutch artists achieved a more monumental landscape. Nature still dominates the scene, but an increased power of stylization makes it speak with greater force. The previous tonal phase, with all its admirable qualities, its plausible rendering of atmosphere, its lively and suggestive painterly touch remained somewhat pale and weak through the lack of strong contrasts and structural accents within the composition. The younger generation wanted something more grandiose. They built up their pictures in vigorous contrasts of solid forms against the airy sky, of light against shade, of cool against warm colours. They created a synthesis of the tectonic and the fluid, of static and dynamic elements, and of colouristic and atmospheric accents. With a kind of heroic spirit, the new masters singled out a windmill, a tree, or an animal and raised it with a monumental feeling to a significant and representative motif seen against the sky. These invigorated motifs become the focus of the composition. They keep the whole design in a state of high tension and hold everything rhythmically

and emotionally related to it. Thus in Jacob van Ruisdael's *Windmill at Wijk bij Duurstede* [267], painted about 1668–70, the sky responds in its cloud formations to the mighty wings of the windmill, and in Aelbert Cuyp's *Hilly Landscape with Cows and Shepherds* [268], datable about a decade earlier, the strong horizontal of the standing cow is echoed in the hazy distance of the rolling country and lends firmness and structure to the whole design. As in Rembrandt's mature phase, which is approximately contemporaneous, these landscapes show classical elements which strengthen the compositional power. Horizontals and verticals are co-ordinated with the Baroque diagonals, which are still alive and help to create a mighty spaciousness. The atmospheric quality is as important as ever in uniting the whole impression. Light breaks now with greater intensity through the clouds, and the clouds themselves gain in substance and volume. The sky forms a gigantic vault above the earth, and in Ruisdael's *Mill at Wijk bij Duurstede* it is admirable how almost every point on the ground and on the water can be related to a corresponding point in the sky. Before such examples of Dutch landscape painting in its mature period it is evident that the terms

268. Aelbert Cuyp: *Hilly Landscape with Cows and Herders*, c.1655–60. New York, Metropolitan Museum of Art, Altman Bequest

'realistic', 'imitative', 'lacking in ideal content' hardly touch the significance of these masterpieces. The force of stylization, or put another way, the power of expressive organization, is as remarkable as the depth of feeling before nature and the pictorial beauty.

The foremost artist of this phase is Jacob van Ruisdael (1628/9–82). He was born at Haarlem, the son of the framemaker and painter Isaack van Ruisdael (1599–1677) The name of his teacher is not documented, but Jacob's early works indicate that his father's paintings had a formative effect,[11] and the influence of his uncle Salomon van Ruysdael and Cornelis Vroom is evident as well. In 1648 Ruisdael (he invariably signed his name 'Ruisdael' never, to our knowledge, 'Ruysdael') was inscribed as a member of the Haarlem guild. He travelled in the early fifties with his friend Nicolaes Berchem, the Italianate landscape painter, to the border region between the newly established Dutch republic and Germany, where his romantic sense discovered

new motifs in the area's rolling countryside, particularly its characteristic water mills, rushing streams, woods, and castles. Young Ruisdael was, however, equally susceptible to the Dutch countryside, especially the sand dunes and the bright atmosphere near Haarlem, which he also portrayed during these years. Both trends, the romantic and the realistic, remained strong after he moved to Amsterdam where his residence is documented in 1657. Here he began to paint his nordic waterfalls which met with a certain popular success, but he continued also to the very end to paint views of the indigenous countryside in all its different aspects. A survey of his large *œuvre* reveals he painted virtually every subject depicted by Dutch landscapists: dunes and country roads, grainfields, panoramas, rivers and canals, woods and

Detail of fig. 267, *Windmill at Wijk bij Duurstede*

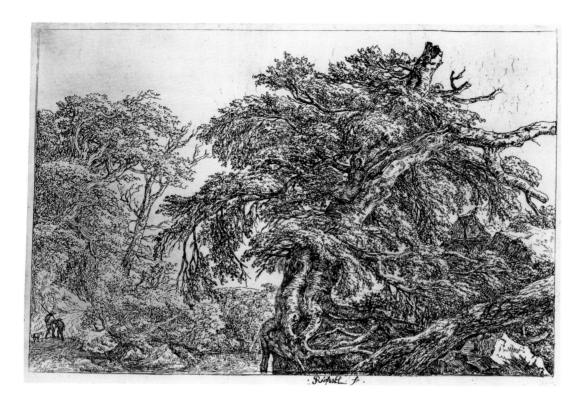

forests, ruins, winter scenes, water and windmills, city views, mountain scenes, Scandinavian landscapes, and seascapes and views of beaches as well. No seventeenth-century landscapist rivals his range. It seems that the only subject he never attempted is an Italianate landscape. About 130 drawings can be attributed to him which range from quick chalk studies probably done in the spot as *aides-mémoire* or composition studies to carefully finished ones designed as independent works. He was not very active as a printmaker. Only thirteen etchings are known and all are datable to the first decade of his activity. His emphasis on the powerful growth of natural forms, seen in his etching of a heavily foliated gigantic ancient beech clinging with its roots to a projection of cliff [269], is as keenly felt in his prints as in his paintings. Why he completely abandoned the technique he mastered so early remains an unsolved riddle.

Little is known about Ruisdael's private life. He did not leave a letter, a note, or a day book. No portrait of him has been identified, and none of his contemporaries made a reference to him. The name of only one of his patrons is known, a fact that indicates, like so many Dutch artists, he worked primarily for the open market. Houbraken writes in his thumbnail biography of him (1721) that his father had him taught Latin in his youth, and further had him trained in medicine, in which he became so proficient that he performed several operations in Amsterdam to great acclaim. Houbraken's story of 'Dr Ruisdael' has its advocates but the record is inconclusive. Ruisdael's production begins so early is hard to allow for training in medicine and, afterwards, the performance of operations in Amsterdam. His artistic development is so continuous and his production so extensive that it is difficult to think that there was time for a second profession, and it is even harder to believe that the

'Jacobus Ruijsdael' [*sic*] who took a medical degree at Caen University in Normandy as late as 1676 is identical with Holland's greatest landscapist, who died in 1682. Is it probable that the artist found time and energy to study for a doctor's degree in northern France during the final stage of his career? Naturally, the spelling 'Ruijsdael' is not an issue of great concern; orthographic changes made by scriveners are not uncommon in seventeenth-century Holland. However, the entry in Amsterdam's *series nominum doctorum* that states 'Jacobus Ruijsdael' took his medical degree at Caen on 15 October 1676 is vigorously scratched out in ink that appears to be identical to the ink used to inscribe it [270]. Why was it expunged? A satisfactory explanation for its deletion has not been found.[12]

Houbraken also writes Ruisdael 'remained a bachelor to the end of his life, men say in order the better to support his old father'. Impressive evidence of his care for his father is offered by the generous provision he made for him in two wills he had drawn up in 1667; his stepmother, who was buried in a pauper's grave in 1672, is not even mentioned in them. For a long time it was thought that toward the end of his life Ruisdael entered Haarlem's Alms House and died there a miserable pauper, circumstances that seem to con-

270. Excerpt from the List of Amsterdam Doctors showing the deletion of the name of 'Jacobus Ruijsdael' who received his medical degree at Caen, 15 October 1676. Amsterdam, Municipal Archives

269. Jacob van Ruisdael: *The Great Beech, with Two Men and a Dog*, c.1651–5. Etching

271. Jacob van Ruisdael: *Trees in a Dune, with a View of Haarlem in the Distance*, c.1647. Paris, Louvre

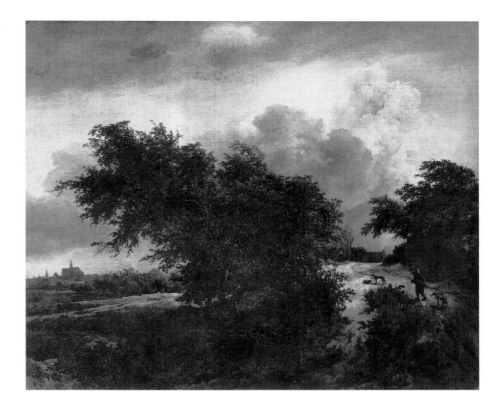

firm Houbraken's comment that he 'could find no hint that fortune was his friend'. But it has been shown that the story of his miserable end is a myth based on a mistaken identity. It was his cousin, the landscapist Jacob Salomonsz van Ruysdael who died impoverished at the Alms House in 1681, not Jacob Isaacksz van Ruisdael.[13] Contemporary records indicate that the artist was not without means and that his pictures were appraised at fair prices during his lifetime. He was not rich, but he earned his bread, and probably a bit more. In 1674 his estate was worth enough to be assessed the special 200th penny tax Amsterdam levied on its citizens to help pay for the costly war that drove Louis XIV from the gates of the city in 1672. The ½ percent tax was demanded only from citizens whose effects were worth more than 1,000 guilders. Jacob paid 10 guilders, an indication that his possessions were valued at 2,000 guilders. In 1678, four years before his death, he was able to extend a loan of 400 guilders to a citizen of Amsterdam.

Ruisdael is one of the exceptional painters who appears on the scene as a precocious complete master. He was active as an independent artist even before he was inscribed as a member of the Haarlem guild in 1648. More than a dozen of his works are signed and dated 1646, when he was a seventeen- or eighteen-year-old teenager, and in the following year the number increases. In these early works there is no fumbling or groping. On the contrary, from the beginning he surpasses his models by his ability to enlarge a detail of nature into a central motif (*Dunes*, 1646, St Petersburg, Hermitage). The sand dunes and clumps of trees around his native town which were his favourite subjects during these years are rendered with loving care and from the moment we recognize his hand until his last years he gave unprecedented meticulous attention to arboreal detail. He was the first artist to depict a variety of trees that are consistently and unequivocally recognizable to the botanist on account of their overall habit.[14]

Jacob's early compositions excel by a great power of concentration and by their vigorous accents and strong coherence. His paint does not have the thin, vibrant quality of Salomon or of van Goyen. He used a heavier paste, which gives his foliage a new rich quality, and one senses that sap flows through the branches and leaves. The people who figure in the early landscapes are not bustling or busy working, like those found in pictures by Salomon van Ruysdael and van Goyen: they appear to stroll contemplatively, or sit and take in the view. There is a convincing impression of depth, but the emphasis is not upon the distant view. Trees, not yet the clouds, are Ruisdael's early heroes. From the moment he picked up his brushes, Ruisdael saw trees as personalities [271]. The artist makes us feel the vital force of their organic growth and the incessant movement which gives them their form. They are mightily rooted in the ground, and their trunks bend in and out, as if they are full of energy, while the branches reach out into space with expansive power. There is both three-dimensional and atmospheric life; the silhouettes are never hard or schematic, but always interesting, and also convincing in their transitions to the air and sky.

During the years from about 1650 to about 1655, the heroic quality of Ruisdael's landscapes increases. The forms become larger and more massive. Giant oaks and beeches as well as shrubs acquire an unprecedented abundance and fullness. Colours become more vivid, space increases in both height and depth, and there is an emphasis on the tectonic structure of the compositions. He strove to achieve heroic effects without sacrificing the individuality of a single tree or

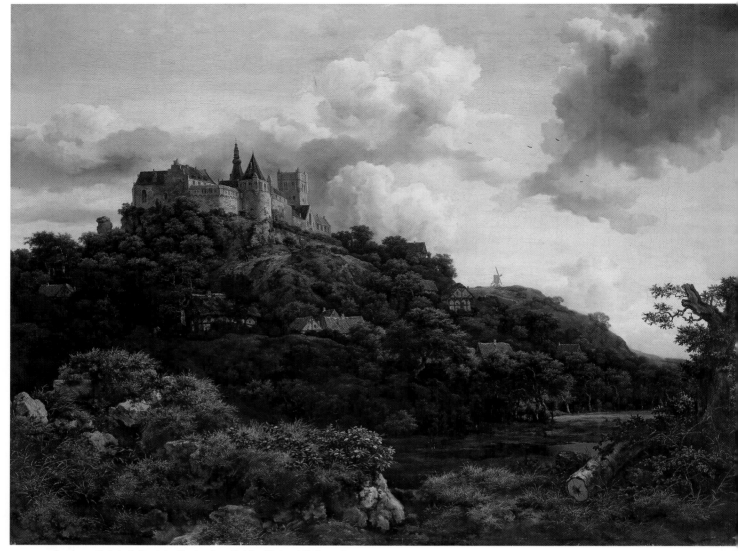

272. Jacob van Ruisdael: *Bentheim Castle*, 1653. Dublin, National Gallery of Ireland

bush. An outstanding example of this tendency is his mighty view of *Bentheim Castle*, dated 1653, at Dublin [272]. Ruisdael visited Bentheim, a small town in Westphalia near the Dutch-German border, when he travelled to the region with his friend Berchem in the early fifties. Bentheim's castle is, in fact, on an unimposing low hill, but in his painting Ruisdael enlarged it into a wooded mountain providing the castle with a commanding position. His invention is a superb expression of his aggrandizement of solid forms during this phase. The dense mass of the mountain, obliquely stretching away into depth, and the coulisses on either side of the front edge of the painting are reminiscent of compositional schemes used by the generation of his teachers, but the spatial clarity is new, as are the strong colours, the energy of the brushwork, and the way he unifies the close view of a nearly overwhelming wealth of detail with the most distant parts of the landscape into a consistent whole. The impact of the broad prospect is as intense as the vegetation seen close up. Ruisdael continued to include Bentheim Castle in his landscapes, seen in various settings and from different viewpoints, until his very last years. Although none have survived, he must have made drawings of it at the site which later served as preliminary studies for paintings.

Another motif Ruisdael discovered on his trip to the Dutch-German border region was the water mill. The half-timbered overshot and undershot mills he favoured were found in the eastern provinces of the Netherlands and in the area near Bentheim. Of course, earlier artists included water mills in their pictures but he was first to make them the principal theme of a painting. The subject became one of the specialities of his pupil Meindert Hobbema, and today, when we think of them, his paintings not Ruisdael's come to mind. But in judging their respective accomplishments it is helpful to recall that Ruisdael painted powerful ones, such as *Two Water Mills and an Open Sluice*, dated 1653 [273], which impresses by the cohesion of its forms and clear daylight effect, before Hobbema held a brush in his hand.

During this stage of his development Ruisdael also painted grand views of woods and dense forests. He began by making them loosely knit, but soon pushed back the masses of trees, stressing large motifs, introduced sharp light accents that help untangle dense spatial relationships and provided small openings that offer vistas to a distant horizon. By the mid-fifties his forest scenes attain a new order, clarity, and stateliness that express the nobility and peaceful beauty of the forest; an outstanding one is *Grain Field at the Edge of a Forest* at Worcester College, Oxford.

Ruins sometimes play a prominent role, and gloomy skies set a melancholy mood. Ruisdael's rare ability to create a compelling and tragic mood in nature is best seen in his famous *Jewish Cemetery* at Dresden [274]. A larger, more elaborate autograph version is at the Detroit Institute of Arts.[15] These works are moralizing landscapes that were painted with a deliberate allegorical programme. The combination of their conspicuous tombs, ruins, large dead beech trees, broken trunks, and rushing streams alludes to the familiar themes of transience and the vanity of life and the ultimate futility of human endeavour, while the burst of light that breaks through the ravening clouds in each painting, their rainbows and the luxuriant growth that contrasts with

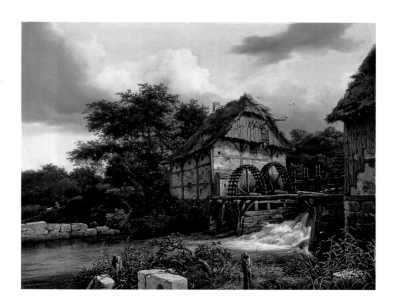

273. Jacob van Ruisdael: *Two Water Mills and an Open Sluice*, 1653. Los Angeles, J. Paul Getty Museum

274. Jacob van Ruisdael: *The Jewish Cemetery*, c.1655–60. Dresden, Gemäldegalerie

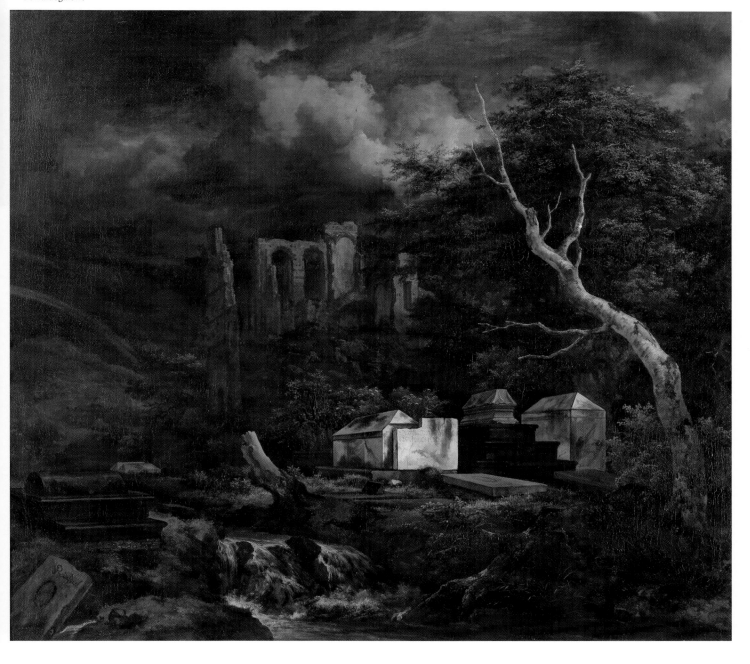

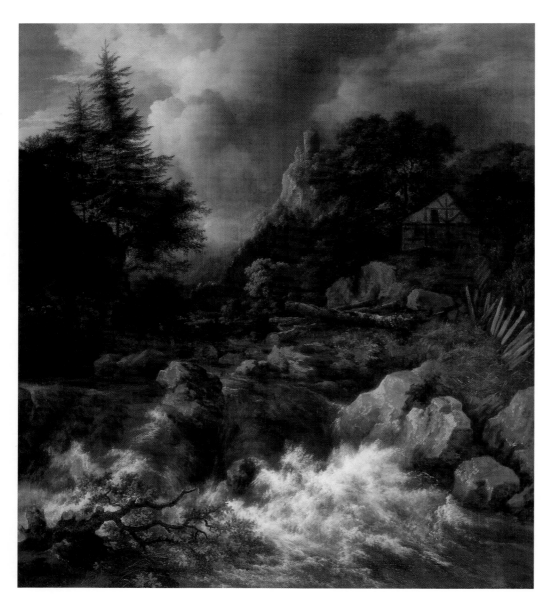

275. Jacob van Ruisdael: *Waterfall in a Mountainous Northern Landscape, with a Castle and a Cottage*, c.1665. Cambridge, Massachusetts, Harvard University Art Museums, Fogg Art Museum

the dead trees offer a promise of hope and renewed life. The masterliness of the Dresden painting lies in the artist's clear and concentrated presentation of these ideas. The eye focuses on the three tombs in the middle distance, where the light is centralized. They present a truthful picture of the actual, identifiable sarcophogi as they can still be seen in the Portuguese-Jewish Cemetery at Ouderkerk on the Amstel River near Amsterdam. Ruisdael made carefully worked-up drawings of the tombs, one of which he used as a preparatory drawing for the paintings. But the landscape settings of the Dresden and Detroit paintings bear no resemblance whatsoever to the site at Ouderkerk. They are Ruisdael's inventions. The cemetery never had monumental ruins. Those seen in the Dresden version were transplants from the shattered remains of Egmond Castle near Alkmaar, a site about forty kilometres from Ouderkerk; they also are based on a preparatory drawing. The ruins seen in the Detroit painting are probably derived from the ruins of Egmond's old Abbey Church. A rushing stream does not bisect the actual burial ground. (Would anyone in his right mind place

tombs near a vigorous stream which would wreak havoc with the tombstones and coffins beneath them when it flooded?) The stream was included as a traditional allusion to the passage of time. Most remarkable is the barren beech tree in the Dresden picture that gestures toward the three tombs and heavenwards. If ever a tree was capable of seducing a viewer to accept the pathetic fallacy of endowing natural forms with human feelings and emotions it is this dead beech.

The iconographical programme of Ruisdael's two versions of the *Jewish Cemetery* leaves no doubt that they were intended as moralizing landscapes. He made no others that can be given a similar unmistakable reading. None of his other existing paintings include tombs; those done by his contemporaries are rare, and some of them are based on his depictions of the sarcophagi at Ouderkerk. However, Ruisdael made numerous pictures that include identifiable or imaginary ruins, dead and broken trees, rushing streams, rivers, and waterfalls. Were these motifs invariably intended by the artist as symbols of transience and the vanity of life,

and does the handful of them that include rainbows allude to hope? It has been argued that this is indeed the case, and that these motifs not only offer the iconographical essence of Ruisdael's landscapes but offer the key to the meaning to seventeenth-century landscape painting. According to this interpretation they were intended as visual sermons to convey the biblical message that man lives in a transient world beset by sinful temptation, but may hope for salvation.[16]

Now, there may have been some devout Dutchmen who chose to interpret these motifs as homilies or metaphors for biblical messages, but it is noteworthy that not a single contemporary source indicates that landscape paintings were viewed this way. Equally important, motifs in these landscapes, like those in so many Dutch pictures, can be given different readings. They are not devoid of ambiguities that permit more than one interpretation. Ruins were also included in pictures as parts of topographical views or for their historical assocations. Dead trees juxtaposed to live ones and luxuriant growth have their natural share in an undiluted image of nature. It strains credulity to accept the notion that every river and waterfall, every ruin and tumble-down cottage, every withered tree in Dutch landscapes are intentional allusions to transience and the *vanitas* theme, that forests were depicted because they represent the dangerous world through which man must pass before he reaches the goal of eternal life, that every wayfarer in a Dutch landscape is an image of man on the road of life, and, since bridges can be read as symbols of Christ, that every image of a person crossing one must needs allude to man *en route* to salvation. An interpretation of Dutch landscape that admits one and only one reading impoverishes the subject. In addition, it fails to take into account how skimpy and flimsy our knowledge of the intentions of Dutch artists is. Broad generalizations based on it are correspondingly shaky.

After Ruisdael had settled in Amsterdam about 1656–7 his compositions broaden, and a certain heaviness in the foreground disappears. The opening of the view suggests that he was impressed by Philips Koninck's panoramic views, but the fresh atmospheric effect, the brilliant glittering daylight which brightens the landscapes, the reflections, and vivid colours in the shadows are completely personal. In the late fifties Ruisdael also began to represent waterfalls in mountainous northern valleys, and in the sixties they became an important theme in his *œuvre*. We have already heard this motif was popularized by Allart van Everdingen after he returned to Holland in 1644 from a trip to Norway and Sweden, and that Ruisdael, who never visited Scandinavia, derived his torrential falls [275] in northern landscapes from Everdingen's art. In his biography of Ruisdael, Houbraken singled them out for special praise, and without, it should be added, a reference to waterfalls as a symbol of the transitoriness of human life:

He painted nature and foreign landscapes, but especially those in which the water is seen crashing down from one rock to another, and finally to spread out in a roar [*geruis*] (to which his name appears to allude) down through the valleys [*dalen*] or spraying out. He could depict water splashing or foaming as it dashed upon the rocks, so naturally, delicately and transparently that it appears to be real.

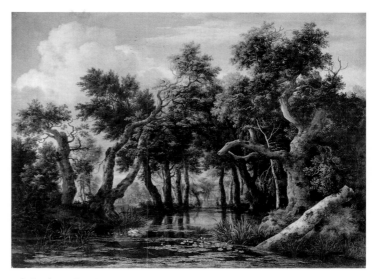

276. Jacob van Ruisdael: *Marsh in a Forest*, c.1665. St Petersburg, Hermitage

277. Jacob van Ruisdael: *Grain Fields*, c.1670. New York, Metropolitan Museum of Art, Altman Bequest

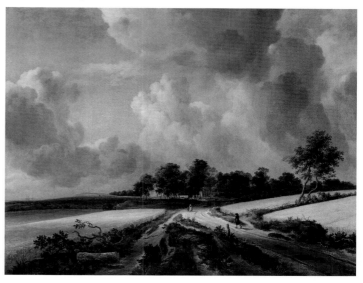

The only other theme Houbraken mentions is Ruisdael's turbulent seascapes, and again without a single moralizing word regarding the sea as a metaphor for life as a voyage fraught with danger.

Among Ruisdael's most personal creations are his large forest scenes of the sixties. In the *Marsh in a Forest* of about 1665 at the Hermitage [276] powerful trees form a mighty group around a lonely pond. The decayed ones speak with their winding branches as vividly as those in full growth. There is more spaciousness now than there was in the earlier phase of the fifties. Massive trees no longer virtually seal off middle and background vistas. One can look into the distance under the trees, and the sky plays a more pronounced role. There is air all round, and the local colour, which was very distinct in the bluish green of the fifties, is somewhat neutralized by a greyish tint in the bronze-brown foliage. In this particular case Jacob van Ruisdael based his composition on a design of Roelandt Savery which was accessible through the engraving of Egidius Sadeler. Yet the

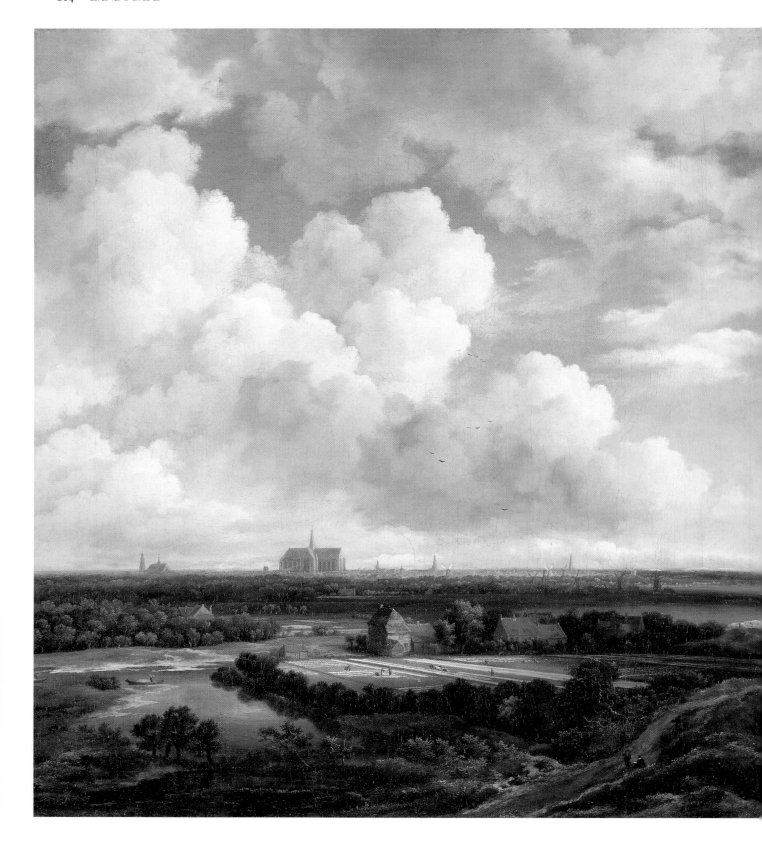

278. Jacob van Ruisdael: *View of Haarlem, with Bleaching Fields*, *c*.1670. Zurich, Kunsthaus, Stiftung L. Ruzicka

transformation of the Mannerist's work into his heroic terms is more significant than the dependence on it. Ruisdael did not accept the bizarre and ornamental play with nature's forms. He created an archetype of the splendour and grandeur of nature.

Of about the same time and equally imposing are the *Windmill at Wijk bij Duurstede*, mentioned above, and many firsthand views of the Dutch landscape in its various aspects. The sea, the shore, the vast fertile plains [277] now become important subjects side by side with the woods and water-falls, and they are always seen under a majestic sky. In his panoramic views of Haarlem with its bleaching grounds, which continue into the seventies, the master's hand is felt in the strength and deceptive simplicity of the compositions. Bleaching fields were familiar sights in his time. After brewing, bleaching linen manufactured in Holland and unbleached cloth imported from England, Germany, and the Baltic Countries was Haarlem's major industry. Jacob's *Haarlempjes* – as they were called in his day – appeal to us because they offer what is now accepted as the most charac-teristic view of the Dutch countryside while achieving an unparalleled degree of openness and height. The one at Zurich, a summit of Jacob's achievement, is an exemplar of the type [278]. Its sky, as the skies in most of them, takes up more than two thirds of the canvas, but the impression of height is increased here by the vertical format, and still more by the dominant part the towering, strongly modelled clouds play in the awe-inspiring aerial zone. The prospect of the plain is shown from an exceptionally distant and elevated point of view. As a result there is a reduction both in scale and in overlappings of the watery dunes, woods, and tracts of land. The firm cohesion of the great cloudy sky gains in mass and significance from its relations to the diminutive forms. The eye can explore here – more than in most other *Haarlempjes* – the vast expanse of this land richly differen-tiated by the gradations of alternating bands of light and shadow into the distance toward a horizon stretched taut as sinew.

Winter landscapes also occur and they are not the least remarkable. In the first-rate example of one at Munich [279] forbidding dark clouds hang over a forlorn snow-covered scene. There is no trace here of the gaiety of Avercamp's better known winterscapes and, unlike his, Ruisdael's con-jures up no image of skaters and other delights of the season. Its subject is a rarer one: the brooding mood of a winter day darkened by threatening clouds.

Around the middle of the seventies Ruisdael's forms become thinner, his touch acquires a miniature-like meticu-lousness, composition loosens, and the mood turns idyllic. Although some impressive paintings can be assigned to his last years (e.g. his *Panoramic View of the Amstel looking toward Amsterdam*, Cambridge, Fitzwilliam Museum, which is datable about 1681 on the basis of topographical evidence), one gains the impression that this great landscapist experienced a weakening of his creative power in his final years.

Among Ruisdael's followers and imitators are his cousin Jacob Salomonsz van Ruysdael, who specialized in wooded landscapes with cattle, and four artists who did dunescapes as well as woods: Cornelis Decker (before 1623–78), Adriaen Verboom (*c*.1628–*c*.1670), Roelof van Vries

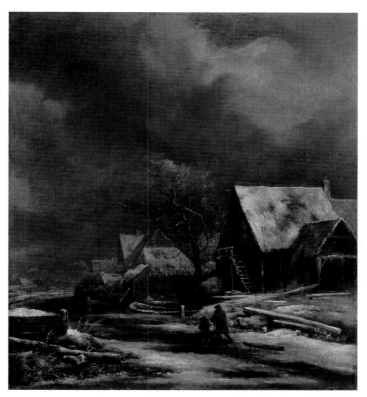

279. Jacob van Ruisdael: *Village in Winter*, *c*.1665. Munich, Alte Pinakothek

(*c*.1631–after 1681) and Salomon Rombouts (active 1652–63). Extensive flat landscapes and panoramic views of Haarlem by Jan Vermeer I van Haarlem (1628–91; also called Johannes van der Meer I) show the impact of Ruisdael's style and so do those by Jan van Kessel (1641–80). Kessel, who may have been Jacob's pupil, treated many other themes depicted by Ruisdael and several of his paintings have passed as works by the master, sometimes with the help of a spurious signature covering his genuine one, as is noted below.

Meindert Hobbema (1638–1709) was Ruisdael's most important follower and his only documented pupil. In 1660 Ruisdael testified that Hobbema 'served and learned with him during several years' in Amsterdam, but it seems that during his youth Hobbema was also stimulated by Salomon van Ruysdael, Cornelis Vroom, and perhaps Anthonie van Borssum (1630/1–77). The small, light-coloured pictures Hobbema made from about 1658 (*River Scene*, 1658, Detroit Institute of Arts, is his earliest extant dated work) until about 1661 show little of the coherence and energy which charac-terize Ruisdael's works. Only about 1662 is the influence of the older master unmistakable. Hobbema's *Forest Swamp* of 1662 at Melbourne (another version, datable about the same time, is in the Thyssen-Bornemisza Foundation, Madrid) is actually based upon one of Ruisdael's etchings (Bartsch 4), and other works of this time show Ruisdael's motifs. Jan van Kessel's copy after the same Ruisdael etching that Hobbema used as a source for his two paintings is at Dresden; acquired for the Dresden gallery before 1743 as a Ruisdael, it passed for an original by the master until it was recognized in the 1920s that a fake Ruisdael signature covered Kessel's auto-graph one.

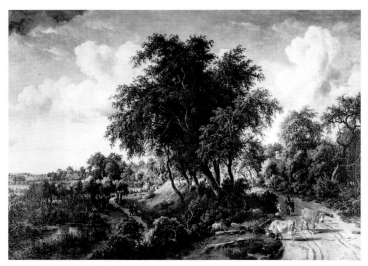

280. Meindert Hobbema: *Landscape with Trees and a Causeway*, 1663. Dublin, National Gallery of Ireland

281. Meindert Hobbema: *Water Mill*, c.1663. London, Wallace Collection

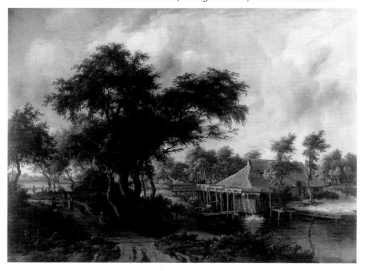

In 1663 Hobbema's style gained more independence (*Landscape with Trees and a Causeway*, 1663, Dublin, National Gallery of Ireland) [280] and, during this and the following years up to 1668, he created a series of masterpieces which gave him an outstanding position side by side with Ruisdael among the great landscapists of Holland. His outlook on nature is less brooding, more sunny and vivacious than Ruisdael's. While the latter favoured compactness of form and composition, Hobbema's tree groups are less tightly built, and their silhouettes are rather feathery. He likes to open up his compositions with various outlooks into a shiny distance, and his luminous skies of an intense white and blue permeate the whole with sparkling daylight. Hobbema's painterly touch is more fluid, and the colours are richly varied in an interplay of bright green and light brown, fine greys, and reds. Often an appealing blond tonality prevails. But Ruisdael is the more resourceful artist. He shows a far greater range of subject matter, and his moods are deeper, his compositions more powerful. Hobbema's favoured motifs are sunny forest scenes opened by roads and glistening

ponds, fairly flat landscapes with scattered tree groups, and water mills. He had a special love for the last named subject; almost three dozen paintings of his water mills are known. None of his contemporaries painted nearly as many. As we have seen, it was his teacher Ruisdael who first made the motif the principal subject of landscapes [see fig. 273 for one dated 1653]. The overshot water mill that figures in Hobbema's characteristic landscape datable about 1663, now in the Wallace Collection [281], was the type found in the eastern province of Gelderland that flanks the German border. In the early fifties, when Ruisdael travelled in the area he made four drawings of the same or very similar mill seen from different viewpoints that served him as preparatory studies for four paintings.[17] Drawings by Hobbema are also known of the mill. Whether he made them on the spot in Gelderland or based them on his teacher's studies is moot. A close variant of the Wallace Collection *Water Mill* is at the Art Institute of Chicago and another version is at the Rijksmuseum, Amsterdam.

Hobbema's output diminished considerably after 1668 when he received the well-paid position as a wine gauger of Amsterdam's octroi and married the maid of an Amsterdam burgomaster. Ruisdael was a witness at this marriage, and one can assume that the two men remained in friendly contact. More certain is Hobbema's close relationship with Jan van Kessel; he was witness and godfather at the baptism of Kessel's infant born in 1675. Hobbema's new position, which he held until the end of his life, probably accounts for the slackening and a certain unevenness in his production during his late decades. A few works of this later period show his compositions broken up into too many detailed areas. The trees acquire an almost linear sharpness, and the pictorial effect hardens.

Yet there are some notable exceptions, one of which almost seems a miracle, because in this work Hobbema not only revives his old grandeur, but surpasses himself as a composer and painter of the Dutch countryside. This is the rightly famous *The Avenue, Middelharnis* [282] of 1689 in the National Gallery, London. It does not take away from the glory of this picture that there are precedents in Dutch landscape painting that date back to the first decades of the century for the conception of a strongly foreshortened road lined with trees in a wide flat landscape. Hobbema altered earlier schemes by centralizing the whole composition, focusing interest on the middle and far distance as well as the immediate foreground with its uncultivated grove on one side and orderly arrangement of saplings on the other, and by the unprecedented height of the lopped, thin trees which carry interest to the towering sky (regrettably, the sky was extensively damaged before the picture was acquired by the gallery in 1871; much of its paint surface is the work of modern restorers). The painting offers a topographically accurate view of the village of Middelharnis on the island of Over Flakee (Province of South Holland) in the mouth of the Maas; the view of the village from the Steene Weg (formerly Boomgaardweg) looks much the same today. Hofstede de Groot was so enchanted by this picture that he ranked it immediately after the *Syndics* by Rembrandt. However, in the mistaken belief that Hobbema gave up painting soon after he became a wine gauger he could not imagine

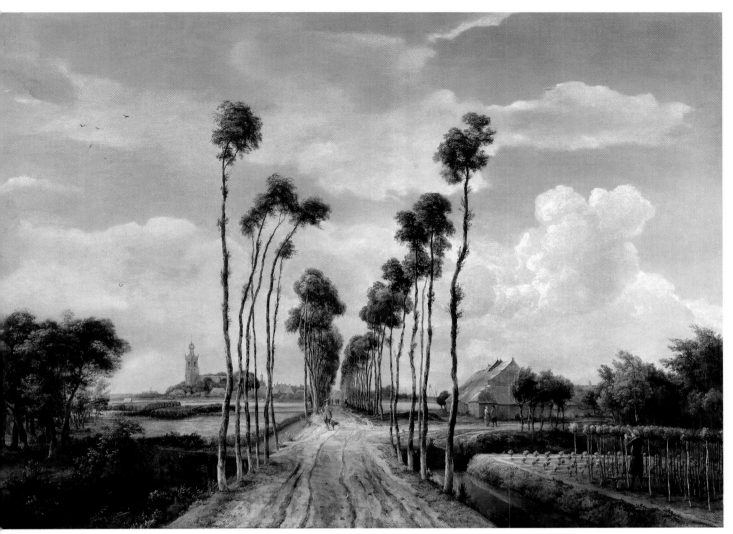

282. Meindert Hobbema: *The Avenue, Middelharnis*, 1689. London, National Gallery

that it was painted in 1689, after Meindert had been relatively unproductive for more than twenty years. So he read the date as 1669, since the third digit is a bit smudged. But is is certain that the date 1689 is correct, and there is, in fact, the exalted spaciousness which often characterizes the Late Baroque, and also a kind of elegance in the elongated, slender trees that goes with the taste of this phase. As for the revival of Hobbema's best pictorial faculties at this stage, it is unusual, but we can say that there is a lighter touch than we find in his work of the sixties. Whatever the rational explanation of the style and date of this masterpiece might be, it is the swan song of Holland's great period of landscape painting which fully deserves its high reputation.

Aelbert Cuyp (1620–91) lived and worked in his native town of Dordrecht, where he was highly respected and belonged by his marriage to the widow of a wealthy regent in 1658 to the patrician class. He owned a fine house in the city as well as a country seat near by. At the time of his death he was one of the city's wealthiest citizens. He apparently painted even less than Hobbema did during the last decades of his life; his activity as an artist seems to stop in about 1660. His first teacher was his father Jacob Gerritsz Cuyp (1594–1652), a portraitist and painter of history and genre pieces. In the forties father and son collaborated, the former

providing figures, the latter contributing the landscapes; only a few portraits by Aelbert have been identified. His earliest independent dated landscapes of 1639 are astonishly eclectic, but by 1641 Aelbert was painting panoramic views of the Dutch countryside in the monochromatic mode of van Goyen. The young Cuyp, however, favoured a distinct yellow tonality as against van Goyen's greyish and brown hues. More important for Cuyp's subsequent development was the impact of the Dutch landscapists who brought an Italianate style from Rome back to Holland; Cuyp himself never travelled to the south. Since very few of Cuyp's landscapes are dated, and none is dated after 1645, it is difficult to say precisely when the characteristic golden light, reminiscent of the Campagna the artist never saw, replaces the earlier paler one, and when mountain ranges, herds of cattle, and figures conspicuously set off against a sky begin to play an important role in his compositions. But his *Ruins at Rijnsburg Abbey* of 1645 (The Netherlands, private collection) indicates that by this date distinct traces of the style of Cornelis Poelenburgh, a member of the first generation of Italianate painters, and Jan Both, the leading artist of the following generation of Italianate landscapists, are evident. Jan Both became Cuyp's principal source of inspiration. Cuyp's *Tall Cliffs along a River* (Rotterdam, Boymans-van

Beuningen Museum), datable about 1650, shows how rapidly he assimilated Both's motifs and sun-drenched light. From this time onward golden sunlight becomes the all-pervading element in Cuyp's paintings. It spreads warmth and beauty over the Dutch countryside, where sturdy animals – most often cows – take the place of human heroes. They stand or rest in complete harmony with nature, breathing the invigorating air of the never-distant sea [283]. Herds of cows in Cuyp's paintings can be seen as allusions to the pride the Dutch took in their celebrated, profitable dairy industry. In literature and emblems of the time the cow was used as a symbol of various abstract ideas (fertility, loyalty, wealth, moderation, and as a symbol of the Netherlands).

Cuyp also made paintings of the lively activity on the great rivers of the Netherlands [284], most often the wide Merwede that forks at Dordrecht into the North Maas and

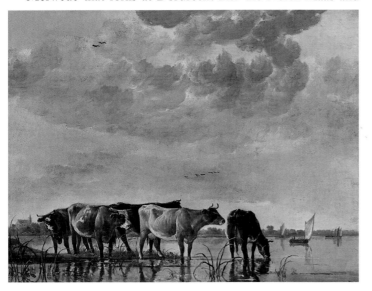

Lower Maas. It was Dordrecht's location at this juncture that made it one of the principal cities of the country until traffic on the Maas was diverted to Rotterdam. Cuyp's river scenes are usually set late in the afternoon and are seen against a luminous, sunny sky that sparkles and glistens on the calm water. He knew Dutch river life intimately. He travelled up the Rhine, and along the Maas, and the Waal making numerous drawings of huge sailing vessels, small craft, rafts, and also views of the land from the water. He was equally at home working on a large or a small scale, and could fill a canvas with the massive dark hull and rigging of a clumsy passage boat making way to a pier or with the decorative and elegant silhouettes of colourful figures on horseback riding into the evening sky [285]. In grandeur of composition Cuyp often matches Ruisdael and the best of Hobbema's work. As a colourist he seems even superior by the glow and richness of his warm palette both in his land and sea pictures. Abraham van Calraet (1642–1722) of Dordrecht was Cuyp's principal seventeenth-century follower. Confusion between the two is compounded by the signature 'A.C.' found on van Calraet's views of Dordrecht, pictures of horsemen, and still lifes; it is sometimes erroneously accepted as Aelbert Cuyp's own monogram. A century later Abraham van Strij (1753–1826), also of Dordrecht, made clever copies and imitations of Cuyp's paintings that have passed as originals.

In the work of Paulus Potter (1625–54), as in Cuyp's, views of nature and animals are seen for their own sake, and not as a backdrop for human action. Potter can paint equally well the bright sunlight and the cool air, but his real fame lies with his penetrating portraits of animals. His best-known work is the life-size *Young Bull* of 1647 at the Mauritshuis, The Hague [286], an unusual heroization of a single animal, a counterpart to the monumental trend of Ruisdael and Cuyp. Although at first blush it appears to be a portrait of a prize young bull Potter most probably composed his famous

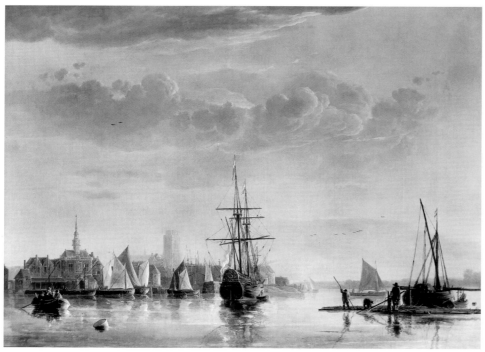

283. Aelbert Cuyp: *Cattle in a River*, c.1650. Budapest, Museum of Fine Arts

284. Aelbert Cuyp: *The Maas at Dordrecht*, c.1655–60. London, Kenwood House, Iveagh Bequest

285. Aelbert Cuyp: *Evening Landscape with Horsemen and Shepherds*, c.1655–60. Collection H.M. Queen Elizabeth II

286. Paulus Potter: *The Young Bull*, 1647. The Hague, Mauritshuis

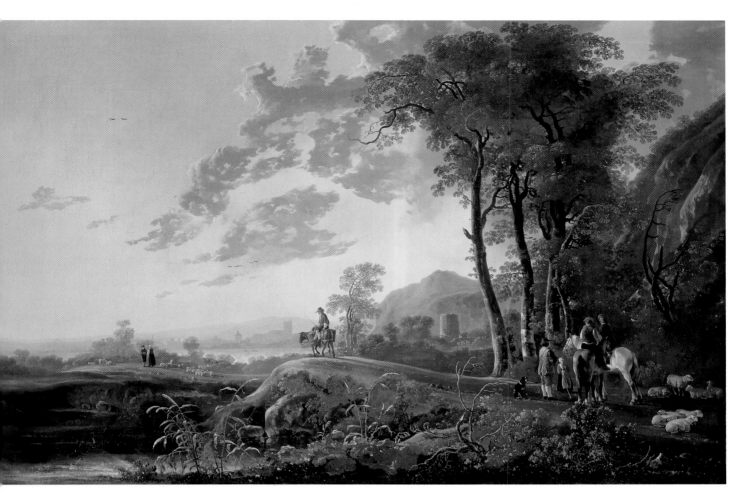

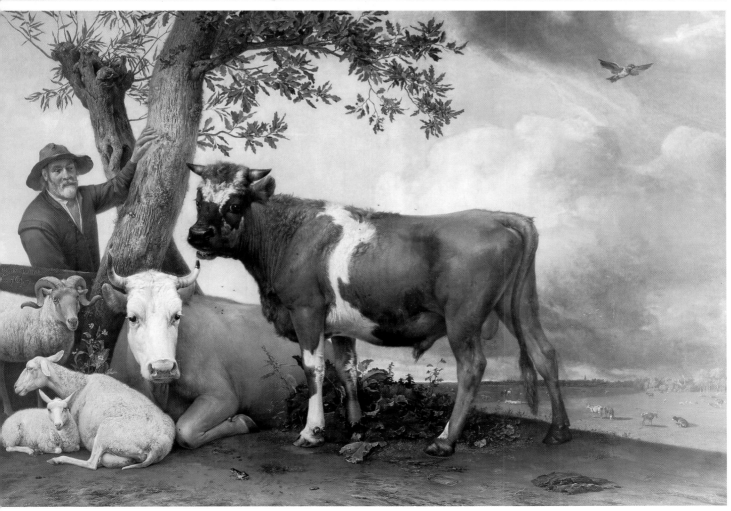

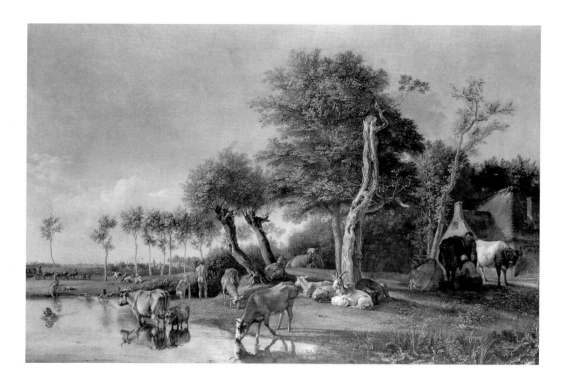

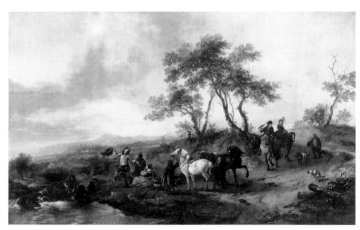

beast from studies of more than one animal since its dewlap, horns, and teeth belong to bulls of different ages. The ancient Greek painter Zeuxis used a similar method; when he painted his portrait of Helen in the city of Croton he chose five beautiful virgins, in order to copy the finest features of each, for in one woman he felt he could not find perfect beauty. During the nineteenth century the *Young Bull* by the twenty-two-year-old Potter ranked close in fame to the *Night Watch*. John Smith, who compiled the first *catalogue raisonné* of the works of the outstanding Dutch artists, wrote in 1834 that such 'is the magical illusion of this picture, that it may fairly be concluded, that the painter has approached as near perfection as the art will ever attain'. Later generations have been less captivated by Potter's fidelity to nature when he worked life-size. Although the shapes of the farmer, the tree, and the bull against the light sky are impressive and the textures of the animals have been convincingly represented by the use of an original impasto which approaches relief, the entire foreground of this huge canvas

– it measures 235.5 × 339 cm – seems airless. Atmosphere enters the picture only in the lovely distant view on the right, where a sunny light plays upon the cattle in the meadows and on the woods, making this passage one of his loveliest landscapes. Potter is more consistent on a small scale, and his cabinet pieces show him at his best [287].

Potter's career was short. He died a few months after his twenty-eighth birthday. His early works show the influence of his father, the painter Pieter Symonsz Potter (*c.*1597/1601–52) and Moeyaert who painted cattle in his biblical and mythological pictures. He is documented as a pupil of Jacob de Wet, a Rembrandt follower, and probably also knew the innovative prints done in the thirties by Moeyaert, Gerrit Bleker (active *c.*1625–56), and Pieter van Laer, which prominently feature cattle, horses, and other livestock; he himself made etchings of animals (for additional references to Pieter van Laer, called Bamboccio, see p. 233 ff. below). The unmistakable close artistic relationship between the Italianate landscapist Karel du Jardin and Potter is a subject that remains to be fully explored.

Potter tried his hand at a few subject paintings (*Orpheus taming the Animals*, 1650, Amsterdam, Rijksmuseum), but the bulk of his work is devoted to horses and to scenes of cows, goats, sheep, and pigs, which show an extraordinary sensitivity to the various ways in which farmyard animals behave at different times of the day as well as to the different quality of light in the morning or at dusk in landscapes that almost invariably make country life appear idyllic. Notable too are his portraits of dogs. A life-size one of an alert wolfhound chained to his doghouse with the artist's full name boldly inscribed on the entrance to the kennel is at the Hermitage, St Petersburg. Although less ambitious than the *Young Bull*, it achieves a comparable monumentality.

Potter worked for the court in The Hague, in nearby Delft, and in 1652 he settled in Amsterdam. According to

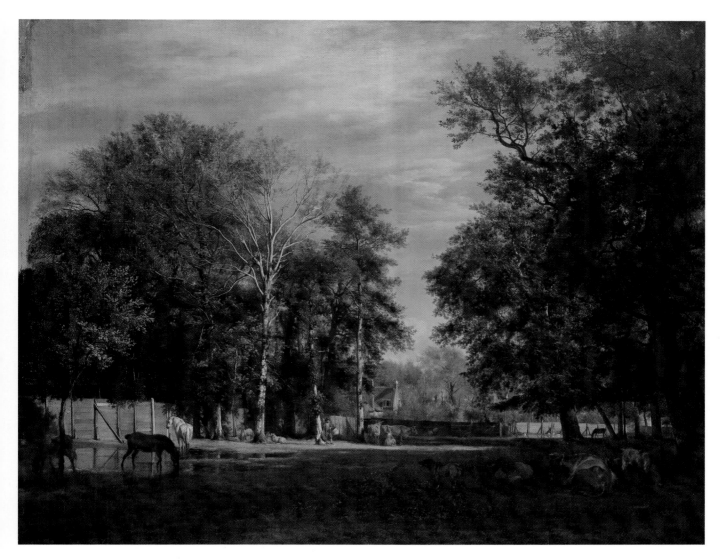

Houbraken Nicolaes Tulp persuaded him to move to the metropolis where the famous doctor became his mentor. If true, once again Tulp showed he had an eye for young talent. Two decades earlier he had asked the twenty-six-year-old Rembrandt to paint the *Anatomy Lesson* which established Rembrandt's reputation in the city. In 1653 Potter painted a life-size equestrian portrait which has been traditionally identified as his likeness of Tulp's son Dirck; however, the tradition may very well be apocryphal.[18] The portrait, now in the Six Collection, Amsterdam, proves that Potter was no exception to the rule that seventeenth-century Dutch painters never match the life-size equestrian portraits of royalty and their ministers by Velázquez, Rubens, or Van Dyck. Rembrandt is not an exception to the rule either. The horse in his *Frederick Rihel on Horseback* of the early 1660s, his only life-size equestrian portrait, now in the National Gallery in London (Bredius-Gerson 255), looks wooden when compared to those painted by Flemish and Spanish Baroque masters.[19]

The most successful Dutch painter of horses was prolific Philips Wouwerman (1619–68) of Haarlem. He rarely painted large pictures: his speciality was small-scale land-scapes and genre scenes which included horses – battles, skirmishes, encampments, scenes at a smithy or in front of an inn, and hunts. As early as 1661 Cornelis de Bie reports that he was Frans Hals's pupil; if correct, it offers evidence that Hals must have encouraged his pupil to find his own way quickly since nothing in Philips's known *œuvre* indicates a connection with him. His early works show some affinity with Pieter Verbeeck (*c.*1610/5–*c.*1652/4), a specialist in small pictures of horses in a landscape (not to be confused with a fish still-life painter who bore the same name), and Jan Wijnants (active 1643–d. 1684), who made landscapes of the sand dunes around Haarlem. Much more decisive for his development was the work of Pieter van Laer, *alias* Bamboccio, whose works, as we have heard, prefigure Potter's animal pictures and are discussed further below. Van Laer returned to Haarlem in about 1639 after more than a decade in Rome. At Haarlem, he continued to paint the little pictures of the outdoor life of ordinary people which he had popularized in Italy. Wouwerman used similar motifs, but the range of his subjects was wider and he was much more productive than Bamboccio. He also had a more elegant and decorative touch, which helps to account for his great success [288]. His fluid and airy treatment and his cool harmonies make Wouwerman's works particularly

attractive. He apparently died a wealthy man; according to Houbraken, his daughter married in 1672 with a 20,000 guilder dowery from her recently deceased father. During the eighteenth century he became one of the most highly esteemed Dutch painters. No princely collection was without a Wouwerman, and the large ones had them by the dozens; the Hermitage at St Petersburg owns more than fifty, the Dresden Gallery more than sixty. Philips's brothers Pieter (1623–82) and Jan (1629–66) were landscapists who favoured the style and subjects of their older sibling; neither, however, matched his refinement, productivity, or achieved his popularity.

Adriaen van de Velde (1636–72), who was more versatile than Philips Wouwerman, also painted small landscapes in which animals and figures play an important role. Bode rightly wrote of the 'Sunday atmosphere' (*Sonntagsstimmung*) of his pictures of the Dutch countryside, and of the precious holiday peace that spreads over his meadows, seen in the bright sparkle of sunny days softened by the haze of the nearby sea. Adriaen was the younger brother of the well known marine painter Willem van de Velde the Younger; they probably were pupils of their father, the marine painter Willem van de Velde the Elder. Adriaen also is said to have studied with Wijnants at Haarlem, but the influence of Wouwerman and Potter is more evident in his early works. Houbraken reports that 'He zealously drew and painted cows, bulls, sheep and landscapes' and adds 'he daily carried his equipment out to the countryside – a practice he continued until the end of his life.' Although many of Adriaen's drawings survive, only a handful made on his excursions to the countryside have been identified; the finest, now at the Amsterdam Historical Museum, served as the basis for his magnificent *Farm* at Berlin [289]. Adriaen also made numerous drawings of clothed and nude models in his studio; many have been identified as preparatory studies for figures in his landscapes and subject pictures.

Some of Adriaen's bucolic landscapes, with neat shepherds and cattle in a peaceful southern setting, filled with warm light and shadow under vivid blue skies, suggest that he had been to Italy. The clear outline of his figures and his sculpturesque feeling for form, which are seen in his etchings and fine drawings as well as his paintings, also argue for firsthand contact with classical art. However, like Cuyp, Wouwerman, and other Dutch painters, he apparently assimilated these qualities from the work of his countrymen who had travelled south of the Alps. There is no evidence he ever visited Italy.

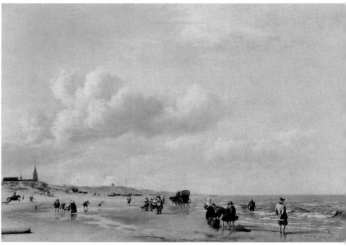

290. Adriaen van de Velde: *The Beach at Scheveningen*, 1658. Kassel, Staatliche Kunstsammlungen

His varied *œuvre* includes winter scenes, portraits in landscape settings, at least one genre piece, and amongst his most original pictures are his rare beach scenes, which capture the lucidity of the moist sea air and have a freshness and rarely matched *plein-air* effect. An outstanding example of the last named is *The Beach at Scheveningen* of 1658, now at Kassel [290]. He was frequently called upon to animate his contemporaries' pictures with his exquisite figures. His staffage appears in paintings by Jacob van Ruisdael, Hobbema, Allart van Everdingen, Philips Koninck, van der Heyden, Wijnants, and Philips de Moucheron. Adriaen, who was Catholic, also painted a few biblical subjects. Five passion pictures painted for a Catholic church in Amsterdam survive (two dated 1664, Nijmegen, Augustine Friars Collection) and so does his strongly classical, life-size *Annunciation* (1667, Amsterdam, Rijksmuseum). His singular allegory, also done in a classical style, of the human soul at the crossroad of life between the virtues of faith, hope, and charity and worldly wealth, power, and sensual love is mainly comprised of figures in a sparse architectural setting (1663; Moscow, Pushkin Museum). Subjects this extraordinarily versatile artist studiously avoided were naval battles and seascapes, the specialities of his father Willem the Elder and his brother Willem the Younger. Both play leading roles in the story of Dutch marine painting, the subject of the following chapter.

Marine Painting

Since the life of the Dutch is inextricably linked with the sea, it is not difficult to understand why marine painting was so popular in Holland. The Dutch live and work on drained and reclaimed land, and from the earliest times their economy has been based on seafaring. Fishing laid the foundation for their prosperity. During the seventeenth century, when the Netherlands was the richest and most powerful nation in Europe, the wealth of the country came primarily from overseas trade. *The IJ at Amsterdam with the 'Gouden Leeuw'* [291], a painting made in 1686 of the crowded harbour at Amsterdam, commissioned by the city from the best-known Dutch marine painter, Willem van de Velde the Younger, gives an excellent idea of Holland's famous sea traffic. In the picture the 'Golden Lion', once the flagship of Admiral Tromp, dominates the wide harbour – the IJ was over a mile wide at this point – and in the background coasters and ships designed for European waters, as well as the India run, can be recognized drying their sails or alongside quays. Only a couple of foreign flags fly from the forest of masts in van de Velde's painting. This is probably an exaggeration. Holland's control of shipping during the seventeenth century was extraordinary, but it was never a virtual monopoly. It is, in fact, difficult to obtain a trustworthy estimate of the size of the Dutch fleet during the seven-

teenth century. Colbert's statement, made in 1655, that the Dutch had fifteen or sixteen thousand ships sailing under their flag is a gross overestimation, but his guess indicates what a rival nation thought about the size of the Dutch fleet when it ruled the Seven Seas. Reliable figures are available for the Baltic trade, however. Publication of the Sound Toll Registers shows that in 1580 more than fifty per cent of the ships passing through the Sound came from ports in the Netherlands. The number steadily increased, and by 1650, during the course of five months, of 1,035 ships sailing into the Baltic from the North Sea, 986 were Dutch.[1] Grain from the Baltic area, the granary of Europe, was transported in Dutch ships to the Mediterranean. Dutch vessels traded everywhere. They were found in north European waters, in Hudson's Bay, and the Dutch established themselves in North America, the West Indies, Brazil, Africa, the East Indies, China, and Japan. Dutchmen who were proud of their merchant fleet and of the powerful navy that protected it made a favourable clientele for great talents such as Willem van de Velde the Younger and Jan van de Cappelle, who specialized in painting ships and the sea. Marine painting became one of the most popular specialities. Van Goyen, Allart van Everdingen, Aelbert Cuyp, and Ruisdael tried their hand at it and painted some of the best, and even

291. Willem van de Velde the Younger: *The IJ at Amsterdam with the 'Gouden Leeuw', former Flagship of Admiral Tromp*, 1686. Amsterdam Historical Museum

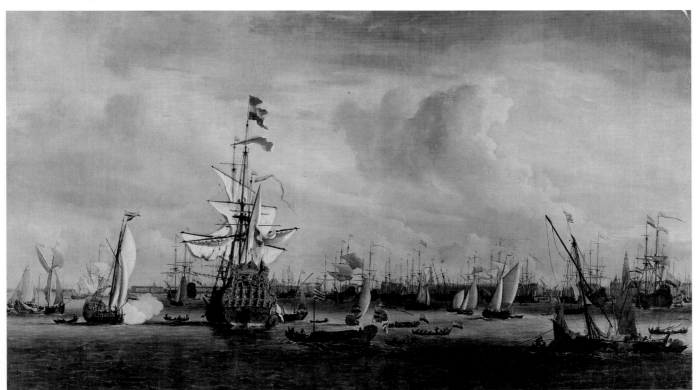

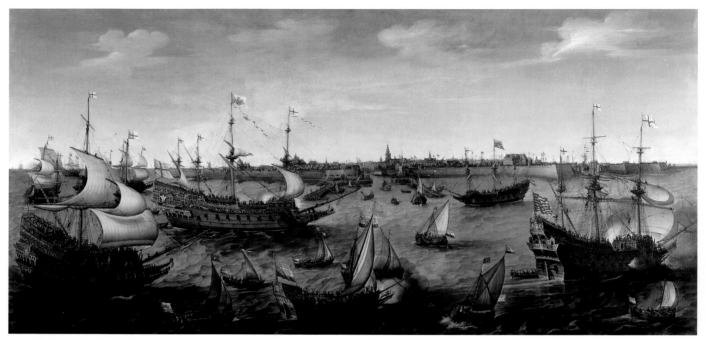

292. Hendrick Vroom: *The Arrival of Frederick V, Elector Palatinate, at Vlissingen, in May 1613*, 1623. Haarlem, Frans Hals Museum

Rembrandt was once attracted to the subject in his *Christ on the Sea of Galilee* (1633, formerly Boston, Isabella Stewart Gardner Museum; stolen 1990).

The patrons of the marine painters must have been critical and discriminating. Most of them knew much about the sea and sailing vessels, and many were familiar with handling ships under sail. In 1693, near the end of his life, van de Velde the Younger concisely summarized the problems which confront a sea painter in a note inscribed on one of his drawings now at the British Museum:

> There is much to observe in beginning a painting; whether you will make it mostly brown or mostly light; you must attend to the subject, as the air and the nature of its colour, the directions of the sun and wind, whether the latter be strong or moderate, are to be chosen as may seem best. Then the sketching of the ordnance or ships under sail . . .[2]

This succinct statement is one of the rare known comments by an important Dutch artist about his work. We can be certain that van de Velde's patrons, in turn, carefully studied and commented upon the way in which he and other Dutch sea painters depicted different hulls under sail, complicated rigging, the movement of the waves, the direction of the sun, the intensity of the wind, and even 'the air and the nature of its colour'.

The preoccupation of van de Velde the Younger with atmospheric effects was not shared by the earlier masters. This is not surprising, since Dutch marine painting shows the same general stylistic development as landscape painting. The early realist tradition is best represented by Hendrick Cornelisz Vroom (1566–1640) of Haarlem, father of the landscapist Cornelis Hendricksz Vroom. Hendrick Vroom has been rightly called the founder of European marine painting. To be sure, artists before Vroom painted marine pic-

tures – for example, *Storm at Sea* (Vienna, Kunsthistorisches Museum) formerly attributed to Pieter Bruegel and now ascribed to Joos de Momper – but Vroom was the first to specialize in this branch of painting. After extensive travels in Europe, Vroom returned to his native town of Haarlem about 1590, where he made most of the works which brought him fame and wealth. His pictures, which are usually large and depict historical maritime events, were primarily portraits of ships. Atmospheric effects are of secondary interest. His acknowledged masterwork, *The Arrival of Frederick V, Elector Palatinate, at Vlissingen in 1613* (1623, Haarlem, Frans Hals Museum) [292], commissioned by the City of Haarlem, offers the best display of the character of his marines. The enormous bird's-eye view (203 × 409 cm) is crammed with multi-coloured anecdotal details. Meticulous attention is given to the hull, rigging, flags, pennants, and other gear of the gigantic four-master and to all the other ships and boats in the roads of Vlissingen (Flushing) as well as to the activities of the sailors manoeuvring their vessels and people involved with the princely arrival. The panorama also offers an accurate distant view of the skyline of Vlissingen as seen from its harbour. The portrait of the city's profile also is characteristic of Vroom. A number of his paintings were specifically done as topographical views of Dutch cities, some with and some without a port; they anticipate cityscapes painted by later Dutch artists. *The Arrival of Frederick V* commemorates the elector's triumphal arrival in Holland with his consort, Elizabeth, daughter of James I of England, in May 1613. At the time Frederick was welcomed as the head of the Union of German Protestant princes. A decade later, when Vroom executed the painting, he was the defeated King of Bohemia, living as a refugee in The Hague. 'The Winter King', as he was called, had lost his crown at the Battle of the White Mountain which restored Bohemia

to Catholicism and to the Habsburgs. After the disaster Frederick found a haven in Holland where he sought support to help him regain his position, but, apart from friendship, there was little the Dutch could offer him. He visited Haarlem in 1623 and probably the city's fathers gave him Vroom's masterpiece on that occasion.[3]

Among Vroom's other notable marines that commemorate historical events is his *Return of the Second Dutch Expedition to the East Indies in 1599* (1599, Amsterdam, Rijksmuseum), a successful financial venture that led to the establishment of Dutch East India Company in 1602. Subjects that were a stimulus to patriotism and national pride were done as well. *Engagement between a Dutch and English Warship, 1605* (1614, Amsterdam, Rijksmuseum 'Nederlands Scheepvaart Museum') depicts the incident when Dutch ships refused to salute a British warship in English territorial waters, an assertion of the Dutch belief in the freedom of the seas which was argued in Hugo de Groot's *Mare Liberum* (1608). Historical naval battles also were portrayed. Vroom's most famous representations of them are not paintings but a set of ten tapestries he designed that offered vast bird's-eye panoramas of the *Defeat of the Spanish Armada by the English Fleet*. The set, commissioned by Charles Howard of Effingham, Lord Admiral of the triumphant fleet, was completed in 1595, and later hung in the old House of Commons until 1834 when it was destroyed with the building by fire. The tapestries are known today from a fine set of eighteenth-century engravings. Vroom designed another set of tapestries depicting memorable battles the Dutch won during the early years of the Eighty Years' War with Spain. This set of five tapestries, now in the Abbey of Middelburg, was ordered by the Province of Zeeland in the 1590s. Vroom's many followers received similar commissions from high placed patrons for paintings of naval battles, princely arrivals, and mercantile fleets that had travelled to far flung places, and the tradition continued well into the century. It comes as no surprise to learn that the demand for naval pictures began to slacken during the last quarter of the century when England took Holland's place as Europe's undisputed ruler of the seas.

Hendrick's son Cornelis Vroom (c.1591–1661), today best known for his landscapes, initially studied with his father and collaborated with him during his early years. The Haarlemmer Cornelis Claesz van Wieringen (c.1580–1633) was probably Hendrick's pupil as well; he ranks as his best and closest follower. Wieringen's multi-coloured paintings are more ornamental, his waves and whitecaps more schematic than Vroom's, and his skies (apart from those in his graphics) are little more than decorative backdrops. His *Battle of Gibraltar* (1622, Amsterdam, Rijksmuseum 'Nederlands Scheepvaart Museum') was commissioned by the Admiralty of Amsterdam in 1621. They first offered the job to Vroom, but after he asked what they considered the outrageous price of 6,000 guilders for his work, they turned to Wieringen and, in the event, paid him 2,450 guilders for his huge painting (152 × 409 cm). About the same time Haarlem's St Hadrian Civic Guards ordered a painting of the *Capture of Damiate* (Haarlem, Frans Hals Museum) [293] which was originally mounted as an overmantel in the company's headquarters (a few years afterwards officers of the company commissioned Frans Hals to paint their group portrait). Wieringen's *Capture of Damiate* represents a pseudo-historical event. According to tradition late twelfth-century crusaders *en route* to the Holy Land tried to capture Damiate, a port city at the mouth of the Nile which had its harbour protected by a heavy chain stretched across it from two moles. The chain was cut, according to legend, when a ship from Haarlem ingeniously fitted with a specially designed saw-toothed prow and keel sailed across it. After this feat and a fierce battle the port fell to the crusaders. The tale exemplified the audacity and courage of early Haarlemmers, and by association, redounded to the glory of citizens of the city. By the sixteenth century the fable had acquired a mythic dimension for Haarlem's patriots. The appetite for it was

293. Cornelis van Wieringen: *The Capture of Damiate*, c.1625. Haarlem, Frans Hals Museum

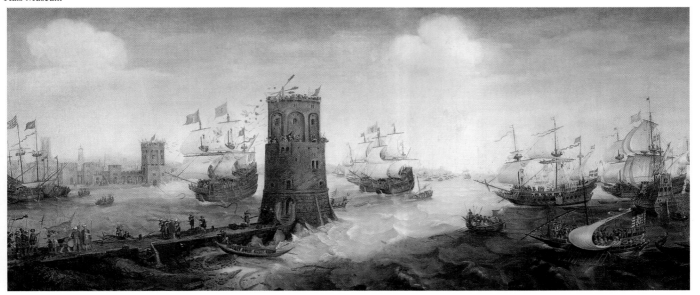

satisfied by later printmakers and painters. Vroom and other artists also made drawings for stained glass windows of the subject, and Wieringen designed a huge tapestry depicting the legendary event for Haarlem's Town Hall which is still mounted there. Anachronisms included in representations of the story, such as contemporary Dutch sailing vessels taking part in a twelfth-century naval battle, obviously did not disconcert the artists or their patrons.[4]

Other followers of Vroom painted historical and quasi-historical maritime events in his style. Among them are Aert Anthonisz (1580–1620; also called Aert van Antum), Cornelis Verbeeck (1590–1637), and Adam Willaerts. Born in Antwerp in 1577, Willaerts settled in Utrecht early in the century and spent the rest of his life there. By the time of his death in 1664, he had seen what artists of the tonal and classical phase had accomplished. His own works began to show a shift in style with their lower viewpoints and more muted colour harmonies. In addition to the standard repertoire of Vroom's followers his *œuvre* includes traditional biblical subjects related to the sea (Jonah and the whale, the miraculous draught of fishes, Christ preaching on the Sea of Galilee), beach scenes with busy large crowds, and views of rocky mountainous shores dotted with pine trees and goats that suggest he had access to works by Roelandt Savery who had settled permanently in Utrecht by 1619. But it is Jan Porcellis who marks the decisive transition from early realism to the tonal phase. This outstanding artist was born at Ghent around 1580–4 of parents who moved to the northern Netherlands in 1584. Houbraken writes his teacher was Hendrick Vroom and to judge from the earliest existing works of about 1610–12 now at Hampton Court (*Ships in a Storm*, *Sea Battle at Night*; both originally overdoors) his information may be correct. Porcellis worked in many places. He is first traceable in Rotterdam where he went bankrupt by 1615. He then moved to Antwerp. By 1622 he returned north and settled for a few years in Haarlem, then in Amsterdam, next in Voorburg near The Hague, and finally in Zoeterwoude in the environs of Leiden. The properties he amassed before his death in 1632 indicate that he had accumulated a considerable fortune during his last years.

Porcellis can be credited with introducing a new subject as well as a new style to marine painting. Grand portraits of ships and historical events never play a role in his pictures, and after 1620 his principal concern is with choppy or stormy seas, palpable atmosphere, overcast skies, and simple working boats. He made the sea and the sky his subject. His *Rough Weather*, signed and dated 1629, at Munich [294], shows the radical break Porcellis made with the earlier tradition. Four-fifths of the painting have been devoted to the ominous sky. Fresh winds toss the small ships and agitate the water. The simple fishing boats and single-masted coastal traders, which have taken the place of Vroom's famous three- or four-masted naval and merchant ships, have been subtly organized according to the diagonal trend of Baroque compositions. Porcellis's touch, still somewhat thin, creates a fine overall atmosphere and a delicate harmony in near-monochromatic colours with greyish tones dominating. He still uses rather minute brushstrokes, but not to delineate precise details of the ships.

The Munich seascape has an unusual feature. It is seen through a *trompe l'œil* painted window which cannot be intended to suggest that we are in an interior looking out at the view. Porcellis draws attention to the window by the illusionistic piece of paper resting prominently and precariously on its sill; the paper tag bears his signature and date. What is the significance of the enigmatic window? It has been proposed that Porcellis employed it to indicate that his painting provides a 'Window on the World', with the world likened to a rough sea through which mortals must perpetually struggle.[5] This suggestion may be correct. Contemporary moralizing texts, emblems, and proverbs testify that the Dutch, whose lives were bound in so many ways to the sea, were familiar with the old tradition of using tempestuous or calm seas and endangered ships or those keeping a steadfast course as metaphors for the way of the world and the vicissitudes of life. When seascapists made pendant marines of a calm and a storm they may have intended them to symbolize positive and negative associations of the sea, and whether artists intended their seascapes to have metaphorical meanings or not, viewers with a propensity to moralize could use them as referential objects that lead to thoughts about the vicissitudes of the voyage of life and the inevitable end of the journey. As late as 1787 the compiler of

294. Jan Porcellis: *Rough Weather*, 1629. Munich, Alte Pinakothek

295. Simon de Vlieger: *Shipwreck*, 1640. Amsterdam Historical Museum

296. Jan Porcellis: *Shipwreck on a Beach*, 1631. The Hague, Mauritshuis

an inventory of all the paintings in Amsterdam's Ouderzijds Huiszittenhuis, an institution dedicated to the distribution of life's basic necessities to poor people confined to their homes, many of whom were disabled sailors or members of families of men lost at sea, had such thoughts when he described Simon de Vlieger's *Shipwreck* [295] as 'Portraying a shipwreck and this is the origin of the poverty of many people confined to this house'.[6] And it is not hard to believe there were viewers who saw the endangered vessels on Ludolf Bakhuizen's *Ships in Distress off a Rocky Coast* [303] as symbolic of the dangers and uncertainty of life's voyage. However, motifs in Bakhuizen's pictures, as in so many Dutch paintings of the period, can be assigned more than one meaning. The two-master, which seems to be sailing safely, with its foresails reefed, through a high sea along a treacherous coast can allude to the need mortals have for the virtues of steadfastness and constancy as they make their way through life. Additionally, then as now, permutations on the ancient ideas of the ship as the Church, the ship of state, the ship of fortune and the ship of fools were made, and the notion of love as a boat that can have a mirror-smooth or rough passage was popular as well.[7] For a discussion of the last named notion see pp. 127–8 above. And surely, then as now, paintings of ships at sea also were viewed merely as ships at sea.

We have mentioned that bespoke large, historical portraits of great ships that trumpet the power of the new nation's navy, mercantile fleet, and the arrival of vessels bearing princes continued during the course of the century, but Porcellis's younger contemporaries and later seascapists more often than not follow his lead by painting cabinet-size pictures of anonymous boats under high skies in unidentifiable seas, rivers, and inland waters. Most of them were probably not commissioned, but done for the open market.

Porcellis's shore scenes are equally remarkable. In 1631, perhaps only a few months before his death in January 1632, Porcellis painted his *Shipwreck on a Beach* at the Mauritshuis [296]. Few later beachscapes match the naturalism of its sombre mood broken by bursts of sunlight indicating that the storm has broken and the spaciousness created by the extensive stretch of beach and huge breakers, low horizon, and high dunes running obliquely into the far distance.

Artists and art lovers quickly recognized Porcellis's extraordinary achievement. Soon after Jan van Goyen sold him a house in Leiden for 1,200 guilders in 1629, his marine pictures began to show the influence of the depth and height of Porcellis's towering skies and his monochromatic mode. Salomon van Ruysdael quickly followed suit. Constantijn Huygens notes in his journal written about 1630, which includes acute appraisals of many contemporary Netherlandish artists, that he should mention Hendrick Vroom in his pages, but Huygens finds Vroom and others even less known than him so inferior to Porcellis that he can hardly mention them in the same breath. There is also reason to believe Huygens collected Porcellis's works before he wrote about him; the seascape mounted above the mantel in Thomas de Keyser's portrait of him with his clerk, dated 1627 [341], is most probably a depiction of one of Porcellis's untraceable marines. Leading artists collected his paintings: Rubens owned one, Rembrandt six, Allart van Everdingen thirteen, Jan van de Cappelle sixteen. The poet Joachim Oudaan published a poem 'On a Thunderstorm by Porcellis'

(1646), and Hoogstraten called him the 'great Raphael of marine painting' (1678), a hackneyed title, yet one that indicates high regard. More importantly, Hoogstraten praised his 'selective naturalness' (*keurlijke natuurlijkheid*), a phrase that beautifully characterizes Porcellis's art, and as Wolfgang Stechow notes, is equally appropriate for all the great landscapists of the period: 'They all selected from nature; but what counts in their selection is nature.'[8]

Porcellis's followers include his son Julius (before 1610–54) and his brother-in-law Henrick van Anthonissen (1605–55 or later). Porcellis's paintings also were copied during his lifetime; in 1631 a collection included no less than twelve of them. Some of Porcellis's works have been wrongly confused with those done by his followers and copyists. We learn that such a muddle occurred in Amsterdam as early as 1661 when four painters, Barent Kleeneknecht, Allart van Everdingen, Willem Kalf and Jacob van Ruisdael, were called upon to judge the authenticity of an alleged Jan Porcellis shore scene with cliffs and figures. Hobbema signed the document as a witness. Kleeneknecht declared that probably almost the whole picture was painted by Hendrick van Anthonissen. Everdingen maintained that Porcellis at most had done something to the cliffs. Kalf was less optimistic; he concluded it had nothing to do either in detail or in general with Porcellis's paintings. In Ruisdael's opinion Porcellis had perhaps begun it, but in its present condition it must not be sold as his work. The alleged Porcellis obviously was not on the borderline. However, there was no agreement regarding an alternate attribution. To contemporary students who attempt to determine the authorship of Dutch paintings done almost four centuries ago, the case is a humbling one. What are our chances of finding definitive attributions for marginal works if four expert witnesses, who had knowledge of the art scene of their time which we can never match, failed to agree upon one? But students of our day also can find a measure of comfort in the affair. It is consoling to learn that experts of the period shared our frequent inability to give firm names to problematic pictures.

Continuity of space in Porcellis's seascapes is not consistently fully convincing. He tends to jump a little too fast over the middle distance, relating the large dark foreground forms directly to the tiny boats in the background. Porcellis's follower Simon de Vlieger (1601/2–53) begins to clarify space over wide expanses of calm water; however, this only occurs in his late seascapes such as his *Calm Sea* of 1649 at Vienna [297]. Earlier de Vlieger concentrates upon ships and fantastic rock formations lashed by colossal waves. The winds abate only in his later works when the Porcellis-like grey tonalities he favoured earlier are replaced by silvery-greys and shimmery sunlight. He was a special favourite of Admiral Sir Lionel Preston, author of *Sea and River Painters of the Netherlands in the Seventeenth Century*, published in 1937. Subsequent research has outdated parts of his study, but his keen appreciation of the achievement of Dutch painters of the sea, based on his own experience as a sailor, is of lasting interest. According to Preston,

There is no one who makes the grey North Sea as real as De Vlieger can, or gives such life and movement to ships. In his pictures we feel the breeze freshening – a sou'wester brewing – clouds rush past the sun, to throw patches of light on the sea and illuminate a large ship heeling to the wind. In a moment the ship will be in shadow and the sea re-lit by everchanging gleams of brilliance... No sea painter has exceeded his powers of aerial perspective nor of those delicate gradations of colour, where in sombre key the contrasts between deep and shallow water are shown by the sun's reflections. There

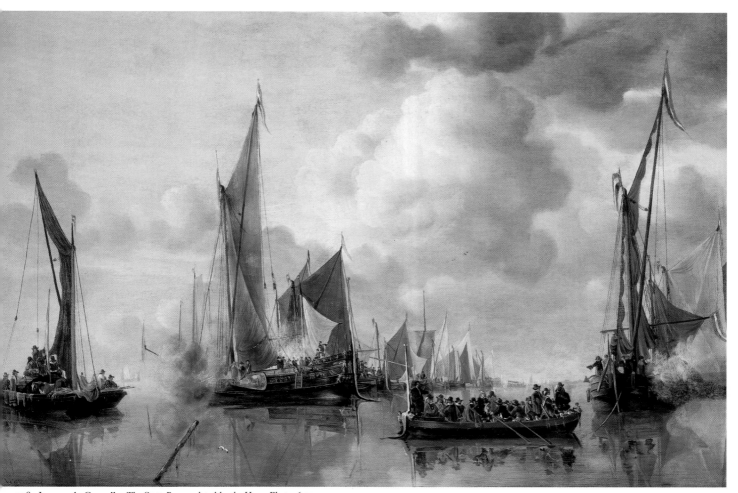

298. Jan van de Cappelle: *The State Barge saluted by the Home Fleet*, 1650. Amsterdam, Rijksmuseum

can be no sailor ... who will not appreciate and understand the truth which came from the brush of De Vlieger.

Preston's favourite was prolific and versatile. His *œuvre* includes depictions of Christ on the Sea of Galilee, panoramic shore scenes teeming with crowds, forest landscapes, and experimental etchings. He made designs to commemorate Maria de' Medici's 1638 entry into Amsterdam, painted organ shutters for the Laurentius Church in Rotterdam, and late in life designed stained glass windows for Amsterdam's New Church for which he was paid the handsome sum of 6,000 guilders. De Vlieger's position as the foremost artist in the transition from marine painting's tonal to its classic phase is secure and his impact on late specialists was great. He helped to form the style of Willem van de Velde the Younger; Hendrick Dubbels's (1620/1–76?) early works are based on his; and the self-taught Amsterdam master Jan van de Cappelle learned much from studying his works.

Jan van de Cappelle (1624/6–79) belongs to the generation of Ruisdael and Cuyp. His compositions, like theirs, gain strength and monumentality by the union of tectonic and dynamic features, and are classic in their perfection [298]. He calms the agitated seas painted by Porcellis and young Simon de Vlieger. Few of van de Cappelle's marines are sea paintings in the strict sense of the word: most of them represent the mouths of wide rivers or quiet inner harbours, where groups of ships parade or lie at anchor in mirror-smooth waters. Masts make a pattern of verticals which is co-ordinated with the horizontals of hulls and the low horizon. The haze found in works by earlier marine painters lifts, and the middle distance acquires more real existence between the foreground forms and the minute details of the far distance. Space opens up widely, yet the design is well-balanced and maintains a powerful coherence as a whole. Essential qualities of van de Cappelle are his full cloud formations, the wonderful transparency of his shadows, and the subtlety of his colourful reflections in calm waters. Early morning or evening are his favourite hours. He was not a man to paint sea battles. His is a holiday mood: cannons salute, drums roll, pennants flutter, and noble personages ride in richly carved, gilded barges. Not many of his works are dated, but it is reasonable to assume that his simple compositions done in silvery greys, which recall Porcellis and de Vlieger, belong to an early phase, and the more complex, colourful works with a golden tonality were done after 1650. He also painted some beach scenes and more than forty winter landscapes. These, like his marines, render nature with a wonderful feeling for the pictorial qualities of Holland's sea atmosphere, with its heavy clouds and translucent air.

Van de Cappelle did not devote all his time to painting: he also helped manage, and then inherited his father's profitable dye-works. At his death he was worth a fortune of more than 90,000 guilders, and owned substantial holdings in real estate

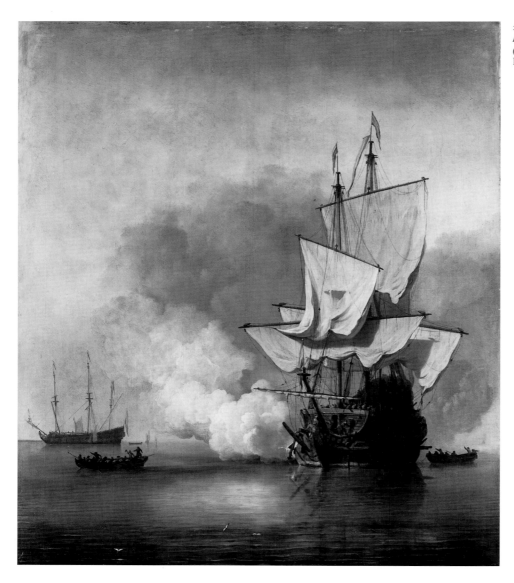

299. Willem van de Velde the Younger: *Dutch Ship getting under way firing a Salute ('The Cannon Shot')*, c.1680. Amsterdam, Rijksmuseum

and a pleasure yacht (from which he probably made sketches for his marine paintings), as well as one of the awesome art collections of his time. Indeed, his collection, known from a posthumous inventory of his estate, was spectacular by any standard.[9] It comprised more than 200 paintings and about 6,000 drawings. He collected vast quantities of works by other seascapists. We have heard he owned sixteen paintings by Porcellis. In his possession he also had nine of Simon de Vlieger's paintings and more than 1,300 of his drawings as well as ten paintings and over 400 drawings by van Goyen. Van de Cappelle owned paintings by Rembrandt, Rubens, Hals, Van Dyck, Brouwer, Hercules Segers, and Avercamp, and he acquired almost 900 drawings by Avercamp and had more than 500 drawings by Rembrandt. His inventory also lists portraits of himself by Rembrandt and Hals; to our knowledge, he was the only Dutchman portrayed by Holland's two greatest portraitists. These portraits have not been identified, and neither have most of the 798 drawings by van de Cappelle's own hand cited in the inventory. Today only a handful are known, a sad reminder of how many of his drawings have been lost. Collation of his inventory with

what exists today of drawings by other artists tells a similar lamentable story.

The first half of the production of Willem van de Velde the Younger (1633–1707) still belongs to the classic phase of Dutch marine painting. In his masterwork, popularly called *The Cannon Shot*, datable about 1680, at the Rijksmuseum [299], he created a grand and well-balanced composition comparable to those by the great landscapists and genre painters of that period. Here a man-of-war is the hero, although not in action and only discharging a salute as it gets underway. The warship is powerfully placed on the right of the picture, and its bright drooping sails are shimmering in the sunlight. The vapour of the shot in the centre of the middle distance directs the view into the transparent far distance, where smaller craft by their horizontal position counter the mighty vertical of the big ship. Soft tonal contrasts, as well as distinct colour accents, co-operate with the linear effects of the tackle to build up a pictorially rich, yet simple and striking design. The lines of the rigging are remarkable both in their precision and in the sensitiveness with which they are drawn. As always in his autograph

300. Willem van de Velde the Younger:
English Ship driven before a Gale, c.1678–80.
Amsterdam, Rijksmuseum

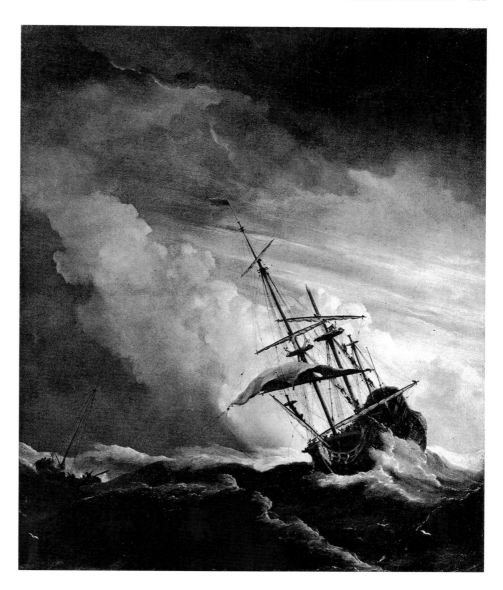

works, they are never harsh and consistently well-adjusted to the aerial perspective.

Willem the Younger's equally impressive *English Ships driven before a Gale* [300], datable about the same time or perhaps a few years earlier than *The Cannon Shot*, and also at the Rijksmuseum, has a single warship as its protagonist as well, but here gale force winds and heavy seas make it pitch and heel under ominous storm clouds that are beginning to blow away. The small vessel riding a trough in the foreground, with its sails lowered, is at the sea's mercy. The two pictures have been called companion pieces but perhaps the artist did not intend them as pendants. Although the dramatic contrast between the seas and skies could hardly be more effective, when the paintings are juxtaposed their compositions are not complementary; moreover, they are of slightly different dimensions (their histories cannot be firmly established until they were joined in the nineteenth century). Whether seen separately or together their imagery may have stimulated in some seventeenth-century viewers notions traditionally associated with vessels in a calm and in a tempestuous sea. But there can be no doubt that experienced

sailors must have marvelled at the artist's expert knowledge and ability to depict ships responding to different weather conditions. They would have recognized straightaway that the Dutch two-decker is just getting under way in a light air, with her fore- and mainsails loosed, her fore topsail half hoisted and her main topsail mast-headed and hauled out to a bowline, and that the English ship driven before a gale has her foresail half lowered and forestay cut away to allow the sail to blow out horizontally.[10]

Willem the Younger, a more versatile sea painter than van de Cappelle, not only represents ships in calm and violent storms but numerous historical naval events. An examination of his *œuvre* also shows that it includes depictions of virtually every type of European vessel. Son of the marine artist Willem van de Velde the Elder (1611–93), he was born in Leiden. By 1636 his family had moved to Amsterdam where his younger brother, the landscapist Adriaen van de Velde, was born. Houbraken says Willem was a pupil of Simon de Vlieger, a statement not contradicted by his early seascapes, but presumably his father, Willem the Elder, was his first teacher. His career is closely linked to his father's activity.

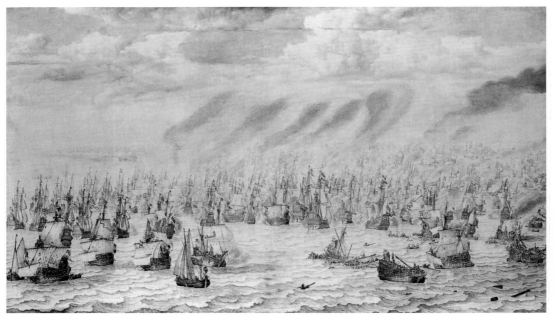

301. Willem van de Velde the Elder: *The Battle of Scheveningen (Ter Heide), 10 August 1653*, 1657. Amsterdam, Rijksmuseum

302. Detail of fig. 301: Self-portrait of Willem van de Velde the Elder sketching from a galliot

The latter is best known for his marines called 'grisailles', which are, in fact, not paintings done with a brush in tones of grey, but scrupulously exact pen drawings executed on the white ground of a canvas or panel in a manner that recalls the technique of engraving [301]; they also are called 'pen paintings'.

Willem the Elder's major works continue the tradition established by Hendrick Vroom and his followers; they document historical naval engagements, but often with a difference. The histories done by earlier marine painters, frequently painted long after the event, were based on secondary sources – written or oral reports, bits and pieces found in earlier prints and drawings, and the like. To be sure, there is evidence that Hendrick Vroom studied ships and the sea from a boat, and that Porcellis did so too for his anonymous marines – probably most seascapists seized opportunities to make studies *naer het leven* as well. But it seems that Willem the Elder was the first marine painter to anticipate the working method used by later war correspondents, photographers, and television crews; for historical scenes he served as his own eyewitness. He gathered visual data by accompanying fleets and upon more than one occasion sketched naval engagements on the spot from a small boat. In his huge 'pen painting' of *The Battle of Scheveningen (Ter Heide), 10 August 1653* (1657, Amsterdam, Rijksmuseum, 170 × 289 cm) [301], the last battle of the First Anglo-Dutch Naval War, he shows himself sketching on the deck of the galliot left of the centre in the foreground [302]. It was at this battle that Admiral Maerten Tromp, Holland's legendary naval hero, was killed, to be subsequently glorified in numerous broadsides, poems, medals, and other works of art. The painting was probably commissioned by Maerten's son Cornelis Tromp. We learn of the privileged help Willem the Elder received from an order Admiral de Ruyter issued in 1666 to a captain during the Second Anglo-Dutch Naval War. De Ruyter ordered the captain

to receive and take on board the galliot under his command Willem van de Velde, ship's draughtsman, and to go with

him ahead or astern or with the fleet, or in such manner as he may judge serviceable for the drawings to be made without failing in any way whatsoever under penalty of severe punishment.[11]

Willem the Elder's drawings range from lightning-quick sketches to carefully worked-up portraits of ships and include sheets that show assembled fleets and virtually every aspect of seventeenth-century ship building. A contemporary praised him for his 'infinite neatness' and noted:

For his better information in his way of Painting, he had a Model of the Masts and Tackle of a Ship always before him, to that nicety and exactness that nothing was wanting in it, nor nothing unproportionable. This Model is still in the hands of his Son.[12]

He used his drawings, which sometimes include notes to help refresh his memory, as a source for his finished 'pen paintings' and his son employed them for his own paintings done in oil colours. Willem the Younger also produced a tremendous stock of drawings; they often have a delicate atmospheric quality that distinguishes them from his father's sketches. The graphic output of father and son was prodigious. Today about 1,400 of their drawings are at the National Maritime Museum, Greenwich, and over 700 are at the Boymans-van Beuningen Museum, Rotterdam; large holdings also are in the Rijksmuseum, Amsterdam, the British Museum, and the Fitzwilliam Museum, Cambridge. No artists provide more exact and useful information for naval historians regarding the precise build and rigging of seventeenth-century vessels than the van de Veldes.

Father and son were active in Amsterdam until the troubled year of 1672, when war with England was resumed and the French invaded Holland. Late in 1672 or early in 1673 they moved to England, where they settled and quickly found favour with Charles II and his brother James, Duke of York. In 1674 the king instructed the Admiralty that Willem the Elder should be granted one hundred pounds annually 'for taking and making Draughts of sea fights', the son to receive the same sum for 'putting the said Draughts into Colours for

our particular use.'[13] The van de Veldes did not completely switch their allegiance to England. Both travelled to Holland, and they made pictures for the Dutch market as well as the English; the most notable example of Willem the Younger's work for the Dutch is his *IJ at Amsterdam* of 1686 [291]. The marines produced in Willem the Younger's studio during the last decades of his career do not have the consistent high quality of those made before he emigrated to England. There is often more agitation, but the pictorial touch becomes rigid and somewhat mannered. Many of the late canvases are official portraits of ships and historical naval engagements. In these works, more attention is paid to the demand for a clear, accurate record of vessels and an event at sea than to atmospheric effects and light. The participation of studio assistants primarily accounts for the change; he seems to have employed them almost from the beginning; but during his last years their participation increased. There is, however, no loss in the quality of his autograph late works and he continued to make exquisite drawings of ships, the sea, and the sky until the very end. Gilpin wrote in 1791 that an old Thames waterman recalled how he used to take Willem the Younger out in his boat on the Thames in all kinds of weather to study the appearance of the sky: 'These

expeditions Vandeveldt called, in his Dutch manner of speaking, *going a skoing*.'[14]

Willem the Younger had many followers. There are vague contemporary references to two sons (Cornelis, Willem III) who are said to have painted marines, but his principal imitators are found among the English marine painters. His extensive productivity in England made him the best-known marine painter there. Numerous English artists worked in his manner during the eighteenth century, and he was adored by Turner and nineteenth-century *plein-air* painters.

Another aspect of the life of ships was the speciality of Pieter Nooms (*c*.1623–68), who signed himself Zeeman (=Seaman); his works often show vessels undergoing repairs or careened for calking and tarring their bottoms. He also depicted views of Paris and Mediterranean and North African ports. His drawings and series of etchings of various types of ships and topographical views of Amsterdam's busy harbour, canals and city gates are prized for their historical information as well as their pictorial qualities.

The outstanding seascapist in the Netherlands after the van de Veldes had moved to England was Ludolf Bakhuizen (1631–1708). He is the last representative of the great tradition of Dutch marine painting; eighteenth-century

303. Ludolf Bakhuizen: *Ships in Distress off a Rocky Coast*, 1667. Washington, National Gallery of Art

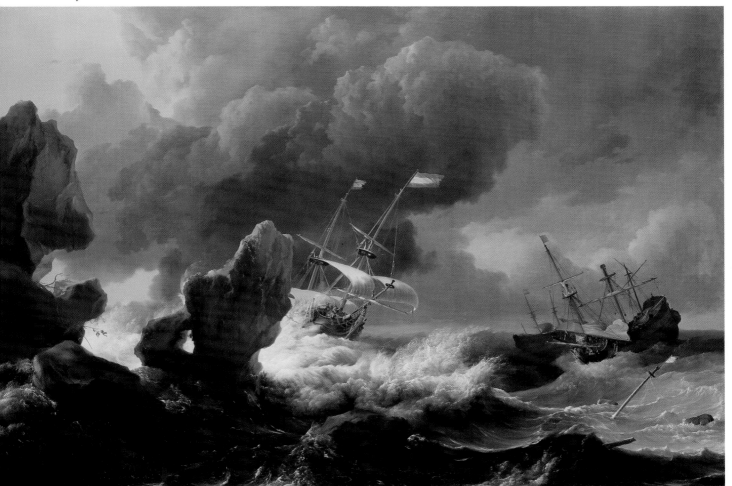

Dutch artists did much less of consequence in this category than in the others they practised. Bakhuizen was born in Emden, Germany, and came to Amsterdam around the middle of the century where he remained for the rest of his life. His high-placed patrons include the burgomasters of Amsterdam, the archduke of Tuscany, Czar Pieter the Great, and various German princes. Dubbels and Willem the Younger's influence is reflected in his lovely calms but he is best known for his stormy scenes. Houbraken writes that when a storm threatened he sometimes went by boat 'to the mouth of the Sea, in order to observe the crash of the Seawater against the coast, and the changes of Air and Water under these conditions.' His *Ships in Distress off a Rocky Coast* of 1667 [303] shows the chilling drama he can bring to the theme. The large cargo ship in the centre is managing to make way along the perilous coast, while on the right, two vessels are in even greater danger. Later his storms become melodramatic, his chiaroscuro effects exaggerated,

and his gigantic waves rather schematic and glass-like. Although some specialists who worked during the last decades of the century are not without interest – Lieve Verschuier (c.1630–86) depicts scenes of ships being calked, often in the dramatic light of the close of day and a few of the nation's whaling industry, and Abraham Storck (1644–1708) painted imaginary Mediterranean ports – neither they nor Bakhuizen were able to maintain the high standard set by van de Cappelle and Willem the Younger. In the late marines, over-agitation and overly emphatic contrasts take the place of subtle co-ordination. The perspective effect is overdone, and the tonal design hardens. As in the work made at the beginning of the century, novelties and anecdotal tendencies become more important than the impression of nature. Too many things happen in the late seascapes. In the tempests, stormy seas and dramatic skies compete as rivals for our attention, and in the calms, a minute realism over-burdens them with detail.

Italianate and Classical Painting

Seventeenth-century Dutch artists discovered the beauties of Italian motifs seen in the warm shimmering light of the south, as well as the more homely ones of their own spacious landscape. In our time the painters of Italian scenes do not enjoy great popularity in all circles, but during the seventeenth and eighteenth centuries, when the classicist aesthetic was generally accepted and Claude and Poussin were ranked without question as the greatest European landscapists, they were more highly esteemed than Dutchmen who made views of their native countryside. Houbraken reports (1718) in his biography of Cornelis Poelenburgh that during the preceding century only artists who had been to Rome were respected, and we know that no eighteenth-century collector preferred an Avercamp, a van Goyen, or even a Jacob van Ruisdael, to a Jan Both or a Nicolaes Berchem. It is noteworthy that at that time more engravings were made after Berchem's works than those of any other Dutch artist, and it is no accident that Ruisdael's characteristic *Great Oak*, signed and dated 1652 [304], was wrongly attributed to Berchem when it was in the collection of Cardinal Silvio Valenti Gonzaga in Rome in about 1750; to be sure, Berchem painted the staffage in Ruisdael's painting, but since he was the far better known and more prized artist he was given credit for the entire painting.[1] Many Dutch Italianate landscape painters were also printmakers – Berchem's signature is found on about fifty etchings – and their own prints helped to spread their name and fame during epochs when the graphic arts were widely collected and appreciated. Herman van Swanevelt, the Dutch classical landscapist whose name is hardly a household word today, made over a hundred etchings, which highly treasured long after they were made. Thomas Girtin made copies of them during the course of his brief career, and Goethe wrote that he admired the lyrical restraint of Swanevelt's etchings of classical ruins even more than Piranesi's dramatic views. A different point of view was expressed by Constable in 1836, when he argued that Both and Berchem, the most popular Dutch Italianate landscapists for more than two centuries, were in fact, poor artists. This position was a radical and unpopular one in 1836. Constable said:

> Both and Berchem, who, by an incongruous mixture of Dutch and Italian taste, produced a bastard style of landscape, destitute of the real excellence of either.... Their art is destitute of sentiment or poetic feeling, because it is factitious, though their works being specious, their reputation is still kept up by the dealers, who continue to sell their pictures for high prices.

After his lecture, one of Constable's listeners, a gentleman possessing a fine collection of pictures, said to him: 'I suppose I had better sell my Berchems.' To which Constable replied: 'No, sir, that will only continue the mischief, *burn them*.'[2]

Constable's belief that Dutch landscape painting not based on real life or a visual experience is insincere, and his struggle to obtain recognition for his own paintings, which do not rely upon bucolic vignettes from Tivoli or Arcadia to enhance their effect, help to explain his low estimate of the Italianate Dutch artists. By the end of the nineteenth century his point of view was generally accepted. Constable's landscapes, as well as those by the Barbizon painters and the Impressionists, helped the public to find qualities in pictures of humble Dutch scenes which earlier generations had overlooked. Prejudice against Dutch painters of idyllic scenes in Italy was also stoked by nineteenth-century nationalism. Dutch painters who depicted the Campagna rather than the national scene were considered 'un-Dutch' and fell from favour. Canvases by Both, Berchem, and du Jardin, once more sought after than works by Rembrandt, Frans Hals, or Vermeer, were relegated to attics and storerooms.

In recent years there has been a revival of interest in these Dutch artists who worked in Italy or came under Italian influence. Impetus was given by the re-appraisal of Caravaggio's achievement, which showed that his Dutch followers made a distinct contribution of their own. It is now seen that Caravaggio's style and spirit even permeated the art of Hals, Rembrandt, and Vermeer, who had no direct contact with the great Lombard. Other Dutch painters who were influenced by the Italian scene are worth studying. The Italianate landscapists introduced new motifs and beautiful painterly effects in more than a few masterpieces. They also contributed to the development of artists such as Aelbert Cuyp, Adriaen van de Velde, and Philips Wouwerman who never visited Italy. The charge that they are insincere Dutchmen because they were inspired by what they saw in Italy instead of in their native land can be dismissed. A reaction to what is seen in the south can be as genuine as one experienced in the north. The quality of an artist's experience and his ability to convey it in his work is of greater consequence than the geographical location which inspired it.

THE FIRST GENERATION

We have already stressed the importance of Elsheimer's poetic little pictures, particularly his landscapes, for the Dutch artists who worked in Italy during the first decade of the century. Elsheimer's influence can also be detected in works by Cornelis Poelenburgh (also Poelenburch; 1594/5–1667) and Bartolomeus Breenbergh (1598/1600–1657), two outstanding figures of the first generation of Dutch Italianate landscape painters. Poelenburgh lived in Italy from 1617 to about 1625–6; Breenbergh was there from 1619 to about 1630. Though neither artist had firsthand contact with Elsheimer, who died in 1610, the German master's exceedingly rare works could still be seen in Italy. Copies of them by Poelenburgh have been identified.

More decisive for the two Dutch artists was the impact of Paulus Bril (1554–1626), a Fleming who arrived in Rome

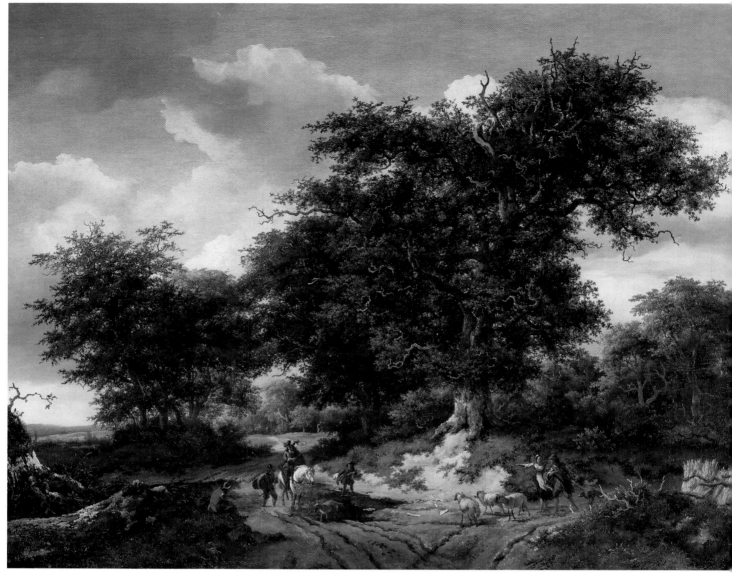

304. Jacob van Ruisdael and Nicolaes Berchem: *The Great Oak*, 1652. Los Angeles County Museum of Art, gift of Mr and Mrs Edward William Carter

by 1582 and remained active there as a landscape specialist for more than forty years. Bril made cabinet-size pictures during the course of his long career in Rome, and during his first decades there also painted large fresco cycles for the Vatican and other ecclesiastical patrons. Poelenburgh and Breenbergh were attracted to Bril's easel paintings, particularly those done under the influence of the Carracci, and members of his circle, which abandon the abrupt transitions of his early mannerist pictures for more compact compositions.

Breenbergh was born in Deventer and there is reason to believe as a youth he was apprenticed in Amsterdam to Pieter Lastman, Jacob or Jan Pynas, or a member of their entourages. It will be recalled that Lastman and the Pynas brothers had been in Italy where they responded to Elsheimer's evocative landscapes. Breenbergh's production as a painter in Rome is still ill-defined; determining its character is complicated by the similarity of his paintings to Poelenburgh's and his readiness to assimilate aspects of the work of other artists. However, there is no question that he

made a large number of fresh, carefully observed pen and wash drawings of the intense sunlight and transparent shadows of the Italian countryside and its buildings and ruins. These sketches, his most original creations, anticipate the luminous daylight drawings Claude made after his second arrival in Rome in 1627. Indeed, some are so dangerously near to the French landscapist's sketches that they have been mistaken for his work. The drawing of the *Ruins of the City Walls, near Porta S Paolo, Rome* [305] has been catalogued as a Claude in spite of Breenbergh's perfectly genuine signature on the sheet.[3] His drawings are also akin to the sun-drenched landscapes by Filippo Napoletano (*c*.1587–1638) and those done a generation later by Jacob van Ulft (1627–89) and the gifted Dutch amateurs Constantijn Huygens II (1628–97) and Jan de Bisschop (1628–71), who was Breenbergh's pupil. Breenbergh used his drawings as a source for pictures after his return to Holland where he settled in Amsterdam. It seems that he made contact with Lastman straightaway. After spending a decade in Italy, he must have looked at the old master's paintings with new eyes. That he was impressed

by them can be seen in the distinct Lastmanian character of the crowd of figures in his *Preaching of St John the Baptist* of 1634 [306]. But his own contribution to the painting of the religious subject (one of the most popular in seventeenth-century Holland, probably because of the importance the Dutch placed on preaching the word of the Gospels) is new, and more significant. It is evident in his skillful integration of the figures into the vast panoramic Italianate landscape, his full control of light and atmospheric effects, and the pronounced accent provided by huge imaginary classical ruins inspired by the remains of the Colosseum. Roman ruins in Italianate landscapes continued to serve as a setting for his principal staples during his years in Holland: religious and mythological subjects and bucolic themes taken from literature. Breenbergh, who remained inventive until the end, also painted small pictures of single biblical figures and a few portraits. His graphic *œuvre* consists of more than thirty lovely etchings of the countryside and ruins of Latium. In 1639–40 he etched a set of seventeen tiny prints (*c.*10 × 6 cm), done with a fine needle, of 'Various ruined buildings within and without Rome' that capture the intensity of Italian light. They are based on sketches he did in Rome.

Poelenburgh's native town was Utrecht, and, like so many Italianate Dutch painters, he studied there with Bloemaert. During his life he achieved greater fame than Breenbergh, and he attracted a large number of followers who used his

305. Bartholomeus Breenbergh: *Ruins of the City Walls near Porta S. Paolo, Rome, c.*1625–7. Drawing: brush and wash. Oxford, Christ Church

306. Bartholomeus Breenbergh: *The Preaching of St John the Baptist*, 1634. New York, Metropolitan Museum of Art

307. Cornelis Poelenburgh: *Rest on the Flight into Egypt*, c.1640. Cambridge, Massachusetts, Harvard University Art Museums, Fogg Art Museum

308. Jan Both and Cornelis van Poelenburgh: *Landscape with the Judgement of Paris*, c.1645–50. London, National Gallery

polished style for arcadian landscapes populated with the same satyrs and nude nymphs he favoured, although in their works the nymphs are usually more hefty. In Italy he enjoyed the patronage of leading Roman families and the Medici court in Florence. He settled in Utrecht after his return from the south and became a leading artist of the city. When Rubens, who owned several of his paintings, travelled to Utrecht in 1627 he visited his studio. In the same year, when the Province of Utrecht made an official wedding gift of four paintings to Amalia van Solms, bride of Stadholder Frederik Hendrik, it included one of his, a *Banquet of the Gods* (the other paintings were an animal and bird picture by Roelandt Savery and pendants by Paulus Moreelse of a *Shepherd* and *Shepherdess*). Poelenburgh became a favourite of the court at The Hague and in 1637 he made the first of several trips to London where he worked for Charles I. His most adoring patron in Holland was Willem Vincent Baron van Wyttenhorst whose collection included fifty-five of his paintings.

Poelenburgh's reputation as a leading representative of the first generation of Italianate artists rests securely on his meticulously finished paintings, usually in cool colour harmonies, of biblical, mythological, historical, and pastoral subjects set in tranquil airy landscapes which make frequent use of classical ruins that help evoke a heroic past. In his *Rest on the Flight into Egypt* [307] the conspicuous foreground fragments of ancient sculpture and architectural remains probably allude to the impending demise of the pagan world and the imminent coming of the New Dispensation. He also made portraits, some in Italianate landscapes (*The Seven Children of Frederick V, 'The Winter King'*, 1628, Budapest, Museum of Fine Arts), and painted figures in pictures by other landscapists. The most beautiful example of his work as a staffage painter are the figures he provided for Jan Both's Italianate landscape which transforms it into a mythological picture, *The Judgement of Paris*, accompanied by a river god and nymphs [308].

Among his numerous followers the one whose works can be closest to his is his pupil Dirck van der Lisse (died 1669). More original is Carel Cornelisz de Hooch whose landscapes can be associated with Poelenburgh as well as Breenbergh. De Hooch remains a shadowy figure; there are a couple of references to him in Haarlem but more place him in Utrecht where he died in 1638 (he was not, as has been erroneously stated, the father of the genre painter Pieter de Hooch). It is not known whether he acquired knowledge of Italianate motifs on a trip south or from Poelenburgh and Breenbergh after they returned to Holland. His most intriguing paintings depict spooky, dramatically lit grottos which house classical sculpture and architectural fragments; two characteristic ones are in the Statens Museum, Copenhagen.

Herman van Swanevelt's works serve as a link between the Poelenburgh-Breenbergh trend and Jan Both and other artists of the second generation of Italianate landscapists. He probably was born in about 1600 at Woerden, near Utrecht. By 1623 he was in Paris, and in the following year he was in Rome. There is no evidence to support the tradition that he lived in Rome about 1627/8 in the same house as Claude Lorrain, but it is certain that he had contact with other French artists as well as Netherlandish ones in the city. For a long time he was banished to the limbo assigned to Claude's followers. However, a fresh examination of his scarce early work, mainly stimulated by an interest in the problem of Claude's early development, indicates that during the beginning of the 1630s his development runs parallel to Claude's, and in some ways even anticipates it. The central composition, the monumental towering tree with its crown cropped by the upper edge of the painting, the golden light, and even the rather clumsy figures of Swanevelt's earliest dated painting, *Landscape with a Biblical Subject (?)* of 1630 [309] are Claudian *avant* Claude (the painting's traditional identification as *Jacob's Departure* does not fit the story as told in Genesis). It has also been noted that Claude

309. Herman van Swanevelt:
Landscape with a Biblical Subject (?),
1630. The Hague, Bredius Museum

based his naturalistic view of the *Campo Vaccino* at the Louvre of 1636, and etching of the same subject and date, on Swanevelt's painting of the site dated 1631 in the Fitzwilliam Museum, Cambridge. In this case, Claude's dependence upon the Dutch painter can be exaggerated; these works are topographical, and their similarity may have been dictated by the commission.

During the thirties, as Swanevelt refined his idyllic landscape style, he worked for princely patrons. The plum was his commission from an agent of Philip IV who was helping the Spanish king assemble the colossal number of paintings needed to help decorate Buen Retiro, Philip's grandiose new palace in Madrid. Among the works ordered for the king were two series of landscapes, one of large-scale pastoral scenes, the other of anchorites in naturalistic settings. Together the two groups numbered more than fifty paintings. Swanevelt contributed to both series. When we consider that Philip acquired about 800 paintings to ornament his new palace, including Velázquez's *Surrender of Breda* and a host of his other masterworks that are now breathtaking accents in the Prado, the landscape commission may appear little more than a touch of gilt added to the king's new golden house. But not so. Other artists who worked on the project include Claude, Poussin, Gaspar Dughet, and Jan Both. What remains of the ensemble gives the best idea of the achievement of the major landscapists active in Rome during the 1630s. It also was the largest, most spectacular landscape commission awarded in Europe during the seventeenth century. After leaving Rome for Paris in 1641 the remainder of Swanevelt's career was mainly spent in the French capital where his paintings and etchings helped to popularize classical landscape in the north. His high-placed Parisian patrons included Cardinal Richelieu; he became *peintre ordinaire* to Louis XIV, and, in 1651, a member of the Académie Royale. Swanevelt made a few trips to his birthplace Woerden before his death in Paris in 1655, and, when in Holland, this pioneer of the 'ideal' landscape also painted 'Dutch' scenery.

ITALIANATE AND CLASSICAL PAINTING FOR STADHOLDER FREDERIK HENDRIK

A Dutch artist whose years in Italy precede Swanevelt's but partially overlap Poelenburgh and Breenbergh's stay there is Paulus Bor (1601–69). He travelled to Italy in the early twenties and returned to his native town of Amersfoort, near Utrecht, by 1626 with a very personal Italianate style that he used for history paintings (his portraits have a distinct Dutch character). Bor's so-called *Enchantress* [310] is characteristic of the draped women who play an important role in his religious, allegorical, and pastoral compositions; they are plump, neckless, and rather lethargic. Bor's forms are clear, smooth, and rounded, and he used colour harmonies of deep green, saffron yellow, greys, and rich silvery white. While in Italy he studied Caravaggio's work, and his soft rhythms, mild light, and beautifully painted stuffs suggest that he paid even closer attention to Caravaggio's follower Orazio Gentileschi. During the 1630s he felt the impact of the young Rembrandt's powerful chiaroscuro. It is significant that this charming, but somewhat awkward artist became one of the painters of large-scale interior decorations in the

Netherlands – a measure of the strength and quality of the decorative tradition in Holland during the first half of the century.

In the late twenties and thirties, when Stadholder Frederik Hendrik, Prince of Orange, needed artists to decorate his restored hunting castle at Honselaarsdijk and Huis ter Nieuwburg, his new country palace near Rijswijk, Paulus Bor was one of those to whom he gave commissions. Both of these residences are now destroyed but contemporary inventories, invoices, and some drawings help conjure up the effect of their painted galleries, ceilings, and stairhalls. At Honselaarsdijk, in addition to Bor, the prince employed Gerrit van Honthorst, an artist with better credentials for large-scale decorations. Others given assignments include van Uyttenbroeck, Theodore Matham, Pieter de Grebber, Christian van Couwenbergh, Cornelis Vroom, and Bramer. Mounted as a mantlepiece in the castle's principal room was a *Crowning of Diana* (now at Potsdam, Sanssouci). This picture, which was given pride of place, was attributed to Rubens and Snyders, an ascription not universally accepted today.

The dressing room of Amalia van Solms, the prince's consort, was decorated with paintings depicting episodes from *Il Pastor Fido*, Guarini's shepherd idyll, by Poelenburgh, his pupil, Dirck van der Lisse, Herman van Swanevelt, and Abraham Bloemaert. The ensemble is an example of the taste for arcadian motifs that began to be favoured by aristo-

310. Paulus Bor: *The Enchantress*, c.1640(?). New York, Metropolitan Museum of Art

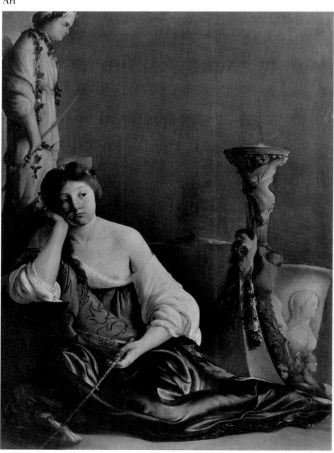

312. Jan van der Heyden: *Huis ten Bosch*, c.1670. London, National Gallery

311. Frans Molenaer: *Huis ten Bosch, Oranjezaal*. Engraving

crats and burghers with aristocratic tastes in the 1620s.[4] The paintings at Huis ter Nieuwburg followed the princely tradition of installing portraits of royalty and views of their palaces in its gallery. Pieter Soutman, Bramer, and van Couwenbergh also worked there. Honthorst was commissioned to paint a very large ceiling. Perhaps it was an illusionistic one similar to the ceiling he painted for his own house in 1622 [see fig. 19]. Drawings of decorative fields in the main room at Honselaarsdijk by Cornelis Holsteyn (1618–58) show that it had high illusionistic wall paintings in steep perspective of figures sitting and leaning over a balcony, a scheme derived from Italian models that Honthorst introduced to the northern Netherlands as early as 1622 (see p. 23 and fig. 19).

The teams Frederik Hendrik assembled to decorate his residences at Honselaarsdijk and Rijswijk, most probably with the close assistance of Constantijn Huygens, his devoted secretary, and Jacob van Campen, who, as we have heard, was a painter but whose reputation as Holland's best classical architect rests on his designs for Amsterdam's new town hall, were hardly ones to rival what Rubens painted for courts of Europe. Frederik Hendrik and his well-informed advisers must have been aware of this. The prince collected as many works by Rubens as he could, and even while at war with Spain, he gave commissions to Rubens and his followers. As for Huygens, he considered Rubens peerless. In about 1630 he wrote in his journal that 'Rubens is one of the wonders of the world . . . no one exists outside the Netherlands, nor shall soon appear, who merits comparison with him . . .' There may be some truth to the report that Frederik Hendrik tried to convince Van Dyck to become his court painter when the Flemish master, then at the height of his fame in Antwerp, visited Holland in 1631–2 before he departed for London. Even though the northern and southern Netherlands were still at war, he made the trip and was warmly welcomed at Frederik Hendrik's court.[5]

Only one intact interior gives us an idea of 'Dutch' large-scale painted wall decorations: the Oranjezaal [311] in Huis ten Bosch (House in the Woods) just outside The Hague.[6] It is a valuable document of the taste of aristocratic circles in Holland around the middle of the century; although the sample is small, it lends support to the view that Dutch painting found its highest expression in easel pictures and not in ambitious decorative schemes. Huis ten Bosch was begun by Frederik Hendrik in 1645 as a suburban retreat for Amalia van Solms. It was designed by Pieter Post in the manner of a Palladian villa. A view by Jan van der Heyden [312] depicts its original state; in the eighteenth century it was altered and wings were added. The Oranjezaal (hall of the House of Orange) is a high central wooden hall built in the shape of a truncated Greek cross with canted corners crowned by an octagonal domed lantern. The height of the hall from the floor to the top of the dome is about nineteen metres. After the death of Frederik Hendrik in 1647, Amalia van Solms decided to have the huge room decorated as a memorial to her husband. The project was completed in 1652. Its elaborate allegorical scheme, devised and strictly controlled by Constantijn Huygens in collaboration with Jacob van Campen, was clearly intended to compete with contemporary Baroque decorations, such as Rubens's glorious Marie de' Medici series in Paris. Huygens was satisfied with the results achieved. He wrote that the decoration at Huis ten Bosch surpassed 'beaucoup d'autres entreprises illustres qu'on rencontre dans les plus grandes cours de la Chrestienté'. Subsequent appraisals have been more critical. When Sir Joshua Reynolds visited the hall during his journey to the Netherlands in 1781, he observed: 'The different hands that have been employed here make variety, it is true; but is VARIETY OF WRETCHEDNESS.'

The Oranjezaal is decorated from the floor to the very top of the dome where, in a painted heaven, *putti* hold a portrait

313. Pieter de Grebber: *Allegory of the Arts and Sciences under Stadholder Frederik Hendrik*, c.1650. The Hague, Huis ten Bosch

314. Jacob Jordaens: *Time as Destroyer and Renewer*, c.1652. The Hague, Huis ten Bosch

315. Caesar van Everdingen: *The Four Muses with Pegasus in the Background*, c.1650. The Hague, Huis ten Bosch

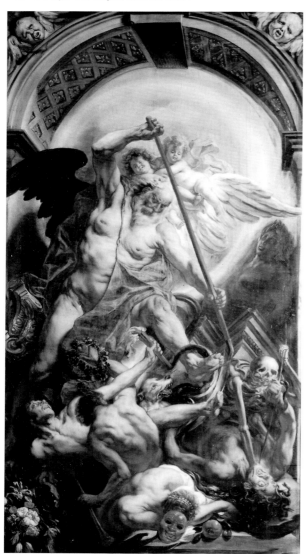

of widowed Amalia, who in turn holds a portrait of her deceased prince. Painted directly on the wooden vaulted ceilings above the hall's arms are classical and allegorical themes that glorify the prince and his virtues [313]. Below them is a series of more than thirty large fields of decoration on canvas in two tiers. The upper one depicts episodes in the prince's life which include classical heroes and mythological figures. The lower tier is mainly devoted to a classical triumphal procession which culminates in *The Apotheosis of Frederik Hendrik*, dated 1651, by the Flemish artist Jacob Jordaens. In addition to portrayals of the prince and his relatives, Jordaens's colossal painting – it is about twice the size of the *Night Watch* – includes about fifty more figures. It is the dominant piece of the entire ensemble. The choice of Jordaens for the enormous centrepiece is indicative of the taste of the court. If Rubens or Van Dyck had been alive when the decoration of the Oranjezaal was planned, it is safe to say heaven and earth would have been moved to procure their services. In the event, Jacob Jordaens, the third member of the grand Flemish trio, then in full maturity, contributed two paintings, a magnificent *Time as Destroyer and Renewer* [314], whose powerful effect is diminished by the dizzying accumulation of paintings in the hall, and the prince's *Apotheosis*. The general iconographic programme of the *Apotheosis* is easy to grasp, but it is crammed with so many esoteric symbolic figures and props that Jordaens himself found it prudent to send Amalia a long exegesis on it: 'Explication du grand tableau triumphal du feu très illustre prince Frédericq Henry de Nassau, prince d'Orange, de louable mémoire, pour Madame Son Altesse la princesse douairère.' Amalia must have found Jordaens's gloss very helpful. Others do too. Today the most erudite iconographers still find it difficult to decipher all of the symbolic references in the painting even after turning to it and the correspondence between Jordaens and Huygens about the painting's programme.

Besides Jordaens, three other artists whose works are characteristically Flemish were given commissions: Theodoor van Thulden, a member of Rubens's circle; Thomas Willeboirts called Bosschaert, a successful Van Dyck epigone; Gonzales Cocques of Antwerp. All of the eight Dutch artists who were selected to participate were either familiar with classistic trends or had close contact with Flemish art. Among them, the most attractive and original was Caesar Boëthius van Everdingen (*c.*1617–78), brother of the landscapist Allart van Everdingen. The refined, generalized forms, clear outlines, and sensitivity to the effects of light of his *Four Muses with Pegasus in the Background* [315] shows what sets him apart. His other histories, genre pieces, and some uncluttered still lifes, such as his *trompe l'œil* paintings of a *Bust of Venus* and *Bust of Adonis* (The Hague, Mauritshuis; Cape Town, The Old Town House; each dated 1665), are almost as attractive. Caesar van Everdingen, a native of Alkmaar, acquired his interest in representing idealized female and male nudes and classical subjects from his connections with artists in Utrecht and Haarlem.

Before Caesar van Everdingen's ten-year stay in the latter city this Alkmaar painter could have been familiar with works done in nearby Haarlem by the group of artists known as the Haarlem Classicists who continued to employ the traditional

historical subjects depicted by the Haarlem Mannerists Goltzius, van Mander, and Cornelis van Haarlem, but following their example, they rejected the distortions and agitation of mannerism for a distinct classicism. Leading members of the group were Pieter de Grebber and Salomon de Bray. Both were called upon to help decorate the Oranjezaal. We have heard that Pieter de Grebber had worked earlier for Frederik Hendrik at Honselaarsdijk. Christian van Couwenbergh, a Delft artist who visited Italy and returned to his native city in 1625 as an uneven Caravaggist, received commissions as well; he had made paintings at Honselaarsdijk and Rijswijk. Pieter Soutman, a Haarlem artist who for a time was a member of Rubens's entourage, and had worked at Rijswijk, was also given a commission. The other Dutch artists given assignments were Honthorst, Jacob van Campen, and Jan Lievens.

It will be remembered that about 1630 Huygens singled out the two young friends Jan Lievens and Rembrandt as the beardless Dutch artists who would soon surpass the achievements of the High Renaissance masters, and that during the thirties and early forties Huygens most probably was responsible for procuring Rembrandt prize commissions: the series of Passion pictures and scenes from the life of Christ painted for Frederik Hendrik. About a decade later Huygens helped Lievens, who had been to Antwerp, where he acquired a Flemish manner, receive a commission for a painting in the Oranjezaal. But Huygens did not even put Rembrandt's name on a list he made of artists worthy of consideration for the project. He must have realized that the style of the mature Rembrandt was too personal for the ensemble he wanted to help create in honour of his prince.

PIETER VAN LAER (BAMBOCCIO) AND THE BAMBOCCIANTI

The group of painters called the *Bamboccianti* differ from the Italianate and classicizing artists who worked for the court at The Hague as chalk from cheese. The leader and principal member of the group is the Haarlem painter Pieter Boddingh van Laer (1599–1642), the first artist to specialize in painting small-scale pictures of the street life of Rome and its environs [317]. He arrived in Rome about 1625 or 1626, where he was nicknamed Bamboccio, probably because of his deformed body (*bamboccio* means deformed child, awkward simpleton, or puppet). The name was used by hostile classicist critics as a disparaging label for members of his circle and followers (*Bamboccianti*), who adopted his subjects and style. Their pictures of scenes in front of inns, market life, labourers and pedlars, landscapes of the Campagna with cattle and shepherds, fighting brigands, beggars, and street musicians were termed *bambocciate*. From van Laer's time until late in the nineteenth century the term was synonymous with low-life genre painting. The influence of the naturalism and chiaroscuro of Caravaggio and the Roman Caravaggists is unmistakable in their works. Sadly, the dark passages in many of their pictures have become rather opaque and are difficult to penetrate, but their focused light and strongly modelled figures still show their debt to Caravaggism.

Contemporary reports suggest that van Laer was a modest, charitable man. Joachim von Sandrart, who knew him well,

316. Pieter van Laer: *Self-Portrait*, *c*.1626–30. Rome, Galleria Pallavicini

317. Pieter van Laer: *Travellers at an Inn*. Paris, Louvre

318. Counterproof after Jan Asselyn: *Painter and Draughtsman working in the Open Air* (*Bent Veughels*). Berlin, Staatliche Museen, Kupferstichkabinett

wrote in his *Teutsche Academie* (1675) that he tended to be melancholic and eased his soul by making music. His striking small self-portrait in profile [316], originally on an octagonal panel later enlarged into a rectangle, shows that he made no attempt to minimize his uncomely features. Apparently Bamboccio's crippled body did not warp his spirit. His sympathetic paintings of the poor and humble never show a trace of bitterness or irony. Although it is risky to read too much into the expression of a portrait, in van Laer's *Self-Portrait* it seems safe to detect a twinkle in his eye and the beginning of a smile on his lips. His contemporaries report that, although he was introspective, he liked fun. While he was in Rome he became one of the leaders of the *Schildersbent* (band of painters), a fraternal organization founded in 1623 that welcomed Dutch and Flemish as well as artists from other northern European countries to join in general merriment and mutual assistance.[7] The society had no fixed programme and no written laws. Members of the group called themselves *Bentvueghels* (birds of a flock) – at a later date they would have been called Bohemians. New members of the group were baptized with wine and received

their *Bent* name from a mock priest. Most of the Dutch artists who travelled to Rome joined the group, and their *Bent* names probably offer a clue to their character as well as their appearance – however, why Leonaert Bramer was dubbed 'Shoe Eye Designed to Receive a Shoelace' (*Nestelghat*) is anyone's guess. Among the founding Dutch members, Poelenburgh was nicknamed 'Satyr', Breenbergh was called 'The Ferret' (*Het Fret*), and Paulus Bor was known as 'Orlando'. The sobriquet of Jan van Bijlert, who is reported to have been another founding member, is unknown. After joining the *Bent* later in the decade, Swanevelt was given the name 'Hermit' (*Heremiet*). A banquet followed the baptism, and when the festivities were over the *Bentvueghels* and their friends marched to the 'Grave of Bacchus', which was, in fact, the red porphyry sarcophagus of the youngest daughter of the Emperor Constantine, at that time in the church of S Costanza, a few miles outside Rome, and now in the Vatican Museum. Here the party continued. The whole ceremony was a parody of the initiation given to new members of the Order of the Golden Fleece. After periods of greater and lesser activity and bacchic irregularities, the *Bentvueghels*

319. Pieter van Laer: *River Landscape with Bathers*. Bremen, Kunsthalle

were finally prohibited by a papal decree in 1720 that forbade ceremonies which could be interpreted as a mockery of the sacrament of baptism.

Van Laer's stylistic development remains unclear and specialists are still of two minds regarding the attribution of some pictures traditionally ascribed to him. There is no record of his teaching or training in Haarlem, but his few known early works indicate he was familiar with Esaias van de Velde's paintings, particularly his cavalry pictures of the 1620s. After his arrival in Rome van Laer settled in the parish of Santa Maria del Popolo, on the via Margutta and the via del Babuino, a neighbourhood that attracted northern artists who worked in the city. There he met Claude, Poussin, Andries Both, and Sandrart. Sandrart tells us that he, van Laer, Claude, and Poussin rode together to nearby Tivoli to paint or draw landscapes from nature. Now, there was nothing unusual about artists making excursions to draw from nature. Artists made such trips as a matter of course since the Renaissance to sketch landscapes that were later composed and worked up in the studio. However, references to artists painting directly from nature are exceedingly rare before Sandrart published this statement (in his *Teutsche Academie* he reports in more than one passage that Claude painted outdoors). Visual evidence that artists of the time painted 'naer het leven' is offered by a drawing inscribed at the top in a fine seventeenth-century hand 'Bent-Vueghels' [318]; the sheet, which is a retouched counterproof of a work by Jan Asselyn, a Dutch Italianate landscapist discussed below, shows a *Bent* member painting at his easel in the open air and another working as a draughtsman.[8]

Whether van Laer painted as well as drew at Tivoli is not known, and none of his scarce painted landscapes qualify as works done on the spot from nature. But how well his outdoor studies served him is evident in the convincing spatial effect created by the cohesion of the terrain and architectural forms, and by the natural light of his signed *River Landscape with Bathers* at Bremen [319]. Landscapes of this type serve as yet another tie between the additive compositions by artists working in the Poelenburgh-Breenbergh tradition and the more unified ones by the following generation of Dutch Italianate artists.

A new note in the Bremen painting is the emphasis van Laer places on the groups of unidealized naked men in the foremost plane. If he looked at classical or Renaissance nudes while he was in Rome, they apparently made no impression on him whatsoever. In his *View of the Tiber at Acquacesto Spring* (Rome, Galleria d'Arte Antica), he offers a grand extensive view of the river and countryside with some figures in the foreground drinking the mineral waters at the site and others defecating at its open air lavatories, a consequence of taking the spring's purgative waters (the site was used by Poussin for the idealized setting of his *St Matthew in a Landscape* [Berlin, Staatliche Museum] and Claude made use of it as well). Van Laer's inclusion of nudes that ignore classical ideals and use of scatological motifs – neither uncommon in Netherlandish art – would have been repugnant to those who maintained artists should depict noble subjects, idealize figures, and follow rules of decorum. For Giovanni Battista Passeri, his early biographer, van Laer's paintings were like a 'window onto life'. At the time, the characterization could be viewed as unsympathetic criticism, but there were collectors as well as artists who responded positively to what they saw through his window. His patrons in Rome include Cardinal Francesco Maria Brancaccio and Don Ferdinando Afán de Alcalá, a Spanish diplomat who had been Viceroy of Naples and a patron of the Spanish painter Ribera, yet another artist inspired by Caravaggio's art. In 1636, van Laer dedicated an unusual series of eight etchings of domestic animals and their keepers to Don Ferdinando. Like Claude's etchings of the thirties they

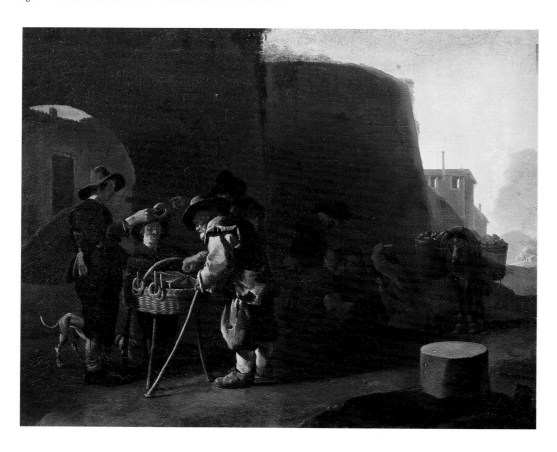

capture the intensity of Italian light. The innovative set made its way to Holland quickly and inspired later series of animal etchings by Paulus Potter, Berchem, and du Jardin. Van Laer also broke new ground by making animals major motifs of paintings instead of ancillary ones. This is seen in his *Mountainous Landscape with Animals and Herdsmen* (Canada, Private Collection) and his *Annunciation to the Shepherds* (The Hague, Bredius Museum); the latter qualifies as an animal picture as well as a history piece.

Among the immediate close followers of van Laer were the Fleming Jan Miel (*c.*1599–1664), who arrived in Rome in the early 1630s and the Roman artist Michelangelo Cerquozzi (1602–60). The figures of herdsmen, stevedores, and dancers that people Claude's landscapes of the 1630s also reveal some of the results of his contact with the *Bamboccianti*. Even an artist of Velázquez's stature and station, who was alive to the polemic between naturalism and classicism during his trips to Rome, found them interesting; the large crowd in his *Philip IV hunting the Wild Boar* (London, National Gallery) includes reminiscences of them.[9]

Van Laer departed from Rome in 1638 and was in Haarlem in the following year. He left his native town again in 1642, and subsequently disappears from the scene. At Haarlem, young Philips Wouwerman and Berchem were part of his succession, but the Caravaggesque aspects of his style escaped them.

Dutch artists of a younger generation who continued working in Bamboccio's style in Rome after he left include Thomas Wijck (*c.*1620–77), Dirk Helmbreker (1633–96), and Johannes Lingelbach (1622–74). The most intriguing member of the trio is Lingelbach who is said to have arrived

in Rome via France in 1644, was certainly there by 1647, reported to have left in 1650, and is documented in Amsterdam in 1653. No work assigned to his Roman years is signed or documented. Nevertheless, more than a dozen have been ascribed to this phase of his activity on the basis of their style; amongst them are some that have been attributed to van Laer. Included in this group is *The Cake Seller* [320], a work distinguished by the dignity it gives to a simple moment in the life of humble people without a trace of the anecdotal or picturesque. The static stance and quiet mood of the old pedlar selling bread rings (*ciambella*) recalls the tragic overtones found in Louis le Nain's paintings of peasants. Since little of the concentrated chiaroscuro effect and restraint are discernible in Lingelbach's firmly documented works that begin to be signed and dated in the early 1650s [321], and even less is found in his numerous signed and dated later paintings which often become crowded and are done in a much lighter and more colourful key, the attribution of *The Cake Seller*, one of most touching of all *bambocciate*, to van Laer is retained here. To complete the story of the search for an attribution for the little masterwork it should be added that some specialists have argued that it was done neither by van Laer nor Lingelbach but by an anonymous artist called the 'Master of the Small Trades'.[10] After his return to the Netherlands Lingelbach adds new motifs to his repertoire: equestrian scenes in sunny landscapes reminiscent of Wouwerman, bright views of imaginary Italianate seaports, and *piazzi* crowded with narrative detail. An interesting variation on the latter is a large panoramic *View of the Dam at Amsterdam*, dated 1656 (Amsterdam Historical Museum) that includes a view of the city's new

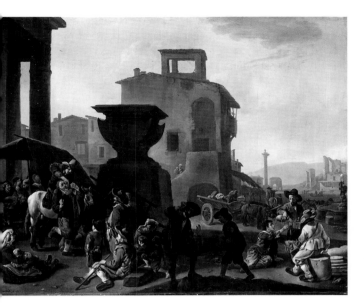

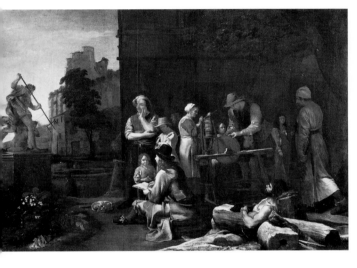

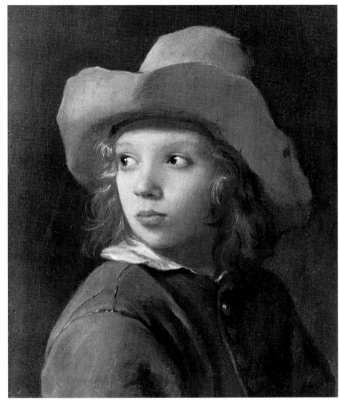

323. Michael Sweerts: *Portrait of a Boy*, c.1660. Hartford, Wadsworth Atheneum

321. Johannes Lingelbach: *Italian Market Place with a Toothpuller on Horseback*, 1651. Amsterdam, Rijksmuseum

322. Michael Sweerts: *Roman Street Scene with a Young Draughtsman*, c.1646–8. Rotterdam, Boymans-van Beuningen Museum

town hall under construction and motley throngs of people doing business or taking their leisure on the principal square.

Although Michael Sweerts was a Fleming (born in Brussels, 1618) his close association in Rome with the Dutch *Bamboccianti* of Lingelbach's generation, and his subsequent stay in Holland merit mention of him here. He arrived in Rome in the mid-forties and the tender pictures he made there during the following years of the life of the women and children and other scenes set in interiors and the streets of contemporary Rome with strong chiaroscuro effects are derived from his assimilation of van Laer's art and study of Roman Caravaggism. However, the bitter-sweet mood and restrained lyricism of his paintings, as well as his colour harmonies of fine blues, violets, greys, and browns, are highly original. He also made a number of history paintings and took a special interest in scenes of young artists working outdoors or in studios from casts of classical sculpture or from life, normally a part of every apprentice's training in both the north and the south. The impact of his own study of antique sculpture is evident in his art. He was also attracted by Baroque sculpture in Rome. The young artist in his

Roman street scene [322] is drawing Bernini's *Neptune and Triton Fountain*, at that time in the garden of Villa Montaldo in Rome and now at the Victoria and Albert Museum, London. Sweerts probably left Rome in about 1654 and by 1656 he had returned to Brussels where he was given permission to open an 'academy for drawing from life'. Sweerts's stay in Amsterdam is only documented for the year 1661, but judging from his *Self-Portrait as a Painter* (Oberlin, Allen Art Museum), which can be dated about 1658 and shows the strong influence of van der Helst's swagger and colour, he had arrived by that year. In any event, his stay in Holland was brief. He left for the Far East in 1661 with a group of missionaries. His superior soon reported that 'the mission was not the right place for him, nor he the right man for the mission'. He was dismissed and died in Goa in 1664. Sweerts's paintings are of a consistently high quality and sometimes reach surprising heights. The mild light, purity of colour, and clarity of forms of his *Portrait of a Boy* (Hartford, Wadsworth Atheneum) [323], datable to his stay in Holland, anticipate the quiet beauty of the portraits of young women that Vermeer painted in the sixties.

THE SECOND GENERATION OF ITALIANATE LANDSCAPISTS

By the time the leading landscapists of the second wave of Italianate Dutch painters came, or are reputed to have been in Rome, Claude and the *Bamboccianti* had evolved their distinctive styles. The young Dutch masters learned from them. It is wrong, however, to view their works as imitations of Claude or Pieter van Laer as is occasionally maintained in the older literature. Each of these painters had a strong artistic personality, and after a brief acquaintance their pictures are unmistakable.

Jan Both, in many ways the most gifted member of the group, had a short life. He was born in about 1615 and died in 1652. During the course of his brief career he evolved a personal conception of Italian landscape which helped to mould northern Europe's ideas about the Roman Campagna for two centuries. Both's native town was Utrecht, where he studied with Bloemaert. His older brother Andries Both (c.1612–41) was also an artist and a Bloemaert pupil. Andries was in Rome in 1635. Works datable before his trip south show that he had a predilection for Bamboccio's subjects before he settled in Rome. Coarse, caricature-like figures are one of Andries's hallmarks and they reappear in *bambocciate* he did in Rome. Their conspicuous presence in *Limekiln with Mora Players* (Budapest, Museum of Fine Arts) suggests that this painting, attributed by some students to van Laer, is more probably a joint effort by the two brothers, Andries contributing the rather grotesque low-life types, and Jan the landscape setting. The precise date when Jan joined his older brother in Rome is unknown, but he was certainly there by the mid-thirties when he was commissioned, along with Swanevelt, Claude, Poussin, and other prominent landscapists working in the city, to provide pastoral and historiated landscapes for Philip IV's Buen Retiro in Madrid (see p. 230 above). Jan and Andries left Rome in 1641 for Venice, where Andries was drowned in an accident. Jan returned to Utrecht in the same year and remained there until his own premature death.

Dated pictures by Jan Both are exceedingly scarce. Of over 300 paintings listed in Hofstede de Groot's catalogue of Both's *œuvre*, only eight are dated. They are of little assistance in working out his development. Moreover, not all the dates are legible or reliable. Wolfgang Stechow, who pioneered the attempt in modern times to rehabilitate the reputation of the Italianate landscapists, noted that the painting which Hofstede de Groot listed as signed and dated 1640, is neither signed nor dated, nor is it by Jan Both.[11] Nothing is known about his artistic accomplishments before he left for Rome, and, except for the landscapes done for Philip IV, few pictures can be securely identified as works painted in Italy. Sandrart, who knew the brothers, gives us some idea about their activities in Rome. According to him, they made landscapes in Claude's style and followed Bamboccio in their smaller pictures. He adds, Jan painted the landscapes and Andries filled them so neatly with people, animals, and birds that the pictures looked as if they were painted by one hand. We have already heard that the *Limekiln with Mora Players* at Budapest may be one of their joint ventures. Another may be the *Capriccio with Figures in the Forum Romanum* (Amsterdam,

Rijksmuseum) which is signed 'Both'. The light, open composition already distinguishes this landscape from those Claude made during the 1630s. The rather squat figures going about their humdrum business in the foreground are similar to others by Andries (e.g. the drawing, now in the Witt Collection, London, signed and dated 'A Both F Roma, 1637'). On the other hand, the landscape and rearrangement of the ruins of the Roman Forum and the luminous atmosphere which pervades them can only be attributed to Jan. The possibility that Jan was responsible for the entire work, and based the figures on Andries's drawings, should not be excluded.

Sandrart writes that Jan Both painted landscapes of the morning hours, when the dew still lies on the fields, and the sun peers out over the mountains, and that the brothers made such wonderful representations of noon, evening, and sunset that it is possible to recognize almost every specific hour of the day as well as appropriate characteristics of the fields, mountains, and trees. This emphasis on the specific qualities of light and nature in a painting is one of the significant differences between Both and Claude. To be sure, Claude also made careful studies of the effects of sunlight and atmosphere, paintings of the times of day, and his discovery that light could be the predominant means of unifying a landscape is rightly considered one of the great innovations in the history of western painting. But Claude's light nearly always plays upon a nostalgic imaginary world inspired by the Campagna and he often used his landscapes as a setting for biblical, historical or mythological scenes. Both's world is imaginary too, but it is a more naturalistic one. For him the Campagna was the land of modern idylls. Classical ruins and monuments seldom occur in works of his maturity, and in his rare historicized landscapes other artists, for example Poelenburgh [308], were called upon to supply needed gods and goddesses. His large *Italian Landscape with Artists sketching* at Amsterdam [324] shows the kind of peaceful everyday theme he preferred. An artist chats with a shepherd, modest travellers and their mules make their way along a winding path, and two men watch the evening sky. Men, animals, and the finely observed botanical detail of wild flowers, luxuriant shrubs, and monumental irregular trees are integrated into the grandiose southern landscape, which has been unified by a complex interweaving of the forms and the warm golden light. Our sense of his creative power as well as that of other outstanding Italianate landscapists increases when we recall that so many of their masterworks in this mode were done in Holland not Italy. The huge scale of the Amsterdam painting (187 × 240 cm) is not unusual in his *œuvre*. Compared to Both's paintings, many of the large-scale views of Italy made by late-seventeenth-century Dutch landscapists look like wallpaper.

Jan Both apparently was not very active as a teacher after he settled in Utrecht. Hendrick Verschuring (1627–90), the virtually unknown Barend Bispinck, and Willem de Heusch (1625–92) were probably his pupils. Of greater consequence was his impact on his contemporaries who were leading

324. Jan Both: *Italian Landscape with Artists sketching*. Amsterdam, Rijksmuseum

325. Jan Asselyn: *Italianate Landscape with a River and an Arched Bridge*, c.1648. Schleissheim, Staatsgalerie, Bayerische Staatsgemäldesammlungen

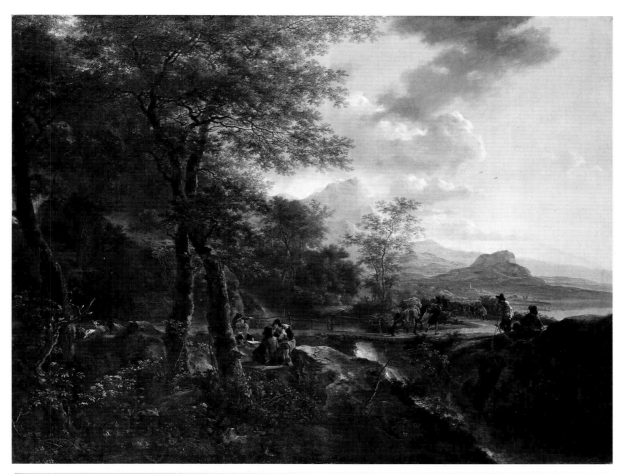

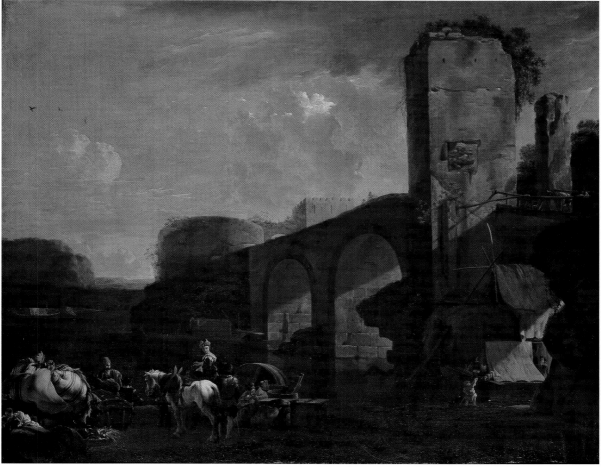

Italianate landscapists (Asselyn, Berchem, Pynacker, Hackaert). Equally important was his decisive influence on the development of Aelbert Cuyp's style. The unmistakable strong reflection of Both's golden light found in Cuyp's landscapes of the 1640s hardly ever dims in his later works.

Jan Asselyn (c.1615–52), Jan Both's exact contemporary, had a much wider repertoire than Both. To be sure, he made his mark with exquisite Italianate landscapes bathed in a luminous light in which large-scale ruins often play a dominant role [325]. His imaginary harbour scenes recall Mediterranean ports and his original extensive panoramic views of the Italian countryside introduce a compositional scheme adopted by Berchem, du Jardin, and Hackaert. But he began in quite a different way. His early works, dated 1634 and 1635, are little views of ferocious cavalry skirmishes which suggest he was apprenticed to Jan Marsten the Younger, a Haarlem battle painter who was a pupil and follower of Esaias van de Velde. Soon afterwards he was said to have travelled to Rome and remained there until about 1643–4. No painting can be documented to his Roman sojourn but on the basis of stylistic evidence a sufficient number establish he was there, and had close contact with the *Bamboccianti* as well as an opportunity to take a hard look at Claude's landscapes. Additionally, he made drawings, often animated with wash, of the grand and modest sights of Rome. We have seen that a counterproof of one of his works depicts members of the *Bent* painting and drawing outdoors [318]. His nickname 'Little Crab' (*Krabbetje*) sounds like one acquired at a *Bent* baptism. However, he could have been given it in Holland before he travelled south, since his sobriquet alludes to his deformed left hand. Rembrandt made a fine etched portrait of him (Bartsch 277; c.1647) which decorously hides his crippled hand by the position of his arm. Originally, Rembrandt included an easel bearing a tantalizing glimpse of one of Asselyn's paintings with characteristic large architectural forms; the picture and easel were burnished away in the second state of the etching.

Asselyn returned to the Netherlands via France where he married in Lyon in 1644–5. Then he moved to Paris where three series of topographical views of Rome were engraved after his drawings by Gabriel Perelle. In Paris he also worked with Swanevelt. By 1647 he was in Amsterdam where he spent the remaining five years of his life. During this brief period he specialized in Italian views saturated with silvery and golden atmospheric effects – Houbraken was not off the mark when he wrote Asselyn was one of the first to bring Claude's pure and light way of painting landscapes to Holland. He also painted winter and night scenes and views of his native land, and pictures of animals and birds as well. His *Threatened Swan* [326], which depicts a life-size swan defending its nest against a dog swimming towards it, was transformed at a later date into an allegory on the vigilance of the Grand Pensionary Johan de Witt (see p. 3 above) by inscriptions added by an unknown hand: under the swan 'De Raad-Pensionarie' (the Grand Pensionary); on one of the eggs in the nest, 'Holland'; and above the dog, 'de viand van de Staat' (the enemy of the State). Asselyn also collaborated with Jan Baptist Weenix on an imposing imaginary view of an Italian harbour with a colossal tower (Vienna, Akademie); the painting is inscribed with both artists' signatures. Willem

Schellinks (died 1678) was upon occasion his close follower, and the Italianate landscapist Frederik de Moucheron (1633–86) was probably his pupil.

Nicolaes (Claes) Berchem, who popularized pictures of Italian pastoral and arcadian scenes, was born at Haarlem in 1620, the son of Pieter Claesz, the outstanding still-life painter. He studied with the father and then, according to Houbraken, with van Goyen, Pieter de Grebber, Jan Wils, and his cousin Jan Baptist Weenix. The last named is highly unlikely since Weenix was a year younger than Berchem. His father's *métier* apparently did not interest him one iota. During the course of his long and extremely prolific career he painted biblical, allegorical, and mythological themes, views of harbours, winter scenes, nocturnals, battles, and some genre scenes, as well as the Italianate landscapes for which he is so justly famous, but he apparently never tried his hand at still-life painting. More crucial for his development as a landscapist than the list of teachers Houbraken cites is what he learned from van Laer, Jan Both, and Asselyn's works.

Berchem entered the Haarlem guild in 1642 and was married in his native city in 1646. There is no documentary evidence that he travelled to Italy. The question of whether he made the trip and if so, when, has been long debated. To judge from his works a reasonable date for the hypothetical trip, which seems likely on the basis of the familiarity with southern landscape, is the fifties.[12] From the beginning Berchem began as a landscapist making easel-size pictures, some of which are historiated. A few life-size mythological subjects done in the late 1640s indicate that he considered working in the direction set by Pieter de Grebber, the Haarlem classicist Houbraken lists as one of his teachers. Examples of this phase are his *Infant Jupiter with a Nymph on the Island of Crete* of 1648 at the Mauritshuis [327], *The Rape of Europa*, dated 1649, at the Hermitage, St Petersburg, and *Vertumnus and Pomona*, datable about the same time, at Braunschweig. Huygens must have been familiar with his

326. Jan Asselyn: *Threatened Swan*, c.1650. Amsterdam, Rijksmuseum

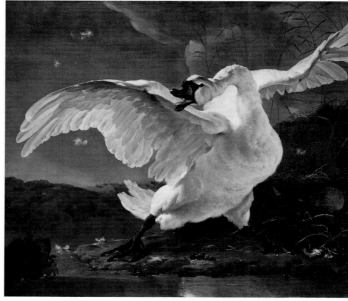

327. Nicolaes Berchem: *The Infant Jupiter with a Nymph on the Island of Crete*, 1648. The Hague, Mauritshuis

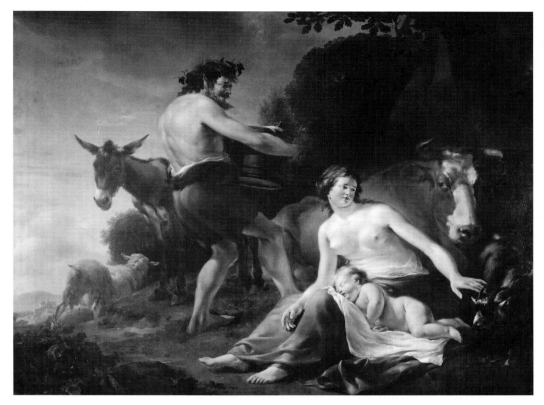

attractive large-scale efforts, because he listed him as a possible candidate for the decoration of the Oranjezaal at Huis ten Bosch. However, Berchem did not make the final list, a regrettable elimination since his large histories indicate that he was more than a match for some of the artists who were selected to decorate Frederik Hendrik's memorial. In about 1650 Berchem travelled to the Dutch-German border region with his friend Jacob van Ruisdael; the trip is documented by his drawing of Bentheim Castle dated 1650 (Frankfurt a. M., Städelsches Kunstinstitut). If his putative trip to Italy was made soon after the journey he almost certainly returned to Haarlem by 1652 since he painted the conspicuous figures in Ruisdael's *Great Oak* [304] in that year.[13] After using Haarlem as the base for his activity for more than three decades, in 1677 he moved to Amsterdam where he spent the last six years of his long life.

There is ample evidence to support Houbraken's statement that Berchem worked constantly from morning until night; Hofstede de Groot lists over 850 paintings, and more than 500 drawings and fifty etchings are attributed to him. He also painted figures in more than one of Ruisdael's landscapes and collaborated with other artists. The landscape and dog in *The Portrait of a Couple* (Amsterdam, Rijksmuseum) is by his hand, while the couple is by Gerrit Dou; both artists signed the picture. *The Calling of St Matthew* at the Mauritshuis is a joint effort signed by Jan Baptist Weenix and Berchem. He was extremely popular and well-paid during his lifetime, and during the following century, when pastoral scenes became even more popular, his fame increased. He was a particular favourite of eighteenth-century French collectors. J.B. Descamps has nothing but praise for him in a volume of his *La vie des peintres flamands et hollandais* published in Paris in 1754, while in the same

breath he dismisses Berchem's father, the master of monochrome still-life painting, as 'a mediocre artist who only painted fish, desserts, sweets, cakes, and some gold or porcelain vases'. In Descamps's time no one questioned the assumption that an artist who painted live cows in a bucolic setting was a more noble representative of the art of painting than one who made pictures of dead herrings.

Berchem's pictures have a more pronounced pastoral character than Both's or Asselyn's. Shepherds and buxom shepherdesses tending their flocks and herdsmen guarding their cattle receive prominent places in his works. His lively figures are seen in sparkling Italian light among ancient ruins, fording rivers, or set against magnificent panoramic views of vast Italian valleys and mountain ranges [328]. The large scale of his figures often suggests his paintings could be classified as pastoral genre scenes as well as landscapes – the same is true of many of Jan Baptist Weenix's Italianate paintings. Wisps of white cloud float in Berchem's dazzling blue skies, and bits of vividly coloured clothing worn by herders, milkmaids, and travellers brighten the cool greens of his landscapes. His peasants enjoy a life of innocence and happiness among their animals. It is an idyllic dream world which appealed to a public that found arcadia a refuge from worldly cares and responsibility. The mood of his pictures justifies the claim that Berchem, who died in 1683, the year Watteau was born, is one of the precursors of the Rococo. Berchem's success stimulated a number of close followers. Karel du Jardin was his pupil. The genre painters Pieter de Hooch and Jacob Ochtervelt, artists who soon went their own way, also studied with him.

Jan Baptist Weenix (1621–60/1) is another versatile Italianate painter. He is best known for his views of the Campagna with emphasis on a mother and child seen against

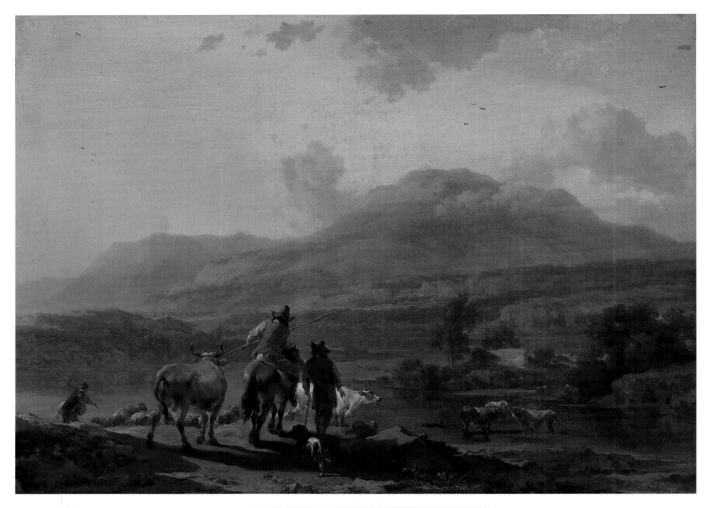

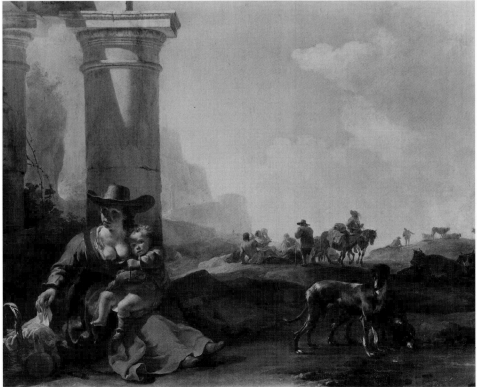

328. Nicolaes Berchem: *Italian Landscape at Sunset*, early 1670s. Munich, Alte Pinakothek

329. Jan Baptist Weenix: *Italian Landscape with Mother and Child*, c.1647–50. Detroit Institute of Arts

massive classical ruins [329], and fanciful Mediterranean seaports (it will be recalled he painted one with Asselyn), but he also painted histories, portraits, and indoor genre scenes as well as some remarkable still lifes with dead game. His son and pupil Jan Weenix (1642–1719) made a speciality of pictures of hunting trophies. Jan Baptist Weenix arrived in Rome in 1642–3 where he enjoyed the patronage of 'Kardinaal Pamfilio', who has been variously identified as Cardinal Giovanni Battista Pamphili, who became Pope Innocent X in 1644, and as the Pope's nephew Cardinal Camillo Pamphili. After he returned to Holland in 1646–7 he invariably signed himself Gio[vanni] Batt[ist]a Weenix. His adoption of the Italian translation of his Christian name and patronymic may have been in honour of Innocent X who gave him at least one commission. In Rome he joined the *Schildersbent* where he was nicknamed *Ratel* (Rattle) because of his speech defect. His sunny views of the shores of the Mediterranean, frequently done on a large scale, teem with crowds that include fashionably dressed ladies and gentlemen riding or strolling near prominent fortresses, colonnades, pyramids, and antique sculpture and columns. The street and country folk that animate works by the *Bamboccianti* appear in his paintings but he never uses their dark Caravagesque manner. His paintings are light in tonality, and though he favours flaming reds, bright yellows, vivid greens and blues, he is never garish. For Weenix's still lifes of hunting trophies see p. 289.

In many ways Karel du Jardin (*c*.1622–78) is the most Dutch of the Italianate painters. His bucolic landscapes are done on a small scale, and have an intimacy lacking in pictures made by Italianates who used a larger format and more ambitious motifs. Du Jardin was apprenticed to Berchem and probably travelled to Italy in the late 1640s or early 1650s, but like so many other Dutch Italianate artists of his generation this early trip south cannot be substantiated. In 1652 he was in Amsterdam and during the next few years his art took an unexpected turn. Instead of settling down in Holland to paint views of the Campagna and the *vita popolare* of Rome, as most Italianate Dutch painters did after their documented or putative trips to Italy, he made pictures of the Dutch countryside which are closely related to Paulus Potter's carefully executed small paintings of cattle in sunny meadows and woods (*The Peasant on his Farm*, 1655, Amsterdam, Rijksmuseum; *Farm Animals in the Shade of a Tree, with a Boy and a sleeping Herdswoman*, 1656, London, National Gallery). During this phase it is sometimes difficult to distinguish the hand of Potter from du Jardin's. By the end of the 1650s he began once again to paint *bambocciate* and modest Italian pastoral scenes. His *Young Shepherd* (The Hague, Mauritshuis) [330], datable to the early 1660s, shows him at his best. The theme is simple. A young boy lies on his back playing with his dog. The sheep, the old grazing horse, and the basket and keg appear to lie about in a haphazard fashion. In a black and white reproduction, only the mountains tell us that this is not a Dutch scene, but when the original or even a good colour reproduction is viewed, warm Italian air and the strong shimmering light of the south permeate it.

Additionally, du Jardin painted handsome portraits of famous citizens in the style of Bartholomeus van der Helst, and his own portrait was painted by van der Helst and by Bol. His *Governors of the Amsterdam Spinhuis* (House of Correction) of 1669 (Amsterdam, Rijksmuseum) does not have the overpowering impact of Rembrandt's *Syndics* or Hals's late regent pieces painted in the same decade (it is impossible to name a Dutch group portrait that does), but it

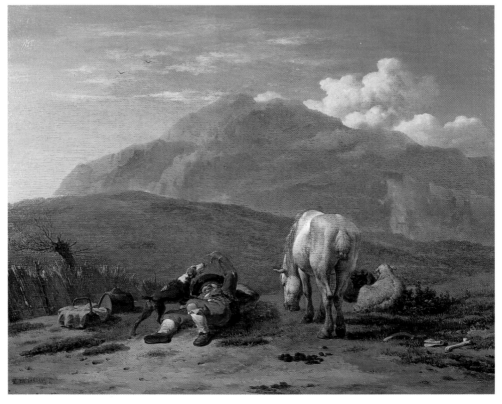

330. Karel du Jardin: *Young Shepherd*, early 1660s. The Hague, Mauritshuis

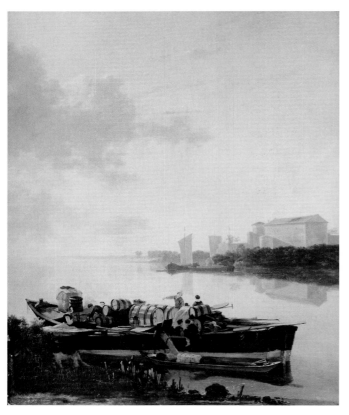

331. Adam Pynacker: *Barges on a River*, c.1655. St Petersburg, Hermitage

remains a beautiful performance. Du Jardin also painted elegant, highly finished religious and allegorical pictures. In addition his *œuvre* includes etchings of Italianate landscapes and of animals. The latter show a distinct debt to the series of animal prints made first by Pieter van Laer and then by Paulus Potter; predictably he suffuses them with southern light and atmosphere.

In 1675 du Jardin is securely documented in Rome. His *Shepherds' Camp*, inscribed 'Roma 1675' (Antwerp, Museum), indicates that during this last phase he found inspiration from the classicizing landscapes painted in Rome by Poussin's follower Gaspar Dughet. Du Jardin did not return to Holland; he died in Venice in 1678. When and where he acquired his nickname *Bokkebaart* (Goat's Beard or Goatee) is unknown. Certain is our knowledge that he was more than able to make ends meet. In Amsterdam he lived in a house on the fashionable Herengracht, and an inventory made of his chattels and movables indicates that in his maturity he enjoyed considerable wealth.

Adam Pynacker (c.1620–73) is said to have spent three years in Italy. Though no documentary evidence supports the statement, the subtly observed reflections of the light clouds in the luminous morning sky upon the mirror-smooth water of his outstanding *Barges on a River* [331] suggest that he had firsthand contact with the landscape of Italy. The picture is unusual in his *œuvre*. More characteristic are paintings of prominent white birches and beeches, elegant reeds, and clumps of thistles streaked with silvery light, seen against distant views of blue mountains. After working in Schiedam, a port town near Rotterdam that was probably his birthplace, and possibly in nearby Delft, he settled in 1661

in Amsterdam where he began to produce large-scale landscapes for patrician homes. Houbraken published a poem (1719) by Pieter Verhoek which describes a room covered with his large canvases. Toward the end of the decade the demand for his landscapes of this type apparently dwindled. The works of his last years, often variations on earlier compositions, are cabinet-size with colours that are rather harsh and metallic.

The youngest notable painter of this generation is Jan Hackaert (1628–85 or after), who made journeys to Switzerland between 1653 and 1656. On his 1655 trip young Hackaert, whose ideal landscapes show the influence of Jan Both, was commissioned to make a series of a completely different type of landscape. The Amsterdam lawyer and collector Laurens van der Hem employed him to make exceptionally large detailed topographical drawings of spots in Switzerland, from the Rhine Falls at Schaffhausen and Lake Zurich, through the dramatic alpine passes and gorges that lead to the country's southern regions. Van der Hem also commissioned a team of other artists (among them Lambert Doomer, Willem Schellinks, Frederik de Moucheron, Jacob Esselens, and Renier Nooms, called Zeeman) to make topographical drawings of sites in Switzerland and other countries. Commercial and economic interests prompted these commissions. In the end, van der Hem's colossal collection of topographic drawings (there are more than forty by Hackaert), maps, charts, and city plans were incorporated into fifty atlas volumes compiled by the Amsterdam cartographer Joan Blaeu (they are now in the National Library, Vienna); the volumes served as the basis of Blaeu's monumental *Atlas Major* published in 1662.

Hackaert is yet another Italianate landscapist for whom there is no external evidence of a trip south of the Alps into Italy. The light and motifs of his scenes of the Campagna, that comprise a large part of his production, suggest that he did. However, we know that he could provide a Swiss landscape with a blue Italian sky and flood it so successfully with southern golden light that it could pass as an Italianate scene; his exquisite panoramic view of *The Lake of Zurich* [332] was long wrongly identified as a representation of Lake Trasimeno in the Appenines.[14]

Hackaert also painted a number of wooded landscapes in Dutch settings with warm light dappling clearings, ponds, and roads lined with tall slender trees crowned with lacey foliage. These works often include elegantly dressed parties departing or returning from a hunt, and, upon occasion, hunters about to make their kill. The figures and animals in them are usually painted by other hands. In some cases it is difficult to give firm attributions to the artists who executed them. However, there is no doubt that Nicolaes Berchem painted the staffage in Hackaert's *Stag Hunt in a Forest* [333] datable about 1660; his name inscribed on the canvas as well as the style of the hunters and animals in this rosy *sous-bois* landscape establish they are his. A few years later Jacob van Ruisdael and Adriaen van de Velde collaborated on a magnificent *Stag Hunt in a Wood with a Marsh* now at Dresden. Hunting scenes were also painted by Aelbert Cuyp and Philips Wouwerman. The figures in these landscapes reflect the vogue hunting enjoyed at this time and which gained strength in the following decades. Their aristocratic asso-

332. Jan Hackaert: *The Lake of Zurich*, c.1673. Amsterdam, Rijksmuseum

333. Jan Hackaert and Nicolaes Berchem: *A Stag Hunt in a Forest*, c.1660. London, National Gallery

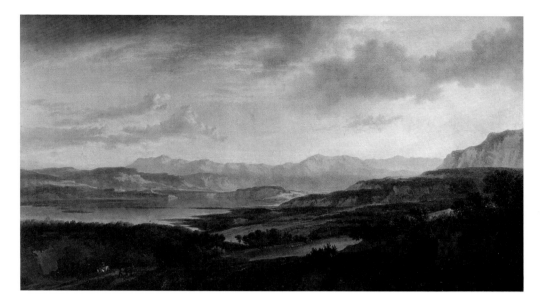

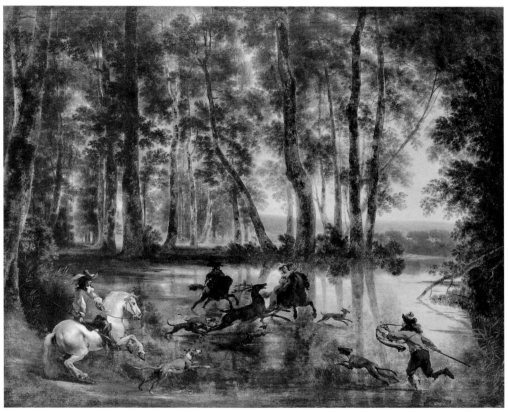

ciations help account for their popularity with a new urban elite who acquired country estates and manors in emulation of the life led by the nobility when lodged in the bosom of nature. They knew well that in the Netherlands hunting was traditionally a strictly regulated activity theoretically limited to the nobility (see p. 288 f.). These patricians must have taken special delight in paintings related to the hunt, and it is safe to say, so did a less privileged clientele who enjoyed the sport vicariously. Similarly, Netherlanders who had experienced the warmth of the hot Italian sun on their backs must have received particular pleasure from Italianate landscapes that now and then offered them a reminder of it, and the vast number of Italian landscapes that were painted indicates they appealed equally to their fellow citizens who never had the opportunity to visit the land where lemons bloom.

Portraiture

The visual arts are as important as any other original source for social and cultural historians. Portraiture is a good case in point. A portrait is a primary document about a sitter's behaviour and environment. It reveals not only the exterior of a person and his or her character, but also something substantial about a patron's social position, attitude, and setting. This is the case even when a single person is represented against a plain, neutral background. Bearing and dress, glances and gestures, manners, indeed a person's whole character is largely formed in reaction to a definite environment. Consequently, every portrait is bound to reflect qualities of a person as a social being.

Another point merits close attention. A portrait always reflects both the objective data presented by the sitter and the subjective interpretation of the artist. The degree of objectivity and subjectivity in a portrait will of course vary during different epochs and with individual artists. Therefore, if we try to concentrate on the objective content we must be on guard not to confuse arbirtrary interpretation with the facts the portraitist faced. We may never get the objective facts with scientific accuracy – they are always tinged with the artist's personality as well as the depth and control we have of our own knowledge of the sitter, the portraitist, and the environment in which they lived – but we can recognize that during some ages there is more concern with the actual appearance of the features of an individual than in others.

If we turn to portraiture of the early phase of the Renaissance, particularly in the north of Europe – such as that of Jan van Eyck and Memling – we find that it retains a medieval flavour. It still reflects the ideals of a feudal society which restrained the free expression of the individual through the medieval concept of the world with strict subordination of a person's thought and action to the supreme position of religion. Individuality is expressed by the close objective rendering of externals, but the restriction laid upon individuals by the spiritual power of the Church and the strict social order in strongly felt. The submission of men and women to God – or the appearance of submission to him – is the important concern, not elevation to the fullest consciousness of their own power. These portraits appear severe and limited in expression. Not only is the sitter's mouth sealed, but the portraitist is reluctant to tell us much about human relationships.

Jakob Burckhardt's famous and still debated thesis that the culture of the Renaissance is marked by the liberation of the individual in society is best borne out by the portraits made by Titian. Titian's patrons confront us with personalities of vigour and free bearing. They appeal to us as people who have come to power, not so much on the basis of their social standing, but rather by their individual merits and achievements. Though they move with dignity and restraint, we do not feel any serious restriction made upon them by their social setting. However, they seem to exist in a well-regulated world, where ideals of order, beauty, and heroism are alive and exert a considerable influence on their actions and achievements. The great individual stands out from society, but at the same time appears to be its natural product, expressing in his or her existence the elevated ideals of Renaissance culture.

The situation changes in the Baroque period. Aristocracy by birth rather than aristocracy by intrinsic force and personality seems stressed by Baroque court portraitists. The creations of Van Dyck, the Baroque court portraitist *par excellence*, especially when he was working for the English court during the thirties, all appear to belong to the same race of courtiers and reflect the ideals of elegance and class consciousness which marked his highly privileged clientele. They considered themselves superior by birth, and appear to look down upon people of lower degree. Yet many seem to lack inner strength, the very qualities which might justify a feeling of superiority. Van Dyck was in complete sympathy with his high-born patrons. He also had the rare ability to endow even an ugly sitter with beauty and yet, it seems, to achieve a likeness, a talent of inestimable value to a portrait specialist. His kind of interpretation fulfils most successfully the claims of a pretentious patronage. A courtly atmosphere is also evident in Velázquez's portraits, but so is the restraining effect of Spanish etiquette. The objective character of Velázquez's portraits is stronger than Van Dyck's. He was less of a flatterer. He records with sincerity, yet with discretion and restraint. We are made to feel something of the ceremonial air of the court of Spain, in which the king was a superior being and where too much individuality was never allowed to come to the fore. Velázquez shows us personality as through a veil. He seems to take a special spiritual distance from his subject which is great enough to subdue an excessively pointed characterisation of either the individual or his social background.

After the courtly atmosphere of Van Dyck and Velázquez, contact with the vigorous and seemingly unrestrained clientele of Frans Hals is like a breath of fresh air. Hals made most of his patrons look genuinely friendly. They seem to greet their fellow-citizens. There is force and naturalness in their personalities, but seldom the heroic atmosphere and tension found in High Renaissance portraits. More often than not Hals expressed with quick vitality the extrovert character of his sitters, and even invigorated their personalities by his own mighty temperament and genius. In contrast to Hals, Rembrandt – in particular the mature Rembrandt – gives little overt indication of a sitter's social attitude. Does this mean that as far as characterization is concerned they are incomplete portraits? Hardly. His portraits are still comprehensive, but they have acquired a new accent. We sense he concentrates upon a different kind of life: it is that which goes on in his subject's thoughts and feelings. It is a life that seems remarkably independent of man's environment. Social status matters little for this kind

334. Paulus Moreelse: *Maurits van Nassau at the Age of Twenty-Nine Weeks*, 1619. Formerly Pepinghen, near Brussels, Jhr. H. Camberlijn d'Amougies

335. Anonymous seventeenth-century Dutch painter: *Woman on her Death Bed*. Brussels, Musées Royaux des Beaux Arts

of characterization. As we have seen, Rembrandt creates the proper atmosphere for introspection by his original use of chiaroscuro, and the costumes he uses in his art are frequently a means of creating a mood rather than a record of conventional dress. It is scarcely necessary to add that Rembrandt's emphasis upon contemplative humility was not a return to a late medieval or Early Renaissance attitude. His sitters seem as free from theological restrictions as they are from social ones.

Other Dutch masters of portraiture are never as exuberant as Hals, or as introspective as Rembrandt. Consequently, their work is probably a more reliable index of the average Dutch *burgerlijk* environment and social atmosphere, which showed a taste for the homely and domestic even in the case of prominent patrons. Dutch aristocrats as well as burghers often appear with little ease or elegance, but with a certain justifiable pride and personal independence, and, as with all seventeenth-century Dutch painting, there is always a decent standard of pictorial execution and craftsmanship.

In the discussion of Hals's and Rembrandt's works we have mentioned virtually every type of portrait Dutch patrons commissioned to satisfy their seemingly insatiable desire to commemorate their existence, station in life and accomplishments as well as keep alive the memory of the dead. The prize assignments were for large group portraits of civic guard officers and their subordinates, of regents, and of surgeons and witnesses of their anatomy lessons. These collective portraits, a genre that had found special favour in the Netherlands since the late fifteenth century, were designed to hang in the public or semi-public rooms of the institutions with which the artists' patrons were affiliated. Private commissions, ranging in size – and price – from tiny

miniatures to life-size full-lengths, portrayed sitters from the cradle to the grave, and occasionally beyond the time a corpse was laid out, for posthumous portraits were ordered too [335], and in some family groups the dead were resurrected in paint and portrayed with the quick.[1] Life-size companion portraits of couples in sundry lengths were more common than double portraits (probably because of the small size of Dutch houses) and it is not astonishing to learn that in some cases it can be established that portrayals of couples commemorate betrothals, weddings, or marriage anniversaries. In aristocratic and elite circles the international courtly taste for historiated portraits was occasionally followed. These works show sitters in the guise of classical, mythological, allegorical, literary, and even biblical characters implying that the model possessed the virtues of the personages whose roles they play. But character and status was most often depicted in a more mundane way by the naturalistic portrayals of patrons dressed in the fashion of their time and class, although then, as now, there were older people who preferred to be seen wearing clothes that were the *dernier cri* when they were young. Additionally, then, as now, accessories and props were introduced to allude to the character or profession of sitters or to abstract ideas. Decoding their meanings is not always as straightforward as it may seem. The modern spectacles through which we look at portraits of another epoch can obscure their meaning.

Consider the smoked herring held in one hand by Pieter van der Morsch and the herrings he has in his straw basket in Frans Hals's portrait of him [336]. At first blush his herrings appear to identify him as a fisherman or fishmonger hawking his wares. This seemingly convincing interpretation, which had been accepted since the portrait entered the literature in the nineteenth century, appears to be clinched by the conspicuous inscription: 'WIE BEGEERT' (Who Desires [One]). However, P.J.J. van Thiel's close study of the seventeenth-century iconology of the smoked herring and of what could be learned about van der Morsch from contemporary

336. Frans Hals: *Pieter van der Morsch*, 1616. Pittsburgh, Carnegie Museum of Art

sources demonstrated this interpretation is wrong.[2] Van der Morsch was not a fisherman or fishmonger. He was a Leiden municipal court messenger who belonged to one of the city's literary societies where he played the part of a buffoon. A book of his own verse includes an epitaph he composed for himself. In it he characterizes himself as a man who distributes smoked herrings. Ample evidence establishes that in his time 'to give someone a smoked herring' (*iemand een bokking geven*) meant to shame someone with a sharp rebuke. The inscription on the painting is not a reference to the sale of smoked herrings. It refers to van der Morsch's readiness to ridicule. In Hals's painting the smoked herrings and inscription have been used to portray van der Morsch in his role as the wise fool of his literary society.

Iconological investigations of most of the accessories and props in Dutch portraits (skulls, timepieces, gloves, coral amulets, flowers, fruits, fountains, etc.) as well as gestures (e.g. joined hands of married couples) have not led to the striking shift in interpretation produced by the study of smoked herrings. Nevertheless, van der Morsch's fish is a helpful reminder that do-it-yourself interpretations of elements in portraits of the period that are not controlled by what can be learned from visual and literary traditions and other contemporary sources can be wide of the mark. The method for determining their significance does not differ from that used for the interpretation of other branches of Dutch painting.

When we turn to the first decades of the century we find centres of portraiture at Delft and The Hague where at various times the stadholder had his court, the States-General its seat, and most foreign diplomats resided. Michiel Jansz van Miereveld (1567–1641) and his pupil Jan Anthonisz van Ravesteyn (c.1572–1657) are the outstanding names. Both artists inspired a host of minor painters. Their portraits are restrained, rather dry visual reports, competent in draughtsmanship and with only a moderate decorative effect. Costumes, armour, and faces are rendered with the same meticulous care and reliability. Miereveld was, it seems, prepared to make some adjustment in the features of a countenance to satisfy a foreign client. A contemporary tells us that when Miereveld received commissions from Frenchmen, he painted them 'with an abundance of benignity'.[3] Though Ravesteyn can be a little more elegant than Miereveld and his touch is sometimes livelier, it is not always easy to separate their hands. Miereveld enjoyed a greater reputation – particularly among court circles in The Hague – and he kept a workshop busy making portraits of members of the house of Orange-Nassau [337] and other noble families. As we have already heard (see p. 13), Joachim von Sandrart reported that he painted over 10,000 portraits during his lifetime. His son-in-law Willem Jacobsz Delff (1580–1638) made a career of engraving copies after them.

337. Michiel van Miereveld: *Maurits, Prince of Orange*. Amsterdam, Rijksmuseum

The matter-of-fact pictures that Miereveld produced seemed to be precisely what Dutch aristocratic circles wanted. When Gerrit van Honthorst, who belonged to a younger and less provincial generation, began to paint portraits for the court at The Hague in the thirties, he was as stiff and impersonal as his predecessors.

Miereveld's pupil Paulus Jansz Moreelse (1571–1638), who was also active as an architect and a painter of subject pictures, practised his master's portrait style in Utrecht with equal dexterity, less severity, and greater versatility. He helped initiate the vogue for pastoral genre pictures and arcadian portraits. His historiated portrait of Countess Sophia Hedwig, dated 1621, shows her with her three sons in the role of the Charity [338]. Her bare breast and the accompanying children are traditional attributes of Charity, the virtue she is personifying. She is depicted wearing a quasi-oriental costume and jewelled headdress, her two eldest sons wear antique tunics, and her lightly draped youngest son wears the two strings of pearls with which he was adorned when Moreelse portrayed him when he was twenty-nine weeks old [334]. In the background there is a muse holding a baby thought to be Sophia's daughter born November 1620. Sophia's family connections give some idea of the clientele that commissioned historiated portraits at the time. Her father was Duke of Braunschweig Wolfenbüttel, her mother a princess of Denmark, her husband, Ernst Casimir, Count of Nassau Dietz, a cousin of the stadholders Maurits and Frederik Hendrik, who became Field Marshall of the United Provinces, Lieutenant Governor of the provinces of Gelderland and Utrecht, and, subsequently, Stadholder of Friesland, Groningen, and Drente.

Daniel Mytens (c.1590–1647), who carried Miereveld's style to Britain, had longer and closer connection with court circles than Moreelse. Born in Delft, then active in The Hague, he was in England by 1618 when he first served Thomas Howard, 2nd Earl of Arundel, the pre-eminent patron and connoisseur of Britain during the first decades of the century. Toward the end of his reign James I sat to him and soon after Charles I succeeded to the throne in 1625 he appointed him 'one of our picture-drawers of our Chamber in ordinarie' for life. His many courtly portraits secure his reputation as the most distinguished portraitist residing in Britain before the arrival of Van Dyck in 1632. Thereafter, Mytens's patronage dropped. He returned permanently to The Hague in 1634. But Charles did not forget him. An inventory reference establishes that he kept Mytens's outstanding *Self-Portrait*, now at Hampton Court, hanging next to those by Rubens and Van Dyck in a little room at Whitehall.[4] Documented proof that Charles possessed the three self-portraits is but one of a number of contemporary inventory references that indicate this type of portraiture was collected. There also was a market for imaginary portraits of picturesque types, often called *tronies* by the Dutch.

Around the same time Cornelis van der Voort (c.1576–1624), Werner van den Valckert (c.1580/5–c.1627), Nicolaes Elisaz Pickenoy (1588–1650/6), and Thomas de Keyser (1596/7–1667) represented portraiture in Amsterdam. All of them distinguished themselves as group portraitists, and until Rembrandt's arrival in Amsterdam in 1631 or 1632 Pickenoy and de Keyser were the most sought after face

338. Paulus Moreelse: *Sophia Hedwig, Countess of Nassau Dietz, portrayed as Charity, with her Three Sons*, 1621. Appeldorn, Rijksmuseum, Het Loo Palace

painters in the principal city of the Netherlands. We have already discussed the significant contributions Frans Hals and Rembrandt made to group portraiture and the demands a successful artist working in this branch of painting meets: he not only makes a good likeness of each individual but shows something of the nature of the group and the relation of those portrayed to it. On the whole, Dutch portraitists placed greater emphasis on individual likeness than on the character of a group. This is understandable. We know group portraits were made to decorate buildings of the organizations which commissioned them. This was flattering for the people represented. A place in a group portrait was a kind of social award for their activity. Since each individual paid to have his or her face included, each sitter could expect full measure.

Cornelis van der Voort made an important innovation to regent group portraiture in about 1617–18 when he had the simple but bright idea of unifying groups of governing officials of institutions around cloth-covered tables, and enlivening his groups by showing some figures seated and some standing.[5] Van der Voort's new scheme was adopted by virtually all seventeenth-century painters of regent portraits, including Hals and Rembrandt, and is still used today by artists and photographers. Although an anatomy lesson is a far cry from a board meeting *The Anatomy Lesson of Dr Sebastian Egbertsz de Vrij* [339], now attributed to Nicolaes Eliasz Pickenoy,[6] which was painted in 1619 as a chimney piece for the chamber of the surgeons' guild of Amsterdam, the artist seems to have taken a cue from van der Voort's

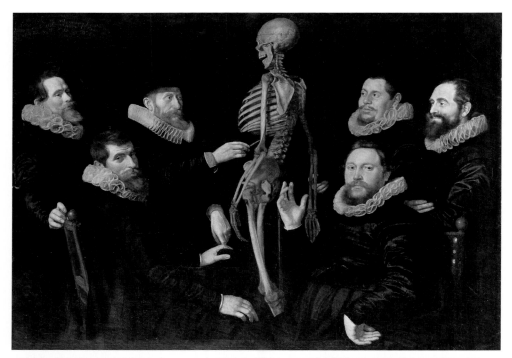

339. Nicolaes Eliasz Pickenoy (attributed to): *Anatomy Lesson of Dr Sebastiaen Egbertsz de Vrij*, 1619. Amsterdam Historical Museum, on loan from the City of Amsterdam

340. Thomas de Keyser: *The Company of Captain Allaert Cloeck*, 1632. Amsterdam, Rijksmuseum, on loan from the City of Amsterdam

innovation. In the strictly symmetrical painting four figures stand and two are seated. The four concentrate on the painting's subject: de Vrij's lecture on osteology aided by a life-size skeleton. They give inner unity to the group portrait. In contrast, the two seated surgeons pay no attention whatsoever to the prelector's lecture; they turn away and make eye contact with us. Their glances, attitudes, and gestures have a positive effect: they help establish an outer unity between the sitters and the spectator; additionally, one of them draws attention to the skeleton in the centre. On the other hand, their total disregard of the surgeon's demonstration lessens the structural and psychological unity of the group. Other characteristics of this early seventeenth-century group portrait are its relief-like arrangement, without much effect of depth – there is no indication of the setting –

and its emphatic uniform light. Juxtaposition of it with Rembrandt's famous *Anatomy Lesson of Dr Tulp* of 1632 [67] immediately impresses us in favour of Rembrandt, as it must have impressed his contemporaries, by its chiaroscuro and the dramatic action which the painter fresh from Leiden gave to the subject. Apart from the fact that both artists followed the convention of depicting a preceptor wearing a hat while lecturing, the group portraits have little in common.

In 1632, the year Rembrandt completed his *Anatomy Lesson of Dr Tulp*, Thomas de Keyser painted his large group portrait of *The Company of Captain Allaert Cloeck* [340]. In it de Keyser follows the Amsterdam tradition of showing civic guards standing full-length that was established by Cornelis Ketel in the previous century (1588, *The Company of Captain Dirck Jacobsz Rosencrans*, Amsterdam, Rijksmuseum). When

341. Thomas de Keyser: *Constantijn Huygens and his Clerk*, 1627. London, National Gallery

Frans Hals was commissioned by Amsterdam guards to paint his so-called *Meagre Company* in 1633 [48], he also used the whole-length scheme; the five guard pieces Hals painted for Haarlem are all knee-length. In his 1632 guard piece de Keyser accentuated the middle group by placing it in front of the other guardsmen, who are on different levels and appear to be on the way to join their officers. Nevertheless, the result is not very satisfactory. There is no indication of a unity between the sixteen figures, and de Keyser's attempt to combine a horizontal setting with the effect of depth by placing symmetrical groups at various distances fails by its stiffness. The painting was commissioned by the guards for the Kloveniersdoelen, where it was mounted with other group portraits of Amsterdam civic guard companies that used the building. Rembrandt's *Night Watch* [83] was hung there a

decade later. De Keyser's 1632 group portrait was one of the paintings Samuel van Hoogstraten must have had in mind when he wrote in 1678 that 'Rembrandt's *Night Watch* will in my opinion outlast all its competitors . . . [and that] as some people feel, all the other pieces stand there beside it like playing cards.'

De Keyser is more original and successful in his small-scale, full-length portraits of one or two figures in interiors surrounded by objects that allude to their interests and achievements. His masterwork in this branch of genre-like portraiture, which he principally formulated and popularized, is *Constantijn Huygens and his Clerk* dated 1627 [341]. Here we see Huygens, who we have met more than once in these pages, in his early thirties after he had served as secretary to the Dutch embassies in Venice and London, been knighted

342. Thomas de Keyser: *Pieter Schout on Horseback*, 1660. Amsterdam, Rijksmuseum

was High Bailiff of Hagstein, on a black Andalusian executing a *pesade* in a dune landscape; the support of the finely executed piece is copper. Dirck Dircksz Santvoort (1610/1–80) continued to work in the style of de Keyser at Amsterdam until the mid-forties when he abandoned work as an artist. For a brief period in his early phase Santvoort fell under Rembrandt's spell (*Supper at Emmaus*, 1633, Paris, Louvre). Afterwards he produced portraits indebted to de Keyser's. The naïve charm of his figures, whose faces appear to be made of highly polished ivory, sets them apart from those done by the average conscientious portraitist of the time.

Representatives of the best level of portraiture around the middle of the century are Johannes Cornelisz Verspronck (before 1603–62) and Bartholomeus van der Helst (1613–70). Both were born in Haarlem, but under different stars. Verspronck remained in Haarlem all his life and never attracted much attention outside of his native city. Van der Helst settled in Amsterdam where, by the early forties, he worked for the high and mighty and won the reputation as the most fashionable Dutch portraitist of his time.

Verspronck was a son of the Haarlem painter Cornelis Engelsz (1574/5–1650) who probably trained him. His earliest existing portraits, done in the mid-thirties, show the strong influence of Frans Hals's invention, but he never attempted to emulate Hals's bold brushwork or temperament. His touch is restrained and his works are highly finished.

343. Johannes Verspronck: *Girl in a Light Blue Dress*, 1641. Amsterdam, Rijksmuseum

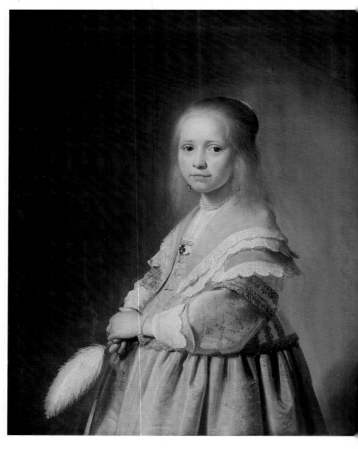

by James I, and appointed secretary to Stadholder Frederik Hendrik, a position that began more than four decades of devoted service to the House of Orange. The objects in the room, which offer a catalogue of the wide range of Huygens's interests, include a Porcellis-like stormy seascape above the fireplace and a small bust-length portrait below it; drawings, compasses, a terrestrial and a celestial globe, a chronometer, a stringed instrument that belongs to the lute family, books and writing paraphernalia on a table covered with a turkey carpet, and a large and rich tapestry depicting a scene from the life of St Francis with Huygens's coat of arms in its upper border. The identity of the young man bringing Huygens a letter is unknown. In a 1785 inventory of the effects of one of Huygens's descendants he is described as his clerk or page (when the painting appeared in an 1822 London auction the compiler of the sale catalogue wrongly attributed it to Aelbert Cuyp and we will never know what wild associations made him title it 'Christopher Columbus in his study'). Not the least quality of the double portrait is the understated tension de Keyser establishes between his two sitters.

In addition to portraits, de Keyser's *œuvre* includes religious and mythological subjects. During the 1640s and 1650s he was active as a stone merchant and mason, and painted less, but afterwards he picked up his brushes more frequently. During his last years he painted a few small-scale equestrian portraits, a type that never gained wide popularity in the Netherlands. The first is *Pieter Schout on Horseback*, dated 1660 [342], which depicts his patrician patron, who

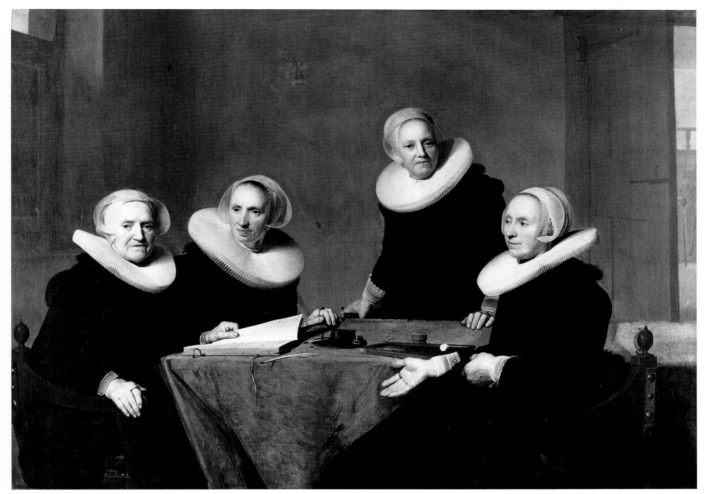

344. Johannes Verspronck: *Regentesses of the St Elizabeth Hospital*, 1641.
Haarlem, Frans Hals Museum, on loan from the Elizabeth Hospital, Haarlem

Original was a penchant he soon developed for depicting sitters off-centre leaving a wide, neutral background to the right or left of them; these areas are always exquisitely modulated from light to dark. This propensity is seen in his portrait of a *Girl in a Light Blue Dress* of 1641 [343]; subsequently, he sets patrons much closer to the canvas's edge. The bright colour scheme of the *Girl in a Light Blue Dress* is unusual in his *œuvre*; his palette rarely deviates from rich, shining blacks, subtle greys, browns, and white. Even in this appealing portrait, one of the most enchanting of the period, we feel that he follows Dutch precedent and does not attempt to make the young girl more beautiful than she actually was. Like Hals, Verspronck was a particularly sensitive portraitist of women. His contemporaries in Haarlem apparently sensed this too. He was never commissioned to paint a regent group portrait but he was hired to execute two of regentesses. They are his most imposing paintings. The first group, dated 1641, depicts the *Regentesses of the St Elizabeth Hospital*, [344]. It was painted as a companion piece to Hals's group portrait of the regents of the same institution executed in the same year [49], and, like Hals's, it was done for the hospital and still belongs to it. The two paintings vie for the distinction of being the first regent group portraits painted in Haarlem.

In the following year Verspronck painted the governing body of a Haarlem orphanage, the *Regentesses of the House of the Holy Ghost* (Haarlem, Frans Hals Museum, on loan from the Nederduitsch Reformed Orphanage, Haarlem); they are accompanied by the institution's housemother with two rosy-cheeked, smiling orphans at her side. Obviously the regentesses wanted to advertise the best aspect of the orphanage in their board room and Verspronck obliged them. The idea of using children as allusions to the principal mandate of regentesses of orphanages was evidently originated by Jacob Backer; an orphan girl, wearing the red and black garb or her institution, is presented by her housemother to the board in Backer's *Regentesses of the Burgher Orphanage of Amsterdam*, datable about 1633–4 (Amsterdam Historical Museum, on loan from the Burgher Orphanage).

A marked change in the Dutch portraitist's conception of his task becomes apparent in the work of Bartholomeus van der Helst. His portraits take on some of Van Dyck's elegance, which began to affect Dutch art about 1640. Adriaen Hanneman (1610–71) returned to The Hague with Van Dyckian motifs about 1637, after more than a ten-year stay in England, and the portraits he and his pupils made for courtly patrons helped to set the new fashion. When his

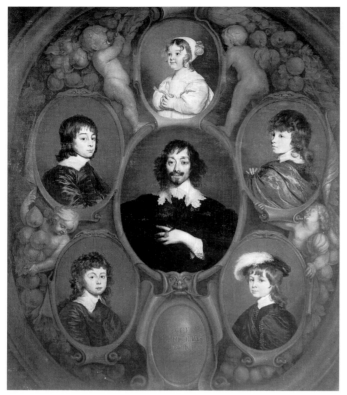

345. Adriaen Hanneman: *Constantijn Huygens and his Five Children*, 1640. The Hague, Mauritshuis

London, from 1632 to 1635, and then in Antwerp until 1644, had an overpowering impact on him. Until his death in 1674 his work as a portraitist and history painter is Van Dyckian and has nothing in common with his early Leiden pictures which are similar to those done at the time by Rembrandt. However, Lievens's freely painted landscapes with strong chiaroscuro effects do not owe anything to Van Dyck, and neither do his highly original woodcuts.

Van der Helst's marriage in Amsterdam in 1636 suggests he had settled there by then. In the following year, at the age of twenty-four, he was commissioned to paint the *Regents of the Walloon Orphanage* [346], his earliest existing dated work. Its crowded composition and dry touch recall the portraits of Nicolaes Eliasz Pickenoy; these similarities are the basis for the hypothesis that Pickenoy was his teacher. A few portraits done in the following year or two show some affinities with Rembrandt, but a pronounced shift starts in 1639 when he began his huge civic guard piece, the *Company of Captain Roelof Bicker* [347]. The picture was one of the seven group portraits commissioned to decorate the new meeting and banquet hall in the Kloveniersdoelen. As we have heard, Rembrandt's *Night Watch* was part of the ensemble; it hung in the same room. The unusual proportions of van der Helst's group portrait (it is almost four times as wide as it is high) are explained by its designated place in the hall. It was designed to fill an end wall over a very high, large fireplace. This place accounts for the painting's long rectangular format and the frieze-like effect of the thirty-two figures he was hired to portray. His solution for breaking strict alignment was to depict the men and boy on the left standing and many of the men on the right seated or descending from a building in the background. By the time the group portrait

lovely portrait, dated 1640, of Constantijn Huygens surrounded by his five young children [345] was acquired for the Mauritshuis in 1822 it was purchased as a Van Dyck, an understandable error; it bore the wrong attribution for more than half a century. The boy portrayed in the upper left medallion of the portrait is Constantijn's son Christiaen who was to win a greater international reputation than his father for constructing the first clock accurately regulated by a pendulum, differentiating the rings around Saturn, and for a number of other significant contributions to mechanics, optics, astronomy, and mathematics.

Jan Mytens (*c.*1614–70), nephew of Daniel, likewise active at The Hague, quickly followed Hanneman's lead, specializing in Van Dyckian family group portraits in park-like landscapes. Cornelis Jonson van Ceulen, Hanneman's friend, can also be credited with helping to popularize Van Dyck's airs and liquid touch in the Netherlands. Jonson, born in 1593 in London of Netherlandish parents, became a popular portraitist in the court circle of Charles I. In 1632, the year Van Dyck arrived in England, he was sworn in as his 'Majestie's servant in ye quality of Picture Drawer'. Jonson emigrated to the Netherlands in 1643, no doubt a move caused by the English Civil War; during the Interregnum he portrayed some Royalist refugees. In the Netherlands he was active in Middelburg, Amsterdam, The Hague, and finally in Utrecht where he worked from 1652 until his death in 1661/2. His travels helped disseminate his cooled interpretation of Van Dyck's dazzling style. Another important conduit for the Flemish master's manner was Jan Lievens whose long contact with his work, first in the court of

346. Bartholomeus van der Helst: *Regents of the Walloon Orphanage*, 1637. Amsterdam, Maison Descartes, on loan from the Régence Hospice Wallon

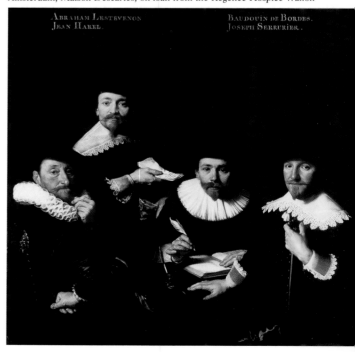

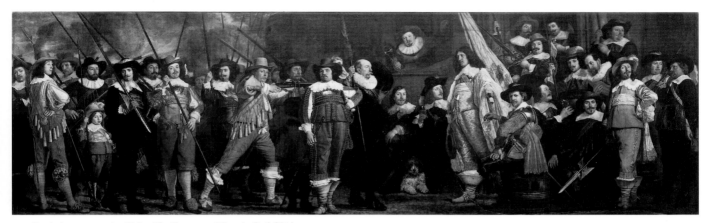

347. Bartholomeus van der Helst: *The Company of Captain Roelof Bicker*,
1639–43. Amsterdam, Rijksmuseum, on loan from the City of Amsterdam

348. Bartholomeus van der Helst: *Celebration of the Peace of Münster, 1648, at the
Crossbowmen's Headquarters*, 1648. Amsterdam, Rijksmuseum, on loan from the
City of Amsterdam

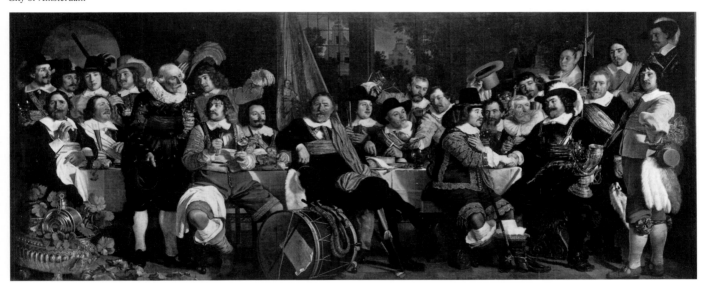

was finished in 1643, van der Helst's reputation was
clinched. Amsterdam was impressed by his swagger, fine
colouring, and clarity, and he soon succeeded Rembrandt as
the favourite portraitist of the city. Most of his patrons, as
well as those of his followers, were wealthy members of the
regent class, admirals, or military heroes. Dutch predicants
and scholars were less fascinated by his manner. Van der
Helst's fame did not diminish during the eighteenth century.
When Sir Joshua Reynolds visited the town hall in Amsterdam
in 1781 he found van der Helst's group portrait of *The
Celebration of the Peace of Münster, 1648, at the Crossbowmen's
Headquarters* [348] far superior to Rembrandt's *Night Watch*
which hung in the same building. Of van der Helst's
Celebration of the Peace of Münster Reynolds wrote

[it] is, perhaps, the first picture of portraits in the world,
comprehending more of those qualities which make a perfect
portrait than any other I have ever seen ... Of this picture I
had before heard great commendations; but it as far exceeded
my expectation, as that [*Night Watch*] of Rembrandt fell
below it. So far, indeed, am I from thinking that this last

picture deserves its great reputation, that it was with difficulty
I could persuade myself that it was painted by Rembrandt ...

In an unpublished manuscript note made during his visit to
Amsterdam Reynolds was more succinct and blunt: 'If it [the
Night Watch] is by Rembrandt it is the worst of him I ever
saw'.[7]

It seems that Reynolds was blind to Rembrandt's new
solution to the complicated problem of painting a group
portrait of civic guards. Rembrandt – as we have indicated
before – decided to unite all the figures in the *Night Watch* in
one concentrated action dramatized by the power of his
chiaroscuro as well as by a great diversity of movement,
instead of merely painting a collection of single likenesses in
a loose composition. In a way Rembrandt's radical solution
annulled the original purpose of the group portrait of guard
companies, which was to represent the likenesses of a large
group of individuals, and transformed it into a historical
painting of unmatched dramatic character and pictorial
glamour.

Though we know that the *Night Watch* was not refused by

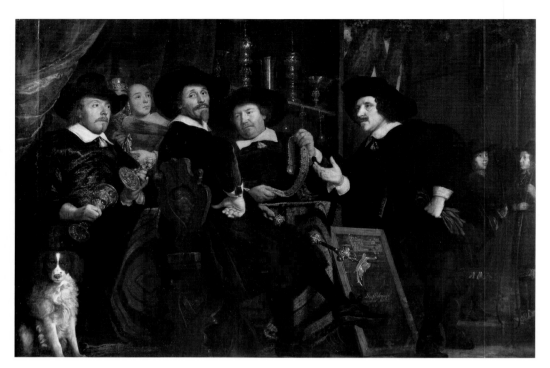

349. Bartholomeus van der Helst: *The Governors of the St Sebastian Archers' Civic Guard*, 1653. Amsterdam, Rijksmuseum, on loan from the City of Amsterdam

the men who commissioned it, apparently neither the artists nor the citizens of Amsterdam were impressed by it. To be sure, Rembrandt's pupil Hoogstraten wrote (1678) that Rembrandt's *Night Watch* made all the other civic guard pieces in the Kloveniersdoelen look like playing cards, but he added a telling reservation: he wished it had more lights. When we turn to visual evidence we find that not a single portraitist tried to emulate Rembrandt's revolutionary achievement. Govert Flinck's *Company of Captain Albert Bas*, painted for the great hall of Kloveniersdoelen in 1645, his group portrait of the *Amsterdam Civic Guard celebrating the Signing of the Peace of Münster* of 1648, van der Helst's painting of the same event [348] – the list can be extended – are all clearly and sharply delineated collective portraits giving each man his due. The interest of Dutch artists and their clients in detailed portrayals won the day. The inclination towards brighter colouring which became popular during the forties by the influence of Van Dyck's followers, came to the fore and found favour with the public.

Moreover, the moment had arrived when portraits of large bands of civic guards were superfluous. In the years after the Peace of Münster the companies were not disbanded, but after 1650 collective portraits of officers and their men were no longer painted. When van der Helst painted group portraits for the Archers' Civic Guard in 1653 [349], the Calivermen's Civic Guard in 1655, and in the following year, the Crossbowmen's Civic Guard, he was commissioned to limit his portraits to the four governors of each company. A few ancillary figures are included but all officers and the rank and file were dismissed. The governors also have changed clothes. They are dressed as regents, not military men, and are seated round a table inspecting in a casual manner the precious treasures of their civic guard company (1653), eating oysters (1655), or busy with paper work (1656). These group portraits help us to see the high plane Rembrandt attains in the *Syndics* of 1662 [109]. Rembrandt's

subject is the same, a group of men seated round a table, but we must not let the simplicity and the evident naturalness of the *Syndics* allow us to overlook the superiority of his artistic achievement. There is no precedent for the depth of his characterization of the individual sitters. The problem of unifying the six men into a group has also been given a perfect solution. We have already discussed how Rembrandt provides a momentary tension and an easy, natural rhythm for the group by slight actions and movements. Rembrandt knows well how to restrain the naturalistic effects, which are obtrusive in van der Helst's groups, by binding together the whole by a well-balanced design and a convincing atmosphere. Of course, in the *Syndics* Rembrandt could hardly represent his models in complete isolation and in the introverted attitude he used in his late single portraits; group portraiture makes better sense when contact between the members of a group is established. Rembrandt not only established the necessary human and pictorial bond, but he creates one which raises the mood of the group portrait to a new level. The work remains the climax of Dutch group portraiture. With the exception of Frans Hals's late regent pieces and a few others (e.g. Karel du Jardin's *Governors of the Amsteram Spinning House* of 1669 at the Rijksmuseum), what follows in this category is of greater historical than aesthetic interest.

Van der Helst's life-size *Abraham del Court and Maria de Keersegieter* of 1654 [350] shows him at the top of his form as a portraitist of private patrons. The drawing of the elegant married couple seated in a garden is faultless and the rendering of their costly garments, the very last word in *haut couture* among the elite circles, is rendered with technical perfection. Nothing is known about del Court as a connoisseur of painting but he certainly was an expert on textiles. He was a cloth merchant and served a term as an official of Amsterdam's textile guild. He must have taken as much delight as his wife did in van der Helst's depiction of Maria's

350. Bartholomeus van der Helst:
*Abraham del Court and Maria de
Keersegieter*, 1654. Rotterdam,
Boymans-van Beuningen Museum

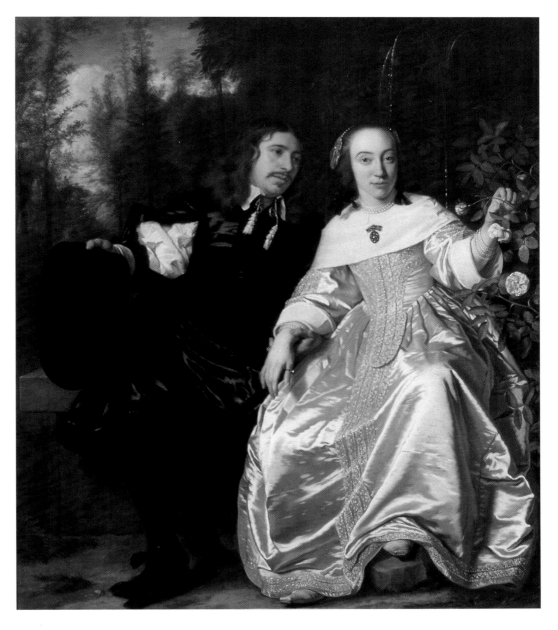

silvery-white satin gown enhanced by the play of light on the silver braid along its front and lower edge. The thorny rose Maria holds probably alludes to the pains and pleasures of love, the fountain in the garden to fecundity, and del Court's gentle support of his wife's wrist to the concord of their joined status. Van der Helst received more commissions than he could handle and not all of them attain the high quality of the del Court double portrait. Marked variations in execution of signed paintings done in the same year signal that he employed assistants to help him meet the demand. One is documented: in 1652 Marcus Waltersz (or Waltusz) agreed to paint and serve him for twelve months for three guilders, three stuivers per week. His contract stipulated he was to work for ten hours a day during the summer months and from dawn until dusk during the winter. For his part van der Helst agreed to teach him as much as possible, and further, on days when Marcus was scheduled to act at the theatre his master was to give him the afternoon free without

docking his weekly wage. Nothing more is known about Marcus's activity as an aspiring painter or actor.

Van der Helst had numerous followers. Most talented was Abraham van der Temple (1622/3–72), whose portraits have been mistaken for his. Nicolaes van Helt Stockade (1614–69) also succeeded in adopting his manner. Both artists were active in Amsterdam during the sixties. Bartholomeus's son Lodewijk (1642–84 or after) was also one of his followers, but with less success. Van der Helst's elegant, colourful portraiture took hold quickly. At Amsterdam before the middle of the century Govert Flinck dropped his earlier Rembrandtesque manner in favour of it, and Ferdinand Bol did the same a few years later.

Even before the death of Verspronck in 1662 and of the octogenarian Frans Hals in 1666, Jan de Bray (*c*.1627–97) became a leading portraitist in Haarlem. In the mid-sixties, about the time Hals painted his late regent and regentess group portraits for Haarlem's Old Men's Almshouse [57,

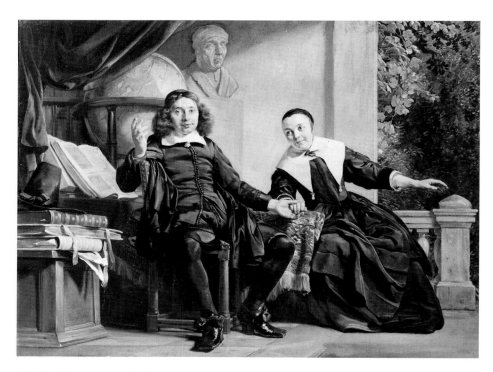

351. Jan de Bray: *Abraham Casteleyn and Margaretha van Bancken*, 1663. Amsterdam, Rijksmuseum

58] de Bray received four commissioned for life-size collective portraits of governors from the city's charitable institutions. Among his work for private patrons one of the most attractive is his double portrait of Abraham Casteleyn, who seems to be casually greeting the viewer, with his chubby wife Margaretha van Bancken at his side [351]. The huge globe and open atlas on his table are references to Casteleyn's work as founder and published of the long-lived *Haarlemse Courant*, a newspaper that won a reputation for quickly and reliably bringing world-wide as well as local news to Holland. The bust is of the Haarlemer Laurensz Coster, titular patron saint of Dutch printers. According to a legendary account first published in 1588, the invention of printing with movable type that transformed civilization was made by Coster, not Gutenberg. The story made him a Haarlem as well as a national hero, and had a very long life. As late as 1856 his townsmen erected a bronze statue in Coster's honour, which still stands in Haarlem's principal square.

Jan de Bray's depiction of Casteleyn seated on the corner of his chair with his legs spread apart recalls the informality Hals introduced to Dutch portraiture; as seen here, the eminent publisher would have been at home in one of Hals's civic guard banquet pieces. But except for his first efforts datable to the early fifties, little more in Jan de Bray's *œuvre* recalls the older master. He often adopted the colourful palette and smooth, limpid manner of van der Helst, qualities evident in his historiated portrait of a *Married Couple in the Guise of Penelope and Odysseus* [352]. His contact with Haarlem's classicizing artists, particularly his father Salomon de Bray who was his teacher, made assimilation of these aspects of van der Helst's popular style an easy step. Fidelity is the theme of the roles played by the unidentified couple in the historiated portrait. Although the woman wears a fashionable dress of her time, the handloom she holds identifies her as Penelope, who, after ten long years, was still waiting for the return of her husband Odysseus from the

Trojan Wars. Others though he was dead, particularly her numerous suitors. She warded off her courters by declaring she would not make a decision regarding re-marriage until she had finished weaving a winding sheet for her father-in-law. Since faithful Penelope was determined to wait she devised a stratagem to trick her wooers; each night she undid the weaving she accomplished during the day. She did not wait in vain. After a decade Odysseus returned disguised as a beggar, recognized only by his old, faithful dog Argus. In the portrait we see the husband dressed in what was acceptable at the time as an antique costume suitable for Odysseus reunited with his Penelope and his dog begging for attention. Jan de Bray made other classicizing historiated portraits as well as history paintings. The various subjects de Bray treated make him refreshingly difficult to categorize. This is equally true of his father Salomon, usually remembered for his classical compositions – it will be recalled that he was selected to paint large decorated fields for the Oranjezaal at Huis ten Bosch. Yet Salomon's double portrait of his nephew's *Twins Clara and Aelbert de Bray* [353] puts him squarely in the tradition of Dutch naturalistic portraiture. The chiaroscuro effect and colour scheme of the painting are reminiscent of Rembrandt's works of the 1640s, but stylistic slots are the last thing to come to mind when confronted by this touching image of two tiny babies wearing what are presumably their baptismal lockets lying in a richly carved gilded Baroque shell-like cradle.

The development of Nicolaes Maes (1634–93) tells much of the story of Dutch portraiture after 1660. Maes's precocious achievement as a gifted Rembrandt pupil has already been discussed. His fame rests primarily on his genre paintings of the intimate life of women and children made at Dordrecht during the fifties. Some Rembrandtesque portraits, datable to the same decade, have been ascribed to him, but their attribution is not certain. Secure are his efficient, workman-like portrayals that are signed and dated

352. Jan de Bray: *A Couple in the Role of Penelope and Odysseus*, 1668. Louisville, J.B. Speed Museum

353. Salomon de Bray: *The Twins Clara and Aelbert de Bray*, c.1646. Scotland, Private Collection

354. Nicolaes Maes: *Jacob de Witt*, 1657. Dordrecht, Dordrechts Museum, on loan from the City of Dordrecht

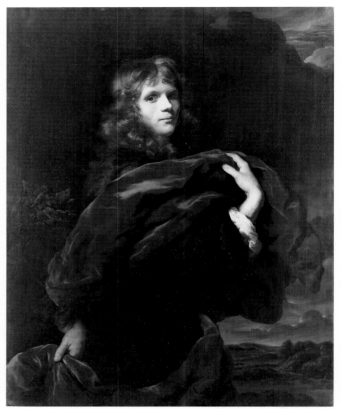

355. Nicolaes Maes: *Portrait of a Young Man*, late 1670s. Munich, Alte Pinakothek

during the second half of the 1650s.[8] The finest of this group is his sober portrait of *Jacob de Witt* [354], the father of Johann de Witt, the leading statesman of the Netherlands during the second half of the century. Maes and the citizens of Dordrecht, who were his principal clients, were apparently satisfied with likenesses of this type, and about 1660 he became a portrait specialist. Around the same time his style also changed dramatically. Houbraken summarizes the shift in a nutshell. He wrote that Maes 'learned the art of painting from Rembrandt but lost that way of painting early, particularly when he took up portraiture and discovered that young ladies especially preferred white to brown'. Maes adopted the bright colours and studied elegance of Flemish artists and the popular late-seventeenth-century French court painters with such success that during the nineteenth century some historians argued that there must have been two Dutchmen named Nicolaes Maes: one who made Rembrandtesque genre pictures, and another who made fashionable portraits which are closer to Rigaud than to Rembrandt. Houbraken, a citizen of Dordrecht who had an opportunity to become well informed about his fellow townsmen, wrote that Maes made a journey to Antwerp to see paintings by Rubens and Van Dyck and that he met Jordaens there too. It has been suggested that this trip accounts for the changes in Maes's style. But no evidence substantiates his trip to the southern Netherlands. Moreover, it is not necessary to postulate one to account for his second manner. He could have learned that ladies prefer to be painted in light instead of shadow from Dutch artists who made the discovery a generation before he did. It was also possible for

him to acquire Van Dyckian airs without leaving Holland. We have seen that the Flemish master's manner had been introduced to the Netherlands by Hanneman and Jonson before Maes's hand is recognizable. They continued to practise it until their deaths in 1671 and 1670, respectively. So did Jan Mytens and younger Jan de Baen (1633–1702), who was a successful classicizing portrait specialist at The Hague after his arrival there in 1660. The story Houbraken tells about de Baen's choice of style is by now a familiar and predictable one. After completing his apprenticeship, Houbraken writes, de Baen had to

decide which style would be most worthy to follow. Paintings by Van Dyck were highly esteemed, and Rembrandt's found many supporters as well. He long stood undecided at this crossroad, not knowing which way was best to follow, but finally selected the manner of the first as the more durable for his model.

Maes achieved great popularity among his contemporaries, who were beginning to emulate French taste and were less reluctant than their grandfathers to show pride and wealth. In 1673 he moved from Dordrecht to Amsterdam, where he spent the last two decades of his life. His late portraits depict his elegantly dressed patrons in a bright steady light, usually against the rosy glow of a landscape [355]. Succulent brushwork and the sense that he is presenting a lively likeness (Houbraken claimed that Maes painted better likenesses than any painter who worked before or after him) distinguish him from other stylish portraitists of the period.

The career of Caspar Netscher (1635/6–84) is similar to

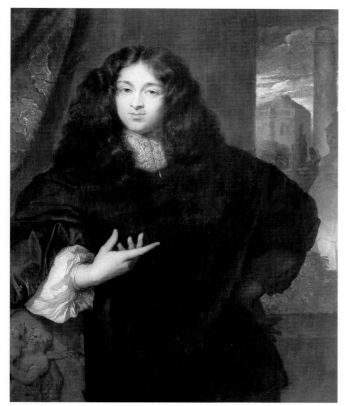

356. Caspar Netscher: *Maurits le Leu de Wilhem*, 1677. The Hague, Mauritshuis

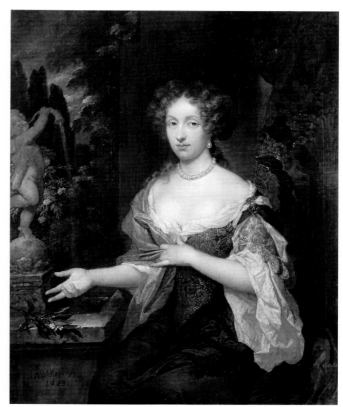

357. Caspar Netscher: *Maria Timmers*, 1683. The Hague, Mauritshuis

Maes's. He started as a painter of genre and subject pictures and then turned almost exclusively to portraiture. The style of his early small, highly finished genre pictures primarily derives from Gerard ter Borch, his teacher, whose fine small-scale paintings were frequently imitated but never equalled (see p. 164). In 1662 Netscher settled at The Hague, where he worked in the manner of its increasingly Frenchified fashionable portraitists. In his little half-lengths Netscher gave special attention to the accurate representation of costly clothes, and followed the international Late Baroque mode of placing his patrician clients against the background of a garden decorated with sculpture as is seen in his portrait of *Maria Timmers* dated 1683 [357], which was done as a pendant to the painting Netscher did of *Maurits le Leu de*

Wilhem six years earlier [356]. Her portrait was most probably commissioned to commemorate their marriage in 1683. In any event, it is evident that Maurits found no reason to have his likeness taken again to make the pair of portraits. Despite Netscher's standardized poses and limited ability to exploit the expressiveness of hands, the meticulousness of his small-scale portraits had great appeal and stimulated a number of minor eighteenth-century Dutch portraitists. His sons Theodoor (1661–1732) and Constantijn (1668–1723) are among his closest imitators, but neither captures his allure. Netscher was able to learn some things from ter Borch, but he failed to pass on to his sons what he had acquired from the outstanding Dutch master of portraits in little.

Architectural Painting

Architectural painting, which was developed as a special branch by Netherlandish artists, offers a great variety of subjects. The two main ones, interiors and town views, have a long history. As early as the fifteenth century Jan van Eyck, Roger van der Weyden, and Geertgen tot Sint Jans, to name a few, used church interiors as a setting for religious pictures and there are paintings by them and their contemporaries that include vistas of creditable townscapes. The crowded action in Pieter Bruegel's paintings done in the following century, frequently takes place in a street or town square. In these works, however, the figures are not subordinated to the architecture. Seventeenth-century Dutch painters were the first to minimize the importance of people in architectural settings in order to emphasize the beauty and power of buildings as an independent subject. Their greatest contribution was the portrayal of church interiors. In these they discovered extraordinary pictorial attraction when the play of sunlight and shadows enlivens the silent space with an almost mystical mood, and a sensitive eye can find tonal configurations of an unforgettable grandeur.

Interest in independent architectural subjects begins in the Late Mannerist period under strong Flemish influence. The first to specialize in this branch was Hans Vredeman de Vries (1527–before 1609?), a painter, architect, theorist, and prolific designer of architectural and ornamental pattern books. Born in Leeuwarden, he was often on the move to various parts of Europe. Antwerp was frequently his base. His paintings are fantastic compilations of a rich variety of features of classical architecture which show his familiarity with Vitruvius and Renaissance architectural treatises; the elegant genre vignettes and occasional biblical scenes that dot his views are his own invention. His son and close follower Paul Vredeman de Vries (1566/7–before 1639) was his sometime collaborator. Their *Palatial Architecture with Figures*, dated 1596 [358], which bears both of their monograms, was done when they were working for the court of the mighty emperor Rudolf II in Prague. Distinguishing who did what on their joint efforts is a kind of secret science. Rudolf's interest in 'perspectives', a generic name for all kinds of architectural painting (and sometimes for landscapes), heralds the kind of collectors who purchased them. They were favoured by well-tutored courtly patrons and art lovers with an interest in mathematics, optics, and the mechanical arts. Hans Vredeman de Vries is best known for his perspective handbooks; most popular was *Perspective, the highly renowned art . . .*, which was published in Latin, Dutch, French and German at The Hague and Leiden in 1604–5. As its lengthy title page advertises, the richly illustrated work offers imaginary depictions of 'churches, temples, palaces, halls, rooms, galleries, squares, passageways, gardens, markets or streets, or other such things . . .' His claim that it would be useful and indispensable for painters, engravers, sculptors, architects, engineers, stone cutters, cabinet makers, carpenters, and all who love the arts was just. His *Perspective* was used as a manual until well into the seventeenth century.

Hendrick van Steenwijck the Elder (*c*.1550–1603), a pupil of Vredeman de Vries, was an equally influential figure. He was probably born in the northern Netherlands, but was active in Germany and Flanders. His son Hendrick van Steenwijck the Younger (*c*.1580–before 1649) received training from his father in Antwerp, then moved to Germany. He was in England between about 1617 and 1637 where he worked for Charles I; an inventory of Charles's collection lists at least a dozen of his paintings and 'A little boock of Proospectives'. The last years of his life were probably spent in Holland. The style and subjects of father and son are very similar. Their views and interiors, stressing perspective and variety of architectural invention, inspired most of the painters of the transitional period. The addition of figures, sometimes by another artist – a practice continued throughout the century – adds an illustrative quality. Generally the Steenwijcks' pictures are small and executed in a miniature fashion on copper. Distinct outlines characterize the drawing, and their bright colours are somewhat hard. They favoured classical and Renaissance architecture for views of palaces and squares. Churches, on the other hand, were usually done in the Gothic style. There is one important exception: in 1573 Steenwijck the Elder painted a view of the interior of the Romanesque cathedral at Aachen (Munich, Alte Pinakothek). It is the earliest dated Netherlandish depiction of an existing church interior. Although their church interiors look like portraits of actual buildings, most are imaginary views. As a rule they represent the church as seen from the nave, and always show it from above – the bird's-eye view also adopted by landscapists active during this period. A high point of view enabled them to exercise their interest in perspective effects leading to an exaggerated distance, and to show as much as possible of the interior, richly decorated with altarpieces and sculpture in contrast to the bareness of Dutch Protestant churches in the next generation. Small figures are spread over the nave and aisles, with an intention to show some biblical episode or merely to entertain and lead the eye into the distance. The Steenwijck tradition was continued in Antwerp by the Flemish painters Peter Neeffs the Elder, who entered the Antwerp guild in 1609 and died *c*.1655/6, and his son Peter Neeffs the Younger (1620–*c*.1675). Like the Vredeman de Vries team and Hendrick van Steenwijck the Elder and the Younger, their hands often are virtually indistinguishable. Neeffs the Elder, however, made one innovation; he can be credited with popularizing church interiors seen by night dramatically illuminated by one or two sources of artificial light.

In Holland, shadowy Hendrick Aerts (active *c*.1600) painted at least one imaginary Gothic church and a couple of views of fantastic Renaissance palaces which are indebted to Vredeman de Vries's model books. Barthold van Bassen (?–1652), a painter-architect active in Delft and The Hague,

358. Hans and Paul Vredeman de Vries: *Palatial Architecture with Figures*, 1596. Vienna, Kunsthistorisches Museum

359. Barthold van Bassen: *Imaginary Church Interior with the Tomb of Prince Willem the Silent*, 1620. Budapest, Museum of Fine Arts

360. Dirck van Delen: *Imaginary Church Interior with the Tomb of Prince Willem the Silent and a Family beside It*, 1645. Amsterdam, Rijksmuseum

and Dirck van Delen (1605–71), sometime municipal official and burgomaster of Arnemuiden, painted church interiors and Renaissance palaces in the Vredeman de Vries and Steenwijck style. Exceptional in van Bassen's œuvre is his 1620 view of the interior of an imaginary church with a depiction of Willem the Silent's celebrated tomb in the New Church at Delft by the leading sculptor Hendrick de Keyser [359], father of Thomas de Keyser. Hendrick began his elaborate sepulchre of the founder of the House of Orange in 1614 and it was only finished in 1622 after the sculptor's death. Thus van Bassen painted the tomb before its completion; since the figures on its top were never *in situ* he probably worked from designs or a model Hendrick de Keyser prepared for the imposing royal monument. Van Bassen's portrayal of the mausoleum is the earliest known depiction of it. In 1645 Dirck van Delen showed the tomb with a family of four posing like tourists beside it [360]. He also placed the tomb in an imaginary church. Only in 1650 did Gerard Houckgeest have the innovative idea of placing it in the interior of the actual church that housed it [365], as well as the tombs of Willem's sons, Stadholders Maurits and Frederik Hendrik, and other members of the House of Orange. Soon afterwards Willem the Silent's tomb was depicted by other architectural painters from various angles with varying emphasis but *in situ* in Delft's New Church. What accounts for the tomb's sudden popularity in the 1650s? Probably it had a special appeal to patrons with strong Orangist sympathies during the bitter struggle between the regents of Holland and the House of Orange that began even before Willem II's premature death in 1650 at the age of twenty-four. The Orangists lost the struggle when the States-General decided not to elect his infant son Willem III stadholder, a decision that initiated the Netherlands' first stadholderless period. Most probably van Bassen also was commissioned by the burgomasters of The Hague to depict for the decoration of their town hall an exterior view of the city's New Church before its completion; the painting, dated 1650 (The Hague, Historical Museum) is an example of a portrait of a specific Dutch building seen in its urban setting and a sign of the new direction Dutch architectural painting takes after its devotion to fantastic exterior and interior views.

One other artist can be mentioned in connection with this phase. He is Rembrandt. The architectural settings of many of his biblical paintings are as fantastic as the buildings constructed by the early specialists. But Rembrandt never paints a church interior for its own sake, or merely to create a perspective effect. His fanciful structures (e.g. *The Presentation in the Temple*, 1631) [64] are always subordinated to the biblical figures, and the lofty imaginary spaces are co-ordinated with chiaroscuro effects to heighten the dramatic action and intensify the mood of scenes from Scripture.

The first artist to abandon the fictive tradition was Pieter Jansz Saenredam (1597–1665). When he appears on the scene, naturalism enters Dutch architectural painting. Faithful representations of specific buildings are not an exception in his works. To the contrary: he consistently made them, hence his title, the 'first portraitist of architecture'. He was born at Assendelft, near Haarlem, the son of

the Mannerist engraver and draughtsman Jan Saenredam. When he was still a child, Pieter's widowed mother moved to Haarlem, where he spent the rest of his life. He studied there from 1612 to 1622 with the portraitist and history painter Frans Pietersz de Grebber. It is not known who taught him the rules of perspective. Possible candidates are the architect-painter Jacob van Campen, who was to design Amsterdam's new town hall, the versatile engineer Simon Stevin, and the surveyor Jan Wils. Saenredam's first biographer, Cornelis de Bie (1661), who was well informed – he knew, for example, that Saenredam joined Haarlem's Guild of St Luke in 1623 – notes 'only about 1628 he devoted himself entirely to painting perspectives, churches, halls, galleries, buildings and other things from the outside as well as the inside, so true to life that nature can display no greater perfection.'[1] There can be little quarrel with the estimate de Bie made of Saenredam's achievement, and his statement about the artist's beginnings as an architectural painter is not contradicted by the evidence now available: Saenredam's earliest dated 'true to life' church interior is inscribed 1628 (*View of St Bavo Church at Haarlem*, Los Angeles, J. Paul Getty Museum). The artist's meticulously dated drawings of sites in the Netherlands enable us to follow his travels during the course of three decades to 's-Hertogenbosch, Assendelft, Alkmaar, and Utrecht. These works, as well as many drawings he made at Haarlem, served as preliminary studies for his paintings.

Saenredam's working method generally consisted of three stages. First he made a preliminary freehand drawing at the site (he himself called them '*naar het leven*' drawings). The freehand study was then used for a more exact construction drawing made in the studio with the aid of measured ground plans and elevations; sometimes he subtly manipulated the dimensions of a building and its elements to heighten pictorial effects. Finished drawings were kept on file as part of the stock to which he turned when he was ready for the final stage: an oil painting on panel. The main outlines of his architectural paintings are frequently transferred by tracing from his construction drawings. A description of his working procedure makes it appear mechanical, and the reader may think it suitable for the production of architectural renderings, not works of art. However, a look at Saenredam's paintings proves this is not the case. None of his paintings – about fifty are known – can be categorized as tinted perspective studies. The unmistakable clarity of his vision and the intensity of his scrupulous observation, as well as a sensitive tonality, mark every one. Only in a few cases did Saenredam paint pictures of sites or buildings he had never seen. His rare views of Rome (e.g. *Santa Maria della Febbre*, 1629, Washington, National Gallery) were not made in Italy, but were based upon sketches taken from Maerten van Heemskerck's famous Roman sketchbook. At the time, Cornelis van Haarlem was most likely the owner of the precious album, which includes numerous drawings by Heemskerck as well as some by unidentified followers. At the time of Saenredam's death it was probably in his possession, it is now a treasure of the Kupferstichkabinett in Berlin. Not much more is known about Saenredam's collection of works of art: a self-portrait by Goltzius, a few paintings by Pieter van Laer and Jacob van Campen. He also must have

361. Pieter Saenredam: *St Mary's Square and St Mary's Church at Utrecht with a View of the Buur Church and the Cathedral Tower*, 18 September 1636. Drawing: pen and watercolour. Haarlem, Teylers Museum

362. Pieter Saenredam: *St Mary's Square and St Mary's Church at Utrecht, with a View of the Buur Church and the Cathedral Tower*, 1662. Rotterdam, Boymans-van Beuningen Museum

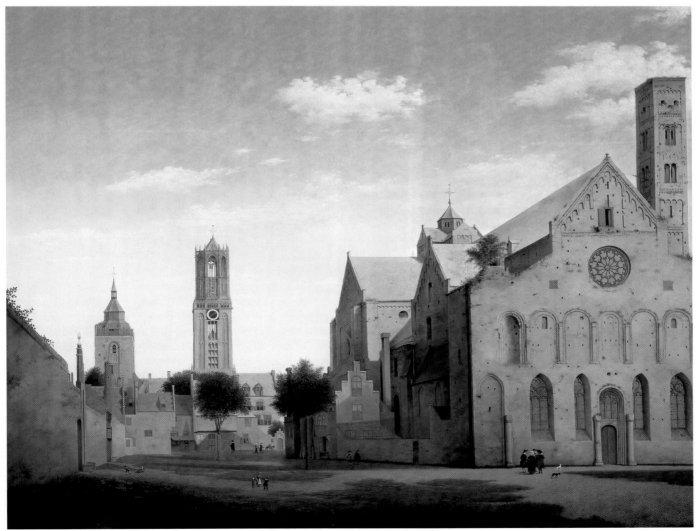

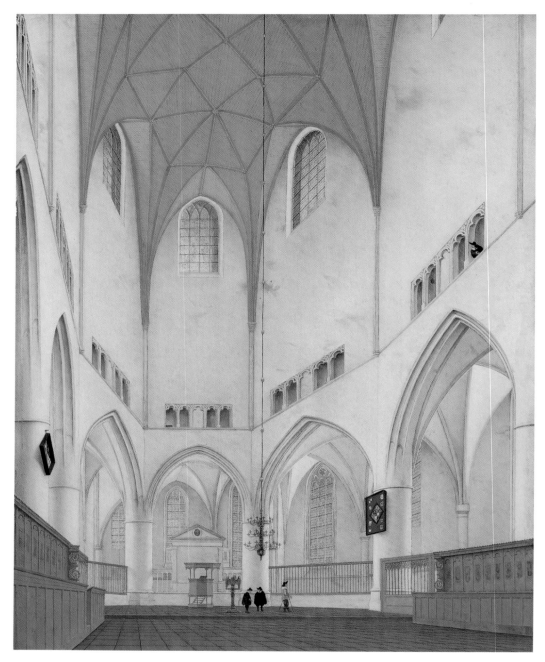

kept van Campen's carefully finished chalk drawing of him, now in the British Museum. The portrait, which shows his strong features, large eyes, and deformed, dwarf-like torso, is inscribed in his beautiful hand 'This was made by Monsieur Jacob van Campen after me, Pieter Saenredam, in the year 1628'. More spectacular was his library. When it was offered at a posthumous auction in 1667, the sale catalogue listed more than 400 titles which indicate that Saenredam cannot be classified as an artist who was an inspired illiterate. Included were Dutch translations from the Greek and Latin (he had no classical languages), works on theology, medicine, descriptions of cities and countries, and travel books. Apart from van Mander's *Schilderboek* and a Dutch translation of Junius's volume on ancient painting, the sale included relatively few titles related to his profession and specialization. Perhaps he owned few books on perspec-

tive because little on the subject was available in Dutch. As for the mysterious absence of available standard works on architecture, such as Salomon de Bray's *Architectura Moderna* (1631) and the sumptuous publication of architectural engravings of Amsterdam's new town hall (1660), it has been reasonably proposed that the passionate book collector probably possessed them but his heirs decided not to put them on the block.[2]

There was something of the archaeologist and antiquarian in Saenredam's make-up. When he made changes in a drawing of a building, he is known to have written a careful note on the sheet stating that it is not a completely faithful document of what he saw on the spot. The inscriptions on his drawings as well as the works themselves support the impression that Saenredam must have been an unusually careful and conscientious worker who loved minute detail.

364. Pieter Saenredam: *Interior of the Choir of St Bavo at Haarlem.* Drawing: pen and black chalk. Weimar, Schlossmuseum

He was a paradigm of both neatness and precision. The lengthy inscription on one of his two drawings of the *Old Town Hall of Amsterdam* (Haarlem, Teylers Museum) sounds rather pedantic to modern ears, but it is characteristic of his approach: 'I made this sketch from a large and finished drawing which I had done from life, showing all the colours as perfectly as I could, on a medium sheet of paper, 15½ inches high and 20 inches wide, Kennemerland foot measure, in the year 1641, on the 15th, 16th, 17th, 18th, 19th, and 20th of July working assiduously on it from morning till evening...' Sixteen years elapsed before the drawing was used as the basis for his painting of the *Old Town Hall* which was acquired by Amsterdam's burgomasters for their chamber in the new town hall, and is now on loan to the Rijksmuseum. A considerable length of time between drawings and a finished painting was not unusual for Saenredam. His drawing done 'from life' of *St Mary's Square and St Mary's Church at Utrecht* is dated 18 September 1636 [361]. The superb painting based on it is dated 1662 [362]. Although a quarter of a century separates the preparatory stage from the finished work, only minor adjustments were made: Saenredam removed two trees and a small barn which obscured part of the wide façade (the barn had actually been removed by the time the painting was made). He also made St Mary's tower less squat. The figures in the drawing can be discounted; they were added by another hand.

During the course of his career there is very little change in his style. The expert draughtsmanship is seen from the beginning to the end. The subtle daylight atmosphere and tonal unity of the view of St Mary's Square of 1662 is evident in works painted three decades earlier. His *Choir of St Bavo* [363], a view done in 1660 of the great church of

Haarlem, which he frequently painted and where he is buried, shows how suitable his delicate blond tonalities and the neatness and transparency of his technique were for the representation of Dutch Protestant churches. The majestic whitewashed interior has been stripped of all decoration. Its bareness emphasizes its structural power. The only furnishings are choir stalls, a simple pulpit, the brass choir screens and lectern, a hanging triple chandelier, an escutcheon, and a memorial tablet. An undated freehand drawing for the painting [364] shows the changes he could make when he translated a sketch into a more precise construction drawing, and then into a painting (the construction drawing for the painting has been untraceable since it appeared in a Haarlem sale in 1786). Most notable are the elimination of a column and its trappings, and the end of one choir stall, and the increase in the height of the choir wall above the triforium gallery; the last named change dramatically increases the spatial effect. In both the drawing and painting Saenredam shows us more than we could possibly see from a single point of view; the peripheral vision of a stationary eye cannot simultaneously take in the very wide angle between the choir stalls seen on either side of their foregrounds. In the painting much more is offered; the observer is not only given a low view into the choir and ambulatory but a view of the choir's towering wooden star-vaulted ceiling as well. These liberties with the conventions of vanishing point perspective were deliberate: they enabled him to increase our sense of the vastness of the imposing interior. Three miniscule figures in the choir and a single one in the triforium gallery also help to set the scale. In the interior Saenredam's fine geometric sense and love of plain surfaces – aspects of his style which are so appealing to our eyes – find their full expression. Only

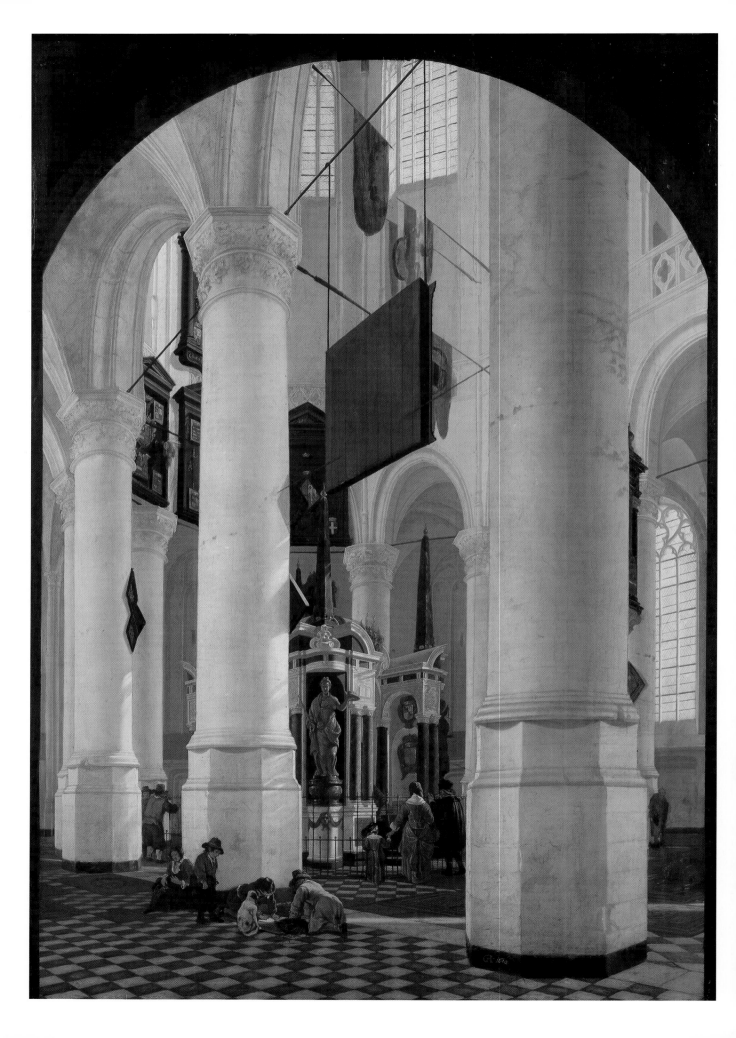

Carel Fabritius and Vermeer were capable of finding such painterly qualities in the rough surfaces of plain whitewashed walls.

About 1650 the most interesting developments in architectural painting took place in Delft, where a new phase began with the church interiors by Gerard Houckgeest, Emanuel de Witte, and Hendrick Cornelisz van Vliet. Stylistic affinites with works done during the decade in the city by Carel Fabritius, Pieter de Hooch, and Vermeer are apparent, and Vermeer's own exceptional masterpieces in this branch of painting – *The Little Street* [185] and *View of Delft* [186] – can be viewed as part of the new movement.

Gerard Houckgeest (*c.*1600–61), probably a van Bassen pupil, began as a painter of imaginary church interiors and Renaissance buildings. Most likely he was in England during the 1630s; Charles I owned at least five 'prospectives' by or partly by him. His fictive *Palace Interior* of 1635, his earliest existing dated painting, is still at Hampton Court. Born in The Hague, Houckgeest is documented in Delft in the 1640s. His first known depiction of an actual church interior is his unexpected *New Church in Delft with the Tomb of Willem the Silent*, dated 1650, now at Hamburg [365]. As we have seen, by the time it was done Saenredam had been painting pictures of identifiable churches for more than two decades; however, juxtaposition of any by Saenredam with Houckgeest's *New Church* shows straightaway what is novel about his painting. In Saenredam's church interiors the line of vision is always at an angle of about 90° to the centre of the nave or to the wall of the building he depicts. In the Hamburg picture Houckgeest, like Saenredam, has kept the field of vision relatively high, but he had the brilliant new idea of shifting his position to the side to give an angle of about 45° to the principal axis of the New Church. The new position creates intriguingly intricate diagonal views across the church. He also has considerably shortened the distance between the viewer and the closest architectural element portrayed, the massive column near the centre. Although the best-known monument in the Netherlands is subordinated to the huge pier and is partially obscured by another one, the allegorical sculptured figure of Freedom on Willem's tomb gains emphasis by the new scheme. The general tonality of the painting is light, yet there is a striking gain in contrast in the values of his colours, a pronounced change from Saenredam's delicate monochromatic mode. Bright rays of sunlight, which are never found in Saenredam's interiors, now enter the church and relieve the powerful weight of the columns. People in the church have gained emphasis too, and their clothing provides some vivid colour accents.

During the following four or five years Houckgeest painted about a half-dozen pictures of both the New and Old Church of Delft using the innovative diagonal perspective of the Hamburg painting. Sometimes he adds a *trompe l'œil* painted curtain to heighten his striking illusionistic effects. Emanuel de Witte experimented with similar perspectival schemes about 1650. His earliest dated interior that employs the new point of view in his *Interior of the Old Church at Delft*, of

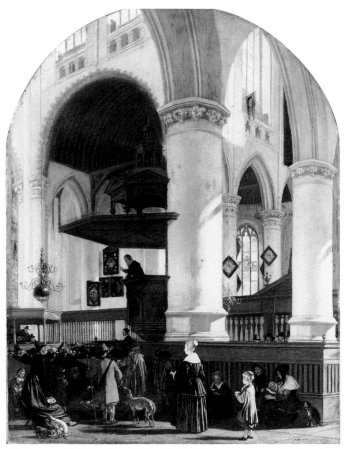

366. Emanuel de Witte: *The Old Church at Delft during a Sermon*, 1651. London, Wallace Collection

1651, now in the Wallace Collection [366]. It does not focus on a tomb, but on the minister preaching from a pulpit, which is still in place, to a large congregation. In de Witte's painting the Word, not patriotism, is stressed.

After their radical innovations neither Houckgeest nor de Witte remained in Delft for very long. By 1651 Houckgeest is recorded as a resident of Steenbergen, a town about forty kilometres south of Rotterdam, and two or three years later he settled in Bergen op Zoom in North Brabant. De Witte moved to Amsterdam by January, 1652, where he spent the rest of his long career. It was the prolific Delft painter Hendrick van Vliet (*c.*1611–75) who subsequently carried on the Houckgeest-de Witte tradition in his native city. He was first active as a rather pedestrian portraitist and to our knowledge turned to painting church interiors in 1652. Using a diagonal construction van Vliet's interior of *The Old Church at Delft* [367] offers a report on a significant new addition to the venerable church. It includes a full-view of the elaborate monument dedicated to Admiral Maerten Tromp which was unveiled in 1658, the year the picture is dated. Not many people in front of the tomb had to be reminded that Tromp, whose most glorious victory was the defeat of the Spanish with a Dutch fleet much inferior in strength at the Battle of the Downs in 1639, was killed in the furious Battle of Scheveningen five years before his monument was dedicated. Most of them also knew that the tomb that can be glimpsed deep in the church's choir belongs to Admiral Piet Hein

365. Gerard Houckgeest: *The New Church at Delft, with the Tomb of Willem the Silent*, 1650. Hamburg, Kunsthalle

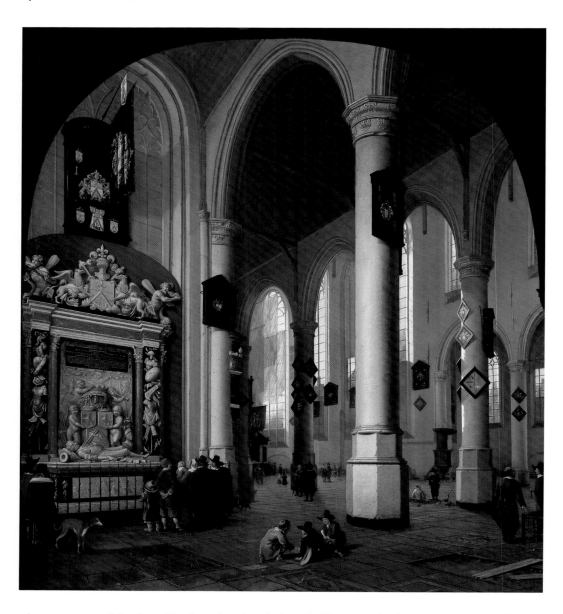

367. Hendrick van Vliet: *The Old Church at Delft with the Tomb of Admiral Maerten Tromp*, 1658. Toledo, Ohio, Toledo Museum of Art

whose capture of the Spanish silver fleet in 1628 made him a national hero particularly adored by the shareholders of the Dutch West Indies Company who, thanks to his prize, received a fifty per cent dividend on their shares that year; his coup also filled the treasury of the northern Netherlands and enabled Frederik Hendrick to lay seige and subdue 's-Hertogenbosch, a Spanish stronghold in the south, with nearly 30,000 men. The modest, slab-less tomb on the church's floor and the gravedigger who has paused to chat with a visitor, both familiar details in church interiors of the period, are reminders of the transience of more ordinary mortals. His painting includes children and dogs; well and less well-trained children and dogs are not infrequent accessories in these paintings. Van Vliet passed on aspects of the Delft style of architectural painting to Daniel de Blieck (died 1673) and Cornelis de Man (1621–1706), a Delft painter better known for genre pictures related to those by Vermeer and Pieter de Hooch. Reflections of the style also can be seen in interiors by Anthonie de Lorme (died 1673) and Isaack van Nickele (c.1633–1703) of Haarlem, one of

the last practitioners of the subject; in their works, particularly van Nickele's, Saenredam's example is of importance.

Consideration of Emanuel de Witte's *œuvre* (c.1616–91/2), underlines the limitations of treating the history of seventeenth-century Dutch painting by subjects. De Witte was also a history painter and a portraitist, he depicted harbour scenes, and his market scenes are as notable as his celebrated church interiors. Only de Witte was able to record the small drama that can occur at the commonplace encounter of a fish vendor and her pretty, well-dressed customer seen in his painting of 1672 at Rotterdam; it appears to be part portrait and part genre, and includes a magnificent fish still life. We know that de Witte made a similar picture earlier which is almost certainly identifiable as a portrait of the fashionably outfitted matron Adriana van Huesden and her little daughter at a stall of Amsterdam's New Fishmarket [368]. Where but in seventeenth-century Holland would an artist be commissisoned to paint a portrait of a woman buying fish? Adriana van Huesden was the wife of an Amsterdam notary who is mentioned below.

368. Emanuel de Witte: *Adriana van Huesden and her Daughter at the New Fishmarket in Amsterdam*, c.1661–3. London, National Gallery

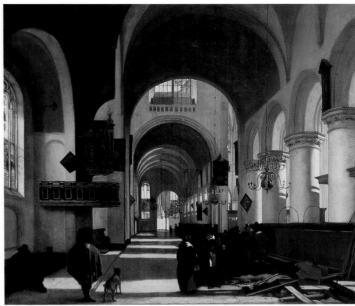

369. Emanuel de Witte: *Interior of a Church*, 1668. Rotterdam, Boymans-van Beuningen Museum

De Witte was born at Alkmaar, the son of a schoolmaster. His teacher is unknown.[3] He entered the Alkmaar guild in 1636 and in 1639–40 he was in Rotterdam. He was in Delft when his daughter was baptized there in 1641, and he entered the Delft guild in the following year. He remained active in the city until 1651–2. A *Danaë*, dated 1641 (Private Collection), is his earliest known work. A few other subject pictures can be placed in the forties as well as a pair of small ter Borch-like portraits (dated 1648) now in Rotterdam. We have heard he only turned to architectural themes in about 1650, an interest probably stimulated by Houckgeest, as is seen in his *Interior of the Old Church at Delft during a Sermon* of 1651 [366]; it is his first dated architectural interior. By 1652 he had settled in Amsterdam, where he spent the rest of his life. He received recognition early. In 1662 he, along with Rembrandt and other leading painters, was praised by the poet Jan Vos as one of the artists who would spread Amsterdam's fame as far and wide as her ships travelled the seas. Nevertheless, he lived a troubled and difficult life. In 1658, the year he was painting a picture for the king of Denmark, his wife and daughter were apprehended for stealing. The former was banished from the city, the latter sentenced to a year in the Spinning House. Two years later his poor financial position obliged him to indenture himself to an Amsterdam notary, the husband of the woman de Witte portrayed on a shopping expedition with her young daughter [368]. De Witte agreed to give him everything he painted in return for board and lodging and 800 guilders per year. As in so many of de Witte's affairs, litigation arose out of this arrangement. He indentured himself several times again. Since he was virtually the only painter of church interiors active in Amsterdam during his four decades there, the demand for his speciality in Holland's richest and most powerful city most probably was slim. Does this hypothesis help explain the difficulties he had making ends meet and

the debts that continued to plague him during his last decades? According to Houbraken, he ended his life by suicide. An unstable character may have contributed to his plight and perhaps helps explain the occasionally uneven quality of his production. He remained prolific as a painter during his entire career, but only one drawing can be attributed to him with certainty: a signed chalk drawing on vellum datable about 1641–2 of a nude Medusa in an album that includes forty additional sketches by different Dutch artists (Boston, Maida and George Abrams Collection).

In Amsterdam de Witte continued to paint views of Delft churches, but he was inspired more often by the metropolis's grand buildings: its Old Church, lofty New Church, Stock Exchange, and, after it was consecrated in 1675, its Portuguese-Jewish Synagogue. By the late fifties the contrast of light and shadow grows stronger and powerful, and he abandons oblique views for more frontal ones. At this time his interiors also become more fanciful. To be sure, other specialists made changes in the architecture they portrayed but de Witte was capable of radically rearranging it to increase massiveness, and to heighten spatial and chiaroscuro effects. He also painted purely imaginary interiors of Catholic and Protestant Gothic and Renaissance churches, and designed others using elements taken from well-known Dutch buildings. But he always convinces us, in an uncanny way, that he has painted a view of a real church. It is a surprise to learn that the *Interior of a Church* at Rotterdam [369] is one of de Witte's compilations and not a view of a known building. The wooden ceiling and the little organ on the left are based on what de Witte saw at the Old Church in Amsterdam; the massive columns – but not their capitals – were modelled after the huge piers at St Bavo in Haarlem. The round arches and the late afternoon sunlight, which glows through the building, are purely imaginary. Distances are still clear, yet darkness will soon fall over this articulated

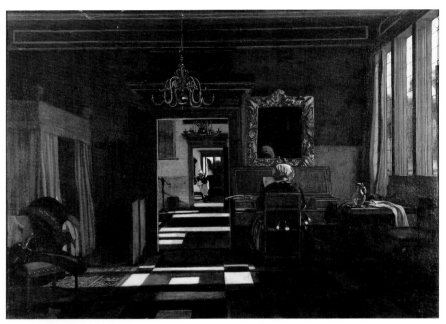

370. Emanuel de Witte: *Interior with a Woman at a Virginal*, c.1665. The Hague, The Netherlands Office for the Fine Arts

371. Gerrit Berckheyde: *The Market Place and St Bavo at Haarlem*, 1674. London, National Gallery

372. Gerrit Berckheyde: *Dam Square, Amsterdam*, 1668. Antwerp, Koninklijk Museum voor Schone Kunsten

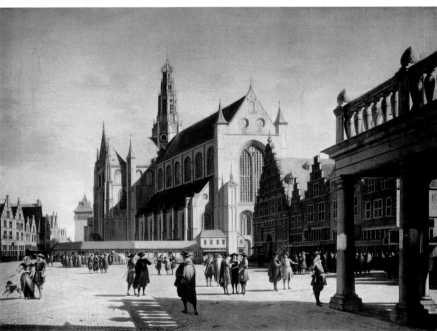

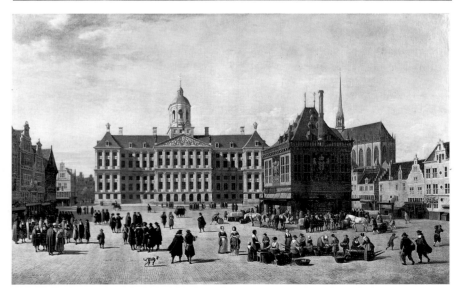

play of forms. And de Witte not only could create majestic church interiors giving the convincing impression of reality; he also endowed them with a profound personal mood. His tonal design organizes the picture plane in a slightly geometrical fashion and substantially contributes to the articulation of the spatial effect. The movements and gestures of his figures are appropriate to the silence suggested by his dark interiors. Comparison of this great artist's works with those by Houckgeest and van Vliet show his wider range, his more powerful spatial effects, and his more interesting pictorial qualities. In general, there is the same noble restraint as in Pieter de Hooch's best genre pieces, Kalf's mature still lifes, and the grand solemnity of Ruisdael's forest scenes. In the Rotterdam church interior an aspect of his reserve is seen in his understated handling of the skull that is hardly visible in the shadowed debris of the open tomb.

Restraint also is a quality that permeates his genre pictures. In his richly furnished domestic *Interior with a Woman at a Virginal* [370] the man in the curtained bed with his clothing and his sword draped over a nearby chair are not the first things noticed when we confront its palpable space, strong sunlight, and sonorous colour harmonies. If Mondrian saw the painting it is not hard to imagine that he would have nodded his head in approval at the banded pattern made by the light on the interior's marble floor. His approval, however, would have been anachronistic if he did not correlate it with the artist's effort to create a plausible illusion of space on the two-dimensional surface of his canvas. Like other seventeenth-century Dutch artists, de Witte saw an inextricable link between a picture's formal qualities and its illusionism.[4]

A younger representative of this generation whose works are often distinguished by pictorial power and vigour of architectural accents is Gerrit Berckheyde (1638–98). He made a few church interiors but specialized in portraits of city squares, streets, and canals, particularly of his native Haarlem, and of Amsterdam and The Hague. We have seen that topographically accurate profile and panoramic views of cities and towns were depicted by Dutch artists since the first decades of the century and after 1650 the type existed as a sub-category in Delft where masterworks that belong to it were produced by Carel Fabritius and Vermeer. However, a new interest in this branch of painting burgeons in the 1660s and it does not slacken until the end of the eighteenth century.

Gerrit Berckheyde was probably the pupil of his elder brother Job Berckheyde (1630–93) who started as a history painter but then turned his hand to architectural painting, genre pieces, landscapes, and portraits. Both brothers travelled to Germany in their youth and worked at Cologne, Bonn, and for the Elector Palatine at Heidelberg. After they returned to Haarlem – Gerrit entered the guild in 1660 – they lived in the same house. Architectural drawings Gerrit made in Germany of streets and buildings were incorporated in a few paintings of imaginary scenes, but most of his works are topographically accurate views. Neither his church interiors nor those by Job show any indication that they were aware of the innovations made at Delft in the early fifites. As Haarlemers they were familiar with the schemes Saenredam

employed and they used them; their colour harmonies and chiaroscuro effects, however, are closer to de Witte's. Gerrit is at his best in his speciality: paintings of a major building, squares, a row of houses or other segments of a city. His view of *The Market Place and St Bavo at Haarlem* (1674, London, National Gallery) [371] is a good example of the new increase in chiaroscuro and colouristic intensity he can achieve in this type of painting. He is usually robust and above the average in pictorial sensitiveness. The firm coherence of his designs as well as his vigourous delineation, leave us with a sense of satisfaction. But he can be repetitive. There exist more than a dozen autograph versions of the London view of Haarlem's main square, with slight variations in the point of view and field of vision. Dated ones range from 1665 to 1697, an indication of the strong market for topographical views of the city. Not every client received paintings of the same high quality. In some repetitions a limited atmospheric quality and a slight dryness can prevail. The demand for views of Amsterdam (but not for the interiors of its churches), was far greater than for portrayals of Haarlem, and Gerrit did his share to satisfy it. He never settled in the metropolis; following studio practice of the time, he made the easy trip from Haarlem to Amsterdam where he sketched preparatory drawings and then returned to his studio to work them up into finished paintings. He earliest view of the new town hall on the Dam [372] bears an autograph inscription stating it was painted at Haarlem in 1668. The painting, done about three years after Amsterdam's principal architectural glory was completed, offers a slightly elevated vista of the wide expanse of the Dam Square, and a full view of the town hall's classical façade as well as the city's weigh house and New Church. During the following three decades Gerrit virtually made a career of depicting the town hall, a symbol of Amsterdam's pride, prestige, and prosperity, from various viewpoints and in different lighting conditions. He also painted five different versions of its side and rear façade flanking a canal that had a flower market on its bank; an excellent version is at the Amsterdam Historical Museum.

Even before Gerrit began to paint vistas of Amsterdam, the city was a centre for the production of topographical views of its urban fabric. Its gates, canals, locks, and landmarks were represented during the fifties and sixties in notable works by Renier Nooms (alias Zeeman), Jan Lingelbach, Jacob van Ruisdael, Hobbema, Jan van Kessel, Jan Wynants, and members of the Beerstraaten family. An index of the interest in the subject is the small avalanche of illustrated histories and descriptions of the city that began to appear in the early sixties. After laying fallow for about fifty years the interest in illustrated historical-topographical descriptions of Amsterdam was rekindled in 1662 with the publication of Melchior Fokkens's *Description of the Widely Renowned Commercial City of Amsterdam* (*Beschrijvinge der wijdt-vermaarde koopstadt Amstelredam*). The volume found a ready market. Not only was it reprinted four times in the year it was published but its text and plates were pirated in the same year. The original publisher issued an enlarged edition of it, also in 1662, with a warning that a pirated edition was in the trade. The warning did not intimidate the pirates one iota. In 1663 they published a stolen edition of

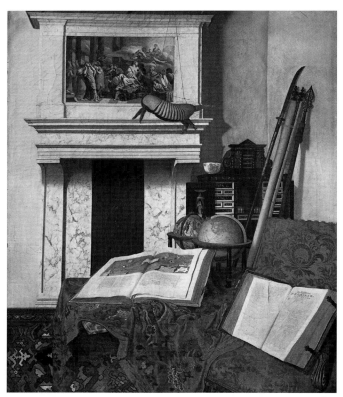

373. Jan van der Heyden: *Still Life with Rarities*, 1712. Budapest, Museum of Fine Arts

374. Jan van der Heyden: Title page of the manuscript *The Light of Lamp Lanterns*, 1679. Haarlem, Stadsbibliotheek

375. Jan van der Heyden: *A View of the Herengracht, Amsterdam*, c.1670. Mr and Mrs Edward William Carter

the enlarged work and in it they had the gall to reprint the warning as well. Fokkens's volume was quickly followed by descriptions of the city by Olfert Dapper (1663), Filips von Zesen (1664) and Tobias van Domselaer (1665). All of them were generously illustrated with engraved topographical views and maps, some of which were most probably sold loose as separate sheets.[5] The appetite for Amsterdam views was stimulated by the great expansion of the city that occurred in 1662–3 which completed the concentric canals of the Herengracht, Keizersgracht, and Prinsengracht, which are still at the heart of the city. Gerrit painted vistas of buildings situated on both the new and old canals. Amongst the most unusual is a panoramic view that accents the city's Synagogue of the Ashkenazim and its much larger Portuguese Synagogue (c.1685; Frankfurt a. M., Städelsches Kunstinstitut); the painting was possibly done for a Jewish patron.

Gerrit's views of The Hague, all datable after the mid-eighties, concentrate exclusively on the area around the Buitenhof (Outer Court) and the Binnenhof (Inner Court), the former castle of the counts of Holland which housed the republic's various governmental offices and still serves the same function today. The cluster of medieval buildings also had strong associations with the House of Orange. It is probably no accident that Gerrit's views of The Hague's official buildings were done after a prince of Orange, Stadholder William III, was once again a national hero, and gained additional glory when he ascended the English throne in 1689. Gerrit's *œuvre* also includes portraits of castles (*Heemstede*; London, Mansion House) and landed estates (*Huis Elswout*, The Hague, Netherlands Office for the Fine

Arts); these types of painting became increasingly popular with patrician landowners in both Holland and Britain during the eighteenth century.

Jan van der Heyden, the other leading architectural painter of this generation and a man of more parts than most Dutch painters, was born in 1637 at Gorkum, a town near Dordrecht. When he was a boy of thirteen his parents settled in Amsterdam; apart from trips to the Rhineland, the northern, and the southern Netherlands he spent his life there. He painted some imaginary cityscapes based on studies done in Germany, which at first blush appear to be true-to-life views, and lovely capriccios which show expert knowledge of the principles of classical architecture (*An Architectural Fantasy*, London, National Gallery). His *œuvre* also includes about forty landscapes that reveal a debt to Adriaen van de Velde, who is credited with painting figures in some of his pictures, and a few intriguing still lifes that can be justifiably categorized as interiors [373]. Van der Heyden is best known for his views of Amsterdam. He took more than a pictorial interest in the city. In 1668 he presented Amsterdam's municipal authorities with a plan to light the entire city with glass lanterns and oil lamps he invented. Acceptance of his plan in 1669 to install more than 2,500 of his lamps made Amsterdam the first European city to enjoy street lighting. The city fathers also appointed him superintendent of municipal lighting at the handsome annual salary of 2,000 guilders per year for life. The title page of his manuscript on his street lamps, which includes an explanation of how to mass produce them, shows a drawing of his invention [374].[6] His lamps were soon installed in Berlin, Leipzig, and other cities – they even found their way to Japan. Those in Amsterdam continued to serve the city until 1840. His lamps also serve art historians today; when they appear in undated paintings by van der Heyden himself, Gerrit Berckheyde, Jacob van Ruisdael, and others, they establish 1669 as a *terminus post quem* for the work. Van der Heyden and his brother made an equally significant contribution to urban life in 1672 when they constructed an improved fire engine with pump-driven flexible coupled hoses, devices that replaced less efficient bucket brigades. Subsequently, Jan was appointed an overseer of Amsterdam's fire department and established a factory to manufacture the pump. In 1690 he and his son published their *Description of the Newly Discovered and Patented Hose Fire Engine and Its Way of Extinguishing Fires . . . (Beschryving der nieuwlijks uitgevonden en ge-octrojeerde Slang-Brand-Spuiten en haare wyze van Brand-Blussen . . .).* The book is richly illustrated with prints after van der Heyden's own drawings and he himself etched and engraved some of its plates. Van der Heyden's inventions and activities related to them made him a very wealthy man. After his death in 1712, the estate of his widow, who died in the same year, was valued at over 80,000 guilders. His estate also included more than seventy of his pictures and a sizeable library.

Most of van der Heyden's paintings were done in the sixties and seventies – his work as inventor, entrepreneur, and city official probably slacked his pace. But he continued to paint until the very end. His latest firmly datable picture, now in Budapest [373], shows the corner of a *Kunstkamer* in strong even light with meticulous depictions of rarities from the natural and man-made world, but not the collector who assembled them. It is proudly inscribed with his monogram and states he painted it when he was seventy-five years old; he attained that age in 1712, the year he died. Among the objects displayed in the *Kunstkamer*, which is most probably a fictive one, are a hanging armour of an armadillo, a copy after an etching of Pietro Testa's *Suicide of Dido* above the marble mantle, an inlaid cabinet used for housing treasured coins and natural specimens, oriental weapons, and on the bright red Chinese embroidered cloth that covers the table globes, one terrestrial and the other celestial, and an open Blaeu atlas. Next to the table there is a red damask covered chair that supports a folio Bible open at the favourite passage of Dutch moralists: Ecclesiastes, Chapter 1, which begins with 'The words of the Preacher . . . vanity of vanities; all is vanity. What profit hath a man of all his labour which he taketh under the sun?' The biblical reference to transience is reinforced by Testa's *Suicide of Dido*, a subject taken from Virgil's *Aeneid* which can be read as an exemplum of love's ephemeral nature. Van der Heyden's message is obvious and familiar. It is one we have heard from artists discussed earlier, and which we shall hear again from some still life specialists mentioned in the following chapter: preparation for salvation is of greater importance than all the treasures, pleasures, and knowledge that can be derived from this world.

As in his late *Still Life with Rarities*, van der Heyden always manages to achieve refinement without prettiness. He is an exquisite composer who keeps great structural clarity. While every brick in his numerous cityscapes is readable, the total impression still dominates through a broad as well as minute disposition of lights and darks, and atmosphere is felt as pervading the whole space and softening the exact definition. In his view of a great bend in the fashionable Herengracht lined with huge lime trees that virtually hide the patrician houses that flank the broad canal [375] he combines his gifts as city painter and landscapist, and captures an aspect of the Venice of the North that bewitched seventeenth-century visitors. An entry John Evelyn made in his diary in 1641 during his visit to Amsterdam about a semi-circular canal next to the Herengracht is applicable to van der Heyden's view:

> . . . nothing more surpriz'd me than that stately, and indeed, incomparable quarter of the Towne, called the Keiser-'graft, or Emperor's Street, which appears to be a Citty in a Wood, through the goodly ranges of the stately and umbrageous Lime-Trees, exactly planted before each man's doore, so curiously wharfed with Clincar'd (a kind of white sun-bak'd brick) and of which material the spacious streetes on either side are paved.

As he frequently does, van der Heyden took liberties with the site. To emphasize the grand curve of the Herengracht he shortened the length of the embankment, thereby eliminating some houses, and he also exaggerated its upward sweep. By judicious selection and adjustment, and choosing unusual points of view, he gives a remarkable feel for the character and atmosphere of urban spaces as well as meticulous portraits of buildings. There was so much to see in Amsterdam. Which way should one turn and where should one look? He explored the city's unusual corners as in his

376. Jan van der Heyden: *Dam Square, Amsterdam, with a View of the New Church*, *c*.1668. Amsterdam Historical Museum

view of Amsterdam's New Church seen from the end of the irregularly shaped Dam in strong, late afternoon light that casts long transparent shadows, where we can explore a small street [376]. On one side of the painting, we merely see a little more than a single pavilion of the long, classical façade of the new town hall and on the other only a bit of the weigh house. Among van der Heyden's numerous depictions of the town hall, not one shows a frontal view of its full façade. For straightforward elevations of the building Amsterdammers called the Eighth Wonder of the World, it

is necessary to turn to other cityscapists. His view of the rear or garden side of Huis ten Bosch at The Hague, is illustrated in fig. 312. As we shall see, van der Heyden's attractive works were the principal inspiration for eighteenth-century architectural painters. His followers, however, used more conventional schemes and were unable to strike the balance van der Heyden maintained between a rich painterly quality and architectural precision. Among eighteenth-century artists one must turn to Canaletto or Bellotto to find his equal.

Still Life

Still-life painting is a less conspicuous theme than land-scape, genre painting, or portraiture, but it is as typical of Dutch taste and pictorial genius. No other country produced still lifes in such quantity or quality, and no other branch of painting reveals more clearly the Dutch devotion to the visible. Much of it reflects their love of domestic culture, so different from the courtly atmosphere of the Baroque in other countries.

It is appropriate that our English word 'still life' derives from the Dutch word *stilleven*. The Dutch themselves only began to use the word *stilleven* about 1650. Before that time they referred to 'still standing objects' (*stilstaende dingen*) or merely labelled their subjects 'breakfast' (*ontbijt*), 'banquet' (*bancquet*), 'fruit piece' (*fruytagie*), 'flower pot' (*blompot*), 'smoking piece' (*toebackje*); the term *'vanitas'* appears and so does 'skull' (*dootshoofd*), and so on.

The special interest of the Netherlander in still-life motifs has a long history. As in so many other categories of their painting, it can already be recognized in fifteenth-century Netherlandish art. The objects used to furnish interiors in altarpieces by Jan van Eyck and Rogier van der Weyden multiply, and these artists treat a vase of flowers, fruit, tableware, a chandelier, books, and even a pair of slippers with unprecedented care and charm. Sometimes their modest accessories were not merely painted for their own sake; they signify something. For example, the lilies in a vase, the immaculate towel hanging from a rack, and the ewer and basin found so frequently in fifteenth-century representations of the bedroom of the Virgin are symbolic references to the Virgin's purity. But it is evident that there had to be an interest in such objects before they could be given a prominent place in religious pictures. Delight in representing food, flowers, and the paraphernalia found in households, merchants' quarters, and scholars' studies continued during the sixteenth century. In pictures of the Virgin and Child and the Holy Family food and flowers are given an important position and often continue to serve a symbolic function. Prominent still lifes occur in biblical scenes which show a meal, and in group portraits of a civic guard company or of a family round a table. *Vanitas* still lifes were occasionally painted on the back of portable altars made for personal worship to remind viewers of the ephemeral nature of life and all our earthly pleasures. The standard *vanitas* motif was a skull, often accompanied by an inscribed *memento mori* admonition. A skull painted by Jan Gossaert in 1517 on the back of a panel of a folding diptych (Paris, Louvre) includes a banderole with a quotation from St Jerome: 'He who is perpetually aware of approaching death will overcome everything with ease'. We have already seen that variations on the theme had a very long life (e.g. Frans Hals's 1611 portrait of *Zaffius* [25]).

During the second half of the sixteenth century the Amsterdam painter Pieter Aertsen and his nephew Joachim Bueckelaer painted monumental market and kitchen scenes which at first glance appear to be pure still lifes, but close inspection often reveals a small biblical episode in the background. For modern viewers it is hard to suppress the feeling that the religious subjects in their paintings were merely added to satisfy clients who wanted a little more than a plentiful display of meat, fish, fruit, and vegetables. However, these scenes are possibly not merely capricious whims of the painters and their patrons. In their pictures that include small biblical scenes in the background – views of Christ in the house of Mary and Martha and views of the Supper at Emmaus for super-abundant foreground still lifes were favourites – conceivably were intended as moralizing reminders that the spiritual food provided by the Bible's teachings is more needful than mountains of mouth-watering edibles. The contrast stressed the distinction between the material and spiritual world.[1]

The Aertsen-Beuckelaer type of still life was developed in Flanders during the seventeenth century by Frans Snyders, Jan Boeckhorst, and other members of Rubens's school, but seldom with biblical representations. Exuberant figures and lively animals play an important part in these sumptuous and decorative works, and under the influence of Rubens, inanimate as well as animate objects acquire verve and vitality. In the northern Netherlands the development took a different turn. There still-life pictures become more intimate and generally more restrained, and are seldom combined with live figures; amongst the exceptions are a few by Cornelis van Haarlem and Wtewael. During the course of the century different types of still life evolved. Some artists became specialists, and a few others, including Rembrandt, Dou, Salomon van Ruysdael, and Metsu, tried their hand now and then at this branch of art. There were those who painted flower pieces and those who represented food, there were specialists in simple breakfasts, opulent banquets, *trompe l'œil* pictures, hunting trophies, and fish. The content of their works was not chosen at random. Each type has its own iconography: the shells, the sole subjects of some still lifes, and also found as components in flower paintings, never appear in a breakfast piece; a twisted lemon peel can be found on a banquet table, but not in a fish still life, and the props used for *vanitas* still lifes – skulls, timepieces, extinguished candles – were well fixed.

The moralizing tradition of *vanitas* still lifes continued and it was not the only type that conveyed a didactic message. When the unusual combination of objects and inscription on a still life painted in 1614 by Johannes Torrentius (born Johannes Sijmonsz van der Beeck; 1589–1644) is deciphered we learn that the tondo is an allegorical still life intended to advertise the virtue of Temperance [377]. The still life, Torrentius's only known painting, depicts a huge, half-full *roemer* (a glass used for drinking wine) between a long-spouted water flagon and a wine jug, with a horse's bridle above them. On the ledge there are two small clay pipes. The inscription on the sheet of music under the glass

377. Johannes Torrentius: *Still Life, Allegory of Temperance*, 1614. Amsterdam, Rijksmuseum

378. Roemer Visscher, '*Elck wat wils*' ('*To each to his own*'). Emblem from *Sinnepoppen*, Amsterdam, 1614

reads: 'That which exists out of measure perishes in evil immeasurably' ('*Wat bu-ten maat be-staat, int on-maats quaat verghaat*'). To the initiated, the implication is clear. Over-indulgence in drinking or smoking tobacco (an intoxicant recently introduced from the New World) should be curbed. Hence the horse's bridle, and the water flagon and wine jug that flank the *roemer*, for if wine is diluted with water its intoxicating effect is tempered. Confirmation of this reading of the still life is offered in an emblem in Roemer Visscher's *Sinnepoppen* [378], the first emblem book published in Dutch in the northern Netherlands. It appeared in 1614, the very year Torrentius painted his tondo. Visscher's *sinnepoppen* (emblems) follow the tripartite arrangement for emblems

that was employed internationally soon after Andrea Alciati established it in the first edition of his *Emblematum Liber* published in 1531: a motto, a picture, and a commentary. The motto in Visscher's *sinnepop* is *Elck wat wils*, which can be translated as 'To each his own'. The picture in his emblem depicts a water flagon and wine pitcher flanking a *roemer* (we can be certain that Roemer Visscher knew that a play could be made on the name of the wine glass and his own Christian name; he used a similar picture and the same motto as a device for the title page of his book). Visscher's commentary on his *sinnepop* explains the motto and the picture by moralizing on the need for everyone to temper his drink with water to his own taste. Temperance, he continues, serves everyone and is applicable to many other things. Among them, we can add, is the need for temperance when attempting to establish the significance of objects in still lifes. Their meaning is not invariably as unequivocal as it is in Torrentius's tondo. They can vary according to their context. We can be confident, for example, that a timepiece in a *vanitas* refers to transience; however, the watches frequently seen in sumptuous still lifes by Jan Davidsz de Heem, Willem Kalf, and Abraham van Beyeren may be intended to allude to the need for temperance at the festive board as well as in life since moderation is another meaning traditionally assigned to timepieces. Whether they also are reminders of the impermanence of the displays of wealth and conspicuous consumption seen in banquet pieces is moot.

Sometimes we are at a loss to explain the significance of objects in still lifes, or indeed to say whether they were intended to have any special meaning at all.[2] What are we to make of the little mouse on a silver platter near a luscious peach in van Beyeren's sumptuous still life at Los Angeles [387]? In his discussion of it, a specialist notes: 'A mouse represents in general the mundane, and sinful world and in particular gluttony. In the Bible it is an unclean and abominated animal . . . [that receives] inevitable punishment: the mouse is either poisoned or caught in a trap.'[3] But is it not sadistic to confront a mortal with a rabelaisian feast and then moralize about the cardinal sin of gluttony? Is it not masochistic to hang in one's home a banquet piece as a perpetual reminder of the need for temperance? Is it not possible that van Beyeren introduced the mouse merely as an amusing conceit? Or did he intend it to both admonish and entertain? A previous unidentified owner of the painting, who was either squeamish about mice or an unrepentant *gourmand* familiar with their iconography, avoided these questions by having the mouse painted out; it only reappeared in the 1980s during the course of a cleaning.

As for Torrentius, he hardly took to heart the temperance message of his still life. Contemporary documents and references establish that he was notorious for his unorthodox conduct and his obscene pictures.[4] He was tortured and sentenced to twenty-years imprisonment by Haarlem's municipal authorities for immorality, blasphemy, and probably for membership in the outlawed Rosicrucian sect. After his imprisonment, Charles I, who admired and collected his pictures, interceded on his behalf with Stadholder Frederik Hendrik. Through the latter's good offices Torrentius was released from prison in 1630 and travelled to

London bearing a few of his paintings, including, it seems, the allegory on Temperance; Charles's brand on the panel's verso places it firmly in his collection. It was anticipated that Torrentius would paint captivating pictures for the English court, but apparently he produced very little in England before returning to Holland.

One of the oldest types of still life is the flower piece. Once established it never lost its popularity. It is appropriate that among the masterpieces of van Gogh, the greatest nineteenth-century Dutch master, his paintings of sunflowers and irises are special favourites. The Dutch are still the most flower-loving people in the world. Today, when flowers may be had on every street corner of the Netherlands, Dutch men and women pick up a bouquet as well as a newspaper as they rush home from work. Then as now, flowers were an important part of the Dutch economy; bulbs remain a primary Dutch export commodity.

It seems that flower painting was established as an independent category in the Netherlands during the third quarter of the sixteenth century, with the rise of a widespread interest in gardening and the cultivation of exotic flowers. Renaissance and Baroque gardens were a kind of outdoor *Kunst- und Wunderkammern*, and we can assume that even before the seventeenth century, when the Dutch became Europe's leading horticulturists, there were Netherlandish botanists, amateur gardeners, and flower lovers who enjoyed possessing beautiful permanent records of familiar and strange blossoms. Literary sources give us the names of a few late-sixteenth-century flower painters. Van Mander is said to have painted flower pieces, and he himself informs us that bouquets were depicted by his friend Cornelis van Haarlem as well as by Pauwels Coecke van Aelst and Lodewyck Jansz van den Bosch. No flower pieces by these painters are known, but van Mander's description of van den Bosch's works gives an idea of them. Van den Bosch, wrote van Mander in 1604, showed flowers 'in a glass of water, and on which he spent so much time, patience and care that they seemed entirely natural. He also painted the heavenly dew on flowers and plants, and furthermore all kinds of insects, butterflies, small flies and similar things . . .' Paintings which fit this description are known by artists who worked in the Netherlands during the first decades of the seventeenth century. The principal member of this group is Ambrosius Bosschaert the Elder (1573–1621), the founder of a dynasty of flower and fruit painters.

Bosschaert the Elder was born at Antwerp and emigrated with his family to Middelburg, where he was mainly active. During his lifetime Middelburg, ancient capital of the province of Zeeland, was second in importance only to Amsterdam. Though Bosschaert never won the international reputation earned by his Flemish contemporary Jan Brueghel, whose *œuvre* includes magnificent flower still lifes, he was extremely successful, and in 1621, the year he died, he was able to command 1,000 guilders for a large flower piece painted for a member of Prince Maurits's retinue. This fee was a high one, but not out of line for work done by accomplished Dutch flower painters. They were, in fact, among the best paid artists of their time. In 1606 Jacques de Gheyn II received 600 guilders for a flower piece painted for Marie de' Medici, and de Gheyn's son is said to have refused to part with another one by his father for over 1,000 guilders.

A prime work by Bosschaert the Elder is his brilliantly coloured *Bouquet in an Arched Window*, datable about 1620, at the Mauritshuis [379]. Jacques de Gheyn II and Roelandt Savery painted similar multi-coloured bouquets in niches, but only Bosschaert showed flowers against an open vista. The painting's exquisite attention to detail recalls works by miniaturists such as those by the Antwerp master Joris Hoefnagel (1542–c.1600) who made wonderous, microscopically accurate watercolours and gouaches for Rudolf II's court at Prague. Of Baroque chiaroscuro there is not a trace. Each bloom in his typically axial symmetrical arrangement is given equal attention and is minutely analysed in an even light. L.J. Bol, author of the closest study made of Bosschaert and his followers, writes of the artist's inspired patience, and he rightly compares Bosschaert's floral arrangements to contemporary Dutch group portraits. The flowers in Bosschaert's bouquets are like

individual portraits placed beside and above each other, each being given its full pound of recognizability. No single one is subordinated, or sacrificed for the sake of composition, lighting, atmosphere or tonality . . . A striving after lucidity and exactitude sometimes leads, with Bosschaert, to hyperrealism: no flower is thus left in the shadow, every corolla emerges clear and radiant, in its own local colour, in the same 'impartial' light. All subjects appear simultaneously in the foreground, in a unity of time, place and 'action' enforced by the painter: a successful *tour de force*.[5]

Analysis of the flower pieces made by Bosschaert and other flower painters of his time reveals that their bouquets were seldom painted from life. They were assembled from a number of independent studies which serve as patterns. The pictures frequently show blossoms which bloom at different seasons of the year, and it is not unusual to find the same flower, shell, or insect in more than one picture. This manner of composing flower pieces was continued by later artists. Moreover, the huge bouquets are usually far too large for the *roemers* or vases that hold them. If set up in the studio they would surely topple over. Botanists and flower lovers are able to give precise identifications to virtually all the blossoms in these elaborate displays and we can be certain their seventeenth-century predecessors could do so as well.

Since ancient times flowers have been related to the idea of transience and seventeenth-century viewers with moralizing propensities could use them as reminders of the brevity of human life which withers like blossoms: 'All flesh is grass, all the goodliness thereof is as the flowers of the field: the grass withereth, the flower fadeth; because the spirit of the Lord bloweth upon it . . .' (Isaiah 40, 6–7) was a biblical passage familiar to Netherlanders of every religious persuasion. Another is 'Man that is born of a woman is of few days, and full of trouble. He cometh forth like a flower, and is cut down . . .' (Job 14, 1–2). Particular flowers also had one or more traditional symbolic associations, but without some collateral evidence it is often difficult to determine which symbolic meaning, if any, to assign to them. Their multivalent meanings can produce different interpretations. Recall the rose lovely Isabella Coymans gives to Stephanus Geraerdts in Frans Hals's pendant portraits

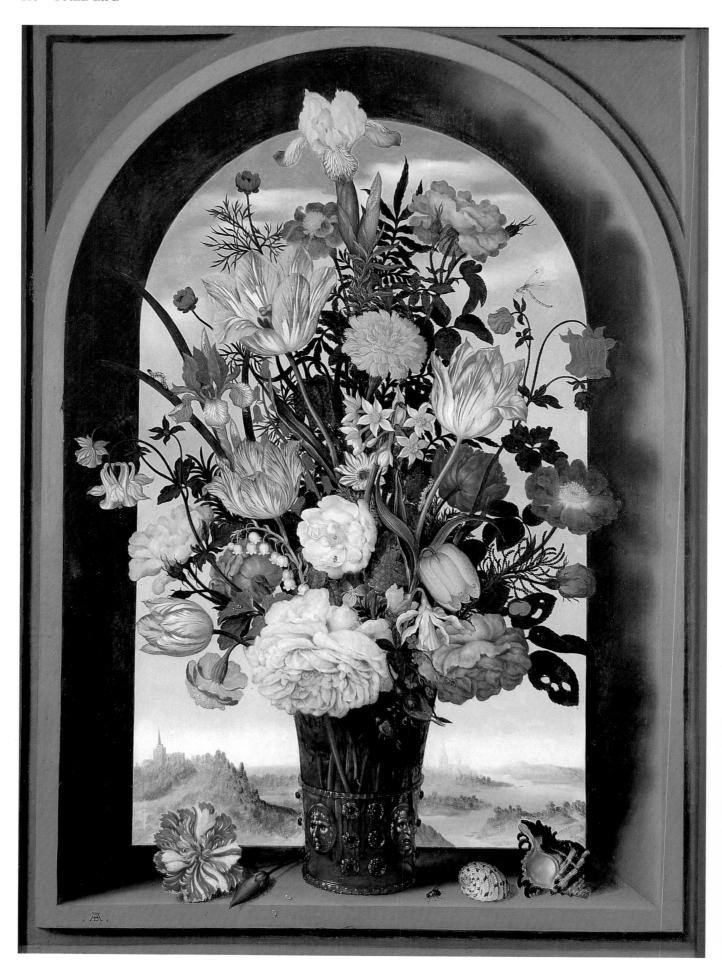

379. Ambrosius Bosschaert the Elder: *Bouquet in an Arched Window*, c.1620. The Hague, Mauritshuis

380. Floris van Dijck: *Still Life*, 1613. Haarlem, Frans Hals Museum

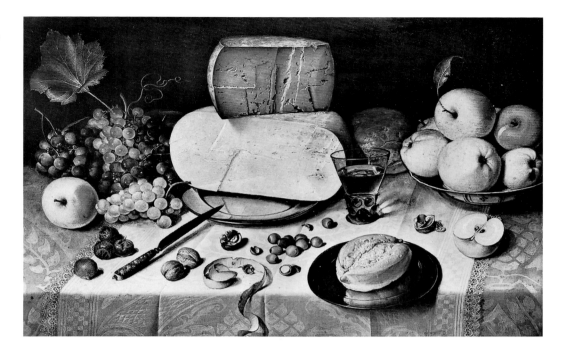

the couple (p. 51 above). However, a few flower pieces spell out their messages unequivocally. One is the rich bouquet at Munich (Alte Pinakothek) signed by both Jan Davidsz de Heem and the Fleming Nicolaes van Veerendael (1640–96). In their collaborative effort they not only included the familiar *memento mori* symbols of a skull and a timepiece as accessories to their flower piece but added a conspicuous crucifix with a piece of paper beneath it upon which an admonition to admirers of ravishing blooms is inscribed: 'But one does not turn to look at the most beautiful flower of all'. De Heem's *Flower Still Life with a Skull* at Dresden underlines the skull's message by including the inscription 'Momento Mori' on a sheet of paper. De Heem also painted a *Fruit Piece*, now at the National Gallery of Ireland, Dublin, which includes a skull and crucifix; although it does not bear an inscribed motto its admonition is clear: think on God's omnipotence and the certainty of death and resurrection.

Bosschaert's type of flower piece remained popular until after the middle of the century. His most interesting follower is his brother-in-law Balthasar van der Ast (1593/4–1657), who manages to avoid the hard, metallic quality of so many others influenced by Bosschaert. Van der Ast's paintings are more varied than Bosschaert's, and they frequently include lively lizards and toads. His particular speciality is the still life composed exclusively of shells. Other painters who continued the Bosschaert tradition are his three sons, Ambrosius (1609–45), Johannes (1610/11–after 1628), Abraham (1612/13–43), and the Haarlem painter Hans Bollongier (c.1600–before April 1675).

Paintings of food laid out on a table were also popular from the beginning of the century. Floris van Dijck (1575–1651), Floris van Schooten (c.1585–after 1655), and Nicolaes Gillis (active c.1610–30) were early specialists of this category. All three worked at Haarlem, but interest in this subject was not confined to Haarlem, or indeed to painters working in Holland. In every country of Europe,

early Baroque artists reacted more spontaneously to the visual world than their predecessors did, and there are Flemish, French, German, Spanish, and Italian still-life painters who share the stylistic and iconographic features found in Floris van Dijck or van Schooten. The subjects and style of Clara Peeters's still lifes place her with this group. Not a single uncontested document has surfaced about her life but there is reason to believe she was active in both Flanders and Holland. To be sure, some national differences remain. The Flemish love of abundance seldom disappears, and a geometric rigour sets off French table pieces from Dutch ones. But all early-seventeenth-century still-life painters of food depict objects from a high point of view, to show as much as possible of the surface of a table [380], a vantage point – as we have heard – similar to the one used by contemporary landscape, marine, and architectural painters. Symetrically arranged platters of fruit, cheese, nuts, sweets, as well as glasses, jugs, and knives, are spread upon a flat tablecloth. Some of them are elaborate enough to qualify as banquet pieces. The inanimate objects appear to pose in a steady light, showing how carefully every surface and texture has been scrutinized and how faithfully everything has been rendered. It is perhaps difficult for us to imagine the amazement and sheer delight seventeenth-century observers took in the skill of artists who could represent delicious food with such exactitude: our eyes have been numbed by countless colour images of food illustrated in cookery books and advertisements designed to sell packaged edibles.

A unique contribution was made by the Dutch still-life painters who appear on the scene around 1620. Their work corresponds to the tonal trend of the landscapists of van Goyen's generation. Pieter Claesz (1597/8–1660) and Willem Claesz Heda (1593/4–1680/2), popularizers of the breakfast piece, are the principal representatives of this phase. Claesz, the father of the landscapist Nicolaes Berchem,

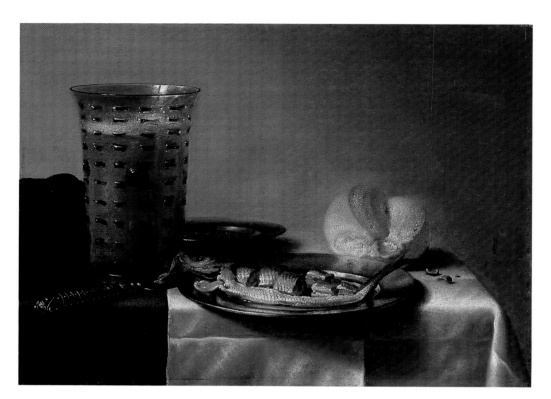

381. Pieter Claesz: *Still Life*, 1636. Rotterdam, Boymans-van Beuningen Museum

was born at Berchem (probably the village near Antwerp).[6] Heda's orgins are obscure. Both were primarily active at Haarlem and underwent similar stylistic developments. Their early works show the influence of the older still-life painters, but they soon limited themselves to the description of a simple meal set near the corner of a table – some bread and cheese, a herring on a pewter dish, a glass of beer or wine, perhaps a silvery pewter vessel, and a white crumpled tablecloth – just enough to suggest a light breakfast or snack [381]. These objects, which always look as if they had been touched by someone who is still close by, are no longer treated as isolated entities: they are grouped together, forming masses along a single diagonal axis. But more important, Pieter Claesz and Heda reacted to the comprehensive forces of light and atmosphere which envelop us and the things with which we live, and they found means to express their reactions to these forces as accurately, immediately, and intensely as possible. As a result, they seem to animate their simple subjects. With a new pictorial mode, they achieve a more dynamic spatial and compositional treatment. The foreground of their unpretentious arrangements becomes spacious, and there is clear recession. Instead of vivid local colours, monochromatic harmonies with sensitive contrasts of *valeurs* of low intensity are favoured, without, however, a loss of the earlier regard for textural differentiation. From the point of view of composition and of colouristic, tonal, and spatial treatment the perfectly balanced still lifes by Claesz and Heda are among the most satisfying Dutch paintings made during the century. Claesz has a more vigourous touch than Heda. He was also a man of simpler tastes. Heda depicts oysters more frequently than herrings, and after 1640 his compositions became larger, richer, and more decorative [382]. To obtain a more monumental effect, during his maturity Heda often abandons the traditional

horizontal format for a vertical one. Ornate silver vessels and costly *façon de Venise* glasses, at the time blown in the Netherlands as well as Venice, intensify the contrasts of *valeurs*, and touches of colour provided by the pink of sliced hams and ripe fruit are combined with an increased chiaroscuro.

The monochromatic style was also practised by Heda's son Gerrit Willemsz Heda (active 1637–before 1702), who worked closely in his father's manner, Jan Jansz van Uyl (1595/6–1639/40), Jan Jansz van der Velde (1620–62?), son of the engraver who bore the same name, and a group of artists who had close associations with Leiden and specialized in *vanitas* still lifes. Although none of the last named group worked only in Leiden or dedicated themselves exclusively to *vanitas* pictures, they are usually called the Leiden *vanitas* painters. Their pictorial arrangements of books and writing materials, rare and precious objects, terrestrial and celestial globes, scientific and musical instruments, pipes, snuffed candles, timepieces, and above all skulls are readily read as symbols of transience and the vanity of all earthly endeavour. Often they continued the old tradition of including appropriate captions or texts on their pictures. The favourite was the admonition from Ecclesiastes 1: 'Vanity of vanities; all is Vanity'. It will be recalled that Jan van der Heyden cited the passage in his *Still Life with Rarities* of 1712 [373]. Harmen Steenwijck (1612–after 1655) was the leading exponent of this category [383]. Born in Delft, he was a pupil of his uncle David Bailly (1584–1657), a Leiden portraitist who painted a few *vanitas* still lifes. Bailly, in turn, studied with Jacques de Gheyn II, whose *Vanitas Still Life* of 1603 (New York, Metropolitan Museum) is the earliest existing Dutch painting of the type. Harmen Steenwijck's brother Pieter (c.1615–after 1654?) and his cousin Pieter Potter (c.1600–52), also pupils of Bailly, practised the genre

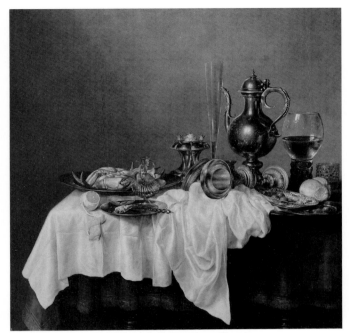

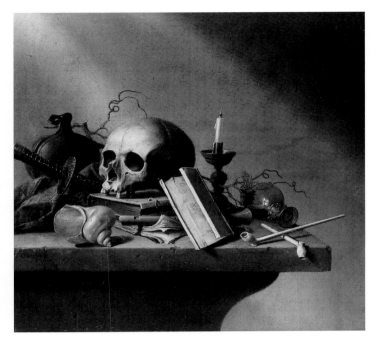

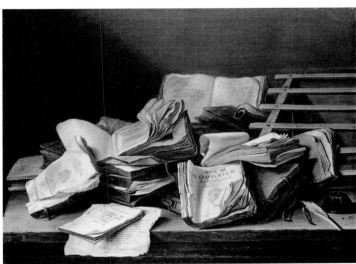

382. Willem Heda: *Still Life*, 1648. St Petersburg, Hermitage

383. Harmen Steenwijck: *Vanitas Still Life*, c.1640. Leiden, Municipal Museum, De Lakenhal

384. Jan Davidsz de Heem: *Vanitas Still Life with Books*, 1628. Paris, Fondation Custodia (Collection F. Lugt)

as well. Reflections of this group of *vanitas* still-life painters are also seen in some of Rembrandt's Leiden pictures of figures in dimly lit interiors surrounded by books and other paraphernalia [62].

Jan Davidsz de Heem (1606–83/4), who was to win an international reputation as one of the greatest European still-life painters, also spent time in Leiden. The most interesting works he painted during his stay there from the mid-twenties to the early thirties are *vanitas* still lifes, mainly comprising piles of old, well-used books that signal the vanity of the scholarly life [384]. The fine browns, ochres, and greys of these almost monochromatic pictures of his early maturity already show the exquisite sensitivity to colour which helped to establish his fame. De Heem worked in other styles. His youthful pictures of flowers, fruit, and shells are in the manner of Balthasar van der Ast, and he also painted simple, restrained still lifes which show his mastery of the chiaroscuro and the subtle tonal treatment of Claesz and Heda. In about 1635 he moved to Antwerp and in 1637 became a citizen of the city. Apart from some trips to Utrecht, his native city, he remained active in Antwerp for two decades and then is registered there as a non-resident citizen. His long stay in Antwerp earns him a place in the history of Flemish as well as Dutch art. By the late 1660s de Heem settled in Utrecht where he lived until 1672, the disastrous year that Louis XIV's armies invaded the Netherlands. Then he returned to Antwerp where he was active until his death. According to Sandrart (1675) he left Utrecht for Antwerp because 'there one could have rare fruit

of all kinds, large plums, peaches, cherries, oranges, lemons, grapes, and others in finer condition and state of ripeness to draw from life...' The reason Sandrart offers for his move can be questioned. Is it not possible that de Heem fled to Antwerp to avoid living under the invading French troops?

It was during his first years in Antwerp that de Heem found his special province. There he painted his famous flower pieces which, as we have seen, occasionally have overt moralizing messages. In Antwerp he made contact with the Flemish Jesuit Daniel Seghers (1590–1661), who, after Jan Brueghel, was the most accomplished south Netherlandish flower painter of the century. Seghers depicted bouquets but his speciality was painting garlands encircling a cartouche with a religious scene, a sculptural image, or a portrait, frequently painted by another artist. De Heem adapted Seghers's cartouche motif and painted hanging garlands as well. The individual blooms in these works are as colourful and as accurately portrayed as Bosschaert's, but they are

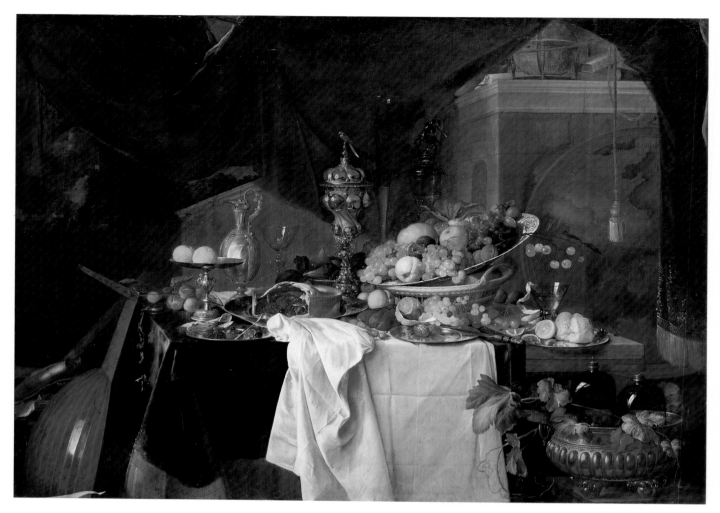

done with a freer brush, introduce chiaroscuro effects, and have asymmetrical arrangements. The host of de Heem's followers and later flower painters use similar pictorial devices.

In Antwerp de Heem also began to paint his celebrated abundant displays on carpet-covered tables piled high with ornate silver platters and baskets of huge, expensive fruit, and glistening lobsters. These works are usually embellished with exquisite trappings, precious metal vessels, and delicate glassware. An outstanding very large, early one at the Louvre [385] was in the collection of Louis XIV before 1683. The Dutch call lavish still lifes of this type *pronk stilleven* (*pronk* means sumptuous or ostentatious). The term is traditionally used to categorize overt displays of magnificent banquets and luxury items painted from the mid- to the late decades of the century. De Heem, Willem Kalf, and Abraham van Beyeren were the leading practitioners of the type. Their patrons presumably belonged to the upper echelons of society and made no secret of their expensive tastes.

De Heem is one of the rare Dutch artists who captured some of the exuberance of Flemish Baroque painting, and soon after he settled in Antwerp in the 1630s his colouristic splendour rivals that of the native Flemings. The success of his flower pieces and *pronk* still lifes won him many pupils and imitators both in Flanders and in the northern Netherlands, and occasionally it is difficult to separate his hand

from works done by his followers. His son Cornelis de Heem (1631–95) can come dangerously close to his father. The Antwerp artist Joris van Son (1623–67) and the Leidener Pieter de Ring (1615–60) successfully adopted his compositional schemes and style. De Ring's works, particularly his fine, large *pronk* still lifes, have been confused with his model's. His custom of signing his still lifes with a ring helps distinguish them. But this clue is not fail-safe. The ring has been known to have been painted out by dealers and collectors who wanted their de Ring to pass as a de Heem. Notable among the artists de Heem trained during his stay in Utrecht who then worked in his manner are the flower and fruit specialists Jacob Marrel (1614–81), Abraham Mignon (1640–79), and Maria van Oosterwijk (1650–93).

De Heem's works were also frequently copied during the eighteenth and nineteenth centuries. As late as 1893 Matisse made a close reduced copy (Nice-Cimioz, Musée Matisse) after the large composition in the Louvre [385]. He sold the copy, then bought it back and used it as an inspiration for his *Variation on a Still Life by de Heem* (1915; New York, Museum of Modern Art) which is about the size of the huge original. Though Matisse's *Variation* on de Heem still shows an unmistakable debt to the Dutch painter's composition, it has been completely translated into his personal style of these years.

If de Heem could have heard Matisse speak about still-

385. Jan Davidsz de Heem: *Still Life ('Le Desserte')*, 1640. Paris, Louvre

386. Willem Kalf: *Still Life with a Nautilus Cup and a Wan-Li Bowl*, 1662. Madrid, Thyssen-Bornemisza Foundation

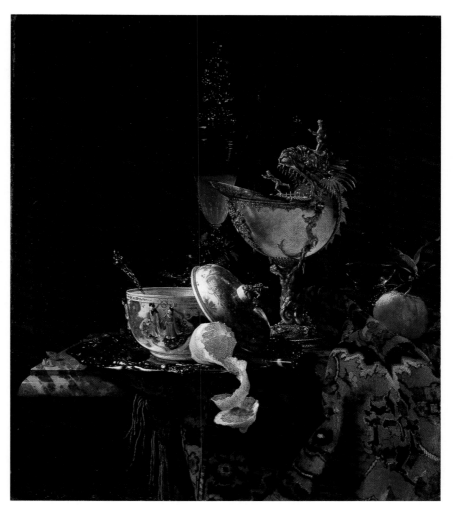

life painting in 1908, he probably would have been baffled by his statement: 'to copy the objects in a still life is nothing'. On the other hand, neither de Heem nor his contemporaries would have insisted that 'to copy the objects is everything'. They may have wondered, but not disagreed, had they heard Matisse maintain that a still-life painter

> must render the emotion they [the objects] awaken in him. The emotion of the ensemble, the interrelation of the objects, the specific character of each object – modified by its relation to the others – all interlaced like a cord or a serpent. The tear-like quality of this slender, fat bellied vase – the generous volume of this copper – must touch you. A still life is as difficult as an antique and the proportions of the various parts as important as the proportions of the head or the hands, for instance, of the antique.[7]

Even after the achievement of the great Baroque still-life painters, and after the accomplishment of Chardin, Courbet, the Impressionists, Cézanne, and van Gogh in this category, Matisse still found it necessary to plead that composing a picture of pots and pans is as difficult as, working after the ancients. Matisse's argument by implication is an impressive tribute to the longevity of the Renaissance tradition that artists worthy of the name must master the canons of ancient art in order to make figure compositions, the brand of painting earlier critics explicitly or implicitly considered superior to the representation of inanimate objects. As far as we

know, no seventeenth-century Dutch still-life master took a stand on this issue. However, one revolutionary Baroque master did. Caravaggio challenged the well-established hierarchy of genres of painting, as well as anticipated Matisse's remarks by three centuries, when he asserted that 'it took as much craftsmanship to paint a good picture of flowers as one of figures.'[8]

The best representative of the classical period of Dutch still-life painting is Willem Kalf. He was born in 1619 in Rotterdam, where he was probably influenced by François Rijckhals (after 1600–47), a Middelburg painter best known for his small peasant scenes which include displays of fruit and vegetables, and of impressive *pronk* still lifes that include sumptuous gold and silver vessels.[9] Kalf began by painting similar motifs: little pictures of kitchens and barns, as well as large still lifes of metalwork, glass, and porcelain. As in the work of other *pronk* still-life painters, the same costly objects appear in his paintings more than once. Examples are the elaborately mounted nautilus cup and the Wan-Li blue and white porcelain bowl decorated with Taoist immortals arranged in pairs with a cover topped by a Fu-lion seen in his outstanding still life of 1662 [386]. Since he was a dealer in works of art as well as a painter he may have used objects in his stock as models. We can be certain that objects such as the nautilus cup and Wan-Li bowl were treasured collector's items.

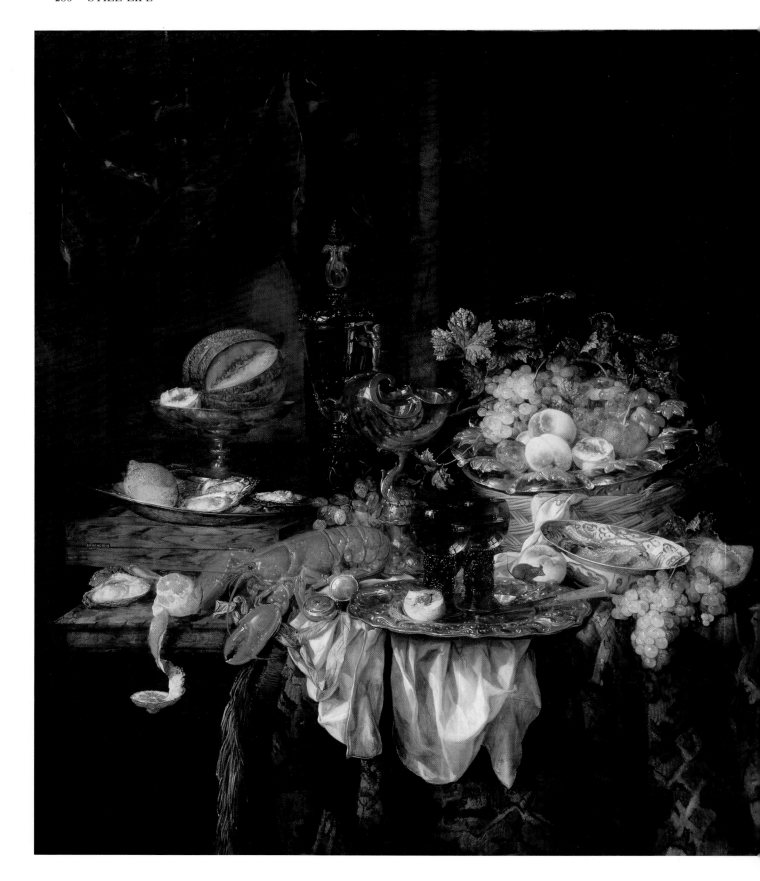

387. Abraham van Beyeren: *Banquet Still Life with a Mouse*, 1667. Los Angeles
County Museum of Art

Kalf's earliest phase is a Parisian period; he was in the French capital by 1641 and he returned to Holland by 1646. Compared to the masterpieces he created during his later years, some of the still lifes made in France of valuable metal objects and fine glassware look crowded and disorderly, though an emphasis on vertical and horizontal elements already shows a tendency towards the tectonic compositions that helps to account for the monumentality of his mature works. Even in his youth Kalf was able to impart a mysterious quality to the precious things he painted. Goethe sensed this when he wrote in 1797 of a Kalf still life dated 1643, now in the Wallraf-Richartz Museum, Cologne:

One must see this picture in order to understand in what respect art is superior to nature and what the spirit of man imparts to objects when it views them with a creative eye. There is no question, at least there is none for me, if I had to choose between the golden vessel or the picture, that I would choose the picture.[10]

In 1651 Kalf was married at Hoorn to Cornelia Fluvier, a talented poet, calligrapher, and engraver of glass; Constantijn Huygens owned one of her engraved *roemers*. The couple's marriage was celebrated in verse by Vondel; his poem includes a brief description of the groom's *pronk* still lifes. Kalf and his wife settled in Amsterdam in 1653 where they lived in very comfortable circumstances. He apparently painted little during the decade that preceded his death in 1693, but he remained active as a dealer.

Kalf's fame rests securely on the *pronk* still lifes of his Amsterdam years. With his sure sense of composition, which is as remarkable as his choice of light and colour accents, these works are seldom ostentatious, but of a noble restraint. His opulence is tempered by calmness and stability. During the Amsterdam years he also reduced the number of objects he represented. He now preferred to show a close view of one or two rhythmically arranged costly vessels and precious glasses, a bowl, perhaps an enamelled watch, and a few pieces of fruit on a table with a marble or rare wood top and rumpled imported carpet [386]. A glowing colourism of great distinction develops, which seems to combine Rembrandt's rich and expressive chiaroscuro with Vermeer's exquisite sense of colour. Kalf's technique also seems to be a combination of Rembrandt's liquid impasto and Vermeer's *pointillé*. Like Vermeer, he gives preference to a blue-yellow accord in his ever-present motif of a peeled lemon with a blue Delft or Chinese bowl. The richly textured nap of the carpets on his tables also recall the beautiful carpets by Vermeer. To our knowledge Kalf had no pupils. His closest follower was Jurriaen Streeck (1632–87). Willem van Aelst (1623–after 1683), better known for his hunting trophy and flower pieces, occasionally painted in his style as well.

Abraham van Beyeren (1620–90), the third outstanding master of *pronk* still lifes, like Jan Davidsz de Heem, who seems to have inspired him, painted sumptuous compositions of lobsters, fruit, and expensive tableware, and included rich draperies and columns to enchance the splendid effect [387]. Van Beyeren, however, hardly ever overloads his compositions in the way that de Heem does; on the other hand, he seldom shows Kalf's moderation. At his best, he is a subtle colourist who works in a light key, with an appealing

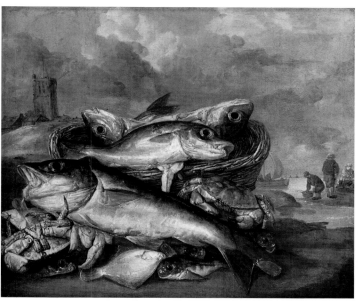

388. Abraham van Beyeren: *Fish Still Life with a View of Egmond aan Zee.* Budapest, Museum of Fine Arts

free and liquid touch. A soft silvery light unifies his fine colour harmonies, anticipating the palette of eighteenth-century painters. This master of banquet tables also painted flower, fruit, and fish pieces. The earliest of the last named, dated 1649, is a huge votive tablet decorated with fish which was painted for the fishermen's guild at Maassluis; it probably was done in collaboration with the fish painter Pieter Verbeek (c.1610/15–54 or later). The tablet, still in Maassluis's Grote Kerk where it was originally installed, predates van Beyeren's earliest *pronkstilleven*, a fact that supports the claim that the fish painter Pieter de Putter (c.1600–59) was his teacher.[11] Van Beyeren's fish pieces seldom attract as much attention as his sumptuous banquet tables. Most people would rather study a picture of an exquisitely laid table than one of a mess of fish. But van Beyeren's celebrations of the abundance of the sea are as remarkable as his festive dinner tables. In them he sometimes includes a glimpse of a beach in the background [388]. The fish and crustacea he painted always look wet – they appear to have been just taken from the water – and the mother-of-pearl greys of his creatures of the sea, their browns, silvers, and white are as delicate and finely felt as the colour accords in his more showy pieces. Additionally, van Beyeren was a gifted painter of marines. The Maassluis votive tablet includes a set of four of his early efforts as a seascapist.

Fish still lifes developed as a category during the century – not an astonishing phenomenon when we recall that fishing, particularly for herring and cod, was a mainstay of the Dutch economy. In addition to van Beyeren and the fish painters cited above, notable exponents of the type are Pieter van Schayenborch (died 1657), Isaac van Duynen (1628–?), Harman Steenwijck, whose *vanitas* still lifes have been mentioned, and Jacob Gillig (c.1626–1701). As the Dutch love for flowers, their love for seafood is proverbial. The Haarlemer Joseph de Bray (died 1664), son of Salomon and brother of Jan, celebrated this taste in his picture, dated 1656, dedicated to the apotheosis of the pickled herring

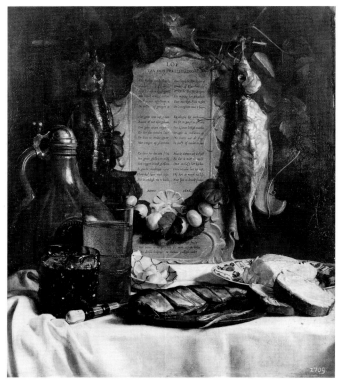

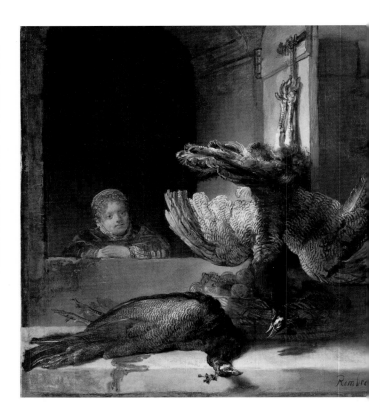

389. Joseph de Bray: *Still Life in Praise of the Pickled Herring*, 1656. Dresden, Gemäldegalerie

390. Rembrandt: *Girl with Dead Peacocks*, *c*.1639. Amsterdam, Rijksmuseum

391. Rembrandt: *The Shell*, 1650. Etching

[389]. Resting behind the large, succulent herring and other objects in the painting's foreground, there is an elaborate tablet, draped with a festoon of herrings and requisite onions, inscribed with a poem by the Remonstrant preacher and poet Jacob Westerbaen: 'In Praise of the Pickled Herring' published in 1633. After telling of the herring's delight to the eye, palette, and its other qualities, Westerbaen adds that consumption of it 'Will make you apt to piss/And you will not fail/(With pardon) to shit/And ceaselessly fart...'¹² – proof, if it is needed, that plain profane messages are as likely to be embodied in Dutch paintings as spiritual ones. De Bray's 1656 *Praise of the Pickled Herring* was evidently a success. In the following year he painted another, somewhat larger still life, now at the Suermondt-Ludwig-Museum, Aachen, dedicated to the same subject. It includes the text of Westerbaen's verse dedicated to the pickled herring, and a brief passage from his poem 'Cupido' on the page of an open folio accompanied by an ample display of herrings and onions.

Still lifes of hunting trophies begin to appear rather late, and were never as popular in the northern Netherlands as in neighbouring Flanders. They are introduced about 1640. Clara Peeters's game piece at the Prado, dated 1611, may be a notable exception; it will be recalled that she probably was active in both Flanders and Holland. The type gains momentum after the middle of the century. Its slow development is related to the social history of hunting in the new republic.¹³ Traditionally, hunting was the privilege of the aristocracy and it remained closely associated with it by laws that remained in effect until the establishment of the Batavian Republic in 1795. Ordinances stipulated who could hunt what, how, and when. They specified, for instance, that only certain members of the nobility and those with special permission could hunt deer. They also specified that only the nobility could shoot hare, rabbit, pheasant, partridge, grouse, ducks, and other game birds. Only small birds, such as finches and thrushes, were fair game for people of all social classes.

Around mid-century unpretentious pictures of a few small dead birds on a simple table were made by Elias Vonck (1605–62), his son Jan (1631–63/4) and Philips Angel (*c*.1608–45 or later). Hunting pieces that include the game and fowl the nobility were permitted to shoot, as well as rich

displays of accessories of the hunt, were done mainly by artists whose activity is datable later in the century. The demand for their works cannot be explained solely by commissions from the nobility, a class that was not large in Holland and whose record as collectors of paintings is not impressive. The demand was stimulated by burghers who enjoyed great prosperity during the decades that followed the ratification of the Treaty of Münster in 1648. Some purchased country estates and began to assume the customs of the aristocracy. The noble sport of hunting was part of the way of life they imitated. If these wealthy patricians were untitled, hunting laws prohibited them from shooting deer and game birds, even on their own estates. However, since hunting trophy pictures had associations with the nobility, possession of them could give non-hunters a feeling of the prestige associated with sport. Moreover, there probably were untitled burghers who honoured Dutch hunting laws more in the breach than in the observance; they too must have found personal satisfaction in mounting hunting trophy pictures on their walls. The appearance of the new wealthy bourgeois class that began to adopt the life-style of the aristocracy also helps explain the vogue that begins about the middle of the century for portraits of sitters in the guise of hunters, a type traditionally reserved for royalty and nobility, and for landscapes that include fashionably dressed hunting parties [333].

Among the earliest Dutch paintings featuring large dead birds is Rembrandt's life-size painting commonly called 'Still Life with Dead Peacocks' of about 1639 [390], although strictly speaking it is not a still life since a little girl leaning on a sill plays such an important role in it. It is not a hunting trophy piece either. Peacocks hardly qualify as game birds. Shooting them is comparable to catching fish in a barrel. The inventory made of Rembrandt's effects in 1656 lists a few untraceable still lifes by him, including some *vanitas* pictures which may date from his Leiden period. Only one unequivocal still life by Rembrandt is known, his small etching of a single shell (Bartsch 159) [391], a marbled conus (*conus marmoreus*), dated 1650. His print, not much larger than a playing card, captures the beauty and mystery of light and shadow playing on an inanimate object more effectively than any done by artists who dedicated their careers to such subjects. Few works better exemplify the axiom less can be more. Additionally, it is virtually certain that Rembrandt was more concerned with the artistic effect of his print than producing an image that would satisfy conchologists who demanded scientific accuracy. When making it he did not etch the marbled conus in reverse; consequently impressions of his print show the shell wound the wrong way. The possibility that he drew in reverse on his copper plate an exceedingly rare left-handed specimen can be entertained.[14] However, this hypothesis loses weight when we recall that reversal of images did not seem to trouble Rembrandt, as we have seen in the discussion of his etched topographical views of Amsterdam's skyline (Bartsch 210) and the plains near Haarlem in his master print known as the *Goldweigher's Field* (Bartsch 214); both prints give mirror images of the familiar sites.[15]

Jan Baptist Weenix, whose Italianate landscapes have been mentioned, was a leading painter of both small and large

392. Jan Baptist Weenix: *Dead Partridge hanging from a Nail*, 1650–2. The Hague, Mauritshuis

game pictures. One of his finest in a modest size, now at the Mauritshuis, The Hague, represents a single dead partridge hanging from a nail against a light-grey wall [392]. The convincing *plein-air* effect, refined painterly treatment, and fine design of the simple motif make it worthy of a place in the museum that houses Fabritius's unrivalled *Goldfinch* [178], and is datable before Fabritius's masterwork. Weenix's dead partridge makes a strong illusionistic effect and is related to *trompe l'œil* paintings that enjoyed a vogue during the third quarter of the century. Cornelius Lilienberg (*c.*1626–after 76), Jacobus Biltius (1633–81), the Scotsman William Gowe Ferguson (1632/3–95), who mainly worked in Holland, and Melchior d'Hondecoeter (1636–95) painted pictures of a similar type. Weenix's repertoire includes cabinet-size paintings of game on a table or ledge; the impact of these works is evident in Salomon van Ruysdael's rare still lifes – only about a half-dozen are known.

Weenix's most famous large-scale trophy piece is the *Dead Deer* [393] with a snarling dog and a hissing cat that suggest the influence of Snyders. While Weenix never matches the dynamic movement in the Flemish master's displays, which look as if they were created to help Diana herself celebrate the abundance of the hunt, his chiaroscuro effect is of a great subtlety and the texture of his paint is soft and beautiful. Weenix belongs to the group of Dutch artists who prospered. During the last years of his life he joined the ranks of the wealthy middle class who owned landed estates when he purchased a grand country manor near Utrecht. Perhaps its grounds provided subjects for his game pictures. Jan Weenix (1640–1719), son of Jan Baptist Weenix, closely

393. Jan Baptist Weenix: *Dead Deer*, c.1655. Amsterdam, Rijksmuseum

emulated his father. He specialized in hunting trophy pieces, usually set in a park seen in the rosy glow of twilight and often embellished with classical and pseudo-classical sculpture, ornamental antique urns, and a view of a palatial house in the background. He also painted huge canvases to decorate whole walls; such a series was painted for the count palatine's castle at Bensberg between around 1710 and 1714 (now at Munich, Alte Pinakothek). Jan Weenix's popular works helped to set the key for the decoration of stately eighteenth-century Dutch homes.

Willem van Aelst (1626–after 1683), a still-life specialist prized for his lovely flower and fruit pieces, and who has been mentioned as a sometime follower of Kalf, also painted a number of elegant game pictures in a clear light. They show close views of dead prey – occasionally accompanied by killed poultry – that include scrupulously painted guns, hunting bags and horns, bells and other gear of the sport [394]. As most trophy pieces they were designed as representative pictures of the sport, not records of the spoils of a specific hunt. During his early maturity (1645–9) van Aelst was in France; subsequently he travelled to Italy. While in Florence he had close contact with his fellow countryman Otto Marseus van Schrieck (discussed below), who worked for the grand duke of Tuscany, Ferdinand II de' Medici. Van Aelst also received commissions from the duke who awarded him a gold medal and chain for his services. In 1656 he returned to the Netherlands with van Schrieck. Both artists soon settled in Amsterdam where they spent the rest of their lives. During the course of van Aelst's almost three-decade activity in Amsterdam he acquired many followers. The eminent flower painter Rachel Ruysch was his pupil.

It is difficult to categorize Otto Marseus van Schrieck (1619/20–78) and his follower Matthias Withoos (1627–1703). They made a few still lifes (Withoos also painted topographical views, harbours, and portraits), but they are best known for their mysterious dark close-ups of the live undergrowth of forest floors that give detailed views of wild flowers, weeds, thistles, and mushrooms animated by phosphorescent butterflies, insects, reptiles, and snakes [395]. These works, strictly speaking not still lifes, have always appealed to collectors of highly finished Dutch cabinet pictures. Naturalists have a field day identifying their flora and fauna, and so do iconographers who give detailed commentaries on their content, which are generally related to the transience theme. Van Schrieck and Withoos travelled to Italy in 1648. In Rome the former received the Bent name 'Sniffer' (*Snuffelaer*), because, according to Houbraken, he sniffed everywhere for strange creatures and plants, and the latter was given the less imaginative nickname 'White Hose' (*Calzetta Bianca*). Withoos returned to the Netherlands in 1653 where he settled in his native Amersfoort; there he painted an imposing panoramic view of the town and was the teacher of Caspar van Wittel who popularized *veduta* painting (see pp. 322–3). As we have heard, van Schrieck and van Aelst returned to their homeland a few years later. After settling in Amsterdam, van Schrieck acquired a parcel of land just outside the city where he kept animals and reptiles. No doubt some are portrayed in his paintings. In addition to Withoos, Willem van Aelst, Rachel Ruysch, and the Italian Paolo Porpora (1629–93) made a few pictures inspired by van Schrieck's highly original paintings.

394. Willem van Aelst: *Hunting Trophy Still Life*, 1664. Stockholm, Nationalmuseum

395. Otto Marseus van Schrieck: *Forest Undergrowth with Reptiles and Insects*, 1662. Braunschweig, Herzog Anton Ulrich-Museum

396. Melchior d'Hondecoeter: *Fight between a Cock and a Turkey*, Munich, Alte Pinakothek

Equally tangential to still life are works by a group of artists who represented live domesticated and wild birds. Their pictures do not belong to the category, but their emphasis on the textural and colouristic beauty of their subjects gives a still-life character to their works. Their patrons probably included the rich burghers who lived as landed aristocrats on estates in the country where they kept exotic as well as native fowl. Just as some painters were called upon by flower fanciers to make portraits of favourite blossoms, others were asked by amateur and professional poultry breeders to paint prize birds and common farmyard specimens. Melchior d'Hondecoeter (1636–95), who also painted a few game still lifes, was the pre-eminent specialist of this branch of painting. Depicting birds was a tradition in

his family. His grandfather was Gillis d'Hondecoeter (*c*.1570–1638), an artist often inspired by Roelandt Savery's landscapes crammed with domesticated and exotic birds and animals, and his father, Gijsbert d'Hondecoeter, was a landscapist and a painter of birds, particularly waterfowl and poultry. Melchior first studied with his father; after Gijsbert's death in 1653 he entered the studio of his uncle, Jan Baptist Weenix, whose varied *œuvre* includes small and large, grandiose displays of birds, albeit dead ones. In his extensive production Melchior retains a good deal of the best qualities of the great age of Dutch painting [396]. He is both observant and gifted as a colourist, and admirably renders the texture of his feathery creatures. Additionally, he produced for country houses large decorative panels that employ live birds as their protagonists and like those painted by his cousin Jan Weenix they are embellished with classical sculpture, columns, fountains, and urns. Similar arrangements of props are found in late seventeenth-century portraiture and landscape.

During the last decades of the century Dutch still-life specialists do not lessen in pictorial quality or in competence of draughtsmanship, but, as we shall see, there is a definite change towards the lighter vein which characterizes the art of the eighteenth century.

PART TWO

1675–1800

Historical Background, Trends of Criticism and Collecting

When Louis XIV signed the Peace of Nijmegen in 1678, he agreed to give up most of the conquests he made after his abortive attempt to crush the republic in 1672. Endorsement of this treaty did not alter the aggressive policy of the king of France. William III's major task (as prince of Orange, captain-general of the Union, stadholder of five provinces of the Netherlands, and then as king of England and leader of the Grand Alliance) remained the same. He had to restrain Louis's imperialism. William's brilliant political manoeuvring and military genuis met with success. In 1697 Louis, exhausted, signed the Peace of Rijswijk, which gave advantages to the Dutch Republic as well as recognizing William as king of England. It was a defeat for France's military and naval forces, but not for French culture and art. On the contrary. During the years of the struggle French taste permeated the art and life of the Netherlands, and aspects of this dependence continued throughout the eighteenth century. The impact of French influence was also strengthened by the wave of French Protestants, the Huguenots, who fled to Holland after the revocation of the Edict of Nantes in 1685. The prince of Orange himself helped to establish French fashion when he employed Daniel Marot, the Huguenot refugee. William put Marot to work as early as 1686–7, and he soon made this gifted Frenchman his chief architect, giving him commissions in Holland and at his court in London.

After William III died, childless, in 1702, the old struggle between the recalcitrant patrician oligarchy of the provinces and the supporters of the House of Orange was resumed. The powerful burgher class successfully prevented the stadholderships of five of the provinces, which had been made hereditary in the House of Orange in 1672, from going to William's cousin, Johan Willem Friso (died 1711), stadholder of Groningen and Friesland. For the second time the republic was stadholderless, and it remained so until the Union was threatened by France during the War of the Austrian Succession in 1747. In this crisis the Dutch turned, as they had so often in the past, to a member of the House of Orange for leadership. Willem IV (1711–51), son of Johan Willem Friso, was made stadholder of all seven provinces, an act that, for the first time, established a single stadholder for all of the provinces. Additionally, the stadholdership of all seven provinces was made hereditary in both the male and female lines. Willem IV also was appointed captain general of all the provinces.

During the second stadholderless period between 1702 and 1747, Dutch affairs were in the hands of loyal counsellors, but none of them ever had power to speak with real authority for the Union in the council of Europe. This became evident soon after the death of William III. Though Dutch armies fought bravely in the War of the Spanish Succession, which began in 1702, and had a real share in Marlborough's great victories, the republic was only able to secure a barrier against a renewal of French aggression and some minor commercial advantages when the Peace of Utrecht was signed in 1713. Their interests were, in fact, sorely compromised by the English, who permitted the defeated French to obtain far better terms than they were in a position to demand.

The Peace of Utrecht marks a turning point in the history of the republic. During the following decades the Dutch avoided foreign entanglements and their impact on the international political scene soon became of little significance. Complacency, or to put it another way, a desire for peace, comfort, and tranquillity descended upon the country. It seems that rest was needed after so much passion and energy had been spent. National grandeur was now a thing of the past. England quickly took Holland's place as the supreme power on the high seas. Around the middle of the century Frederick the Great rightly compared the former close rivals to a great ship of the line towing a small boat in its wake.

Despite Willem IV's powerful position as the stadholder and captain-general of all seven provinces he accomplished little before his premature death in 1751. He was a learned man but lacked the decisiveness and strong will that mark effective generals and statesmen. His son Willem V (1748–1806), who attained the age to assume his hereditary powers in 1766, was probably the most cultivated of all the stadholders who served the republic. However, in affairs of state and military matters he was even more of a weakling than his father. He was a vacillating, ineffective governor prone to fits of hysteria when thwarted or in times of crisis. As stadholder he was much influenced by his intelligent wife Fredericka Sophia Wilhelmina, niece of Frederick the Great, king of Prussia, and by his old guardian and counsellor, Louis, Duke of Brunswick-Wolfenbüttel. These connections brought in German influence.

During the American War of Independence efforts by the Dutch to remain neutral failed. The arrogant British policy of stopping all neutral vessels on the high seas in order to confiscate goods which could aid her enemies forced the Dutch upon the European stage again. The results were disastrous. The country was totally unprepared for war when it broke out in 1780. Moreover, it was difficult to make preparations or to take any decisive action, because Dutch sympathies were split. Willem V and his supporters sided with the English; others wanted to aid the rebellious American colonists. The mighty British navy quickly destroyed Dutch commerce, and her colonial empire was at its mercy. By the time the Dutch signed the Treaty of Paris with the English in 1784, the republic's economy was shattered. As a result of the humiliating defeat, anti-Orange sentiment in the country increased. Willem and his family were forced to flee from The Hague. Only after the Prussian army came to

his rescue in 1787 was he restored to power. Willem managed to hold the reins of a shaky government until 1795, when the French revolutionary army conquered the country. Anti-Orangists, who had taken the name of Patriots, welcomed the French with ardour, and Willem and his family fled to England. This was the pathetic end of the republic of the United Netherlands. The stadholderate and other traditional offices were abolished and the Batavian Republic, entirely dependent upon France, was founded. The country remained a creature of France's destiny until Napoleon's defeat in 1813.

Costly wars of the late seventeenth and eighteenth centuries exhausted the Union's treasury, but the merchant class did not lose its wealth. Commerce continued to flourish, and Amsterdam held its position as an important trading centre and money market until the disaster of 1780. Under a system of taxation designed to favour the patrician class, it was possible for Dutchmen to accumulate great fortunes without making substantial contributions to the republic's exchequer. Huizinga finds the tag 'Golden Age', which is usually given to Holland's great seventeenth century, a more suitable name for his country's eighteenth century, when gold pieces were stuffed in Dutch strong boxes. He prefers to relate the seventeenth century to wood and steel, pitch and tar, paint and ink, daring and piety, fire and imagination, not to gold.[1] His preference tells much more than the traditional hackneyed label.

During the epoch a provincialism and localism developed but the Dutch continued to show an interest in art and natural science, and they lost nothing of their admirable tolerance. Rationalism and the spirit of the Enlightenment were at home in the Netherlands. Noteworthy pedagogical books for artists and amateurs were published and art-historical literature began to appear. Publications of this type had not been a strong suit of the Dutch since van Mander published his *Schilderboek* in 1604. Apart from pattern books for aspiring draughtsmen,[2] the number printed before 1678 when Samuel van Hoogstraten's *Inleyding tot de hooge schoole de schilderkonst* (*Introduction to the Advanced School of Painting*) was published, can be counted on the fingers of one hand. As we have heard, for the most part Hoogstraten's *Inleyding* is an up-dated, expanded version of the section of Karel van Mander's *Schilderboek* devoted to the fundamentals of painting. Key tenets of classical art theory, which had its origin in Renaissance Italy, are found scattered in van Mander and Hoogstraten texts: worthwhile artists do not ape nature but idealize it and search for beauty; since this was the way of the ancients and the best later masters, their standards and example should be followed. Artists who want to excel represent noble subjects that teach as well as delight, follow rules of proportion and perspective, and place a higher premium on drawing than colour. These notions were rationalized and institutionalized in France after the establishment of the Académie Royale de Peinture et de Sculpture in 1648 and were soon diffused through Europe.

In Holland classical art theory was first put into sharp focus by the lawyer and talented amateur draughtsman Jan de Bisschop (1628–71), also known as Johannes Episcopius, the Latinized form of his name, in the brief texts that accompany his *Icones* (1668/9) and *Paradigmata* (1671). The

former volume offers one hundred of his own etchings after Greek and Roman sculpture; the latter book his etchings after drawings by Italian artists, including Raphael, Michelangelo, Annibale Carracci and Domenichino. His texts make clear that he offers the prints in his books as examples of the standard of perfection artists must try to attain and *virtuosi* and collectors must study if they want to acquire the taste he and other classicists assert is best.[3] Although de Bisschop did not intend his volumes as pattern books, they were quickly used for that purpose. Antique sculpture seen in paintings done in the 1670s by Caspar Netscher and Jacob Ochtervelt are pilfered from prints in the *Icones*, and during the following decades Adriaen van der Werff borrowed from the volume too. The etchings in de Bisschop's books vary considerably in quality. His side view of *Venus de' Medici*, after its discovery one of the most frequently copied classical statues, ranks with the best [399]. Others are less good, a fact recognized by amateurs of de Bisschop's day almost before the ink on his prints was dry. In 1669 Christiaen Huygens was sharply critical of the handling of the draperies and postures of the figures in *Icones* and wrote that he and some other more competent connoisseurs 'felt bound to criticize some because they missed what they call "*air de teste*", which means the essence of the sculptures had not been reproduced carefully enough'. Christiaen's just criticisms are found in letters he sent from Paris to de Bisschop himself and his brother Constantijn Huygens II to whom de Bisschop dedicated part of the *Icones*.[4] Despite the uneven quality of their etchings, *Icones* and *Paradigmata* were pirated soon after they were published and reissued more than once during the eighteenth century; there is ample evidence that leading European artists and theorists were familiar with them. However, the Dutch text that was of far greater importance and influence for the promulgation of the fundamentals of classical art theory was Gérard de Laisesse's *Het groot schilderboek* (*The Great Book of Painting*), published in 1707, and frequently reprinted and translated. It is discussed in the following chapter.

Arnold Houbraken's three-volume *De groote schouburgh*, the work that remains the prime source for the lives of seventeenth-century Dutch painters that has been cited frequently in these pages, appeared in 1718–21 (for reference to Houbraken's activity as an artist see p. 305 below). Biographies done in the same vein as Houbraken's appeared soon afterwards. Campo Weyerman's three volumes dedicated to the lives of Dutch painters, *De levensbeschrijvingen der Nederlandsche konst-schilders en konst-schilderessen*, was published in 1729. Although many parts of it baldly plagiarize Houbraken, it includes data that are not in the work that was his main source. Moreover, he did not share Houbraken's classical bias; thus, he often rang changes on what he lifted from him. His text helps account for his reputation as a biting satirist. He also was a controversial figure who spent the nine years before his death in 1747 in prison at The Hague for extortion. The fourth volume of his *Konst-schilders*, which is original, was published posthumously in 1769.[5]

Johan van Gool's *De nieuwe schouburg der Nederlantsche konstschilders en schilderessen* (2 vols. The Hague, 1750–1) picks up the lives of Dutch painters and painteresses where

Houbraken leaves off.[6] He presents biographies of eighteenth-century artists, some of whom he argues should be more highly esteemed than they are in his time and have been undervalued because powerful picture dealers, who he calls scoundrels and worse, have seduced the picture-buying public to believe earlier masters are far superior to contemporary ones. About the same time the same complaint against dealers was lodged in England by Hogarth. Van Gool grants there has been a general decline in the quality of Dutch painting during the period his volumes cover, and is eager to see it recover its former glory. He blames the pernicious influence of dealers for the decline too. According to him they have maliciously managed to persuade potential maecenases of contemporary artists to buy old master paintings, some of them outright fakes or doctored with false signatures, instead of assisting and encouraging artists of their own day. Van Gool believes that painters cannot produce worthwhile pictures without the backing of supportive, enlightened patrons. He reasons their absence had sorely discouraged budding Dutch artists. Whether van Gool's own middling efforts as a landscapist and painter of Potter-like cattle pieces would have been better if he had a patron he does not say.

Van Gool's sharp criticism of dealers detonated a vituperative pamphlet war between him and Gerard Hoet the Younger (died 1760), an art dealer who also was a minor painter. Hoet bore the name of his father, an artist who worked in the classical tradition (see p. 303, below). He shared van Gool's opinion that Dutch art was in decline but in his vigorous defence of dealers he maintained that the artists themselves, not members of the trade, were responsible for the marked shift in quality. A sign of the lively activity in the Dutch art market at the time is Hoet's publication in 1752 of two volumes (*Catalogus of naamlijst van schilderijen met prijzen*, The Hague) which includes lists of paintings in Dutch collections and those that had appeared in Dutch auctions from 1684 until the year the work was published; when available, he also listed the prices paintings fetched at sales. A posthumous third volume, edited by Pieter Terwesten, was issued in 1770. Hoet and Terwesten's lists enabled dealers and collectors, particularly those whose interest in pictures included using them as instruments for investment or speculation, to follow the rise and fall of prices on the market. They belong to the incunabula of the literature on collecting and art prices found today on the shelves of every art reference library and dealer, and remain indispensable for data on the provenance of pictures and provide a yardstick for the history of taste.

Van Gool's objection to the neglect by collectors of artists of his own time was not without foundation but his *cri de coeur* for a change was hardly heard. During the early decades of the century collectors began to show a preference for old masters and by the time van Gool's *Nieuwe schouburg* was published, virtually without exception, collectors showed a predilection for artists who worked during the seventeenth and first decades of the eighteenth century. The tendency to favour them grew stronger after mid-century as did the prices paid for their pictures. Particularly treasured were carefully finished paintings loaded with detail; consequently an early Rembrandt was invariably preferred to a late one.

Wouwerman, late paintings by Adriaen van Ostade, and the Italianates were particularly popular. Rubens and Van Dyck were also perennial favourites as were Teniers and a handful of other Flemings.

Johan Heinrich Wilhelm Tischbein (1751–1829), a well-travelled German artist better known as Wilhelm Tischbein to help distinguish him from almost twenty members of his family who also were artists, and often called the 'Goethe Tischbein' because of his famous portrait of Goethe seated in a classical attitude in the Roman campagna (*c.*1787; Frankfurt, Städelsches Kunstinstitut), was close to the mark when he included a list in his autobiography of the paintings found in a good Dutch cabinet of his day:

> ...a head by Rembrandt; a worked-up Rubens sketch; a painting by Gerrit Dou; [paintings] by the old Mieris; Frans van Mieris; two by Wouwerman, one in his first manner, the other in his last; one by Berchem; A. Cuyp; Ostade; Teniers; Brouwer; Metsu and ter Borch; a church interior by Pieter Neefs; a still life with fruit by de Heem; flowers by Huysum; oxen by Potter; a cattle piece by Adriaen van de Velde; a calm sea by Willem van de Velde; a stormy sea by Bakhuyzen; a picture by Slingelandt; one by Schalcken; a portrait by Van Dyck; a head by Lievens; a [Jan] Breughel; Hondecoeter; van der Werff; Poelenburgh; Elsheimer; Rottenhammer; Snyders; Both; Lairesse; and others.[7]

Tischbein nodded when he failed to include Jan Steen in his list – paintings by his hand never lost favour with the Dutch and he himself raved about him in his autobiography.[8] But it is churlish to quibble with Tischbein. The legitimacy of the names on his roster, based on his visit to the Netherlands in 1771–3, is confirmed by contemporary catalogues and inventories as well as accounts in diaries, letters, and travel books of visitors to the collections which were mainly assembled by wealthy burghers who enjoyed showing their treasures – sometimes blatantly collected as status symbols – to amateurs and artists.

More than a few wealthy private collectors assembled pictures of outstanding quality on a grand scale. To accommodate them they were hung in rooms from wainscotings to ceilings making an effect that to our eyes would look terribly overcrowded. The collection brought together by the Amsterdammer Gerret Braamcamp, who made a fortune as a timber and wine merchant, was among the most celebrated.[9] The catalogue of his posthumous 1771 sale included 313 lots; forty-two less important lots, mainly by minor eighteenth-century Dutch artists, appeared in his sale in the following year. Like most collectors of his day, Braamcamp also assembled drawings *en gros*, sculpture, porcelain, lacquer, gold and silver objects, and fine furniture. His 1771 sale included no less than seventeen paintings by Adriaen van Ostade, and the same number by Wouwerman, ten by Metsu (included were the artist's two best pictures, *A Man writing* and *A Woman reading a Letter* [221, 222]), nine by Berchem, eight by Adriaen van de Velde, and six by Jan Steen. One of his seven Dous, a secular triptych with a nursing mother in the centre, and one side panel depicting students at their lessons, and the other showing a man sharpening a quill, fetched 14,100 guilders; the spectacular price was the highest realised at the auction. The second highest price, 9,050 guilders, was paid for one of his Potters.

The Dou and Potter were purchased for Empress Catherine the Great of Russia, whose agents acquired a large number of outstanding Dutch pictures for her burgeoning collection in St Petersburg at sales in Holland. Not all of the purchases reached her. The Dou and Potter, along with other paintings she acquired at the Braamcamp sale, were lost when the ship carrying them to Russia was wrecked in a storm in the Gulf of Finland.

The prices paid for the Dou and Potter speak volumes about the epoch's taste when we find that a splendid, exceptionally large van Goyen, now a major accent in the collections of The Fine Arts Museums of San Francisco, was knocked down for merely 80 guilders; another brought 33 guilders. Jacob van Ruisdael did only a bit better; the top price paid for one of the four works attributed to him was 264 guilders whilst the low was 125 guilders.

Braamcamp's sale also had a few important Mannerist paintings including Goltzius's *Danaë*, now in Los Angeles [7]; it brought 410 guilders. Cornelius Troost and Jacob de Wit, the eighteenth-century Dutch artists justly ranked as the foremost painters of the time, were represented by three and ten lots respectively. The number by de Wit is exceptional. Both Braamcamp and de Wit were Catholics, which probably helped them establish close contact. De Wit painted the decorations on a *prie-dieu* for Braamcamp; the allegorical picture he was commissioned to paint that glorified Braamcamp's timber business was offered in the sale. The vast majority of the collector's paintings traceable today to museums and collections around the world have stood the test of time. Among those which had overly optimistic attributions are those that were assigned to Braamcamp's relatively small holding of Italian and French paintings. A nude *Venus* offered as a Titian sold for 3,000 guilders, an indication that the buyer accepted the attribution. Later specialists rightly rejected it. When it surfaced in a London sale in the 1950s, it sold for the fair price of £54; at last report the nude found a home in a private collection in Reykjavik, Iceland. Some Dutch paintings had wrong attributions as well. It has long been recognized that not all seven pictures said to be by Rembrandt that were in the auction were by the master. However, these errors pale in significance when we discover his Rembrandt group included the artist's small portrait of the Jewish physician *Ephraim Bonus* (Bredius-Gerson 252; Amsterdam, Rijksmuseum) and his early masterwork *Christ in the Storm on the Sea of Galilee* (1633; Bredius-Gerson 547; *Rembrandt Corpus* A68; formerly Boston, Isabella Stewart Gardner Museum; stolen 1990); the hammer price of the latter was 4,360 guilders, the third highest price realized at the sale.

Other well-to-do burghers who collected more or less on the scale of Braamcamp and whose seventeenth-century Dutch pictures also now rank as the glories of public and private collections include the brothers Jan and Pieter Bisschop who sold haberdashery wholesale and retail in Rotterdam, William Lorimer of The Hague, Hendrik van Herteren, also of The Hague, whose collection was enlarged by his son Adriaen Leonard. More than 100 Herteren pictures are now in the Rijksmuseum, among them Jan Steen's *Feast of St Nicholas* [235]. The 1783 posthumous sale of Pieter Locquet, a *marchand-amateur* of Amsterdam, included

the staggering number of 493 paintings, 140 more than in Braamcamp's 1771 auction. Although it had some gems, its quality was not as consistently high as Braamcamp's. Among his masterpieces was Frans Hals's *Laughing Cavalier* [36], but it obviously was not considered one at the time. It merely fetched 247 guilders at his sale. Hals's painting passed to the collection of Jan Gildemeester Jansz, an Amsterdam merchant who served as Portugal's consul-general;[10] for a portrait of the collector with friends in his private picture gallery see fig. 417, below. At Gildemeester's posthumous 1800 sale, which offered 300 paintings, the *Laughing Cavalier* brought 300 guilders. Gildemeester also owned Vermeer's *Geographer* [175] and a Saenredam now at Glasgow; in accord with the taste of the time, the former was sold for 340 guilders, the latter for 63 guilders. Potter's farmstead scene, known as *The Young Thief* went for 10,850 guilders, the highest price realized at the sale (formerly owned by Braamcamp, it fetched 4,060 guilders at his 1771 auction). Next highest, 8,050 guilders, was paid for Rembrandt's life-size double portrait of the ship builder *Jan Rijcksen and his Wife* (1633; Bredius-Gerson 408, *Rembrandt Corpus* A77). Both paintings were soon acquired by George IV for the remarkable Dutch collection he was building in London and are now in the collection of H.M. Queen Elizabeth II. By 1814 George had acquired no fewer than fourteen Gildemeester paintings for the English crown. The Batavian Republic also acquired a single painting at the Gildemeester sale: Asselyn's *Threatened Swan* [326]. It has the distinction of being the first purchase made for the nation's newly established *Nationale Konst-gallery* at Amsterdam, later called the Rijksmuseum. The anti-Orange patriots who were in power when the painting was acquired were probably as delighted with the added inscriptions on Asselyn's picture which transformed it into an allegorical glorification of the anti-Orange grand pensionary Johan de Witt (see p. 240, above) as they were with its pictorial qualities.

The princes of Orange also assembled works of art but not on the scale of the wealthy Dutch burghers just cited, not to mention a host of others. There is no indication that William III or his successors as stadholders acquired the kind of expert knowledge and steady, burning passion for the acquisition of paintings and the graphic arts that mark genuine collectors. Nevertheless, their collecting activities helped enrich the artistic heritage of the Netherlands.

Never outstanding by international standards, the Orange collection was sadly depleted after Amalia van Solms died in 1675 and bequeathed all of her possessions to her four daughters, three of whom were married to German princes. Consequently much of the seventeenth-century collection left the Netherlands and never returned. Rembrandt's five *Passion* pictures painted for Frederik Hendrik in the 1630s and two paintings depicting scenes from the early life of Christ done in the 1640s disappear from sight after they are cited in Amalia's inventory of 1668 until they surface again in the gallery of the Elector Palatine, Johann Wilhelm at Düsseldorf in 1716. How and when they found their way to Düsseldorf remains a mystery.

William III began to strengthen his house's holdings by the purchase of some Dutch and Italian paintings, and by the transfer of a number of works from the English royal

collection to Holland for the decoration of Het Loo, his hunting palace. The latter group included fine works by Holbein, Piero di Cosimo, and Van Dyck as well as Dou's *Young Mother* [126] which had been given in 1660 by the States-General as part of a gift to Charles II. After William's death in 1702 vigourous efforts by Queen Anne, his sister-in-law, to have the paintings returned to the English Crown failed; the Dou and portraits by Holbein and Piero di Cosimo are still in the Netherlands, on view at the Mauritshuis.

The Orange collection was ravaged again when Marie Louise of Hesse-Kassel, the widow of William's sole heir, Johan Willem Friso, auctioned some sixty of its paintaings in 1713 and sold others in the following decades. Relatively speaking Stadholder Willem IV did not inherit much. He strengthened the collection by purchasing mainly seventeenth- and early eighteenth-century Dutch paintings with an historical interest and, following the fashion of the time, Dutch cabinet pictures with a high polish: Dou, Willem van Mieris the Elder, Schalcken, van der Werff. To his great credit, he also purchased two masterpieces of the great age of Dutch painting: Rembrandt's early *Presentation in the Temple* [64] and Potter's super-realistic, life-size *Young Bull* [286]. Most of his paintings were kept at Het Loo. An inventory made soon after his death of the paintings hung in his living quarters in the Binnenhof at The Hague lists only thirty-four pictures. He evidently felt no compulsion to live with his paintings.

Stadholder Willem V was more of a collector than his father and William III. Foremost a collector of natural history specimens, he also assembled ethnographic material, engraved gems, coins, medals, curiosities, and a good library as well. As for paintings, his interest in them began very early but was not of long duration. His first known purchases were made in 1760 when he was only twelve years old; virtually the last were acquired when he was in his early twenties. During these years he extended the small collection in the stadholder's quarters in The Hague by transferring pictures from Het Loo and other palaces and by activity in sale rooms. His most important acquisition by far was the purchase in 1767 or 1768 of all forty-one paintings offered by the Chief Tax Collector and distinguished connoisseur Govert van Slingelandt of The Hague. Slingelandt concentrated on quality not quantity. He was the kind of collector who never hesitated to sell an artist's painting if he found a better one. All the painters represented in his collection are predictable but the examples of their works are among the best. With the purchase Willem acquired stellar pictures by Rembrandt, ter Borch, Steen, Ostade, Potter, Metsu, Wouwerman, Berchem, du Jardin, Frans van Meris the Elder, and other *fijnschilders*. Rubens, Van Dyck, and Teniers also were well represented. Like so many discriminating Dutch collectors of his day Slingelandt had little interest in contemporary Netherlandish painters. His collection only had one, a genre piece by Philip van Dijk. Willem V shared the prejudice. Even Troost and Jacob de Wit never found a place in his cabinet.

A few years after Willem stopped collecting paintings he had a special gallery constructed for them in a building in the Buitenhof at The Hague, a stone's throw from his living quarters in the Binnenhof. The gallery, displaying 200 of his paintings, opened its doors at set hours to the public in 1775.[11] It was the first picture gallery open to the public in The Netherlands. The life of the gallery was short. It served its function for only twenty years. After Napoleon's army invaded the country in 1795 one of the first acts of the victorious French was seizure of the 200 paintings in the cabinet as war booty. They were sent to France where they were exhibited in the Musée Napoleon at the Louvre with other works the French looted from the finest European collections. When Willem V hastily fled from Holland to England in the same year he took some of his finest natural history specimens, but none of his paintings – there is no question which of his collections he prized most. In 1815, after the Battle of Waterloo and exceedingly difficult negotiations, about 125 of Willem V's painting were returned, in poor condition, to the Netherlands. The new king, Willem I (his name is confusing – he was the son of Willem V) became sovereign of the Netherlands after the departure of the French; he gave them to the nation in the following year. They constitute the nucleus of the Royal Cabinet of Paintings, now housed at the Mauritshuis. To the chagrin of the Dutch, almost forty of the paintings from Willem V's gallery that Napoleon had removed to Paris as 'property of the French nation won by force of arms' still hang in the Louvre and other French museums. One is in Poland. The others are untraceable.

A salient aspect of the period is a decline in the creative impulse of Dutch artists. We have heard that Johan van Gool and Gerard Hoet the Younger acknowledged the fact by the middle of the eighteenth century and that collectors recognized it a few decades earlier when they began to concentrate on acquiring works by earlier Dutch masters rather than paintings by their contemporaries. The shift began to be evident before the turn of the century. It is not an exaggeration to say that the heroic age of Dutch painting was over after the deaths of Frans Hals (1666), Rembrandt (1669), and Vermeer (1675). Reasons can be given for the decline, but it is also well to remember that a culture rarely maintains the vitality and high artistic standard the Dutch sustained for three generations.

During the period the number of artists who continued to practice the well-established categories of painting diminished, and some subjects used by earlier specialists had few practitioners, for example, seascapes and scenes of battles and skirmishes, and architectural interiors had none. But more important was the significant change in the quality of production. Over-refinement set in, and work became more homogeneous. Attempts to come to terms with classicism and the French style served as a leveller, not a catalyst. The strong individuality which marked the minor as well as the great masters of the earlier period virtually disappeared. No painter of genius thundered upon the scene. Eighteenth-century Holland did not produce a Goya. To be sure, Jacob de Wit, Cornelis Troost, and a few others stand out as personalities, but their works look rather provincial when hung alongside those by their great European contemporaries. It can be convincingly argued that even at its highest points, Dutch painting has an insular air. Its commitment to naturalism makes it appear somewhat outside the main stream of Renaissance and Baroque art. Dutch artists

forfeit some of their authority and poetry when their interest in realism weakens. Intense contact with the visual world appears to be one of their main sources of strength and inspiration. During the last decades of the seventeenth century and during the eighteenth century, this contact slackened. As artists made a virtually seamless transition to the new century old forms were often repeated. The weight of tradition and the sense of a great past were felt. Artists seemed to acquire something of the spirit of the Dutch patricians of the period, who were mainly *rentiers*, not *entrepreneurs*. They preferred to live on the dividends of their substantial capital rather than risk new ventures. Even Rembrandt's mature style found no more than one late adherent: Arent de Gelder. Living in relative isolation at Dordrecht, he continued to paint original variations on his master's manner until his death in 1727. At their best, eighteenth-century Dutch artists achieve amiable and decorative results. The most appealing contributions were made by those who turned to the method used with such success by outstanding Netherlandish artists since the fifteenth century. Their works are based on a fresh view of life and nature.

The Decorative Tradition

There was a limited tradition in seventeenth-century Holland for the use of sets of large paintings as permanent decoration for interiors. As we have heard, Honthorst and Bramer made some, and Stadholder Prince Frederik Hendrik and his wife Amalia van Solms commissioned Dutch and Flemish artists to decorate the walls and ceilings of their palaces and country retreats. Upon occasion civic authorities ordered paintings for their municipal buildings; most notable were the commissions Amsterdam's burgomasters gave for the embellishment of the city's new town hall. This type of painting became more popular after the middle of the century. In Amsterdam Nicolaes de Helt Stocade (1614–69) painted allegorical ceilings for the two large front rooms of the grand Trippenhuis owned by members of the fabulously wealthy Trip family which made its fortune as munition dealers. Adam Pynacker and Frederick de Moucheron were employed by other wealthy merchants to embellish town houses and country seats with large series of landscapes done in an Italianate style. Large-scale decorative game pieces by Hondecoeter and Jan Weenix were also popular. William III stimulated the fashion when he built and decorated his new country houses at Soestdijk and Het Loo, and by remodelling his palaces at Breda and Honselaarsdijk as well as those in England.

Holland's most celebrated decorator during the late seventeenth century was Gérard de Lairesse (1640–1711), who was called the 'Dutch Apelles' as well as the 'Dutch Raphael' and the 'Dutch Poussin' by his over-enthusiastic contemporaries and eighteenth-century admirers. Lairesse was born at Liège, where he first received instruction from his father and then from Bertholet Flémalle who had worked in Italy and for many years in Paris where he absorbed a strict classical style. Lairesse received what became an unwavering commitment to the classical tradition from Flémalle as well as an introduction, through reproductive prints, to works by the great Italian Renaissance masters and Baroque Bolognese artists.

In spite of his training, when Lairesse arrived in Amsterdam in about 1665 he was attracted by Rembrandt's mature style. He posed for the great master in the year he settled in Holland; Rembrandt's haunting portrait of the young artist whose face had been disfigured by disease is now in the Metropolitan Museum, New York (Bredius-Gerson 321). Lairesse himself confessed that he admired Rembrandt. He wrote:

> I do not want to deny that I once had a special preference for his manner; but at that time I had hardly begun to understand the infallible rules of art. I found it necessary to recant my error and to repudiate his; since his was based upon nothing but light and fantastic conceits, without models, and which had no firm foundation upon which to stand.[1]

The firm foundation upon which Lairesse wanted to build was the set of classical rules laid down by seventeenth-century French academic artists and theorists. Lairesse of course did not begin with an empty slate. His early training stood him in good stead. Moreover there were precedents for a classical approach to art theory in Holland. As we have heard, Jan de Bisschop argued for it in his *Icones* and *Paradigmata*, and some of its axioms also are recognizable in passages of Hoogstraten's *Inleyding* and van Mander's *Schilderboek*. They were also available in the *Painting of the Ancients* by the Dutch humanist-antiquary Francisco Junius. He published his volume in Latin in 1637 and he himself translated it into English in the following year; it appeared in Dutch in 1641. His study remained the standard text on classical art until Winckelmann published his *Geschichte der Kunst des Altertums* in 1754. There were precedents for classicism in architecture as well, particularly in the works by the painter-architect Jacob van Campen, who began designing classical buildings in the 1630s; the style found its most impressive Dutch expression in his masterpiece, Amsterdam's new town hall. Thanks to the powerful impulses given by van Campen, classicism became the dominant architectural style in Holland by the middle of the seventeenth century and it prevailed well into the eighteenth century. Only a few years before Lairesse arrived in Amsterdam, Constantijn Huygens praised Jacob van Campen as the man 'who vanquished Gothic folly with Roman stateliness and drove old heresy forth before an older truth'.[2] Lairesse wanted to do the same for Dutch painting.

Lairesse's large-scale historical, allegorical, and mythological paintings and grisailles, done in a style that is in accord with the precepts of classical art theory, won wide acclaim. He was called upon to decorate the ceilings and wall panels of numerous civic buildings, palaces, and stately homes. He also collaborated with Johannes Glauber (1646–1726), a landscape painter who did arcadian scenes in Gaspar Dughet's style. William III employed Lairesse at Soestdijk and The Hague. He can still be seen to good advantage at The Hague; his most famous work, a series of seven large paintings representing actual and mythological scenes from the ancient history of Rome, is at the Binnenhof there, and his allegorical ceiling celebrating *Concord, Freedom of Trade*, and *Security*, formerly installed in the home of a rich Amsterdam burgomaster, is now on view in the Peace Palace. One part of the ceiling, which comprised three sections, is illustrated here [397].

Additionally, Lairesse was a prolific and gifted printmaker. His graphic *œuvre* includes a frontispiece for a posthumous edition of de Bisschop's *Paradigmata* and illustrations for publications by members of an Amsterdam literary circle that endorsed French classicist ideas. Lairesse made contact with them soon after he arrived in the city. In 1669 the *literati* formed a society, *Nil Volentius Ardum* (Nothing is too difficult for those with the will), dedicated to the promulgation of classical tenets for the improvement of Dutch literature and drama. In 1681 Andriès Pels, a leading member of the group who had translated into Dutch Horace's literary

397. Gérard de Lairesse: *Allegory of the Freedom of Trade*, 1672. Detail of a section of a ceiling painting. The Hague, Peace Palace

theories, the revered source of classicistic rules for literature, published a poem on the use and abuse of the stage. It includes verses that characterize Rembrandt as 'the foremost heretic of the art of painting' (*de eerste ketter in de Schilderkonst*) because, like those who misuse the stage, he slavishly follows nature not classical rules or the example set by masters such as Raphael, Michelangelo, Titian or Van Dyck. Pels grants Rembrandt had some qualities, particularly as a colourist, but, alas:

He chose no Greek Venus as his model
But rather a washerwoman or a treader of peat from a barn
And called this whim 'imitation of nature'.
Everything else to him was idle ornament. Flabby breasts
Ill-shaped hands, nay, the traces of the lacings
Of the corsets on the stomach, of the garters on the legs,
Must be visible, if nature was to get her due.
This is *his* nature, which would stand no rules
No principles of proportion in the human body.[3]

The type of Greek Venus Pels had in mind when he savaged Rembrandt is exemplified by the *Venus de' Medici* which was included by his friend Jan de Bisschop in the first part of his *Icones*, published in 1668. In his volume de Bisschop includes three etched views of the statue that was almost universally adored as one of the finest representations of

feminine beauty from the time it was first recorded in Rome around 1638 until about the middle of the nineteenth century.[4] One of de Bisschop's etchings of it is illustrated here [399]. Juxtaposition of it with Rembrandt's early etching of a *Naked Woman seated on a Mound* [398] makes Pels's point crystal clear.

The rules of proportion for representing human figures that Pels sorely missed in Rembrandt's nudes and which had been long known to art lovers familiar with classical canons were conveniently provided in Lairesse's well-illustrated *Het groot schilderboek*, published in 1707. The lengthy encyclopaedic volume, which provides much more than the classical principles of proportion, was not seen through the press by Lairesse. After more than two decades of intense activity he went totally blind in about 1690, but continued to play an important role as an arbiter of Dutch taste by lecturing on classical art theory and practice. Lairesse's faith in his doctrine must have been matched by that of the members of his audience, who were willing to listen to a blind man expatiating on the visual arts. After his death the 'Dutch Apelles' was eulogized as the 'Blind Homer'. Before he died his talks were collected and published in two books, *Het groot schilderboek* and *Grondlegginge der teekenkunst* (Fundamentals of the Art of Drawing) which appeared six years

398. Rembrandt: *Naked Woman seated on a Mound*, c.1631–2. Etching

399. Jan de Bisschop after Adriaen Backer: *Venus de' Medici*. Etching. Published in de Bisschop's *Icones*, 1668

earlier. *Het groot schilderboek*, which became the bible of Dutch classicism, is divided into thirteen sections called books. In addition to the rules of proportion, found in the book dedicated to painting the human figure, under the category of beauty, there are books on composition, colour, light and shadow, architecture, sculpture, printmaking, and the painting of ceilings. There are also books on the genres of painting: portraiture, landscape, and still life. The red thread that runs through the volume is the prime importance of edifying history painting and frequent reference is made to classical and more recent literature a learned painter must assimilate. He deplored subjects that were part of the stock-in-trade of genre painters and advised collectors not to show bad taste by acquiring them:

> ...we hardly see a beautiful hall or fine apartment of any cost, that is not decorated with pictures of beggars, bordellos, taverns, tobacco smokers, musicians, dirty children on their pots, and other things more filthy and worse. Who can entertain his friend or a person of repute in an apartment which is in such a mess...[5]

Het groot schilderboek was frequently reprinted and it was translated into German, French, and English. It was widely used into the nineteenth century. As late as 1874 Robert Browning wrote on the flyleaf of his English translation of it: 'I read this book more often and with greater delight when I was a child than any other; and still remember the main of it more gratefully for the good I seem to have got from the prints and wonderful text.'[6]

While Lairesse was active in Amsterdam the demand for large-scale decorative history paintings at The Hague was met by Theodoor van der Schuer (1628–1707) and the brothers Augustinus (1649–1711) and Mattheus Terwesten (1670–1757), who had all received training in Italy. They

add little to the glory of Dutch art. The Terwesten brothers also worked in Berlin. Gerard Hoet (1648–1733), father of Gerard Hoet II, whose pamphlet war with Jan van Gool and valuable compilation of sale catalogues and inventories has been mentioned (p. 297), supplied the demand first in Utrecht and then in The Hague. In 1713 Hoet put his academic ideas for depicting beautiful human figures in a handbook for artists *Ontslote deure der tekenkunst* (*Open Door to the Art of Drawing*; 2nd ed., 1723, French and Dutch versions).

Not long after Lairesse's death, Jacob de Wit (1695–1754), the best eighteenth-century Dutch painter to work in the decorative tradition, appeared on the scene in Amsterdam. De Wit was born of Catholic parents in the city. After a brief period of study with Lairesse's obscure pupil Albert van Spiers, the boy was sent to Antwerp about 1708 where he lived with his uncle, a merchant and art dealer. In Antwerp de Wit was a student of Jacob van Hal. His real teachers in Flanders, however, were Rubens, Van Dyck, and their followers. The studies and careful copies he made of their work served him well when he returned to his native country and settled in Amsterdam in about 1715.

De Wit was the first Dutch artist since the iconoclastic revolts of the sixteenth century to receive numerous commissions for religious pictures made expressly for Dutch Catholic churches and chapels. This was possible because during his lifetime Dutch Catholics began to achieve greater religious freedom. Their clandestine chapels could be abandoned, and they were allowed to hold services without interference from the authorities, as long as their church-going was inconspicuous and their chapels were unobtrusive. But the Protestant authorities remained vigilant. In 1730 a decree warned that 'care should be taken that the meeting places of the Catholics do not have the appearance of

400. Jacob de Wit: *Bacchus and Ceres in the Clouds*, 1751. Ceiling painting. Heemstede, Huis Boschbeek

churches or public buildings, nor should they strike the public eye'.

After de Wit began his career in Amsterdam by doing a series of religious paintings for the Catholic church of Moses and Aaron he quickly became the favourite of wealthy parishes. The decorative overmantles and wall panels let into wainscottings he painted of playful gods, goddesses, and allegorical figures for grand homes in Amsterdam and elsewhere in the republic were equally popular. He also was awarded a few commissions from Paris and London. From the beginning de Wit received top payment for his work. He had a particularly profitable year in 1742 when his yearly income was taxed in Amsterdam at 4,000 guilders, a sum that put him, along with the popular Amsterdam portraitist Jan Maurits Quinkhard, in the highest bracket of the city's taxpayers.[7] His circle of friends included the wealthy Catholic collector Gerret Braamcamp and the successful artists Adriaen van der Werff, Jan van Huysum, and Isaac de Moucheron. By the time of his death he had amassed a fortune and had accumulated a distinguished collection of drawings; the inventory of the latter indicates his lasting predilection for works by Rubens and Van Dyck.

De Wit's appealing style shows a debt to Rubens's strength and vigour and Van Dyck's elegance and grace. What is distinctly his own is the playfulness of his secular paintings,

the lightness of his touch, his urge to give his figure ample space – he did not possess a *horror vaccui* –, and the high key of his palette which is a rococo one of light blues, pinks, and whites. It is not hard to understand why some of his paintings have been mistaken for pictures by Boucher and Tiepolo. He won a reputation for working rapidly; his speed is patent in his numerous masterful drawings, watercolours, and small oil sketches, many of which are preparatory studies for large paintings. Testimony of his gift as a draughtsman are his copies of Rubens as well as some of his own drawings that have been erroneously attributed to the Flemish master. De Wit also did his part to help drawing students learn the rules of art by publishing in 1747 a manual devoted to the ideal proportions of the human body that includes a study of the proportions of the famous classical sculptures Apollo Belvedere and Farnese Hercules (*Teekenboek der proportien van 't menschelyke lighaam*; its plates were engraved by Jan Punt, initiator of the volume). Like so many Dutch drawing books it went through more than one edition (2nd ed., 1790; and then frequently reprinted in the nineteenth century).

De Wit's most original contribution is in the field of ceiling decoration [400]. Here, too, he shows a debt to the Flemish school, particularly Rubens. While he was in Antwerp, he made drawings after the paintings Rubens

began to design in 1620, and agreed to finish before the end of the year for the coffered ceiling of the Jesuit church of St Charles Borromeo at Antwerp, a cycle which introduced to the Lowlands the Italian tradition of viewing figures on a ceiling as seen from below (*di sotto in su*); for Honthorst's more modest ceiling painted in Holland in 1621 depicting figures from a similar viewpoint see fig. 19. When the ceiling of the Jesuit Church was destroyed by a disastrous fire in 1718, de Wit's drawings became a valuable document of Rubens's imposing cycle. He made copies in various media of his original drawings of the ceiling; the best set is now at the British Museum. De Wit mastered the representation of figures as seen from below, and favoured the Italian High Baroque tradition of unifying a ceiling into a single picture to create the illusion of a roof open to the sky. His colours, however, are keyed higher than those used by seventeenth-century masters and the summer skies in which his figures float are filled with sparkling light.

Eighteenth-century Holland gave de Wit little opportunity to practise his art on a large scale, for, apart from Amsterdam's new town hall, Dutch buildings were small compared to the palaces and churches decorated during the century in Italy, France, and Germany. De Wit did in fact paint a gigantic picture for the town hall's council chamber, its most important room. The subject he was assigned for the prestigious commission was a daunting one: a life-size depiction of Moses with all seventy elders he selected after receiving, with them, divine inspiration. In 1736 de Wit began making numerous preliminary sketches for the gargantuan painting; it was completed in the following year. His studies show he made a strenuous effort to do his best for his most important commission, but, in the end, did not carry it off. The painting is a colossal bore. However, the painted bas-reliefs of putti that de Wit did in tones of white and grey as overdoor pieces and friezes for the town hall's chamber, where the Moses painting is still mounted, have charm and are of special interest. They are grisaille imitations of sculpture, a type of painting popular in the Netherlands since the early Renaissance. Like Lairesse, he excelled in this branch of painting [401]. His skill as a painter of *trompe l'œil* marble and stucco reliefs won him international fame and many imitators. His countrymen honoured him by naming an illusionistic picture of this type a '*witje*'. The word is a play on his name; *wit* is the Dutch word for white, and here the suffix '*je*' modifies the noun into an endearing diminutive.

After de Wit's death no Dutch painter of merit carried on his tradition of painting ceilings illusionistically and of composing large sets of decorated panels. The demand for rooms with pictures set into the wainscotting diminished after the middle of the century. Around this time collectors began to show greater interest in displaying easel paintings, particularly by seventeenth- and early eighteenth-century artists than decorating them with large paintings made expressly for their rooms. A vogue for painted, and then printed, wallpaper that began at the beginning of the century also helped to change the fashion. Today little is left of the rooms and stair halls decorated by Dutch artists of the period. Most of the patrician houses, country seats, and public buildings which contained their works have been

401. Jacob de Wit: *Autumn*, 1740. Grisaille. Amsterdam, Rijksmuseum

remodelled or destroyed, and remaining sets have been largely broken and dispersed.

A few artists continued to paint overdoor and overmantel grisailles which reveal an unmistakable debt to Jacob de Wit. Aart Schouman (1710–92), Dirk van der Aa (1731–1809), and the brothers Abraham (1753–1826) and Jacob van Strij (1756–1815) were among the artists who made *witjes*. Aart Schouman and the Strij brothers, like so many eighteenth-century Dutch artists, were very versatile. The name of these artists will appear again in our discussion of eighteenth-century Dutch art as representatives of more than one category of painting. Schouman, for example, made portraits, genre pieces, landscapes, topographical views, wall-hangings, and copied works by seventeenth-century masters. He was also a printmaker and engraver on glass; his finest works are his pure watercolours of birds and animals. Before Schouman appeared on the scene Arnold Houbraken (1660–1719), who is referred to so often as a biographer it is easy to overlook his activity as an artist, showed similar versatility. After studying in his native Dordrecht with Rembrandt's pupils Jacobus Leveck and Samuel van Hoogstraten he devoted his moderate artistic gift to book illustrations, portraits, landscapes, history paintings, wall hangings, chimney pieces, and decorative ceilings. His *Mars and the Personification of Time accompanied by Putti* painted in a classical style for the ceiling of a patrician home is still *in situ* in Dordrecht at the Arend Maartenshof. One wonders if Houbraken and later eighteenth-century Dutch painters would have accomplished more if they had concentrated their energies on a narrow field, in the way that most seventeenth-century Dutch artists did. But the thought is banished when we recall that depiction of a wide variety of subjects has never hampered the quality of the output of major talents.

Genre, Portrait, and Cabinet-sized History Painting

Most of the painters of cabinet pictures active during the last decades of the seventeenth century were versatile. They represented biblical, historical, and mythological events, made bespoke portraits, and depicted genre scenes. But few grasped the importance of the precious discovery made by their predecessors: the significance of the insignificant. To be sure, kitchen maids, tradespeople, and children were still part of their repertoire, but more exalted themes were also frequently attempted. Perhaps these artists had higher ambitions than the earlier specialists. They and their patrons seem to have accepted the academic dogma that the history painter is the only person who can ever attain perfection in the art of painting. If so, the results they achieved did not match their aspirations. They often please but their small pictures seldom suggest the universal ideals which Renaissance and Baroque art theorists proclaimed were the prerogative of the history painter. These artists continue the high standards of workmanship, precise drawing, and minute execution of the masters of the Leiden School and of such domestic painters as ter Borch, Metsu, and Netscher, but in their hands the illustrative tendencies of the earlier painters become more pronounced. Eglon van der Neer (1634?–1703), son of the moonlight and winter landscape specialist Aert van der Neer, carried on ter Borch's and Metsu's tradition of showing interiors with scenes of the life of the wealthy classes, and he did so effectively. The rendering of the costly gown worn by the woman washing her hands attended by an elegantly dressed page in Eglon's painting dated 1675 [402] is inspired by and rivals ter Borch's depictions of such materials. The arrangement of the principal figures and the setting also show a debt to ter Borch. Van der Neer's contributions are the anecdotal episodes in the background: the seductive wench beside a rumpled bed and the eager man trying to enter the room despite the efforts of a maid to block his way. Eglon's sub-plot transforms the rich interior into a high class brothel. The titillating episode makes a strange (perhaps deliberate) contrast with the dignified young woman using a ewer and basin to wash her hands; her toilet utensils and her action were traditionally associated with purity.

Eglon, who painted landscapes as well as history pictures, portraits, and genre scenes, was more peripatetic and had greater financial success than his father Aert who was destitute during his last years – it will be recalled that Aert's attempt in his late maturity to run a modest inn in Amsterdam to help make ends meet ended in bankruptcy. At the beginning of his career Eglon travelled in France where he worked for the Dutch governor of Orange. He returned to Amsterdam by 1659. From 1664 until 1679, Rotterdam was his base. Thereafter, he spent a decade in Brussels. He was appointed court painter of Charles II of Spain in 1687; however, he apparently never made the trip to the king's court. In 1690 he accepted the post of court painter to the Elector Palatine, Johann Wilhelm, in Düsseldorf. Adriaen

van der Werff, Eglon's pupil, made contact with the Elector Palatine in 1696 and quickly became his special favourite. However, Eglon continued to hold his position in Düsseldorf until his death in 1703. Jan Verkolje (1650–93) carried on the ter Borch-Metsu tradition of elegant figures in well-appointed interiors at Delft where he assimilated some of Pieter de Hooch's pictorial effects. Verkolje also painted mythological subjects in a classical manner and portraits, and was a skilled and productive mezzotintist. Michiel van Musscher (1645–1705), active first in Rotterdam and then in The Hague and Amsterdam, often shows an unmistakable debt to Metsu; some of his genre paintings are so close to Metsu's that they have erroneously passed as works by the better-known master. His pictures also reflect the style of Frans van Mieris the Elder.

A sizeable group of artists of these decades still had contact with the older Leiden masters, namely Gerrit Dou and Frans van Mieris the Elder. According to Houbraken, Dou called Frans the Elder 'the prince of his pupils' and said he 'carried the crown away from them all'. His characterization is correct. Frans the Elder, as we noted, founded a dynasty of painters. His sons Jan (1660–90) and Willem (1662–1747) and his grandson Frans the Younger (1689–1763) continued to employ his subjects and used a drier version of his meticulous style. Frans the Younger's portrait of members of three generations of the family shows his pride in it [403]. He depicted himself with palette and brushes in one hand while supporting a self-portrait of his grandfather which is almost certainly identical with the fine chalk drawing on vellum of 1667 now in the British Museum. With his other hand he is pointing to the engraved portrait of his grandfather, based on the 1667 self-portrait illustrated in Houbraken's *Groote schouburgh*, an indication of the fame the founder of the dynasty enjoyed and the importance given to Houbraken's who's who of earlier Dutch artists. In the centre is a portrayal of his eighty-year-old father Willem who looks with admiration at the engraving (there is in fact reason to believe the aged painter was blind when the picture was painted). In his hand Willem holds a rolled up drawing identifiable as a study or copy after the painting on the easel, predictably a *Venus and Cupid*, not a lowly genre piece.

In addition to Frans van Mieris the Elder some of the numerous artists indebted to Dou have already been mentioned (see p. 104). Godfried Schalcken (1643–1706) was one of the most popular and among the best. Born near Dordrecht, according to Houbraken he first studied in Dordrecht with Samuel van Hoogstraten and then with Dou in Leiden. He became the latter's close imitator and won his reputation with candlelight scenes, usually of coquettish young women, done in Dou's manner [404]. In the 1660s he returned to Dordrecht which remained the centre of his activity until 1691, when he settled in The Hague, a city that offered more opportunities than Dordrecht. He travelled to

403. Frans van Mieris the Younger: *Three Generations of the van Mieris Family*, 1742. Leiden, Municipal Museum, De Lakenhal

402. Eglon van der Neer: *Woman washing her Hands*, 1675. The Hague, Mauritshuis
404. Godfried Schalcken: *A Young Woman holding a Candle*, c.1670. Collection H.M. Queen Elizabeth II

London in 1692 where he spent six years. During his London sojourn he painted a half-length of William III in armour seen by candlelight [405]. Here Schalcken used his virtuosity at painting candlelight to give added meaning to the portrait. There were visual and emblematic traditions for using a burning candle as a metaphor for a self-sacrificing individual who burns himself out by helping others. The conceit is used in Nicolaes Eliasz Pickenoy's portrait of Dr Nicolaes Tulp, where the doctor, the protagonist of Rembrandt's celebrated early anatomy lesson, is shown in broad daylight pointing to a burning candle [406]; the inscription carved on a stone parapet, from an emblem book of the period, proclaims 'I consume myself by serving others'. For Schalcken, and probably his patron, the allusion was equally apt for the stadholder King William III, and the artist increased its impact by showing the huge candle burning at night.[1]

Schalcken was justly proud of his candlelight scenes. When he was contacted by an agent of the Grand Duke Cosimo de' Medici for a self-portrait for the duke's gallery of artists' portraits in Florence he stated that he was skilled in painting both day and night scenes but he would recommend a self-portrait by candlelight. In the event, the duke commissioned one which is still at the Uffizi as are the self-portraits he acquired of Frans van Mieris the Elder holding one of his genre pieces and of Eglon van der Neer displaying a mythological scene in a wooded landscape. The Elector Palatine Johann Wilhelm purchased several of Schalcken's paintings and it seems that the artist accepted the elector's

405. Godfried Schalcken: *William III*, c.1695. Amsterdam, Rijksmuseum

406. Nicolaes Eliasz Pickenoy: *Dr Nicolaes Tulp*, 1634. Amsterdam, Six Collection

407. Adriaen van der Werff: *Caressing Couple spied upon by Children*, 1694. Amsterdam, Rijksmuseum

invitation to work for him at his court in Düsseldorf in 1702. After his death Schalcken was eagerly collected; most important picture collections formed during the eighteenth century contained some of his pictures. Carel de Moor (1656–1738), Schalcken's pupil and follower who also studied with Dou, was primarily a portraitist. He too painted a self-portrait for the duke of Tuscany's gallery of artists's self-portraits for which he was awarded a gold medal and chain. Schalcken's other followers include Arnold Boonen (1669–1729) who became one of Amsterdam's most popular portraitists. Boonen painted nocturnal genre pieces as well; they often offer an exaggerated attention to detail. The Dou-Schalcken tradition of candlelight pictures remained popular with Dutch artists until the early nineteenth century. In the hands of its late practitioners treatment of the motif becomes finicky.

Around the turn of the century no painter satisfied the popular demand for small, beautifully finished Dutch pictures better than Adriaen van der Werff (1659–1722). He achieved greater fame and fortune than any of his contemporaries. Houbraken categorically called him 'the greatest art star in the Netherlandish firmament of artists'. Few eighteenth-century critics or collectors quarelled with his judgement. The prices his works fetched during his lifetime are among the highest Dutch artists ever received, and his high evaluation continued until the middle of the nineteenth century. According to Houbraken, he first studied in Rotterdam, near his native town Kralingen, with Cornelis Picolet, an obscure portraitist and genre painter, and then spent

about four years with Eglon van der Neer who agreed to teach him the *fijnschilderij* technique in exchange for devoting half of his time to assisting him. Houbraken was apparently very well informed about the artist; it seems that he had access to an existing van der Werff family archive that included an unpublished biography of the artist, datable about 1719–20, which is annotated by van der Werff himself.[2] Precocious Adriaen was merely seventeen years old when he set himself up as an independent artist specializing in portraits at Rotterdam, the city where he spent most of his life. He was also active there as an architect; his designs reflect a restrained but strong classicism. His principal architectural commission, received from the municipality of Rotterdam in the year before his death, was for the city's new exchange building. It was destroyed when Rotterdam was carpet bombed by the German air force in 1940.

Van der Werff's early portraits and genre pieces reflect the motifs and style of the Leiden school. The device of the window niche popularized by Dou is favoured and so are night scenes. The impact of Netscher's fashionable portraits is seen in his fine half-length *Portrait of a Man* of 1685 (London, National Gallery) portrayed in a verdant park decorated with an antique sculpture of Flora, probably copied from a plate in Jan de Bisschop's *Icones*. In about 1690 van der Werff begins to adopt his characteristic classic style and concentrate on history pictures and portraits. His small painting dated 1694 of a nude couple embracing [407], with two children spying upon the intimate scene set in a garden embellished with statues of Silenus and a dancing satyr, again probably inspired by plates in the *Icones*, shows the qualities that would soon win van der Werff eminence and princely commissions: academic perfection of drawing, beautiful figures, and a porcelain-like finish. Later, his classicism is more strict; figures become statuesque, action is restrained, colours are muted, and erotic resonance is less frequent.

Van der Werff's knowledge of the classical tradition as well as works by Renaissance artists, Italian, French, and Flemish Baroque masters was abetted by his friend and patron Nicolaes Flinck. Nicolaes was the son of Govert Flinck who, after working with Rembrandt in the 1630s, became a leading Amsterdam painter by the middle of the century. The son inherited his father's art collection, and after Nicolaes settled in Rotterdam his discriminating taste and wealth (he married well and became a director of the Dutch East India Company) enabled him to expand it into one of the most impressive Dutch collections of his time. At Nicolaes's home Adriaen could see fine works of classical sculpture including some from the Duke of Buckingham's celebrated collection, paintings attributed to Titian, Correggio, Guido Reni, Poussin, Rubens, and Poelenburgh, and a large collection of prints including engravings by Raphael's copyist and follower Marc Antonio Raimondi. Among the drawings were Italian sheets that de Bisschop transcribed into etchings for his *Paradigmata*. Collecting drawings became Nicolaes's passion. In 1723, a year after van der Werff's death, his drawing collection of about 500 works was sold *en bloc* for 12,000 guilders to William, 2nd Duke of Devonshire; many of them are still at Chatsworth, the Derbyshire seat of the Dukes of Devonshire. The collection

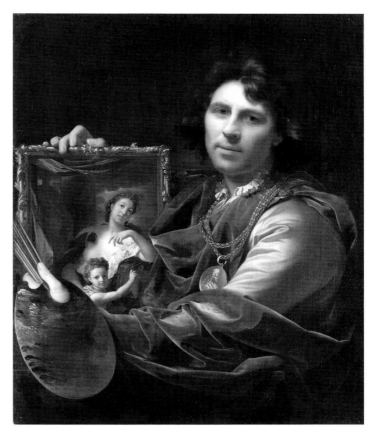

408. Adriaen van der Werff: *Self-Portrait*, 1699. Amsterdam, Rijksmuseum

included outstanding sheets by Mantegna, Leonardo, Raphael, Giulio Romano, Campagnola, Parmigianino, Domenichino, Guido Reni, and a superb group of Rembrandt landscape drawings. Nicolaes's collection was a boon to van der Werff, apart from the Rembrandts, evidence of his study of it can be seen in his work. To judge from his *œuvre* Rembrandt's drawings left him cold.

In 1692 van der Werff travelled to Amsterdam with Flinck to see the impressive Six collection of ancient sculpture. They also visited the home of the wealthy merchant Philips de Flines which had its walls, ceilings, and mantles decorated with large paintings by Lairesse. Upon his return to Rotterdam, van der Werff made large decorative paintings in Lairesse's classic manner for Flinck's home. Van der Werff also executed large-scale wall and ceiling paintings of the same type for the substantial house he acquired in Rotterdam in 1692; some of these panels are preserved in the museum at Kassel. Adriaen's education continued when the two friends visited Antwerp in 1696 to see works by Rubens and Van Dyck in the city's churches and private collections.

In the year van der Werff travelled to Antwerp his fortune was secured by his meeting in Rotterdam with the Elector Palatine, Johann Wilhelm. The elector's interest in Dutch artists of his time has already been mentioned. He commissioned works from the still-life specialist Jan Weenix; he made Eglon van der Neer court painter in 1690; later he gave Weenix the same status. He also patronized Godfried Schalcken. But he ranked van der Werff first. In 1697 he appointed him court painter at the annual salary of 4,000

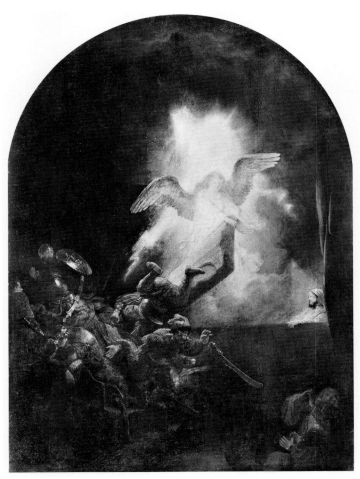

409. Rembrandt: *The Resurrection*, 1639. Munich, Alte Pinakothek

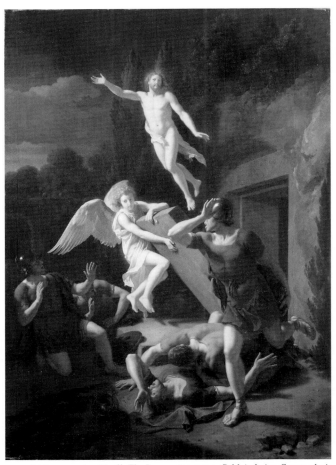

410. Adriaen van der Werff: *The Resurrection*, 1713. Schleissheim, Staatsgalerie, Bayerische Staatsgemäldesammlungen

guilders with the understanding that the artist would spend six months of the year at his court in Düsseldorf. The elector remained van der Werff's Maecenas until his death in 1716. On his second trip to Düsseldorf in 1698 he delivered an *Ecce Homo*, now at Schleissheim, for which the elector awarded him a gold chain and medal. He depicted himself wearing it in his handsome *Self-Portrait* of 1699 [408]. The painting is, in fact, a family portrait; the small framed double portrait he holds portrays his wife and daughter – when they accompanied the artist to Düsseldorf the elector showered them with expensive gifts as well. In 1703 the elector created van der Werff a knight (subsequently he always added his title 'Chev[alier]' to his signature), awarded him with another precious medal set with 95 diamonds, and agreed to pay him 6,000 guilders annually for nine months' work.

Van der Werff's principal commission for the elector was a cabinet-sized series of *The Fifteen Mysteries of the Rosary* painted between 1705–16. Another set of cabinet-sized religious paintings by a Dutch master was in the elector's gallery at Düsseldorf by 1716: the five *Passion* pictures Rembrandt painted for the stadholder Frederik Hendrik in the 1630s, now in Munich (see p. 65, above), and two scenes done in the 1640s from the life of Christ, an *Adoration of the Shepherds*, also at Munich, and an untraceable *Circumcision*, which were painted for the stadholder as well. When and

how the seven Rembrandts made their way from the estate of Frederik Hendrik's widow, who inherited them, to Düsseldorf is unknown. After Rembrandt's *Passion* series was mounted they gave visitors to the gallery an opportunity to match the high Baroque qualities of his most celebrated set of biblical pictures with classical ones by Adriaen. Two are juxtaposed here: Rembrandt's *Resurrection* and van der Werff's treatment of the same theme from his set of *Mysteries of the Rosary* [409, 410]. Their dissimilarities are patent. Van der Werff followed the tradition of showing Christ in the centre of his painting levitating toward heaven. He and the angel at the tomb are clearly outlined figures that display Adriaen's mastery at depicting semi-nude or nude figures according to the norms established by classical and Renaissance artists. Rembrandt depicted a different moment of the miracle, and it appears to occur in a land where nights are darker and whose soldiers belong to a different race than Adriaen's – there is no reason to believe any of them had beautiful, perfectly proportioned limbs. Rembrandt's heavily robed, radiant angel appears in a huge burst of celestial light and is still raising the heavy stone slab of the tomb, an action that seems to make shrouded, dazed Christ rise on the far right, as Lazarus did at the performance of another miracle. The sudden apparition causes Rembrandt's squad of squat guards on the stairs of the sepulchre to flee in fright, shrink in horror, draw daggers, drop swords – one tumbles off the

lid of the tomb. Rembrandt himself characterized their panic in his letter of 1639 to Constantijn Huygens when he wrote that his *Resurrection* was one of the pictures in which 'the greatest and most natural motion and animation has been observed'.

When seen alongside van der Werff's pictures, Rembrandt's paintings may have seemed old-fashioned to some viewers, and to critics, who believed with Andries Pels, that the academic rules of art are sacred, and that Rembrandt was an ignoramus for not following them, they must have appeared heretical. But their acquisition by Johann Wilhelm and their display in his gallery indicate that Rembrandt's fame had not been eclipsed by the new classicism. This was acknowledged in a word by the laconic compiler of a catalogue of the elector's paintings in 1719. He noted that the seven paintings 'were painted by the famous painter Rembrandt' ('*seynd gemahlet von dem berümten Mahler Rembrandt*').[3]

Van der Werff's paintings also were represented in other courts of Europe, thanks to gifts made by Johann Wilhelm and commissions the artist received before and especially after the elector's death. His international clientele included patrons in Germany, France, Russia, and England. Adriaen's brother Pieter van der Werff (1661–1722) was his assistant and close follower. In a daybook the brothers kept they recorded the amount of work each did on a picture and then computed its price upon the basis of their calculations. Pieter also copied his brother's work. Adriaen's success led others to do the same, as well as imitate his manner. Forgeries also were made. Documents refer to a handful of students. One is the portraitist and history painter Philip van Dijk (also van Dyck; 1683–1753) who worked as a court painter for Wilhelm VIII, Landgraven of Hessen, at Kassel, and also for the stadholder Willem IV at The Hague. A few of his subject pictures reflect van der Werff's classical style (*Sarah giving Hagar to Abraham* and *The Dismissal of Hagar*, both at the Louvre) but they miss Adriaen's elegance. Van

Dijk was mainly active as a portraitist working in the tradition of the courtly portraits of Arnold Boonen, another of his teachers. He also made small genre pictures in the manner of the Leiden *fijnschilders*, a mode he acquired from Boonen, who in turn learned the mode from his teacher Godfried Schalcken.

The most original and interesting eighteenth-century Dutch genre and portrait painter is Cornelis Troost (1697–1750). He also was more than proficient with pastels, a medium with a long history that became very popular throughout Europe during the period. Unlike his contemporaries, Troost did not blend pastels with fine gradations to achieve almost imperceptible changes of colour but kept a free touch that provides the lively accents that characterize his oil paintings. He often added areas of watercolour or gouache to his pastels; his mixed-media technique was personal and rarely adopted by other Dutch pastel specialists.

For understandable reasons, Troost is often called the Dutch Hogarth. The artists were exact contemporaries. Both made formal portraits as well as conversation pieces, the name given to small-scale group portraits in a social setting.[4] Both won fame for their series of genre pictures, which are commentaries on the life of their times, and for pictures of contemporary theatrical performances. Also both are satirists, but here there is a fundamental different. Troost is never as critical or aggressive as Hogarth. Unlike Hogarth, he is a humorist without a didactic streak. Troost does not moralize. In his *NELRI* series, his best known work (1739–40; pastel and gouache; The Hague, Mauritshuis; the name is derived from the first letters of the Latin inscriptions which accompany the five views of a group of men enjoying a reunion), we are shown what happens during a gathering that begins quietly in the early evening and ends well after midnight with the participants dead drunk. Instead of moralizing on the evils of drink, as Hogarth was wont to do, Troost's pictures [411] humorously show the stages as well as the psychological and physiological effects of inebriation. In this

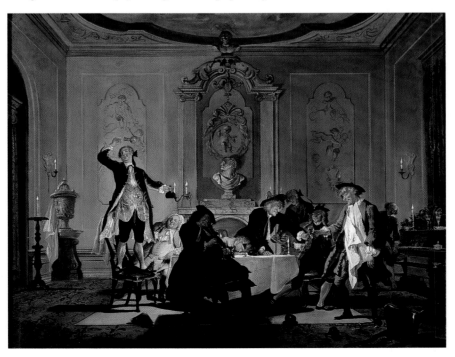

411. Cornelis Troost: *Rumor erat in Casa* (*There was a Commotion in the House*), 1740. Pastel and gouache. The Hague, Mauritshuis

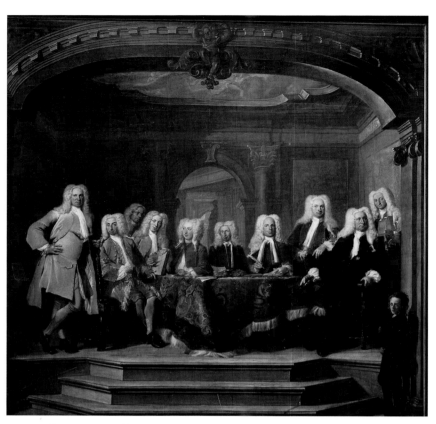

412. Cornelis Troost: *Regents of an Amsterdam Orphanage (Aalmoezeniersweeshuis)*, 1729. Amsterdam, Rijksmuseum

respect his spirit differs from Jan Steen's too. It will be recalled that moralizing was a dominant strain in Steen's art.

Troost's activity centred in Amsterdam, his native city. He studied there with Arnold Boonen who taught him the rudiments of portraiture as well as ways of depicting nocturnal scenes which often occur in his *œuvre*. Troost began as a rather conventional face painter, but he quickly found his stride. In 1724 he was commissioned to do a life-size group portrait of *The Inspectors of Collegium Medicum at Amsterdam* (Amsterdam, Rijksmuseum) which has greater vigour and a bolder touch than portraits by his teacher and contemporaries. It was well received, and important commissions for group portraits followed. Regrettably, the principal ones have suffered. His *Anatomy Lesson of Dr Willem Röell*, done in 1728 (Amsterdam Historical Museum), which shows the surgeon-professor demonstrating the anatomy of the knee to members of Amsterdam's guild of surgeons, has been severely cut – only the centre section has been preserved and its paint surface is badly abraded. The paint surface of Troost's huge group portrait of *The Regents of an Amsterdam Orphanage (Aalmoezeniersweeshuis)*, dated 1729 [412], is in a better state of preservation but it has been considerably cropped on the left and the right and most probably at the top and bottom too. Originally, more of the pilasters on either side of the group portrait were seen, giving it a more pronounced stage-like effect than it has now. We seem to be viewing the line of eight periwigged regents of the Amsterdam orphanage and three of their subordinates in a theatre from front row, centre seats. Our excellent places permit us to scrutinize Troost's fine characterization of his clients but in the end the lack of interaction between the group of men, posing parallel to a table, makes

the large tableau he arranged for the group portrait, which even in its cropped state is larger than the *Night Watch*, rather monotonous.

More appealing than his group portraits are Troost's conversation pieces. His small-scale double portrait of *Jeronimus Tonneman and his Son Jeronimus Jr*, of 1736 at Dublin [413], ranks with the best. It is a type of portrait which continues the tradition of portraying full-length figures, seen in little, in a familiar setting while posing informally or engaged in activities that allude to their status and interests. The tradition was initiated by Thomas de Keyser in the 1620s [341], and was carried on by other artists in their small family portraits (Frans Hals, Molenaer, Adriaen van Ostade, ter Borch, de Hooch, Metsu, Emanuel de Witte). The tradition was broken in about 1675 by the new vogue for courtly portraits and those with a classical flavour. Troost can be credited with resuscitating it in the 1720s, and by the following decade he was its unrivalled master in Holland. To judge from the popularity of conversation pieces at the time, Dutchmen took renewed pleasure in procuring visual records of their love of family and household. These portraits, which remained popular until the end of the century, appealed to affluent families who were proud of their station in life, their accomplishments, and possessions. Conversation pieces were equally popular in England, and some Dutch painters, such as Herman van der Mijn (1684–1741), and his son Frans (1719–83), practised there to help satisfy the English demand.

As in seventeenth-century Dutch portraits of this type, it is sometimes difficult to tell whether the interior or garden which serves as a setting for a conversation piece is imaginary or not. For example, the room in which Tonneman is seated

413. Cornelis Troost: *Jeronimus Tonneman and his Son Jeronimus Jr*, 1736. Dublin, National Gallery of Ireland

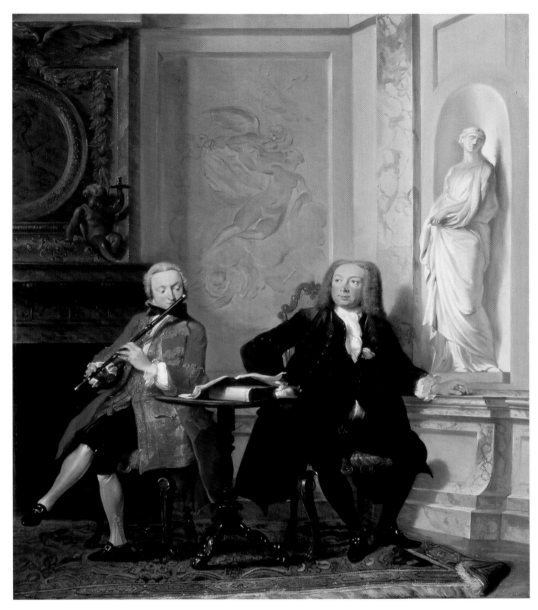

near his son playing a fashionable slender flute looks like a plausible portrait of an interior in his Amsterdam home. It is not. He did not have a room in his home decorated with a statue of St Susanna modelled after a work by the Flemish classical sculptor François du Quesnoy (he and members of his workshop were responsible for the splendid sculptures that decorate Amsterdam's new town hall) or large plaster reliefs of mythological and allegorical subjects. On the other hand, the parchment-bound volume of van Mander's *Schilderboek* that lies on the table doing double duty as a makeshift stand for the son's music and as a sign that we are in the company of people who know something about the arts, is most likely not an imaginary prop. It almost certainly belonged to Tonneman; no less than three copies of van Mander's volume were listed in a 1754 posthumous sale of his effects. The sale also included more than a dozen outstanding works by Troost as well as Goltzius's *Danaë*, now at Los Angeles [7], which was knocked down to Gerret Braamcamp whose remarkable collection is discussed above

(pp. 297–8). Jeronimus Jr's flute is not merely a prop either; he won a reputation as a fine flautist. The artist must have been overjoyed when young Tonneman decided to have himself portrayed in his fashionable bright red velvet garments; flaming red was Troost's favourite colour. We can only guess what Troost's reactions were when he learned in the year after he painted the little double portrait of Tonneman and his son that the latter, during a quarrel with his mistress, who bore his illegitimate child, stabbed her with a pair of scissors and quickly afterwards shipped out as a midshipman to the East Indies.

Troost's depictions of indoor and outdoor scenes from theatrical performances were even more popular than his conversation pieces and they constitute a much larger part of his production. Here too he did not break new ground. Seventeenth-century Dutch artists occasionally used the theatre as sources for their pictures. Frans Hals made characters from the *commedia dell'arte* the subject of genre pieces; painters of arcadian pictures derived motifs from

414. Cornelis Troost: *A Scene from 'Jan Claesz or the Disguised Servant Girl'*, 1739. Pastel and gouache. Paris, Musée des Arts Decoratifs

pastoral plays; Pieter Quast and Jan Steen used characters and scenes from the theatre too. A few of Troost's contemporaries also depicted them as well, but he was the first Dutch artist to make this category of painting a speciality.

Troost's connection with the theatre was close. His wife was the illegitimate daughter of an actress and dancer who married the child's father, the artist-actor Louis Chalon (1687?–1741), after she was born. Both of Troost's in-laws and his wife belonged to Amsterdam's Theatre, a company with permanent players whose profits were given to charitable institutions of the city. Troost himself is listed as an actor in the company in 1718 and again in the early 1720s. He apparently dropped the profession after he was established as an artist but there is no question that he continued to be closely involved with Amsterdam's theatrical world during the following decades.

The scenes that he used for his numerous theatrical pictures were based on the tragedies and, more often, the comedies and farces staged in his time. It is noteworthy that he did not consistently use episodes from plays that were smash hits. His *œuvre* includes themes from plays that apparently were hardly played at all and he had a propensity for the theatrical performances that were popular when he himself was on the boards. Occasionally he invented episodes that were not included in a playwright's original script. His approach to the subject was almost always the same. He depicted scenes from plays as if they were genre pictures. Characteristic is his portrayal of an episode from *Jan Claesz*

or the Disguised Servant Girl, a popular comedy by long lived Thomas Asselyn (c.1602–1701) that has as one of its main themes caustic ridicule of Quakers [414].

Unless we are informed that a genre-like picture by Troost is derived from one of the more than forty plays he illustrated, we are hard-pressed to determine whether or not it belongs to the theatrical category.[5] Works by Troost that show proscenium arches, stage curtains, backdrops, and the like hardly exist (they are only found in one known picture). His theatrical scenes take place in naturalistic-looking domestic interiors, taverns, streets, or landscapes. This is another aspect of Troost's art that distinguishes it from Hogarth's. In Hogarth's theatrical pictures we can often discern the staging and the actual sets used for the scenes he painted. They are accurate enough to be used as documentary sources by historians of the theatre. Moreover, Troost never played Hogarth to a Dutch Garrick or lesser light of the Amsterdam stage. Though he continued to work as a portraitist until the end of his career, his patrons were seldom actors or actresses. One theatrical subject used by Hogarth is absent from his work. Troost never adopted the English artist's bright idea of turning his back to the stage and performers to make the anonymous audience in the stalls or cheaper seats his subject.

Troost had other strings to his bow. He painted stage sets, indoor and outdoor genre pictures, guardroom scenes that translate the branch of painting that was a speciality of Duyster and Codde into a rococo world, and a few wall-hangings and large-scale paintings for the decoration of stately houses. In the last named category the influence of Jacob de Wit is evident, and some of his works show knowledge of pictures by the French masters Nicolas Lancret, François Boucher, and Charles Coypel. Occasionally there is a nod towards Hogarth whose prints were well known on the continent. But none of these artists had a decisive impact on his art. Troost attracted few students; perhaps he did not have the temperament of a pedagogue. He trained his daughter Sarah (1731–1803), who began by making close copies of her father's work and pastel portraits. Later she was one of the many artists of her generation who made copies and imitations of paintings by seventeenth-century Dutch masters. Jacob Buys (1724–1801) is his only other known pupil. Buys came to him after first studying with the topographic artist Cornelis Pronk (1691–1759) who trained a number of artists of the period. Buys's early portraits show the influence of his second teacher. His theatrical pictures, like those done by other Dutch artists after Troost's began to appear, reveal the impact of his second master's treatment of the subject, but they miss his model's verve. During his last decades Buys was active as a book illustrator and upon occasion used a classical style.

Around the middle of the century a few foreigners were active as portraitists in Holland. Among the most popular were two eminent masters of pastel: the Swiss Jean Étienne Liotard (1702–89), who stayed in Holland from 1755 to 1757 and again in 1771–3; and the Frenchman Jean Baptiste Perronneau (1715–83), who visited Holland in 1761–2 and 1772 and returned again in the year of his death. He died in Amsterdam. Reflections of eighteenth-century English portraiture, Reynolds in particular, are also evident during the

period. Reynolds's works became widely known by the many mezzotints done after them. Late in the century the English painter Charles Howard Hodges (1764–1837) worked in The Hague and Amsterdam, where he helped popularize English fashions in portrait painting.

Numerous native portraitists could be relied upon for truthful portrayals and good conversation pieces. The high level they could attain is seen in George van der Mijn's small pendants of the wealthy timber merchant, great collector, and amateur artist *Cornelis Ploos van Amstel*, and his wife *Elizabeth Troost*, daughter of Cornelis Troost [415, 416]. At the time, Amsterdam's art world was closely knit. Elizabeth's sister Sarah married Ploos van Amstel's brother, and George van der Mijn was a close friend of his patron who had contact with the foremost artists, collectors, and intellectuals of the city. Ploos van Amstel invented a new technique for making facsimiles of drawings which he primarily used for reproductions of works by seventeenth-century Dutch masters that he published and sold in sets or individually for one or two guilders, a sign of a taste he shared with his contemporaries and of the appetite the public had for art produced in the previous century. His own collection included more than 7,000 drawings and about 100 paintings. Outstanding old masters were represented in both groups, many of which can be identified today in museums and private collections around the world. Ploos also collected drawings by his contemporaries and copies they made of works by their predecessors. In addition he owned prints – his Rembrandts were choice – sculpture, miniatures, scientific instruments, and a good library.[6] Van der Mijn portrayed

the encyclopaedic collector in his role as an artist; paintings depicting eighteenth-century collectors in their homes surrounded by their treasures on their walls were done in Holland, but not frequently. In van der Mijn's three-quarter-length, Ploos is seen with his chalk holder in one hand and a sketch in the other, seated as informally as Frans Hals portrayed many of his sitters. His portrait of Elizabeth Troost holding a small coffee cup is as sympathetic as a Chardin lady. The touch in passages of both portraits is remarkably free and the colour harmonies are beautiful; the blue of Ploos's informal housecoat and the expanse of his long white satin waistcoat complement Elizabeth's white gown and grey cloak discreetly trimmed with ermine. A single blue ribbon tied to her forearm provides the only vivid colour accent in her costume. George van der Mijn, born in London about 1726/7, was the son of Herman van der Mijn, a Dutch portraitist who worked in England, as has been mentioned, with his older son Frans. After his father's death George travelled to Holland where he settled and appears as an independent artist in Amsterdam around 1750. His early death in 1763 accounts for the small size of his *œuvre*.

The many other portraitists include popular, well-paid Jan Maurits Quinkhard (1688–1772) who received the lion's share of commissions for regent group portraits in Amsterdam. Although less original than Cornelis Troost, he was his principal rival as portraitist; he outlived his competitor by more than twenty years. Among other effective portraitists who made conversation pieces as well are Tilbout Retgers (1710–68), Hendrik Pothoven (1725–95), and Adriaan de

415. George van der Mijn: *Cornelis Ploos van Amstel*, c.1758. The Hague, Mauritshuis

416. George van der Mijn: *Elizabeth Troost*, c.1758. The Hague, Mauritshuis

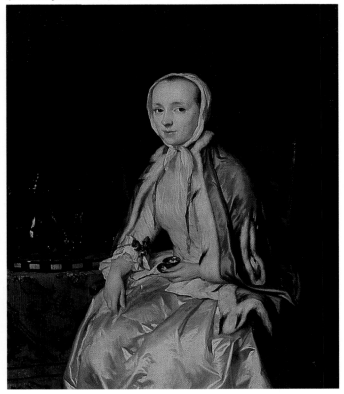

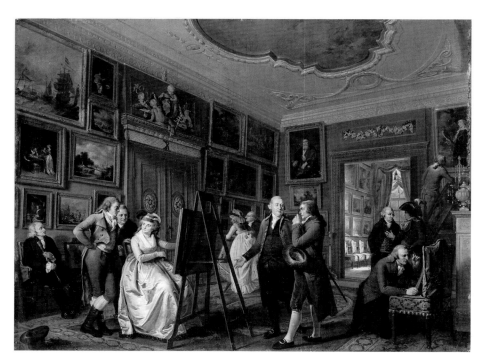

417. Adriaan de Lelie: *The Picture Gallery of Jan Gildemeester in his House on the Herengracht, Amsterdam*, 1794–5. Amsterdam, Rijksmuseum

418. Jan Ekels: *Man sharpening a Pen*, 1784. Amsterdam, Rijksmuseum

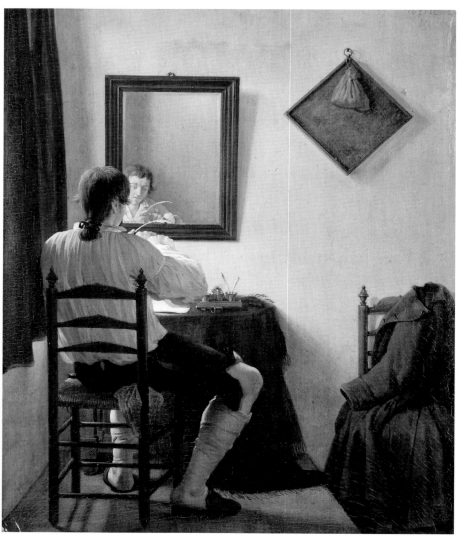

Lelie (1755–1820). Their pictures continue the seventeenth-century tradition of solid craftsmanship. New is the air of relaxed gentility that often enters their work. They also painted genre pictures of domestic life – the line between a conversation piece and a domestic genre picture is not difficult to cross. Their paintings are generally more attractive than those by the eighteenth-century epigones of the Leiden School. Adriaan de Lelie's portrait of the collector Jan Gildemeester Jansz with friends and visitors in his private picture gallery in his house on the Herengracht in Amsterdam [417] is a particularly fine conversation piece. Neither Gildemeester, the stout gentleman in the centre, nor the others appear to be posing for the artist who has given an accurate record of the interior and the collector's framed pictures. It is one of the few paintings that shows a view of a Dutch collection. It comes as no surprise that among the more than a dozen paintings that are identifiable, two are by Rubens, one by Teniers, and all the others are by seventeenth-century Dutch artists[7] (for more on Gildemeester's collection see p. 298).

The scarce works by Jan Ekels the Younger (1759–93) offer another reflection of the marked revival of interest in the great masters of Dutch painting which took place before the middle of the century. The simplicity and clarity of his *Man sharpening a Pen* (1784, Amsterdam, Rijksmuseum) [418] recall works by Vermeer and Metsu. Few of Ekels's contemporaries matched his sensitivity to light and atmosphere, or manner of treating this favourite Dutch theme without a trace of sentimentality. Ekels's intimate description of the young man's room tells us as much about his personality as the reflection of his face in the mirror. This is a rare note. To be sure, a few artists of the previous century went a step further and painted life-like interiors without figures. There is one attributed to Samuel van Hoogstraten at the Louvre (R.F.3722) and, although Jan van der Heyden's *Still Life with Rarities* [373] is almost certainly a portrait of an ideal *Kunstkamer* and includes an unmistakable *vanitas*, it qualifies as another. Nineteenth-century painters (Delacroix, Menzel, van Gogh) were to develop the theme of the interior as a portrait by eliminating the model and showing only the milieu in which an individual lives. An early death prevented Ekels from fulfilling the great promise seen in *Man sharpening a Pen*.

Ekels's slightly older contemporary Wybrand Hendriks (1744–1834) enjoyed a very long career as a painter and draughtsman. During it he made portraits of all types, genre pieces, landscapes, topographical views, and still lifes. His *Interior with a sleeping Man and a Woman mending Stockings* [419], datable to the first decade of the nineteenth century (dated 18—; the last two digits are illegible), also recalls the work of Vermeer and Metsu. However, he lacks the subtle tonal control and strong architectural design of his seventeenth-century models. He also relies more heavily upon the anecdotal for effect than his great predecessors did – Vermeer would have preferred to see a table in the foreground of Hendriks's picture instead of the sleeping old

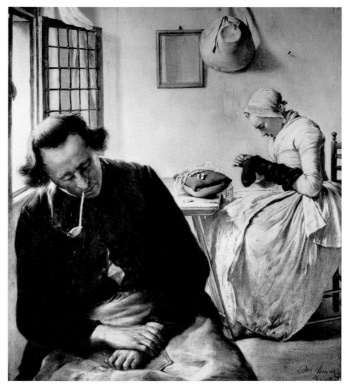

419. Wybrand Hendriks: *Interior with a sleeping Man and a Woman mending Stockings*, 18 –. Haarlem, Frans Hals Museum

man, whose smoking white Gouda pipe indicates that he has just begun his catnap. Hendriks was familiar with some of Vermeer's masterworks: he copied the *View of Delft* [186], and his saccharine *Milkmaid* (Haarlem, Teylers Museum) is a variant of the Delft artist's *Milkmaid* [187]. In his version of the latter the maid looks coyly at the viewer and on the table a sleeping pussycat replaces Vermeer's bread basket. Hendriks made other variants and some straightforward copies after works by leading seventeenth-century artists. Most of them are at the Teylers Museum, Haarlem, where he served as keeper (1786–1819) and was responsible for important acquisitions to its notable collection.

About the same time others were also studying the pictures of Holland's heroic age. Jan van Os (1744–1808), best known as a still-life painter, was one of the few Dutch artists of the period who tried his hand at imitating the early marine specialists. The Dordrecht artist Abraham van Strij made genre pieces in the style of de Hooch and Metsu. His close study of the leading Dordrecht artists Aelbert Cuyp and Arent de Gelder is also patent in his *œuvre*. Jan Baptist Kobell II (1778–1814), a member of a large family of Rotterdam artists, did landscapes with cattle in the style of Potter. Interest in the old Dutch masters was accompanied by an increasing demand for painted copies of their works, and some excellent ones were made. It takes a practised eye to distinguish a genuine landscape by Aelbert Cuyp from one of Abraham van Strij's copies.

420. Adriaen Coorte: *Three Medlars with a Butterfly*, *c.*1705. The
Netherlands, Collection V. de S.

Still-Life, Topographical, and Landscape Painting

Except for the artists who made the exact drawings and watercolours of birds, plants, insects, and shells which were so popular with *dilettanti* of the period, the Dutch tradition of painting unpretentious still lifes virtually died during the eighteenth century. Adriaen Coorte, a strong individualist who never adopted the rhetoric of his contemporaries, was one of the last practitioners of this intimate category. He was mainly active round Middelburg. Perhaps working away from the principal art centres helped him keep his private vision intact. The year of his birth and death have not been discovered but an idea of the period of his activity is offered by his earliest known dated work which is inscribed 1683 and the latest which is dated 1707. The exquisite flowers and fruit, expensive vases and metalware, drapery and linen, and other props found in the over-abundant still lifes painted during his day hardly ever appear in his work. Only one exception can be cited: *Wild Strawberries in a Wan Li Bowl* (1704, Los Angeles, Mr and Mrs Edward William Carter); his inclination was for common, reddish-brown earthenware pots, not imported porcelain bowls. Coorte's pictures are always tiny, his subjects and compositions modest. His typical motifs are a bunch of asparagus, a few peaches, or three medlars with a butterfly on a bare ledge [420]. Nothing more. Objects and light are studied intensely, and are painted with a wondrous tenderness which awakens more feelings about the mystery of our relation to the animate and inanimate world than the better-known showpieces of the period. Coorte's works apparently attracted no special attention during his lifetime; he was forgotten until L.J. Bol recognized his quiet achievement in the 1950s.[1]

Coorte is an isolated phenomenon. The main line of eighteenth-century Dutch still-life painting is represented by the Amsterdamers Rachel Ruysch and Jan van Huysum, who both specialized in elaborate flower and fruit pictures. They were the most popular still-life painters of the period; their works commanded high prices and were found in famous collections throughout Europe, and their colourful paintings still have wide appeal. The status they were accorded in their time indicates there were powerful patrons and collectors who took exception to the teachings of academic theorists who minimized the significance of still lifes by placing them at the lower end of the hierarchy of kinds of painting.[2] In the hands of Rachel Ruysch and Jan van Huysum Dutch flower pieces brighten up again. Their technical perfection and love of minute detail recall the still lifes painted a century earlier by Bosschaert and his followers, and like their predecessors they did not hesitate to include flowers of different seasons in their arrangements. However, neither Ruysch nor van Huysum arranges blooms into evenly lit symmetrical bunches in the way that early-seventeenth-century painters did, and their lively chiaroscuro effects and delightful ornateness show an unmistakable affinity with Late Baroque and Rococo art [421, 422].

Rachel Ruysch (1664–1750) came from a distinguished family: her father was Frederik Ruysch, an eminent Amsterdam professor of botany and anatomy as well as an amateur artist; her mother was the daughter of the architect Pieter Post. After studying with the still-life painter Willem van Aelst, she found her way early. Today, she and Judith Leyster are the best-known Dutch women painters of the seventeenth and eighteenth centuries. But unlike Judith, Rachel enjoyed much more than local fame during her lifetime, she was not forgotten soon after her death, and she did not have to wait until the turn of the twentieth century to be rediscovered. We have heard that she was one of the favourites of the Elector Palatine Johann Wilhelm. In 1708 he appointed her court painter at Düsseldorf. Though she continued to reside in Holland, she frequently visited her patron's court from 1710 to 1713. Although she lived eighty-four years and her dated works establish that she painted from the time she was a young woman until she was an octogenarian, only about a hundred paintings by her are known. Possibly she worked slowly; perhaps her responsibilities as a wife and mother – she had ten children – slowed her pace. The supposition that both factors affected her productivity is probably close to the mark. It will be recalled that Judith Leyster's output was much smaller, and to our knowledge, the period of her activity as an artist much briefer and seemingly concentrated in the years before her marriage.

Although Ruysch was married to the portraitist Juriaen Pool (1666–1745), she invariably signed her paintings with her maiden name. Whether her practice was an indication of a dogged determination to maintain artistic independence from her husband or it was simply customary for married Dutch women of the time of sign works with their family names remains an open question. Her staple is a rather tight arrangement of flowers in a vase, with fruit, reptiles, and insects occasionally serving as accessories. She also painted the undergrowth of forests animated by live creatures in the manner of Otto Marseus van Schrieck. Rachel probably made contact with Marseus van Schrieck's works through her teacher van Aelst; we have heard that both artists were friends who worked together in Italy. However, Rachel's precise description of the more unusual flora and fauna in her works did not come to her secondhand. She had the opportunity to study her father's collection of natural curiosities which he had engraved and began to publish in installments in 1710 (*Thesaurus animalium* and *Thesaurus anatomicum*). Anna Elisabeth Ruysch (died after 1741), Rachel's elder sister, painted flower pieces in her manner.

Jan van Huysum (1682–1749) was a pupil of his father Justus van Huysum the Elder (1659–1716), who also was a flower painter. He won even greater acclaim than Rachel Ruysch. Johan van Gool called him the 'phoenix of flower painters' and offered his work as proof that an artist of his

421. Rachel Ruysch: *A Vase of Flowers*, 1706. Vienna, Kunsthistorisches Museum

422. Jan van Huysum: *Bouquet of Flowers in an Urn*, 1724. Los Angeles County Museum of Art, partial gift of Mr and Mrs Edward William Carter

time could equal or surpass the achievement of earlier painters. He urged young artists to take heart from van Huysum's accomplishment and used him as a shining example of what could be achieved by a Dutch artist of their day which, he acknowledged, saw a general decline in the quality of painting in the Netherlands. Van Huysum had his full share of the patronage van Gool believed an artist must have if he was to succeed. The kings of Poland and Prussia, the dukes of Orleans and Mecklenburg, and the elector of Saxony were among his patrons. While he was still alive, eager collectors paid as much as 1,000 guilders for his pictures, and not long after the artist's death his still life now in Los Angeles [422] appeared in Gerret Braamcamp's famous 1771 sale where it fetched 3,800 guilders. Van Huysum also painted classicizing landscapes reminiscent of Claude, but his still lifes won him his international reputation. His flower pieces, often set on a stone plinth in a garden vase decorated with classicized bas-reliefs are lighter in key than Rachel Ruysch's, and his colours are frequently cooler, with saturated blues and vivid greens making strong accents. Asymmetry, elegance, and a calligraphic sweep came more naturally to him than they did to her – perhaps because he did not experience an encounter with the classic phase of Dutch Baroque art. Rachel did, being almost a generation older than van Huysum. Van Huysum is one of the rare Dutch still-life artists who was active as a draughtsman. Some of his drawings are quick composition studies

for his overflowing flower pieces; others were designed as finished works. The most attractive have a spontaneity and a broad, free touch never found in his highly finished, enamel-smooth paintings [423].

Artists are as adept as other mortals at devising excuses for failing to meet deadlines. Van Huysum may have conjured up one when he wrote to an agent of the duke of Mecklenburg that he was unable to finish a picture for the duke because he could not obtain a yellow rose; otherwise he would have completed the painting the previous year. In the same letter he noted that he lacked grapes, figs, and a pomegranate to complete a fruit still life.[3] On the other hand, he may have been telling the truth. Perhaps he insisted upon doing details from nature and was willing to wait an entire year for a needed blossom or fruit. The practice may explain the double dates which appear on some of his still lifes.

Van Gool remarks that van Huysum was very secretive and allowed no one in his studio while he worked. For a time he made Margareta Haverman (active by 1716), his only pupil, an exception but after she learned how to make deceptively clever still lifes in his style, his biographer writes, he became jealous and dismissed her. This is an oft told story in the early literature and is best taken with a grain of salt. However, in this instance it may be creditable. If van Gool did not have good reason to believe the story that van Huysum's flawed character made him a defective teacher,

423. Jan van Huysum: *Flowers in an Urn*, 1737. Drawing: black chalk and watercolour. New York, Pierpont Morgan Library

most likely he would not have publicized it. Although he maintained van Huysum was the outstanding eighteenth-century Dutch painter, he was neither a biographer who varnished his data, nor one who attempted to enliven his text with unsubstantiated anecdotes. There can be no doubt that van Huysum did not think of himself merely as a painter of pretty, decorative pictures. He occasionally wanted to instruct onlookers as well as delight them. The inscription 'consider the lilies of the field, Solomon in all his glory was not arrayed like one of these' (Matthew 6:28–9) on a vase holding a bouquet of flowers now at the Amsterdam Histori-cal Museum shows that he continued the moralizing tradi-tion of earlier still-life painters. Van Huysum's success attracted numerous close followers, and his style was still in vogue after the middle of the nineteenth century. In addition to his pupil Margareta Haverman his imitators include his younger brother Jacobus (*c.*1687–1740), Jan van Os and his more famous son Georgius Jacobus Johannes van Os (1782–1861), the brothers Gerard (1746–1822) and Cornelis van Spaendonck (1756–1840), and Wybrand Hendriks. Van Huysum also inspired generations of decorators of porcelain and crockery.

Late seventeenth-century landscapists and topographical artists took their cue from earlier Dutch specialists but con-temporary developments beyond the Netherlands also affected their work. For instance, the Haarlemer Jan van Huchtenberg (1647–1733), one of the few Dutch artists of the period who concentrated on battle pictures, was inspired by paintings his fellow townsman Philips Wouwerman did in this category. Equally important for him, however, were the depictions of famous historical battles by Adam Frans van der Meulen (1632–90), a Fleming who became a naturalized Frenchman and was appointed painter to Louis XIV. Van der Meulen accompanied the royal French army and made sketches of encampments and sieges in Flanders (1667), Franche-Comté (1688), and Holland (1672) which he trans-lated into paintings and tapestries. After a trip to Rome in 1667, van Huchtenberg made contact with van der Meulen in France in the same year when he worked under his direction in the Gobelins tapestry factory in Paris. By 1670 van Huchtenberg had returned to Haarlem with an expanded repertoire. In addition to the imaginary battles favoured by his Dutch predecessors he depicted views of actual ones. Among them are ten large paintings of Italian battles done for Prince Eugen of Savoy (1697–1717). He also received commissions from the Elector Palatine Johann Wilhelm and in 1711 was awarded a gold chain and medal from this generous German patron of Dutch artists. Van Huchtenberg's prints offer a *précis* of his subjects which range from refined elegance to brutal realism. They include a series of Louis XIV's military activities after designs by van der Muelen, etchings after his own ten battle paintings done for the prince of Savoy, skirmishes and other scenes of warfare and plunder, hunts, and an unusual set of mortally wounded and dead cavalry horses most probably based on sights he saw on battlefields [424]. The etchings in his series of the demise of cavalry horses are as graphic as the prints of pathetic, worn-out farm horses by Paulus Potter, Holland's best-known animal painter. His set must have been collected by budding and mature artists as models for their own work.

A group of artists travelled to Rome for a longer stay than van Huchtenberg's. There, like many who made the trip before them, they joined the *Bentveughels* and were given nicknames by members of the fraternal organization that had been established in the city by Dutch and other northern artists in 1623.[4] In our story they constitute the third and

424. Jan van Huchtenberg: *A Fallen Horse*. Etching

last generation of Dutch Italianate landscapists. Unlike the *bambocciante*, who depicted the street life of Rome, they concentrated on the landscape of the campagna and the monuments of Rome and its surroundings. To be sure, artists of preceding generations of Italianates also depicted these subjects, but with a significant difference: in the golden southern light of their landscapes aspects of Dutch naturalism are perceptible. Apart from Caspar van Wittel, discussed below, this is seldom the case with the new wave of Italianates. Traces of their Dutch origin virtually disappear and are replaced by their adoption of the motifs and pictorial devices of the foremost seventeenth-century landscapists based in Rome: Claude, Poussin, and Gaspar Dughet. The dramatic views of nature by Salvator Rosa served as models as well. The new wave includes Johannes Glauber (1646–1726) and Albert Meyeringh (1645–1714), both of whom worked in Rome around 1675; and Isaac de Moucheron (1667–1744), son of the Italianate landscapist Frederik de Moucheron, who is recorded in the city in the mid-nineties. Classicizing landscapes by these three artists are basically derived from Gaspar Dughet; Isaac de Moucheron also copied Poussin. Another member of the group, Jacob de Heusch (1657–1701) began working in the style of his uncle Willem de Heusch (died 1692), a follower of Jan Both who signed his first name 'Guglielmo' suggesting that he too travelled south, and had a long stay in Italy. Jacob de Heusch is recorded there as early as 1675 and as late as 1696; whether he returned to Holland during this period is unknown. He used subjects and developed a style based on Dughet and Salvator Rosa. Works by this group of artists as well as those by their *Bent* brothers from the southern Netherlands (e.g. Jan Frans van Bloemen, Abraham Genoels, Hendrick Frans van Lint) served as the conduit for transmission of the international classicizing landscape style to eighteenth-century Holland and were used as a source by their countrymen who never laid eyes on Italy. Jan van Huysum, who never travelled south, is a conspicuous example; his Claudian pastorals are based on art, not experiences in the Campagna di Roma.

Caspar Andriaansz van Wittel, also called Gaspar Vanvitelli, the Italianized form of his name, is the most interesting Italianate artist of the new generation. His speciality was topographically accurate views of cities, but it should be noted straightaway that not all of them are strictly accurate. Like other painters he employed artistic licence. He often made subtle changes in his views to heighten their impact. Pentimenti in his paintings testify to the compositional adjustments he made. Portraits of cities and specific buildings of course were not new, and earlier Dutch paintings of both types are discussed in the present volume. Van Wittel's Dutch and Flemish contemporaries in Italy also made urban views – there was an easy give and take between members of the *Bent*. However, van Wittel was the first Italianate to concentrate on the category; the imaginary classical landscapes that occur in his corpus are exceptional.

Van Wittel's topographical views are called *vedute*. Although the term was used in Italy to characterize pictures of Rome and its environs long before van Wittel appeared on the scene and he had Dutch precursors (e.g. Swanevelt, cf. pp. 229–30), he is rightly credited with establishing *vedute* as

an independent category of painting. In his time the term began to be used to characterize portrayals of other cities and their sites. Van Wittel's own *œuvre* includes some of Venice, Florence, Bologna, Naples, and other places on the Italian peninsula. Strictly speaking one can speak of *vedute* of Amsterdam, Paris, London, Dresden, St Petersburg, and so forth, but customary usage confines the term to topographical views of Italy.

Van Wittel was born in 1653 at Amersfoort near Utrecht where he studied for six years with the Amersfoorter Matthias Withoos known for his surreal-like paintings of forest floors populated by snakes, lizards, and insects similar to those by Otto Marseus van Schrieck with whom he travelled to Italy (see p. 290). Upon his return to Holland Withoos's output included traditional panoramic profile views of Dutch towns. A colossal one of Amersfoort (205 × 430 cm) was acquired by the town's burgomasters in 1671; it is still mounted in Amersfoort's town hall. There can be little question that this part of his teacher's production inspired van Wittel to become a view painter. Topographic drawings the young artist made in Holland before he left for Italy indicate that the direction his art would take was set before he settled in Rome in about 1674, and soon had close contact with Jacob de Heusch. During the course of the following six decades van Wittel never returned to the Netherlands. Apart from travels in Italy, he resided in the papal city until his death in 1736. His patrons were mainly prominent Roman families and foreign tourists. The painter, justly called the first portraitist of modern Rome, was accorded a modicum of official recognition in his adopted city when he was made a member of the Accademia di San Luca, the Roman artists' guild, in 1711.

In Rome van Wittel began by working for Cornelis Meyer, a Dutch hydraulic engineer employed by Clement X to study the navigability of the Tiber. Meyer's volume on the subject, published in 1683, includes large etchings of topographical views of the city by van Wittel datable about 1678.[5] Thus, van Wittel starts in Italy by following the tradition established in the sixteenth century of depicting the sights of the city in prints which culminates in the following century in Piranesi's peerless etchings of Rome. One of van Wittel's etchings for Meyer is a panoramic view of Piazza del Popolo, doubtlessly based on a lost drawing, made from the top of Porto Popolo, the main entrance to the city for travellers arriving from the north [425]. What sets van Wittel apart from earlier printmakers of Roman urban buildings and spaces was the practice he soon began of translating his views into paint. His earliest existing dated painted Roman *veduta*, done in gouache, a medium he favoured, is a view of Piazza del Popolo inscribed 1680 (Berlin) which shows the beautiful square from the very same vantage point as his etching. Four other of his gouaches and three oil paintings of the same view are known. Clearly the market for his *vedute* of the piazza was a good one. So was the demand for his views of other sights of the Eternal City. For example, during a period of more than thirty years he executed five autograph *vedute* of Piazza Navona, dominated by Sant'Agnese, finished by Francesco Borromeo, and Gianlorenzo Bernini's *Four Rivers Fountain*; the one dated 1699 is the most imposing of the group [426]. His versions of the piazza are based on a

425. Gaspar van Wittel: *View of Piazza del Popolo, Rome, c.*1678. Etching

426. Gaspar van Wittel: *View of Piazza Navona, Rome,* 1699. Madrid, Thyssen-Bornemisza Foundation

large perspective drawing squared for transfer. The existing corpus of his working perspective drawings and studies of the elements of buildings is large. He also made beautiful freely sketched views of urban sites and landscapes suffused with Claudian light and transparent shadows, some of which have been erroneously attributed to Claude. Van Wittel's innovative sun-drenched *vedute* done in light tonalities had little influence in his native land but they had an enduring effect in Italy where they set examples for leading eighteenth-century Italian *veduta* painters including Pannini in Rome and Guardi and Canaletto in Venice.

Eighteenth-century topographical artists and landscapists who did not travel south also followed traditions established by late seventeenth painters. City view specialists found inspiration in works by Gerrit Berckheyde and, especially, Jan van der Heyden who became their main model. Van der Heyden's schemes and exactitude were emulated with palettes that used lighter colours by Cornelis Pronk (1691–1759), Jan ten Compe (1713–61), and Paulus Constantin la Fargue (1729–82). Though they lose some of van der Heyden's atmospheric quality, their unassuming views of towns and the countryside under mild or sunny skies are pleasing. Van der Heyden's best follower was Isaak Ouwater (1750–93) who concentrated on cityscapes. His *View of the*

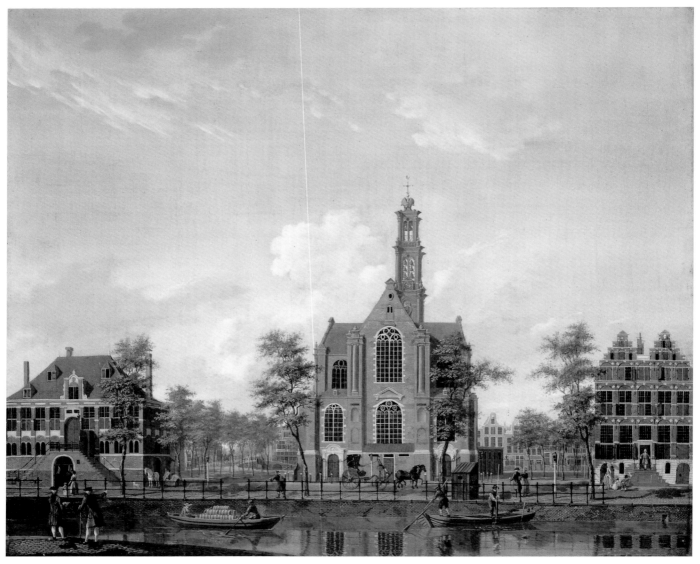

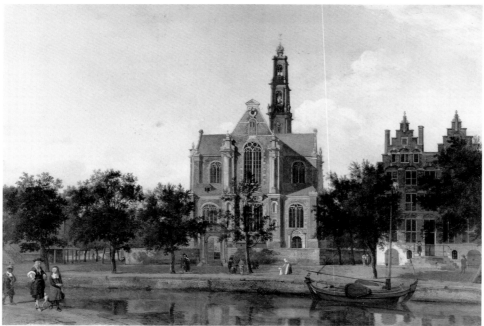

427. Isaak Ouwater: *View of the Westerkerk, Amsterdam*, 1778. Ottawa, National Gallery of Canada

428. Jan van der Heyden: *View of the Westerkerk, Amsterdam*, c.1670. London, Wallace Collection

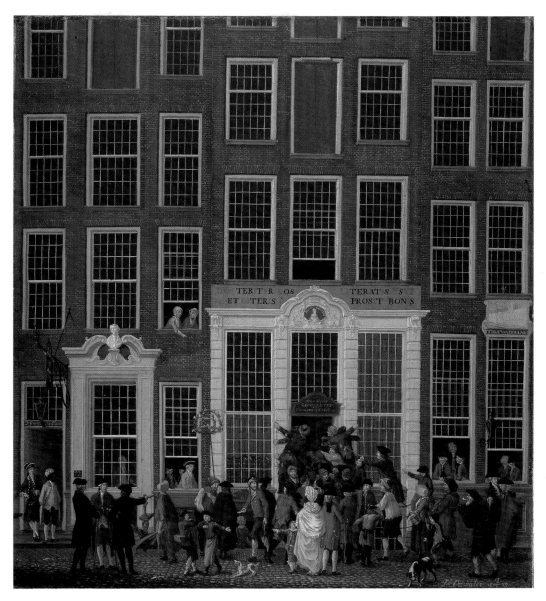

Westerkerk at Amsterdam, dated 1778 [427], is almost identical to two autograph versions of the same subject by van der Heyden, one at the National Gallery, London, the other, smaller in size, at the Wallace Collection [428]; both were painted more than a century earlier. The principal differences between their works is Ouwater's heightening of the sky and his scrupulous record of the changes that had been made to the Westerkerk (in which Rembrandt and Nicolaes Berchem are buried) and its vicinity since van der Heyden painted his views. Although Ouwater's paintings can be a little dry and airless, and, when compared to van der Heyden's, appear timid, he always displays a fine sense of design as is evident in his *Lottery Office* of 1779 [429]. Here his debt to van der Heyden's execution also is unmistakable; in it his minute handling is best enjoyed with a magnifying glass. But his close, frontal view of the street scene is original. The painting is an exact rendering of the façades of three houses in the Kalverstraat at Amsterdam, which have an antiquarian interest that enhances the painting's historical value. The lottery office that the crowd is trying to enter

was first inhabited by Clement de Jonghe, who posed for Rembrandt (Bartsch 272) and was a publisher of Rembrandt's etchings. The house on the right was once occupied by Jacob van Ruisdael, the one on the left by Aert van der Neer.

Vermeer's *Little Street*, one of his two precious cityscapes, inspired Ouwater's close contemporary Dirk van der Laen (also Laan; 1759–1829) who was active in Zwolle. The frontality and a bit of the luminosity and pointillist-like technique of the Delft master's *Little Street* can be seen in a few of his works. During the 1860s, the decade that marks the beginning of the modern passion for Vermeer, van der Laen's *Country House* (Berlin, Staatliche Museen) was wrongly catalogued as an autograph Vermeer by Thoré-Bürger, the historian *cum* critic responsible for the international movement that soon gave Vermeer an unshakable place in the pantheon of western painters.[6] Thanks to corrections made by later scholars to Thoré-Bürger's valuable pioneer efforts not many people would make the same error today.

430. Jurriaan Andriessen: *Sketch of Landscape Decoration for a Wall with a Fireplace*. Drawing: pencil, pen, and watercolour. Amsterdam, Rijksmuseum, Rijksprentenkabinet

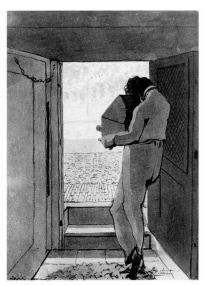

431. Christiaan Andriessen: *Man peering into a Camera Obscura*. Drawing: pen and wash. Amsterdam, Koninklijk Oudheidkundig Genootschap

In few countries of Europe were topographical works as popular as they were in the Netherlands during the eighteenth century. Local pride became as strong as family pride. Every city and town boasts scores of topographical artists who rendered historical and picturesque sites with great skill and infinite patience. Drawings and watercolours of identifiable views and native landscapes by these artists are particularly attractive. Today the bright tonality and lightness of accents of their delicate washes and colour in many of their works on paper are almost in a pristine state of preservation because they have been kept in portfolios to protect them from the deleterious effect of light. Reynier Vinkeles (1741–1816), who specialized in views of Amsterdam, is one of the finest; he also was a prolific printmaker. Dirk Langendijk (1748–1805) used topographical settings for his views of contemporary events, especially battles. Langendijk's panoramic pictures anticipate the reporting done by nineteenth-century magazine and newspaper illustrators, but they have nothing in common with the passionate works which were produced by his contemporary Goya on similar themes.

Landscapists also painted large wall-hangings designed to be set into the wainscottings of rooms. The vogue for them began early in the century and helps explain why the production of easel painting diminished; framed cabinet-sized pictures have no place in rooms covered with large wall-hangings. After the middle of the century, when collecting paintings gained popularity, fewer were painted. Most of the wall-hangings have disappeared but a fine grey wash and watercolour sketch of the wall of an interior with a Louis XV fireplace by Jurriaan Andriessen (1742–1819), Amsterdam's fine painter of them, offers an excellent idea of their scale and effect [430]. One of the large landscapes that flank the fireplace includes a ferry boat scene, the other a fisherman dragging a net; above the tall mirror there is an unidentifiable history scene of a sacrifice. Idealized classical landscapes with motifs derived from Italianate painters were also popular for these large interior decorations. Not all wall-hangings were of high quality. The sub-genre lent itself to hackwork

ground out in studios that were in effect factories; painting them must have been dispiriting for talented artists who did them as pot boilers. Among the legions who produced them are Pieter Barbiers Azn (1717–80) and his son Pieter Barbiers Pzn (1749–1842), Jacob van Strij, and versatile Aart Schouman who practised every branch of painting.

Jacob Cats (1741–99), a successful landscapist and townscape painter whose precisely wrought works clearly favour subjects used by seventeenth-century masters (Adriaen van de Velde, Paulus Potter, Jan van der Heyden) began as a painter of wall-hangings. Cats did figures and cattle in landscapes by his friend Egbert van Drielst (1745–1818). Drielst's sensitive wash drawings and watercolours of the Dutch countryside which often have a *plein-air* effect can reflect an intelligent grasp of Jacob van Ruisdael's achievements, and landscapes he produced in the province of Drente follow Meindert Hobbema's so closely that during his lifetime he was justly called the 'Drentse Hobbema'. Jan Hulswit (1766–1822) also qualifies occasionally as a late follower of Ruisdael and Hobbema.

As a director of Amsterdam's Drawing Academy, Jurriaan Andriessen exerted great influence on the young artists of his time. Among his more than forty pupils was his son Christiaan Andriessen (1775–1846). About 700 of Christiaan's summary drawings, usually generously touched with wash, that belonged to a journal he kept from 1805 to 1808 are known. They are a fascinating record of indoor and outdoor day and night scenes depicting the activities of Amsterdamers of all ages from many walks of life during the time of the French occupation.[7] The one illustrated here [431], dated 20 July but without the year, may be the artist's self-portrait at the open door of the *sousterrain* of his home. Christiaan can be compared with his contemporaries Rowlandson and Chodowiecki, but he never lapses into the gross farces of the former and, although he is not nearly as skillful a draughtsman, he is more pungent and has greater range than the latter. Not infrequently he looks like a forerunner of Constantin Guys.

432. Wouter Johannes van
Troostwijk: *The Rampoortje*, 1809.
Amsterdam, Rijksmuseum

Jurriaan Andriessen also trained Wouter Johannes van Troostwijk (1782–1810), the best landscape painter working in Holland around 1800. Troostwijk began under the influence of Potter, du Jardin, and Adriaen van de Velde, but he soon gained his main inspiration from working outdoors. His view of the Amsterdam gate *The Rampoortje* [432], painted a year before his death at the age of twenty-eight, shows how fresh and lyrical his vision was. If he had lived longer, he would probably have been a leading figure. His motto, 'Observe nature', became the watchword for the European painters who made the most significant contributions during the course of the nineteenth century. It would also have been an appropriate one for the outstanding Dutch artists who preceded him.

List of the Principal Abbreviations used in the Text, Notes, and Bibliography

A.Q. — *The Art Quarterly*

Bartsch — Adam Bartsch, *Le Peintre Graveur*. 21 vols. Leipzig, 1802–21

Benesch — O. Benesch, *The Drawings of Rembrandt*. 6 vols. London, 1954–7; 2nd ed. enlarged and edited by E. Benesch, London-New York, 1973

B.M. — *The Burlington Magazine*

Bredius-Gerson — A. Bredius, *Rembrandt. The Complete Edition of the Paintings*. 3rd rev. ed. by H. Gerson. London-New York, 1969

G.B.A. — *Gazette des Beaux Arts*

Hals Documents — I. van Thiel-Stroman, 'The Hals Documents: Written and Printed Sources, 1582–1679', in *Hals 1989–90*

Hals 1989–90 — S. Slive, et al., *Frans Hals*, exhib. cat., Washington-London-Haarlem, 1989–90

HdG — C. Hofstede de Groot, *Beschreibendes und kritisches Verzeichnis der Werke der hervorragendsten holländischen Maler des XVII. Jahrhunderts*. 10 vols. Esslingen a.N., 1907–28. English translation of vols. 1–8 by E. G. Hawke, London, 1908–27

Jahrb. P.K. — *Jahrbuch der preussischen Kunstsammlungen*

N.K.J. — *Nederlands Kunsthistorisch Jaarboek*

O.H. — *Oud Holland: Nieuwe Bijdragen voor de Geschiedenis der Nederlandsche Kunst, Letterkunde, Nijverheid, enz.*

Rembrandt Corpus — J. Bruyn, B. Haak, S.H. Levie, P. J. J. van Thiel and E. van der Wetering, *A Corpus of Rembrandt Paintings*. The Hague-Boston-London, vol. 1, 1982; vol. 2, 1986; vol. 3, 1989 (in progress)

Rembrandt Documents — W. J. Stauss, M. van der Meulen, et al., *The Rembrandt Documents*. New York, 1979

Slive 1970–4 — S. Slive, *Frans Hals*. 3 vols. New York-London, 1970–4

Sumowski *Drawings* — W. Sumowski, *Drawings of the Rembrandt School*. 10 vols. New York, 1979– (in progress)

Sumowski *Gemälde* — W. Sumowski, *Gemälde der Rembrandt-Schüler*. 6 vols. Landau-Pfalz, 1983

Notes

CHAPTER 2

1. The authors are particularly indebted to Johan Huizinga's 'Nederland's beschaving in de zeventiende eeuw', in *Verzamelde Werken*, 2, *Nederland* (Haarlem, 1948), 412 ff.; trans. in his *Dutch Civilization in the 17th century and Other Essays* (London-Glasgow, 1968), 9–104.

2. R.C. Temple (ed.), *The Travels of Peter Mundy in Europe and Asia: 1608–1667*, 4, *Travels in Europe: 1639–1647* (London, printed for the Hakluyt Society, 1925), 70.

3. E.S. de Beer (ed.), *The Diary of John Evelyn* (Oxford, 1935), 39.

4. The precise number is difficult to establish because a record of baptism, marriage, or burial in a Reformed church is not necessarily proof of Protestantism; the place where these rites were performed was sometimes prescribed by the municipal authorities. Additionally, edicts regulating them were not uniform in Dutch towns and they also changed during the course of the century. Moreover, as they did since the onset of the Reformation, Protestant artists worked for Catholic patrons and adopted Catholic iconography and, conversely, Catholics worked for Protestants. Upon occasion, as in the decoration of Huis ten Bosch for Amalia van Solms, painters of different religious persuasions worked side by side. For a discussion of other aspects of the problem cf. S. Slive, 'Notes on the Relationship of Protestantism to Seventeenth-Century Dutch Painting', *A.Q.*, 19 (1956), 3 ff.; reprinted in *Seventeenth Century Art in Flanders and Holland*, The Garland Library of the History of Art, 9 (New York, 1976), 23–36; and J. Bruyn, *Rembrandt's keuze van bijbelse onderwerpen* (Utrecht, 1959).

CHAPTER 3

1. Karel van Mander, ed. H. Floerke, *Het Leven der doorluchtighe Nederlandtsche en Hooghduytsche schilders*, 2 (Munich-Leipzig, 1906), 314, writes of Cornelis's displeasure with portrait commissions; the same author (*ibid.*, 194 f.) describes Ketel's tricks with his feet.

2. See E. Panofsky, '"Idea": ein Beitrag zur Begriffgeschichte der älteren Kunstliteratur', *Studien der Bibliothek Warburg*, 5 (Leipzig-Berlin, 1924; 2nd revised ed., Berlin, 1960); English trans. by J.J.S. Peake, *Idea: A Concept in Art Theory* (Columbia, 1968).

3. The size of the editions of van Mander's and Hoogstraten's volumes is unknown but a good indication that they did not sit on the shelves of many painters is found in A. Bredius, *Künstler Inventäre*, 8 vols (The Hague, 1915–20), which lists inventories of about 280 artists that date from the sixteenth, seventeenth and eighteenth centuries: van Mander's volume is listed only twelve times and Hoogstraten's book merely once; cited by B. Brenninkmeyer-de Rooij, 'Theories of Art', in B. Haak, *The Golden Age: Dutch Painters of the Seventeenth Century* (New York, 1984), 63.

4. The anonymous biography of van Mander appended to the second edition of the *Schilderboek* (Haarlem, 1618) is the source for the little we know from a contemporary about the Haarlem 'academy'. The biographer writes that shortly after van Mander came to Haarlem in 1583, he and Goltzius and Cornelis van Haarlem founded 'een *Academie*, om nae 't leven te studeeren, Karel wees haer de Italiaensche Maniere, ghelijck 't aen de *Ovidius van Goltzius* wel te sien is en te mercken is . . .' (*ibid.*, appendix, unpaginated). O. Hirschmann, 'Karel van Manders haarlemer Akademie', *Monatshefte für Kunstwissenschaft*, 9 (1918), 213 ff., and A. Dresdner, 'Noch einmal Karel van Manders haarlemer Akademie', *ibid.*, 276 f., rightly pointed out that this 'academy' could not have been an art school. They maintained that it must have been the equivalent of a life-class where artists could gather and draw from life and probably study casts after ancient sculpture. Their conclusions were generally accepted until E.K.J. Reznicek, *Die Zeichnungen von Hendrick Goltzius* (Utrecht, 1961), 1, 215 ff., noted that the report of van Mander's anonymous biographer is contradicted by much of what we know about Goltzius's activities. Reznicek writes that it is hard to believe Goltzius began to work from living models soon after 1583, since it was around this time that he adopted his wild anti-classical style based on Spranger's Mannerism. From 1584 to 1588 he was farthest from 'nature'. It is also noteworthy that during these years he virtually gave up portraiture. There is reason to believe that these artists had close contact from 1588 until 1590 when Goltzius departed for Italy; however, their works of these years still have a Sprangerian character. Only after Goltzius's return from Italy do we find studies of the nude by him that help break the way for those made by later artists – de Gheyn, Rembrandt, Backer, Flinck, and Adriaen van de Velde. Goltzius's earliest known drawing of a nude from a live model is dated 1594 (USA, private coll.); see E.K.J. Reznicek, 'Drawings by Hendrick Goltzius, Thirty Years Later:

Supplement to the 1961 *catalogue raisonné*', *Master Drawings*, 31 (1993), 216–17 and cat. no. K442a. Was it done in a life class? Probably not; it is hard to conceive of an organized group working from the nude in the Dutch society of the time. Moreover, Goltzius is known to have worked in secret. He did not like to show anybody an unfinished work: hardly the man to sit with his colleagues and draw from a posed model. Drawings of nudes by van Mander and Cornelis van Haarlem throw no light on the matter. Only two by van Mander are known; neither was done from life. Those by Cornelis follow Goltzius's trajectory. It also has been noted that working from life (*nae 't leven*) can mean 'working from nature' as well as 'from the live model'; thus, the reference may be to studies the artists made of sculpture and plaster casts, not a naked model; see P.J.J. van Thiel, 'Cornelis van Haarlem as a Draughtsman', *Master Drawings*, 3 (1965), 128. Finally, the meaning of *academie* is not cut and dry. Reznicek suggests that a clue to its meaning is the fact that in the brief passage it is mentioned in the same breath with Goltzius's illustrations of Ovid, which, according to the anonymous biographer, indicate that van Mander showed his friends the 'Italian manner'. It is possible that the 'academy' refers to discussions that van Mander had with his friends on the 'Italian manner' of composing pictures and literally following a text. Goltzius's Ovid illustrations are indeed based on Italian models and faithfully follow Ovid's text. For a brief account of less problematic academies founded in Holland after the middle of the seventeenth century see N. Pevsner, *Academies of Art: Past and Present* (Cambridge, 1940), 129 ff.

5. Cited in L.W. Nichols, 'The "Pen Work" of Hendrik Goltzius', *Philadelphia Museum of Art Bulletin*, 88 (1993), nos 373–4, 6. Nichols's monographic essay presents a thorough study of the Philadelphia picture that includes an analysis of its unusual technique as well as a discussion of the master's other *penwerken*.

6. Goltzius probably tried his hand at oils earlier. There is reference by van Mander to a grisaille which can be dated in the early eighties; cf. Reznicek, *op. cit.* [Note 4, above], 8 f. It is, however, true that he only began to concentrate on painting around 1600. Failing eyesight – the result of years of close work with engraver's tools – and acceptance of the theoretical idea that painting was superior to the other arts help to explain the switch; see E.K.J. Reznicek, 'Het begin van Goltzius loopbaan als schilder', *O.H.*, 75 (1960), 30–49.

7. For the view that Goltzius's intent in *Danaë* is more strictly moralizing than is suggested here see B. Broos, *Great Dutch Paintings from America*, exh. cat., The Hague – San Francisco, 1991, cat.no.22.

8. Joachim van Sandrart, ed. A.R. Peltzer, *Academie der Bau-, Bild- und Mahlerey-Künste* (Munich, 1925), 171.

9. In the vast literature on Elsheimer the best account of his life and work is K. Andrews, *Adam Elsheimer: Paintings, Drawings, Prints* (London, 1977).

10. R.S. Magurn (trans. and ed.), *The Letters of Paul Rubens* (Cambridge, Mass., 1955), 54.

11. A. Tümpel, *et al.*, *The Pre-Rembrandtists*, exh. cat., Sacramento, Calif., 1974, offers an excellent account of the group's work.

12. *The Crowning with Thorns*, London art market, published as a work by ter Brugghen painted in Italy *c.*1610–4 (B. Nicolson, 'Second Thoughts about Terbrugghen', *B.M.*, 102 [1960], 466), was correctly identified by R. Longhi (*Paragone* [1960], no. 131, 57 ff.) as a copy of a work by the French Caravaggesque painter called Valentin, known in the documents as 'Valentin de Boulogne'.

13. D. Bodart, *Louis Finson (Bruges, avant 1580 – Amsterdam 1617), Académie royale de Belgique, Classe de Beaux-Arts, Mémoires*, 2e série, 12 (1970), 12, 30. *The Madonna of the Rosary*, acquired by Finson in Naples, is now in the Kunsthistorisches Museum, Vienna.

14. L.J. Slatkes, [review of B. Nicolson, *The International Caravaggesque Movement*, Oxford, 1979], *Simiolus*, 12 (1981–82), 173–5. The companion piece to Pieter de Grebber's nocturnal *Trio* is a daylight *Musical Trio* at the Museo de Bellas Artes, Bilbao.

15. J.G. van Gelder, 'Antonie van Dyck in Holland in de zeventiende eeuw', *Bulletin Musées Royaux des Beaux-Arts de Belgique* (1959), 45–86, gives a survey of the Flemish artist's activities in the northern Netherlands.

16. H. Braun, *Gerard und Willem van Honthorst* (Gottingen, 1966), 57, document 87.

CHAPTER 4

1. All known contemporary documents and seventeenth-century printed texts related to Hals are published by I. van Thiel-Stroman in *Hals* 1989–90, 371–414. Her compilation, which includes summaries and commentaries, is

based on a fresh examination of the documents. The few published by earlier scholars without adequate archival references or which are now untraceable are signaled. 'Hals Documents' in the following notes refers to data in her compilation.

2. From the time the portrait surfaced in 1919 until a technical examination was made of it in 1986 there was a consensus that it was a fragment of Hals's portrait of Zaffius and that van de Velde's print showed its state before it was mutilated. However, microscopic examination and study of cross-sections of paint samples taken from edges of its panel support in 1986 revealed that the ground and paint layers continue around three edges of the bevelled panel; these findings establish that the panel was primed and painted in its present size. Thus it is not a fragment. For additional findings related to the portrait see K. Groen and E. Hendriks, 'Frans Hals: a Technical Examination', in *Hals* 1989–90, 109–10. In the 1989–90 catalogue (no. 1), I proposed that Haarlem's bust portrait of Zaffius is Hals's preparatory study for the large portrait or an autograph copy of it, and stressed, in either case, it would be unique; to our knowledge, Hals never made painted life-size preparatory studies for his pictures or copied his own works. Subsequently, P.J.J. van Thiel ('Het portret van Jacobus Hendricksz. Zaffius door Frans Hals', *O.H.*, 107 [1993], 84–96) presented strong arguments to support the view that it is a contemporary anonymous copy and that the coat of arms and date of 1611 were probably transcribed from the original. If Haarlem's version of Zaffius is accepted as a copy by another hand, the earliest known works dated by Hals himself must be pushed forward to 1616; they are his *Banquet of the Officers of the St George Civic Guard Company* [29] and *Portrait of Pieter Cornelisz van der Morsch* [336]. Put another way, if Haarlem's *Zaffius* falls from the canon, what one of the most gifted artists who ever held a brush painted before he was thirty-three or thirty-four years old can only be determined on the basis of stylistic and other collateral evidence.

3. Also see p. 125 of the text, and Slive 1974, vol. 3, cat.no.L1 for the lost Berlin painting. The painting has also been attributed to Willem Buytewech and Frans's brother Dirck Hals. However, the former's brushwork is less bold, and the latter, on the occasions when he approximates his brother's style in his rare early oil sketches, is more formulaic.

4. Identification of the sitters was published by S.A.C. Dudok van Heel, 'Een minne met een kindje door Frans Hals', *Jaarboek Centraal Bureau voor Genealogie*, 29 (1975), 146–59.

5. For the history of militia and civic guard pieces in the northern Netherlands see the introductory essays in *Schutters in Holland: Kracht en zenuwen van de stad*, exh. cat., ed. M. Carasso-Kok and J. Levy-van Halm, Haarlem, 1988. Although superseded in some respects, Alois Riegl's 'Das holländische Gruppenporträt', *Jahrbuch der kunsthistorischen Sammlungen des Allerhöchsten Kaiserhauses*, 23 (1902), 71 ff. (reprinted Vienna, 1931) remains fundamental for its penetrating analysis and comprehensive treatment of all types of Dutch group portraiture.

6. K. Levy-van Halm and L. Abraham, 'Frans Hals, Militiaman and Painter: The Civic Guard Portrait as an Historical Document', in *Hals* 1989–90, 93, 102, note 19.

7. The problem of Hals's drawings remains unsolved. Not a single one can be attributed to him with certainty. In my view the best contender, a chalk drawing in the British Museum, which has been published as a preparatory study for Hals's *Portrait of a Man* at St Petersburg, is a copy after it by another hand; cf. Slive 1974, vol. 3, sub cat.no.193. There is now agreement that another contender, a drawing of a *Standing Man* at the Rijksmuseum, that had been proposed as a viable candidate is by another hand; cf. *ibid.*, sub cat.no.31. References to other drawings that have wrongly been assigned to Hals are listed, *ibid.*, 192.

8. Slive 1974, vol. 3, cat.no.L15.

9. Hals Documents, no. 190.

10. Cf. A. Bredius, 'Heeft Frans Hals zijn vrouw geslagen?', *O.H.*, 39 (1921), 64, and his 'Archief-sprokkels betreffende Frans Hals', *O.H.*, 41 (1923–4), 19.

11. See Slive 1970–4. C. Grimm's opinion of Hals's output is much more restrictive. In publications that appeared in 1971 and 1972 he reduced the number to 168 by assigning works accepted by other specialists to members of Hals's circle, imitators, or copyists working after lost originals; see his 'Frans Hals und seine "Schule"', *Münchner Jahrbuch der bildenden Kunst*, 22 (1971), 146–78; *Frans Hals: Entwicklung, Werkanalyse, Gesamtkatalog* (Berlin, 1972). Most startling and unsupportable was his assignment of thirty-five paintings to Hals's son, Frans II; it is impossible to construct a corpus of works by Frans II because not a single documented one is known. Additionally, Grimm more than doubled the number that had been previously attributed to Hals's son Jan, and rejected all paintings of fisher folk by assigning them to the anonymous 'Master of the Fisher Children'. In 1989 Grimm reduced the number he had accepted by cutting it to 145 paintings (*Frans Hals, Das Gesamtwerk* [Stuttgart-Zürich, 1989]). Once again he assigns rejected paintings to members of the artist's circle, imitators, and copyists. His 'Master of the Fisher Children' remains intact as well. New is his rejection of almost all the small portraits. New too is the

understandable disappearance of Hals's will-o'-the-wisp son Frans II from his list, and Frans Hals's son Jan remains only as a possible candidate. Paintings he formerly gave to the two sons and a group he formerly accepted as autograph are now assigned to what he call 'Hals's Workshop'. Leaving aside the questions whether it is appropriate to speak of a thriving Hals workshop in light of the absence of a trace of his impact on his only documented pupils (Pieter van Roestraten, Vincent van der Vinne – perhaps Philips Wouwerman can be added to the list) and the mediocre-to-feeble quality of secure works by his sons, thirteen are assigned to members of the artist's shop without qualification, no less than twenty-eight are given to 'Hand A' (according to Grimm, related to his 'Master of the Fisher Children'), and eleven to 'Hand B' (according to Grimm akin to Jan). Granted: some traditional attributions are not beyond debate, and the state of preservation makes the ascription of others shaky. It also is true that art history, like other disciplines, must admit every question. However, for intellectual self-preservation it is reasonable to decide which questions are worth discussing. To cite one example: Grimm rejects the *Regentesses of the Old Men's Almshouse* [58] and attributes it to 'Hand A', the busiest anonymous hand in Grimm's hypothetical workshop. The present writer believes a discussion of the pros and cons of this attribution to Frans Hals or 'Hand A' would be as profitable as debating whether Shakespeare or another author wrote Hamlet.

12. S. Slive, 'Frans Hals Studies: III Jan Franszoon Hals', *O.H.*, 76 (1961), 176–80; Slive 1970, vol. 1, 168–74; Slive 1974, vol. 3, cat.nos D57, D58, D76, D77.

13. Hals Documents, no. 163.

14. The picture may be identical with 'A Prodigal Son by Frans Hals' listed in an Amsterdam inventory, 28 March 1647 (Hals Documents, no. 119). There is also a reference to a *Prodigal Son* by Hals valued at fl.48 that was used as payment for rent in Amsterdam, 24 March 1646, in a document that is now untraceable (Hals Documents, no. 115). It is conceivable that one or both documents refer to the *Banquet in a Park*, formerly at Berlin; cf. p. 125, below and [157].

15. For a discussion of the anthology of emblems on his colourful jacket and sleeve see Slive 1970, vol. 1, 21–3. Efforts to identify the handsome sitter on the basis of the emblems he wears have not been successful. The painting's popular title, which it only acquired after the middle of the nineteenth century, is not quite accurate; Hals's model is smiling not laughing. When the portrait appeared in the 1865 Comte de Pourtalès-Gorgier sale in Paris it still bore the straightforward title *Portrait d'homme vu à mi-corps*. At that sale Lord Hertford, who gave it a permanent home in the Wallace Collection, acquired it for 51,000 francs after winning what a contemporary described as a Homeric contest with his powerful antagonist Baron James de Rothschild. At the time the price was considered mad. It was hundreds of times more than had been paid for it and other works by Hals at earlier sales (cf. Slive 1974, vol. 3, cat.no.30). The sale did not start the sensational rise in prices paid for the artist's works but the boom was just around the corner.

16. Sir Joshua Reynolds, ed. R.E. Wark, *Discourses on Art* (San Marino, 1959), 109.

17. Hals's four Evangelists were acquired by Catherine II for the Hermitage, St Petersburg, by 1773, sent to the Crimea in 1812, and then disappeared from sight. I. Linnik discovered *St Luke* and *St Matthew* gathering dust in a storeroom of the Odessa Museum wrongly attributed to an unknown Russian artist; cf. I. Linnik, 'Newly Discovered Paintings by Frans Hals', *Iskusstvo*, no. 10 (1959), 70ff. (Russian text); also see Slive 1974, vol. 3, nos 43, 44; *Hals* 1989–90, cat.nos 22, 23. C. Grimm rediscovered *St Mark* which had been heavily re-painted to pass as a seventeenth-century bearded Dutchman holding a Bible; cf. C. Grimm, 'St Markus von Frans Hals', *Maltechnik/Restauro*, 1 (1974), 21–31; *Hals* 1989–90, sub cat.nos 22,23. Hals's *St John* surfaced in a 1997 auction and was snapped-up by the Getty Museum, Los Angeles. There are also references to an untraceable *Denial of Peter* and a *Mary Magdalene* by the artist in old sale catalogues (Hofstede de Groot, 4, Hals, nos 3, 8). Before the four Evangelists were rediscovered one would have thought these were impossible attributions; today it is prudent to treat them with less scepticism.

18. P. Biesboer, 'The Burghers of Haarlem and Their Portrait Painters', in *Hals* 1989–90, 29; 42, note 19, gives a full account of Heythuysen's inventory. Biesboer's subsequent research establishes that Heythuysen and his cousins operated a thriving international business and that his family owned a considerable amount of land. In his native town of Weert he was certainly considered a member of the gentry; his status there perhaps offered him personal justification for having himself portrayed full length, as large as life, with sword in hand. He was not eligible for public office in Haarlem because he was neither a native nor a citizen of the city; cf. *Judith Leyster: A Dutch Master and Her World*, ed. J.A. Welu and P. Biesboer, exh. cat., Haarlem-Worcester, 1993, sub cat.no.31.

19. Three other versions of the Brussels painting by anonymous hands are known; cf. *Hals* 1989–90, cat.no.51. The entry also notes that a technical analysis (1971) of a single sample of blue pigment taken from the fringe on Heythuysen's chair in the Brussels painting determined that it is Prussian blue, a

colour that was not synthesized until *c*.1703–6, and not generally available until 1720. Does its presence indicate that the painting is a copy painted in the eighteenth century or later? To judge from its pictorial qualities it is not, and until it has been established that the trace of Prussian blue is not later repaint, and thorough additional pigment analyses and study of its ground layers confirm they are not in accord with Hals's usage, I am not prepared to demote it to the status of a copy. A dendrochronological analysis of its oak panel support does not contradict the date assigned to the painting here (*ibid.*).

20. Slive 1974, vol. 3, cat.nos 98, 99.

21. For a full transcription and summary of the documents see Hals Documents, nos 73–5, 78.

22. C.P.L. Kinschot, *Genealogie van het geslacht van Schooten . . .* , vol. 1 (Tiel, 1910), 324.

23. *The Complete Letters of Vincent van Gogh*, 2nd ed.; 2 (Greenwich, 1959), letter 428 (to Theo, October 1886), 424.

24. The key role in his rediscovery was played by the French critic Étienne-Josephe Théophile Thoré, writing under the pseudonym W. Bürger, commonly called Thoré-Bürger. His passion for Hals culminated in articles published in *G.B.A.*, 24 (1868), 219–30; 431–48. They appeared two years after the publication of his seminal study on Vermeer, which resuscitated the Delft master's international reputation. For a discussion of part Thoré-Bürger played in the revival of interest in the artist see F.S. Jowell, 'The Rediscovery of Frans Hals', in *Hals 1989–90*, 61–86, esp. 64–70.

CHAPTER 5

1. C. Hofstede de Groot, *Die Urkunden über Rembrandt* (The Hague, 1906), which includes summaries and commentaries on transcriptions of documents and printed texts related to the artist and his family from 1575 to 1721, remains a primary source. W.L. Strauss, M. van der Meulen, *et al.*, *The Rembrandt Documents* (New York, 1979) reprints material in Hofstede de Groot's *Urkunden* and adds English translations and updated commentaries. It also includes documents discovered after Hofstede de Groot's source book was published but nothing that postdates the archival reference to the artist's burial 8 October 1669. In the following notes *Rembrandt Documents* refers to material in it; for a critical review of the volume that provides corrections and additions see B.P.J. Broos, *Simiolus*, 12 (1981–2), 245–62.

2. J. Orlers, *Beschrijvinge der stadt Leyden* [*Description of the City of Leyden*], 2nd ed. (Leiden, 1641), 375. The biography is transcribed in Hofstede de Groot, *op. cit.* [Note 1], no. 86. For an English translation see *Rembrandt Documents*, no. 1641/8. Orlers is the principal source for knowledge of the artist's early life; e.g. thanks to him we know the artist's birth date and his teachers. For more regarding Orlers on Rembrandt see S. Slive, *Rembrandt and His Critics: 1630–1730* (The Hague, 1953), 35–7.

3. The version in the Staatliche Kunstsammlungen, Kassel, accepted as an original since 1749, was published in earlier editions of the present book. For convincing arguments that it is a contemporary copy and support of the attribution to the Amsterdam picture, which appeared on the market in 1957, to the master see *Rembrandt Corpus*, 1, no. A18.

4. An example of a Rembrandt copy, datable about 1635, of a Lastman painting is cited in Chap. 6, Note 2, below.

5. Sceptics of these traditional identifications can safely assert that the only basis for the identification of Rembrandt's father is a drawing datable *c*.1630 of a bearded old man at Oxford (Benesch 56) which is inscribed with his name but the inscription is not in the artist's hand, and that the earliest reference to a depiction of 'Rembrandt's Mother' postdates the artist's death. The latter is found in a posthumous inventory of etchings compiled in 1679 of works that belonged to the Amsterdam printseller Clement de Jonghe. However, the print is not described; hence it is not firmly identifiable. For de Jonghe's inventory see Hofstede de Groot, *op. cit.* [Note 1, above], no. 346, and L. Münz, *Rembrandt's Etchings*, 2 (London, 1951), 210–11. Until additional evidence surfaces we can only guess which, if any, of the old men the artist depicted during his Leiden years can be identified as his father. On the other hand, the same old woman who appears in six of his early etchings (Bartsch 343, 348, 349, 351, 352, 354) is a likely candidate for the print of 'Rembrandt's Mother' that Clement de Jonghe possessed. She also has been recognized by some scholars as a model for a drawing (Benesch 55) and for paintings (see Bredius-Gerson 63–71).

6. Identification of the subject was made by C. Tümpel, 'Ikonografische Beiträge zu Rembrandt', *Jahrbuch der Hamburger Kunstsammlungen*, 16 (1971), 27–30.

7. The complete Latin MS, written between May 1629 and April 1631, was first published by J.A. Worp, *Bijdragen en Mededeelingen van het Historisch Genootschap*, 18 (1897), 1–122. *De Jeugd van Constantijn Huygens door hemzelf beschreven*, trans. and ed. A.H. Kan, with an essay by G. Kamphuis (Rotterdam, 1946) is an annotated Dutch translation of the Latin MS. The English translation of Huygens's passages on Rembrandt and Jan Lievens in G. Schwartz, *Rembrandt,*

His Life and Paintings (New York, 1985), 73–6, includes a helpful commentary. For Huygens on Rembrandt and his contemporaries also see Slive, *op. cit.* [Note 2, above], 9–26.

8. *Proserpine* and *Minerva* are both listed in the 1632 inventory as works by Jan Lievens, but in view of their provenance it is virtually certain they are the paintings now in Berlin and that the compiler of the 1632 inventory confounded the hands of the two friends; cf. *Rembrandt Corpus*, 1, nos. A39, A38, respectively.

9. Earlier he used the joined monogram RHL, which stands for 'Rembrandt Harmenszoon van [of] Leiden' (or Rembrandt Harmensis Leidensis), and the shorter joined monogram RH. Upon occasion in earlier works he also added 'v. Rijn' to his monogram.

10. The cadaver's intact torso establishes that the painting is not the record of an actual event since, at the time, anatomical dissections began not with a forearm but with the removal of the stomach and intestines from the abdominal cavity. This standard procedure would have been followed in private as well as public anatomies; the latter were performed in anatomical theatres for which tickets were sold to people eager to witness the gory spectacle. For a review of the extensive literature by anatomists and art historians on the Tulp *Anatomy* and the hypotheses that have been proposed to explain the significance of its emphasis on the muscles of the forearm and hand see *Rembrandt Corpus*, 2, no. A51. The authors of the Corpus accept the conclusions of W. Schupbach (*The Paradox of Rembrandt's 'Anatomy of Dr. Tulp'* [London, 1982]), who densely but cogently argues the painting is linked to two traditional beliefs Tulp held: that the study of anatomy leads to self-knowledge that man is mortal, yet has a divine essence that makes him like a god, and the hand, the most noble and perfect organ of the body, is emblematic of the wisdom and goodness of God.

11. B.M. du Mortier, 'De handschoen in de huwelijkssymboliek van de zeventiende eeuw', *Bulletin van het Rijksmuseum*, 32 (1984), 195.

12. I. Bergström, 'Rembrandt's double portrait of himself and Saskia at the Dresden Gallery. A tradition transformed', *N.K.J.*, 17 (1966), 143–69, gives a review of earlier interpretations of the subject and the first extensive analysis of it as a depiction of the Prodigal Son. Results of the x-ray examination were published by A. Mayer-Meintschel, 'Rembrandt und Saskia im Gleichnis vom Verloren Sohn', *Staatliche Kunstsammlungen Dresden, Jahrbuch* (1970/71), 39–57. For additional literature and a report on the painting's less than good state of preservation cf. *Rembrandt Corpus*, 3, no. A111.

13. The alterations made to the canvas (probably in the eighteenth century) and their impact on the image are discussed in *Rembrandt Corpus*, 2, no. A88.

14. See H. Gerson, transcription I.H. van Eeghen, translation Y.D. Ovink, *Seven Letters by Rembrandt* (The Hague, 1961). The letters are also transcribed and translated in *Rembrandt Documents*, nos 1636/1, 1636/2, 1639/2–6. An Italian translation of a lost letter Rembrandt sent to his Sicilian patron Don Antonio Ruffo in 1662 also exists (*Rembrandt Documents*, no. 1662/12); it was written in response to Ruffo's complaints about an *Alexander* he painted for him. For the *Aristotle* and *Homer* the artist sent to Ruffo see pp. 84–5 of the text.

15. The seven paintings were inherited by Amalia van Solms, Frederik Hendrik's consort; they are listed in her inventory of 1668. It is not known who inherited them after her death (1675) or when and how they entered the collection in Nürnberg of Johan Wilhelm, Elector Palatine, by 1716. After several moves during the eighteenth and early nineteenth century the bulk of the Electoral collection found a home at the Pinakothek, Munich, which opened in 1836.

16. It also has been observed that the pose of Rembrandt's writhing Samson is closely related to Rubens's colossal painting of classic-like Prometheus bound with his liver being devoured by an eagle (painted by Frans Snyders), which is now in Philadelphia; cf. J.G. van Gelder, 'Rubens in Holland in de zeventiende eeuw', *N.K.J.*, 3 (1950–1), 137–8, and E.K.J. Reznicek, 'Opmerkingen bij Rembrandt', *O.H.*, 91 (1977), 88–91.

17. See E. Panofsky's iconographical study of the painting, 'Der gefesselte Eros', *O.H.*, 50 (1933), 193–217. It has been given eleven other interpretations, probably a record number; four of them relate it to classical figures (Venus, Messalina, Semele, Aegina) and seven to biblical figures (Sarah, Hagar, Potiphar's wife, Rachel, Leah, Bathsheba, Delilah). Apart from Aegina, proposed by G. Schwartz as the subject in 1984 (*op. cit.* [Note 7, above], 129–31), see W.F. Lewinson-Lessing, *et al.*, *Meisterwerke aus der Eremitage* (Prague, 1962), no. 72, for bibliographical references to the other identifications. J.I. Kuznetzow, 'Nieuws over Rembrandt's Danaë', *O.H.*, 82 (1967), 225–33, publishes x-rays and other evidence that establish the painting was significantly altered by the artist in the 1640s.

18. On 15 June 1985 a mentally ill man splashed about one-third of the picture's paint surface with concentrated sulphuric acid and slashed it with a knife in two places before being overcome by a Hermitage guard. The central section suffered most (Danaë's face and body, and drippings from these areas to the bottom of the canvas). Although the extensive damage done to the original paint surface is irreparable, some specialists believe the painting will be exhibitable after the painstaking restoration is completed; others are less optimistic.

See T.P. Aleshina, 'Some Problems Concerning the Restoration of Rembrandt's Painting "Danae",' in: *Rembrandt and His Pupils, Papers given at a Symposium in Nationalmuseum Stockholm, 2–3 October 1992*, ed. G. Cavalli-Björkman (Stockholm, 1993), 223–33; it includes illustrations of the picture after the tragedy and during the course of its restoration.

19. C.P. Schneider, *Rembrandt's Landscapes* (New Haven-London, 1990) attributes eight painted landscapes to the artist in her thorough study of this small part of the master's activity. One work she accepts (*Landscape with a Coach*, dated 1637, Wallace Collection, London; Bredius-Gerson 451) has been rejected in the *Rembrandt Corpus* (3, no. C119); the authors find its signature and date unreliable and assign it to Flinck, *c.*1640.

20. See F. Lugt, *Mit Rembrandt in Amsterdam* (Berlin, 1920; Dutch ed., Amsterdam, 1915).

21. The impact of Raphael's *Castiglione* on Rembrandt's self-portraits of 1639 and 1640 has long been noted. For the significance of Titian's *Ariosto*, particularly on the latter work, see E. de Jongh, 'The spur of wit: Rembrandt's response to an Italian challenge', *Delta, A Review of Arts, Life and Thought in the Netherlands*, 12 (1969), no. 2, 49–67. For the connection between Rembrandt's *Saskia with a Flower* at Dresden and Titian cf. W. Stechow, 'Rembrandt and Titian', *A.Q.*, 5 (1942), 135 ff., E.M. Bloch, 'Rembrandt and the López Collection', *G.B.A.*, 29 (1946), 175 ff.; J.S. Held, 'Flora, Goddess and Courtesan', *De Artibus Opuscula XL, Essays in Honor of Erwin Panofsky*, ed. M. Meiss (New York, 1961), 212–18.

22. The painting was expertly cleaned and restored again after a deranged man slashed it with a knife on 14 September 1975; restoration was completed the following year. *Bulletin van het Rijksmuseum*, 24, nos 1 and 2 (1976), contains reports of the work done by the museum's conservators and other articles related to the 1975–6 restoration. E. Haverkamp-Begemann, *Rembrandt: The Nightwatch* (Princeton, 1982) is the best account of the history and present state of the picture as well as the painting's original setting, the figures portrayed, the significance of their actions, weapons, and costumes. Also see the exhaustive, monographic entry on the painting in *Rembrandt Corpus*, 3, no. A146, pp. 430–85.

23. Samuel van Hoogstraten, *Inleyding tot de hooge schoole der schilderkonst* (Rotterdam, 1678), 176.

24. J.A. Emmens, 'Ay Rembrandt, maal *Cornelis* stem', *N.K.J.*, 7 (1956), 133 ff., reprinted, J.A. Emmens, *Verzameld Werk*, 3 (Amsterdam, 1981), 61 ff.

25. The signature and date of 1661 on the painting are later additions; a date of *c.*1650–5 for it is not incompatible with its style. Perhaps the work is identical with a painting described in Rembrandt's 1656 inventory as 'two moors in a piece by Rembrandt' (*Rembrandt Documents*, no. 1656/12, no. 344).

26. The subject of Isaac and Rebecca is represented in a closely related drawing which shows an early stage of the composition (private collection, Benesch 988). For a discussion of the pictorial tradition of representing a couple in biblical disguise see J. Rosenberg, *Rembrandt: Life and Work*, revised ed. (London, 1964), 128 ff. In the first edition of the present volume the authors reported that A. van Schendel, then director of the Rijksmuseum, kindly informed them that x-rays show that the figures were originally seated as seen in the drawing mentioned above, where the woman was seated on the man's lap. When the artist made the change he covered part of the man's leg by enlarging the woman's skirt on the left; he also enlarged the skirt on the right. These changes explain the slightly ambiguous position of the figures. It is only vaguely indicated that they are standing. A preliminary report of a subsequent technical study and cleaning of the painting (*Rembrandt in a New Light, Rijksmuseum*, no. 7 [1993]) reveals that additional changes were made. The painting was originally larger; it has been cut on four sides, particularly on the left and lower edge, suggesting that its format was once closer to the drawing. The woman wore a larger headpiece which was painted out by the artist. It was also discovered that most of the man's large black beret is an addition made by a later hand. Since it was impossible to determine if Rembrandt himself painted part of it, the familiar beret was reconstructed by conservators during the restoration.

27. H.F. Wijnman, 'Een episode uit het leven van Rembrandt: De geschiedenis van Geertje Dircx', *Jaarboek Amstelodamum*, 60 (1968), 103 ff., is a fundamental discussion of the unsavory affair; the documents are published with English translation in *Rembrandt Documents*, passim. D. Vis, *Rembrandt en Geertje Dircx* (Haarlem, 1965) includes an imaginative but unsuccessful attempt to identify pendant portraits by Frans Hals at the Metropolitan Museum and Frick Collection as his portrayals of the couple before their relationship soured. For the untenability of his identification see S. Slive, *Frans Hals*, 3 (London, 1974), nos 186, 187.

28. The inventory is transcribed with an English translation in *Rembrandt Documents*, no. 1656/12. G. Schwartz, *op. cit.* [Note 7, above], 288–91, gives an useful translation of the inventory with its objects arranged by type. There is evidence that strongly suggests that the inventory of 1656 does not catalogue the artist's entire collection. Lists of works he himself wrote on the back of drawings indicate he had a sub-rosa collection at the time the official inventory was compiled and during the sales of his holdings; cf. L. Münz, 'Eine unpublizierte

Zeichnung Rembrandts', *Alte und Neue Kunst: Wiener Kunstwissenschaftliche Blätter*, 1 (1952), 152–66, and Broos, *op. cit.* [Note 1, above], 260.

29. J.L.A.A.M. Rijkevorsel, *Rembrandt en de traditie* (Rotterdam, 1932); B.P.J. Broos, *Index to the Formal Sources of Rembrandt's Art* (Maarssen, 1977).

30. For an interpretation of this remarkable laughing self-portrait and its relation to Arent de Gelder's *Self-Portrait at an Easel painting an Old Woman* at Frankfurt see p. 119 of the text and Chap. 6, Note 20.

31. F. Lugt, 'Rembrandt's Man with the Magnifying Glass', *Art in America*, 30 (1942), 174 ff., identifies the sitter as the Amsterdam silversmith Jan Lutma the Younger. Neither his identification nor others which have been offered (Spinoza, Titus, or the distinguished Portuguese Jew Miguel de Barrios) is acceptable.

32. The x-rays were published by A. van Schendel, 'De schimmen van de Staalmeesters, een röntgenologisch onderzoek', *O.H.*, 71 (1956), 1 ff.

33. H. van de Waal, 'De Staalmeesters en hun legende', *O.H.*, 71 (1956), 61 ff.; reprinted and englished in his *Steps Toward Rembrandt* (Amsterdam-London, 1974), 247–75.

34. Tacitus, from whom the story is taken (see p. 90 of the text) calls him Julius Civilis, except in one passage where he cites him as Claudius. Following Tacitus, in earlier editions the authors referred to him as Julius. However, since the long tradition in the Rembrandt literature of naming him Claudius seems to be unshakable, this usage has been adopted in the present edition.

35. I.H. van Eeghen, 'Rembrandt's Claudius Civilis and the Funeral Ticket', *Konsthistorisk Tidskrift*, 25 (1956), 55–7. In addition to the preparatory drawing illustrated here, three other drawings at Munich have been related to the painting. C. Müller-Hofstede, 'HdG 409, Eine Nachlese zu den Münchener Civilis-Zeichnungen', *Konsthistorisk Tidskrift*, 25 (1956), 42–55, convincingly demonstrates they are not original; for the now discredited view that they are authentic see Benesch 1058, 1059, 1060. Also see K. Renger and A. Burmester, 'The Munich Rembrandt Forgeries Reconsidered: A New Technical Approach to the Investigation of Drawings', *Master Drawings*, 23–4 (1985–6), 526–37, esp. 534–5; by technical means Renger and Burmester show that a large group of dubious Rembrandt drawings at Munich, formerly considered by many specialists the work of a single culprit called the 'Munich forger', are, in fact, weak compositional or figure studies by Rembrandt followers worked-up later by another hand. A drawing at Edinburgh has been published as a compositional sketch for the painting: E. Haverkamp-Begemann, 'Eine unbekannte Vorzeichnung zum Claudius Civilis', *Neue Beiträge zur Rembrandt-Forschung*, eds. O. von Simpson, J. Kelch (Berlin, 1973), 31–43; its attribution to Rembrandt is unlikely.

36. The possibility that the document refers to another Rembrandt painting commissioned for the town hall and subsequently rejected should not be ruled out, but a viable candidate is unknown. A. Heppner's proposal that Rembrandt's *Moses with the Tablets of the Law* at Berlin (1659; Bredius-Gerson 527) is a contender can be eliminated. C. Brown conclusively demonstrates there is no foundation to the claim that it is connected with the decoration of the town hall; see A. Heppner, '"Moses zeigt die Gesetzestafeln" bei Rembrandt und Bol', *O.H.*, 52 (1935), 241–51, and C. Brown, *et al.*, *Rembrandt, The Master and His Workshop* (New Haven-London, 1991), no. 46, respectively.

37. See H. van de Waal, 'The Iconological Background of Rembrandt's Civilis', *Kunshistorisk Tidskrift*, 25 (1956), 11 ff.; reprinted in his *Steps toward Rembrandt* (Amsterdam-London, 1974), 28–43.

38. H. Bramsen, 'Classicism of Rembrandt's "Bathsheba",' *B.M.*, 92 (1950), 128–31. The engraving appears in François Perrier's *Icones et segmenta . . .* , a compilation of prints after marble reliefs published in Rome, 1645.

39. See W. Stechow, 'Jacob blessing the Sons of Joseph, from Early Christian Times to Rembrandt', *G.B.A.*, 23 (1943), 204 ff.; J. Rosenberg, *op. cit.* [Note 26, above], 224; H. von Einem, *Rembrandt: Der Segen Jakobs* (Bonn, 1950); and I. Manke, 'Zu Rembrandts Jakobsegen in der Kasseler Galerie', *Zeitschrift für Kunstgeschichte*, 23 (1960), 252 ff., who has rightly observed the position of Jacob's left hand. In prepration for the first edition of the present volume the authors made the same observation on a visit to the Kassel museum. Since its publication there has been further discussion of Rembrandt's unusual treatment of the theme: instead of showing displeasure, Joseph calmly accepts his father's blessing of his younger son, and the artist completely eliminates the motif of Jacob's crossed hands as the old patriarch makes his blessing which appears in most earlier representations; Jacob's crossed hands symbolize the Cross. The most significant subsequent contribution to the discussion is Bar-Efrat's observation that when Rembrandt eliminated the Christological symbolism of Jacob's crossed hands he was literally following the text of the official new Dutch translation of the Bible (*Statenbijbel*) authorized in 1637 by the States-General (S. Bar-Efrat, 'Some Remarks on Rembrandt's "Jacob Blessing Ephraim and Mannaseh",' *B.M.*, 129 [1987], 594–5). The painting suffered badly in 1977 when a vandal sprayed sulphuric acid on it as well as on three other paintings at Kassel (including Willem Drost's *Christ and Mary Magdalene* [149]). They were expertly restored by H. von Sonnenberg at the Doerner Institute, Munich, in 1978. His report on the restoration of the pictures ('Rembrandts "Segen Jakobs",'

Maltechnik, 84 [1978], 217–41) includes the results of his thorough technical analysis of *Jacob's Blessing*.

40. H. Gerson assigns the painting to an anonymous Rembrandt pupil working after a design of the master and notes that it is significant that specialists disagree on its date, some placing it in the 1650s and others in the 1660s (note to Bredius-Gerson 526, p. 602). However, the painting is pictorially and psychologically worthy of the artist, and the suggestion that it may have been done in two campaigns (one in the late fifties and the other in the early sixties; cf. A.B. de Vries, *et al.*, *Rembrandt in the Mauritshuis* [Alphen aan den Rijn, 1978], no. XI) may account for the various dates assigned to it. Moreover, its less than good state of preservation should be taken into account. The painting suffered when it was cut in two at some indeterminate date, one piece bearing the figure of Saul, the other David. The upper part of the second piece was cut off to make a better composition. Subsequently the two pieces were sewn together. The missing upper right section was filled in with another piece of canvas; it is now an unmodulated dark area that deadens the spatial effect. Large areas of disfiguring repaint and extensive retouching, perhaps added when the two pieces were sewn together, are also evident on the original paint layer.

CHAPTER 6

1. W. Sumowski, *Gemälde der Rembrandt-Schuler*, 6 vols (Landau-Pfalz, 1983) is indispensable for the study of paintings by Rembrandt's pupils and followers; it includes biographies and catalogues of paintings by the artists arranged alphabetically as well as a Rembrandtesque paintings. Equally important is Sumowski's *Drawings of the Rembrandt School* (New York, 1979–92). Ten volumes of this corpus have been published which catalogue works by artists from Jacob Backer to Franz Wulhagen; the corpus is still in progress.

2. *Rembrandt Documents* (undated), pp. 594–5. The memo is on the verso of his red chalk copy after Pieter Lastman's painting of *Susanna and the Elders* now in the Gemäldegalerie, Berlin. Rembrandt's copy, also at Berlin (Benesch 448), is datable c.1635; it is one of the indications of his continued interest in his teacher's work long after he left his studio.

3. J. Bruyn argues that Rembrandt's large *Frederick Rihel on Horseback*, c.1660–3 (London, National Gallery; Bredius-Gerson 255) is an exception. In his opinion its style indicates it was painted by a heavy-handed assistant and he sees the same hand in three anonymous Rembrandtesque paintings ('An Unknown Assistant in Rembrandt's Workshop in the Early 1660s', *B.M.*, 132 [1990], 714–8). C. Brown recognizes stylistic affinities in the three Rembrandtesque paintings Bruyn cites, but fails to see analogies between them and those in London's equestrian portrait (*The Dutch School, National Gallery Catalogue* [London, 1991], no. 6300), a view I share. Brown adds that technical examination of *Rihel* at the National Gallery found it to be entirely consistent with Rembrandt's other pictures of the period and no discontinuity in technique between horse and rider was discovered. Bruyn conjectures that the assistant whose hand he sees might have been Rembrandt's son Titus but rightly adds that there is insufficient evidence for attributing any painting to him.

4. Published in S. Muller Fz., *Schilders-vereeningen te Utrecht. Bescheiden uit het gemeente-archief* (Utrecht, 1880), 76, no. III, and in J. Bruyn, 'Rembrandt's workshop: its function and production', in C. Brown, *et al.*, *Rembrandt: the Master and his Workshop*, exh cat., Berlin-Amsterdam-London, 1991–92, 70 and 87, note 23. The date of the ordinance is wrongly cited as 1644 in *Rembrandt Corpus*, 2, 50, Note 51.

5. See pp. 60, 331, Note 8, above.

6. J. Orlers, *Beschrijvinge der stadt Leyden*, 2nd ed. (Leiden, 1641), 376.

7. In the first edition it was noted that the picture had been ascribed to Rembrandt and to Lievens – shades of Frederik Hendrik's *Simeon in the Temple* listed in his 1632 inventory – and there also were specialists who argued it was a joint effort by the two friends. Rosenberg and I characterized it as an overambitious, somewhat immature attempt by Rembrandt, probably stimulated by Lievens, to work life-size in about 1625, before he discovered at this stage of his career he was more successful working on a small scale. However, study of a group of life-size paintings by Lievens – some of them recently rediscovered – which are datable about the time of the Raleigh picture supports the attribution to him. It shares the same broad, rather coarse handling and bold colours, and combines the lighting effects and large scale of the Utrecht Caravaggesque painters with the rich detail that both Lievens and Rembrandt learned from Lastman.

8. The much-discussed British Museum drawing is an anomaly; Rembrandt inscribed it '1630' yet it can be safely dated c.1635; see M. Royalton-Kisch, 'Rembrandt's Drawing of *The Entombment of Christ* over *The Raising of Lazarus*', *Master Drawings*, 29 (1991), 263–83, and *ibid.*, 30 (1992), 336–7. Apart from Rembrandt's *Hundred Guilder Print* and his late etched *Three Crosses*, none of Rembrandt's works on paper has a longer bibliography.

9. See E.J. Sluijter, *et al.*, *Leidse Fijnschilders van Gerrit Dou tot Frans van Mieris de Jonge: 1630–1760* (Zwolle-Leiden, 1988), and P. Hecht, *De Hollandse Fijnschilders van Gerard Dou tot Adriaen van der Werff* (Amsterdam-Maarssen-The Hague, 1989). An up-to-date, full-dress study of Dou's work would fill a significant gap; one has not been published since W. Martin's *Gerard Dou* appeared in 1913.

10. Wood strips were removed from the top and bottom of Rembrandt's *Self-Portrait*, which is painted on an oak panel, in 1925, because it was assumed that they were later additions (cf. C. Hofstede de Groot, 'Rembrandt's Painter in a Studio', *B.M.*, 47 [1925], 264 f.). Publication of a photograph of the painting made before the removal of these pieces (cf. S. Slive, 'Rembrandt's "Self-portrait in a Studio"', *B.M.*, 106 [1964], 483–6) suggests that the strips were painted by Rembrandt himself, and that the painting originally showed about one-third more of the artist's studio. If this hypothesis is correct, the easel formerly made a less prominent accent. The hypothesis, however, does not detract from Rembrandt's bold originality. There is still no precedent for the way in which the large dark easel is co-ordinated with space in the picture's present state. The hypothesis is rejected by the authors of the *Rembrandt Corpus* (1, no. 18) who argue that the strips were not added by Rembrandt but by another hand sometime before 1745 to make it pass as a companion piece to *Travellers Resting* (The Hague, Mauritshuis; *Rembrandt Corpus*, 1, no. C12; Bredius-Gerson 556, called 'Rest on the Flight into Egypt') with which it was auctioned in Paris in that year. *Travellers Resting* is a poor imitation of Rembrandt's style, painted on paper stuck to a wooden panel, which earlier cataloguers, as well as Gerson and the *Corpus*, rightly reject. But it is significant that the compiler of the 1745 auction catalogue rejects it too. He specifically states it is not by Rembrandt but 'est de l'École de ce Maître'. The Boston painting he correctly writes 'est peint par le Rimbrant'. It is conceivable, but hardly probable that an original panel painting by Rembrandt was enlarged to pass as a companion to a weak imitation on paper. It is more likely that the imitation on paper was made to fit with the original before its strips were removed – although, the two pictures are ill-matched; neither their subjects nor compositions are related to each other in any way. This too was recognized by the cataloguer. He did not claim they were pendants. The auctioneer merely sold the original and school piece as one lot. He erred, however, when he wrote both pictures are painted on wood. The fact that the Boston panel is bevelled on four sides does not preclude the addition of strips to it. There are cases of enlarged bevelled panels; e.g. Saenredam's *Nave of the Buurkerk, Utrecht* (Fort Worth, Kimbell Art Museum) is made up of three bevelled panels from different planks and, as in the Boston painting, the grain of its panels runs horizontally although the picture has a vertical format.

11. *Rembrandt Documents*, no. 1637/4.

12. The original Flinck signature was almost obliterated at an indeterminate date and replaced with a false Rembrandt signature. The sitter was formerly identified as the Amsterdam rabbi Menasseh ben Israel because of a vague likeness to Rembrandt's undocumented but generally accepted etched portrait of him dated 1636 (Bartsch 269). However, since the age 44 is inscribed on the painting, and it is dated 1637, it is unlikely that it is a portrait of Menasseh who was thirty-three years old in 1637; see A. Behr, 'The Iconography of Menasseh ben Israel', *Transactions of the Jewish Historical Society of England*, 19 (1960), 191–200.

13. Discovery of the remains of the Flinck signature was made by P. Schatborn in 1981. Earlier cataloguers had no doubt it was by him; it was listed as a Flinck by 1775, when it was in the ducal collection, Kassel, and was brought to Paris to be such during the Napoleonic Wars. In 1821 it was sold in Paris as Flinck. It probably acquired Rembrandt's name (and its fake Rembrandt signature?) soon afterward, and apart from a few dissenting voices (Dutuit, 1885; Bode, 1925) it appeared in all of the literature, including previous editions of this book, as a genuine work by the master. For a full discussion of it cf. C.P. Schneider, *Rembrandt's Landscapes* (New Haven-London, 1990), no. R1, and *Rembrandt Corpus*, 3, no. C117.

14. For the inventory see A. Blankert, *Ferdinand Bol (1620–1680), Rembrandt's Pupil* (Doornspijk, 1982), 76–8.

15. Roberto Longhi, 'Monsù Bernardo', *Critica d'Arte*, 3 (1938), 121–30.

16. The messages in these paintings are discussed in W.W. Robinson, 'The *Eavesdroppers* and Related Paintings by Nicolaes Maes', *Holländische Genremalerei in 17. Jahrhundert. Symposium, Berlin 1984, Jahrbuch Preussischer Kulturbesitz*, Sonderband 4 (1987), 285–313.

17. The painting was one of four pictures damaged in Kassel's museum by an acid-spraying vandal in 1977; for references to its restoration see Chapter 5, Note 39 above.

18. It is his etching of *A Young Tethered Bull in a Landscape ('Het Stiertje')*, dated 165[?] (Bartsch 253). There is no reason to assume that the small, lightly etched print, datable c.1650, was the source for Leveck's painting. The attribution to Rembrandt of the poorly preserved *Standing Ox* at Copenhagen (Statens Museum) is unconvincing (Bredius-Gerson 459; cf. Gerson's note to the painting; *ibid.*, pp. 590–1).

19. The paintings by Titus listed in Rembrandt's inventory are: three little dogs done from life; a painted book; a head of [the Virgin] Mary (*Rembrandt Documents*, no. 1656/12, nos 298–300). J. Bruyn has rightly noted that today there is insufficient evidence for attributing a single painting to Titus (see p. 333, Note 3, above). For three problematic drawings which have been attributed to Titus, see W. Sumowski, *Drawings of the Rembrandt School*, 9 (New York, 1985), nos 2207–9.

20. A. Blankert, 'Rembrandt, Zeuxis and Ideal Beauty', *Album Amicorum J.G. van Gelder*, eds J. Bruyn, *et al.* (The Hague, 1973), 32–9. Rembrandt's Cologne *Self-Portrait* is described in a 1761 guide book as 'Rembrandt painting an old woman'. Blankert's ingenious use of this small clue, seemingly of only antiquarian interest, in conjunction with x-rays of the painting and literary sources led him to the probable meaning of the Cologne *Self-Portrait* and its connection with de Gelder's *Self-Portrait* at Frankfurt.

CHAPTER 7

1. First noted in E. de Jongh, *Zinne- en minnebeelden in de schilderkunst van de zeventiende eeuw* (Amsterdam, 1967), 52–3, a key study that helped alert the wider public to allusions in Dutch paintings that are easily missed by modern viewers. The verse appears in Jan Hermansz Krul, *Minnebeelden: Toe-gepast op lievende jonkheyt* (Amsterdam, 1640), 2–3. For subsequent discussions of the significance of marines that figure in interiors see: L.O. Goedde, *Tempest and Shipwreck in Dutch and Flemish Art: Convention, Rhetoric, and Interpretation* (University Park-London, 1989), 148–56; J.A. Welu, 'Seventeenth-Century Dutch Seascapes: An Inside View', *Mirror of Empire: Dutch Marine Art of the Seventeenth Century*, exh. cat., Minneapolis-Toledo-Los Angeles, 1990–1, 51–9.

2. F. Fox Hofrichter, *Judith Leyster: A Woman Painter in Holland's Golden Age* (Doornspijk, 1989) lists more than forty works by the artist; subsequently, she kindly informed me (private communication, 1994) she accepts about thirty-five. J.A. Welu and P. Biesboer, editors of the exh. cat., *Judith Leyster: A Dutch Master and Her World*, Haarlem-Worcester, 1993, accept less than twenty as authentic.

3. W. Franits, '*The Virtues which ought to be in a compleate woman*': Domesticity in Seventeenth-Century Dutch Art (Ann Arbor, 1988), 64–6, argues the man's coins indicate a suitor; additional support for this interpretation is given in the entry on the painting, exh. cat. Haarlem-Worcester, no.11 [Note 2, above]. For the view endorsed here that the man is propositioning the young woman, see Hofrichter, *op. cit.* [Note 2, above], cat.no.16, with references to earlier literature.

4. Another watercolour on parchment of a tulip signed and dated 1643, also at Haarlem, is attributed to her by Hofrichter, *ibid.*, cat.no.46; P. Biesboer in the Leyster exh. cat. 1993 [Note 2, above], 84–5, finds the attribution unsupportable.

5. The earliest reference to the print calls it *Dr Faustus*; it occurs in the list of Valerius Röver's collection in 1731. In the seventeenth century the print was listed as 'A practising Alchemist' (inventory of Clement de Jonghe of 1679; see C. Hofstede de Groot, *Die Urkunden über Rembrandt (1575–1721)* (The Hague, 1906), no. 346, 33, and L. Münz, *Rembrandt's Etchings*, 2 (London, 1951), 33. A Dutch version of Marlowe's *Dr Faustus* was put on the boards in Amsterdam in Rembrandt's time, and he may have been inspired by this production. In any event, the popular image of Faust is closely associated with the etching, and Goethe's great version of Faust can be connected with it. A comprehensive review of the extensive literature on the print as well as its relation to earlier iconographic and pictorial traditions is found in H. van de Waal, 'Rembrandt's Faust Etching, a Socinian document and the iconography of the inspired scholar', *O.H.*, 74 (1964), 7–48, reprinted in his *Steps Towards Rembrandt* (Amsterdam-London, 1974), 133–81; van de Waal's interpretation of the print as a Socinian document remains hypothetical. See also J. Rosenberg, *Rembrandt: Life and Work*, revised ed. (London, 1964), 268–71, and H.T. Carstensen and W. Henningsen, 'Rembrandts sog. Dr. Faustus, zur Archäologie eines Bildsinnes', *O.H.*, 102 (1988), 290–312.

6. A third painting, *St Praxedis*, a close copy after a work by the Florentine artist Felice Ficherelli (1605–69?), signed 'Meer' and dated 1655, has been attributed to Vermeer by A.K. Wheelock, Jr., 'St Praxedis: New Light on the Early Career of Vermeer', *Artibus et Historiae*, no. 14 (1986), 71–89. The attribution has not been endorsed by all specialists.

7. More than 450 documents, many hitherto unpublished, relating to Vermeer and his family are summarized in J.M. Montias, *Vermeer and His Milieu: A Web of Social History* (Princeton, 1989), 268–368. His text, based on the documents, includes a detailed study of the artist's life and the world in which he lived. Equally valuable for a close examination of many aspects of the life of artists in Vermeer's city is Montias's *Artists and Artisans in Delft: A Socio-economic Study of the Seventeenth Century* (Princeton, 1981).

8. See Note 6, above.

9. Similarities have been noted by Vermeer specialists between the heavy paint, warm colours, light, and figure types of *Diana* and *Mary and Martha* and narrative paintings by artists active in Amsterdam around the middle of the century, namely the Dutchman Jacob van Loo (1614–70), who gained a reputa-

tion as a history painter, and the Fleming Erasmus Quellinus II (1607–78), a Rubens pupil. For example, *Diana* has analogies with van Loo's painting of the same subject at Berlin, and *Mary and Martha* is closely connected with Quellinus's depiction of the parable at Valenciennes. Vermeer's familiarity with their works suggests he travelled to Amsterdam before we recognize his hand.

10. For identification of the contemporary title see S. Slive, 'Een dronke slapende meyd aen een tafel', *Festschrift Ulrich Middeldorf* (Berlin, 1968), 452–9. Possibly the painting conjured up multiple meanings. The fragment of a painting of a Cupid with a mask at his feet on the left of the picture may have been intended to relate the woman's condition to an aspect of love, and it also has been noted that her pose is a traditional one for Melancholy and Sloth; cf. *ibid.*, 455–6, and M.M. Kahr, 'Vermeer's Girl Asleep, A Moral Emblem', *Metropolitan Museum Journal*, 6 (1972), 115–32. The results of the Metropolitan Museum's technical examination of the painting are in *Art and Autoradiography: Insights into the Genesis of Paintings by Rembrandt, Van Dyck and Vermeer* (New York, 1982), 18–26.

11. S. Alpers, *The Art of Describing: Dutch Art in the Seventeenth Century* (Chicago, 1983), 152–6.

12. W. Bürger [Étienne-Josephe Théophile Thoré], 'Van der Meer de Delft', *G.B.A.*, 21 (1866), 297–330, 458–70. A few years earlier, however, he was not above criticizing what, at the time, he considered the overly heavy impasto in the *View of Delft* (W. Bürger, *Les Musées de la Hollande* [Paris, 1858], 273.) For a survey of eighteenth- and nineteenth-century artists, critics, and dealers who were aware of Vermeer before Thoré-Bürger's landmark articles appeared in 1866 see A. Blankert, *Vermeer of Delft* (Oxford, 1978), 60–7, and A. Blankert, 'Vermeer and His Public', in A. Blankert, *et al.*, *Vermeer* (New York, 1988), 156–60.

13. The *pointillé* touches in the painting and a few others resemble the diffused highlights seen in unfocused areas of images produced by a camera obscura, a device available to seventeenth-century Dutch artists. Although Vermeer's use of the camera obscura is undocumented, he possibly incorporated effects he observed in one in some pictures. However, it is a major confusion to conclude that the carefully calculated organization and rich pictorial effects of his paintings are based on tracings or transcriptions of images made by the contraption. For a balanced discussion of his possible use of the camera obscura with references to reliable and less reliable literature on the subject see A.K. Wheelock, Jr., *Jan Vermeer* (New York, 1981), 37–9.

14. A.K. Wheelock, Jr., review of Albert Blankert, 'Johannes Vermeer van Delft 1632–1675 (Utrecht-Antwerp, 1975)', *The Art Bulletin*, 59 (1977), 440.

15. W. Bürger [É.J.T. Thoré], 'Van der Meer de Delft', *G.B.A.*, 21 (1866), 460. H. Rudolph, '"Vanitas": Die Bedeutung mittelalterlicher und humanistischer Bildinhalte in der niederländischen Malerei des 17. Jahrhunderts', *Festschrift Wilhelm Pinder* (Leipzig, 1938), 408 ff., called it a *Vanitas* and made the connection between the woman's balance and the painting within the painting of the Last Judgement. Rudolph was one of the first twentieth-century specialists to signal allegorical and symbolic meanings in Dutch paintings that had been generally overlooked. Critics subsequently argued that the painting is not a *Vanitas* but alludes to the divine truth of revealed religion, justice, temperance, or moderation because it can be shown that a balance is used to symbolize these abstract ideas in images and literature of the period. Another tack is taken by those who assume the woman holding a balance is heavy with a child; they find the key to the painting's meaning in her pregnancy. On the basis of this questionable assumption (fashions of the time may account for her pregnant look) it has been proposed the balance is empty because Vermeer or his patron shared the belief that the fate of an unborn child cannot be determined. According to this hypothesis the artist is telling us that an unborn child has an unblemished soul, a tenet held by believers in free-will, not predestination. Her purported pregnancy also has been used to support the notion that the woman is weighing – or about to weigh pearls – to determine the sex of the unknown child, a method said to be practised in Germany until recently. It also has been argued that the pearls are not present to divine the sex of an unborn baby, but allude to St Margaret, whose intercession at childbirth was invoked to help assure a successful term of pregnancy. The various interpretations that have been proposed for Vermeer's masterwork give an idea of the tangled thicket one can enter when reviewing iconographical meanings that have been given to some pictures of the period. For bibliographical references to the interpretations cited above see the 1995 catalogue of Dutch paintings in the National Gallery, Washington, by A.K. Wheelock, Jr.

16. Identification of the model as Clio was made by K.G. Hultén, 'Zu Vermeers Atelierbild', *Konsthistorisk Tidskrift*, 18 (1949), 90 ff.

17. Inventory made upon the occasion of a move of the Dordrecht household of Sara van de Roovere, second wife of Adriaan van Blijenborgh; cited in G.D.J. Schotel, *Het Oud-Hollandsch huisgezin der zeventiende eeuw* (Amsterdam, 1903; reprint 1968), 124–5, and P. Zumthor, *Daily Life in Rembrandt's Holland* (London, 1962), 139. M.H. Benschop, archivist of Dordrecht, kindly communicated (1992) that according to the literature Sara died in 14 September

1657, and that her name is not listed in Dordrecht's burial registers and her inventory is not traceable in the city notarial archives.

18. Observation of the pivotal role played by the man looking at Flinck's invisible *Dentatus* was made by I. Gaskell, *The Thyssen-Bornemisza Collection. Seventeenth-Century Dutch and Flemish Painting* (London, 1990), 284–9, no. 62.

19. S.J. Gudlaugsson, *Gerard ter Borch* (The Hague, 1959), 1, 96 f.

20. A. McNeil Kettering, *Drawings from the Terborch Studio Estate*, 2 vols (The Hague, 1988) presents a fully illustrated detailed catalogue of all the Rijksmuseum's holdings.

21. Gudlaugsson, *op. cit.* [Note 19, above], 1, 161 ff.

22. Formerly erroneously called the Geelinck family. For the correct identification see *Catalogue of Paintings, Picture Gallery, Staatliche Museen* (Berlin, 1978), 288, no. 792, with references to earlier literature.

23. F. Schmidt-Degener's remarks are in his introduction (p. 11) to F. Schmidt-Degener and H.E. van Gelder, trans. G.J. Renier, *Jan Steen* (London, 1927). Following earlier cataloguers Schmidt-Degener erroneously called the painting he described *The Roman Envoys inviting Cincinnatus to take Command of the Army*; Cincinnatus's proverbial frugality seemingly qualified him as the protagonist of the picture. Subsequently, it was noted that the prominent turnips which Plutarch tells us the Samnites found Curius Dentatus boiling when they came to bribe him identify him as the latter (cf. K. Braun, *Jan Steen* [Rotterdam, 1980], cat.no.372). For Flinck's painting of Dentatus refusing bribes painted for Amsterdam's town hall see, pp. 106–7 and fig. 133, above, and the discussion of de Hooch's *Interior of the Council Chamber in the Amsterdam Town*, p. 157, above. Steen's painting of the story last appeared in the sale, anon., London (Sotheby's), 27 March 1963 (no. 52), with the wrong title.

24. Naturally, it does not follow that sensible hypothetical or tentative conclusions cannot be entertained. For example, see H. Perry Chapman, 'Persona and Myth in Houbraken's Life of Jan Steen', *The Art Bulletin*, 75 (1993), 135–150, for the reasonable argument that instead of using stock characters Steen deliberately included self-portraits in his work to promote a fictional image of himself to the public as a comic artist, and to sharpen the impact of his satire and moralizing by including his recognizable self and members of his family in his paintings.

25. Sir Joshua Reynolds, ed. R.E. Wark, *Discourses on Art* (San Marino, 1959), 109–10.

26. W.J.J.C. Bijleveld, 'Het Tuinfeest van Jan Steen, 1677', *O.H.*, 63 (1926), 132–5.

CHAPTER 8

1. The translation from da Hollanda is from C. Holroyd, *Michael Angelo Buonarroti* (London-New York, 1903), 279 f. K. Clark's comments are in his *Landscape into Art* (London, 1949), 26.

2. This was pointed out by W. Stechow, 'Significant Dates on some Seventeenth Century Dutch Landscape Paintings: I, Hendrick Avercamp', *O.H.*, 75 (1960), 80 ff. Stechow's publications of signed and dated Dutch landscapes are indispensable tools for establishing the development of this branch of painting; for his other articles on the subject see the Bibliography, under Landscape.

3. W. Stechow, 'Esaias van de Velde and the Beginnings of Dutch Landscape Painting', *N.K.J.*, 1 (1947), 83 ff., reproduced p. 93, fig. 3; this important untraceable painting is also discussed and illustrated in W. Stechow, *Dutch Landscape Painting of the Seventeenth Century* (London, 1966), 86–7, fig. 168, and in G.S. Keyes's standard work on the artist, *Esaias van den Velde, 1587–1630* (Doornspijk, 1984), 30 and cat.no.14, pl.2.

4. Formerly called *View of Wezel*; correctly identified as Zierikzee by H. Dattenberg in *Niederrheinansichten holländischer Künstler des 17. Jahrhunderts*, exh. cat., Düsseldorf, 1953, 24.

5. A flagrant example of an expansionist view of Segers's painted *œuvre* is found in L.C. Collins, *Hercules Seghers* (Chicago, 1953; reprint, New York, 1978). The majority of the additions listed in this book must be rejected as unconvincing; see the reviews by J.G. van Gelder, *O.H.*, 68 (1953), 156, note 4; W. Stechow, *The Art Bulletin*, 36 (1954), 240 ff.; S. Slive, *College Art Journal*, 14 (1955), 304 ff.; E. Trautscholdt, *B.M.*, 97 (1955), 357 f.

6. J.G. van Gelder, 'Hercules Seghers erbij en eraf', *O.H.*, 65 (1950), 216 f.

7. E. Haverkamp-Begemann, *Hercules Segers. The Complete Etchings* (Amsterdam-The Hague, 1973). The work, which is accompanied by a portfolio of colour facsimiles of the etchings, is valuable for its discussion of the artist's technique as well as other aspects of the prints.

8. The collaborative effort is evident in Hals's portrait of *Isaac Abrahamsz Massa* of 1626 at Toronto and his life-size *Family Group in a Landscape* of c.1648 at the Thyssen-Bornemisza Foundation, Madrid; see Slive 1970–4, 3, cat.nos 32, 177, and Hals 1989–90, nos 21, 67, respectively. The landscape background in Hals's large *Family Group in a Landscape* of the late forties at the National Gallery, London, is also attributable to Molyn, cf. Slive 1970–4, cat.no.176.

9. M.J. Friedländer, *Essays über die Landschaftmalerei und andere Bildgattungen*

(The Hague, 1947), 116.

10. P.J.J. van Thiel, 'Philips Konincks vergezicht met hutten aan de weg', *Bulletin van het Rijksmuseum, Amsterdam*, 15 (1967), 111.

11. J. Giltaij, 'The problem of Isaack van Ruisdael (1599–1677)', *B.M.*, 134 (1992), 180–2; S. Slive, 'A newly discovered Isaack van Ruisdael in Philadelphia', *B.M.*, 139 (1997), 690–2.

12. A recent search at Caen for additional evidence pertinent to the matter has been fruitless; the university's matriculation rolls post-date 1702 and there is no record of dissertations completed before 1792. The case is complicated further when it is recalled that Houbraken probably knew something about surgeons and their activities. He married the daughter of one (Jacob Sasbout Souburg) in Dordrecht in 1685. Was Houbraken misinformed about Ruisdael's putative second profession? If he was, so was the anonymous compiler of the sale catalogue of an auction held in Dordrecht in 1720 who described a lot as 'a very ingenious landscape with a waterfall by Doctor Jacob Ruisdael beautifully and pleasantly painted.' His reference to 'Doctor Jacob Ruisdael' was made a year before Houbraken's biography was published.

13. H.F. Wijnman, 'Het Leven der Ruysdaels. III', *O.H.*, 49 (1932), 265.

14. For a discussion of this aspect of his achievement see P.S. Ashton, S. Slive, A. Davies, 'Jacob van Ruisdael's Trees', *Arnoldia. The Magazine of the Arnold Arboretum*, 42, no. 1 (1982), 2–31.

15. After this version surfaced in the 1920s it was published by J. Rosenberg, '"The Jewish Cemetery" by Jacob van Ruisdael', *Art in America*, 14 (1926), 37 ff. For the history of both paintings see S. Slive, *Jacob van Ruisdael*, exh. cat., The Hague-Cambridge, Mass., 1981–2, cat. nos 20, 21.

16. See J. Bruyn, 'Toward a Scriptural Reading of Seventeenth-Century Landscape Paintings', in P. Sutton, *et al.*, *Masters of 17th-Century Dutch Landscape Painting*, exh. cat., Amsterdam-Boston-Philadelphia, 1987–8, 84–108, with bibliographical references to critics who endorse a similar view.

17. S. Slive, 'Additions to Jacob van Ruisdael', *B.M.*, 133 (1991), 599–602.

18. As noted in the 1972 edition (p. 436, Chap. 8, Note 15) A. Staring kindly informed the authors that an x-ray of the portrait shows a different head underneath the one visible on the painted surface. It is also apparent that a smaller and different coat of arms is under the one on the tree. This evidence suggests that either Potter or another artist transformed a portrait of someone else into a likeness of Dirck. The panoramic view of Schwanenburg and the Neustadt of Cleves in the background of the painting supports this hypothesis; the Tulp family had no connection with Cleves. H. Dattenberg, *Niederrheinansichten holländischer Künstler des 17. Jahrhunderts* (Düsseldorf, 1967), 273, tentatively suggests that the painting may have originally been a portrait of Johan Maurits. A.L. Walsh, 'Paulus Potter: His Works and Their Meaning', diss. Columbia Univ., New York, 1985, 231–8) accepts the proposal that Potter probably painted a different rider in 1653. She also accepts Johan Maurits as a likely candidate for the original rider. She notes he was stadholder of Cleves in 1647 and adds that the wig the rider wears only became fashionable a few decades after Potter's death. The hand that transformed the work remains unidentifiable.

19. The stiffness of Rihel's horse has led J. Bruyn to suggest that it was painted by one of the master's assistants; for the unlikelihood of his proposal see p. 333, Note 3, above.

CHAPTER 9

1. Figures quoted here are from D.W. Davies's modestly titled *A Primer of Dutch Seventeenth Century Overseas Trade* (The Hague, 1961), 9, which presents an admirable survey of the world activities of Holland's merchant fleet at the time when it was the greatest in Europe. The Sound Toll Registers are published in N.E. Bang (ed.), *Tabeller over Skibsfart og Varentransport gennem øresund 1497–1660* (Copenhagen, 1906–33).

2. L. Binyon, *Catalogue of Drawings by British Artists and Artists of Foreign Origin Working in Great Britain ... in the British Museum*, 4 (London, 1907), 266, cat.no.29. The inscription is on a sheet that bears five compositional studies of ships at sea and is monogrammed and dated 1699.

3. Details of the commission and its historical significance are from M. Russell, *Visions of the Sea: Hendrick C. Vroom and the Origins of Dutch Marine Painting* (Leiden, 1983), 166–70.

4. For the Damiate legend and late sixteenth- and seventeenth-century representations of it see H. van de Waal, *Drie eeuwen vaderlandsche geschied-uitbeelding: 1500–1800*, 1 (The Hague, 1952), 243–52.

5. Russell, *op. cit.* [Note 3, above], 80.

6. Published by T. Krielaart, 'Symboliek in zeegezichten,' *Antiek*, 8 (1974), 568–9.

7. L.O. Goedde, *Tempest and Shipwreck in Dutch and Flemish Art: Convention. Rhetoric and Interpretation* (University Park-London, 1989) presents a thorough study of the meanings of stormy as well as calm marines. He stresses that in addition to the traditional references found in seventeenth-century Netherlandish

stormy seascapes there are frequent allusions to man's steadfastness and attempt to maintain control when in dire danger.

8. W. Stechow, *Dutch Landscape Painting of the Seventeenth Century* (London-New York, 1966), 11.

9. The inventory of van de Cappelle's impressive collection is published in A. Bredius, 'De Schilder Johannes van de Cappelle', *O.H.*, 10 (1892), 31–40. For an English translation see M. Russell, *Jan van de Cappelle, 1524/6–1679* (Leigh-on-Sea, 1975), 50–7.

10. For detailed descriptions of the vessels in the artist's *Calm* and *Gale* as well as the set of their sails and rigging as they respond to conditions of the sea and wind see M.S. Robinson, *Van de Velde. A Catalogue of the Paintings of the Elder and Younger Willem van de Velde* (Greenwich, 1990), vol. 1, 292–7, no. 56, vol. 2, 1050–3, no. 57, respectively. Robinson's nautical descriptions in his catalogue *passim* and other publications are exemplary.

11. Cited in D. Cordingly, *et al.*, *The Art of the Van de Veldes*, exh. cat., National Maritime Museum, London, 1982, 12.

12. B. Buckeridge, in 'An Essay towards an English School' (London, 1706); cited from the appended to the English translation of R. de Piles, *The Art of Painting* 3rd ed. (London, n.d.), 473.

13. Cordingly, *et al.*, *op. cit.* [Note 11, above], 15.

14. In the notes to William Gilpin's 'On Landscape Painting, a Poem', in *Three Essays on Picturesque Beauty* (London, 1792), 34.

CHAPTER 10

1. S. Slive, 'Dutch Pictures in the Collection of Cardinal Silvio Valenti Gonzaga (1690–1756)', *Simiolus*, 17 (1987), 169 ff.

2. C.R. Leslie, ed. A. Shirley, *Memoirs of the Life of John Constable* (London, 1937), 392 f.

3. The drawing was published as Breenbergh by A.M. Hind, 'Pseudo-Claude Drawings', *B.M.*, 48 (1926), 192.

4. For a comprehensive study of the development of this theme and its relation to contemporary literature and drama see A. McNeil Kettering, *The Dutch Arcadia: Pastoral Art and its Audience in the Golden Age* (Montclair, 1983).

5. For additional word on Van Dyck's activities in Holland see p. 27, above; for Rubens, see J.G. van Gelder, 'Rubens in Holland in de zeventiends eeuw', *N.K.J.*, 3 (1950/1), 103 ff.

6. J.G. van Gelder, 'De schilders van de Oranjezaal', *N.K.J.*, 1 (1948/9), 118–64, the first thorough study of the decorations, remains basic. An aspect of van Gelder's work is supplemented by H. Peter-Raupp, *Die Iconographie des Oranjezaal* (Hildesheim-New York, 1980). B. Brenninkmeyer-de Rooij, 'Notities betreffende de decoratie van de Oranjezaal in Huis ten Bosch uitgaande van H. Peter-Raupp, *Die Ikonographie des Oranjezaal*', *O.H.*, 96 (1982), 133–90, provides an exhaustive critical review of Peter-Raupp's monograph as well as new data.

7. G.J. Hoogewerff did much spadework on the activities of the *Schildersbent* in Rome. His monograph *De Bentvueghels* (The Hague, 1952) summarizes his earlier publications on this interesting group and presents new material. For a comprehensive bibliography on the subject cf. *I Bamboccianti. Niederländische Malerrebellen im Rom des Barock*, ed. D.A. Levine and E. Mai, exh. cat., Cologne-Utrecht, 1991–2, 307–21.

8. A.C. Steland-Stief, *Die Zeichnungen des Jan Asselijn* (Fridengen, 1989), 170–1; 215–6, cat.no.32; she notes the counterproof may have been made from a painting.

9. For the attribution of the Bamboccio-like *Fight over a Game of Cards before the Spanish Embassy* (Rome, Galleria Pallavicini) to Velázquez see R. Longhi, 'La rissa all' Ambasciata di Spagna', *Paragone*, 1 (1950), 28 ff.; his attribution has been contested by other specialists.

10. J.J. Kren, 'Jan Lingelbach in Rome', *The J. Paul Getty Museum Journal*, 10 (1982), 45–62, argues the case for attributing the picture as well as twelve others to the artist's Roman phase. For a review of subsequent literature including references to students who ascribe the painting to 'The Master of the Small Trades' see *I Bamboccianti*, exh. cat., *op cit* [Note 7, above], cat.no.21.5; in the catalogue the painting is attributed to Lingelbach. In a private communication (1993) A. Blankert kindly informed me he also retains the attribution to van Laer.

11. W. Stechow, 'Jan Both and the Re-Evaluation of Dutch Italianate Landscape Painting', *Actes du XVIIme Congrès International d'Histoire de l'Art, Amsterdam, 1952* (The Hague, 1955), 428 ff. Only two dated paintings by Both have been identified: *Southern Landscape* of 1649 (Canada, private collection; Hofstede de Groot, no. 312; *Italian Recollections: Dutch Painters of the Golden Age*, exh. cat. by F.J. Duparc and L.L. Graif, Montreal, 1990, no. 14) and *Mercury and Argus* of 1650 (Munich Bayerische Staatsgemäldesammlungen, inv.no.140; Hofstede de Groot, no. 14; W. Stechow, *Dutch Landscape Painting of the Seventeenth Century* [London-New York], 1966, 150; 215, note 59). Both's only known dated drawing, inscribed 1643, is at Budapest (inv.no.1914–144).

12. The best summary of the much debated question of Berchem's trip to Italy is in A. Blankert, *Nederlandse 17e eeuwse Italianiserende landschapschilders* (Soest, 1978), 147–9, revised and enlarged edition of the catalogue of the landmark exhibition he organized for the Centraal Museum, Utrecht, 1965. His indispensable study advanced Stechow's earlier efforts on the subject by a giant step. On the basis of the scrappy bits of evidence available Blankert prudently concluded that Berchem may have visited Italy in 1653–4/5. G. Jansen, 'Berchem in Italy: notes on an unpublished painting', *Hoogsteder-Naumann Mercury*, 2 (1985), 13–17, argues that it is plausible to date Berchem's 'Italian journey to the years 1651–3', and adds that Blankert has written elsewhere that the visit most probably occurred between 1650 and 1653 (*ibid.*, 15; A. Blankert, *Artisti Olandesi e Fiamminghi in Italia*, exh. cat., Florence, 1966, 16). However, dating Berchem's visit to Italy 1650/1–3 poses a problem which Jansen and Blankert's revised dates do not consider: if Berchem was in Italy c.1650/1–3, how did he manage to paint the staffage in Ruisdael's *Great Oak* [304] which is firmly dated 1652? Naturally it is not impossible, but it seems unlikely that Ruisdael waited for Berchem to return to Haarlem from a trip south of the Alps to supply the conspicuous figures in his 1652 landscape. Consideration of Berchem's hypothetical sojourn in Italy in the early 1650s should also take into account the staffage that some specialists argue Berchem did for Ruisdael's *View in the Woods*, a landscape that Jacob signed and dated 1653; see P.J.J. van Thiel, *et al.*, *All the paintings of the Rijksmuseum in Amsterdam* (Amsterdam-Maarssen, 1976), 486, inv.nr.A 350). For the view that Ruisdael himself painted the figures in his 1653 picture now at Amsterdam see E. Schaar, 'Studien zu Nicholas Berchem', diss., Cologne, 1958, 36, note 32; I share Schaar's opinion that the staffage in the landscape is Jacob's.

13. See Note 12, above.

14. The correct identification was established by M. Pfister, 'Trasimenischer See oder Zürichsee? Zu einem Gemälde von Jan Hackaert im Rijksmuseum Amsterdam', *Bulletin van het Rijksmuseum*, 20 (1972), 177–81. For support for a date of. c.1673 for the painting see G. Solar, 'Conrad Meyer and Jan Hackaert, Feststellungen um einem Fund', *Beiträge zur Kunst des 17. und 18. Jahrhunderts in Zürich, Schweizerisches Institute für Kunstgeschichte. Jahrbuch, 1974–1977* (Zurich, 1978), 60–1.

CHAPTER 11

1. See A. Pigler, 'Portraying the Dead', *Acta historiae artium Academiae scientiarum Hungaricae*, 4 (1957), 1–75, for a survey of the theme.

2. P.J.J. van Thiel, 'Frans Hals' portret van de Leidse rederijkersnar Pieter Cornelisz van der Morsch, alias Piero (1543–1629). Een bijdrage tot de ikonologie van de bokking', *O.H.*, 76 (1961), 153–72. Also see Slive 1974, 3, cat.no.6, and *Hals* 1989–90, cat.no.4.

3. Samuel van Hoogstraten, *Inleyding tot de hooge schoole der schilderkonst* (Rotterdam, 1678), 44.

4. Manuscript catalogue of the collections of Charles I, drawn up by Abraham van Doort: 'above the door in the little room Between the Kings Withdrawing roome ... and the large Gallerie at Whitehall near self-portraits by Rubens and Van Dyck: the Picture of Mitins done by himself to the shoulder ...'; cited by O. Millar, *The Tudor, Stuart and Early Georgian Pictures in the Collection of Her Majesty the Queen*, 1 (London, 1963), 84, cat.no.114.

5. B. Haak, *Regenten en regentessen, overlieden en chirurgijns: Amsterdamse groepportretten van 1600 tot 1835* (Amsterdam, 1972), 15–16.

6. The painting was unanimously ascribed to Thomas de Keyser until 1983 when P.J.J. van Thiel gave convincing reasons to reject the traditional attribution and proposed that it may have been done by Werner van den Valckert in his pioneer study of Valckert's work as a painter and graphic artist (*O.H.*, 97 [1983], 169–71). Unpersuaded by van Thiel's argument, the attribution to de Keyser is maintained by A. Jensen Adams, 'The Paintings of Thomas de Keyser (1596/7–1667). A Study of Portraiture in Seventeenth-Century Amsterdam', diss., Cambridge, Mass., 1985, 3, cat.no.1. Cogent reasons for attributing the painting to Pickenoy rather than de Keyser or Valckert were published by R.E.O. Ekkart in *Dawn of the Golden Age*, exh. cat., Amsterdam, 1993, cat.no.268. If Ekkart's attribution holds, the painting is Pickenoy's earliest known work.

7. H.W. Beechy (ed.), *The Literary Works of Sir Joshua Reynolds*, 2 (London, 1890), 197. The *Night Watch* was probably in a bad state and disfigured by dirty varnish when Reynolds saw it. He writes: 'It seemed to me to have more of the yellow manner of Boll ... and appears to have been much damaged'; he adds that 'what remains seems to be painted in a poor manner' (*ibid.*). His sharply critical manuscript note, which was not included by Reynolds in his printed text, is preserved in the coll. Frits Lugt, Institut Néerlandais, Paris; it was first published by E. Haverkamp-Begemann, *Rembrandt: The Nightwatch* (Princeton, 1982), 3, note 1.

8. W. Robinson, 'Nicolaes Maes: Some Observations on His Early Portraits', *Rembrandt and His Pupils, Papers given at a Symposium in Nationalmuseum, Stockholm, 2–3 October 1992*, ed. G. Cavalli-Björkman (Stockholm, 1993), 98–118.

CHAPTER 12

1. Cornelis de Bie, *Het Gulden Cabinet* (Antwerp, 1661), 246.

2. Knowledge of Saenredam's remarkable library came to light in 1976 when B. van Selm rediscovered a copy of the 1667 catalogue. The significance of the content of his library is appraised by G. Schwartz and M.J. Bok, *Pieter Saenredam: The Painter and His Time* (New York, 1990), 181–7.

3. According to Houbraken he studied with the Delft still-life painter Willem van Aelst (1627–after 1683), a statement frequently repeated in the literature. However, in this case Houbraken was certainly wrong. As noted below, de Witte had completed his apprenticeship when he joined Alkmaar's guild in 1636. In that year van Aelst was a boy of nine; when de Witte joined Delft's guild in 1642 van Aelst was fifteen and had not yet joined the city's guild.

4. This point is stressed by P. Taylor, 'The Concept of *Houding* in Dutch Art Theory', *Journal of the Warburg and Courtald Institutes*, 55 (1992), 214. In reference to de Witte, Taylor rightly notes the ahistorical tendency of modern critics 'to drive a wedge between form and illusion' (*ibid.*). Frans Hals's remarkable detached brushwork is subject to a similar confusion. As noted in the discussion of his technique in Chapter 4, its patterns are not independent; they are wedded to illusionism.

5. For a discussion of these volumes as well as other books and maps published during the century see I.H. van Eeghen, 'Illustraties van de 17de eeuwse beschrijvingen en plaatwerken van Amsterdam', *Jaarboek Amstelodamum*, 66 (1974), 96–116.

6. There are two almost identical autograph copies of the manuscript: Stadsbibliotheek, Haarlem, no. 187 E 37; private collection of a descendent of A.C. van Eck, Delden, who is a direct descendent of Jan van der Heyden (kind communication [1993] from L. de Vries).

CHAPTER 13

1. J.J. Emmens, ' "Eins aber ist notig" – Zu Inhalt und Bedeutung von Markt- und Küchenstücken des 16. Jahrhunderts', *Album Amicorum J.G. van Gelder*, ed. J. Bruyn, *et al.* (The Hague, 1973), 93–101, called attention to the iconographical significance of these works. His study was followed soon afterwards by A. Grosjean, 'Toward an Interpretation of Pieter Aertsen's Profane Iconography', *Kunsthistorisk Tidskrift*, 43 (1974), 121–43, and K.P.F. Moxey, 'The "Humanist" Market Scenes of Joachim Beuckelaer: Moralizing Exempla or "Slices of Life" ', *Jaarboek Koninklijk Museum voor Schone Kunsten, Antwerp* (1976), 106–87. The meaning of these paintings continues to be debated. For a review and critique of interpretations that have been offered as well as some proposed permutations on their meaning see the articles by K. Moxey, R.L. Falkenburg, E.M. Kavaler, and H. Buijs in *N.K.J.*, 40 (1989), an issue of the yearbook dedicated to Aertsen and his circle.

2. For a balanced discussion of the problem and criticism of some foolish readings see E. de Jongh, 'The interpretation of still-life paintings: possibilities and limits', *Still Life in the Age of Rembrandt*, exh. cat., Aukland, 1982, 27–38.

3. S. Segal, *A Prosperous Past. The Sumptuous Still Life in the Netherlands 1600–1700*, exh. cat., Delft-Cambridge, Mass.-Fort Worth, 1988, 177.

4. Apart from his allegorical *Still Life*, the only work attributable to him is in accord with his reputation for making indecent pictures. It is an amateurish etching of a copulating couple. The attribution of the print is based on an inscription in pen on an impression in the Rijksprentenkabinet, Rijksmuseum, Amsterdam: Torrentius fec.; cf. Hollstein's *Dutch and Flemish Etchings, Engravings and Woodcuts*, 30 (Amsterdam, 1986), 174, repr. For documentary references to bawdy pictures by the artist that are now untraceable see C. White, 'An Undescribed Lost Picture by Jan Torrentius', *Essays in European Art pressented to Egbert Haverkamp-Begemann*, ed. A.-M. Logan (Doornspijk, 1983), 297–8.

5. L.J. Bol, *The Bosschaert Dynasty* (Leigh-on-Sea, 1960), 20.

6. I. van Thiel-Stroman kindly informed me (private communication) that the tradition that Claesz was born in Burgsteinfurt (also Steinfurt), Westphalia, is wrong. Berchem is established as his place of birth in an unpublished document dated 3 January 1661 (Haarlem Municipal Archives, Inventaris Burgerweeshuis, no. 150, p. 76). Her find explains why Pieter Claesz's son Nicolaes (also Claes) adopted the surname Berchem; following a well-established custom he took the name of his father's birthplace.

7. From 'Matisse Speaks to his Students, 1908: Notes by Sarah Stein', cited in A.H. Barr, Jr, *Matisse: His Art and His Public* (New York, 1951), 552. Matisse's copy and variation on the de Heem are reproduced in Barr's book, 170–1.

8. Giovanni Bottari and Stefano Ticozzi, *Raccolta di lettere*, 6 (Milan, 1822), 123: '. . . il Caravaggio disse, che tanta manifattura gli era a fare un quadro buono di fiori, come di figure' (from Vicenzo Giustiniani's letter to Teodoro Amideni).

9. Several of Rijckhals's still lifes were formerly attributed to Frans Hals the Younger on the basis of an erroneous reading of Rijckhals's complicated monogram. A. Bredius, 'De schilder François Ryckhals', *O.H.*, 35 (1917), 1 ff., corrected this error. No signed or documented work by Frans Hals the Younger is known.

10. Johann Wolfgang von Goethe, *Schrifien zur Kunst* (Zürich, 1954), 121, from his MS. 'Zur Erinnerung des Städelschen Kabinetts'. Goethe's fine feeling for Kalf's early achievement is not nullified by the appearance in the art market in the 1970s of a hitherto unknown version of the Cologne picture: see Segal, *op. cit.* [Note 3, above], 185, 274, cat.no.53; he proposes it is the original and demotes the Cologne picture to a copy.

11. H. Gerson, 'P. Verbeek', *O.H.*, 73 (1958), 54 ff., notes that the late dates on fish still lifes by P. Verbeek rule out the suggestion made by I. Bergström, trans. C. Hedström and G. Taylor, *Dutch Still Life Painting* (London-New York, 1956), 229 ff., that van Beyeren also studied with Verbeek.

12. 'Maeckt datmen oock wel pist/En dat u niet en mist/(Met oorelof) het kacken/Geen winden laet hij rust . . .' Westerbaen's 'Lof van de Pekelharingh' appeared in his *Minne-Dichten* (Haarlem, 1633). It is not included in the posthumous publication of his *Gedichten*, 3 vols (The Hague, 1672). According to the Dresden Gemäldegalerie Catalogue (1979), 116, a painting described as 'Lof van den Pekelhaering' is listed in the will of Jacob's brother Jan de Bray (died 1697). It is unknown if the entry refers to the Dresden painting, a copy of it said to be dated 1673 (sale, London, Christie's, 3 May 1974, no. 89), the autograph variant of the painting in Aachen discussed below, or a version dated 1650 that was in the museum in Gotha and sold in 1942. The last named picture is cited in *Das Stilleben und sein Gegenstand: Eine Gemeinschaftsausstellung von Museen aus der UDSSR, der ČSSR und der DDR*, exh. cat., Dresden, 1983, cat.no.22.

13. See S.A. Sullivan, *The Dutch Gamepiece* (Totowa-Montclair, 1984), esp. 33–45.

14. The suggestion is tentatively offered in H. and M. Stix, *The Shell: Five Hundred Million Years of Inspired Design* (New York, 1968), unpaginated, caption to fig. 12.

15. For the topographical prints see p. 112, above. Another etching that offers a mirror image is the artist's *David and Goliath* (Bartsch 36c), one of the four prints Rembrandt made in 1655 to illustrate Menasseh ben Israel's *Piedra Gloriosa* (Amsterdam, 1655). In the literature it has not been noticed that in the print David is depicted about to fling the stone that will slay Goliath with his left hand not his right. Proof that a right-handed David was preferred to a left-handed one is offered by the engraved copies Menasseh commissioned for subsequent editions of his book. The only one of Rembrandt's four etchings the mediocre engraver (Salom Italia?) reversed is *David and Goliath*; the change transforms the youth into a right-handed hero.

CHAPTER 14

1. Johan Huizinga, 'Nederland's beschaving in de zeventiende eeuw', in *Verzamelde Werken*, 2, *Nederland* (Haarlem, 1948), 507; trans. in his *Dutch Civilization in the Seventeenth Century and Other Essays* (London-Glasgow, 1968), 104.

2. J. Bolten, *Method and Practice: Dutch and Flemish Drawing Books 1600–1750* (Landau, 1985) includes an annotated catalogue and commentary on the handbooks.

3. The full title of Jan de Bisschop's *Icones* is *Signorum Verterum Icones*. It was first published at The Hague in two parts: part I in 1668 (fifty etchings), part II in 1669 (fifty etchings); subsequently they were always issued together. De Bisschop's *Paradigmata Graphices Variorum* (The Hague, 1671), commonly called *Paradigmata*, was presumably intended to have one hundred etchings; it was never finished. The 1671 edition includes twenty-five prints. De Bisschop dedicated the two parts of *Icones* to Constantijn Huygens II and Johannes Wtenbogaert, respectively (for Rembrandt's 1639 etching of the latter, popularly called the *Gold Weigher*, see Bartsch 281). *Paradigmata* is dedicated to Jan Six, Rembrandt's sometime patron. The three dedications give de Bisschop's views on art. J. G. van Gelder and I. Jost, *Jan de Bisschop and his Icones and Paradigmata: Classical Antiquities and Italian Drawings for Artistic Instruction in Seventeenth-Century Holland*, ed. K. Andrews, 2 vols (Doornspijk, 1985) is a facsimile of *Icones* and the first posthumous edition of *Paradigmata*. Their study includes D. Freedberg's English translations of the dedications as well as their exhaustive commentary on the volumes.

4. *Ibid.*, vol. 1, 20.

5. T.J. Broos, *Tussen Swart en Ultramarine. De levens van schilders door Jacob Campo Weyerman (1677–1747)* (Amsterdam-Atlanta, Georgia, 1990), is a study of Weyerman's literary work and the little know about his activity as a still-life painter.

6. See L. de Vries, *Diamante gedenkzuilen en leerzaeme voorbeelden: Een bespreking van Jan van Gools 'Nieuwe Schouburg'* (Groningen, 1990) for a keen analysis of the content of the volumes and its author's methodology. The pamphlet war between van Gool and G. Hoet mentioned below is fully discussed and includes facsimiles of the pamphlets.

7. Heinrich Wilhelm Tischbein, ed. K. Mittelstädt, *Aus meinem Leben* (Berlin, 1956), 101. Tischbein most probably confused his references to the old Mieris and Frans van Mieris, but who can fault him? The Mieris family of painters is almost as difficult to sort out as members of the Tischbein dynasty. In the

literature of the time, Frans van Mieris (1635–81), pupil of Dou and the leading Leiden *fijnschilder* after the death of his master, was known as the 'old Mieris'. His sons and pupils, Willem (1662–1747) and Jan (1689–1763), imitated his style as did his grandson Frans van Mieris the Younger (1656–1738); see fig. 403.

8. *Ibid.*, 94–5.

9. C. Bille, *De tempel der kunst, of het kabinet van den heer Braamcamp*, 2 vols (Amsterdam, 1961) is a study of Braamcamp, and the growth and character of his collection. Vol. 2 charts his early auction sales, includes a transcription of his sensational 1771 sale catalogue, and gives the subsequent provenance of his paintings.

10. See C.J. de Bruyn Kops, 'De Amsterdamse verzamelaar Jan Gildemeester Jansz', *Bulletin van het Rijksmuseum*, 13 (1965), 79–114.

11. *De schilderijenzaal prins Willem Vte 's-Gravenhage* (The Hague, 1977), an illustrated catalogue published upon the reopening of Willem's restored picture gallery at The Hague, includes essays on the growth and fate of the collections.

CHAPTER 15

1. Gérard de Lairesse, *Het groot schilderboek* (Amsterdam, 1707), book 5, chap. 22, 325; cf. English trans. by J.F. Fritsch (London, 1778), 193.

2. J.A. Worp (ed.), *De gedichten van Constantijn Huygens* (Groningen, 1896), 247. The lines are from the poem 'Op het Graf vanden heer Iacob van Campen', written 1 May 1658.

3. Andriès Pels, *Gebruik en misbruik des toneels* (Amsterdam, 1681), 35–6. Pertinent passages of the Dutch text of the poem are cited in S. Slive, *Rembrandt and His Critics: 1630–1730* (The Hague, 1953), 210–11.

4. For a history of the statue's reception, which includes an account of dissenting opinions about the statue's merit, see F. Haskell and N. Penny, *Taste and the Antique: The Lure of the Antique* (New Haven-London, 1981), 325–8 and *passim*.

5. Lairesse, *op. cit.* (Note 1, above), book 3, chap. 1, 171; cf. English trans. by J.F. Fritsch (London, 1778), 98.

6. *The Works of Robert Browning*, intro. by F.G. Kenyon (London, 1912), 10, xix.

7. For de Wit's and Quinkhard's 1742 income see W.F.H. Oldewelt, *Kohier van de personeele quotisatie te Amsterdam over het jaar 1742* (Amsterdam, 1945), cited in J.W. Niemeijer, *Hollandse aquarellen uit de 18de eeuw in het Rijksprentenkabinet, Rijksmuseum, Amsterdam*, exh. cat., Foundation Custodia, Paris-Rijksmuseum, Amsterdam, 1990–1, 154, 175.

CHAPTER 16

1. The symbolic meaning of the candle was published by P. Hecht in 'Candlelight and dirty fingers, or royal virtue in disguise: some thoughts on Weyerman and Godfried Schalcken', *Simiolus*, 11 (1980), 23–38. Hecht notes that the significance of the candle was misinterpreted as early as 1729 when Weyerman referred to it in his biography of Schalcken in his *Levens-beschryvingen*, and that later commentators also missed its meaning. The candle and motto in Pickenoy's portrait of Tulp must have had special meaning for the artist. He painted the portrait in lieu of payment for Tulp's treatment of his own sick child; cf. E.W. Moes, *Iconographia Batavia*, 2 (Amsterdam, 1905), no. 8123.

2. The biography and other documents related to the artist are fully published in B. Gaehtgens, *Adriaen van der Werff 1659–1722* (Munich, 1987), 432–74.

3. [G.J. Karsch] *Ausfürliche und gründliche Specification derer vortrefflichen und umschätzbaren Gemählden welche in der Galerie der Churfürstlichen Residentz zu Düsseldorf...* [1719], nos 86–92.

4. A. Staring broke ground for the history of Dutch 'conversation pieces', as he did for so many other areas of the history of eighteenth-century Dutch art, in *De Hollanders thuis* (The Hague, 1956).

5. J.W. Niemeijer's fundamental *Cornelis Troost 1696–1750* (Assen, 1973), 429–30, provides an annotated list of the forty-five plays he identified that either were illustrated by the artist or are directly related to his theatrical pictures, and includes a comprehensive discussion of his treatment of them and the artist's connections with Amsterdam's theatrical world.

6. For a discussion of his multifaceted activities see Th. Laurentius, J.W. Niemeijer, G. Ploos van Amstel, *Cornelis Ploos van Amstel 1726–1798, Kunstverzamelaar en prentuitgever* (Assen, 1980) and G. Ploos van Amstel, *Portret van een koopman en uitvinder: Cornelis Ploos van Amstel* (Assen, 1980).

7. The three-quarter-length portrait of a seated old man mounted on the wall behind Gildemeester and a friend is now in the collection of the Duke of Sutherland, Mertoun, Roxburghshire. It appeared in Gildemeester's 1800 sale as a Rembrandt, and was accepted as one until Gerson doubted its authenticity (Bredius-Gerson 214). It is also rejected in the *Rembrandt Corpus* (C109) where it is ascribed to an anonymous contemporary Rembrandt follower. The other pictures in the painting, which includes works by Dou, ter Borch, de Hooch, Metsu, Ochtervelt, Ruisdael, Hobbema, and A. van de Velde, are identified and reproduced in de Bruyn Kops, *op.cit.* [Chap. 14, Note 10, above], 82–92.

CHAPTER 17

1. L.J. Bol, 'Adriaen Coorte, stilleven-schilder', *N.K.J.* (1952/3), 193 ff. Subsequently Bol arranged the first exhibition of his work (Dordrecht, 1958) and wrote the first catalogue and monograph on the artist: *Adriaen Coorte* (Assen-Amsterdam, 1977).

2. Though Gérard de Lairesse believed artists should concentrate on depicting edifying, noble subjects with idealized figures, in his thorough way he included a section in his *Groot schilderboek* (1707) on still life and another on flower painting. He predictably ruled that artists should only depict beautiful objects and use them allegorically or symbolically to give them didactic meaning. Detailed recipes were provided for achieving this end. His passage on Willem Kalf, whom he admired but faulted, makes his attitude clear: 'Although I have before said, that the famous *Kalf* excelled in still life, yet he could give as little reason for what he did, as others before and since: he only exhibited what occurred to his thoughts; as a Porcelain pot or dish, gold cup, mum-glass, rummer of wine, with lemon-peel hanging on it, clock, horn of mother of pearl, gold or silver footed, silver dish of peaches, or else cut China oranges or lemons, a carpet, and other usual things, without any thought of doing something of importance, which might carry some particular meaning, or be applicable to something...' (cited from the English trans. by J.F. Fritsch [London, 1778], Book 11, Chap. 3, 416). Samuel van Hoogstraten had little to say about still-life painting in his *Inleyding* (1678), apart from his lament that famous collections of his day are packed with these insignificant pictures and painters of them are 'the ordinary soldiers in the army of art' (*ibid.*, 75). Hoogstraten does not mention that he himself did duty as a lowly soldier; for a group of his *trompe l'œil* still lifes see W. Sumowski, *Gemälde der Rembrandt-Schuler*, 2 (London-Pfalz, 1983), nos 881–5.

3. Fr. Schlie, 'Sieben Briefe und eine Quittung von Jan van Huijsum', *O.H.*, 18 (1900), 141.

4. The known *Bentveughel* names given to Dutch and Flemish landscapists of this generation cited in the order in which they are mentioned in the text are: Caspar van Wittel, alias *de Toorts* ('the Torch'); Johannes Glauber, alias *Polidoor* ('Polidorus'); Isaac de Moucheron, alias *Ordonnantie* ('Composition'); Jacob de Heusch, alias *Afdruk* ('Off-set' or 'Reproduction'); Jan Frans van Bloemen, alias *Orizante* ('Horizon'); Abraham Genoels, alias *Archimedes*; Hendrick Frans van Lint, alias *Studio*.

5. Cornelis Meyer, *L'arte di restituire a Roma la tralaciata navigatione del suo Tevere* (Rome, 1683). The preface to the volume is dated 5 April 1678; most likely van Wittel's etchings were made about the same time.

6. The painting was acquired for Berlin from the Suermondt collection in 1874. Thoré-Bürger listed it as a genuine Vermeer in his 1860 catalogue of *La Galerie Suermondt, Aix-la-Chapelle* (p. 34 ff.) and again in his seminal study of the Delft master published in the *G.B.A.*, 21 (1866), 568–9, with an etched copy by Léopold Fleming. Hofstede de Groot corrected the attribution in his *catalogue raisonné* of Vermeer's works published in 1907 (vol. 1, 613, note 15; 614). It is illustrated in E. Koolhaas-Grosfeld's essay in *Op zoek naar de Gouden Eeuw; Nederlandse schilderkunst 1800–50*, exh. cat., Haarlem, 1986, 34, fig. 24. Other van der Laen paintings that show the unmistakable impact of Vermeer's *Little Street* are his untraceable picture that bears the same title as his model (repr. *ibid.*, fig. 25) and his *White House at a Tavern Door*, Aix-la Chapelle, Suermondt Museum (repr. A.B. de Vries, *Jan Vermeer van Delft* [London, *et al.*, 1948], pl. XXVIII). There are references in the literature that wrongly identify the van der Laen painting presently in the Suermondt Museum with the one now at Berlin, which Thoré-Bürger wrongly catalogued as a Vermeer when it was still in the Suermondt collection. For references to Vermeer's reputation from the time of his death until Thoré-Bürger published his pioneer study in 1866 see Chap. 7, Note 12, above.

7. Until I.H. van Eeghen recognized that these drawings are by Christiaan they were wrongly attributed to his father; see her nine articles on them in *Maandblad Amstelodamum*, 51 (1964), and her 'In mijn journaal gezet', *Amsterdam 1805–8. Het getekende dagboek van Christiaan Andriessen* (Alphen aan den Rijn, 1983).

Bibliography

The bibliography is selective. For more comprehensive lists of the vast literature the reader should consult H. van Hall, *Repertorium voor de geschiedenis der Nederlandsche schilder-en graveerkunst*, 2 vols., The Hague, 1936–49 (up to 1946), *Repertorium betreffende de Nederlands(ch)e monumenten van geschiedenis en kunst 1901–1960* (periodicals), 4 vols, The Hague, 1940–62, *Repertorium van boekwerken betreffende de Nederlandse monumenten van geschiedenis en kunst* (up to 1940), The Hague, 1950 (both the latter repertoria ed. by the Koninklijke Nederlandse Oudheidkundige Bond), and the *Bibliography of the Netherlands Institute for Art History* (1943–73/74).

The bibliography and notes supplement each other: numerous references only appear in the bibliography, and on the other hand, some studies are only cited in the notes.

The bibliographical material is arranged under the following headings:

I. GENERAL

A. GENERAL WORKS

NIJHOFF, W. *Bibliographie van Noord-Nederlandsche plaatsbeschrijvingen tot het einde der 18de eeuw*. The Hague, 1894. 2nd ed. revised by F. W. D. C. A. van Hattum. The Hague, 1953.

De Nederlands(ch)e monumenten van geschiedenis en kunst, ed. by the Rijkscommissie tot het Opmaken en Uitgeven van een Inventaris en eene Beschrijving der Nederlandsche Monumenten van Geschiedenis en Kunst. Utrecht, 1912– (in progress).

BARNOUW, A. J., and LANDHEER, B. (eds.). *The Contribution of Holland to the Sciences*. New York, 1943.
 Contains an essay by F. Lugt on Dutch art historians.

SCHMIDT-DEGENER, F. *Verzamelde studies en essays, 1, Het blijvend beeld der Hollandse kunst*. Amsterdam, 1949.
 Essays on aspects of Dutch art by a former director of the Rijksmuseum. Vol. 2 reprints the author's articles on Rembrandt.

SITWELL, S. *The Netherlands*. 2nd ed. London-New York, 1952.
 A study of aspects of art, costume, and social life, with a personal appreciation of the achievement of late seventeenth- and eighteenth-century Dutch artists and craftsmen.

GELDER, H. E. VAN. *Guide to Dutch Art*. The Hague, 1952.
 Brief survey; appendices include a list of museums and maps of provinces and cities.

GELDER, H. E. VAN, DUVERGER, J., *et al. Kunstgeschiedenis der Nederlanden van de middeleeuwen tot onze tijd*. 3rd ed. 3 vols. Antwerp-Utrecht, 1954–6.
 Articles on Dutch and Flemish art from the Middle Ages to modern times.

TIMMERS, J. J. M. *A History of Dutch Life and Art*, trans. by M. F. Hedlund. Amsterdam-Brussels, 1959.
 General survey, profusely illustrated.

GELDER, J. G. VAN. 'Two Aspects of the Dutch Baroque: Reason and Emotion', *De Artibus Opuscula XL: Essays in Honour of Erwin Panofsky*. New York, 1961.

Kunstreisboek voor Nederland. 7th rev. ed. Amsterdam-Antwerp, 1977.
 Topography of art and architecture in the manner of Dehio and *Monumentos españoles*. Often revised and reprinted.

EMMENS, J. A., and LEVIE, S. H. 'The History of Dutch Art History', *Criticism and Theory in the Arts*, ed. R. Ginsberg. Paris, 1963, reprinted in J. A. Emmens, *Kunsthistorische Opstellen*, 2. Amsterdam, 1981.

HERWIJNEN, G. VAN. *Bibliografie van de stedengeschiedenis van Nederland*. Leiden, 1978.

Art in History, History in Art: Studies in seventeenth-century Dutch culture, eds. D. Freedberg and J. de Vries. Santa Monica, 1991.

B. HISTORICAL BACKGROUND

GEYL, P. *Holland and Belgium. Their Common History and their Relations*. Leiden, 1920.

BAASCH, E. *Holländische Wirtschaftsgeschichte*. Jena, 1927.

GEYL, P. *Geschiedenis van de Nederlandsche stam*. 3 vols. Amsterdam, 1930–7.
 The author's *The Revolt of the Netherlands: 1555–1609*, 2nd corrected impression. London, 1962; *The Netherlands in the 17th Century. Part One: 1609–1648*. Rev. ed. London, 1961; *The Netherlands in the 17th Century. Part Two: 1648–1715*. London, 1964, are based on the above work.

ROMEIN, J., and ROMEIN, A. *De lage landen bij de zee. Geïllustreerde geschiedenis van het Nederlandsche volk van Duinkerken tot Delfzijl*. Utrecht, 1934.

ROMEIN, J., and SCHAPER, W. B. *De tachtigjarige oorlog: 1568–1648*. Amsterdam, 1941.

POSTHUMUS, N. W. *Nederlandsche prijsgeschiedenis*. 2 vols. Leiden, 1943.

RENIER, G. J. *The Dutch Nation*. London, 1944.

BRUGMANS, H. *Opkomst en bloei van Amsterdam*. 2nd ed., revised by A. le Cusquino de Bussy and N. W. Posthumus. Amsterdam, 1944.

CLARK, G. N. *The Seventeenth Century*. 2nd ed. Oxford, 1947.

HUIZINGA, J. 'Nederland's beschaving in de zeventiende eeuw', *Verzamelde Werken*, 2. Haarlem, 1948.
 A revised and enlarged version of the author's *Holländische Kultur des siebzehnten Jahrhunderts*, Jena, 1932. Classic survey of the culture of the period. English translation in J. Huizinga, *Dutch Civilization in the Seventeenth Century and Other Essays*, trans. A. J. Pomerans, London, 1968; New York, 1969.

BARBOUR, V. *Capitalism in Amsterdam in the Seventeenth Century* (The Johns Hopkins University Studies in Historical and Political Science, ser. 67, no. 1). Baltimore, 1950.

SLIVE, S. 'Notes on the Relationship of Protestantism to Seventeenth Century Dutch Painting', *A. Q.*, 19 (1956). Reprinted in *Seventeenth Century Art in Flanders and Holland, The Garland Library of the History of Art*, ed. H. W. Janson, 9. New York-London, 1976.

FREMANTLE, K. *The Baroque Town Hall of Amsterdam*. Utrecht, 1959.
 In addition to a detailed history of the building and its decoration, the volume includes an excellent survey of the culture that produced them.

DAVIES, D. W. *A Primer of Dutch Seventeenth Century Overseas Trade*. The Hague, 1961.

KOSSMANN, E. H. 'The Dutch Republic', *New Cambridge Modern History, 5, The Ascendancy of France, 1648–88*. Cambridge, 1961.

BOXER, C. R. *The Dutch Sea-Borne Empire: 1600–1800*. London, 1965.

HALEY, K. H. D. *The Dutch in the Seventeenth Century*. London, 1972.

PRICE, J. L. *Culture and Society in the Dutch Republic during the 17th Century*. London, 1974.

VRIES, J. DE. *The Dutch Rural Economy in the Golden Age, 1500–1700*. New Haven-London, 1974.

BURKE, P. *Venice and Amsterdam. A Study of Seventeenth-Century Elites*. London, 1974.

REGIN, D. *Traders, Artists, Burghers. A Cultural History of Amsterdam in the 17th Century*. Assen, 1976.

PARKER, G. *The Dutch Revolt*. London, 1977.
> A study that gives equal attention to events in Spain and the northern and southern Netherlands from 1549–1609.

Algemene geschiedenis der Nederlanden. 15 vols. Haarlem, 1977–83.

TAVERNE, E. R. M. *In 't land van belofte: in de nieuwe stadt. Ideaal en werkelijkheid van de stadsuitleg in de Republiek 1580–1680*. Maarssen, 1978.

BRIELS, J. C. *De Zuidnederlandse emigratie 1572–1630*. Haarlem, 1978.

William & Mary and Their House, exh. cat., The Pierpont Morgan Library, New York, 1979–80.

ISRAEL, J. I. *The Dutch Republic and the Hispanic World: 1606–1661*. Oxford, 1982.
> Valuable study of the second half of the Eighty Years' War and its immediate aftermath.

KISTENMAKER, R., and GELDER, R. VAN. *Amsterdam. The Golden Age. 1275–1795*. New York, 1983.

SCHEPPER, H. DE. *'Belgium Nostrum' 1500–1650. Over integratie en disintegratie van het Nederland*. Antwerp, 1987.

SPAANS, J. *Haarlem na de Reformatie. Stedelijke cultuur en kerkelijk leven 1577–1620*. The Hague, 1989.

ISRAEL, J. I. *Dutch Primacy in World Trade: 1585–1740*. Oxford, 1989.

ISRAEL, J. I. *Empire and Entrepôts. The Dutch, the Spanish Monarchy and the Jews: 1585–1713*. London-Ronceverte, West Virginia, 1990.

DUKE, A. *Reformation and Revolt in the Low Countries*. London-Ronceverte, West Virginia, 1990.

II. PAINTING

A. BIBLIOGRAPHIES

HALL, H. VAN. *Repertorium voor de geschiedenis der Nederlandsche schilder- en graveerkunst*. 2 vols. The Hague, 1935, 1949.
> The most comprehensive bibliography of Dutch painting and graphic arts from the twelfth century up to 1946.

Bibliography of the Netherlands Institute for Art History, 1. The Hague, 1943–73/74.
> With summaries and commentaries in English on Dutch and Flemish art (architecture excluded).

B. SOURCES AND EIGHTEENTH-CENTURY LITERATURE

MANDER, K. VAN. *Het Schilder-Boeck*. Haarlem, [1603–]1604; reprint, Utrecht, 1969. The 2nd ed., 1618, includes an anonymous biography of van Mander.
> This handbook for painters contains:
> (a) 'Den Grondt der Edel vry Schilder-Const . . .'
> (b) 'Het Leven der oude Antycke Doorluchtighe Schilders . . .'
> (c) 'Het Leven der Moderne/oft dees-tijtsche doorluchtighe Italiaensche Schilders'
> (d) 'Het Leven der Doorluchtighe Nederlandtsche en Hooghduytsche Schilders'
> (e) 'Uytleggingh Op den Metamorphosis Pub. Ovidii Nasonis'
> (f) 'Uytbeeldinge der Figueren . . .'
>
> H. Miedema, *Karel van Mander. Den grondt . . .*, 2 vols., Utrecht, 1973, includes the author's translation into modern Dutch of the work and his valuable commentaries on its text; reviewed by E. K. J. Reznicek, *O.H.*, 89 (1975). On the *Grondt* also see Miedema's article in *The Journal of the History of Ideas*, 34 (1973). The entire *Schilderboek* has not been translated. The section on 'Lives of the Netherlandish and German Painters' has been edited and translated into French by H. Hymans, 2 vols, Paris, 1884–5; into German by H. Floerke, 2 vols, Munich-Leipzig, 1906; English (unreliable) by C. van de Wall, New York, 1936. R. Hoecker, *Das Lehrgedicht des Karel van Mander (Quellenstudien zur holländischen Kunstgeschichte*, 8), The Hague, 1915, is a German translation of 'The Fundamentals of Painting'; also see O. Hirschmann, 'Beitrag zu einer Kommentar von Karel van Manders "Grondt der Edel vry Schilderconst",' *O.H.*, 33 (1915). H. Noë, *Carel van Mander en Italië*, The Hague, 1954, edits and transcribes the last chapters of van Mander's lives of the Italian artists. H. E. Greve, *De bronnen van Carel van Mander*, The Hague, 1903, is an analysis of the sources. Also cf. R. Jacobsen, *Carel van Mander (1548–1606), dichter en prozaschrijver*, Rotterdam, 1906, and the following by H. Miedema: *Kunst, kunstenaar en kunstwerk bij Karel van Mander: een analyse van zijn*

levensbeschrijvingen, Alphen aan de Rijn, 1981; *Karel van Manders' Leven der moderne, oft dees-tijtsche doorluchtighe Italiaensche schilders en hun bron*, Alphen aan de Rijn, 1984. W.S. Melion, *Shaping the Netherlandish Canon: Karel van Mander's Schilder-Boeck*, Chicago-London, 1991, argues that van Mander attempts to establish a new identity for Netherlandish art and did not work in the tradition of earlier Italian theorists.

HUYGENS, C. Fragment of an autobiography. MS. in the Royal Library, The Hague. J. A. Worp published the text in *Bijdragen en Mededeelingen van het Historisch Genootschap*, 18 (1897).
> Important references to painters active in the Netherlands *c*.1630. See J. A. Worp, 'Constantijn Huygens over de schilders van zijn tijd', *O.H.*, 19 (1891); A. H. Kan, *De jeugd van Constantijn Huygens door hemzelf beschreven*, Rotterdam, 1946 (with an essay by G. Kamphuis, 'Constantijn Huygens als kunstcriticus'); *Mijn jeugd*, trans. and commentary, C. L. Heegakkers, Amsterdam, 1987.

BUCHELL, A. VAN. *Arnoldus Buchelius, 'Res Pictoriae' (Aanteekeningen over kunstenaars en kunstwerken) 1583–1639*, ed. G. J. Hoogewerff and I. Q. van Regteren Altena. The Hague, 1928.
> Notes on artists and their work kept by an Utrecht jurist during the course of his travels in the Netherlands.

AMPZING, S. *Beschrijvinge ende lof der stad Haerlem in Holland*. Haarlem, 1628.

JUNIUS, F. *De pictura veterum*. Amsterdam, 1637; English translation by the author. *On the Painting of the Ancients*. London, 1638; Dutch translation, Middelburg, 1641.
> *Franciscus Junius, The Literature of Classical Art*, 2 vols, eds E. K. Aldrich, P. Fehl, and R. Fehl. Berkeley, etc., 1991, is a critical ed. of *The Painting of the Ancients* (vol. 1) and an annotated English translation of Junius's *Catalogus Architectorium . . .* (vol. 2).

ANGEL, P. *Lof der schilder-konst*. Leiden, 1642.
> An address in 'Praise of Painting'. Cf. H. Miedema, 'Philip Angel's "Lof der schilderkonst"', *O.H.*, 103 (1989) for an exhaustive study of the author's life and text; the latter mainly comprises stale generalizations.

ORLERS, J. J. *Beschrijvinge der stad Leyden*. Leiden, 1642.

NORGATE, EDWARD. *Miniatura or The Art of Limning*, ed. M. Hardie. Oxford, 1919.
> The edition, primarily based on a MS dateable to the late 1640s, includes recipes for painting various subjects and references to the achievement of Netherlandish artists.

PARIVAL, J. DE. *Les délices de la Hollande*. Leiden, 1651.

BIE, C. DE. *Het gulden cabinet van de edele vry schilder-const*. Antwerp, 1661. Reprint, Soest, 1971, with an introduction by G. Lemmens.
> The title page is dated 1661; the colophon is dated 1662.

MONCONYS, B. DE. *Journal des voyages*. 3 vols. Lyon, 1665–6.

FÉLIBIEN, A. *Entretiens sur les vies et les ouvrages des plus excellens peintres . . .* 5 vols. Paris, 1666–88.

BLEISWIJCK, D. VAN. *Beschrijvinge der stadt Delft*. 2 vols. Delft, 1667.

BISSCHOP, J. DE. *Signorum Veterum Icones*. The Hague, 1668–9.

BISSCHOP, J. DE. *Paradigmata Graphices Variorum*. The Hague, 1671.
> For a facsimile of both of de Bisschop's volumes and a thorough analysis of their texts see J. G. van Gelder and I. Jost, *Jan de Bisschop and his Icones and Paradigmata . . .*, ed. K. Andrews, Doornspijk, 1985.

GOEREE, W. *Inleyding tot de al-ghemeene teycken-konst*. Middelburg, 1668.

GOEREE, W. *Inleyding tot de practijck der al-gemeene schilder-konst* Middelburg, 1670. Reprint, Soest, 1974.

SANDRART, J. VON. *Teutsche Academie*. Nuremberg, 1675–9; Latin ed., 1683.
> A. R. Peltzer published an edition (Munich, 1925) with an introduction and extensive notes.

HOOGSTRATEN, S. VAN. *Inleyding tot de hooge schoole der schilder-konst anders de zichtbaere werelt*. Rotterdam, 1678. Reprint, Utrecht, 1969.
> A handbook for artists by a Rembrandt pupil. For a discussion of the volume see the essay by C. Brusati in *De zichtbare werelt. Schilderkunst uit de Gouden Eeuw in Hollands oudste stad*, exh. cat., Dordrecht, 1992–3. Also see HOOGSTRATEN under M. ARTISTS IN ALPHABETICAL SEQUENCE.

GOEREE, W. *Natuurlyk en schilderkonstig ontwerp der mensch-kunde*. Amsterdam, 1682. Reprint, Soest, 1974.

PILES, R. DE. *Abregé de la vie des peintres*. Paris, 1699.

LAIRESSE, G. DE. *Grondlegginge ter teekenkonst*. Amsterdam, 1701.

LAIRESSE, G. DE. *Het groot schilderboek*. Amsterdam, 1707. Reprint, Soest, 1969.
> Lairesse's handbooks were frequently translated and reprinted. For bibliographical references cf. J. J. M. Timmers, *Gérard Lairesse*, Amsterdam, 1942. Also see G. Kaufmann, 'Studien zum groszen Malerbuch des Gerard Lairesse', *Jahrbuch für Aesthetik und allgemeine Kunstwissenschaft*, 3 (1955–7).

HOUBRAKEN, A. *De groote schouwburgh der Nederlantsche konstschilders en schilderessen.* 3 vols. Amsterdam, 1718–21; 2nd ed., The Hague, 1753.

Indispensable. Principal source for the lives of numerous seventeenth-century Dutch and Flemish artists. The German translation by A. von Wurzbach (Vienna, 1880) emasculates this fundamental work by expurgating all passages the translator considered philosophical, anecdotal, didactic, or boring. A reprint edited by P. T. A. Swillens (3 vols, Maastricht, 1943–53) has handy indices; also reprinted, Amsterdam, 1976. See C. Hofstede de Groot, *Arnold Houbraken und seine 'Groote Schouburgh'*, The Hague, 1893, for a reliable analysis of the text and Houbraken's sources.

WEYERMAN, J. C. *De levens-beschryvingen der Nederlandsche konst-schilders en konst-schilderessen.* 4 vols. The Hague, 1729–69.

The first volumes (1729) plagiarize Houbraken; the fourth (1769) contains original material. See also D. J. H. ter Horst, 'De geschriften van Jan Campo Weyerman', *Het Boek*, 28 (1944), and T. J. Broos, *Tussen zwaart en ultramarijn. De levens van schilders beschreven door Jacob Campo Weyerman (1677–1747).* Amsterdam, 1990.

DEZALLIER D'ARGENVILLE, A. J., *Abrégé de la vie des plus fameux peintres.* 3 vols. Paris, 1745–52.

GOOL, J. VAN. *De nieuwe schouburg der Nederlantsche kunstschilders en schilderessen.* 2 vols. The Hague, 1750–1. Reprint, Soest, 1971.

Biographies of eighteenth-century arists, a continuation of Houbraken's *Groote schouburgh.* For a thorough analysis of the volumes see L. de Vries, *Diamante gedenkzuilen en leerzaeme voorbeelden: Een bespreking van Johan van Gools 'Nieuwe schouburg'*, Groningen, 1990.

HOET, G. *Catalogus of naamlyst van schilderyen.* 2 vols. The Hague, 1752.

Transcriptions of sale catalogues and collection inventories from 1684 to 1752. Continued by P. Terwesten. *Catalogus of naamlyst van schilderyen.* The Hague, 1770; the 3 vols reprinted, Soest, 1976.

DESCAMPS, J. D. *La vie des peintres flamands et hollandais.* 4 vols. Paris, 1753–63.

WAGENAAR, J. *Amsterdam, in zijne opkomst, aanwas, geschiedenissen, voorregten, koophandel, gebouwen, kerkenstaat, schoolen, schutterije, gilden en regeringe.* 4 vols. Amsterdam, 1760–88. Reprint, Alphen aan den Rijn-Amsterdam, 1971–2.

REYNOLDS, J. 'A Journey to Flanders and Holland in the Year 1781', *The Literary Works of Sir Joshua Reynolds*, vol. 2, ed. W. Beechy. London, 1890.

Notes on pictures viewed in the Netherlands.

OBREEN, F. D. O. *Archief voor Nederlandse kunstgeschiedenis.* 7 vols. Rotterdam, 1877–90. Reprint, Soest, 1976.

Collection of documents on painters, sculptors, printmakers, architects, and craftsmen.

BREDIUS, A. *Künstler-Inventare: Urkunden zur Geschichte der holländischen Kunst des XVIten, XVIIten und XVIIIten Jahrhunderts.* 8 vols. The Hague, 1915–22.

Artists' inventories, documents on their lives, and collections.

NIJSTAD, A. *Nederlandse schilders in publikaties vóór 1700: een register.* The Hague, 1978.

C. LEXICA

EIJNDEN, R. VAN, and WILLIGEN, A. VAN DER. *Geschiedenis der vaderlandsche schilderkunst sedert de helft der XVIII eeuw.* 3 vols. Haarlem, 1816–20. Supplement, 1840.

IMMERZEEL, J., JR. *De levens en werken der Hollandsche en Vlaamsche kunstschilders, beeldhouwers, graveurs en bouwmeesters.* 3 vols. Amsterdam, 1842–3.

KRAMM, C. *De levens en werken der Hollandsche en Vlaamsche kunstschilders.* 6 vols. Amsterdam, 1857–64. Reprint, Amsterdam, 1974.

BLANC, C. *Histoire des peintres de toutes les écoles depuis la Renaissance jusqu'à nos jours. École hollandaise.* 2 vols. Paris, 1867.

WURZBACH, A. VON. *Niederländisches Künstler-Lexikon.* 3 vols. Vienna-Leipzig, 1906–11.

Although superseded in many respects by later publications, it still should be consulted. Helpful biographical references and lists of works including prints by and after artists. The author's outspoken prejudices add to rather than detract from its readability.

THIEME, U., and BECKER, F. *Allgemeines Lexikon der bildender Künste.* 37 vols. Leipzig, 1907–50. Reprint, Zwickau, 1964.

More authoritative than Wurzbach but like his lexicon also superseded in some entries by later publications.

WALLER, F. G. *Biografisch woordenboek van noordnederlandsche graveurs.* The Hague, 1938.

BERNT, W. *Die niederländischen Maler des 17. Jahrhunderts.* 3 vols. Munich,

1948; vol. 4 (supplement), 1962; 3rd rev. ed., 3 vols. Munich, 1969–70, 4th rev. ed., 5 vols. Munich, 1979, incorporates Bernt's *Die niederländischen Zeichner des 17. Jahrhunderts.* 2 vols. Munich, 1957–8.

Valuable lexicon that includes large illustrations. A 3 vol. English ed. was published in London, 1970. The 4th German ed. includes works by 905 Dutch and Flemish artists.

HOLLSTEIN, F. W. H. *Dutch and Flemish Etchings, Engravings and Woodcuts,* 1–. Amsterdam, n.d. (in progress).

Alphabetically arranged list of works by Netherlandish graphic artists. Later volumes are more profusely illustrated than earlier ones.

SCHEEN, P. A. *Lexicon Nederlandse beeldende kunstenaars: 1750–1880.* The Hague, 1981.

GEALT, A. M. *Painting of the Golden Age. A Biographical Dictionary of Seventeenth-Century European Painters.* Westport, Connecticut, 1993.

D. SOCIAL AND ECONOMIC HISTORY

SCHOTEL, G. D. J. *Het oudhollandse huisgezin.* Haarlem, 1868.

SCHOTEL, G. D. J. *Het maatschappelijk leven onzer vaderen in de zeventiende eeuw.* Rotterdam, 1869.

Both studies by Schotel are still useful.

MURRIS, R. *La Hollande et les hollandais au XVIIe et au XVIIIe siècles vus par les français.* Paris, 1925.

Discussion of French travel literature with references to works of art. Well documented.

HAUSER, A. *The Social History of Art.* 2 vols. London, 1951. Reprint, 4 vols. London, 1962.

ZUMTHOR, P. *Daily Life in Rembrandt's Holland.* Trans. from the French by S. W. Taylor. London, 1962.

Useful survey of aspects of urban and rural life.

VRIES, J. DE. *The Dutch Rural Economy in the Golden Age.* New Haven, 1974.

MONTIAS, J. M. *Artists and Artisans in Delft. A Socio-Economic Study of the Seventeenth Century.* Princeton, 1982.

Detailed, documented analysis of the milieu in which artists and artisans worked.

SCHAMA, S. *The Embarrassment of Riches. An Interpretation of Dutch Culture in the Golden Age.* New York, 1987.

Cornucopian study of the relation of northern Netherlandish art to Dutch cultural values.

E. COSTUME

SCHOTEL, G. D. J. *Bijdrage tot de geschiedenis der kerkelijke en wereldlijke kleding.* The Hague, 1854.

THIENEN, F. VAN. *Das Kostüm der Blütezeit Hollands: 1600–1660.* Berlin, 1930.

Still a standard work.

THIENEN, F. VAN. 'Een en ander over de kleding van Nederlandsche boeren in de zeventiende eeuw', *Oudheidkundig Jaarboek*, 1 (1932).

KINDEREN-BESIER, J. H. DER. *Spelevaart der mode.* Amsterdam, 1950.

THIENEN, F. VAN. *The Great Age of Holland: 1600–60 (Costume of Western World Series).* London, 1951.

A brief survey.

LEVEY, S. M. *Lace, a History.* London, Victoria and Albert Museum, 1983.

WARDLE, P. 'Needle and Bobbin in Seventeenth-Century Holland', *Bulletin of the Needle and Bobbin Club*, 66 (1983).

MORTIER, B. M. DU. 'De handschoen in de huwelijkssymboliek van de zeventiende eeuw', *Bulletin van het Rijksmuseum*, 32 (1984).

WARDLE, P. 'Embroidery Most Sumptuously Wrought: Dutch Embroidery Designs in the Metropolitan Museum of Art, New York', *Bulletin of the Needle and Bobbin Club*, 69 (1986).

MORTIER, B. M. DU. 'Costume in Frans Hals', in *Hals 1989–90.*

F. ARTISTS' TRAINING, GUILDS, AND SOCIAL POSITION

WILLIGEN, A. VAN DER. *Les artistes de Harlem. Notices historiques avec un précis sur la Gilde de St. Luc.* 2nd ed. Haarlem-The Hague, 1870. Reprint, Nieuwkoop, 1970.

Documents on Haarlem artists and their training.

MULLER, FZ., S. *Schilders-vereenigingen te Utrecht. Bescheiden uit het Gemeentearchief.* Utrecht, 1880.

GRAM, J. *De schildersconfrerie Pictura en hare academie van beeldende kunsten te 's Gravenhage: 1682–1882.* Rotterdam, 1882.

History of the oldest academy in Holland.

MARTIN, W. 'The Life of a Dutch Artist in the Seventeenth Century', *B.M.*, 7 (1905); 8 (1905–6); 10 (1906–7); 11 (1907). Parts of the study are reprinted in *Seventeenth Century Art in Flanders and Holland. The Garland Library of the History of Art*, 9. New York, 1976.

HOOGEWERFF, G. J. 'Nederlandsche schilders en scholing in de 17de eeuw', *Mededeelingen van het Nederlandsch Historisch Instituut te Rome*, 9 (1929).

PEVSNER, N. *Academies of Art Past and Present.* Cambridge, 1940.
 Includes a section on Dutch guilds and academies.

OLDEWELT, W. F. H. *Het St Lucasgilde (Amsterdamsche Archiefvondsten).* Amsterdam, 1942.

HOOGEWERFF, G. J. *De geschiedenis van de St Lucasgilden in Nederland.* Amsterdam, 1947.

EMMENS, J. A., and LEMMENS, G. T. M. *De schilder in zijn wereld. Van Jan van Eyck tot Van Gogh en Ensor*, exh. cat., Delft-Antwerp, 1964–5.

EEGHEN, I. H. VAN. 'Het Amsterdamse Sint Lucasgilde in de 17de eeuw', *Jaarboek Amstelodamum*, 61 (1969).

TAVERNE, E. R. M. 'Een Amsterdams Lucasfeest in 1618', *Simiolus*, 4 (1970).

TAVERNE, E. R. M. 'Salomon de Bray and the Reorganization of the Haarlem Guild of St. Luke in 1631', *Simiolus*, 6 (1972–3).

MONTIAS, J. M. 'The Guild of St. Luke in 17th-Century Delft and the Economic Status of Artists and Artisans', *Simiolus*, 9 (1977).

BOLTEN, J. *Het Noord-en Zuidnederlandse tekenboek, 1600–1750.* Ter Aar, 1979.
 Valuable survey of drawing and model books published during the period with full bibliographical references. The author's *Method and Practices. Dutch and Flemish Drawing Books: 1600–1750*, Landau, 1985, is a revised, expanded, well-illustrated trans. of the work.

MIEDEMA, H. *De archiefbescheiden van het St Lukasgilde te Haarlem: 1497–1798.* 2 vols. Alphen aan den Rijn, 1980.
 Full transcription of the guild's existing records with commentary.

BRUYN, J. 'Rembrandt's workshop–function and production', in C. Brown, et al., *Rembrandt: The Master and His Workshop*, exh. cat., Berlin-Amsterdam-London, 1991–2.
 In addition to a survey of the master's workshop practice, includes observations on the training and working methods of artists of the period.

G. PATRONS, COLLECTING, AND THE ART TRADE

(Also see entries below under K. 1. *History*, Huis ten Bosch, and under M. PLOOS VAN AMSTEL.)

[MARTYN, T.] *The English Connoisseur: Containing an Account of Whatever is Curious in Painting, Sculpture &c. In the Palaces and Seats of the Nobility . . . of England.* 2nd rev. ed. 2 vols. Dublin, 1767. Reprint, Farnborough, Hants., 1968.

WAAGEN, G. F. *Treasures of Art in Great Britain.* 3 vols. London, 1854; suppl. vol., 1857.
 Basic for the history of collecting in Britain.

BREDIUS, A. 'De kunsthandel te Amsterdam in de XVIIde eeuw', *Amsterdamsch Jaarboekje* (1891).

FLOERKE, H. *Studien zur niederländischen Kunst- und Kulturgeschichte, Die Formen des Kunsthandels, das Atelier und die Sammler in den Niederlanden von 15.–18. Jahrhundert.* Munich-Leipzig, 1905. Reprint, Soest, 1972.
 Pioneer study that remains valuable.

HUDIG, F. W. *Frederik Hendrik en de kunst van zijn tijd.* Amsterdam, 1928.

LUGT, F. 'Italiaansche kunstwerken in Nederlandsche verzamelingen van vroeger tijden', *O.H.*, 53 (1936).

LUGT, F. *Répertoire des catalogues de ventes publiques intéressant l'art ou la curiosité.* 4 vols. The Hague-Paris, 1938–87.
 Indispensable for its lists of sale catalogues published from 1600 to 1925. Includes data on the type and number of works offered and the present location of copies of the catalogues.

SLOTHOUWER, D. F. *De paleizen van Frederik Hendrik.* Leiden, n.d. [1945].

GELDER, J. G. VAN. 'De opdrachten van de Oranjes aan Thomas Willeboirts Bosschaert en Gonzales Coques', *O.H.*, 64 (1949).

MAHON, D. 'Notes on the "Dutch Gift" to Charles II', *B.M.*, 91 (1949); 92 (1950).

THIEME, G. *Kunsthandel in den Niederlanden im 17. Jahrhundert.* Cologne, 1959.

BILLE, C. *De tempel der kunst of het kabinet van den heer Braamcamp.* Amsterdam, 1961.
 Thorough study of Braamcamp's (1699–1771) impressive cabinet which gives a vivid picture of patronage and collecting in eighteenth-century Holland. Comprehensive English summary.

BRUYN, J., and MILLAR, O. 'Notes on the Royal Collection—III: The Dutch Gift' to Charles I', *B.M.*, 104 (1962).

GELDER, J. G. VAN. '"Notes on the Royal Collection—IV: The "Dutch Gift" of 1610 to Henry, Prince of "Whalis", and Some Other "Presents", *B.M.*, 105 (1963).

The Orange and the Rose: Holland and Britain in the Age of Observation, 1600–1750, exh. cat., Victoria and Albert Museum, London, 1964.

BRUYN KOPS, C. J. DE. 'De Amsterdamse verzamelaar Jan Gildemeester Jansz', *Bulletin van het Rijksmuseum*, 13 (1965).

SNOEP, D. P. 'Honselaerdijk: restauraties op papier', *O.H.*, 84 (1969).
 A reconstruction of the architecture and decoration of Frederik Hendrik's house, Honselaerdijk.

WEIJTENS, F. H. C. *De Arundel-collectie. Commencement de la fin Amersfoort 1655.* Utrecht, 1971.

DUVERGER, E. 'Abraham van Diepenbeeck en Gonzales Coques aan het werk voor de stadhouder Frederik Hendrik, prins van Oranje', *Jaarboek van het Koninklijk Museum voor Schone Kunsten Antwerpen*, 12 (1972).

DROSSAERS, S. W. A., and LUNSINGH SCHEURLEER, TH. H., *Inventarissen de inboedels van de Oranjes . . . 1567–1795*, 1. The Hague, 1974.

BLANKERT, A. *Kunst als regeringszaak in Amsterdam in de 17de eeuw. Rondom schilderijen van Ferdinand Bol*, exh. cat., Royal Palace, Amsterdam, 1975.

LOGAN, A.-M. S. *The "Cabinet" of the Brothers Gerard and Jan Reynst.* Amsterdam-Oxford-New York, 1979.

William & Mary and Their House, exh. cat., Pierpont Morgan Library, New York, 1979.

Zo wijd de wereld strekt. Tentoonstelling naar aanleiding van de 300ste sterfdag van Johan Maurits van Nassau-Siegen op 20 december 1979, exh. cat., Mauritshuis, The Hague, 1979.

BOOGAART, E. VAN DEN, et al. *Johan Maurits van Nassau-Siegen. 1604–1679. A Humanist Prince in Europe and Brazil. Essays on the Occasion of the Tercentenary of His Death.* The Hague, 1979.

BROWN, J., and ELLIOTT, J. H. *A Palace for a King: The Buen Retiro and the Court of Philip IV.* New Haven-London, 1980.
 Includes a discussion of the landscapes ordered in Rome for Philip from Both, Swanevelt, et al.

SLIVE, S. 'Dutch Pictures in the collection of Cardinal Silvio Valenti Gonzaga (1690–1756)', *Simiolus*, 17 (1987).

VERROEN, T. L. J. '"Een verstandig ryk man", de achttiende-eeuwse verzamelaar Adriaan Leonard van Heteren', *Leids Kunsthistorisch Jaarboek*, 4 (1985), Delft, 1987.

BARGHAHN, B. VON. *Philip IV and the 'Golden House' of the Buen Retiro* (diss.). 2 vols. New York-London, 1986.

BROWN, J., and ELLIOTT, J. H. 'The Marquis of Castel Rodrigo and the Landscape Paintings in the Buen Retiro', *B.M.*, 129 (1987).

WILLIAMS, J. L. *Dutch Art and Scotland. A Reflection of Taste*, exh. cat., National Gallery of Scotland, Edinburgh, 1992.

H. RELATIONS WITH FOREIGN COUNTRIES

(Also cf. entries under I. 2. *Caravaggisti* and I. 3. *Italianate Painters and the Bentvueghels*)

GERSON, H. *Ausbreitung und Nachwirkung der holländische Malerei des 17. Jahrhunderts.* Haarlem, 1942. New ed., intro. by B. W. Meijer, Amsterdam, 1983.
 The basic study, fully documented.

DACOSTA KAUFMANN, T. *The School of Prague: Painting at the Court of Rudolf II.* Chicago-London, 1988.
 Includes comprehensive discussions and catalogues of works by Dutch artists Rudolf collected and patronized (Roelandt Savery, Hans and Paul Vredeman de Vries, et al.).

I. GENERAL HISTORY OF PAINTING

SMITH, J. *A Catalogue Raisonné of the Works of the Most Eminent Dutch, Flemish and French Painters.* 9 vols. London, 1829–42.
 Valuable for the early provenance of Dutch pictures and of interest as the first catalogue raisonné of works of many of the principal Dutch painters. The basis for Hofstede de Groot's monumental catalogue published in the following century.

NIEUWENHUYS, C. J. *A Review of the Lives and Works of Some of the Most Eminent Painters.* London. 1834.
 Includes Dutch artists. Lists current prices.

KUGLER, F. D. *Handbuch der Geschichte der Malerei.* 2 vols. Berlin, 1847. English trans. 'by a lady': *Handbook of Painting, the German, Flemish, Dutch, Spanish and French Schools*, ed. Sir E. Head. 2 vols. London, 1854.

BÜRGER, W. (Étienne Jos. Théoph. Thoré). *Les Musées de Hollande, Amsterdam et La Haye.* Paris, 1858.

The author is best known for resuscitating Vermeer (*G.B.A.*, *21*, 1866) and Frans Hals (*G.B.A.*, *24*, 1868); he is equally penetrating in this study on Dutch pictures in the museums of Holland.

WAAGEN, G. F. *Handbook of Painting. The German, Flemish and Dutch Schools.* 2 vols. London, 1860.
Based on Kugler, 1854.

FROMENTIN, E. *Les Maîtres d'autrefois Belgique-Hollande.* Paris, 1876.
Frequently translated and reprinted essay on fifteenth- and seventeenth-century Dutch and Flemish masters. *The Masters of Past Time: Dutch and Flemish Painting from Van Eyck to Rembrandt*, with an introduction and notes by H. Gerson, London, 1948, is a useful English edition. For a brilliant appraisal of Fromentin's book cf. M. Schapiro, *Partisan Review*, 16 (1949); reprinted as the introduction to an English translation of the volume, Schocken Books, New York, 1963, and in Schapiro's *Theory and Philosophy of Art: Style, Artist and Society*, New York, 1994.

HAVARD, H. *L'Art et les artistes hollandais.* 4 vols. Paris, 1879–81.

BODE, W. *Studien zur Geschichte der holländischen Malerei.* Braunschweig, 1883.
A work which laid the foundation for subsequent important studies by the author as well as for those made by other specialists in the field.

BODE, W. *Rembrandt und seine Zeitgenossen.* Leipzig, 1906.
Characterizations of the achievement of leading Dutch and Flemish Baroque painters. English translation and revised 2nd ed. (1907) by M. L. Clarke, *Great Masters of Dutch and Flemish Painting*, London-New York, 1909.

HOFSTEDE DE GROOT, C. *Beschreibendes und kritisches Verzeichnis der Werke der hervorragendsten holländischen Maler des XVII. Jahrhunderts.* 10 vols. Esslingen a N., 1907–28. English trans. of vols. 1–8 by E. G. Hawke, London, 1908–27. The English translation of vols. 1–8 was published in reduced format facsimile, 2 vols., Teaneck, New Jersey-Cambridge [England], 1976; vols. 9–10 of the German edition, which were not translated, were published in 1 vol. in the same way and year.
Indispensable, although in need of revision and in some cases superseded by subsequent studies. Includes biographies and lists of pupils and followers as well as references to untraceable or unidentified works.
Vol. 1, Jan Steen, Gabriel Metsu, Gerard Dou, Pieter de Hooch, Carel Fabritius, Johannes Vermeer.
Vol. 2, Aelbert Cuyp, Philips Wouwerman.
Vol. 3, Frans Hals, Adriaen van Ostade, Isack van Ostade, Adriaen Brouwer.
Vol. 4, Jacob van Ruisdael, Meindert Hobbema, Adriaen van de Velde, Paulus Potter.
Vol. 5, Gerard ter Borch, Caspar Netscher, Godfried Schalcken, Pieter van Slingeland, Eglon Hendrik van der Neer.
Vol. 6, Rembrandt, Nicolaes Maes.
Vol. 7, Willem van de Velde (II), Johannes van de Cappelle, Ludolf Bakhuyzen, Aert van der Neer.
Vol. 8, Jan van Goyen, Jan van der Heyden, Johannes Wijnants.
Vol. 9, Johannes Hackaert, Nicolaes Berchem, Karel du Jardin, Jan Both, Adam Pijnacker.
Vol. 10, Frans van Mieris d.A., Willem van Mieris, Adriaen van der Werff, Rachel Ruysch, J. van Huysum.

JANTZEN, H. *Niederländische Malerei im 17. Jahrhundert.* Leipzig, 1912.
Short survey, still useful for its clear exposition of stylistic changes.

BODE, W. VON. *Die Meister der holländischen und vlämischen Malerschulen.* Leipzig, 1917.
A much expanded and partly reworked edition of the author's *Rembrandt und seine Zeitgenossen*. The 8th ed., Leipzig, 1956, has helpful notes by E. Plietzsch.

MARTIN, W. *Alt-holländische Bilder.* Berlin, 1918.
For the collector.

ROH, F. *Holländische Malerei.* Jena, 1921.

FRIEDLÄNDER, M. J. *Die niederländische Malerei des 17. Jahrhunderts (Propyläen Kunstgeschichte, 12).* Berlin, 1923.

DROST, W. *Barockmalerei in den germanischen Ländern (Handbuch der Kunstwissenschaft).* Wildpark-Potsdam, 1926.

MARTIN, W. *De Hollandsche schilderkunst in de 17de eeuw.* 2 vols. Amsterdam, 1935–6; 2nd ed. Amsterdam, 1942.
These volumes (*Frans Hals en zijn tijd* and *Rembrandt en zijn tijd*), which offer a vast amount of material and extensive notes, retain their value.

GOLDSCHMIDT, A. 'Style in Dutch Painting in the Seventeenth Century', *A.Q.*, 2 (1939).

BLOCH, V. 'Die haarlemer Klassizisten', *O.H.*, 57 (1940).

REGTEREN ALTENA, I. Q. VAN. *De Nederlandse geest in de schilderkunst.* Zeist, 1941.
Essay on the essential qualities of Dutch painting.

BOON, K. G. *De schilders voor Rembrandt. De inleiding tot het bloeitijdperk.* Antwerp, 1942.
Useful short study of the transition from Late Mannerism to realism.

HUEBNER, F. M. *Nederlandsche en Vlaamsche rococo-schilders.* The Hague, 1943.

Cornelis Troost en zijn tijd, exh. cat., Museum Boymans, Rotterdam, 1946.
Brief survey of the eighteenth century.

KNOEF, J. *Tusschen rococo en romantiek.* The Hague, 1948.
Essays on Jurriaan Andriessen, Jan Ekels, Adriaan de Lelie, W. J. van Troostwijk, and others active around 1800.

STARING, A. 'Haagsche hofschilders uit de 18de eeuw', *Kunsthistorische Verkenningen*, 3 (1948).

FRIEDLÄNDER, M. J. *Landscape, Portrait, Still-life; Their Origin and Development*, trans. from the German ed. of 1947 by R. F. C. Hull. Oxford, 1949.
Essays which include penetrating observations on the treatment of the various categories of painting by the great Dutch masters.

GERSON, H. *De Nederlandse schilderkunst.* 3 vols. Amsterdam, 1950–61. (*Van Geertgen tot Frans Hals*, vol. 1, 1950; *Het tijdperk van Rembrandt en Vermeer*, vol. 2, 1952; *Voor en na Van Gogh*, vol. 3, 1961.)
Survey of six centuries of Dutch art by a leading authority.

KNUTTEL, G. WZN. *De Nederlandse schilderkunst van Van Eyck tot Van Gogh.* 2nd ed. Amsterdam, 1950.

BENTSSON, Å., and OMBERG, H. 'Structural Changes in Dutch Seventeenth Century Landscape, Still-life, Genre and Architecture Painting', *Figura*, 1 (1951).

MARTIN, W. *Dutch Painting of the Great Period: 1650–1697.* Trans. from the Dutch by D. Horning. London, 1951.
Less satisfactory than the author's other contributions to the history of Dutch painting.

VIPPER, B. R. *The Formation of Realism in Seventeenth Century Dutch Painting* (in Russian). Moscow, 1957.

PLIETZSCH, E. 'Randbemerkungen zur holländischen Malerei vom Ende des 17. Jahrhunderts', *Festschrift Friedrich Winkler*. Berlin, 1959.
An appreciation of late-seventeenth-century painters.

PLIETZSCH, E. *Holländische und flämische Maler des XVII. Jahrhunderts.* Leipzig, 1960.
Written as a supplement to Bode's *Die Meister der holländischen und vlämischen Malerschulen*. Treats painters Bode did not discuss. Lacks documentation.

MACLAREN, N. *The Dutch School.* National Gallery Catalogues. London, 1960. Revised and expanded edition by C. Brown, London, 1991.
MacLaren's catalogue set the standard for subsequent museum catalogues of Dutch painting.

DEMETZ, P. 'Defenses of Dutch Painting and the Theory of Realism', *Comparative Literature*, 15 (1962).

BROCHHAGEN, E., and KNÜTTEL, B. *Alte Pinakothek München. Katalog III. Holländische Malerei des 17. Jahrhunderts.* Munich, 1967.
Also see the museum's 1983 catalogue of its exhibited paintings.

PAUW-DE VEEN, L. DE. *De begrippen 'schilder', 'schilderij' en 'schilderen' in de zeventiende eeuw.* Brussels, 1969.

BOL, L. J. *Holländische Maler des 17. Jahrhunderts nahe den grossen Meistern: Landschaften und Stilleben.* Braunschweig, 1969.

NASH, J. M. *The Age of Rembrandt and Vermeer: Dutch Painting in the Seventeenth Century.* London, 1972.

BLANKERT, A. *Amsterdams Historisch Museum. Schilderijen daterend van voor 1800. Voorlopige catalogus.* Amsterdam, 1975–9.
Includes contributions by R. Ruurs.

Art in Seventeenth Century Holland. A Loan Exhibition, National Gallery, London, 1976.

THIEL, P. J. J. VAN, et al. *All the Paintings of the Rijksmuseum in Amsterdam.* Amsterdam-Maarssen, 1976; *First Supplement. 1976–91.* Amsterdam-The Hague, 1992.

WURFBAIN, M, I., et al. *Geschildert tot Leyden anno 1626*, exh. cat., Leiden, 1976–7.
Painting in Leiden as Rembrandt begins to find his stride.

FUCHS, R. H. *Dutch Painting.* London-New York, 1978.

KAHR, M. M. *Dutch Painting in the Seventeenth Century.* New York, etc., 1978.

WRIGHT, C. *Paintings in Dutch Museums. An Index of Oil Paintings in Public Collections in the Netherlands by Artists Born before 1870.* London-Totowa-Amsterdam, 1980.

ACKLEY, C. S. *Printmaking in the Age of Rembrandt*, exh. cat., Boston-St Louis, 1980–1.

Notable for its pithy discussions of prints by major and less well-known printmakers, many of whom were painters.

WALSH, J., JR., and SCHNEIDER, C. P. *A Mirror of Nature. Dutch Paintings from the Collection of Mr and Mrs Edward William Carter*, exh. cat., Los Angeles-Boston-New York, 1981–2; 2nd ed., Los Angeles, 1992–3.

WHITE, C. *The Dutch Pictures in the Collection of Her Majesty the Queen*. Cambridge, 1982.

With a documented study of royal connections with Dutch art from the Tudors and early Stuarts to modern times.

BOL, L. J. '*Goede onbekenden.*' *Hedendaagse herkenning en waardering van verscholen, voorbijgezien en onderschat talent*. Utrecht, 1982.

KUZNETSOV, Y., and LINNIK, I. *Dutch Paintings in Soviet Museums*. New York-Leningrad, 1982.

ALPERS, S. *The Art of Describing: Dutch Art in the Seventeenth Century*. Chicago, 1983.

Includes perceptive observations on the relationship of the arts to the natural sciences and cartography; however, the author's emphasis on the descriptive character of Dutch art is excessive and her claim that its foundation differs fundamentally from Italian art is questionable.

HOFRICHTER, F. F. *Haarlem: the Seventeenth Century*, exh. cat., Jean Voorhees Zimmerli Art Museum, New Brunswick, 1983.

HAAK, B. *The Golden Age. Dutch Painters of the Seventeenth Century*, trans. and ed. E. W. Treeman, New York, 1984.

Comprehensive history arranged by periods (*c.*1600–25; 1625–50; 1650–80) with each period sub-divided into centres of activity (Amsterdam, Haarlem, Middelburg, Utrecht, *etc.*). Bibliography includes a section on urban history, cities, and towns.

The Royal Picture Gallery. Mauritshuis, ed. H. R. Hoetink. Amsterdam-New York, 1985.

POTTERTON, H. *Dutch Seventeenth- and Eighteenth-Century Paintings in the National Gallery of Ireland*. Dublin, 1986.

SUTTON, P. C. *A Guide to Dutch Art in America*. Grand Rapids-Kampen, 1986.

Op zoek naar de Gouden Eeuw. Nederlandse schilderkunst 1800–1850, eds. L. van Tilborgh and G. Jansen, exh. cat., Frans Hals Museum, Haarlem, 1986.

CHIARINI, M. *Il secolo di Rembrandt. Pittura olandese del Seicento nelle Gallerie fiorentine*, exh. cat., Pitti Palace, Florence, 1987.

BRIELS, J. *Vlaamse schilders in de noordelijke Nederlanden in het begin van de Gouden Eeuw*. Antwerp, 1987.

BIAŁOSTOCKI, J. 'Mere Imitation of Nature or Symbolic Image of the World? Problems in the Interpretation of Dutch Painting of the XVIIth Century', *The Message of Images. Studies in the History of Art*. Vienna, 1988.

SLUYTER, E. J., *et al. Leidse fijnschilders. Van Gerrit Dou tot Frans van Mieris de Jonge. 1630–1760*, exh. cat., Leiden, 1988.

HECHT, P. *De Hollandse fijnschilders. Van Gerard Dou tot Adriaen van der Werff*, exh. cat., Rijksmuseum, Amsterdam, 1989.

GASKELL, I. *Seventeenth-Century Dutch and Flemish Painting. The Thyssen-Bornemisza Collection*. London, 1989.

CHIARINI, M. *I dipinti olandesi del seicento e del settecento. Gallerie e musei statli di Firenze*. Rome, 1989.

LE BIHAN, O. *L'or et l'ombre. La peinture hollandaise du XVIIe et du XVIIIe siècles au Musée des Beaux-Arts de Bordeaux*. Bordeaux, 1990.

JANSSEN, P. H. *Schilders in Utrecht: 1600–1700*. Utrecht, n.d. [*c.*1990].

BLANKERT, A. *Museum Bredius. Catalogus van de schilderijen en de tekeningen*. The Hague, 1991.

NIEMEIJER, J. W. *Hollandse aquarellen uit de 18de eeuw in het Rijksprentenkabinet, Rijksmuseum, Amsterdam*, exh. cat., Fondation Custodia, Paris-Rijksmuseum, Amsterdam, 1990–1.

INGAMELLS, J. *The Wallace Collection. Catalogue of Pictures. Vol. 4, Dutch and Flemish*. London, 1992.

TRNEK, R. *Die holländischen Gemälde des 17. Jahrhunderts in der Gemäldegalerie der Akademie der bildenden Künste in Wien*. Vienna, etc., 1992.

De zichtbaere werelt. Schilderkunst uit de Gouden Eeuw in Hollands oudste stad, ed. P. Marijnissen, exh. cat., Dordrechts Museum, Dordrecht, 1992–3.

Catalogue of seventeenth-century Dordrecht painters; includes essays on its figure painters, S. van Hoogstraten as art theorist, and the city's collectors.

LUIJTEN, G., SUCHTELEN, A. VAN, *et al. Dawn of the Golden Age: 1580–1620*, exh. cat., Rijksmuseum, Amsterdam, 1993–4.

The encyclopaedic catalogue offers a mine of information on the arts of the period (architecture is excluded).

1. Mannerism

KAUFFMANN, H. 'Der Manierismus in Holland und die Schule von Fontainebleau', *Jahrb. P.K.*, 44 (1923).

See the critical review by W. Stechow, *Kritische Berichte zur kunstgeschichtlichen Literatur*, 1 (1927–8).

ANTAL, F. 'Zum Problem des niederländischen Manierismus', *Kritische Berichte zur kunstgeschichtlichen Literatur*, 2 (1928–9).

BAUMGART, F. 'Zusammenhänge der niederländischen mit der italienischen Malerei in der zweiten Hälfte des 16. Jahrhunderts', *Marburger Jahrbuch für Kunstwissenschaft*, 13 (1944).

REZNICEK, E. K. J. 'Realism as a "Side Road or Byway" in Dutch Art', *Studies in Western Art, Acts of the Twentieth International Congress of the History of Art*, 2, Princeton, 1963.

Dutch Mannerism: Apogee and Epilogue, exh. cat., Vassar College Art Gallery, Poughkeepsie, N.Y., 1970.

Introduction by W. Stechow.

MIEDEMA, H. 'On Mannerism and *maniera*', *Simiolus*, 10, (1978–9).

2. Caravaggisti

VOSS, H. 'Vermeer van Delft und die Utrechter Schule', *Monatshefte für Kunstwissenschaft*, 5 (1912).

Pioneer study that recognized the connection between the Utrecht school and Vermeer.

FOKKER, T. H. 'Nederlandsche schilders in Zuid-Italië', *O.H.*, 46 (1929).

SCHNEIDER, A. VON. *Caravaggio und die Niederländer*. Marburg-Lahn, 1933.

First monograph on the subject; reprint, Amsterdam, 1967.

LONGHI, R. Introduction to exhibition *Catalogo Mostra del Caravaggio e dei Caravaggeschi*. Milan, 1951.

GELDER, J. G. VAN. Introduction to exhibition *Caravaggio en de Nederlanden*. Utrecht-Antwerp, 1952.

NICOLSON, B. *The International Caravaggesque Movement. List of Pictures by Caravaggio and His Followers throughout Europe from 1590 to 1650*. Oxford, 1979.

2nd ed., revised and enlarged by L. Vertova, Torino, 1989.

BLANKERT, A., SLATKES, L., *et al. Nieuw licht op de Gouden Eeuw. Hendrick ter Brugghen en tijdgenoten*, exh. cat., Utrecht-Braunschweig, 1986–7.

The proceedings of a symposium held in connection with the exhibition at Braunschweig was published by the Herzog Anton Ulrich-Museum (1988), ed. R. Kleesmann.

3. Italianate Painters and the Bentvueghels

BERTOLOTTI, A. *Artisti belgi ed olandesi a Roma nei secoli XVI e XVII*. Florence, 1880.

HOOGEWERFF, G. J. 'De stichting van de Nederlandsche schildersbent te Rome', *Feest-bundel Dr Abraham Bredius*. Amsterdam, 1915.

GERSTENBERG, K. *Die ideale Landschaftsmalerei, Ihre Begründung und Vollendung in Rom*. Halle, 1923.

HOOGEWERFF, G. J. *Nederlandsche kunstenaars te Rome (1600–1725). Studiën van het Nederlandsch Historisch Instituut te Rome*, 3. The Hague, 1942.

Collection of earlier articles published in the *Mededeelingen* of the Dutch Institute at Rome.

BRIGANTI, G. *I Bamboccianti*, exh. cat., Palazzo Massimo alle Colonne, Rome, 1950.

HOOGEWERFF, G. J. *De Bentvueghels*. The Hague, 1952.

Nederlanders te Rome, exh. cat., University Print Room, Leiden, 1954.

BRIGANTI, G. 'Bamboccianti', in *Encyclopedia of World Art*, 2. New York-Toronto-London, 1956.

Italy through Dutch Eyes. Dutch Seventeenth Century Landscape Artists in Italy, exh. cat., University of Michigan Museum of Art, Ann Arbor, 1964.

ZWOLLO, A. *Hollandse en Vlaamse veduteschilders te Rome: 1675–1725*. Assen, 1973.

Important contribution with monographic chapters on the principal *veduta* painters; English summary.

TILANUS, J. L. L. *Het graphische werk van drie Italianisanten: Jan Both, Nicolaes Berchem en Karel Dujardin* (diss.). Ghent, 1975.

SCHOOR, H. VAN DE. 'Bentvueghel signatures in Santa Costanza in Rome', *Mededelingen van het Nederlands Historisch Instituut te Rome*, 38 (1976).

SALERNO, L. *Pittori di paesaggio del seicento a Roma*. 3 vols, 1977–80. Bilingual text; English trans. C. Whitfield and C. Engass.

Comprehensive, well-illustrated, and documented survey.

BLANKERT, A. *Nederlandse 17e eeuwse Italianiserende landschapschilders*. Soest, 1978.
> Standard work. Revised ed. of catalogue of exhibition at Centraal Museum, Utrecht, 1965. Includes English introduction.

SCHLOSS, C. S. *Travel, Trade, and Temptation. The Dutch Italianate Harbor Scene, 1640–1680*. Ann Arbor, 1982.

BRIGANTI, G., TREZZANI, L., AND LAUREATI, L. *The Bamboccianti*, trans. R. E. Wolf. Rome, 1983.

LEVINE, D. A. *The Art of the Bamboccianti* (diss.). Princeton, 1984.

HARRIS, A. SUTHERLAND. *Landscape Painting in Rome 1595–1675*, exh. cat., R. L. Feigen, New York, 1985.

JANSEN, G., and LUIJTEN, G. *Italianisanten en Bamboccianten. Het Italianiserend landschap en genre door Nederlandse kunstenaars uit de seventiende eeuw*, exh. cat., Museum Boymans-van Beuningen, Rotterdam, 1988.

DUPARC, F. J., and GREIF, L. L. *Italian Recollections: Dutch Painters of the Golden Age*, exh. cat., Montreal Museum of Fine Arts, 1990.

I Bamboccianti: Niederländische Malerrebellen im Rom des Barock, exh. cat., eds. D. A. Levine and E. Mai, Wallraf-Richartz-Museum, Cologne-Centraal Museum, Utrecht, 1991–2.

J. ICONOGRAPHY

TIETZE-CONRAT, E. 'L'Allegorie dans la peinture classique hollandaise', *G.B.A.*, 17 (1928).

MÂLE, E. *L'Art religieux après le concile de Trente*. Paris, 1932.

RUDOLPH, H. '"Vanitas": Die Bedeutung mittelalterlicher und humanistischer Bildinhalte in der niederländischen Malerei des 17. Jahrhunderts', *Festschrift Wilhelm Pinder*. Leipzig, 1938.
> Important paper that called attention to allegorical meanings in Dutch painting which were easily overlooked by modern observers.

KNIPPING, J. B. *De iconografie van de Contra-Reformatie in de Nederlanden*. 2 vols. Hilversum, 1939–40. English translation by the author: *Iconography of the Counter Reformation in the Netherlands: Heaven on Earth*. 2 vols. Nieuwkoop-Leiden, 1974.

PRAZ, M. *Studies in Seventeenth-Century Imagery (Studies of the Warburg Institute, 3)*. 2 vols. London, 1939–47; 2nd ed., Rome, 1964.
> A study of emblem literature with extensive bibliography.

KAUFFMANN, H. 'Die fünf Sinne in der niederländischen Malerei des 17. Jahrhunderts', *Kunstgeschichtliche Studien*. Breslau, 1944.

WAAL, H. VAN DE. *Decimal Index of the Art of the Low Countries: D.I.A.L.* Published by the Rijksbureau voor Kunsthistorische Documentatie. The Hague, 1950–.
> A comprehensive iconographical index file of art in the Low Countries made up of coded postcard-size photographys.

PIGLER, A. *Barockthemen. Eine Auswahl von Verzeichnissen zur Ikonographie des 17. und 18. Jahrhunderts*. 2 vols. Budapest, 1956; 2nd ed. 3 vols, 1974.
> Lists subjects painted by Baroque artists with numerous references to Dutch painters.

HECKSCHER, W. S., and WIRTH, K.-A. 'Emblem, Emblembuch', *Reallexikon zur deutschen Kunstgeschichte*. Stuttgart, 1959.
> Exhaustive article which includes many references to Dutch art.

SLIVE, S. 'Realism and Symbolism in Seventeenth Century Dutch Painting', *Daedalus, Journal of the American Academy of Arts and Sciences* (Summer, 1962). Reprinted in *Seventeenth Century Art in Flanders and Holland, The Garland Library of the History of Art*. ed. H. W. Janson, 9. New York-London, 1976.

JONGH, E. DE. *Zinne- en minnebeelden in de schilderkunst van de seventiende eeuw*, in the series *Nederlands en Belgisch Kunstbezit uit Openbare Verzamelingen*, 1967.
> A key study that demonstrated the hardiness of emblematic references in painting of the period.

HENKEL, A., and SCHÖNE, A. *Emblemata, Handbuch zur Sinnbildkunst des XVI. und XVII. Jahrhunderts*. Stuttgart, 1967. Abridged ed. 1978.

LANDWEHR, J. *Emblem Books in the Low Countries 1554–1949. A Bibliography*. Utrecht, 1970.

JONGH, E. DE. 'Realism en schijnrealism in de schilderkunst van de zeventiende eeuw', in *Rembrandt en zijn tijd*, exh. cat., Musée des Beaux Arts, Brussels, 1971.

JONGH, E. DE. 'Grape Symbolism in Paintings of the 16th and 17th Centuries', *Simiolus*, 7 (1974).

FREEDBERG, D. 'The Problem of Images in Northern Europe and Its Repercussions in the Netherlands', *Hafnia Copenhagen Papers in the History of Art* (1976).

Wort und Bild in der niederländische Kunst und Literatur des 16. und 17. Jahrhunderts, eds. H. Vekeman and J. Müller Hofstede. Erftstadt, 1984.

SLUIJTER, E. J. *De 'heydensche fabulen' in de Noordnederlandse schilderkunst circa 1590–1670* (diss.). Leiden, 1986.
> An interpretation of depictions of narrative subjects from classical mythology.

SLUIJTER, E, J. 'Belering en verhuiling? Enkele 17de eeuwse teksten over de schilderkonst en de iconologische bandering van Noordnederlands schilderijen uit deze periode', *De seventiende eeuw*, 4 (1988).

BEDAUX, J. B. *The Reality of Symbols. Studies in the Iconology of Netherlandish Art 1400–1800*. The Hague-Maarssen, 1990.

JONGH, E. DE. 'De iconologische benadering van de zeventiende-eeuwse Nederlandse schilderkunst', *De Gouden Eeuw in perspectief. Het beeld van de Nederlandse zeventiende-eeuwse schilderkonst in later tijd*, eds. F. Grijzenhout and H. van Veen. Nijmegen-Heerlen, 1992.

SCHULZE, S., *et al. Leselust: Niederländische Malerei von Rembrandt bis Vermeer*, exh. cat., Kunsthalle, Frankfurt, 1993.
> On the iconography of the book, reading, and writing in Dutch painting.

JONGH, E. DE. *Kwesties van betekenis. Thema en motief in de Nederlandse schilderkunst van de zeventiende eeuw*. Leiden, 1995.
> Includes a reprint of nine articles and an unpublished lecture.

K. SUBJECT MATTER

1. History

(Also cf. B. HISTORICAL BACKGROUND, entry under FREMANTLE, and entries under J. ICONOGRAPHY)

MULLER, F. *Beredeneerde beschrijving van Nederlandsche historieplaten, zinneprenten en historische kaarten*. Amsterdam, 1863–82. Reprint, Amsterdam, 1970.

GELDER, J. G. VAN. 'De schilders van der Oranjezaal', *N.K.J.*, 2 (1948–9).
> Publication of documents; identification of subjects and artists of the pictures in the Oranjezaal at Huis ten Bosch which was decorated as a memorial to Frederik Hendrik. Still indispensable.

WAAL, H. VAN DE. *Drie eeuwen vaderlandsche geschied-uitbeelding, 1500–1800. Een iconologische studie*. 2 vols. The Hague, 1952.
> Fundamental study of Dutch history painting with an important discussion of the commissions for Amsterdam's town hall. Includes a full English summary.

DOHMANN, A. 'Les évenements contemporains dans la peinture hollandaise du XVIIe siècle' (trans. M. Camus), *Revue d'Histoire Moderne et Contemporaine*, 5 (1958).

BLANKERT, A. 'Heraclitus en Democritus: in het bijzonder in de Nederlandse kunst van de 17de eeuw', *N.K.J.*, 18 (1967).

SNOEP, D. P. 'Van Atlas tot last: aspecten van de betekenis van het Atlasmotief', *Simiolus*, 2 (1967–8).

LANDWEHR, J. *Splendid Ceremonies. State Entries and Royal Funerals in the Low Countries. 1515–1791. A Bibliography*. Leiden, 1971.

SNOEP, D. P. *Praal en propaganda. Triumfalia in de Noordelijke Nederlanden in de 16de en 17de eeuw*. Alphen aan den Rijn, 1975.

BUCHBINDER-GREEN, B. J. *The Painted Decorations of the Town Hall of Amsterdam*. Ann Arbor-London, 1976.

BADER, A. *The Bible through Dutch Eyes: From Genesis through the Apocrypha*, exh. cat., Milwaukee Art Center, 1976.

PETER-RAUPP, H. *Die Ikonographie des Oranjezaal*, Hildesheim-New York, 1980.

BLANKERT, A., *et al. Gods, Saints and Heroes. Dutch Painting in the Age of Rembrandt*, exh. cat., Washington-Detroit, 1980–1.
> Pathbreaking exhibition that stressed the significance of history painting during the period.

BRENNINKMEYER-DE ROOIJ, B. 'Notities betreffende de decoratie van de Oranjezaal in Huis ten Bosch, uitgaande van H. Peter-Raupp, *Die Ikonographie des Oranjezaal*, Hildesheim/New York 1980', *O.H.*, 96 (1982).

Het Oude Testament in de schilderkunst van de Gouden Eeuw, ed. C. Tümpel, exh. cat., Joods Historisch Museum, Amsterdam, 1992.

BROOS, B. *Intimacies and Intrigues. History Painting in the Mauritshuis*. The Hague, 1993.
> Catalogue of a selection of the gallery's history paintings that date from the fifteenth to the eighteenth century.

2. Literature and Theatre

(Also see entries below under M. MOEYAERT, QUAST, AND STEEN.)

GUDLAUGSSON, S. J. *Ikonographische Studien über die holländische Malerei und das Theater des 17. Jahrhunderts*. Würzburg, 1938.

GUDLAUGSSON, S. J. 'Bredero's Lucelle door eenige zeventiende eeuwsche meesters uitgebeeld', *N.K.J.*, 1 (1947).

GUDLAUGSSON, S. J. 'Representations of Granida in Dutch Seventeenth-Century Painting', *B.M.*, 90 (1948); *ibid.*, 91 (1949).

BROM, G. *Schilderkunst en literatuur in de 16e en 17e eeuw*. Utrecht, 1957.

VEEN, P. A. F. VAN. *De Soeticheydt des Buyten-Levens, vergheselschapt met de Boucken. Het hofdicht als tak van een georgische literatuur.* The Hague, 1960.

BEENING, T. J. *Het landschap in de Nederlandse letterkunde van de Renaissance.* Nijmegen, 1963.

't kan verkeren. Gerbrand Adriaensz. Bredero. 1585–1618, exh. cat., Amsterdam Historical Museum, 1968.

ALPERS, S. 'Realism as a Comic Mode: Low-Life Painting Seen through Bredero's Eyes', *Simiolus*, 8 (1975–6).
> Critical response by H. Miedama, *Simiolus*, 9 (1977); rebuttal by S. Alpers, *Simiolus*, 10 (1978–9).

GELDER, J. G. VAN. 'Pastor Fido-voorstellingen in de Nederlandse kunst van de zeventiende eeuw', *O.H.*, 92 (1978).

KETTERING, A. *The Dutch Arcadia. Pastoral Art and Its Audience in the Golden Age.* Montclair, 1983.
> Standard work that offers a thorough treatment of sources and patronage.

3. Portraiture

MULLER, F. *Beschrijvende catalogus van 7000 portretten van Nederlanders . . .* Amsterdam, 1853. Reprint, Soest, 1972.

MEIJER, D. C., JR. 'De Amsterdamsche schutters-stukken in en buiten het nieuwe Rijksmuseum', *O.H.*, 3 (1885); 4 (1886); 6 (1887); 7 (1888).

SOMEREN, J. F. VAN, ed. *Beschrijvende catalogus van gegraveerde portretten van Nederlanders . . . Vervolg op Frederik Mullers catalogus van 7000 portretten van Nederlanders.* 3 vols. Amsterdam, 1888–91.

MOES, E. *Iconographia Batava; beredeneerde lijst van geschilderde en gebeeldhouwde portretten van Noord-Nederlanders in vorige eeuwen.* 2 vols. Amsterdam, 1897–1905.
> A revised and enlarged MS copy is in the Rijksprentenkabinet, Rijksmuseum, Amsterdam.

RIEGL, A. 'Das holländische Gruppenporträt', *Jahrbuch der Kunsthistorischen Sammlungen in Wien*, 13 (1902).
> A basic work. It is not necessary to accept the author's ideas about Dutch *Kunstwollen*, which he subdivides into an Amsterdam and a Haarlem *Kunstwollen*, to profit from his keen observations on the history of Dutch group portraits from Geertgen tot Sint Jans to Rembrandt. Reprint, Vienna, 1931, 2 vols., with notes by L. Münz.

DÜLBERG, F. *Das holländische Porträt des XVII. Jahrhunderts.* Leipzig, 1923.

VRIES, A. B. DE. *Het Noord-Nederlandsch portret in de tweede helft van de 16e Eeuw.* Amsterdam, 1934.
> Includes a survey of portraitists active *c.*1600.

STARING, A. *Fransche kunstenaars en hun Hollandsche modellen, in de 18de en in den aanvang der 19de eeuw.* The Hague, 1947.
> On the vogue for French portraitists.

EDWARDS, R. *Early Conversation Pictures from the Middle Ages to about 1730.* London, 1954.
> Includes Dutch examples.

STARING, A. *De Hollanders thuis, gezelschap-stukken uit drie eeuwen.* The Hague, 1956.
> On conversation pieces, with an essay in English.

HALL, H. VAN. *Portretten van Nederlandsche beeldende kunstenaars.* Amsterdam, 1963.

WASSENBERGH, A. *De portretkunst in Friesland in de zeventiende eeuw.* Lochem, 1967.

WISHNEVSKY, R. *Studie zum 'portrait historié' in den Niederlanden* (diss.). Munich, 1967.

HAAK. B. *Regenten en regentessen, overleden en chirurgijns. Amsterdamse groepsportretten van 1600 tot 1835*, exh. cat., Amsterdam Historical Museum, 1972.

HINZ, B. 'Studien zur Geschichte de Ehepaarbildnisses', *Marburger Jahrbuch für Kunstwissenschaft*, 19 (1974).

GERSON, H. *Hollandse portretschilders van de zeventiende eeuw.* Maarssen, 1975.

In het zadel. Het Nederlandse ruiterportret van 1550 tot 1900, exh. cat., Fries Museum, Leeuwarden-Noordbrabants Museum, 's-Hertogenbosch-Provinciaal Museum van Drenthe, Assen, 1979–80.

SMITH, D. R. *Masks of Wedlock. Seventeenth-Century Dutch Marriage Portraiture.* Ann Arbor, 1982.

RAUPP, H.-J. *Untersuchungen zu Künstlerbildnis und Künstlerdarstellung in der Niederlanden im 17. Jahrhundert.* Hildesheim-Zurich-New York, 1984.

JONGH. E. DE. *Portretten van echt en trouw. Huwelijk en gezin in de Nederlandse kunst van de zeventiende eeuw*, exh. cat., Frans Hals Museum, Haarlem, 1986.

CARASSO-KOK, M., LEVY-VAN HALM, J., *et al. Schutters in Holland. Kracht en zenuwen van de stad*, exh. cat., Frans Hals Museum, Haarlem, 1988.

BIESBOER, P. 'The Burghers of Haarlem and their Portrait Painters', in Hals 1989–90.

LANGEDIJK, K. *Die Selbstbildnisse der holländischen und flämischen Kunstler in den Uffizien.* Florence, 1992.

4. Genre

BURCKHARDT, J. 'Über die niederländische Genremalerei', *Vorträge 1844–1887.* Basel, 1919.

BRIEGER, L. *Das Genrebild.* Munich, 1922.
> Dutch artists are included in this general history of European genre painting.

BUDDE, I. *Die Idylle in holländischen Barock.* Cologne, 1929.
> See the critical review by W. Stechow, *Kritische Berichte zur Kunstgeschichtlichen Literatur*, 2 (1928–9).

MÜLLER, C. 'De meesters van het Hollandsche binnenhuis', *Maandblad voor Beeldende Kunsten*, 8 (1931).

WÜRTENBERGER, F. *Das holländische Gesellschaftsbild.* Schramberg im Schwarzwald, 1937.
> Includes an account of the relation of the early realists to the Late Mannerists.

MULS, J. *De boer in de kunst.* Leuven, 1946.
> Brief account of the peasant in European art.

BAX, D. *Skilders wat vertel.* Oxford Unviersity Press, 1951.
> An inaugural lecture with observations on the connections between Bruegel's followers and the early genre painters.

PLIETZSCH, E. 'Randbemerkungen zur holländischen Interieurmalerei am Beginn des 17. Jahrhunderts', *Wallraf-Richartz-Jahrbuch*, 18 (1956).
> Mainly on the artists in Hals's circle (Dirk Hals, Buytewech, Leyster, Molenaer, Codde).

KEYSZELITZ, R. *Der 'Clavis interpretandi' in der holländischen Malerei des 17. Jahrhunderts.* Munich, 1957.
> Typewritten thesis on symbolism and allegories in Dutch genre painting.

JONGH, E. DE. 'Erotica in vogelperspectief: De dubbelzinnigheid van een reeks 17de eeuwse genrevoorstellingen', *Simiolus*, 3 (1968–9).
> On double meanings in some seventeenth-century Dutch genre paintings.

RENGER, K. *Lockere Gesellschaft – Zur Ikonographie des Verlorenen Sohnes und von Wirtshausszenen in der niederländischen Malerei.* Berlin, 1970.

SNOEP-REITSMA, E. *Verschuivende betekenissen van zeventiende-eeuwse Nederlandse genrevoorstellingen.* Deventer, 1975.

JONGH, E. DE. 'Pearls of Virtue and Pearls of Vice', *Simiolus*, 8 (1975–6).

JONGH, E. DE, *et al. Tot lering en vermaak. Betekenissen van Hollandse genrevoorstellingen uit de zeventiende eeuw*, exh. cat., Rijksmusem, Amsterdam, 1976.

JONGH, E. DE, *et al. Die Sprache der Bilder. Realität und Bedeutung in der niederländischen Malerei des 17. Jahrhunderts*, exh. cat., Herzog Anton Ulrich-Museum, Braunschweig, 1978.
> Includes essays by L. Dittrich and K. Renger.

DURANTI, M. F. *The Child in Seventeenth-Century Dutch Painting.* Ann Arbor, 1983.
> Includes observations on portraiture and genre painting.

RAUPP, H.-J. 'Aufsätze zu einer Theorie der Genremalerei in den Niederländen im 17. Jahrhundert', *Zeitschrift für Kunstgeschichte*, 26 (1983).

LIEDTKE, W. A. 'Toward a History of Dutch Genre Painting', *De arte et libris, Festschrift Erasmus 1934–1984.* Amsterdam, 1984.

BROWN, C. *Scenes of Everyday Life. Dutch Genre Painting of the Seventeenth Century.* London, 1984.

SUTTON, P., *et al. Masters of Seventeenth-Century Dutch Genre Painting*, exh. cat., Philadelphia-Berlin-London, 1984.
> Comprehensive coverage of the subject. The proceedings of a symposium held in connection with the exhibition at Berlin was published by the Staatliche Museen Preussischer Kulturbesitz (1987), eds. H. Bock and T. W. Gaehtgens, *Jahrbuch Preussischer Kulturbesitz*, Sonderband 4, 1987.

FRANITS, W. F. *Paragons of Virtue: Women and Domesticity in Seventeenth-Century Dutch Art.* New York, 1993.

5. Landscape

(Also see entries above under I. 3. *Italianate Painters and the Bentvueghels.*)

JONGH, J. DE. *Het Hollandse landschap in ontstaan en wording.* The Hague, 1903; German ed., 1905.

MICHEL, É. *Les maîtres du paysage*. Paris, 1906.

PLIETZSCH, E. *Die frankenthaler Künstlerkolonie und Gillis van Coninxloo*. Leipzig, 1910. Reprint, Soest, 1972.

BLOK, I. 'Teekeningen van Esaias van de Velde, Jan van Goyen en P. de Molyn', *Oude Kunst*, 3 (1917–8).

ROH, F. *Holländische Landschaftsmalerei des 17. Jahrhunderts*. Leipzig, 1923.

GROSSE, R. *Die holländische Landschaft Kunst, 1600–1650*. Berlin-Leipzig, 1925.

HAVELAAR, J. *De Nederlandsche landschapkunst tot het einde der zeventiende eeuw*. Amsterdam, 1931.

RACZYNSKI, J. A. *Die flämische Landschaft vor Rubens*. Frankfurt am Main, 1937.
> Study of the Late Mannerists in the southern Netherlands.

BENGTSSON, Å. *Studies on the Rise of Realistic Landscape Painting in Holland: 1610–1625 (Figura, 3)*. Stockholm, 1952.
> Discussion of the prominent role played by Haarlem landscapists. Cf. critical review by J. G. van Gelder, *B.M.*, 95 (1953), and the author's response, *ibid.*

GOMBRICH, E. H. 'Renaissance Artistic Theory and the Development of Landscape Painting', *G.B.A.*, 41 (1953). Reprinted in the author's *Norm and Form. Studies in the Art of the Renaissance*, London, 1966.
> The way art theory helped to create a clientele for early landscapists.

GELDER, H. E. VAN. *Holland by Dutch Artists in Paintings, Drawings, Woodcuts, Engravings and Etchings*. Amsterdam, 1959.
> Pictorial survey of six centuries of Dutch landscape art with a brief introduction.

STECHOW, W. 'Landscape Paintings in Dutch Seventeenth Century Interiors', *N.K.J.*, 11 (1960).

STECHOW, W. 'The Winter Landscape in the History of Art', *Criticism*, 2 (1960).
> Includes Dutch artists.

STECHOW, W. 'Significant Dates on Some Seventeenth Century Landscape Paintings', *O.H.*, 75 (1960).
> Discussion of dated works by H. Avercamp, H. Swanevelt, A. Cuyp, A. Pijnacker. Also see the author's 'Über das Verhältnis zwischen Signatur und Chronologie bei einigen holländischen Künstlern des 17. Jahrhunderts', in *Festschrift Dr. H. C. Eduard Trautscholdt*, Hamburg, 1965.

GERSON, H. Introduction to the catalogue of the exhibition *Landschap in de Nederlanden 1550–1630*. Breda-Ghent, 1961.

STECHOW, W. *Dutch Landscape Painting of the Seventeenth Century*. London, 1966. Revised ed. 1968.
> An indispensable typological study.

DATTENBERG, H. *Niederrheinansichten holländischer Künstler des 17. Jahrhunderts*. Düsseldorf, 1967.
> Compendium of Dutch landscapists who made views of the Lower Rhine region.

HASSELT, C. VAN. *Dessins de paysagistes hollandais du XVIIe siècle, de la collection particulière conservée à l'Institut nèerlandais de Paris*. 2 vols., exh. cat., Bibliothèque Royale Albert Ier, Brussels – Museum Boymans-van Beuningen, Rotterdam – Institut Néerlandais, Paris – Kunstmuseum, Bern, 1968–9.
> Exemplary entries that set the standard for subsequent Dutch drawing catalogues.

FRANZ, H. G. *Niederländische Landschaftsmalerei im Zeitalter des Manierismus*. 2 vols. Graz, 1969.

LAMBERT, A. M. *The Making of the Dutch Landscape: An Historical Geography of the Netherlands*. London, 1971.

Het Hollandse 17de eeuwse landschap, exh. cat., De Lakenhal, Leiden, 1972.

GROOT, I. DE. *Landschappen. Etsen van de Nederlandse meesters uit de zeventiende eeuw*. Maarssen, 1979.

FREEDBERG, D. *Dutch Landscape Prints of the Seventeenth Century*. London, 1980.
> Best survey of the subject.

RAUPP, H.-J. 'Zur Bedeutung von Thema und Symbol für die holländische Landschaftsmalerei des 17. Jahrhunderts', *Jahrbuch der Staatliche Kunstsammlungen in Baden-Württemberg*, 17 (1980).

HAVERKAMP-BEGEMANN, E., and CHONG, A. 'Dutch landscape painting and its associations', in *The Royal Picture Gallery. Mauritshuis*, ed. H. R. Hoetink. Amsterdam-New York, 1985.

BROWN, C., et al. *Dutch Landscape. The Early Years, Haarlem and Amsterdam 1590–1660*, exh. cat., National Gallery, London, 1986.
> Includes an English translation of van Mander's section on landscape published in his *Schilderboek*, 1604.

SUTTON, P. C., et al. *Masters of 17th-Century Landscape Painting*, exh. cat., Amsterdam-Boston-Philadelphia, 1987.
> With a comprehensive survey by Sutton and essays by S. Schama, J. A. Bruyn, and A. Chong.

SCHAPELBOUMAN, M., and SCHATBORN, P. *Land en water. Hollandse tekeningen uit de 17de eeuw in het Rijksprentenkabinet*, exh. cat., Amsterdam, 1987.

SLIVE, S. 'The Manor Kostverloren: Vicissitudes of a Seventeenth-Century Landscape Motif', *The Age of Rembrandt. Studies in Seventeenth-Century Dutch Painting. Papers in Art History from the Pennsylvania State University*, eds. R. E. Fleischer and S. S. Munshower, 3 (1988).

DUPARC, F. J. *Landscape in Perspective. Drawings by Rembrandt and His Contemporaries*, exh. cat., Cambridge, Massachusetts-Montreal, 1988.

FALKENBURG, R. 'De betekenis van de geschilderde Hollandse landschap van de zeventiende eeuw: een beschouwing naar inleiding van enkele interpretaties', *Theoretische Geschiedenis*, 18 (1989).

FALKENBURG, R. 'Landschapschilderkunst en doperse spiritualiteit in de 17de eeuw – een connectie?', *Doopgezinde Bijdragen*, new series: 16 (1990).

VIGNAU-WILBERG, T. *Das Land am Meer. Holländische Landschaft in 17. Jahrhundert*, exh. cat., Munich-Bonn, 1993.
> Survey of the subject as treated by graphic artists; most examples from the Staatlichen Graphischen Sammlungen, Munich.

BAKKER, B., LEEFLANG, H., et al. *Nederland naar 't leven: Landschappenprenten uit de Gouden Eeuw*, exh. cat., Rembrandthuis, Amsterdam, 1993.

BIZANZ-PRAKKEN, M. *Die Landschaft im Jahrhundert Rembrandts. Niederländische Zeichnungen des 17. Jahrhunderts aus der graph. Sammlungen Albertina*, exh. cat., Vienna, 1993.

LEVESQUE, C. *Journey through Landscape in Seventeenth-Century Holland. The Haarlem Print Series and Dutch Identity*. University Park, Pennsylvania, 1994.

6. Animal Painting

(Also see entries below under M. LAER, VAN, and POTTER.)

Meesterlijk vee. Nederlandse veeschilders. 1600–1900, exh. cat., Dordrecht-Leeuwarden, 1988.

7. Marine

JANTZEN, H. 'De ruimte in de Hollandsche zeeschildering', *Onze Kunst* (1910).

WILLIS, F. C. *Die niederländische Marinemalerei*. Leipzig, 1911.

PRESTON, L. *Sea and River Painters of the Netherlands in the Seventeenth Century*. London, 1937. Reprint, Leigh-on-Sea, 1980.

Maritieme geschiedenis der Nederlanden. Zeventiende eeuw, van 1585 tot ca. 1680, ed., L. M. Akveld, et al. Bussum, 1970.

BOL, L. J. *Die holländische Marinemalerei des 17. Jahrhunderts*. Braunschweig, 1973.

GROOT, I. DE, and VORSTMAN, R. *Zeilschepen prenten van de Nederlandse meesters de zestiende tot de negentiende eeuw*. Maarssen-London, 1980.

GOEDDE, L. O. *Tempest and Shipwreck in Dutch and Flemish Art. Convention, Rhetoric and Interpretation*. University Park-London, 1989.
> The volume offers a rich discussion of the poetics of marine painting and an interpretation of its metaphorical and symbolic meanings as well as its relationship to treatment of the theme in scripture and literature.

KEYES, G. S., et al. *Mirror of Empire. Dutch Marine Art of the Seventeenth Century*, exh. cat., Minneapolis-Toledo-Los Angeles, 1990–1.
> With a historical survey, essays on cartography of the period, and marine pictures within Dutch paintings.

8. Architecture and Topographical Painting

(Also see Zwollo above, under II. 1. 3. *Italianate Painters and the Bentvueghels*.)

JANTZEN, H. *Das niederländische Architekturbild*. Leipzig, 1910. Reprint, Braunschweig, 1979.
> A basic study, with a discussion of many lesser known architectural painters.

FRITZ, R. *Das Stadt- und Strassenbild in der holländischen Malerei des 17. Jahrhunderts*. Stuttgart, 1932.

Nederlandse architectuurschilders 1600–1900, exh. cat., Centraal Museum, Utrecht, 1953.

Opkomst en bloei van het Noordnederlandse stadsgezicht in de 17de eeuw. The Dutch Cityscape in the 17th Century and its Sources, exh. cat., Amsterdam Historical Museum-Art Gallery of Ontario, Toronto, 1977.

WHEELOCK, A. K., JR. *Perspective, Optics and Delft Artists around 1650*. New York-London, 1977.

Oost-Nederland model. Landschappen, stads- en dorpgezichten van de 17de–19de eeuw, exh. cat., Rijksmuseum Twenthe, Enschede, 1980.

LIEDTKE, W. A. *Architectural Painting in Delft. Gerard Houckgeest, Hendrik van*

Vliet, Emanuel de Witte. Doornspijk, 1982.
 Standard work.
GILTAIJ, J., *et al. Perspectives: Saenredam and the architectural painters of the 17th century*, exh. cat., Museum Boymans-van Beuningen, Rotterdam, 1991.

9. Still Life

SJÖBLOM, A. *Die koloristische Entwicklung des niederländischen Stillebens im 17. Jahrhunderts*. Würzburg, 1917.
WARNER, R. *Dutch and Flemish Flower and Fruit Painters of the XVIIth and XVIIIth Centuries*. Amsterdam, 1928. 2d rev. ed. 1975.
ZARNOWSKA, E. *La nature-morte hollandaise. Les principaux représentants, ses origines, son influence*. Brussels-Maastricht, 1929.
VORENKAMP, A. P. A. *Bijdrage tot de geschiedenis van het Hollandsche stilleven in de XVII eeuw*. Leiden, 1933.
GELDER, J. G. VAN. 'Van blompot en blomglas', *Elsevier's geïllustreerd maandschrift*, 46 (1936).
 Pioneer essay on origins.
BADELT, E. *Das Stilleben als bürgerliches Bildthema und seine Entwicklung von den Anfängen bis zur Gegenwart* (diss.). Munich, 1938.
GELDER, H. E. VAN. *W. C. Heda, A. van Beyeren, W. Kalf* (Palet Serie). Amsterdam, 1941.
 Essays on three important masters.
VROOM, N. R. A. *De schilders van het monochrome banketje*. Amsterdam, 1945. The author's *A Modest Message as Intimated by the Painters of the 'Monochrome Banketje'*, 2 vols, Schiedam, 1980, is a revised, expanded English edition.
LUTTERVELT, R. VAN. *Schilders van het stilleven*. Naarden, 1947.
GELDER, J. G. VAN. *Catalogue of the Collection of Dutch and Flemish Still-life Pictures, Ashmolean Museum*. Oxford, 1950.
BERGSTRÖM, I. *Dutch Still-life Painting in the Seventeenth Century*. Trans. C. Hedström and G. Taylor. New York, 1956.
 A comprehensive study.
GOMBRICH, E. H. 'Tradition and Expression in Western Still-life', *B.M.*, 103 (1961).
BERGSTÖRM, I., and WURFBAIN, M. L. *Ijdelheid der ijdelheden. Hollandse vanitas-voorstellingen uit de zeventiende eeuw*, exh. cat., De Lakenhal, Leiden, 1970.
Stilleben in Europa, exh. cat., Münster-Baden-Baden, 1979.
 Encyclopaedic treatment of the subject with contributions by twenty-six authors.
JONGH, E. DE, *et al. Still-Life in the Age of Rembrandt*, exh. cat., City Art Gallery, Auckland, 1982.
SEGAL, S. *A Flowery Past: A Survey of Dutch and Flemish Flower Painting from 1600 to the Present*, exh. cat., Gallery de Boer, Amsterdam-Noordbrabants Museum, 's-Hertogenbosch, 1982.
MAYER-MEINTSCHEL, A., KUSNEZOW, J. I., and DANILOWA, I. J. *Das Stilleben und sein Gegenstand*, exh. cat., Dresden-Leningrad-Moscow, 1983–4.
SULLIVAN, S. A. *The Dutch Gamepiece*, Totowa-Montclair, 1984.
KUILE, O. TER. *Seventeenth-century North Netherlandish Still Lifes*. The Hague, 1985.
 Catalogue of the extensive holdings of the Rijksdienst Beeldende Kunst (Netherlands Office of the Fine Arts) with an introductory essay.
KURETSKY, S. DONAHUE. 'Het schilderen van bloemen in de 17de eeuw', in *Flora & Pictura. Kunstschrift Openbaar Kunstbezit*, 1987, no. 3.
SEGAL, S. *A Prosperous Past. The Sumptuous Still Life in the Netherlands 1600–1700*, exh. cat., Delft-Cambridge, Massachusetts-Fort Worth, 1988.
WHEELOCK, A. K., JR., *et al. Still Lifes of the Golden Age. Northern European Paintings from the Heinz Family Collection*, exh. cat., National Gallery of Art, Washington, 1989.
SEGAL, S. *Flowers and Nature. Netherlandish Flower Painting of Four Centuries*, exh. cat., Osaka-Tokyo-Sydney, 1990.
SCHAMA, S. 'Perishable commodities: Dutch still-life painting and the "Empire of Things", in *Consumption and the World of Goods*, eds. V. Brewer and R. Porter. London-New York, 1993.

L. TECHNICAL STUDIES

(Also cf. entries below under M: BROUWER, REMBRANDT; H. *Technique and Technical Studies*; VERMEER, *3. Special Studies*.)

SAYRE, E. V., and LECHTMAN, H. N. 'Neutron Activation Autoradiography of Oil Paintings', *Studies in Conservation*, 13 (1968).
ASPEREN DE BOER, J. R. J. VAN. 'An Introduction to the Scientific Examination of Paintings', *N.K.J.*, 26 (1975).

BRUYN, J. 'Een onderzoek naar 17de-eeuwse schilderijformaten, voornamelijk in Noord-Nederland', *O.H.*, 93 (1979).
MIEDEMA, H. 'Verder onderzoek naar zeventiende-eeuwse schilderijformaten in Noord-Nederland', *O.H.*, 95 (1981).
BAUCH, J., and EKSTEIN, D. 'Woodbiological Investigations on Panels of Rembrandt Paintings', *Wood Science and Technology*, 15 (1981).
AINSWORTH, M. W., *et al. Art and Autoradiography. Insights into Paintings by Rembrandt, Van Dyck and Vermeer*. New York, 1982.
KLEIN, P., *et al.* 'New Findings for the Dendrochronological Dating of Panel Paintings of the 15th to 17th Century', *ICOM Committee for Restoration*, 1 (1987).
BIJL, M. '"The Meagre Company" and Frans Hals's Working Method', in *Hals* 1989–90.
GROEN, K., and HENDRIKS, E. 'Frans Hals: a Technical Examination', in *Hals* 1989–90.

M. ARTISTS IN ALPHABETICAL SEQUENCE

AELST, VAN
 Bredius, A. 'Archiefsprokkelingen. Enkele gegevens over Willem van Aelst', *O.H.*, 54 (1937).
AERTS
 Jantzen, H. 'Hendrick Aerts', *Monatshefte für Kunstwissenschaft*, 6 (1913).
 Daniëls, G. I. M. 'Kerkgeschiedenis en politiek in het perspectief van Hendrick Aerts', *Antiek*, 9 (1974–5).
ANDRIESSEN, CHRISTIAAN
 Eeghen, I. H. van. *In mijn journaal gezet, Amsterdam 1805–1808. Het getekende dagboek van Christiaan Andriessen*. Alphen aan den Rijn, 1983.
ANGEL
 Bol, L. J. 'Philips Angel van Middelburg en Philips Angel van Leiden', *O.H.*, 64 (1949).
 (Also see entries above under II. B. SOURCES AND EIGHTEENTH-CENTURY LITERATURE.)
ARENTSZ (CABEL)
 Poensgen, G. 'Arent Arentsz (genannt Cabel) und sein Verhältnis zu Hendrik Avercamp', *O.H.*, 41 (1923–4).
 Eeghen, I. H. van. 'Meerhuizen of de Pauwentuin en Arent Arentsz, genaamd Cabel', *Maandblad Amstelodamum*, 54 (1967).
 Eeghen, I. H. van, 'Nogmaals de Pauwentuin', *Maandblad Amstelodamum*, 55 (1968).
ASSELYN
 Steland-Stief, A. C. *Jan Asselijn nach 1610 bis 1652*. Amsterdam, 1971.
 Steland, A. C. *Die Zeichnungen des Jan Asselijn*. Fridingen, 1989.
AVERCAMP
 Welcker, C. J. *Hendrik Avercamp 1585–1634, bijgenaamd 'de Stomme van Campen', en Barent Avercamp, 1612–1679*. Zwolle, 1933.
 New edition, with œuvre catalogue revised by D. J. Hensbroek-van der Poel, Doornspijk, 1979.
BABUREN, VAN
 Swillens, P. T. A. 'De Schilder Theodorus (of Dirck?) van Baburen', *O.H.*, 48 (1931).
 Gowing, L. 'Light on Baburen and Vermeer', *B.M.*, 93 (1951).
 Slatkes, L. J. *Dirck van Baburen*. Utrecht, 1962.
 Monograph and handlist of authentic works. Cf. review by B. Nicolson, *B.M.*, 104 (1962).
 Slatkes, L. J. 'Additions to Dirck van Baburen', *Album Amicorum J. G. van Gelder*. The Hague, 1973.
BACKER
 Bauch, K. *Jacob Adriaensz Backer*. Berlin, 1926.
 Pioneer study with œuvre catalogue.
 Sumowski *Gemälde*. Vols. 1, 5, 6: 'Jacob Adriaensz Backer'.
BAILLY
 Boström, K. 'David Bailly's Stilleben', *Konsthistoriskt Tidskrift*, 18 (1949).
 Bruyn, J. 'David Bailly, "fort bon peintre en pourtraicts et en vie coye"', *O.H.*, 66 (1951).
 Popper-Voskuil, N. 'Self-portraiture and Vanitas Still-Life Painting in 17th-Century Holland in Reference to David Bailly's Vanitas Oeuvre', *Pantheon*, 31 (1973).
 Baar, P. J. M. de. 'Het overlijden van David Bailly', *O.H.*, 87 (1973).
 Wurfbain, M. 'David Bailly's *Vanitas* of 1651', in *The Age of Rembrandt. Studies in Seventeenth-Century Dutch Paintings*, eds. R. E. Fleischer and S. S. Munshower, *Papers in Art History from Pennsylvania State University*, 3 (1988).
BAKHUIZEN
 HdG. Vol. 7, 'Ludolf Bakhuysen'.
 Broos, B., *et al. Ludolf Bakhuizen. 1631–1708. Schryfmeester-teyckenaer-*

schilder, exh. cat., Rijksmuseum 'Nederlands Scheepvaart Museum', Amsterdam, 1985.

BAMBOCCIO *see* LAER, VAN

BEECK, VAN DER *see* TORRENTIUS

BEGA
Pearce, B. *Cornelis Bega Etchings*, exh. cat., Art Gallery of South Australia, Adelaide, 1977.
Begheyn, P. J. 'Biografische gegevens betreffende de Haarlemse schilder Cornelis Bega (ca. 1632–1664) en zijn verwanten', *O.H.*, 93 (1979).

BERCHEM
HdG. Vol. 9, 'Nicolaes Berchem'.
Sick, I. von. *Nicolaes Berchem: ein Vorläufer des Rokoko*. Cologne, 1930.
Schaar, E. 'Berchem und Begeijn', *O.H.*, 69 (1954).
 On a close follower.
Schaar, E. *Studien zu Nicolaes Berchem*. Cologne, 1958.
Kuznetsov, Y. 'Claes Berchem and his Works in the Hermitage', in *Iz istorii russkogo i zapadnoevropeiskogo iskusstva [Festschrift* for V. N. Lasareff] (Russian text). Moscow, 1960.
Schatborn, P. 'Figuurstudies van Nicolaes Berchem', *Bulletin van het Rijksmuseum*, 22 (1974).

BERCKHEYDE, GERRIT and JOB
Stechow, W. 'Job Berckheyde's "Bakery Shop"', *Allen Memorial Art Museum Bulletin*, 15 (1957).
Lawrence, C. *Gerrit Adriaensz Berckheyde (1638–1698)*. Doornspijk, 1991.

BEYEREN, VAN
Blok, I. 'Abraham van Beyeren', *Onze Kunst*, 32 (1918).
Gelder, H. E. van. *W. C. Heda, A. van Beyeren, W. Kalf (Palet Serie)*. Amsterdam, 1941.

BISSCHOP, DE
Gelder, J. G. van. 'Jan de Bisschop 1628–1671', *O.H.*, 86 (1971).
Jellema, R. E., and Plomp, M. *Episcopius: Jan de Bisschop (1628–1671)*, exh. cat., Het Rembrandthuis, Amsterdam, 1992.
 Also see entries above under II. B. SOURCES AND EIGHTEENTH-CENTURY LITERATURE.

BLOEMAERT
Müller, C. 'Abraham Bloemaert als Landschaftsmaler', *O.H.*, 44 (1927).
Delbanco, G. *Der Maler Abraham Bloemaert*. Strasbourg, 1928.
 Cf. reviews by F. Antal, *Kritische Berichte zur kunstgeschichtliche Literatur*, 2 (1928–9), and H. Kauffmann, *O.H.*, 48 (1931).
Slatkin, R. Shoolman. 'Abraham Bloemaert and François Boucher: Affinity and Relationship', *Master Drawings*, 14 (1976).
Roethlisberger, M. G., and Bok, M. J. *Abraham Bloemaert and His Sons. Paintings and Prints*. 2 vols. Doornspijk, 1993.
 Exhaustive study by Roethlisberger of works by Abraham and his sons Hendrick, Cornelis, Frederick, and Adriaen. Biographies and documents by Bok.

BOL
Bredius, A. 'Did Rembrandt Paint the Portrait of Elizabeth Bas?', *B.M.*, 20 (1911–22).
Bredius, A. 'Self-portraits by Ferdinand Bol', *B.M.*, 42 (1923).
Schneider, H. 'Ferdinand Bol als Monumentmaler im Amsterdamer Rathaus', *Jahrb. P.K.*, 47 (1926).
Blankert, A. *Ferdinand Bol (1616–1680). Rembrandt's Pupil*. Doornspijk, 1982.
 Standard monograph and catalogue.
Sumowski *Gemälde*. Vols. 1, 5, 6: 'Ferdinand Bol'.

BOR
Plietzsch, E. 'Paulus Bor', *Jahrb. P.K.*, 32 (1916).
Bloch, V. 'Zur Malerei des Paulus Bor', *O.H.*, 45 (1928).
Bloch, V. 'Orlando', *O.H.*, 64 (1949).
 Cf. a note on this article by I. Q. van Regteren Altena, *ibid.*
Gudlaugsson, S. J. 'Paulus Bor als portrettist', in *Miscellanea I.Q. van Regteren Altena*. Amsterdam, 1969.
 Attribution of portraits formerly attributed to Jan de Bray to Paulus Bor.
Moltke, J. W. von. 'Die Gemälde des Paulus Bor von Amersfoort', *Westfalen*, 55 (1977).

BORCH, GERARD AND GESINA TER
HdG. Vol. 5, 'Gerard ter Borch'.
Gudlaugsson, S. J. *Gerard ter Borch*. 2 vols. The Hague, 1959–60.
 Monograph with complete bibliography and exhaustive critical catalogue raisonné.
Vos., J. 'Gesina ter Borch: schilderes, dichteres en model (1631–1690)', *Overijssel. Jaarboek voor cultuur en historie*, 14 (1960).
Gerard ter Borch: Zwolle 1617–Deventer 1681, exh. cat., The Hague-Münster, 1974.

Kettering, A. M. *Drawings from the ter Borch Estate*. 2 vols. The Hague, 1988.
 Outstanding catalogue of more than 1000 sheets in the Prentenkabinet, Rijksmuseum, by Gerard ter Borch, his father Gerard the Elder, his sister Gesina and brother Moses as well as other members of his family and circle; includes sketchbooks and a facsimile of Gesina's poetry album.

BOSSCHAERT
Bol, L. J. *The Bosschaert Dynasty*. Leigh-on-Sea, 1960.
 Standard work on this family of painters. Also cf. the author's articles in *O.H.*, 70 (1955), 71 (1956), and *Tableau*, 3 (1980–1).

BOTH, ANDRIES and JAN
HdG. Vol. 9, 'Jan Both'.
Bruyn, L. de. 'Het geboorte jaar van Jan Both', *O.H.*, 67 (1952).
Stechow, W. 'Jan Both and the Re-Evaluation of Dutch Italianate Landscape Painting', *Actes du XVIIme Congrès International d'Histoire d l'Art*. Amsterdam, 1952; The Hague, 1955.
 Also see W. Stechow, 'Jan Both and Dutch Italianate Landscape Painting', *Magazine of Art*, 46 (1953).
Waddingham, M. R. 'Andries and Jan Both in France and Italy', *Paragone*, 15 (1964).
Haverkamp-Begemann, E. 'The Youthful Work of Andries Both: His Landscape Drawings', *Tribute to Wolfgang Stechow*. New York, 1976.
Burke, J. D. *Jan Both: Paintings, Drawings and Prints*. New York-London, 1976.

BOURSSE
Plietzsch, E. 'Jacobus Vrel und Esaias Boursse', *Zeitschrift für Kunstgeschichte*, 3 (1949).
Brière-Misme, C. 'Un "intimiste" hollandais Esaias Boursse, 1631–1672', *O.H.*, 69 (1954).

BRAMER
Wichmann, H. *Leonaert Bramer*. Leipzig, 1923.
Leonaert Bramers Zeichnungen zum Tyl Ulenspiegel, ed. E. W. Bredt. Leipzig, 1924.
Peer, A. J. J. M. van. 'Rondom Jan Vermeer: III. Leonard Bramer, leermeester van Jan Vermeer?', *O.H.*, 74 (1959).
Hofrichter, F. F., *et al. Leonaert Bramer. 1596–1674. A Painter of the Night*, exh. cat., Haggerty Museum of Art, Marquette University, Milwaukee, 1992.
Plomp, M., *et al. Leonaert Bramer, 1596–1674: Ingenious Painter and Draughtsman in Rome and Delft*, exh. cat., Het Prinsenhof, Delft, 1994.
 Includes Plomp's discussion of the artist's extensive output as draughtsman (*c.*1300 sheets), and a summary of Wichmann's painting catalogue and supplement to it.

BRAY, JAN and SALOMON DE
Moltke, J. W. von. 'Jan de Bray', *Marburger Jahrbuch für Kunstwissenschaft*, 11–12, (1938–9).
 Basic study with œuvre catalogue. For the attribution of portraits formerly ascribed to Jan de Bray to Paulus Bor, see the article by S. J. Gudlaugsson cited under BOR above.
Moltke, J. W. von. 'Salomon de Bray', *Marburger Jahrbuch für Kunstwissenschaft*, 11–12 (1938–9).
 Basic study with œuvre catalogue.
Bloch, V. 'Haarlemer klassizisten', *O.H.*, 57 (1940).
 On S. de Bray, P. de Grebber, and R. J. van Blommendael.
Marel, A. van der. 'De kunstschilders De Bray en hun familie', *De Nederlandsche Leeuw*, 81 (1964).
Taverne, E. R. M. 'Salomon de Bray's ontwerp voor de drinkhoorn van Het Loffelijke Gilde van St. Hubert te Haarlem', *N.K.J.*, 23 (1972).

BREENBERGH
Stechow, W. 'Bartholomeus Breenbergh, Landschafts- und Historienmaler', *Jahrb. P.K.*, 51 (1930).
Feinblatt, E. 'Note on Paintings by Bartholomeus Breenbergh', *A.Q.*, 12 (1949).
Bautier, P. 'Les peintres hollandais Poelenburg et Breenbergh à Florence', *Études d'Art*, 4, (1949).
Schaar, E. 'Poelenburgh und Breenbergh in Italien und ein Bild Elsheimers', *Mitteilungen des Kunsthistorischen Instituts in Florenz*, 9 (1959).
Roethlisberger, M. *Bartholomäus Breenbergh, Handzeichnungen*. Berlin, 1969.
Nalis, H. J. 'Bartholomeus Breenbergh: aantekeningen over zijn leven en verwanten', *Vereeniging tot Beoefening van Overijsselsch Regt en Geschiedenis. Verslagen en Mededelingen*, 87 (1972).
Rothlisberger, M. *Bartholomeus Breenbergh: the Paintings*. Berlin-New York, 1981.

Roethlisberger, M. 'New Works by Bartholomeus Breenbergh', *O.H.*, 99 (1985).

BREKELENKAM
Lasius, A. *Quiringh van Brekelenkam*. Doornspijk, 1992.

BRONCHORST
Hoogewerff, G. J. 'Jan Gerritsz en Jan Jansz van Bronchorst, schilders van Utrecht', *O.H.*, 74 (1959).
Judson, J. R. 'Allegory of Dawn and Night', *Wadsworth Atheneum Bulletin* (1966).
Döring, T. *Studien zur Künstlerfamilie van Bronchorst*. Alfter, 1993.

BROUWER
Unger, J. H. W. 'A. Brouwer te Haarlem', *O.H.*, 2 (1884).
HdG. Vol. 3, 'Adriaen Brouwer'.
Schmidt-Degener, F. *Adriaen Brouwer et son évolution artistique*. Brussels, 1908.
Bode, W. von. *Adriaen Brouwer, sein Leben und seine Werke*. Berlin, 1924.
Höhne, E. *Adriaen Brouwer*. Leipzig, 1960.
Knuttel, G. *Adriaen Brouwer; the Master and his Work*. Trans. J. G. Talma-Schilthuis and R. Wheaton. The Hague, 1962.
 Includes some unconvincing attributions.
Renger, K. *Adriaen Brouwer und das holländische Bauerngenre 1600–1660*, exh. cat., Alte Pinakothek, Munich, 1986.
 Best up-to-date study. Includes a valuable analysis of the material structure of the artist's paintings by H. von Sonnenburg.

BRUGGHEN, TER
Longhi, R. 'Ter Brugghen e la parte nostra', *Vita Artistica*, 2 (1927).
 Early appreciation of the artist's importance.
Baker, C. H. C. 'Hendrick Terbrugghen and plein air', *B.M.*, 50 (1927).
Stechow, W. 'Terbrugghen's S. Sebastian', *B.M.*, 96 (1954).
Nicolson, B. *Hendrick Terbrugghen*. London, 1958.
 Keen appraisal of the artist's achievement and richly documented critical catalogue of his *œuvre*. Comprehensive bibliography.
Longhi, R. 'Terbrugghen e Valentin', *Paragone*, 131 (1960).
Nicolson, B. 'Second Thoughts about Terbrugghen', *B.M.*, 102 (1960).
Slatkes, L. J. *Hendrik Terbrugghen in America*, exh. cat., Dayton-Baltimore, 1965–6.
Thiel, P. J. J. van. 'De aanbidding der koningen en ander vroeg werk van Hendrick ter Brugghen', *Bulletin van het Rijksmuseum*, 19 (1971).
Nicolson, B. 'Terbrugghen since 1960', *Album Amicorum J. G. van Gelder*. The Hague, 1973.
Jongh, E. de. *Een schilderij centraal. De slapende Mars van Hendrick ter Brugghen*, exh. cat., Centraal Museum, Utrecht, 1980.
 Also see entries above under I. *2. Caravaggisti*.

BUYTEWECH
Goldschmidt, A. 'Willem Buytewech', *Jahrb. P.K.*, 23 (1902).
 Pioneer study.
Martin, W. 'Hoe schilderde Willem Buytewech?', *O.H.*, 34 (1916).
Martin, W. 'W. Buytewech, Rembrandt en Frans Hals', *O.H.*, 42 (1925).
Poensgen, G. 'Beiträge zur Kunst des Willem Buytewech', *Jahrb. P.K.*, 47 (1926).
Knuttel, G. 'Willem Buytewech', *Mededeelingen van de Dienst voor Kunsten en Wetenschappen der Gemeente 's-Gravenhage*, no. 4, 2 (1926–31).
Knuttel, G. 'W. Buytewech: van manierisme tot naturalisme', *Mededeelingen van de Dienst voor Kunsten en Wetenschappen der Gemeente 's-Gravenhage*, no. 5–6, 2 (1926–31).
Gelder, J. G. van. 'De etsen van Willem Buytewech', *O.H.*, 48 (1931).
 For a revision of van Gelder's catalogue cf. E. Haverkamp-Begemann, 'The Etchings of Willem Buytewech' in *Prints*, New York-Chicago-San Francisco, 1962.
Haverkamp-Begemann, E. *Willem Buytewech*. Amsterdam, 1959.
 Standard work with *œuvre* catalogue.
Kunstreich, J. S. *Der 'Geistreiche Willem': Studien zu Willem Buytewech*. Kiel, 1959.
 For a critique cf. Haverkamp-Begemann's monograph cited above.
Willem Buytewech: 1591–1624, exh. cat., Rotterdam-Paris, 1974–5.

CABEL *see* ARENTSZ

CALRAET
Dalen, J. L. van. 'De familie Van Calraet', *O.H.*, 42 (1925).
Bol, L. J. '"Goede onbekenden", 2: Van Calraet en Susenier', *Tableau*, 2 (1979–80).

CAMPEN, VAN
Swillens, P. T. A. *Jacob van Campen. Schilder en bouwmeester*. Assen, 1961.
 Standard monograph on his activity as architect and painter. Reprint, Arnhem, 1979.

CAPPELLE, VAN DE
Bredius, A. 'De schilder Johannes van de Cappelle', *O.H.*, 10 (1892).

HdG. Vol. 7, 'Johannes van de Cappelle'.
Valentiner, W. R. 'Jan van de Capelle', *A.Q.*, 4 (1941).
 Identification of Bredius-Gerson 254 as a portrait of van de Cappelle by Rembrandt is not convincing.
Russell, M. *Jan van de Cappelle, 1624–1679*. Leigh-on-Sea, 1975.
 Brings HdG's catalogue up to date and adds new material.

CEULEN *see* JONSON VAN CEULEN

CLAESZ
Brunner-Bulst, M. *Pieter Claesz. Der Hauptmeister des Haarlemer Stillebens im 17. Jahrhundert*. Freren, 1989.

CODDE
Dozy, C. M. 'Pieter Codde, de schilder en de dichter', *O.H.*, 2 (1884).
Bredius, A. 'Iets over Pieter Codde en Willem DUYSTER', *O.H.*, 6 (1888).
Brandt, P., Jr. 'Notities over het leven en werk van den Amsterdamschen schilder Pieter Codde', *Historia*, 12 (1947).
Béguin, S. 'Pieter Codde et Jacob Duck', *O.H.*, 67 (1952).
 Also see entry below under DUYSTER.

CONINXLOO, VAN
Laes, A. 'Gilles van Coninxloo, rénovateur du paysage flamand au XVIe siècle', *Annuaire des Musées Royaux des Beaux-Arts de Belgique*, 2 (1939).
Franz, H. G. 'De boslandschappen van Gillis van Coninxloo en hun voorbeelden', *Bulletin Museum Boymans-van Beuningen*, 14 (1963).

COORTE
Bol, L. J. 'Adriaen Coorte, stillevenschilder', *N.K.J.*, 4, (1952–3).
Bol, L. J. *Adriaen Coorte: A Unique Late Seventeenth-Century Dutch Still-Life Painter*. Assen, 1977.

CORNELISZ VAN HAARLEM
Stechow, W. 'Cornelis van Haarlem en de Hollandsche laat-manieristiche schilderkunst', *Elsevier's geïllustreerd maandschrift*, 90 (1935).
 Pioneer paper on the history of Late Mannerism as well as Cornelis.
Bruyn, J. 'Een keukenstuk van Cornelis Cornelisz van Haarlem', *O.H.*, 66 (1951).
Thiel, P. J. J. van. 'Cornelis Cornelisz van Haarlem as a Draughtsman', *Master Drawings*, 3 (1965).
Thiel, P. J. J. van. 'Cornelis Cornelisz van Haarlem: his first ten years as a painter, 1582–1592', *Netherlandish Mannerism . . . a symposium in the Nationalmuseum Stockholm . . .* ed. G. Cavalli-Björkman. Stockholm, 1985.
McGee, J. L. *Cornelis Corneliszoon van Haarlem (1562–1638): patrons, friends and Dutch Humanists*. Nieuwkoop, 1991.
Thiel, I. and P. van. 'The Four Musketeers. An Attempt at an Identification of the First Militia Piece by Cornelis Cornelisz van Haarlem', *Shop Talk. Studies in Honor of Seymour Slive*. Cambridge, 1995
 Identification of the militia men in the painting illustrated in fig. 32.
Brière-Misme, C. 'De nouveau le maître C.B.', *La Revue des Arts*, 5 (1955).

CUYP, AELBERT and BENJAMIN
Michel, É. 'Une famille d'artistes hollandais. Les Cuyp', *G.B.A.*, 7 (1892).
HdG. Vol. 2, 'Aelbert Cuyp'.
Boström, K. 'Benjamin Cuyp', *Konsthistorisk Tidskrift*, 13 (1944).
Gelder, J. G. van, and Jost, I. 'Vroeg contact van Aelbert Cuyp met Utrecht', in *Miscellanea I.Q. van Regteren Altena*. Amsterdam, 1969.
Gelder, J. G. van, and Jost, I. 'Doorzagen op Aelbert Cuyp', *N.K.J.*, 23 (1972).
Reiss, S. *Aelbert Cuyp*. New York-Boston, 1975.
 Brief introduction; summary catalogue.
Veerman, W., et. al. *Aelbert Cuyp en zijn familie. Schilders te Dordrecht*, exh. cat., Dordrechts Museum, Dordrecht, 1977.
Ember, I. 'Rembrandtsche Elemente in den Werken Benjamin Cuyps', *Acta Historiae Artium*, 24 (1978).
Ember, I. 'Benjamin Gerritsz Cuyp (1612–1652)', *Acta Historiae Artium*, 25 (1979); part II, 'Benjamin Cuyp, der Genremaler', *Acta Historiae Artium*, 26 (1980).
Sumowski *Gemälde*. Vols. 5, 6: 'Benjamin Gerritsz Cuyp'.
Slive, S. 'Saint Philip Baptizing the Ethiopian Eunuch by Aelbert Cuyp', *The Menil Collection*. New York, 1987.
Chong, A. 'New Dated Works from Aelbert Cuyp's Early Career', *B.M.*, 133 (1991).

DELEN, VAN
Blade, T. T. *The Paintings of Dirck van Delen* (diss.). Ann Arbor, 1976.

DELFF
Franken Dz., D. *L'Oeuvre de Willem Jacobszoon Delff*. Amsterdam, 1872.
Riemsdijk, B. W. F. van. 'De portretten van Jacob Willemsz Delf, en zijne drie zonen', *O.H.*, 12 (1894).
Haverkorn van Rijsewijk, P. 'De kunstenaarsfamilie Delff', *O.H.*, 18 (1900).

DIJCK, ABRAHAM VAN
Sumowski *Gemälde*. Vols. 1, 5: 'Abraham van Dijck'.
DOOMER
Bredius, A. 'Lambert Doomer (1622–1700)', *La Revue de l'Art Ancien et Moderne*, 28 (1910).
Wortel, T. 'Lambert Doomer te Alkmaar', *O.H.*, 46 (1929).
Hofstede de Groot, C., and Speiss, W. 'Die Rheinlandschaften von Lambert Doomer', *Wallraf-Richartsz-Jahrbuch*, 3–4 (1926–7); N.F. 1 (1930).
Schulz, W. *Lambert Doomer 1624–1700. Leben und Werke* (diss.). 2 vols. Berlin, 1972.
Schulz, W. *Lambert Doomer. Sämtliche Zeichnungen*. Berlin-New York, 1974.
Schulz, W. 'Lambert Doomer als Maler', *O.H.*, 92 (1978).
Sumowski *Gemälde*. Vols. 1, 5, 6: 'Lambert Doomer'.
DOU
Martin, W. *Gerard Dou*. Trans. from the Dutch ed. of 1901 by Clara Bell. London, 1902.
HdG. Vol. 1, 'Gerard Dou'.
Martin, W. *Gerard Dou (Klassiker der Kunst, 24)*, Stuttgart-Berlin, 1913.
Still the standard work.
Snoep-Reitsma, E. 'De waterzuchtige vrouw van Gerard Dou en de betekenis van de lampetkan', in *Album Amicorum J. G. van Gelder*. The Hague, 1973.
Emmens, J. A. 'Natuur, onderwijzing en oefening. Bij een drieluik van Gerrit Dou', *Kunsthistorische opstellen*, 2. Amsterdam, 1981.
Sumowski *Gemälde*. Vols. 1, 5, 6: 'Gerard Dou'.
Sluijter, E. J. *De lof der schilderkonst. Over schilderijen van Gerrit Dou (1613–1675) en een traktaat van Philips Angel uit 1642*. Hilversum, 1993.
DROST
Valentiner, W. R. 'Willem Drost, Pupil of Rembrandt', *A.Q.*, 2 (1939).
Pont, D. 'De compositie "Ruth en Naomi" te Bremen en te Oxford. Toeschrijving aan Willem Drost', *O.H.*, 75 (1960).
Sumowski, W. 'Beiträge zu Willem Drost', *Pantheon*, 27 (1969).
Sumowski *Gemälde*. Vols. 1, 5, 6: 'Willem Drost'.
DUBBELS
Middendorf, U. *Hendrik Jacobsz Dubbels (1621–1707). Gemälde und Zeichnungen mit kritischem Oeuvrekatalog*. Freren, 1989.
DUCK
Welu, J. A. 'Card Players and Merrymakers: a Moral Lesson', *Worcester Art Museum Bulletin*, 4 (1975).
Also see entries above under CODDE.
DUJARDIN *see* JARDIN, DU
DULLAERT
Ruys, H. J. A. 'Heiman Dullaert (1636–1684)', *O.H.*, 31 (1913).
Putte, C. A. van. *Heijman Dullaert*. 2 vols. Groningen, 1978.
Study of his painting and poetry.
Sumowski *Gemälde*. Vols. 1, 5, 6: 'Heyman Dullaert'.
DUSART
Trautscholdt, E. 'Beiträge zu Cornelis Dusart', *N.K.J.*, 17 (1966).
DUYSTER
Playter, C. B. *Willem Duyster and Pieter Codde: The 'Duystere Werelt' of Dutch Genre Painting c.1625–35* (diss.). Cambridge, Massachusetts, 1972.
Also see entries above under CODDE.
ECKHOUT
Thomsen, T. *Albert Eckhout, ein niederländischer Maler und sein Gönner Moritz der Brasilianer; ein Kulturbild aus dem 17. Jahrhundert*. Copenhagen, 1938.
Gelder, H. E. van. 'Twee Braziliaanse schildpadden door Albert Eckhout', *O.H.*, 75 (1960).
EECKHOUT, VAN DEN
Sumowski, W. 'Gerbrand van den Eeckhout als Zeichner', *O.H.*, 77 (1962).
Sumowski *Gemälde*. Vols. 2, 5, 6: 'Gerbrand van den Eeckhout'.
ELIASZ *see* PICKENOY
ELINGA
Hofstede de Groot, C. 'De schilder Janssens-Elinga, een navolger van Pieter de Hooch', *O.H.*, 9 (1891).
Brière-Misme, C. 'A Dutch Intimist, Pieter Janssens Elinga', *G.B.A.* (1947. 1), (1947. 2), (1948. 1).
EVERDINGEN, ALLART and CAESAR VAN
Bruinvis, C. W. 'De Van Everdingens', *O.H.*, 17 (1899).
Granberg, O. *Allart van Everdingen*. Stockholm, 1902.
Kalff, S. 'Twee Alkmaarder schilders', *Elsevier's geïllustreerd maandschrift*, 53 (1922).

Bloch, V. 'Pro Caesar Boetius van Everdingen', *O.H.*, 53 (1936).
Davies, A. I. *Allart van Everdingen*. New York-London, 1978.
FABRITIUS, BARENT
Pont, D. *Barent Fabritius, 1624–1673*. Utrecht, 1958.
Monograph with *œuvre* catalogue and full bibliography.
Sumowski, W. 'Zum Werk von Barend und Carel Fabritius', *Jahrbuch der Staatlichen Kunstsammlungen in Baden-Württemberg*, 1 (1964).
Liedtke, W. A. 'The Three "Parables" by Barent Fabritius with a Chronological List of His Paintings from 1660 Onward', *B.M.*, 119 (1977).
Sumowski *Gemälde*. Vols. 2, 5, 6: 'Barend Fabritius'.
FABRITIUS, CAREL
HdG. Vol. 1, 'Carel Fabritius'.
Wijnman, H. F. 'De schilder Carel Fabritius', *O.H.*, 48 (1931).
Paper on his life and work.
Valentiner, W. R. 'Carel and Barent Fabritius', *The Art Bulletin*, 14 (1932).
Schuurman, K. E. *Carel Fabritius (Palet Serie)*. Amsterdam, 1947.
Wheelock, A. K. 'Carel Fabritius: Perspective and Optics in Delft', *N.K.J.*, 24 (1973).
Liedtke, W. A. 'The "View in Delft" by Carel Fabritius', *B.M.*, 118 (1976).
Brown, C. *Carel Fabritius. Complete Edition with a Catalogue Raisonné*. Oxford, 1981.
Standard work.
Sumowski *Gemälde*. Vols. 2, 5: 'Carel Fabritius'.
FLINCK
Scheltema, P. 'Govert Flinck', *Aemstel's Oudheid*, 2 (1856).
Schneider, H. 'Govert Flinck en Juriaen Ovens in het Stadhuis te Amsterdam', *O.H.*, 42 (1925).
Welcker, A. 'G. Flinck', *O.H.*, 57 (1940).
Gelder, J. G. van. 'Vroege werken van Govert Flinck', *Kunsthistorische Mededeelingen van het Rijksbureau voor Kunsthistorische Documentatie*, 1 (1946).
Moltke, J. W. von. *Govaert Flinck*. Amsterdam, 1965.
Govaert Flinck, der Kleefsche Apelles, 1610–1660, exh. cat., Haus Koekkoek, Cleves, 1965.
Sumowski *Gemälde*. Vols. 2, 5, 6: 'Govaert Flinck'.
GALEN, VAN
Plietzsch, E. 'Das Gemälde "De Rechtspleging van Graaf Willem de Goede" von Nicolaes van Galen', *Mouseion*. Cologne, 1960.
GEEST, VAN
Wassenbergh, A. 'Wybrand Simonsz van Geest' in *De portretkunst in Friesland in de zeventiende eeuw*. Lochem, 1967.
GELDER, DE
Lilienfeld, K. *Arent de Gelder*. The Hague, 1914.
Monograph with *œuvre* catalogue.
Lilienfeld, K. 'Neues über Leben und Werke Aert de Gelder', *Kunstchronik und Kunstmarkt*, 30–1 (1918–9).
Sumowski *Gemälde*. Vols. 2, 5, 6: 'Aert de Gelder'.
Moltke, J. W. von, *et al.* *Arent de Gelder: Dordrecht 1645–1727*, ed. K. L. Belkin. Doornspijk, 1994.
Standard monograph and catalogue.
GHEYN II, DE
Regteren Altena, I. Q. van. *Jacques de Gheyn. An Introduction to the Study of his Drawings*. Amsterdam, 1935.
Bergström, I. 'De Gheyn as a *Vanitas* Painter', *O.H.*, 85 (1970).
Judson, J. R. *The Drawings of Jacob de Gheyn II*. New York, 1973.
Regteren Altena, I. Q. van. *Jacques de Gheyn. Three Generations*. 3 vols. The Hague-Boston-London, 1983.
Standard study, with catalogues of works by Jacques I, Jacques II, and Jacques III.
GOLTZIUS
Hirschmann, O. *Hendrick Goltzius als Maler 1600–1617*. The Hague, 1916.
Hirschmann, O. *Hendrick Goltzius (Meister der Graphik series)*. Leipzig, 1919.
Study of the prints.
Reznicek E. K. J. 'Het begin van Goltzius' loopbaan als schilder', *O.H.*, 75 (1960).
Reznicek, E. K. J. *Die Zeichnungen von Hendrick Goltzius*. 2 vols. Utrecht, 1961.
Indispensable monograph and catalogue of the drawings. Includes a discussion of the artistic scene in the Netherlands around 1600.
Strauss, W. L. *Hendrik Goltzius, 1558–1617; the Complete Engravings and Woodcuts*. 2 vols. New York, 1977.
Bialer, N. A. *Chiaroscuro Woodcuts. Hendrick Goltzius (1558–1617) and His*

Time, exh. cat., Amsterdam-Cleveland, 1992–3.

Nichols, L. W. 'The "Pen Works" of Hendrik Goltzius', *Philadelphia Museum of Art Bulletin*, 88, nos. 373–4 (1993).

N.K.J., 42–3 (1991–2).

 The double volume is dedicated to Goltzius; includes documents, an exhaustive bibliography, and more than a dozen articles on aspects of his and his contemporaries' work.

Reznicek, E. K. J., *Goltzius Drawings Rediscovered 1962–1992*. New York, 1993.

 Supplement to the author's catalogue raisonné of 1961.

GOUDT

Reitlinger, H. S. 'Hendrik, Count Goudt', *Print Collectors Quarterly*, 8 (1921).

Weizsäcker, H. 'Hendrick Goudt', *O.H.*, 45 (1928).

Hoek, D. 'Biografische bijzonderheden over Hendrik Goudt (1583–1648)', *O.H.*, 85 (1970).

 Also see K. Andrews, *Adam Elsheimer: Paintings-Drawings-Prints*. London, 1977, *passim*, for a discussion of Goudt's seven prints after Elsheimer.

GOYEN, VAN

Bredius, A. 'Jan Josephszoon van Goyen. Nieuwe bijdragen tot zijne biographie', *O.H.*, 14 (1896).

Lugt, F. *Catalogue des œuvres de Jan van Goyen réunies par Fred. Muller & Cie au Musée Communal de la ville d'Amsterdam*. Amsterdam, 1903.

 Pioneer work.

HdG. Vol. 8, 'Jan van Goyen'.

Volhard, H. *Die Grundtypen der Landschaftsbilder Jan van Goyens und ihre Entwicklung*. Frankfurt a. M., 1927.

Gelder, J. G. van. 'Pennetegringer af Jan van Goyen', *Kunstmusetts Aarsskrift*, 24 (1937).

 Study of the early drawings.

Waal, H. van de. *Jan van Goyen* (*Palet Serie*). Amsterdam, 1941.

 Sensitive appraisal.

Beck, H.-U. 'Jan van Goyens Handzeichnungen als Vorzeichnungen', *O.H.*, 72 (1957).

Beck, H.-U. *Ein Skizzenbuch von Jan van Goyen*. The Hague, 1961.

Dobrzycka, A. *Jan van Goyen*, Poznan, 1966.

Beck, H.-U. *Jan van Goyen 1596–1656. Ein Oeuvreverzeichnis*, vols. 1 & 2, Amsterdam, 1972; vol. 3, Doornspijk, 1987; vol. 4, *Die Künstler um Jan van Goyen*, Doornspijk, 1991.

 Standard catalogue raisonné of the artist's prodigious production as painter and draughtsman, and of works by the many landscapists in his circle.

GREBBER, PIETER DE

Bloch, V. 'Haarlemer klassizisten', *O.H.*, 57 (1940).

Thiel, P. J. J. van. 'De Grebbers regels van de kunst', *O.H.*, 80 (1965).

Dirkse, P. 'Pieter de Grebber: Haarlems schilder tussen begijnen, kloppen en pastoors', *Jaarboek Haarlem* (1978).

HAAGEN, VAN DER

Haggen, J. K. van der. *De schilders van der Haagen en hun werk. Met catalogus van de schilderijen en teekeningen van Joris van der Haagen*. Voorburg, 1932.

HACKAERT

HdG. Vol. 9, 'Johannes Hackaert'.

Pfister, M. 'Trasimenischer See oder Zürichsee? Zu einem Gemälde von Jan Hackaert im Rijksmuseum Amsterdam', *Bulletin van het Rijksmuseum*, 20 (1972).

Solar, G. *Jan Hackaert. Die schweizer Ansichten: 1653–1656. Zeichnungen eines niederländischen Malers als frühe Bilddokumente der Alpenlandschaft*. Zurich, 1981.

 Authoritative study of the Swiss views with fine facsimiles.

HALS, DIRCK

Bürger, W. [É. J. T. Thoré]. 'Dirk Hals et les fils de Frans Hals', *G.B.A.*, 25 (1868).

Bredius, A. 'Archiefsprokkels betreffende Dirck Hals', *O.H.*, 41 (1923–4).

Schatborn, P. 'Olieverfschetsen van Dirck Hals', *Bulletin van het Rijksmuseum*, 21 (1973).

HALS, FRANS

1. Documents and Literary Sources

Thiel-Stroman, I. van. 'The Frans Hals Documents: Written and Printed Sources, 1582–1679', in *Hals 1989–90*.

 Transcription and commentary, with full bibliographical references, of all the known written documents and printed texts related to the artist and his family. Includes hitherto unpublished documents.

Houbraken, A. *De groote schouburgh*, 1. Amsterdam, 1718.

 The Dutch edition of *Hals 1989–90* transcribes Houbraken's

biography. English, French, and German translations are in editions of the catalogue published in those languages.

2. Painting Catalogues

Moes, E. W. *Frans Hals, sa vie et son œuvre*. Brussels, 1909.

HdG. Vol. 3, 'Frans Hals'.

Bode, W. von, and Binder, M. J. *Frans Hals*. 2 vols. Berlin, 1914.

Valentiner, W. R. *Frans Hals* (*Klassiker der Kunst*). 2nd ed. Berlin-Leipzig, 1923.

 Valentiner published additions to his corpus in *Art in America*, 16 (1928), 23 (1935).

Valentiner, W. R. *Frans Hals Paintings in America*. Westport, Connecticut, 1936.

Trivas, N. S. *The Paintings of Frans Hals*. New York, 1941.

Slive, S. *Frans Hals*. 3 vols. London-New York, 1970–4.

 Monograph and catalogue raisonné; includes a discussion of drawings variously attributed to Hals. The critical review by B. P. J. Broos (*Simiolus*, 10 [1978–9]) introduces new data and fresh observations.

Montagni, E. C. *Tout l'œuvre peint de Frans Hals*. Paris, 1976 (trans. by S. Darses of Italian ed., Milan, 1974).

Grimm, C. *Frans Hals, Das Gesamtwerk*. Stuttgart-Zurich, 1989.

 For comments on this volume see Chap. 4, Note 11 above.

3. Monographs and Studies

Bürger, W. [É. J. T. Thoré]. 'Frans Hals', *G.B.A.*, 24 (1868).

 Pioneer study that helped establish Hals's international reputation.

Bode, W. *Frans Hals und seine Schule*. Leipzig, 1871.

 Bode's dissertation. Reprinted in *Jahrbuch für Kunstwissenschaft*, 4 (1871).

Bredius, A. 'Heeft Frans Hals zijn vrouw geslagen?', *O.H.*, 39 (1921).

 Establishes that Frans Cornelisz Hals, a weaver, not Frans Fransz Hals, the painter, was asked to appear before the Haarlem authorities for cruelty to his wife.

Schmidt-Degener, F. *Frans Hals*. Amsterdam, 1924.

Dülberg, F. *Frans Hals: ein Leben und ein Werk*. Stuttgart, 1930.

Baard, H. P. *Frans Hals, the Civic Guard Portrait Groups*. Amsterdam-Antwerp, 1949.

 Translation of Dutch ed. of 1948.

Valkenburg, C. C. van. 'De Haarlemse schuttersstukken 1: Maaltijd van officieren van de Sint Jorisdoelen (Frans Hals, 1616). Identificatie der voorgestelde schuttersofficieren', *Haerlem Jaarboek 1958*. Haarlem, 1959; 'De Haarlemse schuttersstukken 4: Maaltijd van officieren van de Sint Jorisdoelen (Frans Hals, 1627); 5: Maaltijd van officieren van de Cluveniersdoelen (Frans Hals, 1627); 6: Officieren en onderofficieren van de Cluveniersdoelen (Frans Hals, 1633); 7: Officieren en onderofficieren van de Sint Jorisdoelen (Frans Hals, 1639)', *Haerlem Jaarboek 1961*. Haarlem, 1962.

 Publication of documents identifying most of the officers in the group portraits Hals painted of Haarlem's civic guards.

Linnik, I. 'Newly Discovered Paintings by Frans Hals', *Iskusstvo*, no. 10 (1959) (Russian text).

 Publication of Hals's *St Luke* and *St Matthew* at Odessa. Also see Linnik's note in *Soobcheniia Gosudarstvennogo Ermitazha*, 17 (1960) (Russian text).

Jongh, E. de, and Vinken, P. J. 'Frans Hals als voortzetter van een emblematische traditie', *O.H.*, 76 (1961).

 On emblematic meanings in Hals's *Portrait of a Married Couple* (Amsterdam).

Slive, S. 'Frans Hals Studies', *O.H.*, 76 (1961).

 1. Juvenalia; 2. *St Luke* and *St Matthew* at Odessa; 3. Jan Franszoon Hals.

Thiel, P. J. J. van. 'Frans Hals portret van de leidse rederijkersnar Pieter Cornelisz. van der Morsch alias Piero (1543–1628)', *O.H.*, 76 (1961).

 On the iconography of the portrait of van der Morsch at Pittsburgh.

Frans Hals, exh. cat., Haarlem, 1962 (introd. H. P. Baard; cat. S. Slive).

Slive, S. *Frans Hals: Das Festmahl der St. Georgs-Schützengilde, 1616*. Stuttgart, 1962.

Slive, S. 'On the Meaning of Frans Hals' *Malle Babbe*', *B.M.*, 105 (1963).

Vinken P. J., and Jongh, E. de. 'De boosaardigheid van Hals' regenten en regentessen', *O.H.*, 78 (1963).

 A valuable history of the criticism of Hals's late group portraits, but the authors' argument that portraitists cannot portray even an aspect of a sitter's character is not convincing.

Kauffmann, H. 'Die Schützenbilder des Frans Hals', in *Walter*

Friedlaender zum 90. Geburtstag. Berlin, 1965.

Grimm, C. 'Frans Hals und seine 'Schule'',' *Münchner Jahrbuch der bildenden Kunst*, 22 (1971).
 For a review of the author's effort to ascribe paintings to the 'Fisherchildren Master', Judith Leyster, Jan Hals, and Frans Hals the Younger see Slive 1970–4, 3, under cat. no. 155.

Grimm, C. *Frans Hals. Entwicklung, Werkanalyse, Gesamtkatalog*. Berlin, 1972.
 Includes a chronological list of works accepted by the author.

Boot, M. 'Über Willem van Heythuysen, seinen Nachlass und die symbolische Bedeutung des Porträts von Frans Hals in München', *Pantheon*, 31 (1973).

Jowell, F. S. 'Thoré-Bürger and the Revival of Frans Hals', *The Art Bulletin*, 56 (1974).

Eeghen, I. H. van. 'Pieter Codde en Frans Hals', *Maandblad Amstelodamum*, 61 (1974).
 Includes a review of Slive 1970–4.

Grimm, C. 'St Markus von Frans Hals', *Maltechnik/Restauro*, 1 (1974).
 Publication and report of the restoration of Hals's *St Mark*.

Baard, H. P. *Frans Hals*, trans. George Stuyk. New York-London, 1981.

Damsté, P. H. 'De geschiedenis van het portret van Jaspar Schade door Frans Hals', *O.H.*, 99 (1985).

Hals 1989–90 (Slive, S., *et al.*, *Frans Hals*, exh. cat., Washington-London-Haarlem, 1989–90).
 Includes articles by P. Biesboer (Haarlem portraitists and their patrons), B. M. du Mortier (costume in Hals), F. Jowell (the rediscovery of Hals), K. Levy-van Halm (Hals as militiaman and painter), M. Bijl ('The Meagre Company' and Hals's working method), K. Groen and E. Hendriks (report on technical examinations of Hals's paintings), and I. van Thiel-Stroman's compilation of the Hals documents.

Köhler, N., and Levy-van Halm, K. *Frans Hals. Militia Pieces*. Antwerp, 1990.

HANNEMAN
Kuile, O. ter. *Adriaen Hanneman 1604–1671; een Haags portretschilder*. Alphen aan den Rijn, 1976.

HEDA
Gelder, H. E. van. *W. C. Heda, A. van Beyeren, W. Kalf (Palet Serie)*. Amsterdam, 1941.

HEEM, DE
Toman, H. 'Über die Malerfamilie De Heem', *Repertorium für Kunstwissenschaft*, 11 (1888).

Bergström, I. 'De Heem's Painting of His First Dutch Period', *O.H.*, 71 (1956).

Mirimonde, A. P. de. 'Musique et symbolisme chez Jan-Davidszoon de Heem, Cornelis-Janszoon et Jan II Janszoon de Heem', *Jaarboek van het Koninklijk Museum voor Schone Kunsten Antwerpen*, 10 (1970).

Segal, S. *Jan Davidsz de Heem en zijn kring*, exh. cat., Utrecht-Braunschweig, 1991.

HELST, VAN DER
Gelder, J. J. de. *Bartholomeus van der Helst*. Rotterdam, 1921.
 Monograph with œuvre catalogue.

HELT STOCKADE, VAN
Moes, E. W. 'Nicolaes van Helt Stocade', *Amsterdamsch Jaarboekje* (1902).

Demonts, L. 'Nicolas van Helt Stockade. Nimègue 1614, enterré à Amsterdam le 26 Nov. 1669', *Revue de l'Art Ancien*, 68 (1935).

HEYDEN, VAN DER
Breen, J. C. 'Jan van der Heyden', *Jaarboek van het genootschap Amstelodamum*, 11 (1913).

Bode, W. von. 'Jan van der Heyden', *Zeitschrift für bildende Kunst*, 26 (1915).

HdG. Vol. 8, 'Jan van der Heyden'.

Jan van der Heyden, exh. cat., Amsterdam Historical Museum, Amsterdam, 1937.

Kleyn, A. R. 'Jan van der Heyden', *Sibbe*, 2 (1944).

Wagner, H. *Jan van der Heyden: 1637–1712*. Amsterdam-Haarlem, 1971.
 Monograph with œuvre catalogue.

Vries, L. de. *Jan van der Heyden*. Amsterdam, 1984.

HOBBEMA
Michel, É. *Hobbema et les paysagistes de son temps en Hollande*. Paris, 1890.

HdG. Vol. 4, 'Meindert Hobbema'.

Bredius, A. 'Uit Hobbema's laatste levensjaren', *O.H.*, 28 (1910), also cf. 29 (1911); 33 (1915).

Rosenberg, J. 'Hobbema', *Jahrb. P.K.*, 48 (1927).

Broulhiet, G. *Meindert Hobbema*. Paris, 1938.
 Many unconvincing attributions; see the critical review by K. E.

Simon, *Zeitschrift für Kunstgeschichte*, 9 (1940). Remains useful for its numerous illustrations.

Gerson, H. 'Een Hobbema van 1665', *Kunsthistorische Mededeelingen van het Rijksbureau voor Kunsthistorische Documentatie*, 2 (1947).
 Relation of some landscapes to one dated 1665 (Zürich, Ruzicka Collection).

Stechow, W. 'The Early Years of Hobbema', *A.Q.*, 22 (Spring 1959).
 Important study on the artist's early development.

Imdahl, M. 'Ein Beitrag zu Meindert Hobbemas Allee von Middelharnis', *Festschrift Kurt Badt*. Berlin, 1961.

HONDECOETER, DE
Bredius, A. 'De schilders Melchior de Hondecoeter en Johan le Ducq', *Archief voor Nederl. Kunstgeschiedenis*, ed. F. D. O. Obreen, 5 (1882–3).

HONTHORST, VAN
Hoogewerff, G. J. *Gherardo delle Notti*. Rome, 1924.

Millar, O. 'Charles I, Honthorst, and Van Dyck', *B.M.*, 96 (1954).

Reznicek, E. K. J. 'Een vroeg portret van Gerard van Honthorst', *O.H.*, 70 (1955).

Judson, J. R. *Gerrit van Honthorst. A Discussion of His Position in Dutch Art*. The Hague, 1959.

Braun, H. *Gerard und Willem van Honthorst*. Göttingen, 1966.

Reznicek, E. K. J. 'Hont Horstiana', *N.K.J.*, 23 (1972).

Meyere, J. A. L. de. 'Nieuwe gegevens over Gerard van Honthorst's beschilderd plafond uit 1622', *Jaarboek Oud-Utrecht* (1976).

HOOCH, DE
HdG. Vol. 1, 'Pieter de Hooch'.

Baker, C. H. C. *Pieter de Hooch*. London, 1925.

Valentiner, W. R. 'Pieter de Hooch', *Art in America*, 15 (1927).

Valentiner, W. R. 'Dutch Genre Painters in the Manner of de Hooch', *Art in America*, 17 (1928).

Valentiner, W. R. *Pieter de Hooch (Klassiker der Kunst)*. Stuttgart, 1929.

Thienen, F. van. *Pieter de Hooch (Palet Serie)*. Amsterdam, 1945.

Sutton, P. C. *Pieter de Hooch, Complete Edition*. Ithaca-Oxford, 1980.
 Standard monograph and catalogue; includes a discussion of his followers.

HOOGHE, DE
Henkel, M. D. 'Romeijn de Hooghe', *Maandblad voor beeldende Kunsten*, 3 (1926).

Landwehr, J. *Romeyn de Hooghe (1645–1708) as Book Illustrator; A Bibliography*. Amsterdam, 1970.

Landwehr, J. *Romeyn de Hooghe the Etcher*. Leiden, 1972.
 Catalogue of prints other than book illustrations.

Wilson, W. H. *The Art of Romeyn de Hooghe: An Atlas of European Late Baroque Culture* (diss.). Cambridge, Massachusetts, 1974.

Wilson, W. H. '"The Circumcision." A Drawing by Romeyn de Hooghe', *Master Drawings*, 13 (1975).

HOOGSTRATEN, VAN
Kronig, J. O. 'Zwei Selbstbildnisse von Samuel van Hoogstraeten', *Kunstchronik*, 25 (1914).

Valentiner, W. R. 'Rembrandt and Samuel van Hoogstraeten', *Art in America*, 18 (1930).

Richardson, E. P. 'Samuel van Hoogstraeten and Carel Fabritius', *Art in America*, 25 (1937).
 On their preoccupation with problems of perspective.

Sumowski *Gemälde*. Vols. 2, 5, 6: 'Samuel van Hoogstraten'.

Abbing, M. R. *De schilder en schrijver Samuel van Hoogstraten (1627–1678). Eigentijdse bronnen en œuvre van gesigneerde schilderijen*. Leiden, 1993.
 Also see entries above under II. B. SOURCES AND EIGHTEENTH-CENTURY LITERATURE.

HORST
Bredius, A. 'Gerrit Willemsz Horst', *O.H.*, 50 (1933).

Valentiner, W. R. 'Zum Werk Gerrit Willemsz Horst's', *O.H.*, 50 (1933).

Sumowski *Gemälde*. Vols. 2, 5, 6: 'Gerrit Willemsz Horst'.

HOUCKGEEST
Blade, T. T. 'Two Interior Views of the Old Church in Delft' [G. Houckgeest and E. de Witte], *Museum Studies*, 6 (1971).

Vries, L. de. 'Gerard Houckgeest', *Jahrbuch der Hamburger Kunstsammlungen*, 20 (1975).

Wheelock, A. K., Jr. 'Gerard Houckgeest and Emanuel de Witte: Architectural Painting in Delft around 1650', *Simiolus*, 8 (1975–6).

HUYSUM, VAN
Schlie, F. 'Sieben Briefe und eine Quittung von Jan van Huijsum', *O.H.*, 18 (1900).

HdG. Vol. 10, 'Jan van Huysum'.

Grant, M. H. *Jan van Huysum 1682–1749, including a catalogue raisonné of the artist's fruit and flower paintings*. Leigh-on-Sea, 1954.

White, C. *The Flower Drawings of Jan van Huysum*. Leigh-on-Sea, 1964.
JACOBSZ
Straat, H. L. 'Lambert Jacobsz, schilder', *De Vrije Fries*, 28 (1925).
Wijnman, H. F. 'Nieuwe gegevens omtrent den schilder Lambert Jacobsz', *O.H.*, 47 (1930).
Halbertsma, M. 'Lambert Jacobsz, een Amsterdammer in Leeuwarden', *De Vrije Fries*, 52 (1972).
JARDIN, DU
HdG. Vol. 9, 'Karel du Jardin'.
Marguery, H. 'Les animaux dans l'œuvre de Karel Du Jardin', *Amateur*, 4 (1925).
Knoef, J. 'Het etswerk van Karel Du Jardin', *Elsevier's geïllustreerd maandschrift*, 73 (1927).
Brochhagen, E. 'Karel Dujardins späte Landschaften', *Bulletin Musées des Beaux Arts*, 6 (1957).
Brochhagen, E. *Karel Dujardin*. Cologne, 1958.
JONGH, CLAUDE DE
Hayes, J. 'Claude de Jongh', *B.M.*, 98 (1956).
Bok, M. J. 'Claude de Jongh, "Painter Sorely Incapacitated in His Arms",' *Hoogsteder-Naumann Mercury*, 10 (1989).
JONGH, LUDOLF DE
Haverkorn van Rijsewijk, P. 'Ludolf de Jongh', *O.H.*, 14 (1896).
Fleischer, R. E. 'Ludolf de Jongh and the Early Work of Pieter de Hooch', *O.H.*, 92 (1978).
Fleischer, R. E. *Ludolf de Jongh (1616-1679). Painter of Rotterdam*. Doornspijk, 1989.
JONSON VAN CEULEN
Finberg, A. 'A Chronological List of Portraits by Cornelius Johnson or Jonson', *Walpole Society*, 10 (1921-2).
JOUDERVILIE
Hofstede de Groot, C. 'Isaac de Jouderville, leerling van Rembrandt?', *O.H.*, 17 (1899).
Wetering, E. van de. 'Isaac Jouderville, a Pupil of Rembrandt', in *The Impact of a Genius. Rembrandt, his Pupils and Followers in the Seventeenth Century*, exh. cat., K. & V. Waterman, Amsterdam-Groninger Museum, Groningen, 1983.
Sumowski *Gemälde*. Vols. 2, 5, 6: 'Isaac de Jourdreville'.
KALF
Blok, I. 'Willem Kalf', *Onze Kunst*, 18 (1919).
Gelder, H. E. van. *W. C. Heda, A. van Beyeren, W. Kalf (Palet Serie)*. Amsterdam, 1941.
Gelder, H. E. van. 'Aanteekeningen over Willem Kalf en Cornelia Pluvier', *O.H.*, 59 (1942).
Luttervelt, R. van. 'Aanteekeningen over de ontwikkeling van Willem Kalf', *O.H.*, 60 (1943).
Grisebach, L. *Willem Kalf 1619-1693*. Berlin, 1974
Monograph and œuvre catalogue.
KEIL see KEILHAU
KEILHAU (also called MONSÙ BERNARDO)
Longhi, R. 'Monsù Bernardo', *Critica d'Arte*, 3 (1938).
Bloch, V. '"Monsù Bernardo" in het Mauritshuis', *Maandblad voor beeldende Kunsten*, 22 (1946).
Sumowski *Gemälde*. Vol. 3: 'Bernhard Keil'.
Heimbürger, M. *Bernardo Keilhau detto Monsù Bernardo*. Rome, 1988.
Monograph and catalogue; includes a transcription of Baldinucci's lengthy biography of the artist published in 1728.
KESSEL, VAN
Davies, A. I. *Jan van Kessel (1641-1680)*. Doornspijk, 1992.
Monograph and detailed catalogue of paintings and drawings.
KETEL
Stechow, W. 'Cornelis Ketels Einzelbildnisse', *Zeitschrift für bildende Kunst*, 63 (1929-30).
Judson, J. R. 'A New Insight into Cornelis Ketel's Method of Portraiture', *Master Drawings*, 1 (1963).
KEYSER, DE
Oldenbourg, R. *Thomas de Keysers Tätigkeit als Maler*. Leipzig, 1911.
Adams, A. Jensen. *The Paintings of Thomas de Keyser (1596/97-1667). A Study of Portraiture in Seventeenth-Century Amsterdam* (diss). 3 vols. Cambridge, Massachusetts, 1985.
KICK
Bredius, A., and Bode, W. von. 'Der amsterdamer Genremaler Symon Kick', *Jahrb. P.K.*, 10 (1889).
KNÜPFER
Weizsäcker, H. 'Nikolaus Knüpfer und Adam Elsheimer', *Repertorium für Kunstwissenschaft*, 21 (1898).
Willnau, C. 'Von Elsheimer's Contento zu Knüpfer's Contentement',

Zeitschrift für bildende Kunst, 65 (1931-2).
Brinkhuis, G. 'Nieuwe gegevens over den kunstschilder Nicolaus Knupfer', *Jaarboekje van Oud Utrecht* (1935).
Kuznetsov, Y. I. 'Nikolaus Knüpfer', *Trudy Gosudarstvennogo Ermitazha*, 8 (1964) (Russian text).
Comprehensive study with œuvre catalogue. The author published a revised Dutch version in *O.H.*, 88 (1974).
KOBELL
Obreen, F. D. O. 'De Hollandsche tak der schildersfamilie Kobell', *Archief voor Nederl. Kunstgeschiedenis*, 7 (1888-90).
KONINCK, PHILIPS
Falck, G. 'Einige Bermerkungen über Philips Konincks Tätigkeit als Zeichner', *Festschrift für Max J. Friedlaender*. Leipzig, 1927.
Gerson, H. *Philips Koninck*. Berlin, 1936.
Standard monograph with catalogue of paintings and drawings. Reprint, Berlin, 1980.
Thiel, P. J. J. van. 'Philips Konincks vergezicht met hutten aan de weg', *Bulletin van het Rijksmuseum*, 15 (1967).
Sumowski *Gemälde*. Vols. 3, 5, 6: 'Philips Koninck'.
KONINCK, SALOMON
Sumowski *Gemälde*. Vols. 3, 5, 6: 'Salomon Koninck'.
LAER, VAN (BAMBOCCIO)
Hoogewerff, G. J. 'Pieter van Laer en zijn vrienden', *O.H.*, 49 (1932), 50 (1933).
Briganti, G. 'Pieter van Laer e Michel Cerquozzi', *Proporzione*, 3 (1950).
Janeck, A. *Untersuchung über den holländischen Maler Pieter van Laer, genannt Bamboccio* (diss.). Würzburg, 1968.
Blankert, A. 'Over Pieter van Laer als dier- en landschapschilder', *O.H.*, 83 (1968).
Levine, D. A. 'Pieter van Laer's "Artists's Tavern": An Ironic Commentary on Art', *Holländische Genremalerei im 17. Jahrhundert, Symposium, Berlin, 1984, Jahrbuch Preussischer Kulturbesitz*, Sonderband 4 (1987).
Also cf. entries above under II. 1. 3. *Italianate Painters and the Bentvueghels*.
LAIRESSE
Timmers, J. J. M. *Gérard Lairesse*. Vol. 1, Amsterdam, 1942.
The subsequent volume of this useful work was not published.
Snoep, D. P. 'Gérard Lairesse als plafond- en kamerschilder', *Bulletin van het Rijksmuseum*, 18 (1970).
Roy, A. *Gérard Lairesse. 1640-1711*. Paris, 1992.
Also cf. entries above under II. B. SOURCES AND EIGHTEENTH-CENTURY LITERATURE.
LASTMAN
Freise, K. *Pieter Lastman, sein Leben und seine Kunst*. Leipzig, 1911.
Müller, C. 'Studien zu Lastman und Rembrandt', *Jahrb. P.K.*, 50 (1929).
Rijckevorsel, J. L. A. A. M. van. 'Lastmaniana', *O.H.*, 51 (1934).
Sjtsjerbatsjewa, M. 'Pieter Lastman's Gemälde in der Ermitage', *Musée Hermitage*, 1 (1940); Russian text with a German summary.
Welcker, A. 'Pieter Lastman als teekenaar van landschap en figuur', *O.H.*, 62 (1947).
Bauch, K. 'Frühwerke Pieter Lastmans', *Münchener Jahrbuch der bildenden Kunst*, 2 (1951).
Walicki, M. 'Lastmaniana', *Biuletyn Historii Sztuki*, 16 (1954).
Bauch, K. 'Handzeichnungen Pieter Lastmans', *Münchener Jahrbuch der bildenden Kunst*, 6 (1955).
Bauch, K. 'Entwurf und Komposition bei Pieter Lastman', *Münchener Jahrbuch der bildenden Kunst*, 6 (1955).
Wittrock, I. 'Abraham's Calling. A Motif in Some Paintings by Pieter Lastman and Claes Moeyaert', *Konsthistorisk Tidskrift*, 43 (1974).
Dudok van Heel, S. A. C. 'Waar woonde en werkte Pieter Lastman (1583-1633)?', *Maandblad Amstelodamum*, 62 (1975).
Broos, B. P. J. 'Rembrandt and Lastman's *Coriolanus*: the History Piece in 17th Century Theory and Practice', *Simiolus*, 8 (1975-6).
Tümpel, A. '"Ruth erklärt Naomi die Treue" von Pieter Lastman. Zur Genese eines typischen Barockthemas', *Niederdeutsche Beiträge zur Kunstgeschichte*, 17 (1978).
Tümpel, A., Schatborn, P., et al. *Pieter Lastman, the Man who taught Rembrandt*, exh. cat., Rembrandthuis, Amsterdam, 1991.
Text in English and Dutch; with an extensive bibliography of earlier literature.
LEVECK
Sumowski *Gemälde*. Vols. 3, 5, 6: 'Jacobus Levecq'.
LEYSTER
Hofstede de Groot, C. 'Judith Leyster', *Jahrb. P.K.*, 14 (1893).
Bredius, A. 'Een conflict tusschen Frans Hals en Judith Leyster', *O.H.*, 35 (1917).

Schneider, A. von. 'Gerard Honthorst und Judith Leyster', *O.H.*, 40 (1922).

Harms, J. 'Judith Leyster. Ihr Leben und ihr Werk', *O.H.*, 44 (1927).
 Publication of a dissertation in five articles which is to be used with caution.

Neurdenberg, E. 'Judith Leyster', *O.H.*, 46 (1929).

Wijnman, H. F. 'Het geboortejaar van Judith Leyster', *O.H.*, 49 (1932).

Hofrichter, F. F. *Judith Leyster. A Woman Painter in Holland's Golden Age*. Doornspijk, 1989.

Welu, J. A., Biesboer, P., *et al. Judith Leyster: A Dutch Master and Her World*, exh. cat., Haarlem-Worcester, 1993.
 Includes biographies and essays on the artist and her Haarlem contemporaries; also has entries on a group of works traditionally given to Leyster which the organizers reject.

LIEVENS

Schneider, H. *Jan Lievens, sein Leben und seine Werke*. Haarlem, 1932.
 Reprinted, with a supplement by R. E. O. Ekkart, Amsterdam, 1973.
 Standard monograph with *œuvre* catalogue.

Simon, K. E. 'Beiträge zur Malerei des Rembrandtkreises: I. Lievens und Ter Brugghen', *Zeitschrift für Kunstgeschichte*, 5 (1936).

Gerson, H. 'Twee vroege studies van Jan Lievens', *O.H.*, 69 (1954).

Michalkowa, J. 'Les tableaux de Jan Lievens dans les collections polonaises', *Biuletyn Historii Sztuki*, 18 (1956).

Schendel, A. van. 'Het portret van Constantijn Huygens door Jan Lievens', *Bulletin van het Rijksmuseum*, 11 (1963).

Bauch, K. 'I. Zum Werk des Jan Lievens', *Pantheon*, 25 (1967), 160 ff.; 2, *ibid.*, 259 ff.

Jan Lievens, ein Maler im Schatten Rembrandts, ed. R. Klessmann, exh. cat., Herzog Anton Ulrich-Museum, Braunschweig, 1979.

Sumowski *Gemälde*. Vols. 3, 5, 6: 'Jan Lievens'.

Schatborn, P., and Ornstein-van Slooten, E. *Jan Lievens 1607–1674. Prints and Drawings*, exh. cat., Rembrandthuis, Amsterdam, 1988–9.
 Also see entries below under RIJN, REMBRANDT VAN, 7. *Special Studies*, A. THE LEIDEN YEARS (1625–31).

LINGELBACH

Burger-Wegener, C. *Johannes Lingelbach 1622–1674*. Berlin, 1976.

Kren, T. J. 'Johannes Lingelbach in Rome', *The J. Paul Getty Museum Journal*, 10 (1982).

LISS

Steinbart, K. *Johann Liss*. Vienna, 1946.

Johann Liss, exh. cat., Augsburg-Cleveland Museum of Art, 1975–6.

LOO, VAN

Schneider, A. von. 'Jacob van Loo', *Zeitschrift für bildende Kunst*, 59 (1925–6).

Watering, W. L. van de. 'On Jacob van Loo's "Portrait of a Young Woman",' *Minneapolis Institute Art Bulletin*, 63 (1976–7).

LYS *see* LISS

MAES

Veth, G. H. 'Aanteekeningen omtrent eenige Dordrechtsche schilders: 18. Nicolaes Maes', *O.H.*, 8 (1890).

HdG. Vol. 6, 'Nicolaes Maes'.

Valentiner, W. R. 'Early Drawings by Nicolaes Maes', *B.M.*, 43 (1923).

Bredius, A. 'Bijdragen tot een biografie van Nicolaes Maes', *O.H.*, 41 (1923–4).

Valentiner, W. R. *Nicolaes Maes*. Stuttgart-Berlin-Leipzig, 1924.

Slive, S. 'A Family Portrait by Nicolaes Maes', *Annual Report of the Fogg Art Museum 1957–1958* (1959).
 On a work datable *c.*1680.

Walsh, J., Jr. 'The Earliest Dated Painting by Nicolaes Maes', *Metropolitan Museum Journal*, 6 (1972).

Robinson, W. '"The Sacrifice of Isaac": an unpublished painting by Nicolaes Maes', *B.M.*, 126 (1984).

Sumowski *Gemälde*. Vols. 3, 5, 6: 'Nicolaes Maes'.

Robinson, W. W. 'The "Eavesdroppers" and Related Paintings by Nicolaes Maes', *Holländische Genremalerei im 17. Jahrhundert, Symposium, Berlin, 1984, Jahrbuch Preussischer Kulturbesitz*, Sonderband 4 (1987).

Robinson, W. W. 'Nicolaes Maes: Some Observations on His Early Portraits', *Rembrandt and His Pupils, Papers given at a Symposium in Nationalmuseum, Stockholm, 2–3 October 1992*, ed. G. Cavalli-Björkman, Stockholm, 1993.

MAN, DE

Brière-Misme, C. 'Un émule de Vermeer et de Pieter de Hooch: Cornelis de Man', *O.H.*, 52 (1935).

MANCADAN

Kronig, J. O. 'De schilder Mancadan', *Onze Kunst*, 18 (1910).

Heppner, A. 'J. S. Mancadan', *O.H.*, 51 (1934).

Wassenbergh, A. 'Landschappen van J. S. Mancadan', *Vereeniging Rembrandt* (1952–3).

Boschma, C. 'Nieuwe gegevens omtrent J. S. Mancadan', *O.H.*, 81 (1966).

MANDER, VAN

Valentiner, E. *Karel van Mander als Maler*. Strassburg, 1930.

Regteren Altena, I. Q. van. 'Carel van Mander', *Elsevier's geïllustreerd maandschrift*, 93 (1937).

Waal, H. van de. 'Nieuwe bijzonderheden over Carel van Mander's Haarlemsche tijd', *O.H.*, 54 (1937).

Miedema, H. *Karel van Mander (1548–1606). Het bio-bibliografisch materiaal*. Amsterdam, 1972.
 Also cf. entries above under II. B. SOURCES AND EIGHTEENTH-CENTURY LITERATURE.

MEER, JOHANNES VAN DER, *see* VERMEER I (VAN HAARLEM), JAN

METSU

Kronig, J. O. 'Gabriel Metsu', *La Revue de l'Art Ancien et Moderne*, 25 (1909).

HdG. Vol. 1, 'Gabriel Metsu'.

Plietzsch, E. 'Gabriel Metsu', *Pantheon*, 17 (1936).

Gils, J. B. F. van. 'De Stockholmer "Smidse" van Gabriel Metsu', *O.H.*, 60 (1943).
 On the picture as an illustration of a proverb.

Regteren Altena, I. Q. van. 'Gabriel Metsu as Draughtsman', *Master Drawings*, 1 (1963).

Gabriel Metsu, exh. cat., De Lakenhal, Leiden, 1966.

Gudlaugsson, S. J. 'Kanttekeningen bij de ontwikkeling van Metsu', *O.H.*, 83 (1968).

Schneede, U. M. 'Gabriel Metsu und der holländische Realismus', *O.H.*, 83 (1968).

Robinson, F. W. *Gabriel Metsu (1629–1667). A Study of His Place in Dutch Genre Painting of the Golden Age*. New York, 1974.

MIEL

Kren, T. *Jan Miel (1598–1664), a Flemish Painter in Rome*. 3 vols. Ann Arbor, 1980.

MIEREVELD

Havard, H. *Michiel van Mierevelt et son gendre*. Paris, 1892.

MIERIS THE ELDER, FRANS VAN

HdG. Vol. 10, 'Frans van Mieris'.

Naumann, O. 'Frans van Mieris as a Draughtsman', *Master Drawings*, 16 (1978).

Naumann, O. *Frans van Mieris (1635–1681) the Elder*. 2 vols. Doornspijk, 1981.
 Standard monograph and *œuvre* catalogue.

MIERIS, WILLEM VAN

HdG. Vol. 10, 'Willem van Mieris'.

MIGNON

Kraemer-Noble, M. *Abraham Mignon, 1640–79*. Leigh-on Sea, 1973.

MITJENS

Kuile, O. ter. 'Daniël Mijtens, "His Majesty's Picture-Drawer",' *N.K.J.*, 20 (1969).

MOEYAERT

Thiel, P. J. J. van. 'Moeyaert and Bredero: a Curious Case of Dutch Theatre as Depicted in Art', *Simiolus*, 6 (1972–3).

Tümpel, A. 'Claes Cornelisz Moeyaert. Katalog der Gemälde', *O.H.*, 88 (1974).

Dudok van Heel, S. A. C. 'De schilder Claes Moeyaert en zijn familie', *Jaarboek Amstelodamum*, 68 (1976).

MOLENAER

Bode, W. von, and Bredius, A. 'Der haarlemer Maler Johannes Molenaer in Amsterdam', *Jahrb. P.K.*, 11 (1890).

Bredius, A. 'Jan Miense Molenaer. Nieuwe gegevens omtrent zijn leven en zijn werk', *O.H.*, 26 (1908).

Thiel, P. J. J. van. 'Marriage Symbolism in a Musical Party by Jan Miense Molenaer', *Simiolus*, 2 (1967–8).

Hinz, B. 'Das Familienbildnis des J. M. Molenaer in Haarlem. Aspekte zur Ambivalenz der Porträtfunktion', *Städel-Jahrbuch*, n.s. 4 (1973).

MOLYN

Granberg, O. *Pieter de Molijn och Spåren af hans Konst*. Stockholm, 1883.

Granberg, O. 'Pieter de Molyn und seine Kunst', *Zeitschrift für bildende Kunst*, 19 (1884).

MOREELSE

Jonge, C. H. de. *Paulus Moreelse portret- en genreschilder te Utrecht, 1571–1638*. Assen, 1938.
 Monograph with *œuvre* catalogue.

MUSSCHER, VAN

Thiel, P. J. J. van. 'Michiel van Musscher's vroegste werk naar aanleiding van zijn portret van het echtpaar Comans', *Bulletin van het Rijksmuseum*, 17 (1969).

Thiel, P. J. J. van. 'Andermaal Michiel van Musscher: zijn zelfportretten', *Bulletin van het Rijksmuseum*, 22 (1974).

NEER, AERT VAN DER

Bredius, A. 'Aernout (Aert) van der Neer', *O.H.*, 18 (1900), 28 (1910), 39 (1921).

HdG. Vol. 7, 'Aert van der Neer'.

Kauffmann, H. 'Die Farbenkunst von Aert van der Neer', *Festschrift Adolf Goldschmidt*. Leipzig, 1923.

Seifertová-Korecká, H. 'Das Genrebild des Aert van der Neer in Liberec', *O.H.*, 77 (1962).

Bachmann, F. *Die Landschaften des Aert van der Neer*. Neustadt an der Aisch, 1966.

Bachmann, F. 'Die Herkunft der Frühwerke des Aert van der Neer', *O.H.*, 89 (1975).

Bachmann, F. *Aert van der Neer*. Bremen, 1982.

NEER, EGLON HENDRIK VAN DER

HdG. Vol. 5, 'Eglon Hendrik van der Neer'.

NETSCHER

Bredius, A. 'Een en ander over Casper Netscher', *O.H.*, 5 (1887).

HdG. Vol. 5, 'Caspar Netscher'.

NOOMS (called ZEEMAN)

Knoef, J. 'Reinier Nooms (1623–1667 of '68)', *Elsevier's geïllustreerd maandschrift*, 29 (1919).

OCHTERVELT

Valentiner, W. R. 'Jacob Ochtervelt', *Art in America*, 12 (1923–4).

Plietzsch, E. 'Jacob Ochtervelt', *Pantheon*, 20 (1937).

Kuretsky, S. Donahue. *The Paintings of Jacob Ochtervelt (1634–1682)*. Oxford, 1979.

Standard monograph with catalogue raisonné.

OEVER, TEN

Plietzsch, E. 'Hendrick ten Oever', *Pantheon*, 29 (1942).

Verbeek, J., and Schotman, J. W. *Hendrick ten Oever. Een vergeten Overijssels meester uit de zeventiende eeuw*. Zwolle, 1957.

OOSTERWIJCK

Bosboom-Toussaint, A. L. C. *De bloemenschilderes Maria van Oosterwijck*. Leiden, 1862.

Bredius, A. 'Archiefsprokkelingen. Een en ander over Maria van Oosterwyck, "vermaert Konstschilderesse",' *O.H.*, 52 (1935).

Lindenburg, R. 'Maria van Oosterwyck (1630–1693)', *Delftse vrouwen van vroeger door Delftse vrouwen van nu*. Delft, 1975.

OS, VAN

Mitchell, P. *Jan van Os: 1744–1808*. Leigh-on-Sea, 1968.

OSTADE, ADRIAEN and ISACK VAN

Gaedertz, R. *Adriaen van Ostade. Sein Leben und seine Kunst*. Lübeck, 1869.

HdG. Vol. 3, 'Adriaen van Ostade'.

HdG. Vol. 3, 'Isack van Ostade'.

Rovinski, D., and Tchétchouline, N. *L'Oeuvre gravé d'Adrien van Ostade*. St Petersburg, 1912.

Catalogue raisonné which later students have revised. Valuable for its 221 untouched phototypes of successive states of the etchings.

Bode, W. von. 'Die beiden Ostade', *Zeitschrift für bildende Kunst*, 27 (1916).

Trautscholdt, E. 'Notes on Adriaen van Ostade', *B.M.*, 54 (1929).

Godefroy, L. *L'Oeuvre gravé de Adriaen van Ostade*. Paris, 1930.

Glück C. 'Ein vlämischer Kopist Adriaen van Ostades' (Victorijns)', *O.H.*, 49 (1932).

Scheyer, E. 'Portraits of the Brothers van Ostade', *A.Q.*, 2 (1939).

Kuznetsov, Y. *Catalogue of Adriaen van Ostade Exhibition held at the Hermitage* (in Russian). Leningrad, 1960.

First-rate introduction and critical catalogue.

Klessmann, R. 'Die Anfänge des Bauerninterieurs bei den Brüdern Ostade', *Jahrbuch der Berliner Museen*, 2 (1960).

Haak, B. 'Adriaen van Ostade, landschap met oude eik', *Bulletin van het Rijksmuseum*, 12 (1964).

Schnackenburg, B. 'Die Anfänge des Bauerninterieurs bei Adriaen van Ostade', *O.H.*, 85 (1970).

Schnackenburg, B. *Adriaen van Ostade. Isack van Ostade. Zeichnungen und Aquarelle*. 2 vols. Hamburg, 1981.

Standard monograph and catalogue raisonné.

Vogel, G. H. *Adriaen van Ostade*. Leipzig, 1989.

OVENS

Schmidt, H. *Jürgen Ovens. Sein Leben und seine Werke*. Kiel, 1922.

Schlüter-Göttsche, G. *Jürgen Ovens. Ein schleswig-holsteinischer Barockmaler*. Heide in Holstein, 1978.

Sumowski *Gemälde*. Vols. 3, 5, 6: 'Jürgen Ovens'.

PAUDISS

Sumowski *Gemälde*. Vol. 4, 6: 'Christoph Paudiss'.

PEETERS

Decoteau, P. H. *Clara Peeters (1594–ca.1640) and the Development of Still-Life Painting in Northern Europe*. Lingen, 1992.

PICKENOY

Six, J. 'Nicolaes Eliasz Pickenoy', *O.H.*, 4 (1886).

PLOOS VAN AMSTEL

Alten, F. von. *Cornelis Ploos van Amstel. Kunstliebhaber und Kupferstecher*. Leipzig, 1874.

Huffel, N. G. *Cornelis Ploos van Amstel en zijne medewerkers en tijdgenooten*. Utrecht, 1921.

Bye, A. E. 'Ploos van Amstel', *Print Collectors' Quarterly*, 13 (1926).

Laurentius, T., Niemeijer, J. W., and Ploos van Amstel, G. *Cornelis Ploos van Amstel, 1726–1798. Kunstverzamelaar en prentuitgever*. Assen, 1980.

Ploos van Amstel, G. *Portret van een koopman en uitvinder: Cornelis Ploos van Amstel*. Assen, 1980.

PLUYM, VAN DER

Kronig, J. O. 'Carel van der Pluijm. A Little Known Follower of Rembrandt', *B.M.*, 26 (1914–15).

Bredius, A. 'Karel van der Pluym, neef en leerling van Rembrandt', *O.H.*, 48 (1931).

Sumowski *Gemälde*. Vol. 4: 'Karel van der Pluym'.

POEL, VAN DER

Goldschmidt, A. 'Egbert van der Poel und Adriaen van der Poel', *O.H.*, 40 (1922).

POELENBURGH

Frimmel, T. von. 'Cornelis Poelenburg und seine Nachfolger', *Studien und Skizzen zur Gemäldekunde*, 1 (1913–15); 2 (1915–16); 4 (1918–19); *Neue Blätter für Gemäldekunde*, 1 (1922–3).

Bautier, P. 'Les peintres hollandais Poelenburg et Breenberg à Florence', *Études d'Art*, 4 (1949).

Schaar, E. 'Poelenburgh und Breenbergh in Italien und ein Bild Elsheimers', *Mitteilungen des Kunsthistorischen Institutes in Florenz*, 9 (1959).

Chiarini, M. 'Ipotesi sugli inizi di Cornelis van Poelenburgh', *N.K.J.*, 23 (1972).

Sluijter-Seijfert, N. C. *Cornelis van Poelenburch (ca.1593–1667)*. Haarlem, 1984.

Chong. A. 'The Drawings of Cornelius van Poelenburch', *Master Drawings*, 25 (1987).

PORCELLIS

Bredius, A. 'Johannes Porcellis, zijn leven, zijn werken', *O.H.*, 23 (1905).

Walsh, J., Jr. 'The Dutch Marine Painters Jan and Julius Porcellis' 1. 'Jan's Early Career', *B.M.*, 116 (1974); 2. 'Jan's Maturity and "de jonge Porcellis",' *ibid*.

Duverger, E. 'Nadere gegevens over de Antwerpse periode van Jan Porcellis', *Jaarboek van het Koninklijk Museum voor Schone Kunsten Antwerpen*, 16 (1976).

POST, FRANS

Smith, R. C., Jr. 'The Brazilian Landscapes of Frans Post', *A.Q.*, 1 (1938).

Sousa-Leão, J. de. 'Frans Post in Brazil', *B.M.*, 80 (1942).

Benisovich, M. 'History of the "Tenture des Indes",' *B.M.*, 83 (1943). On the tapestries made for Louis XIV.

Larsen, E. *Frans Post*. Amsterdam-Rio de Janeiro, 1962. The author's thesis that Post's pictorial effects were achieved by the use of a mechanical contraption is not convincing.

Sousa Leão, J. de. *Frans Post 1612–1680*. Amsterdam, 1973.

POST, PIETER

Blok, G. A. C. 'Pieter Post, 1608–1669; der Baumeister der Prinzen von Oranien und des Fürsten Johann Moritz von Nassau-Siegen', *Siegerland. Blätter des Vereins für Heimatkunde und Heimatschutz im Siegerland samt Nachbargebieten* (1936–7).

Gudlaugsson, S. J. 'Aanvullingen omtrent Pieter Post's werkzaamheid als schilder', *O.H.*, 69 (1954).

POT

Bredius, A., and Haverkorn van Rijsewijk, P. 'Hendrick Gerritsz Pot', *O.H.*, 5 (1887).

POTTER

Westrheene, T. van. *Paulus Potter, sa vie et ses oeuvres*. The Hague, 1867.

Michel, É. *Paul Potter*. Paris, 1907.

HdG. Vol. 4, 'Paulus Potter'.

Arps-Aubert, R. von. *Die Entwicklung des reinen Tierbildes in der Kunst Paulus Potter*. Halle, 1932.

Borenius, T. 'Paulus Potter', *B.M.*, 81 (1942).

Walsh, A. L. *Paulus Potter: His Works and Their Meaning* (diss.). Columbia University, New York, 1985.
> Includes documents and an account of the career of Paulus's father Pieter Symonsz Potter.

PYNACKER
HdG. Vol. 9, 'Adam Pijnacker'.

Harwood, L. B. *Adam Pynacker (c.1620–1673)*. Doornspijk, 1988.
> Monograph and *œuvre* catalogue.

PYNAS, JACOB and JAN
Bauch, K. 'Die Gemälde des Jan Pynas', *O.H.*, 52 (1935).

Bauch, K. 'Die Zeichnungen des Jan Pynas', *O.H.*, 52 (1935).

Bauch, K. 'Die Gemälde des Jakob Pynas', *O.H.*, 53 (1936).

Bauch, K. 'Handzeichnungen des Jakob Pynas', *O.H.*, 54 (1937).

Oehler, L. 'Zu einigen Bildern aus Elsheimers Umkreis', *Städel-Jahrbuch*, n.s. 1 (1967).

QUAST
Bredius, A. 'Pieter Jansz Quast', *O.H.*, 20 (1902).

Stanton Hirst, B. A. *The Influence of the Theatre on the Works of Pieter Jansz Quast* (diss.). Madison, Wisconsin, 1978.

RAVESTEYN
Bredius, A., and Moes, E. W. 'De schilderfamilie Ravesteyn', *O.H.*, 9 (1891); 10 (1892).

RENESSE, VAN
Hammen Nicz, J. van der. 'Constantijn Daniel van Renesse (1626–1680)', *Taxandria*, 17 (1910).

Sumowski *Gemälde*. Vol. 4, 6: 'Constantijn Daniel van Renesse'.

RIJCKHALS
Bredius, A. 'De schilder François Ryckhals', *O.H.*, 35 (1917).

Bol, L. J. '"Goede onbekenden" III: F. Ryckhals en omgeving', *Tableau*, 2 (1979–80).

RIJN, REMBRANDT VAN

1. Bibliography
Hall, H. van. *Repertorium voor de geschiedenis der Nederlandsche schilder- en graveerkunst*. 2 vols. The Hague, 1935–49.

Benesch, O. *Rembrandt, Werk und Forschung*. Vienna, 1935.

Bibliography of the Netherlands Institute for Art History, 1. The Hague, 1943–73/74.

2. Documents and Printed Sources
Hofstede de Groot, C. *Die Urkunden über Rembrandt (1575–1721)*. The Hague, 1906.
> Still indispensable.

Strauss, W. I., Meulen, M. van der, *et al. The Rembrandt Documents*. New York, 1979.
> Includes no document that postdates Rembrandt's burial, 8 October 1669; see the critical review by B. P. J. Broos, *Simiolus*, 12 (1981–2).

3. Painting Catalogues
Smith, J. A *Catalogue Raisonné of the Works of the Most Eminent Dutch, Flemish and French Painters*, 7, Rembrandt van Rhyn. London, 1836.
> The first comprehensive catalogue of Rembrandt's paintings.

Bode, W. von, and Hofstede de Groot, C. *The Complete Work of Rembrandt*. 8 vols. Paris, 1897–1906.

HdG. Vol. 6, 'Rembrandt'.

Valentiner, W. R. *Rembrandt (Klassiker der Kunst)*. 3rd ed. Stuttgart-Berlin, 1908.

Valentiner, W. R. *Rembrandt, Wiedergefundene Gemälde (1910–22) (Klassiker der Kunst)*. 2nd ed. Berlin-Leipzig, 1922.

Valentiner, W. R. *Rembrandt Paintings in America*. New York, 1932.

Bredius, A. *The Paintings of Rembrandt*. New York, 1935. 3rd ed. revised by H. Gerson, London-New York, 1969.

Bauch, K. *Rembrandt Gemälde*. Berlin, 1966.

Vries, A. B. de, *et al. Rembrandt in the Mauritshuis*. Alphen aan den Rijn, 1978.
> Catalogue of the gallery's paintings by and attributed to the artist.

Bruyn, J., Haak, B., Levie, S. H., Thiel, P. J. J. van, and Wetering, E. van der. *A Corpus of Rembrandt Paintings*. The Hague-Boston-London, 1 (1982); 2 (1986); 3 (1989) [in progress].
> Although specialists do not endorse all of the authors' conclusions, the three vols. published to date, which cover the years from 1625 to 1642, are indispensable; they offer the most exhaustive study by far of all aspects of paintings traditionally attributed to the artist.

4. Etching Catalogues
Gersaint, E.-F. *Catalogue raisonné de toutes les pièces qui forment l'oeuvre de Rembrandt . . .* Paris, 1751.
> First printed catalogue. English trans., London, 1752.

Bartsch, A. *Catalogue raisonné de toutes les estampes qui forment l'oeuvre de Rembrandt et ceux de ses principaux imitateurs*. Vienna, 1797.

Rovinski, D. *L'Oeuvre gravé de Rembrandt*. 4 vols. St Petersburg, 1890.
> Includes 1000 unretouched phototypes of different states of the etchings.

Hind, A. M. A *Catalogue of Rembrandt's Etchings Chronologically Arranged and Completely Illustrated*. 2nd ed. 2 vols. London, 1923; reprint, New York, 1967.

Münz, L. *Rembrandt's Etchings. Reproductions of the Whole Original Etched Work*. 2 vols. London, 1952.

Boon, K. G. *The Complete Etchings of Rembrandt*. London-New York, 1963.

Biörklund, G., with the assistance of Barnard, O. H. *Rembrandt's Etchings True and False*. Stockholm-London-Paris, 1955; 2nd rev. ed., Stockholm-New York, 1968.

White, C., and Boon, K. G. *Rembrandt's Etchings: An Illustrated Critical Catalogue*. 2 vols. Amsterdam-London-New York, 1969.
> The catalogue also appears as vols. 18, 19 in Hollstein's *Dutch and Flemish Etchings, Engravings and Woodcuts*, Amsterdam, 1969.

5. Drawing Catalogues
Hofstede de Groot, C. *Die Handzeichnungen Rembrandts*. Haarlem, 1906.
> Not illustrated.

Valentiner, W. R. *Die Handzeichnungen Rembrandts (Klassiker der Kunst)*. 2 vols. Stuttgart-New York, 1925–34.
> Not complete. Landscapes, figure studies, nudes not published. Contains discussions of pupils' works.

Benesch, O. *The Drawings of Rembrandt, A Critical and Chronological Catalogue*. 6 vols. London, 1954–7. 2nd ed., enlarged and edited by E. Benesch. 6 vols. London-New York, 1973.
> A monumental corpus with a comprehensive bibliography. Includes drawings attributed to Rembrandt and copies. Connoisseurs have rightly questioned some of the attributions; nevertheless it remains the foundation for study of the artist's drawings.

Slive, S. *Drawings of Rembrandt, With a Selection of Drawings by his Pupils and Followers*. 2 vols. New York, 1965; frequently reprinted.
> A newly edited publication based on the facsimile series of 550 drawings edited by F. Lippmann, C. Hofstede de Groot, *et al.* London-Berlin, 1888–1911.

Broos, B. *Oude tekeningen in het bezit van de Gemeentemusea van Amsterdam, waaronder de collectie Fodor. Deel 3. Rembrandt en tekenaars uit zijn omgeving*. Amsterdam, 1981.

Schatborn, P. *Catalogue of Dutch and Flemish Drawings in the Rijksmuseum. IV: Drawings by Rembrandt, his anonymous pupils and followers*. The Hague, 1985.

Giltaij, J. *The Drawings by Rembrandt and his School in the Museum Boymans-van Beuningen*. Rotterdam, 1988.

Starcky, E. *Rembrandt et son école*, exh. cat., Louvre, Paris, 1988–9.

Royalton-Kisch, M. *Drawings by Rembrandt and his Circle in the British Museum*, exh. cat., British Museum, London, 1992.

6. Monographs
Koloff, E. 'Rembrandt's Leben und Werke, nach neuen Actenstücken und Gesichtspunkten geschildert', *Raumers Historisches Taschenbuch*, 5 (1854). Reprinted (ed. C. Tümpel) in *Deutsches Bibel-Archiv, Abhandlungen und Vorträge*, 4. Hamburg, 1971.

Vosmaer, C. *Rembrandt Harmensz van Rijn, ses précurseurs et ses années d'apprentissage*. The Hague, 1863.

Vosmaer, C. *Rembrandt Harmensz van Rijn, sa vie et ses oeuvres*. The Hague, 1868.

Michel, É. *Rembrandt, sa vie, son oeuvre et son temps*. Paris, 1893.

Veth, J. *Rembrandts Leben und Kunst*. Leipzig, 1908.

Neumann, C. *Rembrandt*. 2 vols. 4th ed. Munich, 1924.

Weisbach, W. *Rembrandt*. Berlin, 1926.

Hind, A. M. *Rembrandt*. Cambridge, Massachusetts, 1932.

Gelder, H. E. van. *Rembrandt (Palet Serie)*. Amsterdam, 1946.

Rosenberg, J. *Rembrandt*. 2 vols. Cambridge, Massachusetts, 1948; 2nd rev. ed., London, 1964.
> Includes a concordance of the principal catalogues of Rembrandt's paintings with an indication of the author's opinion on authenticity.

White, C. *Rembrandt and his World*. London-New York, 1964.
> Excellent short study of the artist's life, his friends, and his patrons.

Also see the Dutch translation by J. M. Komter with extensive additional notes by H. F. Wijnman, The Hague, 1964. The author's *Rembrandt*, London, 1984, is a rev. ed. which includes a discussion of the master's art.

Gerson, H. *Rembrandt Paintings*. Amsterdam, 1968.

Haak, B. *Rembrandt, His Life, His Work, His Time*. New York, 1969.

Kitson, M. *Rembrandt*. London, 1969.

White, C. *Rembrandt as an Etcher, a Study of the Artist at Work*. 2 vols. London, 1969.

 The best study of the artist's activity as an etcher.

Fuchs, R. H. *Rembrandt in Amsterdam*. Trans. P. Wardle and A. Griffiths. New York, 1969.

Schwartz, G. *Rembrandt: His Life, His Paintings*. Middlesex-New York, 1985.

Tümpel, C. *Rembrandt: Mythos und Methode*. Königstein im Taunus, 1986.

 With contributions by A. Tümpel.

Alpers, S. *Rembrandt's Enterprise. The Studio and the Market*. Chicago, 1988.

Chapman, H. P. *Rembrandt's Self-Portraits: A Study in Seventeenth-Century Identity*. Princeton, 1990.

 Includes a comprehensive bibliography of earlier literature on the subject.

Bal, M. *Reading 'Rembrandt'. Beyond the Word-Image Opposition*. Cambridge etc., 1991.

7. Special Studies

A. THE LEIDEN YEARS (1625-31)

Fraenger, W. *Der junge Rembrandt*. Heidelberg, 1920.

 Includes a discussion of van Vliet's relation to Rembrandt.

Müller-Hofstede, C. 'Studien zu Lastman und Rembrant', *Jahrb. P. K.*, 50 (1929).

Bauch, K. *Die Kunst des jungen Rembrandt*. Heidelberg, 1933.

Martin, W. 'Uit Rembrandts leidsche jaren', *Jaarboek van de Maatschappij der Nederlandsche Letterkunde te Leiden* (1936-7).

Bauch, K. 'Rembrandt und Lievens', *Wallraf-Richartz-Jahrbuch*, 11 (1939).

 Important study of the early drawings.

Slive, S. 'Art Historians and Art Critics, 2. Huygens on Rembrandt', *B.M.*, 94 (1952).

Münz, L. 'Rembrandt's Bild von Mutter und Vater', *Jahrbuch der kunsthistorischen Sammlungen in Wien*, 50 (1953).

Gelder, H. E. van. 'Constantijn Huygens en Rembrandt', *O.H.*, 74 (1959).

Bauch, K. *Der frühe Rembrandt und seine Zeit. Studien zur geschichtlichen Bedeutung seines Frühstils*. Berlin, 1960.

Gerson, H. 'La Lapidation de Saint Étienne peinte par Rembrandt en 1625', *Bulletin des Musées et Monuments Lyonnais*, 3, no. 4 (1962).

 Publication of the signed and dated picture of 1625 at Lyon.

Slive, S. 'The Young Rembrandt', *Allen Memorial Art Museum Bulletin, Oberlin, Ohio*, 20 (1963). Reprinted in *Seventeenth Century Art in Flanders and Holland. The Garland Library of the History of Art*, 9, New York-London, 1976.

Slive, S. 'Rembrandt's "Self-portrait in a Studio",' *B.M.*, 106 (1964).

 Suggests that the small Boston *Self-portrait* of *c*.1629 (Bredius-Gerson 419; *Rembrandt Corpus*, 1, no. A18) is a fragment and offers a reconstruction.

Stechow, W. 'Some Observations on Rembrandt and Lastman', *O.H.*, 84 (1969).

Vogelaar, C., *et al. Rembrandt & Lievens in Leiden*, exh. cat., De Lakenhal, Leiden, 1991-2.

 Includes essays on the artists' works and their relationship; text in English and Dutch.

B. FIRST AMSTERDAM PERIOD (1632-9)

Kauffmann, H. 'Rembrandt und die Humanisten vom Muiderkring', *Jahrb. P.K.*, 41 (1920).

Six, J. 'La Famosa Accademia di Eeulenborg', *Jaarboek der Koninklijke Akademie van Wetenschappen te Amsterdam* (1925-6).

Bloch, E. M. 'Rembrandt and the Lopez Collection', *G.B.A.*, 29 (1946).

Wijnman, H. F. 'Rembrandt en Hendrik Uylenburgh te Amsterdam', *Maandblad Amstelodamum*, 43 (1956).

Heckscher, W. S. *Rembrandt's Anatomy of Dr Nicolaas Tulp. An Iconological Study*. New York, 1958.

Haussherr, R. 'Zur Menetekel-Inschrift auf Rembrandts Belsazarbild', *O.H.*, 78 (1963).

 Notes that the cryptic Aramaic inscription on the picture of *c*.1635 in London (Bredius-Gerson 497; *Rembrandt Corpus*, 3, no. A110) corresponds to its form in rabbi Menasseh ben Israel's *De termino vitae*, Amsterdam, 1639. His find establishes that the painter had contact with the rabbi before his book was published.

Bergström, I. 'Rembrandt's Double Portrait of Himself and Saskia at the Dresden Gallery', *N.K.J.*, 17 (1966).

 On the relation of the work to representations of the Prodigal Son.

Kuznetzow, J. I. 'Nieuws over Rembrandts Danae', *O.H.*, 82 (1967).

Kuznetsov, Y. I. *Rembrandt's 'Danae': The Enigma of Its Creation* (Russian text); English and French summaries. Leningrad, 1970.

Manuth, V. *Ikonografische Studien zu den Historien des Alten Testaments bei Rembrandt und seiner frühen Amsterdamer Schule* (diss.). Berlin, 1987.

 Includes a catalogue of Jan Victors's biblical paintings.

C. THE MIDDLE PERIOD (1640-7)

Emmens, J. A. 'Ay Rembrandt, maal Cornelis stem', *N.K.J.*, 7 (1956).

 Analysis of Vondel's lines on Rembrandt's portrait of Anslo. Reprinted in J. A. Emmens, *Kunsthistorische Opstelling*, 1, Amsterdam, 1981.

Haverkamp-Begemann, E. *Rembrandt: The Night Watch*. Princeton, 1982.

 Comprehensive study of the painting; includes an extensive bibliography of earlier literature.

Kemp, W. *Rembrandt. Die Heilige Familie, oder die Kunst, einen Vorhang zu lüften*. Frankfurt a. M., 1986.

 On the *Holy Family* at Kassel (Bredius-Gerson 572).

Brown, C., *et al. Rembrandt's 'Girl at a Window'*, exh. cat., Dulwich Picture Gallery, London, 1993.

 Study of Bredius-Gerson 368 and related works.

D. THE MATURE PERIOD (1648-69)

Eisler, M. *Der alte Rembrandt*. Vienna, 1927.

Münz, L. 'Rembrandts Alterstil und die Barockklassik', *Jahrbuch der kunsthistorischen Sammlungen in Wien*, 9 (1935).

Regteren Altena, I. Q. van. 'Retouches aan ons Rembrandtbeeld, I: De zoogenaamde voorstudie voor de Anatomische Les van Dr Deyman', *O.H.*, 65 (1950).

 Establishes that Benesch 1175 is a drawing made to show the anatomy lesson in its architectural setting.

Benesch, O. 'Worldly and Religious Portraits in Rembrandt's Late Work', *A.Q.*, 19 (1956).

Blankert, A. 'Rembrandt, Zeuxis and Ideal Beauty', in *Album Amicorum J. G. van Gelder*. The Hague, 1973.

 Interpretation of the self-portrait at Cologne (Bredius-Gerson 61) as the artist in the guise of Zeuxis.

Haussherr, R. *Rembrandts Jacobssegen. Überlegungen zur Deutung des Gemäldes in der Kasseler Galerie*. Opladen, 1976.

Carroll, M. D. 'Rembrandt as a Meditational Printmaker', *The Art Bulletin*, 63 (1982).

 Perceptive analyses of the *Ecce Homo* (Bartsch 76) and *Three Crosses* (Bartsch 78).

i. Commissions for Don Antonio Ruffo

Ruffo, V. 'Galleria Ruffo nel secolo XVII in Messina', *Bollettino d'Arte*, 10 (1916).

 Documents concerning Rembrandt's connection with his Sicilian patron.

Hoogewerff, G. 'Rembrandt en een italiaansche Maecenas', *O.H.*, 35 (1917).

Rosenberg, J. 'Rembrandt and Guercino', *A.Q.*, 7 (1944).

 Publication of Guercino's preparatory drawing for a companion piece to *Aristotle Contemplating the Bust of Homer*.

Einem, H. von. 'Rembrandt und Homer', *Wallraf-Richartz-Jahrbuch*, 14 (1952).

Held, J. S. *Rembrandt's 'Aristotle' and Other Rembrandt Studies*. Princeton, 1969. Rev. and expanded ed., Princeton, 1991.

 Includes essays on the *'Polish' Rider*, *Juno*, Rembrandt and the book of Tobit, and the myth of the *Night Watch*.

ii. The Polish Rider

Held, J. 'Rembrandt's "Polish" Rider', *The Art Bulletin*, 26 (1944). Reprinted in the author's *Rembrandt's 'Aristotle' and Other Rembrandt Studies*, rev. ed., Princeton, 1991.

Ciechanowiecki, A. 'Notes on the Ownership of Rembrandt's "Polish Rider"', *The Art Bulletin*, 42 (1960).

Białostocki, J. 'Rembrandt's "Eques Polonus"', *O.H.*, 84 (1969).

iii. Commissions for the Town Hall

Schneider, H. 'Govert Flinck en Juriaen Ovens in het Stadhuis te Amsterdam', *O.H.*, 42 (1925).

Heppner, A. '"Moses zeigt die Gesetztafeln" bei Rembrandt und Bol', *O.H.*, 52 (1935).

Konsthistorisk Tidskrift, nos. 1 and 2, 25 (1956). Special issue: 'Rembrandt's Claudius Civilis'.
> With important contributions by H. van de Waal, A. van Schendel. C. Müller-Hofstede, L. Münz, C. Nordenfalk, I. H. van Eeghen, and C. Bille.

Nordenfalk, C. *The Batavians Oath of Allegiance. Rembrandt's only Monumental Painting*. Stockholm, 1982.
> With an extensive bibliography.

iv. The Syndics

Waal, H. van de. 'De Staalmeesters en hun legende', *O.H.*, 71 (1956). Translated in the author's *Steps Towards Rembrandt*, Amsterdam-London, 1974.

Eeghen, I. H. van. 'De Staalmeesters', *O.H.*, 73 (1958).
> Identification of the syndics.

E. BIBLICAL SUBJECTS

Stechow, W. 'Rembrandts Darstellungen der Kreuzabnahme', *Jahrb. P.K.*, 50 (1929).

Stechow, W. 'Rembrandt's Darstellungen des Emmausmahles', *Zeitschrift für Kunstgeschichte*, 3 (1934).

Haman, R. 'Hagars Abscheid bei Rembrandt und im Rembrandt-Kreise', *Marburger Jahrbuch für Kunstwissenschaft*, 8–9 (1936).

Waal, H. van de. 'Hagar en de Woestijn door Rembrandt en zijn school', *N.K.J.*, 1 (1947). Translated in the author's *Steps towards Rembrandt*, Amsterdam-London, 1974.

Rotermund, H. M. 'Rembrandts Bibel', *N.K.J.*, 5 (1953–4).

Visser't Hooft, W. A. *Rembrandt and the Gospel*. London, 1957.

Bruyn, J. *Rembrandt's keuze van Bijbelse onderwerpen*. Utrecht, 1959.

Slive, S. 'An Unpublished "Head of Christ" by Rembrandt', *The Art Bulletin*, 47 (1965).

Tümpel, C. 'Ikonographische Beiträge zu Rembrandt', *Jahrbuch der Hamburger Kunstsammlungen*, 13 (1968); part 2, *ibid.*, 16 (1971).

Tümpel, C. 'Studien zur Ikonographie der Historien Rembrandts', *N.K.J.*, 20 (1969).
> Fundamental for the interpretation of the iconography of the artist's biblical pictures.

Waal, H. van de. 'Rembrandt and the Feast of Purim', *O.H.*, 84 (1969). Reprinted in the author's *Steps Towards Rembrandt*, Amsterdam-London, 1974.

Tümpel, C., and Tümpel, A. *Rembrandt legt die Bibel aus*, exh. cat., Kupferstichkabinett, Staatliche Museen, Berlin, 1970.

Halewood, W. H. *Six Subjects of Reformation Art: A Preface to Rembrandt*. Toronto, 1982.

Carstensen, H. T. *Empirie als Bildsprache. Überlegungen zum Judischen Einfluss auf Rembrandts Kunst*. Hamburg, 1993.

Halewood, W. H. 'Rembrandt's Low Diction', *O.H.*, 107 (1993).

F. RELATION TO ANCIENT AND RENAISSANCE ART

Saxl, F. 'Rembrandt und Italien,' *O.H.*, 41 (1923–4).

Stechow, W. 'The Myth of Philemon and Baucis', *Journal of the Warburg and Courtauld Institutes*, 4 (1940–1).

Keiser, W. 'Über Rembrandts Verhältnis zur Antike', *Zeitschrift für Kunstgeschichte*, 10 (1941–2).

Stechow, W. 'Rembrandt and Titian', *A.Q.*, 5 (1942).

Bramsen, H. 'The Classicism of Rembrandt's "Bathsheba",' *B.M.*, 92 (1950).

Rosenberg, J. 'Rembrandt and Mantegna', *A.Q.*, 19 (1956).

Saxl, F. 'Rembrandt and Classical Antiquity', *Lectures*. London, 1957.

Kraft, K. 'Der behelmte Alexander der Grosse', *Jahrbuch für Numismatik und Geldgeschichte*, 15 (1965).

Clark, K. *Rembrandt and the Italian Renaissance*. New York, 1968.

Jongh, E. de. 'The Spur of Wit: Rembrandt's Response to an Italian Challenge', *Delta. A Review of Arts, Life and Thought in the Netherlands*, 12 (1969).

White, C. 'A Rembrandt Copy after a Titian Landscape', *Master Drawings*, 13 (1975).

G. LANDSCAPE

Lugt, F. *Mit Rembrandt in Amsterdam*. Berlin, 1920; Dutch ed., 1915.
> Identification of the sites of Rembrandt's etchings and drawings.

Schneider, C. P., *et al. Rembrandt's Landscapes: Drawings and Prints*, exh. cat., National Gallery of Art, Washington, 1990.

Schneider, C. P. *Rembrandt's Landscapes*. New Haven-London, 1990.

H. TECHNIQUE AND TECHNICAL STUDIES

Laurie, A. P. *The Brushwork of Rembrandt and his School*. London, 1932.

Rosenberg, J. 'Rembrandt's Technical Means and their Stylistic Significance', *Technical Studies in the Field of the Fine Arts*, 8 (1940).

Schendel, A. van. 'De schimmen van de Staalmeesters, Een röntgenologisch onderzoek', *O.H.*, 71 (1956).
> Publication of X-rays.

Hours, M. 'Rembrandt: observations et présentation de radiographies exécutées d'après les portraits et compositions du Musée du Louvre', *Bulletin du Laboratoire du Musée du Louvre*, 6 (1961).

Froentjes, W. 'Schilderde Rembrandt op goud', *O.H.*, 84 (1969).

Sonnenburg, H. F. von. 'Rembrandts "Segen Jacobs",' *Maltechnik/Restauro* (1978).

Wetering, E. van de. 'Painting Materials and Working Methods' in *Rembrandt Corpus*, 1, 1982.

Wetering, E. van de. 'The Canvas Support' in *Rembrandt Corpus*, 2, 1986.

Bomford, D., *et al. Art in the Making. Rembrandt*, exh. cat., National Gallery, London, 1988–9.

I. OTHER SPECIALIZED STUDIES

Neumann, C. *Aus der Werkstatt Rembrandts*. Heidelberg, 1918.

Ricci, C. *Rembrandt in Italia*, Milan, 1918.

Charrington, J. *A Catalogue of the Mezzotints after, or said to be after, Rembrandt*. Cambridge, 1923.

Schmidt-Degener, F. *Rembrandt und der holländische Barock*. Leipzig, 1928.

Rijckevorsel, J. L. A. A. M. van. *Rembrandt en de Traditie*. Rotterdam, 1932.

Landsberger, F. *Rembrandt, the Jews and the Bible*. Trans. F. N. Gerson. Philadelphia, 1946.

Scholte, J. H. *Rembrandt en Vondel*. The Hague, 1946.

Schmidt-Degener, F. *Rembrandt und der holländische Barock*, 2. Amsterdam, 1950.
> Collected essays.

Slive, S. 'Rembrandt and his Contemporary Critics', *Journal of the History of Ideas*, 14 (1953).

Slive, S. *Rembrandt and his Critics: 1630–1730*. The Hague, 1953. Reprint, New York, 1988.
> Appraisal of sources. The publisher of the 1988 reprint neither sought nor obtained the author's permission for its publication; hence it appears without a new introduction or revisions that take account of subsequent research.

Gelder, J. G. van. 'Rembrandt en de zeventiende eeuw', *De Gids* (1956).

Valentiner, W. R. *Rembrandt and Spinoza*. London, 1957.

Białostocki, J. 'Ikonographische Forschungen zu Rembrandts Werk', *Münchener Jahrbuch der bildenden Kunst*, 8 (1957).

Michalkowa, J., and Białostocki, J. *Rembrandt w oczach wsólczesnych*. Warsaw, 1957.
> Translation of seventeenth- and early eighteenth-century sources into Polish. With a commentary.

Frey, D. 'Das Fragmentarische als das Wandelbare bei Rembrandt', *Das Unvollendente als künstlerische Form*. A symposium ed. by J. A. Schmoll gen. Eisenwerth. Bern-Munich, 1959.

Heiland, S., and Lüdecke, H. *Rembrandt und die Nachwelt*. Leipzig, 1960.

Scheller, R. W. 'Rembrandt's reputatie van Houbraken tot Scheltema', *N.K.J.*, 12 (1961).

Gerson, H. *Seven Letters by Rembrandt*. Transcription by I. H. van Eeghen, trans. Y. D. Ovink. The Hague, 1961.
> Rembrandt's correspondence with Constantijn Huygens regarding the Passion series commissioned by Frederik Hendrik.

Bauch, K. 'Iconographische Stil', in the author's *Studien zur Kunstgeschichte*. Berlin, 1967.

Robinson, F. W. 'Rembrandt's Influence in Eighteenth-Century Venice', *N.K.J.*, 18 (1967).

Emmens, J. A. *Rembrandt en de regels van de kunst*. Utrecht, 1968. Reprint, Amsterdam, 1979.
> On the development of theories held by seventeenth-century classicistic art critics and their estimate of the artist. Includes an English summary.

Helsdingen, H. W. van. 'Enkele opmerkingen over het Franse zeventiende-eeuwse Rembrandt-beeld', *O.H.*, 84 (1969).

Scheller, R. W. 'Rembrandt en de encyclopedische verzameling', *O.H.*, 84 (1969).

Waal, H. van de. 'Rembrandt at Vondel's Tragedy "Gijsbrecht van Aemstel", in *Miscellanea I.Q. van Regteren Altena*. Amsterdam, 1969. Reprinted in the author's *Steps Towards Rembrandt*, Amsterdam-London, 1974.

Rembrandt after Three Hundred Years. An Exhibition of Rembrandt and His

Followers, Chicago-Minneapolis-Detroit, 1969–70.
> Painting entries by J. R. Judson; drawing entries by E. Haverkamp-Begemann and A.-M. Logan.

Benesch, O. *Collected Writings. Volume 1. Rembrandt*, ed. E. Benesch. London, 1970.

Białostocki, J. 'Rembrandt and Posterity', *N.K.J.*, 23 (1972).

Filedt Kok, J. P. *Rembrandt Etchings & Drawings in the Rembrandt House*. Maarssen, 1972.

Rembrandt After Three Hundred Years: A Symposium – Rembrandt and His Followers. Chicago, 1973.
> Publication of a symposium held at The Art Institute of Chicago in 1969. Includes papers by J. G. van Gelder, H. Gerson, J. Bruyn, J. S. Held, J. Białostocki, H. F. von Sonnenburg, J. Rosenberg, J. A. Emmens, C. J. White.

Neue Beiträge zur Rembrandt-Forschung, ed. O. von Simson and J. Kelch. Berlin, 1973.
> Publication of a symposium held at Berlin in 1969. Papers by J. Rosenberg, E. Haverkamp-Begemann, R. H. Fuchs, W. Sumowski, J. S. Held, J. Białostocki, C. Tümpel, J. Q. van Regteren Altena, J. G. van Gelder, H. Gerson, R. W. Scheller, *et al.*

The Pre-Rembrandtists, exh. cat., E. B. Crocker Art Gallery, Sacramento, California, 1974.
> Introduction and catalogue by A. Tümpel; iconographic essay by C. Tümpel.

Waal, H. van de. *Steps Toward Rembrandt; Collected Articles: 1937–1972*. Amsterdam-London, 1974.
> Includes articles on the artist's biblical and historical subjects, and portraiture.

Broos, B. J. P. *Index to the Formal Sources of Rembrandt's Art*, Maarssen, 1977.

White, C., *et al. Rembrandt in Eighteenth-Century England*. New Haven, 1983.

Meijer, B. W. *Rembrandt nel Seicento toscano*. Florence, 1983.

Kelch, J., *et al. Bilder im Blickpunkt. Der Mann mit dem Goldhelm*. Berlin, 1986.
> Published by the Gemäldegalerie in conjunction with the Rathgen-Forschungslabor SMPK and the Hahn-Meitner Institute for Atomic Research; presents the case that the *Man with the Golden Helmet* (Bredius-Gerson 128) is not by Rembrandt.

Brown, J., Kelch, J., and Thiel, P. van, *et al. Rembrandt: the Master and his Workshop. Paintings*, exh. cat., Berlin-Amsterdam-London, 1991–2.
> Includes entries on paintings by the artist and members of his circle; also essays on his life, workshop, technique, the results of technical analysis, and a survey of Rembrandt criticism.

Bevers, H., Schatborn, P., and Welzel, B. *Rembrandt: the Master and his Workshop. Drawings and Etchings*, exh. cat., Berlin-Amsterdam-London, 1991–2.

8. Pupils and Followers

Rovinski, D. *L'Oeuvre gravé des élèves de Rembrandt et des maîtres qui ont gravé dans son goût*. St Petersburg, 1894.
> Includes 478 unretouched phototypes of the prints.

Hofstede de Groot, C. 'Rembrandt's onderwijs aan zijne leerlingen', *Feest-bundel Dr Abraham Bredius*. Amsterdam, 1915.

Falck, G. 'Über einige von Rembrandt übergegangene Schülerzeichnungen', *Jahrb. P.K.*, 54 (1924).

Münz, L. 'Rembrandts Korrekturen von Schülerzeichnungen nach 1650, oder Rembrandts bewusste Lehre von der Affektgestaltung von Figur und Raum', *Jahrbuch der kunsthistorischen Sammlungen in Wien*, 9 (1935).

Isarlov, G. 'Rembrandt et son entourage', *La Renaissance* (July–September, 1936).

Münz, L. 'Maes, Aert de Gelder, Barent Fabritius und Rembrandt', *Die Graphischen Künste*, N.F. 2 (1937).

Wessem, J. N. van. *Rembrandt als leermeester*, exh. cat., De Lakenhal, Leiden, 1956.

Gerson, H. 'Probleme der Rembrandtschule', *Kunstchronik*, 10 (1957).

Gerson, H. 'Rembrandt en de schilderkunst in Haarlem' in *Miscellanea I. Q. van Regteren Altena*. Amsterdam, 1969.

Rembrandt and His Pupils, exh. cat., Montreal-Toronto, 1969.
> Catalogue entries by D. G. Carter.

Haverkamp-Begemann, E. 'Rembrandt as a Teacher', *Actes du XXIIe Congrès Internationale d'histoire de l'art*, 2, Budapest, 1972.

Sumowski, W. *Drawings of the Rembrandt School*. 10 vols. New York, 1979– (in progress).

Sumowski, W. *Gemälde der Rembrandt-Schüler*, 6 vols. Landau-Pfalz, 1983.

The Impact of a Genius. Rembrandt, His Pupils and Followers in the Seventeenth Century, exh. cat., K. & V. Waterman, Amsterdam-Groninger Museum, Groningen, 1983.
> B. Broos's contribution to the catalogue distinguishes between artists who should be classified as pupils and those who were followers as well as charts documented pupils, those cited in early sources, artists first mentioned by Houbraken (1718–21), and those who make an appearance as members of Rembrandt's circle in literature published during the following centuries. The catalogue also includes contributions by A. Blankert, G. Jansen, W. van de Watering and E. van de Wetering.

Schatborn, P., and Ornstein-van Slooten, E. *Bij Rembrandt in de Leer/ Rembrandt as Teacher*, exh. cat., Rembrandthuis, Amsterdam, 1984–5.

The Hoogsteder Exhibition of Rembrandt's Academy. The Hague, 1992.
> Catalogue of paintings by Rembrandt's pupils with essays by P.-H. Janssen and W. Sumowski; entries on the paintings by the former.

> Also see entries above to M. ARTISTS IN ALPHABETICAL SEQUENCE *passim* and RIJN, REMBRANDT VAN: 7. I. OTHER SPECIALIZED STUDIES.

RIJN, TITUS VAN
Welcker, A. 'Titus van Rijn als Teekenaar', *O.H.*, 55 (1938).
Sumowski *Drawings*. Vol. 9, 'Titus van Rijn'.

RING, DE
Moes, E. W. 'Pieter de Ring', *O.H.*, 6 (1888).
Kinder, T. T. 'Pieter de Ring, a Still-Life Painter in Seventeenth-Century Holland', *Indiana University Art Museum*, 2 (1979).

ROESTRATEN
Kuile, O. ter. 'Een Hollands stilleven door Pieter van Roestraeten in 1696 te Londen geschilderd', *Antiek*, 4 (1969–70).
Shaw, L. B. 'Pieter van Roestraeten and the English "vanitas",' *B.M.*, 132 (1990).

ROGHMAN, ROELANT
Wyck, H. W. M., Kloek, W. T., *et al. De kasteeltekening van Roelant Roghman*. 2 vols., Alphen aan den Rijn, 1989–90.
Sumowski *Gemälde*. Vol. 4, 'Roelant Roghman'.

ROUSSEAUX
Bredius, A. 'Le Peintre Jacques de Rousseaux', *G.B.A.*, 5 (1922).
Sumowski *Gemälde*. Vol. 4, 'Jacques des Rousseaux'.

RUISDAEL, ISAACK VAN
Wurzbach, A. von. 'Der Meister Izack van Ruisdael', *Zeitschrift für bildende Kunst*, 12 (1877).
Simon, K. E. 'Isaack van Ruisdael', *B.M.*, 67 (1935).
Giltaij, J. 'The problem of Isaack van Ruisdael (1599–1677)', *B.M.*, 134 (1992).
Slive, S, 'A newly discovered Isaack van Ruisdael in Philadelphis', *B.M.*, 139 (1997).

RUISDAEL, JACOB VAN
1. Documents
Wijnman, H. F. 'Hst leven der Ruysdaels', *O.H.*, 49 (1932), pp. 49–69, 173–81, 258–75.
Articles documenting the life of the artist and his family.

2. Catalogues
HdG. Vol. 4, 'Jacob van Ruisdael'.
Rosenberg, J. *Jacob van Ruisdael*. Berlin, 1928.
> Monograph includes a catalogue of the paintings and pioneer list of the drawings.

Giltay, J. 'De tekeningen van Jacob van Ruisdael', *O.H.*, 94 (1980).
> Catalogue raisonné of the drawings and discussion of their character and history. Also catalogues sheets attributable to Hobbema.

Slive, S. 'Etchings', in *Jacob van Ruisdael*, exh. cat., The Hague-Cambridge, Massachusetts, 1981–2.
> Includes references to earlier literature on the artist's thirteen prints.

3. Monographs and Special Studies
Riegl, A. 'Jacob van Ruysdael', *Die Graphischen Künste*, 35 (1902); reprinted in *Gesammelte Aufsätze*, ed. K. M. Swoboda. Vienna, 1928.
Rosenberg, J. '"The Jewish Cemetery" by Jacob van Ruisdael', *Art in America*, 14 (1926).
> Publication of the versions in Detroit and Dresden.

Zwarts, J. 'Het motief van Jacob van Ruisdael "Jodenkerkhof",' *Oudheidkundig Jaarboek*, 8 (1928).
> Unconvincing attempt to date versions of the *Jewish Cemetery* to the late 1670s.

Simon, K. E. *Jacob van Ruisdael, eine Darstellung seiner Entwicklung*. Berlin, 1930.

Reprint, with additions and corrections of a dissertation published in 1927.

Gerson, H. 'The Development of Ruisdael', *B.M.*, 65 (1934).

Simon, K. E. '"Doctor" Jacob van Ruisdael', *B.M.*, 67 (1935).

Simon, K. E. 'Wann hat Ruisdael die Bilder des Judenfriedhofs gemalt?', *Festschrift für Adolph Goldschmidt*. Berlin, 1935.

Rosenau, H. 'The Dates of Jacob van Ruisdael's "Jewish Cemeteries"', *O.H.*, 63 (1958).
 Dates the drawings related to the pictures before 1674 and unconvincingly places the paintings later.

Wiegand, W. *Ruisdael-Studien. Ein Versuch zur Ikonologie der Landschaftmalerei* (diss.). Hamburg, 1961.

Kouznetsov, I. 'Sur le symbolisme dans les paysages de Jacob van Ruisdael', *Bulletin du Musée Nationale de Varsovie*, 14 (1973).

Fuchs, R. H. 'Over het landschap. Een verslag naar aanleiding van Jacob van Ruisdael, "Het Korenveld"', *Tijdschrift voor Geschiedenis*, 86 (1973).
 On the semiotics of the landscapes with special reference to *The Grain Field* at Rotterdam.

Slive, S. 'Notes on Three Drawings by Jacob van Ruisdael' in *Album Amicorum J. G. van Gelder*. The Hague, 1973.

Burke, J. D. 'Ruisdael and his Haarlempjes', *M, A Quarterly Review of the Montreal Museum of Fine Arts*, 6 (1974).

Vega, L. A. *Het Beth Haim van Ouderkerk: beelden van een Portugees-Joodse begraafplaats. The Beth Haim of Ouderkerk aan de Amstel: Images of a Portuguese Jewish Cemetery in Holland*. Assen, 1975.

Kauffmann, H. 'Jacob van Ruisdael, "Die Mühle von Wijk bei Duurstede",' *Festschrift für Otto von Simson zum 65. Geburtstag*. Frankfurt, 1977.

Scheyer, E. 'The Iconography of Jacob van Ruisdael's *Cemetery*', *Bulletin of the Detroit Institute of Arts*, 55 (1977).

Slive, S. *Jacob van Ruisdael*, exh. cat., The Hague-Cambridge, Massachusetts, 1981–2.

Slive, S. 'Additions to Jacob van Ruisdael', *B.M.*, 133 (1991).

Slive, S. 'Jacob van Ruisdael's variation on a theme by Rubens at Bilbao', *O.H.*, 111 (1997).

RUISSCHER
Welcker, A. 'Johannes Ruyscher', *O.H.*, 49 (1932); 50 (1933); 51 (1934); 57 (1940).

Trautscholdt, E. 'Johannes Ruisscher alias Jonge Hercules: Die Radierungen', suppl. in E. Haverkamp-Begemann, *Hercules Segers*. Amsterdam-The Hague, 1973.

RUYSCH
HdG. Vol. 10, 'Rachel Ruysch'.

Grant, M. H. *Rachel Ruysch*. Leigh-on-Sea, 1956.

Šíp, J. 'Notities bij het stilleven van Rachel Ruysch', *N.K.J.*, 19 (1968).

RUYSDAEL, SALOMON VAN
Stechow, W. *Salomon van Ruysdael*. Berlin, 1938. 2nd revised and enlarged edition, Berlin, 1975.
 Standard work, with catalogue raisonné.

Niemeijer, J. W. 'Het topografisch element in enkele riviergezichten van Salomon van Ruysdael nader beschouwd', *O.H.*, 74 (1959).

Scholtens, H. J. J. 'Salomon van Ruysdael in de contreien van Holland's landengte', *O.H.*, 77 (1962).

SAENREDAM
Regteren Altena, I. Q. van. 'Saenredam Archaeolog', *O.H.*, 48 (1931).

Swillens, P. T. A. *Pieter Jansz. Saenredam*. Amsterdam, 1935. Reprint, Soest, 1970.
 Pioneer monograph and catalogue.

Catalogue Raisonné of the Works by Pieter Jansz. Saenredam. Utrecht, 1961.
 Published on the occasion of an exhibition at the Centraal Museum, Utrecht. Includes essays by P. T. A. Swillens and I. Q. van Regteren Altena.

Schwartz, G. 'Saenredam, Huygens and the Utrecht Bull', *Simiolus*, 1 (1966–7).

Liedtke, W. A. 'Saenredam's Space', *O.H.*, 86 (1971).

Liedtke, W. A. 'The New Church in Haarlem Series: Saenredam's Sketching Style in Relation to Perspective', *Simiolus*, 8 (1975–6).

Ruurs, R. 'Saenredam: constructies', *O.H.*, 96 (1982).

Kemp, M. 'Simon Stevin and Pieter Saenredam: a study of mathematics and vision in Dutch science and art', *The Art Bulletin*, 68 (1986).

Ruurs, R. *Saenredam. The Art of Perspective*. Amsterdam, etc., 1987.

Schwartz, G., and Bok, M. J. *Pieter Saenredam. The Painter and His Time*. New York [1990].
 Standard monograph and catalogue.

SAFTLEVEN, CORNELIS
Schulz, W. *Cornelis Saftleven 1607–1681. Leben und Werke. Mit einem*

kritischen Katalog der Gemälde und Zeichnungen. Berlin-New York, 1978.

SAFTLEVEN, HERMAN
Nieuwstraten, J. 'De ontwikkeling van Herman Saftlevens kunst tot 1650. Spiegel van stromingen in de Nederlandse landschapschilderkunst', *N.K.J.*, 16 (1965).

Klinge-Gross, M. 'Herman Saftleven als Zeichner und Maler bäuerlicher Interieurs. Zur Entstehung des südholländischen Bildtyps mit Stilleben aus ländischem Hausrat und Gerät', *Wallraf-Richartz-Jahrbuch*, 38 (1976).

Schulz, W. *Herman Saftleven 1609–1685. Leben und Werke. Mit einem kritischen Katalog der Gemälde und Zeichnungen*. Berlin-New York, 1982.

SANDRART
Klemm, C. *Joachim von Sandrart. Kunst-Werke und Lebenslauf.* Berlin, 1986.
 Also see above under II. B. SOURCES AND EIGHTEENTH-CENTURY LITERATURE.

SAVERY
Erasmus, K. *Roelant Savery, sein Leven und seine Werke*. Halle, 1908.

Białostocki, J. 'Les bêtes et les humains de Roelant Savery', *Bulletin Koninklijke Musea voor Schone Kunsten, Brussels*, no. 7 (1958).

Spicer, J. A. 'The "Naer het leven" Drawings: by Pieter Bruegel or Roelandt Savery?', *Master Drawings*, 8 (1970).
 Conclusive demonstration that a group of drawings traditionally attributed to Bruegel is in fact by Savery.

Franz, H. G. 'Zum Werk des Roeland Savery', *Jahrbuch des Kunsthistorischen Institutes der Universität Graz*, 15–16 (1979–80).

Spicer-Durham, J. A. *The Drawings of Roelandt Savery* (diss.). Yale University, 1979; *ibid*, Ann Arbor, 1986.

Müllenmeister, K. J. *Roelant Savery 1576–1639. Hofmaler Kaiser Rudolf II* Freren, 1988.

SCHALCKEN
HdG. Vol. 5, 'G. Schalcken'.

Hecht, P. 'Candlelight and Dirty Fingers, or Royal Virtue in Disguise: Some Thoughts on Weyerman and Godfried Schalcken', *Simiolus*, 11 (1980).

Beherman, T. *Godfried Schalcken (1643–1706)*. Paris, 1988.
 Monograph with *œuvre* catalogue.

SCHELLINKS
Vries, A. D. de. 'Willem Schellinks, schilder, teekenaar, etser, dichter', *O.H.*, 1 (1883).

Berg, H. M. van den. 'Willem Schellinks en Lambert Doomer in Frankrijk', *Oudheidkundig Jaarboek*, 11 (1942).

SCHOOTEN, VAN
Gammelbo, P. 'Floris Gerritsz. van Schooten', *N.K.J.*, 17 (1966).

SCHOUMAN
Roever, N. de. 'Aert Schouman volgens zijne aanteekenboekjes', *O.H.*, 6 (1888).

Bol, L. J. Introduction to catalogue *Aart Schouman*. Dordrechts Museum, 1960.

Bol, L. J. *Aart Schouman (1710–1792). Ingenious Painter and Draughtsman*. Doornspijk, 1991.

SEGERS
Bode, W. von. 'Der Maler Hercules Seghers', *Jahrb. P.K.*, 24 (1903).

Springer, J. *Die Radierungen des Herkules Seghers*. 3 vols. Berlin, 1910–12.
 Catalogue and sixty-six facsimilies.

Pfister, K. *Herkules Seghers*. Munich, 1921.

Fraenger, W. *Die Radierungen des Hercules Seghers*. Erlenbach-Zürich, 1922.

Trautscholdt, E. 'Der Maler Herkules Seghers', *Pantheon*, 25 (1940).

Knuttel Wzn., G. *Hercules Seghers (Palet Serie)*. Amsterdam, 1941.

Collins, L. C. *Hercules Seghers*. Chicago, 1953.

Haverkamp-Begemann, E. *Hercules Seghers*, exh. cat., Museum Boymans, Rotterdam, 1954.

Regteren Altena, I. Q. van. 'Hercules Seghers en de topografie', *Rijksmuseum Bulletin*, 3 (1955).

Trautscholdt, E. 'Neues Bemühen um Hercules Seghers', *Imprimatur*, 12 (1955).

Leusden, W. van. *The Etchings of Hercules Seghers and the Problem of his Graphic Technique*. Trans. St John Nixon. Utrecht, 1961.

Haverkamp-Begemann, E. *Hercules Seghers*. Amsterdam, 1968.

Haverkamp-Begemann, E. *Hercules Segers: The Complete Etchings*. Amsterdam, 1973.
 Standard catalogue raisonné. Includes facsimile reproductions and a supplement on J. Ruischer by E. Trautscholdt.

Rowlands, J. *Hercules Segers*. New York-Amsterdam, 1979.

SLINGELAND, VAN
HdG. Vol. 5, 'Pieter van Slingeland'.

SORGH
Schneemann, L. *Henrick Martensz Sorgh. A Painter of Rotterdam. With a Catalogue Raisonné* (diss.). Ann Arbor, 1982.

STEEN
Westrheene Wz, T. van. *Jan Steen. Étude sur l'art en Holland.* The Hague, 1856.
Marius, G. H. *Jan Steen.* Amsterdam, 1906.
HdG. Vol. 1, 'Jan Steen'.
Antal, F. 'Concerning Some Jan Steen Pictures in America', *Art in America*, 13 (1925).
Schmidt-Degener, F., and Gelder, H. E. van. *Jan Steen.* Trans. G. J. Renier. London, 1927.
Hofstede de Groot, C. 'Jan Steen and his Master Nicholaes Knupfers', *Art in America*, 16 (1927–8).
Stechow, W. 'Bemerkungen zu Jan Steens künstlerischer Entwicklung', *Zeitschrift für bildende Kunst*, 62 (1928–9).
Gils, J. B. F. van. 'Jan Steen en de rederijkers', *O.H.*, 52 (1935).
Martin, W. 'Jan Steen as Landscape Painter', *B.M.*, 67 (1935).
Jonge, C. H. *Jan Steen (Palet Serie).* Amsterdam, 1939.
Heppner, A. 'The Popular Theatre of the Rederijkers in the Work of Jan Steen and His Contemporaries', *Journal of the Warburg and Courtauld Institutes*, 3 (1939–40).
Simon, K. E. 'Jan Steen und Utrecht', *Pantheon*, 26 (1940).
Regteren Altena, I. Q. van. 'Hoe teekende Jan Steen?', *O.H.*, 60 (1943).
Gudlaugsson, S. J. *De komedianten bij Jan Steen en zijn tijdgenooten.* The Hague, 1945. English trans., *The Comedians in the Work of Jan Steen and his Contemporaries*, Soest, 1970.
Gerson, H. 'Landschappen van Jan Steen', *Kunsthistorische Mededeelingen van het Rijksbureau voor kunsthistorische Documentatie*, 3 (1948).
Bijleveld, W. J. J. C. *Om den Hoenderhoef door Jan Steen.* Leiden, 1950.
Groot, C. W. de. *Jan Steen in woord en beeld.* Utrecht-Nijmegen, 1952.
Martin, W. *Jan Steen.* Amsterdam, 1954.
Kuznetsov, Y. 'The Paintings by Jan Steen in the Hermitage', *Yearbook of the Institute for the History of Art (Moscow)*, (Russian text) 1958.
Domela, P. N. H. *Jan Steen*, exh. cat., Mauritshuis, The Hague, 1958–9.
Criegern, A. von. *Ikonografische Studien zu den fröhlichen Gesellschaft Jan Steens.* Tübingen, 1971.
Stechow, W. 'Jan Steen's Representations of the Marriage in Cana', *N.K.J.*, 23 (1972).
Vries, L. de. 'Achttiende- en negentiende-eeuwse auteurs over Jan Steen', *O.H.*, 87 (1973).
Vries, L. de. *Jan Steen.* Amsterdam, 1976.
Kirschenbaum, B. D. *The Religious and Historical Paintings of Jan Steen.* New York-Montclair, 1977.
Vries, L. de. *Jan Steen 'de klucht-schilder'* (diss.). Groningen, 1977.
Braun, K. *Alle tot nu toe bekende schlderijen van Jan Steen.* Rotterdam, 1980.
Sutton, P. C. 'The Life and Art of Jan Steen', *Bulletin, Philadelphia Museum of Art*, 78 (1982–3).
Chapman, H. Perry, *et al.*, *Jan Steen Painter and Story Teller*, exh. cat., National Gallery of Art, Washington-Rijksmuseum, Amsterdam, 1996–7.

STEENWIJCK
Bredius, A. 'De Schilders Pieter en Harmen Steenwijck', *O.H.*, 8 (1890).
Koozin, K. *The Vanitas Still Lives of Harmen Steenwyk. Metamorphic Realism.* Lewiston, New York, etc., 1990.

SWANENBURGH, VAN
Michel, É. 'Jacob Swanenburch, le premier maître de Rembrandt', *La Chronique des Arts et de la Curiosité* (1905).
Frimmel, T. von. 'Das signierte Werk des Jacob Isaaksz van Swanenburgh in der Galerie zu Kopenhagen; Der Jacob Isaaksz van Swanenburgh in der Augsburger Galerie', *Blätter für Gemäldekunde*, 2 (1906).

SWANEVELT, VAN
Henkel, M. D. von. 'Swaneveld und Piranesi in Goethescher Beleuchtung', *Zeitschrift für bildende Kunst*, 58 (1924–5).
Waddington, M. R. 'Herman van Swanevelt in Rome', *Paragone*, 121 (1960).
Bodart, D. 'La biografia di Herman van Swanevelt scritta da Giovanni Battista Passeri', *Storia dell'Arte*, 12 (1971).
Blume, A. C. 'Herman van Swanevelt and his Prints', *O.H.*, 108 (1994).

SWEERTS
Martin, W. 'Michiel Sweerts als schilder. Proeve van een biografie en een catalogus van zijn schilderijen', *O.H.*, 25 (1907).
The first attempt to establish Sweerts's *œuvre*.

Stechow, W. 'Some Portraits by Michiel Sweerts', *A.Q.*, 14 (1951).
Kultzen, R. *Michael Sweerts en tijdgenoten*, exh. cat., Rotterdam-Rome, 1958.
Bloch, V. *Michael Sweerts.* The Hague, 1968.
Perceptive essay with a note on the artist's relation to foreign missions by J. Guennou.
Horster, M. 'Antikenkenntnis in Michael Sweerts' "Römischem Ringkampf",' *Jahrbuch der Staatlichen Kunstsammlungen in Baden-Württemberg*, 11 (1974).
Kultzen, R. 'Michiel Sweerts als Lernender und Lehrer', *Münchner Jahrbuch der bildenden Kunst*, 33 (1982).
Kultzen, R. *Michiel Sweerts. Brussels, 1618–Goa, 1664*, Doorspijk, 1996.

TEMPEL, VAN DEN
Wijnman, H. F. 'De schilder Abraham van den Tempel', in *Uit de kring van Rembrandt en Vondel.* Amsterdam, 1959.

TENGNAGEL
Schneider, H. 'Der Maler Jan Tengnagel', *O.H.*, 39 (1921).

TERBORCH *see* BORCH, TER
TERBRUGGHEN *see* BRUGGHEN, TER

TORRENTIUS
Bredius, A. *Johannes Sijmonsz Torrentius.* The Hague, 1909.
Rehorst, A. J. *Torrentius.* Rotterdam, 1939.
Herbert, Z. *Still Life with a Bridle.* Trans. J. and B. Carpenter. New York, 1991.
Collection of essays by the Polish poet that includes one on Torrentius's tondo.

TROOST
Huell, A. ver. *Cornelis Troost.* Arnhem, 1873.
Knoef, J. *Cornelis Troost (Palet Serie).* Amsterdam, 1947.
Niemeijer, J. W. *Cornelius Troost: 1696–1750.* Assen, 1973.
Authoritative monograph and catalogue.
Buijsen, E., and Niemeijer, J. W. *Cornelis Troost and the Theatre of His Time. Plays of the 18th Century*, exh. cat., Mauritshuis, The Hague, 1993.

TROOSTWIJK, VAN
Vries, J. de. 'Iets over den kunstschilder Wouter Joannes van Trootswijck', *Vaderlandsche letteroefeningen*, 2 (1815).
Knoef, J. 'W. J. van Troostwijk', *Elsevier's geïllustreerd maandschrift*, 78 (1929).

UYL, DEN
Bredius, A. 'Jan Jansz Uyl (een nalezing)', *O.H.*, 35 (1917); *ibid*, 38 (1920).
Boer, P. de. 'Jan Jansz den Uyl', *O.H.*, 57 (1940).

UYTTENBROECK
Weisner, U. 'Die Gemälde des Moyses van Uyttenbroeck', *O.H.*, 79 (1964).

VALCKERT, VAN DEN
Hudig, F. W. 'Werner van den Valckert', *O.H.*, 54 (1937).
Taverne, E. R. M. 'Een Amsterdams Lucasfeest in 1618', *Simiolus*, 4 (1970).
Thiel, P. J. J. van. 'Werner Jacobsz van den Valckert', *O.H.*, 97 (1983).

VANVITELLI *see* WITTEL VAN

VELDE, VAN DE VELDE FAMILY
Bradley, W. A. 'The Van de Veldes', *Print Collectors' Quarterly*, 7 (1917).
Michel, É. *Les van de Velde.* Paris, 1892.
Manteuffel, K. Z. von. *Die Künstler Familie van de Velde.* Bielefeld-Leipzig, 1927.

VELDE, ADRIAEN VAN DE
Michel, É. 'Adrien van de Velde', *L'Art, Revue Mensuelle*, 53 (1892).
Bode, W. 'Adriaen van de Velde', *Die graphischen Künste*, 19 (1906).
HdG. Vol. 4, 'Adriaen van de Velde'.
Gelder, J. G. van. 'Adriaen van de Velde, Christus aan het Kruis', *Kunsthistorische Mededeelingen van het Rijksbureau voor kunsthistorische Documentatie*, 1 (1946).
Schatborn, P. '"De Hut" van Adriaen van de Velde', *Bulletin van het Rijksmuseum*, 23 (1975).
Robinson, W. W. 'Preparatory Drawings by Adriaen van de Velde', *Master Drawings*, 17 (1979).
Robinson, W. W. 'Some Studies of Nude Models by Adriaen van de Velde', *Donum Amicorum, Essays in Honour of Per Bjurström.* Stockholm, 1993.

VELDE, ESAIAS VAN DE
Poensgen, G. *Der Landschaftstil des Esaias van de Velde.* Freiburg, 1924.
Stechow, W. 'Esaias van de Velde and the Beginnings of Dutch Landscape Painting', *N.K.J.*, 1 (1947).
Keyes, G. S. *Esaias van den Velde (1587–1630).* Doornspijk, 1984.

Authoritative monograph and catalogue of the painted and graphic *œuvre*.

VELDE, JAN VAN DE

Gelder, J. G. van. *Jan van de Velde, 1593–1641, teekenaar-schilder*. The Hague, 1933.

Standard monograph and catalogue. Addenda by the author in *O.H.*, 70 (1955).

VELDE, WILLEM I and WILLEM II VAN DE

HdG. Vol. 7, 'W. van de Velde II'.

Baard, H. P. *Willem van de Velde de Oude, Willem van de Velde de Jonge (Palet Serie)*. Amsterdam, 1942.

Robinson, M. S. *Van de Velde Drawings . . . in the National Maritime Museum*. 2 vols. Cambridge, 1958–74.

Weber, R. E. J. 'Willem van de Velde de Oude als topograaf van onze zeegaten', *O.H.*, 90 (1976).

Weber, R. E. J. 'The Artistic Relationship between the Ship Draughtsman Willem van de Velde the Elder and His Son the Marine Painter in the Year 1664', *Master Drawings*, 17 (1979).

Robinson, M. S. *The Willem van de Velde Drawings in the Boymans-van Beuningen Museum Rotterdam*. 3 vols. Rotterdam, 1979.

Cordingly, D., *et al. The Art of the Van de Veldes. Paintings and Drawings by the Great Dutch Marine Artists and Their English Followers*, exh. cat., National Maritime Museum, London, 1982.

Robinson, M. S. *Van de Velde. A Catalogue of the Paintings of the Elder and Younger van de Velde*. 2 vols. Greenwich, 1990.

VENNE, VAN DE

Franken Dz., D. *Adriaen van de Venne*. Amsterdam, 1878.

Knuttel, G. *Das Gemälde des Seelenfischfangs von Adriaen Pietersz van de Venne*. The Hague, 1917.

Bol, L. J. 'Een middelburgse Brueghel groep. VIII. Adriaen Pietersz van de Venne, schilder en teyckenaer: A. Middelburgse periode c. 1614–1625; B. Haagse periode 1625–1662', *O.H.*, 73 (1958).

Bol, L. J. *Adriaen van de Venne. Painter and Draughtsman*. Doornspijk, 1989.

Royalton-Kisch, M. *Adriaen van de Venne's Album in the Department of Prints and Drawings in the British Museum*. London, 1988.

Publication of an album of more than 100 drawings that includes a comprehensive study of the artist's life and work.

VERELST

Lewis, F. *Simon Pietersz Verelst. The God of Flowers. 1644–1721*. Leigh-on-Sea, 1979.

VERMEER, JOHANNES (JAN)

1. Documents and Sources

Montias, J. M. *Vermeer and His Milieu. A Web of Social History*. Princeton, 1989.

Includes summaries and bibliographical references to more than 450 documents related to the Vermeer family from 1596 to 1749.

2. Catalogues and monographs

Bürger, W. (Étienne Jos. Théoph. Thoré). *Van der Meer de Delft*. Paris, 1866.

Reprint of the articles (*G.B.A.*, 21, 1866) which established the artist's *œuvre*. Although not all of the author's attributions are acceptable today, the study remains a basic account. A modern reprint is available in A. Blum, *Vermeer et Thoré Bürger*, Geneva, 1945.

HdG. Vol. 1, 'Johannes Vermeer'.

Plietzsch, E. *Vermeer van Delft*. Leipzig, 1911.

Lazarev, V. N. *Vermeer* (in Russian). Moscow, 1933.

Hale, P. L. *Vermeer*. New ed. completed and prepared for the press by F. W. Coburn and R. F. Hale. London, 1937.

Thienen, F. W. S. van. *Vermeer (Palet Serie)*. Amsterdam, 1939.

Vries, A. B. de. *Jan Vermeer van Delft*. 2nd ed. London-New York, 1948.

Swillens, P. T. A. *Johannes Vermeer*. Utrecht, 1950.

Gowing, L. *Vermeer*. London, 1952. New ed. New York-Evanston, 1970.

Tout Vermeer de Delft, ed. A. Malraux. Paris, 1952.

Text includes 'Pages sur Vermeer par Marcel Proust'. The chronology based on identification of members of the artist's family is unsuccessful.

Bloch, V. *Tutta la pittura di Vermeer di Delft*. Milan, 1954.

Goldscheider, L. *Jan Vermeer*. London, 1958.

Blankert, A., with contributions by R. Ruurs and W. L. van de Watering. *Johannes Vermeer van Delft: 1632–1675*. Utrecht-Antwerp, 1975.

Monograph and catalogue of the paintings. *Vermeer of Delft*, Oxford, 1978, is an English translation of the volume.

Snow, E. *A Study of Vermeer*. Berkeley, 1979; revised and enlarged ed.,

Berkeley, 1993.

Wheelock, A. K., Jr. *Jan Vermeer*. New York-London, 1981.

Blankert, A., *et al. Vermeer*. New York, 1988.

Includes the catalogue raisonné Blankert and his colleagues published in 1975 and an essay by J. W. Montias on the Vermeer family.

Nash, J. *Vermeer*. London, 1991.

Arasse, D. *Vermeer. Faith in Painting*. Trans. T. Grabar. Princeton, 1993.

Wheelock, A. K. Jr. *Vermeer and the Art of Painting*, New Haven and London, 1995.

Johannes Vermeer, exh. cat., ed. A. K. Wheelock Jr., National Gallery of Art, Washington-Mauritshuis, The Hague, 1995–6.

3. Special Studies

Voss, H. 'Vermeer van Delft und die Utrechter Schule', *Monatshefte für Kunstwissenschaft*, 5 (1912).

Barnouw, A. J. 'Vermeers zogenaamd Novum Testamentum', *O.H.*, 32 (1914).

Gelder, J. G. van. 'Een teekening van Carel Fabritius en een teekening van Johannes Vermeer', *O.H.*, 48 (1931).

Heppner, A. 'Vermeer – seine kunstlerische Herkunft und Ausstrahlung', *Pantheon*, 16 (1935).

Huyghe, R. 'Vermeer et Proust', *L'Amour de l'Art* (1936).

Bredius, A. 'A New Vermeer: Christ and the Disciples at Emmaus', *B.M.*, 71 (1937).

Publication of the notorious Vermeer forgery by Han van Meegeren as an authentic work. For a discussion of van Meegeren's falsifications see P. B. Coremans, *Van Meegeren's Faked Vermeers and De Hoochs: A Scientific Examination*. Trans. A. Hardy and C. Hutt. Amsterdam, 1949.

Hulten, K. G. 'Zu Vermeers Atelierbild', *Konsthistorisk Tidskrift*, 18 (1949).

Gelder, J. G. van. *De Schilderkunst van Jan Vermeer*. With a commentary by J. A. Emmens. Utrecht, 1958.

A more convincing interpretation of the *Allegory of Painting* at Vienna than the one offered by H. Sedlmayr, 'Der Ruhm der Malkunst Jan Vermeer "De schilderconst"', *Festschrift für Hans Jantzen*, Berlin, 1951, or C. de Tolnay, 'L'Atelier de Vermeer', *G.B.A.* (April 1953). Also cf. K. Badt, *Modell und Maler von Jan Vermeer. Probleme de Interpretation; eine Streitschrift gegen Hans Sedlmayr*, Cologne, 1961.

Seymour, C., Jr. 'Dark Chamber and Light-Filled Room: Vermeer and the Camera Obscura', *Art Bulletin*, 46 (1964).

Kühn, H. 'A Study of the Pigments Used by Jan Vermeer', *Report and Studies in the History of Art, National Gallery of Art (Washington)*, 2 (1968).

Slive, S. 'Een dronke slapende meyd aan een tafel', in *Festschrift Ulrich Middeldorf*. Berlin, 1968.

Fink, D. A. 'Vermeer's Use of the Camera Obscura – a Comparative Study', *The Art Bulletin*, 53 (1971).

Kahr, M. M. 'Vermeer's Girl Asleep, A Moral Emblem', *Metropolitan Museum Journal*, 6 (1972).

Welu, J. A. 'Vermeer: His Cartographic Sources', *The Art Bulletin*, 57 (1975).

Welu, J. A. *Vermeer and Cartography* (diss.), Boston University, 1977, University Microfilms International, Ann Arbor, 1977.

Wheelock, A. K., Jr. 'Zur Technik zweier Bilder, die Vermeer zugeschrieben sind', *Maltechnik/Restauro*, 84 (1978).

Seth, L. 'Vermeer och van Veens Amorum Emblemata', *Konsthistorisk Tidskrift*, 49 (1980).

VERMEER I (VAN HAARLEM), JAN

Linfert, C. 'Eine Landschaft des Haarlemer Vermeer im Wallraf-Richartz-Museum zu Köln', *Kunstchronik*, 53 (1929–30).

VERSPRONCK

Kalff, S. 'Een Haarlemsch portretschilder uit de Gouden Eeuw', *De Nieuwe Gids*, 34 (1918).

Ekkart, R. E. O. *Johannes Cornelisz. Verspronck; leven en werken van een Haarlems portretschilder uit de 17de eeuw*, exh. cat., Frans Hals Museum, Haarlem, 1979.

This exhibition catalogue does double duty as the authoritative monograph and catalogue raisonné of the artist's work.

VICTORS

Zafran, E. 'Jan Victors and the Bible', *Israel Museum News*, 12 (1977).

Miller, D. *Jan Victors, 1619–1676* (diss.). 2 vols. University of Delaware, 1985.

Sumowski *Gemälde*. Vol. 4, 6: 'Jan Victors'.

Also see above under RIJN, REMBRANDT VAN: 7. B. Manuth, V.

VINCKBOONS

Coninckx, H. 'David Vinckboons, peintre, et son oeuvre et la famille de ce nom', *Annales de l'Académie Royale d'Archéologie de Belgique*, 59 (1907).

Held, J. S. 'Notes on David Vinckboons', *O.H.*, 66 (1951).

Goossens, K. *David Vinckboons*. Antwerp, 1954. Reprint, Soest, 1977.
See review by S. Slive, *The Art Bulletin*, 39 (1957).

Goossens, K. 'Nog meer over David Vinckboons', *Jaarboek van het Koninklijk Museum voor Schone Kunsten Antwerpen*, 6 (1966).

VINNE, VINCENT LAURENSZ VAN DER

Dagelijkse aentekeninge van Vincent Laurensz van der Vinne. Reisjournaal van een Haarlems schilder 1652–1655, ed. S. Sliggers, Jr. Haarlem, 1979.

VISSCHER

Simon, M. *Claes Jansz Visscher* (diss). Freiburg im Breisgau, 1958.

VLIEGER, DE

Haverkorn van Rijsewijk, P. 'Simon Jacobsz de Vlieger', *O.H.*, 9 (1891); 11 (1893).

Heppner, A. 'Simon de Vlieger und der "Pseudo-Van de Venne"', *O.H.*, 47 (1930).

Kelch, J. *Simon de Vlieger als Marinemaler* (diss.). Berlin, 1971.

VLIET, VAN

Bober, H. *Jan van Vliet's Book of Crafts and Trades: With a Reappraisal of His Etchings*. Albany, New York, 1981.

Royalton-Kisch, M. 'Over Rembrandt en van Vliet', *De Kroniek van het Rembrandthuis*, 36 (1984).

VOORT, VAN DER

Six, J. 'Cornelis van der Voort. Een eerste poging tot het terugvinden van zijn werk als portretschilder', *O.H.*, 5 (1887); also cf. *ibid*, 19 (1911); 36 (1918).

VOSMAER

Donahue, S. 'Daniel Vosmaer', *Vassar Journal of Undergraduate Studies*, 19 (1964).

VREDEMAN DE VRIES, HANS and PAUL

Schneede, U. M. 'Interieurs von Hans und Paul Vredeman', *N.K.J.*, 18 (1967).

Ballegeer, J. P. C. M. 'Enkele voorbeelden van de invloed van Hans en Paulus Vredeman de Vries op de architectuurschilders in de Nederlanden gedurende de XVIe en XVIIe eeuw', *Gentse Bijdragen tot de Kunstgeschiedenis en de Oudheidkunde*, 20 (1967).

Ehrman, J. 'Hans Vredeman de Vries (Leeuwarden 1527–Anvers 1606), *G.B.A.*, 121 (1979).

VREL

Valentiner, W. R. 'Paintings by Pieter de Hooch and Jacobus Vrel', *Bulletin of the Detroit Institute of Arts*, 9 (1927–8).

Brière-Misme, C. 'Un Intimiste hollandais: Jacob Vrel', *Revue de L'Art Ancien et Moderne*, 68 (1935).

Régnier, G. 'Jacob Vrel, un Vermeer du Pauvre', *G.B.A.*, 110 (1968).

VROOM, CORNELIS

Rosenberg, J. 'Cornelis Hendricksz Vroom', *Jahrb. P.K.*, 49 (1928).

Keyes, G. S. *Cornelis Vroom: Marine and Landscape Artist*. 2 vols. Alphen aan den Rijn, 1975.
See review by P. Biesboer, *Simiolus*, 10 (1978–9).

VROOM, HENDRICK CORNELIS

Russell, M. *Visions of the Sea. Hendrick C. Vroom and the Origins of Dutch Marine Painting*. Leiden, 1983.
Standard monograph (without *œuvre* catalogue). The chapter on 'Mundus Mare – The vanitas seascape' offers an excellent, brief survey of marine symbolism.

WEENIX, JAN and JAN BAPTIST

Stechow, W. 'Jan Baptist Weenix', *A.Q.*, 11 (1948).

Stechow, W. 'A Wall Paneling by Jan Weenix', *Allen Memorial Art Museum Bulletin*, 27 (1969).

Ginnings, R. J. *The Art of Jan Baptist Weenix and Jan Weenix* (diss.). University of Delaware, 1970.

Schloss, C. S. 'The Early Italianate Genre Paintings by Jan Weenix', *O.H.*, 97 (1982).

WERFF, VAN DER

HdG. Vol. 10, 'Adriaen van der Werff'.

Plietzsch, E. 'Adriaen van der Werff', *A.Q.*, 14 (1951).

Adriaen van der Werff (1659–1722). Hofmaler des Kurfürsten Johann Wilhelm von der Pfalz, exh. cat., Alte Pinakothek, Munich, 1972.

Snoep. D. P., and Thiels, C. *Adriaen van der Werff. Kralingen 1659–1722 Rotterdam*, exh. cat., Historisch Museum, Rotterdam, 1973.

Becker, J. '"Dieses emblematische Stück stellet die Erziehung der Jugend vor". Zu Adriaen van der Werff. München, Alte Pinakothek, Inv. Nr. 250', *O.H.*, 90 (1976).

Gaehtgens, B. *Adriaen van der Werff 1659–1722*. Munich, 1987.
Standard monograph and catalogue raisonné; includes a transcription of contemporary documents.

WET, DE

Chudzikowski, A. 'Les éléments Rembrandtesques dans l'œuvre de Jacob de Wet', *Biuletyn Historii Sztuki*, 18 (1956).

Sumowski *Gemälde*. Vol. 4, 6: 'Jacob Willemsz de Wet'.

WIERINGEN, VAN

Keyes, G. S. 'Cornelis Claesz van Wieringen', *O.H.*, 93 (1979).

WIJK

Schnackenburg, B. 'Die Anfänge von Thomas Adriaensz Wyck (1620–1677) als Zeichner und Maler', *O.H.*, 106 (1992).

WIJNANTS

Bredius, A. 'Een en ander over Jan Wijnants', *O.H.*, 29 (1911).

HdG. Vol. 8, 'Johannes Wijnants'.

WIT, DE

Staring, A. *Jacob de Wit*. Amsterdam, 1958.
Standard monograph.

Huisken, J., and Lammertse, F., *Jacob de Wit: de Amsteltitiaan. Jacob de Wit: the Titian of the Amstel*, exh. cat., Royal Palace, Amsterdam, 1986.

WITTE, DE

Richardson, E. P. 'De Witte and the Imaginative Nature of Dutch Art', *A.Q.*, 1 (1938).

Manke, I. *Emanuel de Witte 1617–1692*. Amsterdam, 1963.
Comprehensive monograph and *œuvre* catalogue. The author published a supplement to her catalogue in *Pantheon*, 30 (1972).

WITTEL, VAN

Briganti, G. *Gaspar van Wittel et l'origine delle veduta settecentesca*. Rome, 1966.

Zwollo, A. 'Caspar van Wittel (1653–1736)', in the author's *Hollandse en Vlaamse vedutenschilders te Rome 1675–1725*. Assen, 1973.
The chapter offers the best survey of the artist's work and achievement.

Witztum, W. *Drawings by Gaspar van Wittel (1652/53–1736) from Neapolitan Collections*, exh. cat., National Gallery of Canada, Ottawa, 1977.

WOUWERMAN

HdG. Vol. 2, 'Philips Wouwerman'.

Duparc, F. J. 'Philips Wouwerman, 1619–1668', *O.H.*, 107 (1993).

WTEWAEL

Lindeman, C. M. A. A. *Joachim Anthonisz. Wtewael*. Utrecht, 1929.
See sharply critical reviews by F. Antal, *Kritische Berichte*, 2 (1928–9), and W. Stechow, *Kunstchronik*, 63 (1929–30).

McGrath, E. 'A Netherlandish History by Joachim Wtewael', *Journal of the Warburg and Courtauld Institutes*, 38 (1975).

Helliesen, S. 'Thronus Justitiae, A Series of Pictures of Justice by Joachim Wtewael', *O.H.*, 91 (1977).

Lowenthal, A. W. *Joachim Wtewael and Dutch Mannerism*. Doornspijk, 1986.
Standard monograph and catalogue; includes a catalogue of paintings by Peter, Joachim's son.

ZEEMAN *see* NOOMS

Index

Photograph Credits

The author and the publishers wish to express their gratitude to those individuals and institutions who generously supported this publication by waiving or reducing their fees. In most cases, the illustrations have been made from photographs and transparencies provided by the owners or custodians of the works. Those plates for which further credit is due are:

Los Angeles County Museum of Art. Gift of the Ahmanson Foundation: 7; Scala: 20, 320; © Ursula Edelmann, Frankfurt am Main: 73; Artothek: 76 (Joachim Blauel), 152 (Joachim Blauel), 170 (Ursula Edelmann), 216; Courtauld Institute: 80, 231; Photo © RMN: 115, 148, 195, 317, 385; AKG, London: 119, 120; Sächsisches Landesbibliothek Dresden/Deutsche Fotothek: 274; © 1995, Copyright by Kunsthaus Zurich. All rights reserved. The Prof. Dr. L. Ruzicka Foundation: 278; The Governing Body, Christ Church, Oxford: 305; Royal Collections, Royal Palace Huis ten Bosch, The Hague: 313, 314; ICCD, Rome: 316; Los Angeles County Museum of Art: 375; partial gift of Mr and Mrs Edward William Carter, 422; British Library: 399; Copyright British Museum: 91, 425; Paul Voorham: 420.